Teaching Children Art

Jack A. Hobbs
Illinois State University

Jean C. Rush
Illinois State University
The University of Arizona

Prentice Hall
Upper Saddle River, New Jersey 07458

Library of Congress Cataloging-in-Publication Data

Hobbs, Jack A.
 Teaching children art / Jack A. Hobbs and Jean C. Rush.
 p. cm.
 Includes bibliographical references and index.
 ISBN 0-13-104159-2
 1. Art—Study and teaching (Elementary)—United States. I. Rush.
Jean C. II. Title.
 N362.H6 1997
 372.5′044′0973—dc20 96-27721
 CIP

Acquisitions Editor: Bud Therien
Production Editor: Jean Lapidus
Prepress and Manufacturing Buyer: Robert Anderson
Copy Editor: Maria Caruso
Indexer: Maria Caruso
Line Art Coordinator: Michele Giusti
Electronic Art: Maria Piper
 Mirella Signoretto
Color Insert Design and Layout: Mirella Signoretto
Photo Researcher: Joelle Burrows
Cover Design: Bruce Kenselaar
Cover Image: Age 9, male, *Rhinos,* Hong Kong.
 (Courtesy of the International Collection of Child Art,
 Illinois State University, Normal, IL.)

This book was set in 10.5/12.5 Palatino by Black Dot Graphics
and was printed and bound by Courier Companies, Inc.
The cover was printed by The Lehigh Press, Inc.

Printed in the United States of America
10 9 8 7 6 5 4 3 2 1

ISBN 0-13-104159-2

PRENTICE-HALL INTERNATIONAL (UK) LIMITED, *LONDON*
PRENTICE-HALL OF AUSTRALIA PTY. LIMITED, *SYDNEY*
PRENTICE-HALL CANADA INC., *TORONTO*
PRENTICE-HALL HISPANOAMERICANA, S.A., *MEXICO*
PRENTICE-HALL OF INDIA PRIVATE LIMITED, *NEW DELHI*
PRENTICE-HALL OF JAPAN, INC., *TOKYO*
SIMON & SCHUSTER ASIA PTE. LTD., *SINGAPORE*
EDITORA PRENTICE-HALL DO BRASIL, LTDA., *RIO DE JANEIRO*

To **Harry S. Broudy**,
a teacher who brought big ideas in art education
within reach of *everyone*.

J.A.H.
J.C.R.

Contents

Preface

Are you an artist? Do you regularly visit art museums? Or are you someone who "cannot draw a straight line?" Perhaps you have never studied art history and do not even know an artist. Either way, teaching art to children is a challenge. Either way, this book is written for you.

Teaching Children Art reaches out to two audiences: *students* preparing to be elementary art specialists or classroom teachers, and *practicing teachers* who want to know more about teaching art. The book reflects today's approach to art education: the recognition that, whether making art or responding to it, children are engaged in thoughtful, creative activity.

Dramatic changes have occurred in elementary art education in recent years. One of these changes is the belief that art is a subject for serious study. Another is the inclusion of practices drawn from aesthetics, art history, and art criticism, in addition to making art. A third is the reflection of emphases in elementary education itself—active learning, respect for student diversity, performance assessment, and the public demand for more educational rigor, among others.

Clearly, a new and different reference work is needed for a new and different elementary art education. *Teaching Children Art* is written to be that book. *TCA* is more than an overview of the stages of development, curriculum theory, and the characteristics of art media, although it covers these. In addition, it gives you something we believe is more valuable: a sense that education is indispensable to basic literacy in art.

Basic literacy is the ability to understand art concepts, in addition to facts and technical skills, and to apply these concepts with intelligence and discrimination when creating artwork, analyzing it, describing art of the past, or inquiring into its nature and value to human beings. Concepts are ideas. Ideas about form, technique, interpretation, and expression allow students to solve many art-related problems with imagination.

Moreover, serious art study is indispensable to general education. Art is compatible with many other subjects; indeed, some see it as a catalyst for improving the quality of elementary education overall. Creative thought and an appreciation of our visual heritage—as nourished by a sound art education—is a characteristic of the prepared mind, and a mind that enjoys learning for its own sake.

The emphasis on basic artistic literacy found in *Teaching Children Art,* while aimed at those who teach children, is consistent with art instruction for all ages. It is an emphasis that all good art teachers sense but only have begun to articulate within the past 15 years. *TCA* undertakes, by incorporating compatible expressions and dimensions of this

view into a single volume, to reveal a conceptually consistent, integrated, and comprehensive school of thought about elementary art education.

Finally, *Teaching Children Art* is full of practical suggestions and examples of day-to-day teaching of artistic literacy. These include ways of stimulating discussions in aesthetics, using art as a centerpiece for critical thinking, analyzing and criticizing art, eliciting interest in art history, organizing conceptually consistent studio projects, planning a curriculum, assessing artistic performance, integrating art with other subjects, integrating art with the popular culture, reaching out to children with special needs, and teaching art in a culturally–diverse classroom. Many of these topics, as they apply to elementary art education, may be found only here.

A book like this would be impossible without the ideas and consultation of others. We are grateful for being able to draw upon works from other sources—published books and journals as well as unpublished manuscripts and personal correspondence—containing significant contributions to art education by teachers and scholars too numerous to mention individually here, but whom you will find cited throughout our text and on our list of resources for knowing about and teaching art.

In addition, we are indebted to Elizabeth Cochran, elementary classroom teacher, Chicago Public Schools, for sharing her teaching experiences; Lila Crespin, an independent art consultant and former elementary teacher, for her suggestions on classroom procedures with art materials and readability for teachers; to Margaret Klempay DiBlasio, University of Minnesota, and W. Dwaine Greer, The University of Arizona, for reviewing theoretical issues with us; to Wayne Enstice, University of Cincinnati, and Harold Gregor, Illinois State University, for discussing issues important to artists, as well as allowing us to reproduce their paintings; to Donald D. Gruber, middle school art specialist teacher, Clinton, Illinois, Public Schools, for providing his students' art; to Karen Hamblen, Louisiana State University, who reviewed the material and advised us on the subject of cultural diversity; to Donella Hess-Grabill, Illinois State University, who reviewed the material on children with special needs; to Jessie Lovano–Kerr, The Florida State University, who provided information on the Comprehensive Holistic Assessment Task (CHAT) of the Florida Institute for Art Education; to Stevie Mack, CRIZMAC Art and Cultural Education Materials and former elementary art specialist teacher, for providing examples of child art, art learning materials, and a readability assessment; to Stephen Meckstroth, Illinois State University, who provided examples from the university's collection of African art; to Barry Moore, International Collection of Child Art, Illinois State University, for examples from the collection; to Richard A. Salome, Illinois State University, who helped us with the chapter on graphic development; and to Donald Jack Davis and R. William McCarter, University of North Texas, for their information about the collaborative teaching model of the North Texas Institute for Educators on the Visual Arts. Nothing is more appreciated than friends willing to augment authors' knowledge and to point out infelicities of thinking or wording. We appreciate their advice so freely given.

In addition, many reviewers of our entire manuscript exercised their good sense and sharp eyes to prevent errors in judgment and format. We especially thank Laura H. Chapman, independent consultant in art education, Cincinnati, OH; Edmund B. Feldman, University of Georgia; Stephen LeWinter, University of Tennessee; Carol Seefeldt, University of Maryland; Jon W. Sharer, Arizona State University; Nancy E. Walkup, University of North Texas; and Nathan B. Winters, University of Utah. Finally, we thank Norwell (Bud) Therien of Prentice Hall for his patience and support for this project from the beginning. We also thank Jean Lapidus for her expertise and skill in overseeing the production phase, as well as Joelle Burrows for photo research, and Maria Piper and Mirella Signoretto for the electronic art and color insert.

Jack A. Hobbs
Jean C. Rush

1

What is Elementary Art Education About?

Twelve-year-old Edward sits at a computer in his bedroom. He is writing his seventh-grade social studies report, a unit on China illustrated with color photographs from a CD-ROM encyclopedia. You could easily mistake the format of Edward's report, both its cover and its typeface and layout, for an issue of *National Geographic* (a magazine Edward admires). It is easy to see that Edward has spent a long time on his report, convincing evidence that he enjoys what he is doing.

Edward has been studying art since kindergarten and computer skills since third grade, although not in art classes; his experiences in art were with more traditional media. Since entering middle school last year, Edward has taken 9 weeks of basic design and 9 weeks of art history. The benefits of these studies are visible in the quality of his report.

Does Edward seem like an above-average elementary art student? There are more children like Edward in our schools than you might imagine, and many more to come. Some may be especially gifted in art, some merely technologically adept; either way, their computers, color monitors, laser printers, and CD-ROMs are light years away from a felt-tip marker, a pair of scissors, and library paste. Yet, the Edwards among tomorrow's adults—most of whom will not be artists—will need even more acquaintance with art in order to

get the most from their twenty-first-century lives. How can you, as an art teacher, challenge an adolescent who may be more computer-literate than you are?

You will soon be answering real classroom questions like these. You are embarking on one of the most exciting and timely pursuits in all of education: teaching children art. Moreover, the art period is often elementary students' favorite part of the school day.

You also can take pride in the fact that art activities—whether using paint, modeling clay, the computer, or just looking at and talking about artworks—are not only an enjoyable diversion from the more "academic" routines of school but can provide worthwhile learning in their own right. Art allows children to give form to their experiences of self and environment, thus giving you, their teacher, a fresh view on their world (Fig. 1–1). In addition, art can be a catalyst for organizing and enlarging upon other learnings in the classroom, often providing a perspective on knowledge unavailable in other subjects.

What would our society be like without art— no films, paintings, sculptures, jewelry, pottery, architectural monuments, product designs, advertisements, or even comic strips? Because of your interest in teaching, you may find it hard to imagine such an impoverished world. Perhaps you

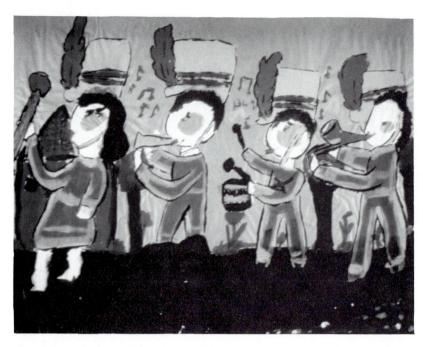

Figure 1-1 Drawing by an 8-year-old girl.

(Courtesy of International Collection of Child Art, Illinois State University, Normal, IL.)

already recognize the visual arts as an essential means of nonverbal communication, as a language we share with other cultures, and as a primary source of information about past civilizations, as well as a source of pleasure and satisfaction.

Unfortunately there are many adults from varied backgrounds who, for various reasons, cannot appreciate or participate in the riches of their visual culture as fully as they could. The challenge of elementary art education is to create a school environment that will prevent such a misfortune in the future by nourishing children's aesthetic sensibilities and inventive capacities. If this sounds like a big job, it is. But what a rewarding one! This book is intended to help you meet this challenge and reap its rewards, whether you are now, or plan to be, a member of the teaching profession, and whether you are more interested in teaching an elementary grade or specializing in art.

Many questions about teaching may spring to mind. What will I teach? Do I know enough about art? Or children? If art fosters individual expression, how can I teach art to a roomful of second graders all at the same time? What more will third graders or sixth graders require? Will my classroom be a mess?

You are right to ask these realistic questions. In order to teach art well, you will want to know about many facets of art education: such things as why you should teach art, what to teach, and what research says about the nature of children and child development. You will also need to understand the language of art, the nature of visual problem solving, how to organize lessons and classrooms, and whether or not you can reach children with widely varying abilities.

Examining these and other aspects of elementary art education is the task of our book. This chapter begins by sorting out and highlighting some of the basic themes involved in its title: What is elementary art education about? These themes, too, may be posed in the form of leading questions: What is the role of art education today? What is the nature of artistic development? How do I go about teaching art? Can I reach all learners? What is the language of art? Does the school environment accommodate art? In conclusion, we will see how art education has become what it is today.

WHAT IS THE ROLE OF ART EDUCATION TODAY?

To most Americans, there is something magical about art. We recognize that every child has the potential to express feelings and ideas through

images, and this seems akin to what artists in our society are able to do. Conventional wisdom calls this magic *creativity*—the ability to think and to express those thoughts with ingenuity. Today, many educators recommend that all students experience the arts during their elementary years (although visual art is not necessarily found in the curricula of all grade-school districts).

Aesthetic literacy is another benefit of art education. Aesthetic literacy refers to being able to "read" or interpret another person's images in order to enjoy and appreciate them. Understanding art unlocks the treasures of the world's diverse cultures for students, and also allows them to communicate across cultures. Children today live in a global society in which all kinds of information carried by television images, both aesthetic and nonaesthetic, is already changing lives worldwide.

Many art programs offer children comprehensive knowledge about art. Art has become a school subject studied seriously in its own right. Comprehensive art introduces children to concepts drawn from aesthetics, art criticism, and art history as well as from making art. The term *knowledge* refers not simply to a collection of facts, but also to the many ways that children can use information to invent new knowledge—by describing, analyzing, interpreting, and evaluating. These processes constitute what we ordinarily call creativity, and we can teach them to children.

It is tempting to go on. Instead, we recommend that you read more about these issues in Chapter 2, *Why Teach Art?* and Chapter 3, *Knowing What to Teach*. Both of these discuss in detail the rationale and the content for art education.

WHAT IS THE NATURE OF ARTISTIC DEVELOPMENT?

This book is about elementary art education, that is, children from early childhood through eighth grade. You may be surprised to learn that there are astonishing differences between the artistic performance of 5-year-olds and that of 13-year-olds. These raise a classic question in the field: are the differences between the drawings of a 6-year-old and a 10-year-old due mostly to natural development or to environmental influences; in other words, to "nature" or "nurture"? This question, a venerable one about learning and child develop-

ment that goes back to the Greeks (and applies to all forms of children's artistic expression), is treated in detail in Chapter 4, *Child Development in Drawing*.

Do 6-year-olds like the same kind of pictures as 10-year-olds? Children's responses to art, what we might call their aesthetic behavior, also vary according to their ages and levels of mental development. You may satisfy your questions regarding children's typical responses to art in Chapter 5, *Child Development in Responding to Art*.

Meanwhile Chapter 6, *Thinking Without Words*, examines children's use of symbols and aesthetic concepts in artistic problem solving. There is considerable evidence that children think as they make art, and that they think with visual images. We can understand children's artistic thinking better by observing how artists think—how they pose artistic problems and how they reason as they solve them. Let us not forget thinking with words, however, and the art historians and art critics who use them inventively. Teaching children art means teaching them to think with both images and with words.

HOW DO I GO ABOUT TEACHING ART?

Knowing the rationale for art and children's ways of processing nonverbal information is a good start, but these do not address such issues as planning and devising a curriculum, establishing scope and sequence, and implementing a curriculum. Are there reliable up-to-date curriculum guides? Are there graded textbooks on art for children to use? If not, where do you start?

How do you include art history, art criticism, aesthetics, and studio art and still maintain conceptual focus? Art education majors or art specialists who are comfortable teaching studio projects may feel uneasy with leading discussions or having students write papers. Elementary education majors or classroom teachers, who easily handle the latter, may find themselves uncomfortable about teaching studio art. And both are apt to exclaim about aesthetics, "I didn't study that in college!"

What about integrating art with other subjects? How do you go about combining art with social studies, with language arts, or with science? Can you do this on your own? What are the advantages and disadvantages of interdisciplinary units? What are the pitfalls of working with other teachers?

Five chapters in the middle of the book—and they are long ones—seek to answer these questions: Chapters 7, *Planning an Art Program*, 8, *Thinking and Talking About Art*, 9, *Problem Solving in Tutored Images*, 10, *Accounting for Learning*, and 11, *Integrating Art with Other Subjects*.

CAN I REACH ALL LEARNERS?

Knowing how most children respond to and perform in art at various age levels does not necessarily prepare you to deal with all of the kinds of children in American schools. Consider, for example, the effects on art of cultural differences related to geography, such as between New England and Texas, or related to density of population, as among inner city, suburban, and rural settings, or related to wealth, as between rich and poor.

Also, as you know, Americans come from diverse racial and ethnic groups. By the year 2000, one third of all students in America will consist of these minorities. In addition, not all American children come with the same bundle of capacities. You will most surely work with exceptional children at some time during your teaching career.

The terms *multiculturalism*, *inclusion*, and *diversity* are recurring watchwords in the literature of art education today. Should all students receive the same lesson content, but different teaching methods, depending on the group? Or should each group receive different content and teaching? These and other issues are examined in Chapter 12, *Art for the Culturally Diverse Classroom*, and Chapter 13, *Teaching All Learners*.

WHAT IS THE LANGUAGE OF ART?

To the extent that aesthetics, art criticism, and art history are now part of art education, establishing the nature of art becomes an important undertaking. This may strike those of you who are not college art majors or art specialist teachers as odd. After all, one assumes that an art educator knows what art is. But those of you who are specializing in art realize that in today's world it is not easy to pin down the concept of art (sometimes specified as the *visual arts*).

In the mid 1800s, when art education was just getting started, art was easy to define. It was painting, sculpture, and architecture made in the Western tradition. Beginning around the turn of the century, three developments occurred that were to substantially change the visual arts: (1) the acceptance of crafts as art (Fig. 1–2), (2) the acceptance of non-Western aesthetic objects as art, most noticeably Japanese wood-block prints and African sculpture, and (3) the modern art movement.

In the late 1800s a movement known as *arts and crafts* revived the making of objects like furniture and pottery by hand in protest against the aesthetically inferior, mass-produced products of the new industrial age. The new sciences of archeology and anthropology stimulated a growing interest in various kinds of tribal objects: masks, cult images, charms, and even tools and weapons (Fig. 1–3). Eventually these "artifacts" came to be appreciated as art, and today every major art museum has a significant collection of well-designed utilitarian objects and non-Western art from a variety of times and places.

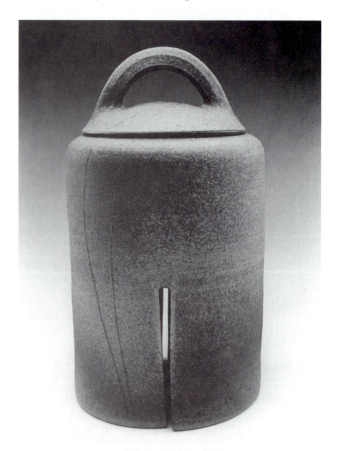

Figure 1-2 Karen Karnes, *Covered Jar*, 14" high. Stoneware pot with lid, 1988.

(Courtesy of Garth Clark Gallery, New York)
(Photograph by Karen Karnes)

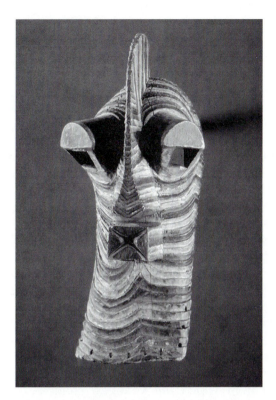

Figure 1-3 African Mask, wood with pigment, 24 1/4" (61.7 cm) high. Songe peoples, Eastern Central Congo. (Item 7335, mask, Songe peoples)

(Courtesy of The African Collection, Illinois State University, Normal, IL.)

In the early 1900s modern art not only challenged realistic styles, it also introduced new ways of thinking about and making art. New media (materials and methods) stemming from new technologies, such as photography, film, video, and computer art, made their way into the art world. Some contemporary art, known as "happenings" or "performance art," even makes use of the human body (Fig. 1–4).

The visual arts today are not only incredibly abundant but also incredibly diverse. Artists and art critics are constantly redefining the visual arts in response to creative breakthroughs and changing intellectual moods. The different media and their visual concepts—what artists, art historians, critics, and aestheticians employ and how they use them speaking in the language of art—are reviewed in Chapter 14, *The Language of Art*, Chapter 15, *Processes in Two-Dimensional Art*, Chapter 16, *Three-Dimensional Art*, and Chapter 17, *The Art of Sequence and Movement*.

DOES THE SCHOOL ENVIRONMENT ACCOMMODATE ART?

The requirements of art production differ from those of most classroom subjects, and managing them with skill takes practice. There are standards for children's responsible classroom behavior even though they are engaged in active learning. One of your primary responsibilities will be to maintain a safe environment for your students because some art materials are hazardous to children's health.

You, not the buildings you teach in, will create the learning environment in your classroom and beyond. You may find yourself helping colleagues in your school or district to learn about art. You may become an observer in others' classrooms, evaluating their teaching or the success of your district art program.

There is widespread interest in educational reform today. Reform involves the discussion of many issues. What constitutes excellence in art

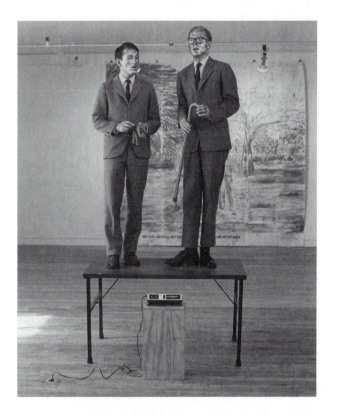

Figure 1-4 Gilbert and George, *The Singing Sculpture* in *Underneath the Arches . . . 1971.*

(Courtesy of Sonnabend Gallery, New York.)(Photograph by Nick Sheidy)

education? Should there be a national curriculum? Should the art teacher be an artist? Can the arts become a catalyst for reform in other subjects? You will find discussions of these and other topics in Chapter 18, *Classroom Protocols in Art*, Chapter 19, *The Learning Environment*, and Chapter 20, *Educational Policy and the Arts*.

HOW DID ART EDUCATION BECOME WHAT IT IS TODAY?

Although the presence of art in the elementary curriculum is taken for granted today, this was not always the case. In the cathedral schools and academies of preindustrial Europe, children learned basic literacy, the Bible, and Latin—but not art. In the towns and villages of the American colonies, where most children grew up in the Puritan faith, there was little time for art, let alone for teaching it in the schools. Before the nineteenth century, art education for children was virtually unknown in Europe or America.

The Common School Movement and Drawing

In the early 1800s, educators in this country began to hear about the methods of Johann Heinrich Pestalozzi, the famous Swiss educational reformer. Among other things, Pestalozzi advocated the teaching of drawing. Prior to the Civil War, manuals on drawing appeared, and a few American educators were bold enough to try teaching it. Influential in this regard was Horace Mann (1796–1859), who traveled to Prussia to observe that country's methods of teaching drawing and returned to publish his observations in an 1844 volume of the *Common School Journal*.[1] Up to this point, however, drawing in American schools was isolated and sporadic.

Walter Smith

Following the Civil War, Massachusetts textile mills began to lose their market share to foreign competition. It had become painfully clear in the 1867 Paris world's fair that, compared to the products of other countries, Boston's were lacking in good design. A generation earlier, the English apparently solved the same problem by introducing drawing into the schools. Right or wrong, the assumption was that workers would produce better products if they knew how to draw.

Prompted by a petition signed by Boston business leaders, the Massachusetts Board of Education passed the Drawing Act of 1870. In 1871, Walter Smith, an English drawing master familiar with England's system, accepted the positions of art supervisor for the city of Boston and art education supervisor for the state of Massachusetts. As if these jobs were not enough, he founded and became the first head of the Massachusetts Normal Art School.

Smith created a graded curriculum of drawing and a system of preservice and in-service training for teachers of art. He also established links with the community through talks and exhibitions of children's drawings. In other words, he was the first to *institutionalize* art in the schools.

What was Smith's art program? A rigorous system in which the youngest children copied simple geometric patterns drawn by the teacher while older elementary children observed and drew simple geometric shapes. Except for uniform increases in complexity, including some drawing from plaster casts of human anatomy in high school, this rote style of learning remained essentially the same throughout the grades. Anyone familiar with art education today finds it ironic that the field had its beginnings in a program intended to prepare people for the trades and organized around geometric drawing and copywork.

The Child-Centered Tradition

Pestalozzi's system of drawing was also geometric (though intended to improve children's powers of observation and handwriting skills rather than prepare them for industry). Pestalozzi is not remembered for his drawing instruction, not even by art educators. He is remembered for being the prophet and initiator of *child-centered* education.

Child-centered education is organized around the needs of the child rather than around subject matter, employing methods that involve direct contact with the physical world as much as possible. To learn geology, for example, students are

exhorted to examine real rocks and soil samples rather than study terminology. "Hands-on" and "active learning" are favorite watchwords.

Pestalozzi, a compassionate man who founded a school for orphaned boys at Yverdon, Switzerland, was a follower of the famous romanticist Jean Jacques Rousseau. Pestalozzi, like Rousseau, believed that children were inherently good, and that evil entered the individual via influences from society. The moral conflict between human potential and the demands and distractions of a corrupt society is a perennial theme among both romantics and child-centered advocates.

Friedrich Froebel, who studied and taught with Pestalozzi at Yverdon, echoed his mentor's beliefs about the sanctity of the child. His particular interest in early childhood led him to an original insight—the importance of play. In a special school for young children that he called a *kindergarten* (children's garden), Froebel devised a curriculum—a system of "gifts"—based on this insight. Designed to stimulate learning through well-directed play, the gifts consisted of such things as colored balls of yarn and all kinds of forms carved from wood. With these, the children were expected to form concepts of color, number, and proportion, but also to exercise their abilities to come up with creative arrangements.

In America, the child-centered tradition was to take a different turn in the latter part of the nineteenth century. G. Stanley Hall led the *child-study movement* (the precursor of educational psychology). Like Pestalozzi and Froebel, Hall placed the child at the center of the educational process. But unlike them he relied not on idealism or intuition, but on science.

Hall established the nation's first psychology lab (at Johns Hopkins University) and launched the *American Journal of Psychology*. In a widely read monograph, "The Content of Children's Minds" (1891), he reported his discovery that children think more in pictures and gestures than in words.[2] This led him and his colleagues to explore the nature of child imagery. As one of them explained, "A few years ago we scolded and whipped children [for natural drawing]; today we must see it in a most valuable line of development."[3] Another colleague developed a theory of developmental stages in drawing. Hall and his colleague were interested in child art because of

its *clinical* value rather than its artistic value. Nevertheless, the serious study of child art, in and of itself, was a breakthrough for art education.

At first, few, if any, connections were seen between these developments and the actual practice of teaching art. By the turn of the century, however, such connections became more apparent. By now, it is fair to say that theories in art education are indebted to the pioneering work of Hall and his colleagues. Recent practices in art education usually resemble those of Froebel more than those of Walter Smith.

John Dewey and Progressive Education

One of Hall's doctoral students at Johns Hopkins was John Dewey. In 1894 Dewey accepted a position at the University of Chicago where he began to publish his ideas on education and to establish a laboratory school. The school became the site of child-centered experiments where Dewey often expected the students, not the teachers, to set the agendas.

"It is always *today* in the teacher's practice," Dewey exhorted.[4] But the students' agenda notwithstanding, the teacher's knowledge was also important. In Dewey's system, the teacher needed to know both subject matter and the needs of the student. The challenge was to keep the experience of the student flowing in the direction of what the teacher already knows.

Dewey later continued his interest in and writing on the subject of educational reform from a new position at Teachers College, Columbia University. Because of his reputation as a profound thinker—on numerous subjects, not just education—his credibility was incontestable. Meanwhile, the attention he was attracting was beginning to assume the proportions of a movement. By the 1920s, a society and a journal with the name *Progressive Education* had been launched as more and more joined the crusade.

How was the spirit and thinking of progressive education reflected in art education? Words such as "creativity" and "expression," and phrases such as "self-directed activity" and "child-as-artist" began to appear in the educational literature. In a 1926 issue of *Progressive Education*, Hughes Mearns advocated giving wing to the child's "natural creative impulses."[5] In a 1924 art

methods text Margaret Mathias, a product of Teachers College, liberally quoted Dewey to argue for the fostering of "self-expression" and helping students only "as the need arises and is felt by the children."[6] Mathias also provided her version of the stages of development in drawing—"manipulative," "symbolic," and "realistic"—though without grade-level equivalents.

Other Traditions, Some Short Lived

Other practices in art education came and went between the times of Walter Smith and Mathias. Manual training coexisted with art until the Smith-Hughes Act (1918), which made federal subsidies available for vocational education, thus prompting art and industrial arts to go their separate ways. A movement called *picture study*, intended to instill not only art appreciation but also moral values, emerged at the turn of the century. By the 1920s it, too, had waned.

Some practices had more staying power. Providing lessons on design, a practice initiated by Arthur Wesley Dow at the turn of the century, continued into the twenties and even later (see Chapter 14, *The Language of Art*). A popular methods text, also published in 1924, was dedicated to Dow and organized around the elements and principles of design: "mass," "unity," "balance," "rhythm," and so forth.[7] These principles were invoked in a program called "Art for Daily Living," a depression-era concept aimed at elevating community taste in the home and the workplace.

Still, the overriding trend in American art education was the increase in child centeredness. One reason is that art (particularly *making* art) is perfectly suited to the aims and methods of child-centeredness. Because it is enjoyed by children—given the right conditions—it can be said, at least to this extent, to satisfy their needs. Further, it is clearly a hands-on active pursuit in which the student is in contact with physical material.

Viktor Lowenfeld

In 1947, 9 years after fleeing the German invasion of his native Austria, Viktor Lowenfeld published the first edition of his highly influential *Creative and Mental Growth*. In the book's opening

sentences Lowenfeld stated, "If children developed without any interference from the outside world . . . Every child would use his deeply rooted creative impulse without inhibition, confident in his own kind of expression."[8] Lowenfeld felt that modern society tends to repress natural creativity.

But Lowenfeld also affirmed a direct connection between spontaneous creativity and mental health. Describing the case of a disturbed boy, Lowenfeld explained that the boy was inhibited because he had lost confidence in his drawing ability, which in turn had been caused by his parents setting standards that were too strict. "Don't impose your own images on a child! . . . Never let a child copy anything!" Lowenfeld admonished.[9]

Although warning against adult imposition, Lowenfeld did not advocate passivity on the part of parents or teachers, nor did he downplay the mental side of development. To the contrary, he was very specific about the need of age-appropriate strategies for eliciting authentic self-expression in order to foster the growth of the whole child. To this end, he provided psychologically based descriptions of the stages of artistic development, from "scribbling" (ages 2–4) to the "crises of adolescence" (ages 13–17), together with ways to stimulate creativity and evaluate results at each stage. He even included elaborate tables with listings under such headings as space, color, human figure, design, and stimulation topics.

Lowenfeld's descriptions of child development in art were vivid and authoritative. These, together with an almost evangelical tone of writing, captured the imagination of a whole generation of art teachers. Lowenfeld had provided them not only with an articulated program, but with a rationale based on the most urgent of human needs: sound mental and emotional growth. In other words, if a child did not receive creative art in school, his or her growth into a normal, healthy adult might be jeopardized. In keeping with Lowenfeld's philosophy, the 1949 position statement of the newly formed National Art Education Association (NAEA) held that *"art is less a body of subject matter than a developmental activity"* (italics added).[10]

In the late 1950s, reacting to the successful launching of a space satellite (*Sputnik*) by the Soviet Union, American education experienced a pendulum swing toward the academic subjects.

Art educators' reaction was not to change their commitment to a hands-on art program, but to change their rhetoric. Instead of promoting self-expression and mental health, art education literature promoted creativity, as articles on the need for "creative problem-solving" flourished. This shift in semantics, intended to suggest that the problems of the space industry could be solved by creative studio projects in the school, was an effort on the part of art education to defend its niche in general education.

Post Lowenfeld

By the mid 1960s, a soul-searching examination of basic premises occurred among art education leaders, that is, those actively publishing articles from, primarily, positions in higher education. Psychological models, particularly Lowenfeld's, were brought under scrutiny. Researchers criticized Lowenfeld for making extravagant claims for his methods, assuming his descriptions of child art were universal, and excluding art history and art criticism from the art education.

Art educators also questioned the Lowenfeld-influenced emphasis on mental health and personality development that pervaded the field. In 1964 the NAEA changed a sentence in its position statement to read that art *is a body of knowledge* (italics added). Anthropological and sociological models for understanding child art were introduced, especially by June King McFee. Art history and art criticism received more attention. Several doctoral dissertations were devoted to the study of perception. In 1966 Ralph Smith launched the *Journal of Aesthetic Education*.

An influential event of the 1960s was a seminar on aesthetics and art criticism held at Pennsylvania State University in 1965. The ideas generated in that seminar—encapsulated in a publication popularly known as the *Penn State Papers*[11]—became the seminal influence behind a series of curriculum development projects on aesthetic education. A pervasive theme of those papers was that art education possessed, or should possess, a structure like that of any other academic discipline, and that its content should be broadened to include ideas from art history, art criticism, and perhaps other allied fields as well. *Aesthetic education* was the rubric often used to

refer to this new thinking about art education.

It should be understood that not everyone was enthusiastic about either aesthetic education or the notion of structure. Many art teachers continued to champion the Lowenfeld model, which was more attuned than aesthetic education to a development in the late 1960s called the *open classroom*. Child centered and antistructure in the extreme, the open-classroom movement received a great deal of attention not only in the educational literature but also in the public media. By the early 1970s even some rural districts in middle America were literally tearing down walls to accommodate the new trend.

The open classroom concept served eventually to stimulate a negative reaction, and the mid 1970s saw the emergence of a "back-to-basics" sentiment. Members of this conservative movement ranged from those who advocated more quality in the schools to ultra conservatives who wanted to revive the "3 Rs." Some art educators, especially those who noticed art programs being lost to academic subjects, began to fashion a rationale for art as a basic subject. In 1979, the NAEA published a monograph, edited by Stephen M. Dobbs, entitled *Arts Education and Back to Basics.*[12]

By the early 1980s a chasm had become apparent between the arts and the academic subjects in elementary education. All across America public school funding cutbacks forced districts to make painful choices, and many art teachers lost their jobs. In California alone, passage of an initiative to reduce property taxes, Proposition 13, resulted in the dismissal of all elementary art specialist teachers in the public schools.

Art As a Subject of Serious Study

It was with reference to California classroom teachers' need for assistance in teaching art that art educator W. Dwaine Greer first devised and named discipline-based art education. In a 1984 article published in *Studies in Art Education*, the research journal of the NAEA, Greer set forth the principles of DBAE, as discipline-based art education has come to be known. According to Greer, DBAE referred to art education that followed three principles of content, curriculum, and con-

text. It was to base its content on four disciplines of the arts: aesthetics, studio production, art criticism, and art history. It was to teach art "by means of a formal, continuous curriculum in the same way as other academic subjects."[13] It was to adapt itself to the environment of the public schools, rather than try to change school practices to accommodate art.

The content of DBAE was certainly not new; Greer had brought together strands of thinking dating to the 1960s when art educators began to reexamine the premises of art education. But Greer's insistence on interrelating concepts from a number of disciplines, supported by written curriculum and school-friendly instruction, was decidedly innovative. Greer's model did more than merely embellish studio-based art programs; it proposed ensuring children's systematic conceptual development in all areas of art, even when working with art materials.[14]

And significantly, DBAE was a synthesis that caught on! Maybe it was the easy-to-remember label. Undoubtedly the early backing of the J. Paul Getty Trust was crucial.[15] Certainly the successes of the Getty Los Angeles Institute for Educators on the Visual Arts, 1982 to 1989, and subsequent regional consortia for professional development played important roles.[16, 17, 18]

The conservative thinking about education under the patronage of the Reagan-Bush administrations also gave DBAE some momentum. Numerous commissions and study groups published reports on the allegedly deplorable state of the nation's schools and demanded a greater commitment to excellence. The Getty Education Institute for the Arts, formerly the Getty Center for Education in the Arts, held national workshops and disseminated many publications in support of the DBAE concept.

Whatever the reasons, DBAE managed to energize a change in the direction of art education. Discourse on DBAE, both pro and con, dominated the programs of the NAEA annual conferences throughout the 1980s as its principles gradually earned teacher approval. DBAE did not gain favor without a struggle. Many art educators criticized DBAE for being too structured, too teacher centered, too Eurocentric, and too elitist in its insistence on teaching the fine arts, and many still do.[19] DBAE is not without areas needing improvement, but it is fair to say that those involved with it have

been open to criticism and worked hard to improve its philosophy and practices.

Over the years since 1982, discipline-based art education has evolved in a way consistent with practices in elementary education as a whole. Teaching cognitive skills has replaced behavior modification, for example; in art, teaching cognitive skills has enhanced children's ability to use media in an expressive way. Schools have emphasized the teaching of values; teaching students to value many kinds of art—commensurate with the multiple aesthetic values within our diverse society—has expanded the traditional focus on the aesthetic legacy of Western Europe. Art teachers have shaped discipline-based art education to suit varied local educational agendas until, today, we can find many forms of DBAE. [20]

Have their changes eroded Greer's original vision, or has DBAE prospered by adapting to changing times? Significantly, by the 1990s, there were signs that the discourse had begun to impact the field at all levels. The new position statement of the NAEA, while not calling itself discipline based, was congruent with DBAE principles—or perhaps vice versa, depending on your point of view. Outcome statements for teaching art drafted by state boards of education also reflected the influence of DBAE principles. Textbooks on art history and art appreciation were being marketed for use in the public schools in quantities not seen since the turn of the century.

Most significantly, the *Goals 2000: Educate America Act*, a law passed by congress in 1993, acknowledged that the arts are a core subject—as important to education as English, mathematics, history, civics and government, geography, science, and foreign language.[21] Pursuant to this legislative initiative, the National Art Education Association and other arts associations drafted sets of national standards for their respective fields. The standards for the visual arts—while not using the same language as DBAE—clearly reflect the influence of the discipline-based movement.

SUMMARY

In teaching children art, you face the challenge of preparing them to live in tomorrow's world. In elementary education you may find yourself teaching three- or four-year-olds, or twelve-year-

olds like Edward, or any age and ability level in between. Each child has different needs. We intend to give you the means to be a confident and effective teacher, but you are providing the most essential thing—your commitment to children and to seeing them succeed.

You have many questions about what and how to teach. This is a good sign—it means you are approaching teaching realistically. Have we answered your questions about elementary art education in this chapter? Certainly not! We have only helped you raise some more.

Our intent is to pique your interest in the field by teasing out numerous issues you will encounter in your search to find out what elementary art education is: What is the role of art education today? What is the nature of artistic expression? How do I go about teaching art? Can I reach all learners? What is the language of art? And finally, how did art education become what it is today? We hope you will be able to find answers to most of those questions within the following pages of this book, and that they will give you a well-rounded picture of American art education.

Our field has gone through many phases since its beginnings in the nineteenth century. At one time or another it has emphasized drawing, manual training, picture study, moral education, design, mental health, and creativity. In addition to its own pendulum swings, art education has reacted to the periodic swings and changes in mood that occur in public education as a whole.

Knowing the past of art education is a logical starting point for beginning to understand the present, and perhaps to answer your many questions concerning what art education is about now. Don't expect to find simple answers, or any one answer, in the following pages. Still, after reading those pages, your understanding of the field should be much richer. And then, perhaps, you will be in a position to formulate your own questions and answers as you practice art education into the next century.

NOTES

1. Mann, Horace. (1844). *Common School Journal* Vol. VI, p. 354.

2. Wygant, Foster. (1983). *Art in American schools in the nineteenth century.* Cincinnati: Interwood Press, p. 109.

3. Barnes, Earle (ed.). (1896–97). *Studies in education: A series of ten numbers devoted to child study and the history of education.* Palo Alto, CA: Stanford University.

4. Dewey, John. (1916). Democracy and Education. In Park Joe (1968), *Selected readings in the philosophy of education.* New York: Macmillan, p. 95.

5. Mearns, Hughes. (1926). The creative experience, *Progressive education* April, May, June.

6. Mathias, Margaret. (1924). *The beginnings of art in the public schools.* New York: Scribner.

7. Boas, Belle. (1924). *Art in the school.* New York: Doubleday.

8. Lowenfeld, Victor. (1947). *Creative and mental growth.* New York: Macmillan, p. 1.

9. Ibid., p. 2.

10. Efland, Arthur D. (1990). *A history of art education: Intellectual and social currents in teaching the visual arts.* New York: Teachers College Press, p. 228.

11. Mattil, Edward L. (Project Director) (1966). *A seminar in art education for research and curriculum development* (Cooperative Research Project V002). University Park, PA: The Pennsylvania State University.

12. Dobbs, Stephen M. (ed.). (1979). *Arts education and back to basics.* Reston, VA: The National Art Education Association.

13. Greer, W. Dwaine. (1984). Discipline-based art education: Approaching art as a subject of study, *Studies in Art Education* 25 (4), p. 215.

14. DiBlasio, Margaret Klempay. (1985). Continuing the Translation: Further Delineation of the DBAE Format, *Studies in Art Education, 26* (4), p. 203.

15. Through the Center for Education in the Visual Arts, Leilani Lattin Duke, Director.

16. W. Dwaine Greer, Director.

17. J. Paul Getty Trust. (1993). *Improving visual arts education: Final report on the Los Angeles Getty Institute for Educators on the Visual Arts.* Los Angeles: Author.

18. There are Getty-funded regional consortia in six states: California, Florida, Nebraska, Ohio, Tennessee, and Texas. See Wilson, Brent. (1996). *The quiet evolution: Implementing discipline-based art education in six regional professional development consortia.* Los Angeles: The Getty Center for Education in the Visual Arts.

19. Burton, Judith, Lederman, Arlene, and London, Peter (eds.). (1988). *Beyond DBAE: The case for multiple visions of art education.* North Dartmouth, MA: University Council on Art Education.

20. For a comprehensive account of these changes, see Delacruz, Elizabeth Manley, and Dunn, Phillip C. (1996). The evolution of discipline-based art education, *The Journal of Aesthetic Education, 30* (3), 67-82.

21. National Art Education Association. (1994). *The national visual arts standards.* Reston, VA: Author.

2

Why Teach Art?

Caroline, 4 years old, works intently at the kitchen table with her colored felt-tip markers. She deliberately and confidently selects the red, then the green, and finally the blue pen as she depicts her dog Teak. She is absorbed in thought. "There's Teak!" she announces upon completing her drawing, which in a timeless and magical process becomes Teak even to our adult eyes.

You may justifiably wonder why we teach art to children when they seem to invent it so well by themselves. In fact, you would be unusual if you did not question the intent of those who intervene in such a natural process as the impulse to express ideas graphically. Can't we leave well enough alone? We know that human beings have drawn or painted or modeled images like the wounded bison at Altamira (Fig. 2–1) since the Paleolithic era (or Old Stone Age), some 20,000 years ago. We still admire the creations of these Stone Age artists for their aesthetic qualities. Surely these early artists did not go to elementary school.

Yet the paintings on those rocky cave walls in Spain and France vibrate with meaning. The images of bison, deer, and sabre-tooth tigers literally capture the spirits of their living counterparts and the experiences of their creators. They give form to memories of the hunt and fears of ferocious predators and hopes for food and the continued fertility of the animals that provide it. They make the invisible, visible, and the forgotten, real.

The animals in cave paintings are depicted so knowledgeably that we can still identify them. We do not know who or where the first artist was, but we suspect he—we believe it was a man—lived long before the Stone Age. We do know that by the Stone Age groups of people inscribed those magic images on cave walls. Moreover, the forms of those images varied from group to group; the people who lived near Altamira had a different artistic style than those who lived at Lascaux (Fig. 2-2) (see **color insert** #1). We conclude that each group of early painters learned art from their community's elders.

Like their forebears, children today also learn the magic of art. We call that magic inventiveness (or creativity or originality or ingenuity); it is the ability to conceive of the new, the different, the undiscovered. Inventiveness is a valuable skill in all fields and to all societies. It is the hallmark of what developmental psychologist Howard Gardner calls a genuine (or disciplinary) understanding of art.[1] Only someone who is knowledgeable *about* art can be inventive *in* it.

AESTHETIC LITERACY

Imagine that you want to build a house, but you find yourself unable to measure and saw wood. The boards you nail together are crooked and

Figure 2-1 *Crouching Bison*, Paleolithic cave painting of a crouching bison (ca. 15,000-10,000 B.C.). Altamira, Spain. (Courtesy of The Granger Collection, #APA136)

unstable. You want lights, but electrical circuits and wiring are a mystery. You like hot and cold running water, but you have no concept of plumbing. You would need to understand concepts drawn from many different bodies of knowledge, whose principles have been established by experts, to build your house.

Creating a work of art (as an artist does), or estimating its significance (as an art critic does), or verifying the authenticity of a work made in the past (as an art historian does), or discussing the nature of art (as an aesthetician does) are all inventive activities. Their makers construct something. Each activity just mentioned uses a different body of knowledge, but each contributes to the house that we call *art*.

Just as it is difficult to build a house without blueprints drawn by an architect, it is difficult to master inventive activities in the visual arts without "blueprints" that spell out basic principles of construction. Each art object, or piece of art criticism, or documentation of historical authenticity, or aesthetic argument is a blueprint in the following respect: each conveys certain concepts selected from the body of artistic knowledge that it represents. The artistic concepts that these objects share are what we call their *aesthetic properties*. Learning to read these aesthetic properties is the process of becoming aesthetically literate.

Aesthetic literacy can benefit all children, whether or not they will grow up to be artists, art critics, art historians, or aestheticians. In order to discover what these benefits are, however, we are going to look at the way knowledge about art informs the activities of these skilled people who make art or respond to it in some way. What distinguishes arts professionals from the rest of us is the inventiveness of their acts: making art, analyzing and evaluating it, researching its past, interpreting and debating its meaning.

The opportunity for inventive activity through art—not facts about art—is what aesthetic literacy can offer all children in elementary schools. We may learn about art from those who practice it most knowledgeably—those we call artists, or critics, or historians, or aestheticians—but these opportunities are available to all of us. How sturdy a house each of us will build and how innovative it may be depends upon the the effort we make, the knowledge we accumulate, and perhaps (for a few) upon some innate aptitude—shall we call it talent?—that is difficult to define. All children may become builders as well as adults. Nurturing children's inventiveness through art is an appropriate and attainable goal for those of us who teach art in elementary schools.

Why Learn Art?

If our goal is to teach inventiveness the question *Why teach art?* is not the same as *Why learn art?* (or Why learn about art?), although the two questions are similar. Before we provide reasons for teaching art, we should clarify the distinction between teaching and learning. Why teach art? asks about the process of art education: the ways in which organizing knowledge can facilitate its acquisition. Why learn art? asks about the end result of art education: the benefits art knowledge can bring to individuals' lives.

Before discussing why we teach art, let us consider why children should learn it. Chapter 1 provided some reasons that are widely held: in order to understand human experience, think inventively, express and interpret nonverbal ideas, remember past civilizations, appreciate other cultures, make discriminating judgments about our own culture, and enjoy the spiritual riches of the visual arts now and in the future. These benefits of art are essential for any child whom society will one day consider broadly educated.

The Role of Imagery

Educational philosopher Harry S. Broudy points out how works of art accomplish these ends. All of the arts provide us with portraits of human feeling.[2] Aesthetic images, like all images, convey information—about hope or despair, wealth or poverty, virtue or depravity, courage or cowardice, and all the rest of our human values and conditions. We will explore the value of interpreting these messages of art in coming chapters.

The extent to which children can create or understand aesthetic images depends upon the richness of their knowledge about art. Much of this knowledge takes the form of mental images that are unavailable from any other school subject. When elementary education can equip children with a rich store of images, it gives them a key to their cultural heritage.

Children are unaware of cultural benefits of art; they learn art because it is self-fulfilling. Our collective society, however, wants elementary school children to learn art for the same reasons we want them to learn the physical sciences, or math, or history, or the social sciences. We want children to learn what they will need in order to become fully participating members of society—not only an American but a global society, not only in today's world but in tomorrow's.

Serious Art Study

Art educator Diana Korzenik tells us that in 1877 an Ohio drawing instructor, Langdon S. Thompson, gave three reasons why children should learn to draw that still describe thinking in art education. The first reason was *disciplinarian*, "the development of intelligence, exercising perception, judgment and imagination." The second was *utilitarian*, "how it will help the child grow into an adult who can use art to earn a living." The third was *aesthetic*, "the development of taste, love of the beautiful," and appreciation of "the highest degree of culture known or imagined in this life."[3] Korzenik extends Thompson's disciplinarian reason to include "art making as a tool for children's learning other school subjects."[4]

Thompson's reasons apply to aesthetic literacy in its broadest sense, not only regarding studio activities but the contemplation of the meaning of art. As you may recall from Chapter 1, over the course of time Americans came to see art making in public schools as frivolous. Schooling has practical as well as self-fulfilling purposes, and American parents have tended to favor practicality. Especially after the Sputnik crisis in the 1950s,

when the survival of democracy seemed to depend on science and technology, parents wanted their children to learn more about these subjects even if they crowded the arts out of the school day.

Today parents understand that studies in art can be just as rigorous as in other subjects. Contemporary post-cold-war society has a crisis of values. In this climate, the arts have academic standing because of their ability to convey cultural values and self-esteem. Educators, legislators, business leaders, and parents involved in educational reform describe their educational goals for all subjects in similar language. For example, the United States Department of Labor identified a number of competencies necessary for the modern workplace that could also apply to art They include the following:

- Creative thinking.
- Decision making.
- Problem solving.
- Learning how to learn.
- Collaboration.
- Self-management.[5]

Debates following publication of the *Goals 2000: Educate America Act*,[6] mentioned in Chapter 1, suggest that the arts may even be used as catalysts to produce reform in other school subjects. Some data show that "the best schools have the best arts programs."[7] Many people in the sciences as well as in the arts now argue that inclusion of the arts in an elementary school curriculum improves the quality of its academic education.[8]

Cultural Understanding

Learning to interpret the visual imagery of art helps children to distinguish the positive from the negative images of their visual culture, which are growing increasingly sophisticated and difficult to interpret. Children experience analogs of the visual arts from birth. A doll, a picture book, a set of blocks, a backyard sandbox, a television set, all of these childhood artifacts have counterparts in adult art. Coloring books, drawings by older siblings, Sesame Street, and Saturday morning cartoons convey not only mixed messages about life, but mixed messages about art. At their best, these

messages can be inventive and stimulating; at their worst, stereotypical and mind numbing.

Without the kind of help that schools can provide, children can become avid and uncritical consumers of the nonverbal messages sent by video arcades, television advertising, regular adult programming, and computer games. Their art education benefits society when, as adults, they can solve problems in an imaginative way, resist the allure of commercial consumerism, base future actions on historical precedent, and respect differences in others. Korzenik believes this last to be a fourth reason to learn art: "art making to help children understand themselves and others."[9]

The Creative Process

Most art teachers believe that using art materials allows children to express their feelings and ideas more effectively than studying academic subjects alone, primarily because art has no "right answers." At any rate, variety of outcomes is cherished in art classes; we regard variety as characteristic of individuality. When each child has the ability to draw, paint, or model something that is different from what any other child makes, art seems to have therapeutic effects. Self-expression is seen as particularly useful in promoting self-esteem and even later success in life.

Participating in the creative process remains the heart of most elementary school art learning. Current thinking about art education expands children's artistic opportunities by recognizing that children can be creative—inventive—in responding to art as well as in making it. Fortunately, the number of models for invention in critical, historical, and aesthetic areas of art is increasing rapidly. We will provide some in later chapters.

Children appear to create and respond to art intuitively. They clearly experience the exhilaration so characteristic of adult inventive activity. Child art has a straightforward, spontaneous quality that we adults find aesthetically endearing (see Chapter 4). Most of us strive to protect the lively, creative spark that bubbles up so easily in young children. We turn now to the question of teaching art. What effect might we have on children's inventive impulses by asking them to learn about art in an academic way?

WHY TEACH ART?

Art education is a hybrid, meaning that it joins two institutions: the art world and public education. This union is particularly visible in elementary schools. Virtually all elementary education is general; children study a range of subjects, most of them taught in the same classroom by the same teacher. Society expects children "to master the literacies, concepts, and disciplinary forms" that lead to the "ability to apply such knowledge appropriately in new situations,"[10] an ability that denotes genuine understanding. Significantly, general education affects art education much more than we often recognize.

In the course of a general education elementary teachers introduce students to several kinds of languages. One kind uses words. Another uses numbers. A third uses musical tones. Art uses pictures or, as we prefer to call them, *images*. Images can occur in poetry, in music, in bodily movement, in touch, in taste, and in odor. Images can be three dimensional as well as two dimensional, or images can be seen only in the mind's eye; can't you still smell Mom's apple pie?

The language of imagery is a complicated one. Schools can prepare children to recognize the aesthetic properties[11] and visual symbols and metaphors necessary to interpret the meaning of art. Teaching children to read art is no easier than teaching them to read our written language. If children find reading books difficult without instruction, and most of them do, they will also find it difficult to read the language of art.

Informal schooling in making art begins in early childhood when three-year-olds discover they can make graphic symbols with pencil and crayon (as you can see in Chapter 4, Fig. 4–4). Parents are their first teachers. Formal schooling, to extend our house-building metaphor, first teaches children how to be skillful "carpenters." They practice using tools: a pencil, paintbrush, potter's wheel, or camera. As their technical skills improve, learners begin to appreciate the rules that govern stable construction: the visual elements and the principles of design.

The process in responding to art is similar. We cannot teach aesthetics per se in elementary schools, or art criticism, or art history, but we should teach selected concepts from them (Chapters 5 and 8). General education may be an end in itself or it may establish a foundation for more specialized studies later on, should children choose to pursue them. Whether they remain appreciators or go on to be artists, art critics, art historians, or aestheticians, all children should gain a general level of knowledgeability during their elementary years.

Art enriches general education. On the other hand, we ought to recognize that children also need a general education in order to learn art. For example, comprehension of written material is as essential to many areas of art as comprehension of visual images. Understanding art history requires familiarity with a broader historical spectrum. Critical thinking skills sharpened in the sciences and language arts also apply to the visual arts. Solving aesthetic problems requires the same kind of logic as mathematics, and so on.

A child's physical and mental growth has a lot to do with the form of children's art, as you will discover in Chapter 4, but it is not the entire story. Why teach art? We teach art in order to show others something they want to learn, or that society wants them to learn, that they are are unlikely to discover easily by themselves. Teaching (nurture) unlocks the potential that maturation (nature) provides.

Teaching Toward Understanding

Most art educators agree that the school subject called art covers four kinds of knowledge, generally referred to as aesthetics, art criticism, art history, and the production of art or "studio" art. Nevertheless, studying art by learning about four distinct bodies of knowledge, also called *disciplines*, may sound like the story of the blind men and the elephant. One feels the legs, a second feels the trunk, a third feels the tail, and so on, and each comes to a different conclusion about the nature of a beast too large to embrace all at once.

It is true that practitioners of each discipline attempt to understand art by collecting evidence about different aspects of it. *Aestheticians* address the nature and value of art. *Art critics* analyze and interpret contemporary art. *Art historians* concern themselves with works of art as they exist in historical and social contexts. And *artists* create art.

Unlike the blind men, all of them together give some sense of the magnitude of what we call simply *art*.

Every elementary school subject is grounded in one or more disciplines. Practitioners of each discipline have different frames of reference and different ways of verifying evidence. As children become literate in any school subject, the organizational principles of its underlying discipline or disciplines shape the way they express ideas. Learning these principles allows children to be inventive in particular ways.

Designing a house is working toward a different end than finding a cure for cancer, for example. The architect and the oncologist use different skills, concepts, kinds of reasoning, and even languages. The chances that the architect will discover a cure for cancer, or that the oncologist will design an innovative house, are so small that we can safely say they are nonexistent. New discoveries in any field occur to those who are prepared to recognize them.

Elementary school children, of course, are not adults. They need not become specialists in any discipline, but benefit from knowing something about a number of them. We want children to be generally, not narrowly, educated. In the best of all worlds, because of their early introduction in school, recipients of a general education would continue to appreciate and create the visual arts as adults just as well as as they read, compute, and understand concepts in any field.

Benefits of Intervention

Since the 1920s, one of the most compelling aims of teaching art has been to safeguard children's artistic development. Until quite recently children's abilities to create graphic images and symbols were thought to evolve independently of instruction, in pretty much the same way all over the world. The term *development* refers to children's maturation, a physical and mental process we believe all human beings experience in the same way.

Even though children at any stage of development seem able to make individual artistic statements, you will see in Chapter 4 that adults have been able to find similarities of execution among children of various ages. These norms or age-related characteristics that appear to occur universally have proven useful for the study of maturation. Many educators have considered art making to be an observable, dependable developmental activity.

Teaching children knowledge about art intervenes in this developmental process. Teaching art can produce observable departures from the developmental norms described in Chapter 4; that is, it can either accelerate or retard children's performance relative to their level of maturation. Anyone who values knowledgeable child art tends to see intervention as positive, and most teachers today share this view. They reason that children introduced to the principles of art early will learn them sooner than they might otherwise, and that this knowledge will increase their ability to be inventive.

Even so, if you value the self-expressive and therapeutic benefits of making art you may fear that intervention might alter children's developmental patterns. There is no evidence that children left to their own devices develop into artists or people who appreciate art, however. In fact, in the United States, the National Assessment of Educational Progress provides considerable evidence to the contrary.[12, 13] Now many art educators doubt that a school environment without adult guidance can adequately nurture children's artistic abilities.

Broudy and Aesthetic Education

During the 1960s, following Sputnik, ideas about what constitutes knowledgeable teaching changed considerably. The 1965 *Penn State Papers* mentioned in Chapter 1 suggested that children in elementary schools should learn to appreciate art as well as to make it. Some of the participants in the Penn State seminar went on to develop a humanitieslike approach to art called *aesthetic education*.

The aesthetic information in art from which viewers derive meaning is visual. Broudy points out that even the meaning of spoken and written language depends on imagery that words once described, although we may no longer remember it. For example, the Latin roots of the word *conspire* literally mean *breathing together*. *Conspire* calls up in our mind's eye an image of two heads close together, one whispering into the other's ear. The image conveys the meaning.

We remember images from our experience of the real world, sometimes in bits and pieces. These images may convey moods or feelings. For example, a downturned mouth or slumping posture may represent sadness, the softness of a feather may denote gentleness, the yellow of sunshine may communicate a feeling of warmth and happiness, or sharp, staccato contrasts of dark and light may shock or disorient the viewer. We develop a vocabulary of mental images just as we develop a vocabulary of words, much of it earlier than words.

In the same way we store in memory images acquired from objects of art, which illustrate more complex ideas or ambiguous concepts. For example, to most of us the *Statue of Liberty* signifies democracy, while Dali's *Persistence of Memory* (Fig. 2–3) conveys a feeling of indefinable disquiet. We draw on our memories of past experiences with art when we interpret or create art in the present. We can neither read art nor be inventive artistically without them.

The rationale of aesthetic education suggests the need for an approach to teaching that depends on the presentation of art knowledge. Although university art educators developed curriculum materials for aesthetic education during the late 1960s and early 1970s, the idea did not catch on in the public schools. It was the late 1970s before some of these attempts were to bear fruit. Broudy, a pioneer in teaching aesthetic perception to university students from all of the arts, became involved in three memorable programs that have affected how art is taught in public schools: The

Figure 2-3 Salvador Dali (1904-1989). *The Persistence of Memory* (1931). Oil on canvas, 9 1/2 x 13" (24.1 x 33 cm). (Courtesy of the Museum of Modern Art, #K6534) (Given anonymously)

Aesthetic Eye (Los Angeles, late 1970s), Project HEART (Helping Education through Arts Resources for Teachers; Decatur, Illinois, late 1970s to early 1980s), and the Getty Institute for Educators on the Visual Arts (Los Angeles, 1982–1989).[14, 15, 16]

From Broudy to DBAE

Broudy maintains that children need help in order to understand the meaning of art, particularly fine art. To Broudy, fine art constitutes a visual literature no less significant or less difficult than the verbal literature that is a core humanities discipline. Broudy recommends that elementary teachers who wish to do justice to their subject build on the three disciplines associated with aesthetic education—studio art, art history, and art criticism—and, in addition, on a fourth discipline, aesthetics. The approach to teaching art based on Broudy's rationale, described in Chapter 1, has become known as *discipline-based art education* (DBAE).[17, 18]

Many spokespersons for elementary education now endorse the comprehensive content associated with the discipline-based point of view, if not all of its ways of teaching it. Comprehensive content is consistent with the academic rigor associated with current educational reforms. Reformers consider the visual arts as means of communication, as documents that record the history of civilization, as bodies of aesthetic knowledge that are unique. These characteristics make all of the arts attractive components of general education.

Broudy even recommends that elementary schools focus on fine art, and let children learn about popular art informally. Not all art educators take such a hard-and-fast position, believing that there is merit in including some aspects of popular culture in an art education program. First, a study of popular art can build bridges to the enjoyment of fine art. Second, developing a mature perspective on popular art will make students more discriminating and better consumers of the kind of art that they are bound to encounter in everyday life (Chapter 17 presents these ideas in more detail).

Still, anyone who agrees with a more comprehensive approach to art content needs to understand why Broudy emphasizes learning about fine art. Art knowledge is incremental. Broudy sees the fine arts as the most complicated and the most inventive forms of the visual arts. If that is true, the fine arts are more aesthetically challenging than popular, applied, or folk arts, and understanding them requires greater knowledge. If greater knowledge leads to greater inventiveness, then we have good reason to recommend teaching children art.

TEACHING TOWARD KNOWLEDGEABILITY

We all recognize the term *old master*. We are accustomed to judging artists, particularly those of the past, according to their degree of mastery within the world of art. We know as well that some art critics, art historians, and aestheticians are more capable than others. In fact, we see an ever-increasing degree of knowledgeability in every aspect of the domain of art, not only among the art professionals, but the art institutions, the art audiences, and the art objects themselves.

The Domain of Art

Let us distinguish among at least four components in the domain of art. *Objects* or *documents* like works of art, reviews of exhibitions, historical attributions, and aesthetic theories are important, if not the most important, elements of the art domain. Then there are the *art professionals*, not only artists but all those who authenticate, catalog, interpret the meaning of, evaluate, exhibit, sell, publicize, and teach art. The *social institutions* that display art and educate the public about it, constitute a third component consisting of art museums, schools, publications, and even families. Our fourth component will consist of *audiences*, the consumers who appreciate art, buy it, enjoy it, and often make it themselves on a recreational basis.

While we recognize that members of each component have attributes in common, we also find that their internal characteristics are quite diverse. Take art objects as an example. When we say art, what objects do we have in mind? The *Mona Lisa*, hanging in the Louvre? A contemporary film? A 1953 yellow Cadillac convertible? A

drawing by a two-year-old child? Each of these is a work of art in someone's mind.

The *Mona Lisa* is an old master, as is the artist himself. The film is contemporary popular art. The Cadillac is a classic example of automotive design, and the child's drawing is typical of many children prior to enrolling in school. Each of these works requires different levels of skill to complete, different levels of literacy to interpret, and different levels of significance in our society. We put the child's drawing on the refrigerator door, we ride in the convertible, we entertain ourselves with the film, and we go to the Louvre to see the *Mona Lisa* because it is one of the masterpieces of all time. What can these distinctions tell us about why we teach elementary art?

Nonuniversal Development

In 1980, developmental psychologist David Henry Feldman introduced a concept of nonuniversal cognitive development that explains some of the differences between popular and fine art, between naive and sophisticated audiences, and between lay people and professionals.[19] Cognition is the process by which knowledge is acquired (see Chapter 6). Feldman observed that while all children's thought processes develop in similar ways up to a certain age, their ways of thinking diverge as they become increasingly influenced by their surroundings.

Further, the acquisition of advanced knowledge is not automatic; it depends on the level of education in any particular area reached by each individual. Something more than native ability accounts for the differences between "blue collar" and "white collar" jobs in any society. Something more than native ability accounts for the differences of taste among art appreciators and differences of skill among arts practitioners. While in real life these distinctions may not always be clear cut—there are many people who are difficult to classify—Feldman's categories are particularly useful for explaining the function of formal education.

Mastery in Art

Feldman distinguishes the following levels of mastery in any discipline: *universal*, *cultural*, *disci-*

pline based, *idiosyncratic*, and *unique*. In order to make this continuum clearer with respect to the domain of art, we have constructed a table (Table 2–1), Characteristics of Discipline Mastery in Art. Table 2–1 shows you what kinds of art objects, art practitioners, art institutions, and art audiences you can ascribe to each of Feldman's levels.

The row headings on the left denote five levels of competence in the four art disciplines, from the kind achieved by everyone just by being human (the universal level) to the kind achieved by only one human being over the course of recorded history (the unique level). One of the levels in our table, the *cultural*, has two subgroups, labeled (A) *folk arts* and (B) *popular and applied arts*, although there are five levels there are actually six headings. You can see that the subheadings *early childhood arts*, *folk arts*, *popular and applied arts*, and *fine arts* represent distinct aesthetic differences.

The column headings across the top identify the domain components: *art objects*, *art practitioners*, *art institutions*, and *art audiences*. Each column contains typical (though not all) members within each component and their distinguishing characteristics at each level of mastery. These characteristics reflect the degree of competence that objects, institutions, and people show. Competence may be thought of as knowledgeability, or discipline mastery, or inventiveness. Competence increases from the universal level to the unique.

While young children demonstrate similar thought processes the world over, as adults some of them will achieve more advanced levels of knowledge and skill than others. Feldman theorizes that certain kinds of environmental conditions account for the advances of some individuals over others. One of these environmental conditions is formal education.

In Feldman's classifications, a natural predisposition for art, sometimes called *talent*, is not sufficient to become a professional artist, critic, historian, or aesthetician. Why teach art? To become aesthetically literate is a deliberate decision; it requires effort; it is a learning process. With respect to both art practitioners and their audiences, Feldman's developmental regions describe an educational continuum along which all individuals move as they gain knowledge and skills.

TABLE 2–1 Characteristics of Discipline Mastery in Art

	Art Objects	Art Practitioners	Art Institutions	Art Audiences
Domain of Art	*Art Criticism History Theory*	*Artist Art Critic Art Historian Aesthetician*	*Museums Publications Tradition Schools*	*Museum Visitors Families Appreciators Collectors*
Levels of mastery [a]	**Art Objects**	**Art Practitioners**	**Art Institutions**	**Art Audiences**
I. Universal: Early Childhood Arts	Earliest non-representational graphic expressions Acultural	Common World-wide Young children Spontaneous Inevitable, invariant Widely acknowledged	Parents No instruction Preschool	Family Friends
II.A. Cultural: Folk Arts	Discipline-unrelated Culture-specific Applied Handcrafted Skillful	Common Amateur Indigenous Adult to early childhood Nonspontaneous Popular	Tradition Informal instruction Unschooled Cottage industry	Many people Discipline-expert to discipline-unaware Wealthy to poor
II.B. Cultural: Popular and Applied Arts	Discipline-related Culture-specific Applied Electronic media, film Hobbies Kitsch	Common Professional and amateur Adult to early childhood Nonspontaneous Popular	Mass media Mass marketing Popular literature Formal instruction General education Elementary school High school College	Most people Discipline-aware (basic literacy) to discipline-unaware Wealthy to poor
III. Discipline Based: Fine Arts	Discipline literate Culture-transcending Theoretical Hierarchical Sequential	Uncommon Discipline-proficient (mastery, internalized) Aesthetically motivated Organized Selective	Art Criticism Galleries Scholarly literature Specialized instruction Professional education	Some people Discipline-literate Well-to-do
IV. Idiosyn-cratic: Fine Arts	Discipline-enlarging Novel Specialized Avant-garde Expressive	Unusual Expert Boundary breaker Trend setter Unpopular	Art Criticism Galleries Professional literature Beyond instruction	Few people Discipline-expert Connoisseurs Wealthy
V. Unique: Fine Arts	Discipline-defining or transcending Original Masterpieces Innovative	Rare Single person Visionary Creative or destructive Acclaimed	Art History Museums Scholarly, professional and popular literature Aesthetics	Many people Discipline-expert to discipline-unaware Wealthy to poor

[a]Terms assigned to levels of mastery are adapted from Fig. 1–2, Developmental regions from universal to unique. In David H. Feldman, ed., *Beyond Universals in Cognitive Development*, Norwood, NJ: Ablex, 1980, p. 9.

LEVELS OF MASTERY AND THE ARTIST

To illustrate Feldman's levels of mastery, let us examine the path to mastery taken by the artist. We select the artist as an example because later on you will be able to compare Feldman's nonuniversal continuum to the better known universal continuum of children's graphic development, and also to the less well-known pattern of aesthetic development (see Chapters 4 and 5). If space permitted, we could also expand upon patterns of inventive activity for critics, historians, and aestheticians. They, too, begin at the universal level and extend to the unique.

Universal Level

We can observe universal behaviors in art when children are quite young by examining what they draw. Children can be said to remain in the universal stage of graphic achievement only until the time that they begin to modify their earliest drawings in response to suggestions from adults. This means that the universal level lasts only until the age of three or thereabouts, on average. These earliest artistic behaviors occur in every human being, are spontaneous, and are widely reported throughout diverse cultures around the world.

Cultural Level: Folk Arts; Popular and Applied Arts

Quite soon after making spontaneous images, children begin to respond to and learn from their environments. Their education in early childhood is usually informal rather than in a classroom. They make images that purposely represent specific objects and ideas. As soon as youngsters begin to adapt their artwork in response to other people or to other influences in their environment, we can consider them at Feldman's cultural level.

Within each culture there are certain kinds of knowledge that all members of the culture inevitably acquire: no one is surprised when a child in France begins to speak French about the age of two, rather than Swahili or English. In the visual arts, for example, a school child in Japan is likely to draw calligraphic characters with a brush. A child in America may create comic books that might include the spatial conventions of the television screen. A child of the Muslim faith may draw designs without using the human figure.

The acquisition of these and more advanced culture-specific forms of nonverbal communication are widespread throughout every society. Child art reflects children's experiences with visual images prevalent in their cultures. Two kinds of images found at the cultural level are those called *folk arts* and the *popular* (and *applied*) *arts*.

Folk Arts Think of folk arts as those arts representing traditional skills in any geographic area or ethnic group. They are culture specific and their practice is passed on by means of informal schooling. Many folk arts produce highly skillful aesthetic objects, like the carved wooden figure from West Africa (Fig. 5–2) or the wool Bayeux tapestry from eleventh century France (Fig. 2–4). Folk arts are made by hand and generally serve some practical or symbolic purpose in the lives of their makers.

Popular and Applied Arts The popular arts today require a high level of competence, some degree of which may be learned informally, but much of which is learned formally in schools. All cultures expect their children to understand and practice things such as reading, writing, computing, history, and the rules of their government; these expectations define a basic level of verbal and numerical literacy. Think of understanding and making popular and applied art as a basic level of artistic literacy.

Basic artistic literacy shares many concepts and skills with the fine arts just as, for example, computation does with mathematics. Advertising art, commercially released films, the high-volume production of handcrafted ceramic dinnerware, and computer-imaged logos generated for television stations are created by highly competent artists. Artistic activity at Feldman's popular level is not necessarily practice of the art disciplines, however, any more than being able to add, subtract, multiply, and divide makes someone a mathematician. In Feldman's matrix, popular and applied art might be called *discipline related*. Popular and applied art is discipline related when it is done extremely well, and its production demonstrates high levels of skill.

Figure 2-4 *The Fleet Leaving for England* (ca. 1073-1088); Bayeux tapestry detail. Wool embroidery on linen, 20" x 231'. Bayeux, France, Town Hall.
(Courtesy of Art Resource #50004284) (Photograph by Giraudon)

Discipline-Based Level

An excellent sign painter does not necessarily paint pictures that would be welcomed in art galleries. The differences between the sign painter, assigned to Feldman's cultural level, and the fine artist, considered to be discipline based, have to do with the theoretical level at which each works. In many cases the philosophical distinction between highly skillful applied artists and fine artists is exceedingly narrow, however, if not erased altogether (Fig. 2–5).

Discipline-based careers are called *professions*, and fewer people practice them than the number who perform jobs at the cultural level. There are fewer doctors than nurses, for example, fewer engineers than mechanics, fewer architects than contractors, and fewer fine artists than applied designers.

Professional people prepare themselves longer, because they prepare in more depth, before society considers them ready to enter the workplace.

In art, discipline-based professionals are most closely associated with the fine arts. The *fine arts* are often defined as works of art that have aesthetic meaning rather than a practical function. Works of art in all societies become metaphors for important cultural values and ideas, and in the fine arts we find some of the most complex visual messages that exist in our civilization.

Idiosyncratic Level

Only a few artists reach Feldman's idiosyncratic level of mastery. If literacy in the discipline is uncommon, proficiency at the idiosyncratic or

Figure 2-5 Albert Paley, *Portal Gates* (1980). Forged and fabricated steel, brass, and bronze, 13'6" high. Albany, NY: Senate Chambers, Capitol Building.
(Courtesy of Paley Studios, Ltd.)

highly personal level may be said to be unusual. Artists at this level are the experts, the boundary breakers, the conspicuous ones. They are the "household names" (at least to other artists), the ones whose art brings "megabucks" in the New York, Los Angeles, or Houston galleries.

Andy Warhol (Fig. 5–3) was such an artist in his day; Christo (Fig. 8–2) is one now. They belong to the avant-garde; they generate novelty; they are the artists *a la mode*, the trend setters. Contemporary critics give them their approval. Their ultimate reputation must wait for the perspective of history; it will depend on whether or not tomorrow's audiences will still find them significant.

Unique Level

On Feldman's highest level of mastery are the artists for whom it may be said there is, and always will be, only one for all time. One Rembrandt van Rijn. One Käthe Kollwitz (Fig. 9–6). One Ichiryusai Hiroshige (Fig. 9–4). One Diego Velàsquez (Fig. 2–6). These are the kinds of artists who, as we look at their works, have the power to transform our understanding of the world from that point on. No one else will ever take these artists' places.

Such unique individuals are rare in any discipline. They are the visionaries, the people who unequivocally deserve being called *creative* because each changed the shape of art forever. The works of these artists are known and loved the world over. They transcend national boundaries. Exhibitions of their art attract thousands of visitors. Over time, the innovations of artists who are unique have proven so enduring that they and their creators eventually become part of the popular culture.

LEVELS OF MASTERY AND AESTHETIC LITERACY

Remember, in elementary school you will deal with students who are mainly at Feldman's cultural level. Sometimes you can aid your students' transition from universal to cultural levels in the lower grades (see Chapter 4). You can most certainly affect the quality of their cultural level competence in the upper grades. The cultural level is where we hope students with a general education will function productively and grow as adults.

Your goal is aesthetic literacy by the time they leave elementary school. Aesthetic literacy will give your students ways to interpret their experiences that will improve the quality of their lives on a personal level and affect the quality of their contributions to society as both consumers and citizens. They will be appreciators of fine art as well as discriminating consumers of popular and folk art They will be able to tell the difference between the good and the bad, between the truly valuable and the meretricious.

For those students destined to advance to the next level, the discipline level, reaching aesthetic literacy by eighth grade may save them years of

remedial study later on. Feldman cautions that not every individual will move through all regions of mastery. Nor will all individuals move through the cultural level at the same pace. Not all cultural environments are equally hospitable to the acquisition of knowledge and skills in general. Formal education in most societies is the way of empowering individuals to develop within their culture as well as to advance in their chosen disciplines. Some societies place higher value on learning than others; some value the arts more than others.

SUMMARY

Why teach art? We teach art because it is a form of expression. In some way every individual is unique, and creative, and that is the appeal of "self-expression" in making art. Yet the term *artis-tic expression* means something more. It describes someone's ability to convey an idea, or mood, or action to others using the media and compositional devices of art. Each of the four art disciplines have their own kinds of informed expression.

We teach art because it requires thought. *Perception* is the ability to produce order from disorder (to perceive and understand). *Inventiveness* is the ability to shape familiar elements into new configurations. *Imagination* is the ability to picture objects in the mind's eye, thereby freeing ourselves from the constraints of reality. Some individuals, young or old, seem able to use their imaginations. Others need to learn to imagine. The term *creative* in popular use indicates someone who is expressive, inventive, and imaginative. Creativity is a characteristic of a prepared mind, a disciplined mind.

Figure 2-6 Diego Velàzquez (1599-1600), *Las Meninas* (The Maids of Honor) (1656). Oil on canvas, 10' x 5 1/4" x 9' 3/4". Prado, Madrid.

(Courtesy of Art Resource #50016173)(Photograph by Archivi Alinari)

We teach art because it provides our children access to the world's cultures. Art challenges us to understand our diverse cultural origins and our shared strengths. We want our children to know the aesthetic monuments of civilization that are the source of our humanity because they will be the foundation for their future achievements in the arts. We want all Americans to be culturally literate.

We teach art because it transcends culture. People who are literate in any discipline can communicate with one another across cultural boundaries. The fact that all human beings share an aesthetic capability among cultures is more telling than the fact that there may be differences in aesthetic preferences or artistic styles from culture to culture. The more aesthetic information that people of many cultures share, the more that culture-specific styles tend to give way to individual styles that are culture transcending.

We teach art so that future generations can survive in an information society, particularly when that information is based increasingly on visual images. American children who watch television from birth need help in becoming discriminating audiences who can distinguish true and valuable visual information from the worthless or the manipulative. Art can provide skills of critical thinking that enable Americans to select nourishing information from among the unpalatable or, worse yet, the poisonous.

Teaching art is a demanding task. We cannot assume that everyone in America recognizes the value of fine art and believes that society as a whole would benefit from more of it. One reason arts advocacy has been less successful than hoped may be that, because most advocates are aesthetically literate, they value art at a different level of mastery from those of most Americans. We all hear the same words, but words have different meanings depending on our frames of reference.

Strong elementary teachers are generally able to articulate three things: why art education belongs in schools; what kinds of art knowledge and skills their students should learn; and the age at which certain kinds of content can best benefit their students. Teachers who can justify the formal study of art tend to build strong art programs in keeping with the educational goals of their schools. Teachers who know something about the art disciplines strive to see that learners will achieve appropriate literacy levels in them. Teachers who have realistic expectations for each age will present art lessons that are meaningful to learners. These three tasks are not easy ones, but they are goals toward which we can all work. As this book unfolds we will spend more time discussing each one.

NOTES

1. Gardner, Howard. (1991). *The unschooled mind: How children think and how schools should teach*, New York: Basic Books, p. 9.

2. Broudy, Harry S. (1972). *Enlightened cherishing: An essay on aesthetic education.* Urbana, IL: University of Illinois.

3. Brown, Maurice., and Korzenik, Diana. (1993). *Art making and education.* Urbana, IL: University of Illinois, p. 121.

4. Ibid., p. 131.

5. Secretary's Commission on Achieving Necessary Skills. (1991). *What work requires of schools.* Washington, DC: U. S. Department of Labor.

6. Consortium of National Arts Education Associations. (1994). *National standards for art education: What every young American should know and be able to do in the arts.* Reston, VA: Music Educators National Conference.

7. Fowler, Charles. (1994). Strong arts, strong. schools. *Educational Leadership, 52* (3): 4–9.

8. The J. Paul Getty Trust. (1993). *Perspectives on education reform: Arts education as catalyst.* Los Angeles, CA: Author.

9. Brown and Korzenik, op. cit., p. 175.

10. Gardner, op. cit., p. 7.

11. Aesthetic properties are the visual elements (sensory properties)—*line, shape, texture, value, color, space*—and principles of design (formal properties)—*variety, unity, movement, stability, rhythm, balance*—explained in detail in Chapter 14.

12. National Assessment of Educational Progress in Art. (1978). *Knowledge about art.* Washington, DC: National Center for Educational Statistics, U.S. Department of Health, Education and Welfare, Education Division.

13. National Assessment of Educational Progress in Art. (1978). *Attitudes toward art.* Washington, DC: National Center for Educational Statistics, U.S. Department of Health, Education and Welfare, Education Division.

14. Efland, Arthur.. (1987). Curriculum antecedents of discipline-based art education. *Journal of Aesthetic Education, 21* (2): 82–85.

15. Stake, Robert. (1985). Learning art: Sketches of art education in America's schools; Decatur and Champaign, Illinois. In *Beyond creating: The place for art in America's schools.* Los Angeles, CA: The J. Paul Getty Trust, pp. 34–36.

16. Getty Center for Education in the Arts. (1993). *Improving visual arts education: Final report on the Los Angeles Getty Institute for Educators on the Visual Arts.* Los Angeles, CA: The J. Paul Getty Trust.

17. Greer, W. Dwaine (1984). Discipline-based art education: Approaching art as a subject of study. *Studies in Art Education,* 25 (4): 212–218.

18. Smith, Ralph A. (ed.). (1987). Special issue: Discipline-based art education. *Journal of Aesthetic Education,* 21 (2): i–259.

19. Feldman, David H. (1980). *Beyond universals in cognitive development.* Norwood, NJ: Ablex.

3
Knowing What to Teach

If you remember your own elementary art experiences, you most likely recall making things; perhaps using finger paint in kindergarten (Fig. 3–1) (see **color insert** #1), coloring a clown with crayons in second grade (Fig. 3–2a), drawing a cat with magic markers in third (Fig. 3–3), making a chick that pops out of an Easter egg in fourth (Fig. 3–2b), or, as a fifth grader, painting a happy face (Fig. 3–4). To most children art class means working with art materials. Even if your projects were more sophisticated than these are, elementary art often seems to have little to do with art and much in common with play.

Will these kinds of typical activities introduce art concepts, teach problem solving, and lead to an appreciation of culture? The answer for all of them is probably "no" or, at best, a reluctant "maybe" depending on the circumstances under which they took place. The child who made the chick followed an adult's pattern, so the chick pictured here looks almost the same as those made by all of the child's classmates; no art learning here. The clown, also a pattern that a child colored with crayons to in order to complete, is another "no." The "happy face" is a cultural stereotype; sorry, "no" again.

Figure 3-2a Second-grade art project.

Figure 3-2b Fourth-grade art project.
(Both photographs by Jean Rush)

The finger painting and the cat seem to be quite individual and spontaneous statements, however. Do they suggest good teaching? Finger painting (or any art project) is not necessarily a learning experience for children just because the results look fresh and colorful. In order to call it art learning, we need to know more about it.

How many times has this child made a similar picture? What else besides finger painting did the teacher ask this child to do? What aesthetic concepts does this finger painting display? Are they appropriate for this learners' level of development? Will they lead to more advanced understanding of art?

Making marks with finger paint may be an impulsive activity for five-year-olds; making art, for adults, is premeditated. Some people might wish to believe that immersion in the artistic process produces aesthetic literacy in and of itself, but as we learned in Chapter 2, experience shows otherwise. The aesthetic literacy level of most adult Americans, measured by their ability to draw the human figure, is about that of adolescents in seventh or eighth grade (Figs. 3–5 and 3–6).[1]

Figure 3-3 Third-grade art project.
(Photograph by Jean Rush)

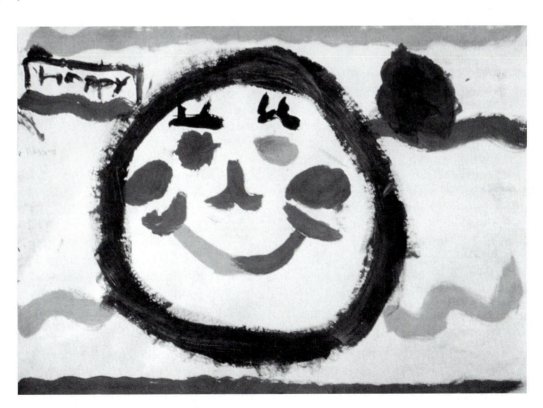

Figure 3-4 Fifth-grade art project.
(Photograph by Jean Rush)

Figure 3-5 Adult figure drawing.
(Photograph by Jean Rush)

Figure 3-6 Adolescent (seventh-grade) drawing.
(Photograph by Jean Rush)

Conventional wisdom says that's because eighth grade is the point at which the formal art education of most Americans stops. If we look at the so-called *norms* or average behavior in graphic development, however, it is unclear how much credit public schools deserve for adults' aesthetic literacy. The characteristics of eighth-grade drawings seem to be the result of immersion in the popular culture more than anything else. If so, art programs have little to boast about. One would expect that children who are taking art in school would demonstrate an understanding of it that is measurably different from those who are not.

KNOWLEDGEABLE TEACHING

What would your elementary art classes look like if you wanted your students to be as knowledgeable in art as in the sciences, mathematics, or history? Would your second graders color ready-made images? If not, what would they do instead? Could your fifth graders do something that would teach them more about art than painting happy faces? Let us see if we can spell out what kind of art knowledge helps children get from the spontaneous inventive activity of early childhood to the deliberate, informed inventiveness of the mature artist, art critic, art historian, or aesthetician.

The best kind of art teaching encourages children to use knowledge in a *generative* way. Your students should use aesthetic concepts to solve problems, thereby coming to new understanding; in other words, learning to think and reason. Reading works of art and making them go hand in hand, as we learned in Chapter 2. Whether your students work with art materials or with words, your aim—as a knowledgeable teacher—is to provide them with the information and skills they need to understand art and to

express ideas artistically. Your goal is to teach children to think and learn for themselves.[2]

You will recognize knowledgeable art teaching when you see elementary children using concepts they are not likely to know unless they have been in school. Here are some examples from art production: a tree drawn by a kindergartner that describes the intricate shapes of its leaves and branches (Fig. 3–7); a landscape with pictorial space painted by a second grader (Fig. 3–8); a fifth-grade contour drawing of a particular plant (Fig. 3–9). These images show us more careful observations of nature than children of these ages usually make. They testify to the skills of these children's art teachers.

Knowledgeable teaching takes three things into account: first, the kinds of concepts and inventive processes used by arts professionals; second, the ways in which children mature, physically and mentally; and third, the fact that human beings learn to walk before they run, that is, they advance from simpler and easier concepts and skills to more complex and difficult ones. Throughout the book we refer to these factors by three "c-words": *content*, for aesthetic concepts and the inventive processes by which they are put to work; *child development*, for physical, mental, and artistic maturation; and *curriculum* (plural, *curricula*), for any written document that organizes content in a sequence beginning with relatively simple things that continue to become more complex as time passes.

Good content consists of valid art concepts and inventive processes, child development governs when to teach them, and a curriculum establishes the sequence in which to teach them. The rest of this chapter will examine content, especially the kinds of inventive processes the art disciplines share. We will also look at the kinds of elementary school teachers who convey this content to children—classroom teachers, art specialist teachers, and community professionals—to see what each one does.

Becoming conversant with content, child development, and curriculum is a tall order; be patient. It will take you some time and many more chapters. Eventually you will develop a sense of what knowledgeable teaching is about and the confidence that you, too, are becoming a knowledgeable art teacher.

Figure 3-7 Kindergarten drawing of a tree.
(Photograph by Jean Rush)

COMPREHENSIVE CONTENT

What will you teach your students? The content of art education has become more comprehensive during the last two decades because of teachers' interest in aspects of art other than simply making "projects." If we say that four art disciplines are more comprehensive than one, what does that mean?

First, comprehensive content is content that has conceptual breadth. In addition to art production, you will teach students selected concepts about aesthetics, art criticism, art history. Second, you will teach students to use those concepts in the same ways—though not at the same levels of competence—that artists, art historians, art critics, and aestheticians do. You will teach students to use the same kinds of inventive processes by which arts professionals put their knowledge to work.

Teaching content from all of the art disciplines does not diminish the importance of the

Figure 3-8 Landscape painted by a second grader.
(Courtesy of Deborah Christine, CRIZMAC Art and Cultural Educational Materials)

Figure 3-9 Fifth-grade contour drawing of foliage.
(Photograph by Jean Rush)

studio experience. On the contrary, conceptual breadth gives artists more expressive options and it gives art appreciators access to more kinds of art. It also provides you with more ways of reaching your students than if you restrict them to making art.

But are your first graders old enough to learn aesthetics, or art history, or art criticism? You know that children display artistic behavior from an early age and show signs of art learning by the time they are about three years old. Think of the levels of mastery through which individuals pass as they become familiar with art (see Table 2–1). You will be teaching concepts that are appropriate for the cultural level. You will not be teaching at the discipline-based level, and so you will not teach art disciplines themselves.

Remember, few of us adults who are generally educated will reach Feldman's discipline-based level of mastery in more than one field, if that. Nor should we wish to. Most of us remain at

Feldman's cultural level in most subjects. Your students will not practice the disciplines per se any more than the rest of us do. Your goal in elementary art education is aesthetic literacy by eighth grade. You will be teaching children content that is consistent with the art disciplines, and appropriate to your students' ages, at each step along the way.

We look to the disciplines for standards by which to judge content in art education. If the art taught in elementary schools is consistent with concepts and practices in the disciplines, children will have valid art learning experiences throughout their general education. A good elementary art program would not provide misleading information that might give students false expectations, either of themselves or of art.

PUTTING KNOWLEDGE TO WORK

At the beginning of this chapter, all of the projects given as typical examples of elementary art presumably echo what artists do, in the sense that children used art materials to create a visual image. The children who made the finger painting and the cat made some artistic choices. The others did not; these projects misrepresent artists because they are not inventive activities.

The rest of this chapter will focus on what art professionals *do*—how they use what they know to create new knowledge. What they *know*—various concepts about art—we discuss in passing. If you want to pursue art concepts in more depth, you can find them discussed in Chapters 14, 15, 16, and 17. For now, we are interested in the way that arts professionals apply these concepts. Of the two kinds of art knowledge, concepts and their application, application is the key if children are to learn how to think for themselves.

Differences Among the Disciplines

What do inventive classroom activities look like? An activity becomes inventive when students use what they know to learn something new. Some inventive activities may lead to finished works of child art or finished statements about art; some may remain unfinished. Some products

may look imaginative, in the sense of being different from those of other children, but some may not.

Activities in each area of art have a distinct character. Sometimes children use art materials; at others they talk or write about art. Learning how some artists throughout history influence others seems far removed from learning how etchings differ from engravings, for example. Interpreting the expressive properties of Van Gogh's *Sunflowers* (Fig. 5–1) seems different from expressing your own feelings by drawing a picture about your summer trip to the Adirondacks.

Technical knowledge also varies. Joining words together differs considerably from joining two pieces of clay. Nevertheless, writing a piece of art criticism can be as inventive as shaping a clay sculpture. We said invention is solving problems. What kinds of problems do practitioners of each of the art disciplines address? Let us look at the distinctive character of these disciplinary activities in more detail.

Art Production *Artistry* or the creation of art is the domain of the *artist*. This is a primary function, without which there would be no other arts disciplines. Each artist, generally working alone, organizes aesthetic concepts like line, shape, texture, and color within the constraints of media like water-based paint on paper, clay, collage, or pieces of wood assembled into a sculpture—art materials you might use in elementary school. Artists are able to convey powerful nonverbal messages by the way in which they shape these materials.

Artists solve problems as they work. They ask themselves, "How can I best convey this idea?" "Does this medium suit my purpose?" "What if I were to combine materials in an unorthodox way?" "Might this color detract viewers from my subject?" "What if my message appears trite?"

Art Criticism *Art critics* attempt to establish the quality, meaning, and significance of individual works of contemporary art. They describe, analyze, interpret, and evaluate them. By evaluating objects of art, critics also evaluate artists. Critics set standards. Critics analyze a particular artwork in terms of its subject matter, its formal structure,

and its expressive characteristics; they subsequently use their analyses to illuminate the relation of the components to each other and to the whole work.

The critic's ultimate reference is his or her own perceptions and artistic values. The critic solves problems much as the artist does. Critics ask themselves, "What is the significance of this work?" "What was the artist's intent?" "What social values influenced his or her thinking?" "Is the work innovative, or merely novel?"

Art History *Art historians* attempt to verify and interpret art objects made in the past. The inquiries of art historians are rooted in historical fact. For historians, the art object is a historical document to be examined, dated, attributed to an artist, and restored to its correct place in the known chronological and social framework. Historians follow where the data lead. Historians examine subject matter, symbols, styles, social conditions, an artist's patrons, and the life of the artist for clues to the work's meaning and function.

Historians, too, solve problems. "What is the work's historical significance?" "Has it been overlooked by preceding generations?" "Did earlier historians attribute it to the wrong artist?" "What was its function?" "Did the public of that day like it?" "Is its artist the founder of a style, or only a follower?"

Aesthetics *Aestheticians* are philosophers who construct theories of the fine arts, and their theories deserve more mention that we give them here; you will read more about them in Chapters 5 and 8. For now, think of aesthetics as a concern with principles of art more than with art objects. Aestheticians inquire into the nature of art and the creative process. They reflect, deliberate, reason logically, and think critically in the sense of making fine discriminations.

Aestheticians advance hypotheses and test them by deductive reasoning. "Is representation dead, and if so, why?" "If art may be valued for its own sake, what are the reasons for this?" "Is art a physical object or a concept?" "What is the nature of an aesthetic response?" "Are there standards of art, or only personal preference?"

The Whole and the Parts

Defining each art discipline in terms of its inventive activities, however, is reminiscent of the distinctions made about the elephant by the blind men described in Chapter 2. It is an academic exercise. In the real world of art we seldom observe such distinctions with precision, for two reasons.

First, disciplines are continually evolving. Second, some activities that appear to be discipline-specific use concepts and inventive processes shared by all of the disciplines. Such things as aesthetic properties,[3] the kinds of media artists use, styles of art, and landmark works and artists are central to art production, criticism, history, and aesthetics. This sort of knowledge has long been a sign of literacy in the visual arts.

But beyond sharing concepts, the practitioners of all disciplines share certain ways of addressing problems that contribute to their ability to be inventive. Critics, for example, often cite historical precedent. Artists engage in critical reflection on their own aesthetic process. Historians make aesthetic judgments. Artists and nonartists use the same perceptual skills when looking at an object of art, whether it is their own or made by someone else. The boundaries of the disciplines are therefore best regarded as fluid, rather than fixed.

We call these ways of addressing problems *disciplinary processes* for purposes of our subsequent discussions. Being able to engage in these disciplinary processes is an important part of aesthetic literacy. Without them, names of artists and dates and even visual elements and principles of design are inert information of little use. In order to tie the disciplinary processes to their characteristic kinds of information, we formatted them into a table. Each subheading in the text below refers to a corresponding part of Table 3–1. It might be helpful to refer to Table 3–1 as we go along; looking at the text and the table together should be easier to understand than reading them separately.[4]

DISCIPLINARY PROCESSES

Artists, aestheticians, art historians, and art critics, like people in other walks of life, attempt to learn more about the physical world and the human

condition. Scientists base objective, scientific theories on facts, while artists build subjective, aesthetic statements with sensory and formal aesthetic properties (the visual elements and principles of design). Because there can be no appreciation, interpretation, or documentation of art objects without the creative efforts of the artists who produce them, we sometimes overlook the fact that all art professionals—even those whose work looks like that of scientists—share the artist's ability to be inventive.

The form of school art activities varies—writing a critical essay is different in many respects than shaping a clay pot. The average person (parents, school principals, school board members) can identify activities that relate to art production, art criticism, art history, and aesthetics in any elementary school. The inventive processes that these activities share are not as apparent.

We often use the term *creativity* to refer to inventive activity overall, but inventive people use at least five kinds of disciplinary processes. The fact that aestheticians, critics, historians, and artists refer to these five processes by various names can be confusing. Table 3–1 therefore groups them according to function as *descriptive, formal, interpretive* (both *internal* and *external*) and *evaluative* processes, although space limitations mean that the list of examples is incomplete.

You will encounter rudimentary versions of these processes throughout later chapters as we discuss facets of teaching art at the elementary and middle grades. Remember, children are not mature, and their inventive activities reflect this. You should not expect children's inventive behavior to look exactly like that of the adults on whose activities they are modeled. The levels of mastery in Chapter 2 tell us that inventive behavior must be practiced before it becomes achievable, and childhood is a time for practice.

Descriptive Processes

The literal meaning of the verb *describe* is to draw a picture of something. A verbal description means that we represent something in words instead of a graphic image. An artist, art critic, art historian, or aesthetician usually seeks to depict or in some other way give an overview of features of work to be examined or undertaken.

Within the disciplines of art criticism and art history, description becomes a factual account of the art object that is under study (see Chapter 8). Art critics and art historians both compile who-what-when-where kinds of data that, when taken together, establish various dimensions of the work. The critic will describe art within the context of the present, the historian within the context of the past. Description may be more difficult for historians than for critics, since many descriptive facts about an art object may be unknown. The historian's job is to discover them, and to authenticate the work before much further study or interpretation can be done.

Aestheticians identify basic principles or premises on which to base a theory of the nature of art, the creative processes, or the disciplines themselves. Aestheticians seek to establish, from examining one particular art object or several related objects, principles that will describe many similar works of art. Aestheticians' descriptions are not definitive in the sense of providing conclusive statements recognized by everyone in the field. Instead, the many points of view put forward by aestheticians are continually and sometimes heatedly contested.

With respect to the creation of art, descriptive processes can refer to conceptual decisions that artists make as they conceive a particular work. A landscape artist like the English painter John Constable (Fig. 3–10) (see **color insert** #1) may observe the real world and decide to represent it in a rather straightforward way. An artist like the American Hans Hoffman (Fig. 14–17) may decide to think more abstractly about forms or ideas suggested by his observation of real objects. Sometimes artists' sources of inspiration come from imagining what might be, instead of reflecting what is. In any case, as artists begin their work they set artistic problems for themselves that will define or describe the completed art object.

Formal Processes

Formal analysis is often used by art students. They analyze the visual elements (line, shape, texture, value, color, space), design principles (variety, unity, movement, stability, rhythm, balance),

TABLE 3–1 The Disciplines of Art: The Components of Basic Aesthetic Literacy[a]

	The Disciplines			
	Aesthetics	*Art Criticism*	*Art History*	*Art Production*
Disciplinary Characteristics	The branch of philosophy that provides theories of the fine arts. The branch of metaphysics concerned with the laws of perception. Concerned more with principles than with art objects.	The attempt to establish the quality, meaning, and significance of objects of contemporary art (and thus artists) by describing, analyzing, interpreting, and comparing them.	The objective verification and interpretation of art objects made in the passt; rooted in historical fact; uses art objects as historical documents.	The creation of art objects; their inventiveness; their origination; artistry; making art; studio art.

Disciplinary Processes	Kinds of Knowledge and Activities[b, c]			
	Aesthetics	*Criticism*	*History*	*Production*
Descriptive	Nature of subject Nature of art Nature of the creative process Nature of art criticism Nature of art history	Subject Artist Date Location	Subject Authorship Chronology Geography Authentication	Observation Representation Abstraction Imagination Intuition Expression Problem setting: artistic hypotheses
Formal	Elements of art[d] (Sensory properties) Principles of Art[e] (Formal properties) Nature of style Nature of aesthetic perception	Elements of art (Sensory properties) Principles of art (Formal properties) Style Technical properties[f] Aesthetic perception	Elements of art (Sensory properties) Principles of art (Formal properties) Style/technique Attribution Aesthetic perception	Elements of art (Sensory properties) Principles of art (Formal properties) Technical properties (Media, techniques) Aesthetic perception

[a]Discipline content is adapted from, among others, Spratt, Frederick, Kleinbauer, W. Eugene, Risatti, Howard., and Crawford, Donald W., in Ralph A. Smith, Discipline-based art education: Origins, meaning, and development, 197-239. Urbana, IL: University of Illinois, 1987. The form of the diagram is adapted from W. Dwaine Greer, A structure of discipline concepts for DBAE, p. 228. *Studies in Art Education*, 1980, 28 (4), 227-233.

[b]The specific knowledge and skills included in this diagram are intended to exemplify the range of possible kinds within the art disciplines. They are an incomplete listing of all possible kinds of knowledge and skills found in each art discipline.

[c]In many cases, similar kinds of knowledge and skills will be found on the same line under all four disciplines, reading from left to right. Sometimes, however, items on the same line are quite different. Placing items on the same line is not meant to suggest similarity unless identical terms are used.

[d]Elements of art (sensory properties): Such things as line, shape, texture, value, color, and space.

[e]Formal properties: Such things as variety, unity, movement, stability, rhythm, and balance.

[f]Technical properties: Such things as media, techniques, manipulation, fabrication, and craftsmanship.

and technical features of a work of art. It is virtually the same in all art disciplines. The purpose of formal analysis is to uncover the internal organization (called *composition* or *design*) of a work of art, particularly with respect to the way it helps to establish meaning. Formal analysis develops knowledge of the language of art (see aesthetic scanning and the Feldman method in Chapter 8), something considered so essential to art education that it has its own chapter (Chapter 14).

Formal analysis examines aesthetic dimensions of art objects that we can see (*visual* charac-

TABLE 3–1 **The Disciplines of Art: The Components of Basic Aesthetic Literacy (continued)**

Disciplinary Processes	Kinds of Knowledge and Activities			
	Aesthetics	*Art Criticism*	*Art History*	*Art Production*
Interpretative (Internal)	*Appreciation* Nature of aesthetic experiences Metaphor Symbolism Representation Interpretation Expressiveness	*Interpretation* Ideology Mood Metaphor Symbolism Narration Explication Innovation	*Explanation* Idealogy Function Metaphor Iconography Provenance Restoration Innovation	*Expression* Ideas Feelings, moods Metaphor Symbols Humor Incongruity Novelty, originality
Interpretative (External)	Cultural context: folk arts, popular arts, fine arts Social context: technical, political, economic, religious, psychological, and scientific values Intellectual context: contemporary and historical ideas, ideals	Cultural context: folk arts, popular arts, fine arts Social context: technical, political, economic, religious, psychological, and scientific values Intellectual context: contemporary ideas Artistic movements Artist's intent	Cultural context: folk arts, popular arts, fine arts Social context: technical, political, economic, religious, psychological, and scientific values History of ideas Semiotics Patronage Artist's biographies	Cultural context: folk arts, popular arts, fine arts Social context: technical, political, economic, religious, psychological, and scientific values Intellectual context: contemporary and historical ideas, ideals
Evaluative	Aesthetic value: art for its own sake Aesthetic appreciation: enjoyment, interpretation Critical Thinking: reflection, deliberation, logical reasoning Critical evaluation: value of standards for judging art instead of personal reference or contemporary fashion	Standards for art: formal excellence, originality, sincerity, artistic significance Critical (discriminating) value judgments: historical, recreative, judicial	Historical greatness Historical significance Historical judgments	Standards for art: formal structure, technique, expressiveness Critical (discriminating) analysis of the work of art in progress: formal analysis, technical analysis, expressive analysis Problem solving: verification of artistic hypotheses

teristics) or touch (*tactile* characteristics) or perceive through our other senses of taste, hearing, or smell. These perceptible features were used pedagogically by Walter Gropius (Fig. 3–11), Wassily Kandinsky (Fig. 3–12) (see **color insert** #1), and Josef Albers (Fig. 8–5), all of whom taught at the German school of design called the Bauhaus from 1919 to 1933. Gropius, an architect, and Albers, a painter, later emigrated to the United States, where their influence on art education was profound.[5]

Interpretive Processes

Interpretation is the process of creating meaning. Meaning is the touchstone of art—the test that most of us use to distinguish art from nonart. The meaning of art wherever found, not form or subject matter or technique for their own sakes, is the "bottom line" for viewers. The fact that art means something to us is why we teach interpretive processes in elementary schools.

Figure 3-11 Walter Gropius, *Project for City Center for Boston Back Bay* (1953).
(Photograph of the model by Walter Gropius)
(Courtesy of Harvard University Art Museum, #BRGA 122.1).

Artists may create metaphors for joy or anger, patriotism or social criticism, liberty or injustice, paradise or the horrors of war. They may or may not depend on the aesthetic properties of form. Their works may tell stories with humor, intentionally shock, or contain ambiguous metaphors with multiple interpretations. Viewers interpret these messages when they "read" works of art. We can distinguish two kinds of interpretive processes, *internal* and *external*.

Internal Processes Some interpretive processes are discipline specific, so we use slightly different words to describe each one. For artists, we use *expression*. For art critics, we use *interpretation*. For art historians, we use *explanation*. For aestheticians, we use *appreciation*.

Artists, both before and after Warhol, express meaning through some configuration of forms that we can see, touch, hear, or otherwise perceive through our senses. Contemporary artists have more avenues for expressing meaning than in any previous society: more materials, more styles, more symbols, and a more literate audience. They may tell a story, create a mood, imagine new worlds, comment on society, or give a shape to ideas.

Critics may discuss a work of art in terms of its narrative, its mood, its innovation, its symbolism, its form, and relate all of these to each other and to the whole work. Art historians may explain the work's symbols, its ideas, its function, who made it and why, and recreate its appearance as it was before the ravages of time. Aestheticians may

look at a work and debate the validity of formalism, or the ambiguity of contemporary symbolism, or the need for psychical distance in responding to works of art.

External Processes All artists work within particular cultural and social contexts that influence their aesthetic orientation, their ideas, and their values. All objects of art reflect these influences. Contextual influences make important contributions to the style and meaning of works of art, even though we call them external to the disciplinary aspects of the works.

There are at least three kinds of external contexts: cultural, social, and intellectual. *Culture* here does not have the classical meaning—a body of knowledge comprised of noble ideas—but more the sociological meaning—a way of life of a society—applied to the world of art. The *cultural context* refers to the artistic climate in which a work of art is produced. The cultural context of art such as the Baule sculpture from Africa (Fig. 5–2) differs from the context that produced many styles of European historical art; the context contributes to its meaning.

The *social context* runs the gamut of values found in the societies in which artists live or have lived. These include technical, political, economic, religious, psychological, and scientific values. The German artist Käethe Kollwitz, made real the horrors of war, for example (Fig. 9–6). The American artist George Caleb Bingham gave us a romantic view of American pioneer life (Fig. 11–3). The values held by all artists reflect the values of their times and shape the meaning of their work.

The *intellectual context* refers to ideas, either contemporary or historical, that excite artists and then find expression in their work. Mythology inspired the classical Greeks. Christianity produced a large body of art from the middle ages through the Renaissance. Scientific discoveries in optics played a role in late nineteenth-century Impressionism. Sigmund Freud's study of dreams influenced the turn-of-the century Surrealists (Fig. 2–3).

Evaluative Processes

Practitioners of each art discipline make evaluative judgments in the course of their inventive activities. They evaluate their own work and that of others. They apply the criteria of their own disciplinary frameworks. You will make similar judgments when you evaluate your students' work (see Chapter 10).

Artists continually ponder the way they have solved problems they encountered while working on a particular piece of art. Critical analysis allows artists to form and test artistic hypotheses. If one hypothesis is unverified—if they judge a solution to be weak—they form and test another, until one proves satisfactory. Each artist has personal standards for formal structure, technique, and expressed meaning.

Value judgments of art critics are similar to those of artists, but their purposes may differ. Some critics may wish to retrace the path of a contemporary artist's inventive activity, but others may wish to compare the work of one artist with another in order to rank them in order of excellence. Art historians may wish to recreate artistic problems or assign comparative rankings to artists of the past.

Aestheticians may deliberate the contributions of art to society. They may compare two different aesthetic points of view. They may debate the reasons given by critics for declaring a work of art good, in order to determine which reasons can support the judgment. Aestheticians may attempt to discern the truth of competing theories of art and their relative values for defining art.

The process of evaluating art in order to make judgments about it is often referred to as critical thinking. Critical thinking requires reflection, deliberation, and logical reasoning. Critical thinking is a skill useful in many areas of our lives.

WHO TEACHES ART?

The inventive processes just described may seem desirable but the task of conveying them to children may be hard to imagine at this point. Earlier we said that there are three kinds of teachers who have responsibilities for art programs in elementary schools. They are classroom teachers, art specialist teachers, and community art professionals. Let us look at their roles in more detail.

Classroom teachers carry the responsibility for a pot pourri of subjects, of which art may be one. Classroom teachers spend a great deal of time with children at one grade level, generally as

the major teacher for twenty-five to thirty-five children (on average) for an entire school year. Although other teachers may work with this group intermittently during the school week, classroom teachers know these children best.

Classroom teachers are generalists in all of the subjects they teach, including art. They rely on textbooks to convey discipline concepts in some of these subjects, and consider textbooks a feasible approach to art. Many classroom teachers who learned to teach 15 or 20 years ago did not study art education. With inservice or preservice preparation, classroom teachers can provide quality art instruction. They also can weave art into other subjects, opportunities unavailable to art specialists.

Art specialist teachers are proficient in the subject of art. They may or may not have classrooms of their own, but in either event they divide their time among all of the grade levels in one or more elementary schools. Art specialists may see three to eight hundred children (on average) once or twice a week. Art specialists in elementary schools were generally art majors, rather than education majors, during their undergraduate preparation. They took many more class hours of art than classroom teachers, but many less hours of elementary education.

The community in which any elementary school is located also contains many kinds of arts professionals who can assist teachers both in and outside of classrooms. Most communities have at least one library and some have an art museum, and somewhere in each state there will be a state education agency, a state arts council, and a state university with artists and art education professors whom teachers may contact if they wish. Most museums have educators on staff as well as docents (tour guides); there are also community librarians, state education specialists, arts council staff, visiting artists, and art and art education professors, all of whom can provide resources that include materials and classroom visits. These community art professionals may teach children in school, provide programs for groups of children who visit their facilities, conduct educational workshops for teachers, or meet with individual teachers.

Classroom teachers provide most of the art instruction in most American public schools because many districts have no art specialist teachers. Perhaps one third or less of all schools—

exact figures are unavailable—employ art specialists to teach elementary art outside of the day-to-day routine of academic classes. Some school districts have a curriculum specialist in art who coordinates instruction from all sources, provides resource materials, and offers teachers other kinds of assistance.

Collaborative Teaching

When a number of professionals in and out of schools combine their skills to provide art programs, it is called collaborative teaching. Collaborative teaching is gaining support among art educators across the United States. For example, the North Texas Institute for Educators on the Visual Arts (NTIEVA)[6] employs collaborative teaching that involves classroom teachers, art specialist teachers, professional and volunteer community resource people, and university professors.[7] The NTIEVA consortium is made up of six school districts, five museums, two arts councils, two state agencies, and a university. The success of their collaborative teaching shows that when a number of people work together toward an instructional goal, they can provide school art programs of high quality.

Members of the consortium agree that basic art instruction is the foundation of any high-quality program, and that the best learning situations are created when art specialist and classroom teachers work together. Beyond basic instruction, teachers and community arts professionals like museum educators and artists may elaborate on the content of basic art lessons as the need arises. Teachers also integrate art with other academic subjects.

Collaborative teaching means that classroom teachers and art specialists divide teaching responsibilities between them, with each person fulfilling a specific function. Different organizational patterns occur in different schools. Both classroom and art specialist teachers may work with school and community librarians, local museum educators, local and state arts agencies, visiting artists, PTA members, and other professional and volunteer resource people to enhance their own classroom activities (see Table 3–2).

School administrators—a broad term that may include superintendents, principals, curriculum specialists, and art supervisors—provide support in the form of equipment and materials,

including reproductions of works of art, textbooks and other published resources, time for curriculum planning, and ongoing educational opportunities for teachers (also called *inservice* or *staff development* workshops). Art education professors at the university sometimes act as resource people. Often they are consortium organizers and facilitators.

Strengths of Classroom Teachers Each district in the Texas model has a slightly different collaborative organization, but in most of them classroom teachers share responsibility for basic art instruction with an art specialist. Classroom teachers use either locally developed or commercially available curriculum resource materials. These materials are selected jointly by the classroom teacher, the art specialist, and the district curriculum coordinator. They provide a basic vocabulary of grade-appropriate, discipline-related art concepts contained in user friendly lesson formats.

With instruction based on appropriate curriculum materials, including textbooks for the children, classroom teachers can offer a variety of solid art learning situations that are sequenced and comprehensive in scope. In this respect, teachers can follow the instructional pattern used in other subjects. In collaborative teaching, classroom teachers introduce fundamental art concepts that stand on their own in the absence of art specialists. Art specialists can rely on these concepts when they extend art learning beyond the basic curriculum.

Developing lessons in which art is taught in conjunction with other subjects is the other major responsibility of Texas classroom teachers (see Chapter 11). Classroom teachers encounter many opportunities during the school day for children to study concepts like pattern, common to art and mathematics, or skills like perceptual discrimination, shared by art criticism and the beginning sciences. In this way they are able to broaden the scope of the art curriculum and also strengthen related academic skills needed for art learning.

Whether or not schools have art specialists (and specialists are strongly recommended), collaboration constitutes a fundamental role change welcomed by many classroom teachers. Teaching art provides them with opportunities to add variety to the school day, which enlivens and legit-

TABLE 3-2
A Collaborative Teaching Model[a]

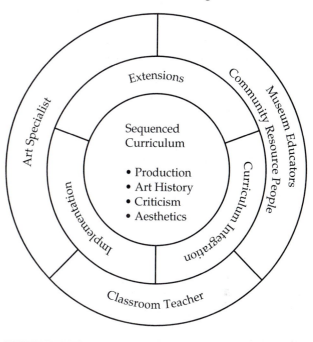

[a]Davis, Donald Jack, and McCarter, R. William. (1994). An experiment in school/museum/university collaboration. *Metropolitan Universities*, IV (4): 2–34.

imizes many inventive activities they already teach. Collaborative teaching emphasizes the valuable contributions classroom teachers make because of their general knowledge.

Strengths of Art Specialist Teachers In collaborative teaching, art specialists assume primary responsibility for content, including the scope and sequence of the curriculum. They are responsible for classroom activities that incorporate art knowledge and skills beyond the basic art curriculum. Specialists can tailor curriculum extensions specifically to respond to local conditions. They may extend learning situations in published curriculum materials being used in their districts. They may develop special enrichment activities that provide a counterpoint to basic art studies.

Art specialists also advise classroom teachers of the strengths and weaknesses of commercially published curriculum materials prior to their joint selection of materials most appropriate for their school or district. They aid classroom teachers in understanding the art disciplines and developing

inventive activities that teach concepts from art history, criticism, and aesthetics as well as in art production. Art specialists give flexibility to an art program. Art specialists also have time to organize the community professionals who provide classroom teachers with resource materials and activities.

Collaborative teaching changes the traditional role of the elementary art specialist from the primary provider of basic art instruction to the provider of more advanced art concepts and instructional support for classroom teachers. The specialist's depth of content complements the classroom teacher's breadth. In providing advanced lesson content, art specialists in a collaborative situation face challenges more appropriate to their preparation. District administrators and classroom colleagues value their subject matter expertise.

Strengths of Community Resource Professionals Museum educators, arts agency staffs, artists, and other arts people in any community are a valuable instructional resource for teachers. In the Texas consortium these community resource people work closely with art specialists to prepare materials for use in classrooms that support each school's artistic goals. These materials might relate to such things as local architecture, museum collections, artists and their works, and books and videotapes in public libraries.

Community institutions can also provide new learning environments accessible by field trips. They host staff development enrichment programs and provide experts to present them. They can find and organize professionals. They can sponsor fund raising drives to support art programs beyond the levels possible on school budgets alone. Collaborative teaching calls on the specialized talents of people in surrounding communities and lets them become a part of the instructional team.

Strengths of University Professionals Universities form a particular subcategory of community institutions that support school art programs. University professors are both a blessing and a curse to teachers in the public schools because they want to help them succeed but may also give unsolicited advice. (We authors are allowed to make that observation because we are of the academic persuasion ourselves.) Professors responsi-

ble for preservice art education may be found in both education and art departments.

University professors have certain things to offer, however. One is their ability to contribute to staff development; another is their ability to write grant proposals; a third is their ability to write curriculum; and a fourth is their ability to facilitate communication among consortium members. All of these activities can make positive contributions to collaborative teaching, but they should not be misinterpreted as the mechanisms that make it work. What makes collaboration work in the Texas consortium is the commitment of participating teachers who recognize the value of its results.

Strengths of Collaborative Teaching

Most art teaching in elementary schools seems likely to continue being the responsibility of classroom teachers, as all other school subjects are, for both financial and philosophical reasons. Unfortunately, even when classroom teachers have comprehensive and grade appropriate teaching materials (and these are now commercially available for districts without art specialists), many find it difficult to teach art to the same extent that they teach other subject areas if they lack substantial preservice or in-service preparation. With collaborative teaching, however, the strength of the art program—reinforced by arts professionals—can increase noticeably.

One of the most valuable benefits for classroom teachers is access to art colleagues and community professionals, whose participation provides (in effect) continuous in-service support by modeling art procedures that are difficult for nonarts people to translate from the printed page. Flexible thinking with respect to teachers' responsibilities also seems to offer the promise of increased program quality even when funds are scarce and staffing is less than ideal. Specialists, too, feel appreciated and supported for their elaborations of teaching materials and other resources that enhance the quality of art programs.

How does an elementary classroom teacher have time to add another "serious" subject to an already crowded school day? Many teachers use a work of art as a theme around which to focus concepts that they teach in other subjects. This focus helps them to identify the most important con-

cepts in science, language arts, and mathematics, as well as in art, which unifies rather than fragments the school day (more on this in Chapter 11). Far from feeling overloaded, many classroom teachers report that art has brought new excitement to teaching and relieved their feelings of "burnout."

R. William McCarter observes, with respect to the North Texas Institute, that "both the art specialist teachers and the classroom teachers are always discovering the power of the art image to focus the learning of the child. It is our experience that the specialists are as surprised as anyone about the discipline that they thought they understood so well. The fresh aproach of the classroom teacher to our own discipline has been the major discovery of our Institute."[8]

A collaborative teaching approach redefines the instructional roles of those associated with art programs, particularly the classroom teacher and the art specialist. It extends the scope of the classroom teacher by adding interesting subject matter. It extends the audience of the art specialist from children to adults, even though the specialist continues to spend some time teaching children. It provides a more legitimate place in the school program for community professionals. Without a sense of shared purpose, these can be seen as disadvantages. Collaborative teaching succeeds when all providers of art instruction can see its benefits and feel that their contributions are of equal importance.

SUMMARY

Knowledgeable teaching depends on content, child development, and curriculum. Leaders in contemporary art education recommend an approach that conveys comprehensive content. The term *comprehensive* refers to the inclusion of aesthetics, art criticism, art history, and art production. If you are to be the kind of teacher who nurtures children's inventiveness in art, it is particularly important to have a sense of the inventive processes that these art disciplines represent.

Converting comprehensive art content into teaching materials that encourage children to learn is difficult. It should be reassuring to know that you will not have to face this task alone.

There are excellent published materials available for those with an overall sense of the disciplines who are willing to seek them out. A number of them are listed at the end of this book. If you are an art specialist and wish to undertake this demanding task, you will benefit from these resources as well.

Parents, teachers, school administrators, and other adults in the cultural community are well equipped to see the advantages of sound art content in general education. Aesthetics, art criticism, art history, and art production represent distinct, recognizable bodies of knowledge. Their inventive processes, which constitute what we are used to calling "creativity," are descriptive, formal, interpretive, and evaluative, and children can practice all of them.

There are three kinds of art teachers in elementary and middle schools: classroom teachers, art specialist teachers, and community professionals. You will find a place for yourself in one of those three categories. Whichever you choose, you will have an important part to play in children's education. Comprehensive content is a reflection of a comprehensive subject. Collaborative teaching is well designed for a subject of such scope within the context of general education.

NOTES

1. Rush, Jean C., and Shumaker, Mary Susan. (1982, March 21). Characteristics of adults' figure drawings: Observations of the postadolescent stasis in graphic development. New York: Paper presented at the American Educational Research Association.

2. Resnick, Lauren B. and Klopfer, Leopold E. (1989). *Toward the thinking curriculum: Current cognitive research; 1989 yearbook of the Association for Supervision and Curriculum Development,* Alexandria, VA: ASCD, pp. 1–2.

3. Aesthetic properties are the visual elements (sensory properties)—*line, shape, texture, value, color, space*—and principles of design (formal properties)—*variety, unity, movement, stability, rhythm, balance*—explained in detail in Chapter 14.

4. The order in which your students should encounter these processes—which is not always the order you see in the table—is the subject for later chapters on the construction of art curricula.

5. **Form versus formalism.** In light of contemporary developments in art and aesthetics, it should be pointed out here that formal analysis of works of art is not the same thing as *formalism*, the aesthetic

point of view that developed as a result of artists' fascination with form to the exclusion of subject matter. An aesthetic revolution against formalism began in the 1960s, based on the idea that art and non-art sometimes look the same (see Chapter 5). At the same time, almost every American art school still requires students to learn formal analysis during the first year or even two years. The changing importance of form in some contemporary art has not yet displaced its predominance in the training of most artists.

6. Directed by art educators Donald Jack Davis and R. William McCarter, North Texas University.

NTIEVA is supported by the Getty Center for Education in the Arts. It provides regional staff development and assistance in implementation of K-12 discipline-based art education (DBAE) programs in southwestern public school districts.

7. Davis, Donald Jack, and McCarter, R. William. (1994). An experiment in school/museum/university collaboration. *Metropolitan Universities, IV* (4): 25–34.

8. McCarter, R. William. (1996). Personal correspondence.

4
Child Development in Drawing

Katie is drawing a picture. She is three years old, and she intently moves a fat marking pen in her hand around and around the paper, back and forth, in circles and swoops, lines crossing other lines. "Katie, draw me a doggie," says her mother. Katie makes a circle. "How about a Mommy?" Katie makes a slightly bigger circle. "Now, where's Katie?" A third circle appears, and then more lines and circles (Fig. 4–1). Katie's graphic communication of meaning has begun.

The fact that production is one of the four areas around which art lessons should be organized is probably reason enough to devote a chapter to the characteristics of child art and how they change as children grow. There are, however, even more important reasons for knowing the kinds of images children typically make at different ages. Child art provides us with glimpses into the ways children view and represent the world. This, of course, is useful if we intend to plan appropriate lessons that foster their artistic development, not only in art production but in art history, aesthetics, and art criticism.

Throughout the book we'll be using the term *child art* to refer to all images children make with art materials, the earliest of which are drawings. While children's artistic development is visible in their three-dimensional art (sculpture and crafts, for example) as well as art of two dimensions

(paintings, drawings, and prints), the latter has become the main focus of developmental research studies. Since our goal in this chapter is tracing artistic development, rather than cataloging kinds of media children use, we, too, have illustrated it with examples of two dimensional work. All observations of artistic development, however, apply to both.

OVERVIEW

Children's artistic development corresponds to their physical and intellectual growth. Until adopting the concept of nonuniversal development, most art educators considered the pattern of children's artistic development to be *innate* (inborn), *invariant* in its sequence (a child must successfully complete one stage before passing on to the next), and *universal* (the same in all cultures), ending at adolescence. Now, after research by David Feldman and others, artistic development is most generally seen as an ongoing process that begins at birth and continues throughout life, whose rate and extent is affected by both informal and formal education.

Think of children's artistic development as the way innate physical and intellectual abilities are stimulated by knowledge about art. Growth

Figure 4-1 Photo of Katie.
(Courtesy of Katie's parents)(Photograph by Linda Tjaden)

rates are set at birth, but children acquire artistic knowledge one step at a time from their environments; one kind of knowledge opens the door to another. All children glean certain kinds of art knowledge in an informal fashion, depending on the circumstances of their lives; but if children are to realize their full artistic potential as they grow into adolescence and adulthood, they should also learn about art from more substantial experiences in school.

As children develop artistically their images become more visually complex and more realistic. A number of psychologists and art educators have grouped child art into developmental stages or styles that correspond to age. The distinctiveness of these styles depends on the same aesthetic properties and the same compositional devices to express meaning found in adult art, albeit in simpler terms. Children's immature perceptual abilities means that their art will not look like that of adults, nor would we want it to.

Developmental styles chronicle for us the changes in children's thinking and perceptions of the world as they mature. So, too, they document children's expanding knowledge about art, and how that knowledge changes the way they organize visual images. Whether maturation or learning has the upper hand remains unclear. Art educators continue to debate how much of children's increasing artistic adeptness depends on "nature" or genetics and how much on "nurture" or experience.

No one disputes, however, that without formal art instruction children's artistic development will be hit or miss. Children deliberately strive for mastery over art tools, techniques, and aesthetic concepts throughout childhood. The "fresh" quality in the art of six year olds also reflects a naiveté that children intuitively seek to dispel. But without the expressive options schooling supplies, most children's artistic inventiveness visibly wanes by preadolescence. Well planned elementary art

experiences can augment children's inherent desire for knowledge, helping them move through the developmental styles more quickly and farther than they might otherwise go on their own.

HYPOTHESES ABOUT GRAPHIC REPRESENTATION

Drawing, an act requiring both seeing and representing, is one of the most complicated of human behaviors. Seeing itself is a complex process of handling optical information involving both the eye and brain. Given normal vision and looking at the same subject, two people might have similar retinal images but not necessarily see the same thing. What they see depends on how their minds process the visual data—involving such variables as age, personality, intelligence, past experience, and, of course, culture.

Just exactly how a given child sees something is always a mystery. The mystery is further compounded when we factor in representation which, in addition to seeing, involves such variables as psychomotor ability, choice of medium, drawing strategies, and a host of personal choices. Why, you may ask, is a child's drawing so lacking in detail or so distorted or, even, so fantastical? We know that young children don't perceive trees as shaped like lollipops and suns as having smiling faces any more than adults. Any notion that children are somehow perceptually deficient is readily ruled out.

Might children simply be deficient in drawing, that is, unable to represent what they see? Such a hypothesis assumes that the goal of art is to duplicate the retinal image as closely as possible, a condition commonly called realism. Realism in art, as we saw in Chapter 1, was challenged by the modern art movement. Further, it has not always been appreciated in cultures outside the West.

Still, the average American adult—the modern movement notwithstanding—does value realism in art, and so does the average older child. Indeed, because of their tendency to evaluate art on the basis of its "looking right," many older children are dissatisfied and frustrated by their drawings. But this urge for realism does not seem to exist among younger children—those under the age of eight or nine. To the contrary, they love to

draw and are very proud of their representations, lack of realism notwithstanding.

Another hypothesis about child art that held sway for a number of years was that children draw what they *know*, not what they *see*. For example, the sides of a street, as any child knows, are parallel; the best way to represent a street, thus, is to show it in *plan* (Fig. 4–2), rather than in perspective. Faced with the problem of showing people standing on both sides, the child artist of Figure 2 made those on the near side upside down. From the standpoint of what we normally see, this is not a satisfactory solution. But from the standpoint of what we know about streets and people, it certainly could be.

Still another hypothesis that gained currency around mid century was that a child's picture is not a representation of what the youngster sees or knows, but a "projection" of what she *feels*. In this view, a child's drawing is a mirror of her impulses, anxieties, and complexes, and can be used as a test of personality. In a drawing of the human body a nose may stand for a penis, a mouth, the vulva; overemphasis on, or omission of, these features would point to various sexual anxieties, and so on. Today this approach is favored chiefly by those who use it as a tool for working with disturbed children and adults.

CHILD ART AND SYMBOLISM

Current researchers see child art as a symbolic domain. Developmental psychologist Howard Gardner makes the case that all art is "an activity of the mind, an activity that involves the use of and transformation of various kinds of symbols."[1] But whereas the symbols constructed by an adult artist may resemble things in the real world (but not always), the symbols of a child, especially those of a young child, may not.

Children invent symbols or equivalents for objects and events that correspond structurally but not optically to actual objects. Thus a circle can be a satisfactory equivalent for a dog, a mommy, or Katie herself (see Fig. 4–1). A circle can also serve as a head, a torso, or the foliage of a tree. Straight lines can symbolize a street, as in Figure 4–2, or the branches of tree.

These constructions are independent of the retinal image and they can vary from child to

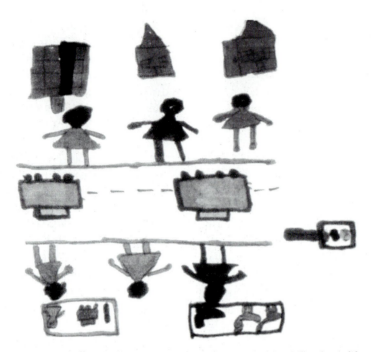

Figure 4-2 Age 10, female, Iran. This youngster solved a difficult problem—representing both sides of a street—by placing figures on one baseline, rotating the paper, and placing figures on a second baseline. This strategy of opposing baselines to represent two sides of anything—a street, picnic table, football field, etc.—is sometimes identified as "fold-up."
(Courtesy of the International Collection of Child Art, Illinois State University, Normal, IL.)

child. Katie might represent a tree as a solid trunk topped by a circle. Matthew might symbolize the branches as spokes with right-angle spikes.

Claire Golomb, an authority on child art, is a child psychologist in the tradition of Rudolph Arnheim and Gestalt psychology. "The whole is greater than the sum of its parts," Gestaltists are fond of saying. For example, when listening to music, one hears the melody, not separate notes. Because Gestaltists think their principles are basic to all human perception, Golomb and others who subscribe to this school of thinking believe that the symbols young children make are universal to all cultures.[2]

One of the strongest exponents of universal symbols was Rhoda Kellogg, a preschool teacher who collected thousands of drawings from thirty countries during the 1950s and 1960s. Through a study of her collection, Kellogg discovered what she believed to be classes of forms used by all children. Curiously, one of these is the *mandala* (Fig. 4–3), a sacred symbol in Asian cultures and also one of the universal "archetypes" identified by psychiatrist Carl Gustav Jung in his theory of a

"collective unconscious." Extrapolating from her discoveries, and stimulated by their connections with Jung's archetypes, Kellogg has even suggested that there may be universals in adult art.[3]

ARE THERE UNIVERSALS IN CHILD ART?

An opposing school of thinking proclaims that many of the symbols children make are relative to time and place. Led by art educators Marjorie and Brent Wilson, this view is partially indebted to art historian Ernst Gombrich's concept of schema. A schema is a sort of visual code that professional artists learn—consciously or unconsciously—from the works of other artists and by which they represent things in the world. Like a gestalt, a *schema* is an equivalent that corresponds structurally, but not always literally, to objects in nature.

Through a process of matching a schema with other schemas or with nature itself, the artist continually improves upon it. The Wilsons have extended this notion by claiming that children, knowingly or not, borrow both from the popular

Figure 2-2 *Hall of Bulls*, Lascaux (Dordogne) France (ca. 15,000-10,000 B.C.E Upper Paleolithic). (Courtesy of Hans Hinz/Colorfoto Hans Hinz, Basel) (Photograph by Hans Hinz)

Figure 3-1 Fingerpainting by a five-year old child. (Photograph by Jean Rush)

Figure 3-10 John Constable, *Wivenhoe Park, Essex* (1816). Oil on canvas, 22 1/8 x 39 7/8″ (56.1 x 101.2 cm). Framed: 30 5/8 × 48 1/4 × 3 1/2″ (77.8 × 122.5 × 8.8 cm) National Gallery of Art, Washington, D.C. (Widener Collection, 1942.9.10 PA)

Figure 3-12 Wassily Kandinsky, *Composition IX, No. 625* (1936). Oil on canvas, 47 1/8 × 76 3/4.″ Paris Musée National d'Art Moderne. (Courtesy of Scala/Art Resource (c) 1997, #500005508, Artists' Rights Society (ARS), New York/ADAGP, Paris) (Photograph by Scala)

Figure 4-6 Age 8, female, U.S.A. With exception of the outlined, round heads, this drawing by an 8-year- old American girl employs a method of continuous line to describe the contours of the marching figures. Notice that clothing and hair are used to define gender. (Courtesy of the International Collection of Child Art, Illinois State University, Normal, IL.)

Figure 4-9 Age 15, male, *Mother Returns from the Market*, India. Cultural influences can be seen in the arabesque patterns both in the woman's costume and in some background areas. Gender differences in the figures, particularly seen in the proportions of waists and hips, are also in evidence. (Courtesy of the International Collection of Child Art, Illinois State University, Normal, IL.)

Figure 4-11 Age 16, male, *Beach*, South Africa. This example by a South African adolescent not only successfully employs realism and expressionism to project meaning, but also exhibits a striking composition in terms of its overall design and use of color. (Courtesy of the International Collection of Child Art, Illinois State University, Normal, IL.)

Figure 5-1 Vincent van Gogh, *Vase with Fourteen Sunflowers,* Arles (January 1889). Oil on canvas, 95 × 73 cm. Van Gogh Museum, Amsterdam. (Vincent van Gogh Stichting/Foundation)

Figure 4-3 Mandala figure.

culture and from other children. Children's first views of zoo animals, for example, are from commercial illustrations; but, the Wilsons add, "there is another powerful influence that appears just about the time that children begin to draw their first human figures, the influence of other children."[4] In their studies of isolated communities in Egypt, the Wilsons discovered what might be described as independent "cultures" of child art having their own unique traditions and pictorial conventions.[5]

The Wilsons argue that beyond a certain age child art demonstrates few universals and is affected more by culture than by nature. Golomb counters this, claiming that the styles the Wilsons discovered among children of remote villages fall within the range of possible variations of child art found among urban Western children and, for that matter, anywhere in the world. This kind of debate over universals, related to the perennial nature-nurture riddle in education, is a persistent one among students of child art.

The assumption of universality is also challenged by the views of David Feldman regarding *regions* or levels of mastery through which children pass in learning a particular domain of knowledge. While Feldman calls the initial level

universal, the one that occurs in infancy (see Table 2-1 in Chapter 2), he considers the next level, no matter how widespread its occurrence, to be nonuniversal and culture specific. (Beyond that, the levels become increasingly dependent on specialized training and commitment to a particular discipline.)

It is at Feldman's *cultural* level—the one that would characterize most of the art achievement in elementary education—where the debate over universal versus nonuniversal is most heated. In an attempt to shed light on the debate, art educator W. Lambert Brittain compared the drawings of suburban New York children with those of Australian Aboriginal children—two populations with obviously different cultural backgrounds. Taking pains to keep everything but culture equal, Brittain personally saw to it that each group used the same paper and drawing tools and were given the same motivation.

Brittain found that the drawings of both groups were remarkably similar under the age of six. Beyond that, the most striking difference consisted of the fact that the New York children used baselines (a horizontal line across the bottom of the drawing to indicate ground) much more frequently. Brittain suggested that this may be because American children were more exposed to images in story books and television, both of which are seen as viewed through a rectangular frame.[6]

A recent study by art educator Jeannine Perez[7] seems to support Brittain's findings. Perez examined 500 pictures representing 12 countries from the International Collection of Child Art at Illinois State University. To determine whether a symbol was universal or culturally-related she looked to see whether it occurred in all 12 countries and how frequently it occurred in each country.[8]

Among symbols that appeared to be universal were circles (including mandalas), bottle-men, "Egyptian" figures (frontal bodies with profile heads), triangle-roofed houses, and stick and lollipop trees. Among characteristics identified as culturally-influenced were clothing, objects, design motifs, racial characteristics, and subject matter (the picture's narrative). The works of younger children (ages 3 to 6) contained the most universal symbols, the works of older children showed the most cultural influences.

As interesting as both studies may be, we question whether any children's symbols are produced in the absence of adult influence or even Western influence. Given that most child art is collected from children in school settings, together with the fact that visual culture today is virtually international (consider the pervasiveness of photography, comics, and even T-shirts), it is hard to imagine a culturally "uncontaminated" population of children anywhere in the world, including the Aboriginal children studied by Brittain.

THE EFFECTS OF EDUCATION

Your position on the universal issue will have a bearing on how you think art education will affect children's artistic development. If a trait is universal, we assume it to be an innate characteristic. Those who regard children's symbol development as innate tend to believe that to tamper with it in certain ways runs the risk of damaging it.

Viktor Lowenfeld believed that certain kinds of tampering were so destructive that they thwarted not only the art of the child but also children's mental and emotional growth. Among his worst taboos was copywork, which he regarded as the arch enemy of free expression. He also considered the presence of advertising and "funny books" in the culture to have harmful influences on children's growth.[9] In a similar vein, Kellogg disparaged everything from coloring books to animated cartoons because they "fix in the child's mind certain adult-devised formulas for representing objects."[10]

The wisdom of protecting children from the influences of adult-generated art had been taken for granted in art education for years until the Wilsons turned this orthodoxy on its head. They did not simply proclaim that copying is harmless, they baldly advocated it! One of their books, *Teaching Drawing from Art* (co-authored with Al Hurwitz), is a manual on how to stimulate creativity through the use of professional works of art, including copying them at times.[11]

As we saw earlier, the Wilsons believe that beyond age 6 or 7 child art is affected more by environmental factors than by natural factors. There is no such thing as an "innocent eye"—even among children. Whether we like it or not, say the Wilsons, children are prone to copy. So, why not

expose them to the best art available? That's how artists learn, after all—by looking at one another's work.

Copying is not the only strategy for teaching children to draw, by any means, nor the only objection Lowenfeld had to teaching art. The Wilsons' writings have caught the attention of art teachers, and due to their and others' efforts the art education field has moved towards comprehensive art education in recent years and away from Lowenfeld. Teaching art is now widely seen as beneficial. Chapter 9 will further clarify ways in which you can teach children to produce artistic images.

SEVERAL VIEWS ABOUT THE STAGES OF DEVELOPMENT

In 1913 what may have been the first art education text to focus on drawing development was published by Walter Sargent.[12] A decade later, Margaret Mathias (Chapter 1) based an art curriculum on three developmental stages—*manipulative*, *symbolic*, and *realistic*. Shortly after World War II, Lowenfeld submitted a more comprehensive list of stages—*scribbling, preschematic, schematic, gang age, the stage of reasoning,* and *the crises of adolescence* (which was subdivided into "visual" and "haptic" personality types).[13]

Lowenfeld's stages are compatible with those of his contemporary Jean Piaget, a Swiss psychologist whose writings have had enormous influence on the field of developmental psychology. Piaget theorized about universal stages in the development of children's thought processes, proposing three: *Preoperational* (ages 2 - 7), *Concrete Operations* (7 - 11), and *Formal Operations* (11 - adult).[14] Piaget believed that these three levels of thought would occur in all children in the absence of tutoring or special environmental conditions.

Lowenfeld's descriptions of children's artistic development were the most articulate and comprehensive up to that time. They were immensely influential, and their accuracy was uncontested by art teachers for many years. Later, as Lowenfeld's theories about the harmful effects of interfering with the child's natural development began to be questioned, art educator June King McFee also challenged his assumptions of universality with regard to his developmental

stages.

McFee, citing studies of the art of Orotchen children in northern Siberia and of Indian children of the Northwest Coast, pointed out that some tendencies of drawing are related to culture and not chronological age, and that in any case, patterns of development within and among children are far more varied than Lowenfeld suggested.[15] Other art educators questioned the notion of an invariant sequence in a child's growth. Still others pointed out that children often regress to an earlier stage, or that different stages of development are often combined in a single artwork. Many, while acknowledging the role of development, refrained from identifying stages altogether.

McFee herself suggests organizing the variables of artistic production around just three overlapping stages—*scribbling*, *schematic*, and *cultural realism*.[16] Art educator and researcher Betty Lark-Horovitz also names just three: *scribbling*, *schematic*, and *true-to-appearance*, with a "mixed stage" sometimes interposed between the last two.[17] Golomb refers only to overall development—a matter of moving from "simple, undifferentiated forms" to more complex ones.[18]

Kellogg does not set forth stages for all ages but does describe the successive steps—*patterns*, *shapes*, *designs*, and *pictorials*—through which young children progress.[19] The Wilsons provide an overview of a whole range of unnamed steps, but purposely avoid any indications of the ages at which these steps occur.[20] Gardner avoids the issue altogether although he provides helpful insights about the parallels between artistic production and other behaviors, particularly mental development.

Developmental Styles of Graphic Representation

Developmental changes in child art are continuous, so that stages or levels do not precisely correspond to age, Even so, it is helpful to recognize their essential characteristics when you look at the work of your own students. Ages and developmental levels are loosely related, and your students (as a result of your teaching) will undoubtedly exhibit a wider range of artistic development than a description of styles might inadvertently suggest. This will be all to the good as long as you

help them advance when they are developmentally ready and remember that children of every age and ability have certain accomplishments that are beyond their reach.

For the purposes of understanding elementary education, we have chosen to describe five broad developmental levels identified by art educator Richard A. Salome.[21] Using examples of child art drawn from the international collection at Illinois State University, Salome classified these levels as *scribbling*, *preschematic*, *schematic*, *transitional*, and *realistic*, and developed a set of characteristics and descriptions for each.[22] Salome's levels are therefore loosely age-related; they span the years from birth to adolescence (junior high school; and in fact throughout life if art education does not continue).

We have renamed Salome's realism level *cultural realism* for added scope. This label (borrowed from McFee) refers to the styles and pictorial conventions of the adult culture in which children live and to which older children aspire.[23] These conventions can vary from those found in Western fine art painting to those in tribal ideograms, or even those in adventure comics. Today, due to the ubiquity of mass media, adult-generated graphics are mostly Westernized the world over.

Because each of Salome's levels has certain defining visual characteristics, we will refer to them as developmental *styles*, not unlike the *renaissance*, *baroque*, and *neoclassical* styles used to describe periods in art history. Just as a historical style is a global classification containing numerous individual styles—the painters Gentileschi, Rubens, and Velasquez are all classified as baroque—so is a developmental style. The style of scribbling (ages 1 - 3), for example, comes in as many different varieties as there are infants. And just as the progress of art history is not strictly linear, child art styles, even though basically age-related, overlap, regress, and occasionally leapfrog, even bypassing a stage.

Scribbling

Scribbling generally occurs during the first through third years. Kellogg identifies four age-related stages within the scribbling style: *pattern*, *shape*, *design*, and *pictorial*. While this book does

not divide scribbling into such well-defined plateaus, we agree that this style does evolve. Unless you teach in a preschool setting, you will not likely encounter the scribbling style, especially in its earlier stages.

The beginnings of child art consist of apparently random marks—looping, arcing, vertical, horizontal, or dotted—lacking directional control and resulting more from movements of arm and hand than from a desire to make an image. Somewhat later, inchoate, but seemingly intentional, diagrams and patterns begin to emerge. Such forms apparently are meaningful to children, who observe the lines they make, gradually begin responding to them, and with practice develop systems for producing patterns and enclosed shapes. This corresponds to what Gardner calls the beginnings of "first-order symbolic knowledge" mastery, a significant step in the process of joining the human community.[24]

Next, with more control, children create more defined shapes such as ovals, sunbursts, and right-angle oblongs which may be overlapped or placed in separate spaces on the paper. Around three years of age, children begin to tell stories about their scribbles, often while drawing, which may result in adding more lines. Purposefully produced enclosed shapes with smaller shapes and dots inside occur soon thereafter. The making of enclosed shapes placed in different locations on the paper leads to the next level of style when children begin to practice with depicting figures and objects.

Figure 4-4 Age 4, female, Belgium. This drawing illustrates the continual change and experimentation characteristic of early representative symbol making. How many different symbols for the figure can you find in this drawing?

(Courtesy of the International Collection of Child Art, Illinois State University, Normal, IL.)

Preschematic

The preschematic style is typical of many preschoolers, some kindergartners and a few first graders. From ages three to five, children's drawings shift from gestural action to vague representations. They begin to create shapes—usually circular, with internal markings—meant to represent the human figure, although these early shapes may be difficult to recognize without assistance from the child. Circles and ovals are dominant. So-called "global" figures consist of a circle or oval with internal marks for facial features. These are followed by circular shapes with attached lines for arms and legs, often referred to as "tadpole" figures (Fig. 4–4).

A figure may consist of facial features and limbs in the right places but without an enclosing outline, making it hard to recognize. Circular and oval shapes may be connected to represent head and body, with lines for arms or legs extended from either shape. Torsos and legs may consist of two parallel lines extended from an oval representing the head. In parts of the paper around the figure the child is apt to place additional scribbles and outlined shapes. Details are few, parts are often missing, and shapes and lines that make up the object or figure lose meaning when separated from the whole. The ambiguity of these early figures makes it difficult to determine if they are human, male, female, child, adult, or animal without the child's description.

Early representative symbols are changed

frequently, and sometimes vary within the same picture. This vacillating between solutions is reminiscent of what Feldman describes as *internal disequilibrium*—"competition among the child's alternatives for dealing with experience."[25] In this case, competing alternatives vie in a child's mind for a consistent system of representing figures and objects (see Fig. 4–4). What children decide to put in a figure can be affected by many factors: the assigned task, adult instructions, the medium, and the sequence in which the various parts are drawn. The use of color is limited and random until the child discovers that it can help to define an object. Pictorial organization in preschematic art, including color use, is usually random with figures floating in space.

We should not assume that early representations of human shapes indicate all a child knows about the human figure. Golomb found that children can verbally describe parts not represented in their drawings. She also found that three- to four-year old children in the scribbling stage could produce global and tadpole representations of the figure when she dictated the parts of the figure. Children have fairly clear concepts of what the human figure looks like and, through instruction, observation, borrowing, and practice, they develop a repertory of shapes and drawing systems that work in representing a variety of objects.

Descriptions of steps leading to a representational plateau suggest that children have to pass through each step. Prior experience in scribbling is not, however, an absolute necessity for children or adults to begin producing elementary human shapes such as those described for the preschematic style. According to earlier studies in the field, children from primitive and remote cultures, with no previous access to paper and pencils, progressed in one or two drawings, and sometimes in the same drawing, from scribbles to simple human shapes.

Schematic

The schematic style corresponds to a period of childhood that is a favorite among many adults: between ages five and eight (although, for some children, the style continues to predominate even to adolescence). Like their younger peers, five, six, and seven year olds are open and eager to learn,

yet their attention spans are longer, and because they have acquired a minimum level of verbal skill, they are easier to work with. Unlike older children, they retain their innocence and are not yet adversely affected by peer pressure. They continue to respect and like adults, especially those who care for them.

Many art educators consider this a peak period of artistic expression. Like the children themselves, schematic art tends to be bold, unaffected, and brimming with enthusiasm (Fig. 4–5). To adults knowledgeable in art, it has affinities with primitive art or the paintings of the Fauves (an early twentieth-century avant garde). To parents and teachers it symbolizes childhood at its innocent best. Perhaps most significantly, children at this age not only like art but are irrepressibly confident of their expressive abilities. They glory in their new-found mastery of depiction. Nothing in their environment or imagination is too daunting to draw. The technical term in developmental psychology for such a plateau of success and achievement, coined by Piaget, is *equilibration*.

A *schema* is a form concept that children develop (more or less spontaneously) for representing a figure or object—not unlike the way the term is used by Gombrich to explain the methods of professional artists. In terms of artistic development, a schema is a flat symbol drawn without the benefit of shading, foreshortening, or any of the devices used to indicate depth. Typically the same symbol is repeated with little variation unless some urgency or special experience (like art education) prompts a change. Still, schemas can indicate general differences between such things as people, animals, buildings, and trees. Because of their often repetitive use of symbols, schematic pictures tend to be endowed with strong rhythms and coherent design. But these same conditions can sometimes lead to stereotyped solutions or monotonous compositions. This hardening process is sometimes called *consolidation*, when a child enters a cycle of shoring up hard-won successes.

Early in schematic expression, a particular symbol tends to stand for an entire class of anything—*Bird*, rather than a specific kind of bird such as sparrow, robin, or crow. An early schematic child tends to be stingy with detail, employing the simplest shape to represent the character of something. Arnheim's law of differentiation

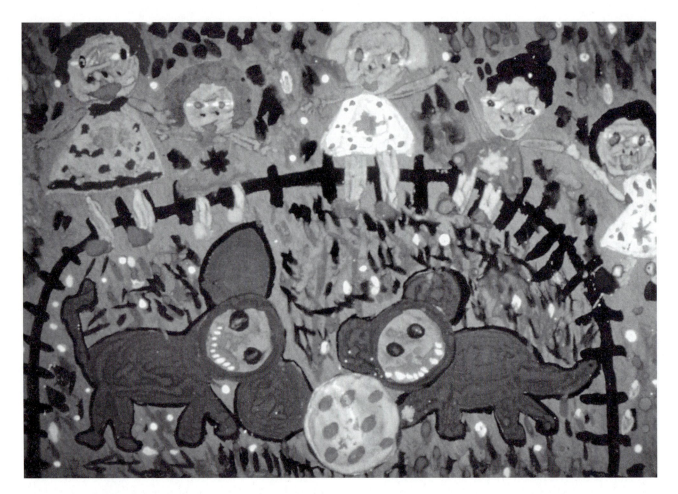

Figure 4-5 Age 4, female, Russia. Schema are form concepts a child develops for figures and objects which are repeated with little variation unless some urgency or experience requires a change. Despite their tendency of repetition, many schematic pictures, like this one of children watching monkeys at play, are full of life.
(Courtesy of the International Collection of Child Art, Illinois State University, Normal, IL.)

explains, "Until a visual feature becomes differentiated, the total range of its possibilities will be represented by the structurally simplest among them."[26]

British psychologist Norman Freeman calls this a "canonical view"— the aspect of an object "that most nearly stands in for the whole thing."[27] Later, schemas become more complex. The visual elements also exhibit greater differentiation, wherein the lines children draw have more inflection, their shapes more complexity, their colors a greater range of hues, and their figures a keener sense of proportion and more detail.

At first children draw human figures in frontal position with separately outlined, attached geometric parts. Typically, the head is round or oval with circles and dots for eyes and nose, a line for the mouth. The rest of the figure is apt to have incongruous proportions. Limbs appear stiff due to lack of joints. Action is seldom shown. Later, some children begin to draw a single contour line surrounding the entire body, rather than separately outlined parts (Fig. 4–6) (see **color insert** #1). Profile heads begin to appear. Clothing is used to identify gender. Bending (either angled or rounded) arms and legs appear in some works, and combinations of side and frontal views in the same figure appear in others. Efforts to depict movement and action often result in profile figures, leaning torsos, and extended arms. (Drawings of the figure and other objects from memory at any age generally include less information than those made from observation.)

Schematic drawings differ markedly from

their preschematic forebears in their compositions, as children develop new spatial systems. Arbitrary placement of figures and objects—which often appear to float in space—gives way to side by side placement and positioning at the bottom edge of the paper, sometimes referred to as *paper basing*. Identification of the bottom of the paper as the ground leads to the drawing of a left-right line, which serves as a base line on which all things stand. The area above is the sky which is also represented with a left-right line or area of color at the top of the page.

Multiple baselines, drawn one above the other, are used to solve the problem of representing near and far, and to accommodate more objects and figures. (See Fig. 4–7; in addition to multiple baselines, this child also made the background figures smaller than the foreground figures.) Other solutions for representing depth

include "plan and elevation" (that is, presenting the top and four sides of an object such as an automobile), "transparency" or "X-ray," (showing an inside/outside view of a house, a train, or pregnant woman), and "fold ups" (opposing base lines with objects drawn perpendicular to them to indicate opposite sides of a river or street—as in Fig. 4–2).

Among those charmed by schematic art is Gardner. About its young creators he says, "Having mastered the basic steps of drawing and learned to produce acceptable likenesses of common objects about them, they go on to produce works that are lively, organized, and almost unfailingly pleasing to behold." Indeed Gardner is so charmed that he regrets the passing of this stage: "The flowering of child art is real and powerful but, like other flora, it is seasonal." [28]

Figure 4-7 Age 6, female, Japan. The use of two baselines, one above the other to indicate spatial depth, is a solution often found in schematic drawings. Reducing the sizes of figures and objects that are higher on the picture plane, however, is a solution more typical of transitional drawings.

(Courtesy of the International Collection of Child Art, Illinois State University, Normal, IL.)

Transitional

Before detailing the transitional style, it will be appropriate to explain a general behavioral change in children with regard to art. The French cultural critic Andre Malraux observed that when a very young child makes art, "his gift controls him, not he his gift."[29] At some point, often in third grade, perhaps earlier, children no longer are "unconscious" with regard to their graphic representations. They begin to notice the discrepancy between their efforts and those of others, particularly the products of popular culture, and conclude that theirs are inadequate.

The "gift" is no longer in control, and children try to control it—often unsuccessfully. Gardner explains that both children and adults feel that something vital is lost: "A certain freedom, flexibility, *joie de vivre*, and a special fresh exploratory flavor...are gone."[30] Freedom yields to concern for precision and detail, freshness gives way to an often stultifying desire for realism. In some children, particularly in the absence of an art teacher, these conditions can lead to frustration and loss of interest in art.

It should be noted that not all art educators lament this passing of innocence. To the contrary, the Wilsons believe that children are ready for newer, untried approaches at this point; that their increased consciousness opens up rather than closes off opportunities. This insight is similar to what Feldman calls *external disequilibrium*—when children are mature enough to recognize the discrepancy between the environment and their current models of dealing with it, but have not as yet developed successful new models.[31] Supposedly they are ready for change and an advance to a higher level.

But in art, the task of solving pictorial problems is often too daunting without a teacher's help. Details of how to deal with children's frustrations about art is a subject for a later chapter. Suffice it to say at this point that children react differently; while many lose interest in drawing, some become even more interested. Further, there is more to art than drawing. In some areas of art, growth and increased sophistication are indeed welcome. For example, improved psychomotor skills enable children to do much more in studio crafts (pottery, fibers, wood, metals, and so on); their intellectual growth enables them to perform much more adequately in such things as art history and criticism. These increases more than offset the decrease in naiveté.

The transitional style, not surprisingly, is often characterized by a mismatch between children's artistic skills and their own standards. Schematic and realistic traits often appear in the same drawing. For example, figures may be somewhat natural looking while the spatial solution is schematic, or pictorial depth is relatively realistic while figures and objects retain schematic characteristics (Fig. 4–8).

Some youngsters actively try to achieve realism in their drawings, while others do not. Some are more aware of graphic qualities such as shading, line variance, and perspective, and attempt to incorporate these in their own works. Some are more sensitive to expressive aspects of drawings and paintings such as the use of lines and colors to communicate particular moods.

Copying—which children often initiate even before entering the school environment—becomes more evident as they try to improve representational skills. But again, the degree of this kind of obsession differs with individuals. Cultural media such as comic books, science fiction, magazine illustrations, advertisements and television shows—all of which were banes to Lowenfeld and Kellogg—are prime sources of information for all children.

Compared to their schematic counterparts, transitional-style figures are endowed with more detail in clothing, hair, anatomy, and even role or vocational attributes (Fig. 4–9) (see **color insert #1**). A figure may be depicted in front, back, and side views, and in action, but often appears stiff because of angular joints. Shading and foreshortening are seldom used, resulting in a flat appearance, although overlapping of bodily parts imparts some depth.

Proportions are more realistic, while gender distinctions are indicated not only by clothing differences but sometimes by anatomical differences in such things as torsos and hips (see Fig. 4–9). The continuous contour often includes a neck, rather than just head and body. Depictions of clothing, hair styles, and even moods and actions are commonly influenced by popular art.

Methods for representing depth include placement of figures and objects on a ground plane rather than a base line. Other devices include overlap, diminishing the size of more dis-

Figure 4-8 Age 12, male, *Snowball Battle with Friends*, U.S.A. While the figures are basically schematic, the space in the picture reveals a number of realistic traits: a receding ground plane, overlapping, distant objects placed higher, and a foreshortened wall.
(Courtesy of the International Collection of Child Art, Illinois State University, Normal, IL.)

tant objects, placing more distant objects higher in the picture, and sometimes either isometric or linear perspective (see, again, Fig. 4–9).[32] Color is more realistic, and sometimes used for expressive purposes. Variations of hue, value, and intensity appear in efforts to communicate moods. In addition, as child psychologist Dennie Wolf observes, many children begin to employ the conventions of comic strips such as motion lines, "zip ribbons," and sweat beads for expressive purposes.[33] In the final analysis, while transitional compositions may be less spontaneous and rhythmical than their schematic counterparts, they are more sophisticated, driven by the needs of representational realism or expressing a pervasive mood.

The transitional style, then, is a mixture of schematic and realistic solutions employed in various degrees depending on each child. It should be understood that although most children undergo a significant attitude change with regard to art, not all children change their style in significant ways. Beyond the age of eight, some, perhaps a minority, continue to remain essentially in the schematic style. Also, because of the diminished level of enthusiasm on the part of many, the results produced by a given child can vary a great deal from drawing to drawing.

These variations together with differences in quality are affected by many factors. Chief among these, of course, is skillful teaching. All of the transitional examples in this chapter were made under the supervision of teachers. The role of the teacher in motivating, coaching, being a resource, and so on, may be more decisive in affecting the quality of transitional-style work than it is for the other four styles. That the examples in this section are generally vivid and of high quality is probably as much a testament to the skill of the teachers as it is to the skill of the students.

Cultural Realism

As we indicated earlier, cultural realism refers to the predominately realistic pictorial conventions to which older children aspire. With regard to this style as a level of development, Gardner observes

that "researchers are uncertain about whether the shift to a realistic aesthetic is a natural development, one brought about by the culture at large, or one spurred on by teachers, peers or older students."[34] As suggested earlier, researchers' uncertainty is exacerbated by the international nature of contemporary visual culture and the fact that researchers generally have access only to children in school settings.

Although by definition, cultural realism is culture-relative, the question remains whether this pertains to a particular culture, international culture, or both. If you teach American adolescents—even those of diverse ethnic backgrounds—you are not likely to have children in your classroom who are deeply influenced by a non-Western style of art (Fig. 4–10), let alone any who might aspire to become skilled in such a style. American popular culture, for good or bad, seems to have reached every corner of the planet. Ethnic differences among American students—with regard to their tastes in graphic styles—have been largely neutralized by the popular culture. The same could probably be said about recent immigrants. Even so, Western visual culture—which varies from Andrew Wyeth to Walt Disney to adventure comics—is quite pluralistic, and some of this range may be reflected in the various styles that your more ambitious drawers try to emulate. Further this range can be extended or tempered by instruction.

Bear in mind that there is great variation in the skills of adolescents, and drawing is *not* a serious matter for most. Most American children do not improve in their graphic skills much after the eighth year of school—primarily because that is usually the last year in which they study art. Those adolescents for whom drawing is a serious matter after the end of formal training are in the minority. And those who are quite successful at it are sometimes defined as "talented." (The extent to which artistic success is attributable to talent, giftedness, or to *study* is a subject to be detailed in later chapters.) The description of this style, therefore, will pertain to those few in junior high school who have had an excellent schooling in art, or to the even fewer who have attained an untypically advanced level of graphic ability on their own. Again, all of the examples reproduced in this chapter were created under the direction of teachers.

Relatively speaking, human figures are represented in correct proportions and in correct size

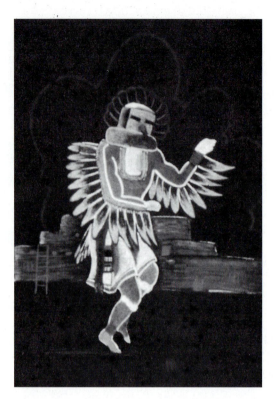

Figure 4-10 Age 15, male, *Indian Dancer*, Native American. The colors and design of the costume are clearly influenced by the local culture, in this case, Amerindian. Notice, however, that the style of the figure—its proportions, the foreshortening of some of its parts—and the fact the adobe structure in the background is greatly reduced in size to suggest distance are signs of Western influence.

(Courtesy of the International Collection of Child Art, Illinois State University, Normal, IL.)

relationships to other objects and to the environment. The effects of changing conditions such as motion, light, distance, and viewing angle are attempted, if not always depicted accurately. Human figures are shown in a variety of positions and situations. They are placed in pictorial space, and are endowed with depth through the use of shading and the foreshortening of limbs where appropriate.

A serious drawer also begins to show an understanding of the relationship between clothing and the body underneath, as he differentiates the shapes and folds of clothing (Fig. 4–11) (see **color insert** #1). His lines assume more variety and more sensitivity to real contours as he strives to realize a clothed figure as convincingly as possible. He is also more attuned to the subtleties of

facial expressions and characterization.

Color is used both realistically and expressively. An advanced adolescent is able to manipulate hues and variations in value to reinforce an expression of sadness, anxiety, happiness, loneliness, and so forth. She is prone to express humor, social criticism, fantasy, exaggeration, and dramatization in her works, and to invoke a wider range of symbols to serve her expressive ends. Both boys and girls are keenly aware of current styles of clothing and behavior, especially those that signify their own generation, and often attempt to symbolize these in their work.

Pictorial depth is achieved through all the devices, including shading, overlapping, foreshortening, diminishing size, location, and isometric, and linear or aerial perspective. Because of a broad range of abilities and experience levels among adolescents, compositional standards vary. Often, he or she is too preoccupied with realism, the narrative element, or the mood of a picture to be very interested in design and composition—except in cases where, with good instruction, the student effects a happy marriage between narrative and composition (see again, Fig. 4–11).

Among highly motivated students in art, the impulse to improve one's drawing (which usually means drawing more realistically) seems to be much stronger than the need to improve one's taste or understanding of good design. Ambitious drawers, like young athletes, are largely self motivated. On the other hand, good drawing, like good throwing or running, requires guided practice. Still, drawing skill is only one of the things valued by the art teacher—and probably not the most important one at that. The other things are more intangible and can perhaps be summed up in two words, *aesthetic sensitivity*—sensitivity to balance and proportion, to color harmonies, to good design, to expressive properties, to style. Aesthetic sensitivity, which is perhaps latent in every student but which is rarely sought after by adolescents, generally has to be nurtured in the art classroom.

SUMMARY

Children's artistic development is chronicled for us in child art. Artistic development depends on the way each person's physical and intellectual growth patterns are shaped from birth by knowledge gained from that individual's experience. All children gain rudimentary kinds of knowledge about organizing art images without schooling, albeit in a haphazard manner, but they are less likely to acquire more substantial kinds without formal art education.

Child art becomes more complex and realistic the older children grow. Drawing requires both perception and representation of the world, and children do both differently than adults. Children, particularly when young, invent symbols that correspond structurally but not optically to actual objects. Although some art educators have interpreted the appearance of some symbols in art by children of many cultures to mean that artistic development is universal, recent research suggests otherwise.

Nevertheless, art educators can and do group child art into broad categories according to their visual appearance. These developmental stages or levels have the same characteristics as artistic styles. Familiarity with the stylistic characteristics of art by children of different ages will keep you from expecting children to draw (or make other kinds of art) that is inappropriate for their ages. When you have a sense of what is normal or "average" artistic understanding for various age levels, you will be able to recognize performance that is exceptional (either above or below normal) in some way.

Katie's impulse to make circles at age three is probably innate. But as she grows older, sees more pictures, and goes to school, her symbols and her ways of organizing them will change—not only because of natural causes but also because of her responses to her culture and her teachers. If Katie is lucky enough to have good art teachers in elementary school, she should perform at a level that is above average for her age.

This chapter described five styles of graphic development. You will soon be choosing appropriate media, setting objectives, selecting appropriate themes, targeting outcomes, and so forth for your students. Knowledge of developmental styles provides useful generalizations on which to base curriculum and to plan classroom instruction. Knowledge of these styles can also help you gauge growth and changes in performance and, correspondingly, to gauge the effects of your teaching.

On a common sense level, you can get insights into children's feelings and attitudes through such unmysterious clues as choice of subject matter and composition when they make art. Finally, knowledge of developmental styles and the growth markers that take place within every style can provide clues about a child's general maturity. We certainly do not recommend trying to "psycho-analyze" children by their artwork, but common sense suggests that teaching children art should be a developmentally appropriate undertaking.

NOTES

1. Gardner, Howard. (1990). *Art education and human development.* Los Angeles, CA: The J. Paul Getty Trust., p. 9.

2. Golomb, Claire. (1974). *The child's creation of a pictorial world.* Berkeley, CA: University of California Press, p.6.

3. Kellogg, Rhoda. (1969). *Analyzing children's art.* Palo Alto, CA: National Press Books.

4. Wilson, Marjorie, and Wilson, Brent (1982). *Teaching children to draw: A Guide for teachers and parents.* Englewood Cliffs, NJ: Prentice-Hall, p. 64.

5. Ibid.

6. Brittain, W. Lambert. (1990). Children's drawings: A comparison of two cultures. In Bernard Young, (ed). *Art, culture, and ethnicity.* Reston, VA: The National Art Education Association, p. 189 (reprinted from *The Journal of Multi-cultural and Cross-cultural Research in Art Education,* Fall 1985.

7. Perez, Jeannine (1993). *A cross-national study of child art: Comparing for universal and culturally influenced characteristics.* Unpublished doctoral dissertation, Illinois State University.

8. Perez considered a symbol universal if it occurred in at least 10% of the child art from each of the 12 countries in her study.

9. Lowenfeld, Viktor. (1952). *Creative and mental growth* (revised ed.). New York: Macmillian, p. 1.

10. Kellogg, op. cit., p. 145.

11. Wilson, Brent, Hurwitz, Al, and Wilson, Marjorie (1987). *Teaching drawing from art.* Worcester, MA: Davis.

12. Sargent, Walter. (1912). *Fine and industrial arts in elementary schools.* Boston: Ginn & Co.

13. Lowenfeld, Viktor. (1947). *Creative and mental growth.* New York: Macmillan.

14. To give you a general (although greatly oversimplified) idea of these stages, Piaget saw the thought of preoperational children as static, centered on the state of a material like a glass of water and not on its transformation when it is poured into another container. Piaget found that preoperational children judge the same water, when poured into a wider, flatter dish, to be a different amount because its state is different. Concrete operational children, Piaget said, can comprehend that the same amount of water has simply shifted from one state to another. Children with formal operational abilities can, in addition, draw conclusions from a pattern of observed events and imagine hypothetical situations: what shape the same amount of water might take when poured into a taller, thinner container, for example. (From Ginsburg, Herbert, and Opper, Sylvia. [1969]. *Piaget's theory of intellectual development: An introduction.* Englewood Cliffs, NJ: Prentice Hall.)

15. McFee, June King (1961). *Preparation for art.* Belmont, CA: Wadsworth Publishing Company, Inc., pp. 84-90.

16. Ibid., pp. 159-160.

17. Lark-Horovitz, Betty, Lewis, Hilda, and Luca, Mark. (1973). *Understanding children's art for better teaching,* second edition. Columbus, OH: Charles E. Merrill Publishing Company, pp. 9-15.

18. Golomb, op. cit., p. 337.

19. Kellogg, op. cit., p. 41.

20. Wilson and Wilson, op. cit., p. 64.

21. Salome, Richard A. (1991-92). Instructional Development Grant. Normal, IL: Illinois State University.

22. Perez (op. cit.) found that 32% of the pictures by 3 to 6 year olds clearly fell into the *preschematic* level, another 5% of the pictures by 7 to 12 year olds were *preschematic* also, and the rest were by younger or older children or displayed characteristics of more than one style. This held true for older students as well. Among Perez's adolescent group, 35% of the pictures by 13 to 19 year olds were clearly at the realistic level, while 8% by the 7 to 12 group also could be called *realistic*. Perez also found that these patterns were reasonably consistent across cultures.

23. McFee, op. cit., pp. 159-160.

24. Gardner (1990), op. cit., p. 26.

25. Feldman, David H. (1980). *Beyond universals in graphic development.* Norwood, NJ: Ablex, p. 46.

26. Arnheim, Rudolf. (1974). *Art and visual perception: A psychology of the creative eye* (The new version). Berkeley and Los Angeles: The University of California Press.

27. Freeman, Norman. (1980). *Strategies of representation in young children: Analysis of spatial skills and drawing processes.* London: Academic Press, p. 17.

28. Gardner, Howard. (1980). *Artful scribbles: The significance of children's drawings.* New York: Basic Books, p. 94.

29. Malraux, Andre (1953). *The voices of silence.* Garden City, NY: Doubleday, p. 280.

30. Gardner (1980), op. cit., p. 142.

31. Feldman, op. cit., pp. 108-111.

32. If you are unfamiliar with these devices, you can find them explained in Chapter 14.

33. Wolf, Dennie Palmer (1987). "The Growth of Three Aesthetic Stances: What Developmental Psychology Suggests About Discipline-Based Art Education." Seminar Proceedings. *Issues in discipline-based art education: Strengthening the stance, extending the horizons.* Los Angeles, CA: The J. Paul Getty Trust., p. 92.

34. Gardner (1990), op. cit., p. 19.

5
Child Development in Responding to Art

And now, *aesthetics*!

Recall that aesthetics has been mentioned in earlier chapters as one of the four areas to be considered in teaching art. Indeed, in a recent position statement, the National Art Education Association advocated that aesthetics be included in all secondary and elementary programs.[1] Not everyone in art education, however, is enthused about this. Even those who may be opposed to teaching aesthetics per se nevertheless believe in fostering newer, more inclusive, conceptions about art—a major goal of aesthetics instruction.

Aesthetics is probably the least understood of all the subjects falling under the heading of art, and the most problematical for those attempting to design programs for its use. For one thing, many of us teachers have never taken a formal course in aesthetics—including even those of us who are (or were) art majors. For another, the field of art education avoided mention of the subject until the 1960s, when the possibility of aesthetic education began to be broached (Chapter 1). Only recently has literature come out about ways to teach aesthetics or, more precisely how to include aesthetic inquiry in the classroom.

You need not break out into a cold sweat at the mere mention of the word. This chapter is intended to show that (1) aesthetics is not all that daunting, and (2) it is actually fun and very teachable (more on the topic of teaching aesthetic inquiry is in Chapter 8).

WHAT IS AESTHETICS ?

The term aesthetics was first coined by German philosopher Alexander Gottlieb Baumgarten in the eighteenth century. As a special branch of philosophy aesthetics was concerned then not with art but with theories about beauty and the sublime. An eighteenth-century English philosopher (The Third Earl of Shaftesbury) introduced the idea of *dis–interested satisfaction* to separate experiences in the aesthetic domain from those that are primarily religious, moral, or cognitive. A bouquet of flowers, for example, may be enjoyed for its own sake rather than for the sake of personal gain or acquiring knowledge or inspiring us to action. The concept of disinterested satisfaction became a convention of aesthetic thinking that persists to this day. More will be said about this later.

Since the eighteenth century, aesthetics has assumed a variety of forms related to various philosophical traditions. In continental Europe it has often been associated with German idealism. For many years in this country it was associated with an American philosophy called *pragmatism*. (This was largely because of a book on aesthetics,

Art As Experience, written by John Dewey, the famous educator discussed in Chapter 1).[2] There is even a significant tradition of Marxist aesthetics. In this country, a tradition called *analytical philosophy*—which does not develop new theories so much as seek to clarify old theories—has held sway in recent years. In one way or another, these traditions have tried to answer basic questions about art and the aesthetic.

Theories of Art

Related to the philosophical legacy is a tradition of theories about art itself. Often, these consist of spelling out the proper relationship between the viewer and art. They define what one should look for in a work, what constitutes artistic value, and even, in some cases, the difference between art and nonart. It will be helpful to review these theories under the following headings: *mimesis*, *expressionism*, *formalism*, and *contextualism*.

Mimesis The theory of mimesis says that all art is imitation. Although as old as Plato (the fourth-century B.C.E. philosopher who first articulated it) and linked to the rise of realistic painting during the Renaissance, mimesis lives on today in such popular art forms as photography, film, and television. Ideally in mimetic art, the art medium (the material nature of the work) is invisible—a "window on the world," as they used to say about realistic painting. Realism is the major criterion of excellence, but also, because of the importance placed on subject matter, beauty is often a companion criterion. The major theory and standard of Western painting for nearly five centuries, mimesis became discredited in the professional art world when the modern movement and nonrealistic styles emerged at the end of the last century.

Still, realism not only continues today in many art forms, such as photography and film, but remains a popular notion among the general public. Also, as you may recall in Chapter 4, school-aged children often hold themselves to a standard of realism when they draw. Thus, many in the population, old and young, are unwitting advocates of the mimesis theory. This suggests that a reason for art education may be to foster open-mindedness toward *non*realistic styles of art —not only twentieth-century "modern art" but also much non-Western art. Another reason would be to disabuse people of the naive assump-

tion that a medium should, or even *can* be, invisible, like a mirror. The notion that a photograph is an unmediated record of a scene, for example, is a popular misconception. There are many ways in which the photographic image can be manipulated or altered—ways that seriously challenge the popular notion that photographs are "real." Future chapters will not only demonstrate these ways but also discuss what to look for in photography and other modern media.

Expressionism Expressionism emphasizes the communication of emotion. It did not emerge as a serious theory of art until the late nineteenth century. Although an outgrowth of the romantic movement of that century, expressionism was to play an important role in twentieth-century art. Leo Tolstoy, the famous novelist, was a great believer in the idea that an artist transmits his or her feelings "by means of certain external signs" and that "other people are infected by these feelings and also experience them."[3] Unlike the theory of mimesis, expressionism emphasizes the form of a work (its colors and textures, for example), particularly in painting. When viewing Van Gogh's *Fourteen Sunflowers in a Vase*, for example, we are especially conscious of the vivid yellows and thick, lively brushwork (Fig. 5–1) (see **color insert #1**). These, as much as the image of the flowers themselves, are expected to contribute to the general mood of joy. In much of the art after Van Gogh's generation, the form and medium become even more important, so much so that it supposedly matters little whether the picture is about flowers, a nude, or a landscape with regard to the feelings expressed.

The problems with this theory begin with the difficulty of explaining just how a personal feeling is embodied in artistic form. Tolstoy himself was not clear in this, nor did he provide a theory of feeling. The word "express" is derived from Latin meaning to "press out" as in squeezing juice out of grapes. Even if the term is used metaphorically, questions still remain: Is the viewer required to experience the same feeling as the artist? Can an artist who is sad create a happy work, or vice versa? Was Van Gogh elated when he painted the sunflowers? If he was not, was he insincere? Is sincerity a touchstone? If so, how do we verify the motives of the artist? Does one judge a work on the strength of the work's expression, or the nobleness of the feelings expressed?

Formalism A theory of art peculiar to this century, formalism finds meaning in the arrangements of the formal elements—colors, lines, shapes, etc.—independent of any subject matter. Clive Bell, an English critic in the early part of this century, developed a concept called significant form.[4] Significant form arouses an "aesthetic emotion" which, in this case, is unrelated to the feelings or inner state of the artist as it is in expressionism. To Bell, subject matter was deemed irrelevant, as was everything external to the work. He said that the viewer need bring "nothing from life, no knowledge of its ideas and affairs, no familiarity with its emotions."[5] Finally, only works with significant form could be considered art. Bell went so far as to dismiss as nonart many famous and popular paintings of his time because they lacked significant form.

Recent formalist writers, while less direct than Bell, also stress the "autonomy" of form—again, the arrangement of the elements—and have tried to isolate this as the true essence of art. Formalism became the standard of art in 1950s and early 1960s because of the influence of American art critics writing on behalf of the abstract styles that came out at that time (see works by Albers, Chapter 8, Fig. 8–5 [**color insert #2**] and by Hofmann, Chapter 14, Fig. 14–17 [**color insert #3**]). If it is difficult to explain expressionism, it is even more difficult to describe significant form, the genesis of formalism. Bell never defined significant form beyond describing it as "lines and colours combined in a particular way."[6] He never defined aesthetic emotion except to say that it was caused by significant form. Perhaps something as ineffable as artistic form cannot be described precisely. But then to proceed to proclaim it to be a touchstone of excellence and the only way to tell the difference between art and nonart, begs the question.

Contextualism Contextualism is not so much a theory of art as a set of assumptions about the relationships between art and society. A principle of Dewey's *Art As Experience* is that people constantly interact with their natural and symbolic environments and that art should be viewed as an agent in this context.[7] Dewey's 1935 insights, though still relevant, have been reinterpreted in light of today's more pluralistic art world and a global society. Whereas his book, as the title suggests, is mostly about art and personal experience, current contextualist writing stresses the roles of

history and culture. In this respect contextualism differs sharply from formalism. Indeed formalists criticize contextualists for spending too much time on sociology and not enough on art. The fear, educationally, is that curricular decisions are apt to be driven by social considerations rather than art. This could lead to such bland ideas as "Art for Daily Living," a 1930s program about choosing well-designed consumer products (Chapter 1). Another complaint is contextualism's relativism, a fact that raises a number of questions. If formal criteria are ignored in deference to a work's sociohistorical setting, how do we know if something is an artwork or just an artifact? How do we judge works of foreign cultures? Are there common aesthetic criteria? On what basis do we judge student work? On what basis do we select exemplars for study? How do we identify models of excellence?

To summarize, a single example—an African wood carving (Fig. 5–2)—will serve to briefly compare the four theories in action. An advocate of mimesis would criticize the sculpture, if not

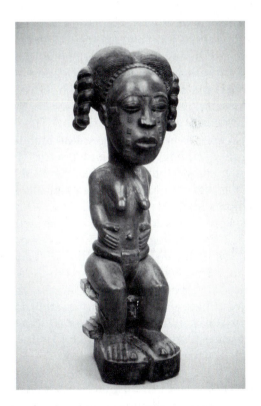

Figure 5–2 Seated female figure (African sculpture), wood 16 5/8" (42.3 cm) high, Baule peoples, Ivory Coast. (Item 7130, seated female figure, Baule peoples) (The African Collection at Illinois State University, Normal, IL.)
(Photographed by Jack Hobbs)

dismiss it altogether, for its lack of realistic proportions. Conversely, a formalist would appreciate its proportions (but for opposite reasons), and also admire the incised details that accent the hand-rubbed surface. An expressionist would praise the sculpture's directness and lack of inhibition. Finally, a contextualist would try to investigate the work in the context of that particular tribal culture—assuming that he or she could access this information. Let's say the information was available and it showed that the artist was trying to create an effective "spirit spouse," a magical object which, like a real spouse, had to be propitiated to keep it happy. Further, let us say it was known the artist was not in the least bit concerned about such issues as realism, his or her feelings, or significant form. This would bring into question, but not necessarily discredit, the first three interpretations. As you can see, each of the four positions has its own perspective and limitations.

Recent Theories

Questions about form and expression, among others, are continuing issues in aesthetics. However, in recent years, one issue—the definition of art—has gotten the most press. Just one hundred years ago, American educator and philosopher William T. Harris could confidently say that, "The several fine arts are—in an ascending scale—architecture, sculpture, painting, music, and poetry."[8] Harris not only knew what they were, he could rank them. His was a simpler time, aesthetically speaking. Things like collages, (see Chapter 15) assemblages, (see Chapter 16), and welded sculpture did not exist. Photography (which existed at the time) was not considered worthy of being art. Objects from such places as Pre-Columbian America or tribal Africa were largely ignored. However, these examples bring us only to midcentury. What would Harris have said about happenings, earthworks, body art, and performance pieces (see Chapter 1, Fig. 1–4)?

The Open Concept How do we make sense out of an art world that has become absurdly pluralistic, some would say chaotic? One answer is "don't come up with another theory." In a 1956 article, aesthetician Morris Weitz calls theories of art vain attempts "to define what cannot be defined."[9] Art, he says, should be considered an "open concept" in which new cases are continually added, thus expanding and revising the concept. Weitz compares art to games. Just as it is futile to look for common properties in all games (everything from solitaire to soccer), so it is in today's art. Weitz suggests family resemblances as the best way to understand linkages in the art world. While a member at one end of an extended family has nothing in common with a member at the other end, that member nevertheless resembles the nearest one, and that one resembles the next, and so on until the other end is reached. By analogy each artwork is linked to its nearest relative, though it may have nothing in common with those at the opposite extreme. Weitz dismisses all theories, including Bell's, as inadequate. But he goes on to say that each in its time had the virtue of bringing to the public discourse features of art which had heretofore been ignored or discounted. At the turn of the century, for example, in the transition between premodern and modern art, Clive Bell's theory was useful in focusing on features peculiar to a new art. However, today, as we have already suggested, his theory is no longer that useful.

The Institutional Theory Weitz notwithstanding, aesthetician George Dickie has come up with a theory to define art in today's pluralistic art world. To Dickie, an artwork is simply a status conferred by the "artworld."[10] The latter is a network of institutions—such as galleries, museums, the art press, universities, and so on—and authorities—such as artists, curators, museum directors, teachers, and art critics (as diagrammed in Table 2–1, Chapter 2). The public is usually a willing participant because it accepts the convention and authority of an art world. Thus, for example, art status is conferred when a judge of a juried show is confronted with an especially novel work and enters it in the show, or when an art historian discovers a trove of pictures by a forgotten nineteenth-century photographer and brings them to the attention of the public, or when a museum curator decides a tribal object is an artwork rather than an archeological artifact. These kinds of decisions go on all the time. Dickie's theory conveniently does away with fixed standards like mimesis or significant form, and locates the argument within a social context. It helps to account

not only for the novel products of recent art but also for a vast body of things from medieval, ancient, and foreign cultures, which were probably intended by their original makers to be ceremonial or utilitarian objects instead of art objects. Rather, it is today's art world that "intends" them as art objects.

Despite its advantages, Dickie's definition of art has been criticized for being circular rather than a true definition. As Gene Blocker explains, "At most, Dickie provides us with a *de facto* criterion after the decision has already been made."[11] The definition has been caricatured by Arthur Danto, who says, sarcastically, something is art if it is "so designated by effete snobs of the artworld."[12]

Metaphorical Interpretation In 1964 the famous Pop artist Andy Warhol created Brillo Boxes, a sculpture made of plywood boxes painted to look exactly like the cases of Brillo pads available in your supermarket (Fig. 5–3). During Warhol's time and since, many artists have either imitated banal objects or incorporated real objects into their works. As a result it is sometimes difficult for the lay person to tell the difference between an art object and an ordinary object.

Danto, the most talked about aesthetician today, has developed a theory that addresses that situation and also provides a basis for interpretation. It is symmetrically opposite to Bell's. Bell stated that to know something is an artwork one must respond aesthetically to significant form. Danto says that to respond aesthetically, "one must first know that the object is an artwork."[13]

This is an important point: An artwork may resemble, or even have been, an ordinary object. But unlike ordinary objects, artworks belong to a particular symbolic environment we call art. While to some extent Danto's theory may acknowledge the institutional theory, Danto goes beyond Dickie to claim a principle common to all art. According to him, the structure of an artwork does not lie in its appearance. Rather, this structure is more akin to a metaphor. To "unpack" the meaning of the metaphor requires the collaboration of the viewer, who has to be aware not only of the work but of such things as the artist's intentions, similar works, and, often, public discourse about that particular kind of art. To unpack the Warhol (no pun intended), that is, to recognize the

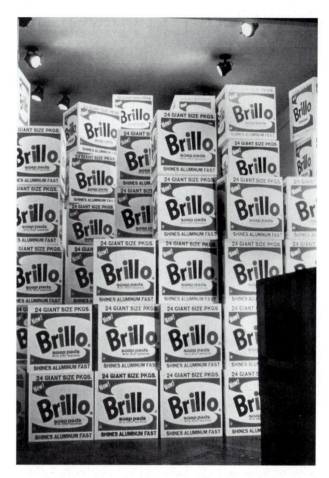

Figure 5–3 Andy Warhol, (1928-1987), *Brillo Boxes*, 1964. Pittsburgh: Andy Warhol Museum.
(Photograph by John Schiff/Stable Gallery)(Courtesy of Andy Warhol Foundation for the Visual Arts, IV 16.002)

boxes as a witty commentary on both commercial packaging and the venerated tradition of mimesis, one would have to know something about the context of Pop Art. Among other things, Pop artists such as Warhol took delight in mocking mass culture while at the same time bedeviling the art world.

To illustrate the application of his theory in other scenarios, Danto has invented paradigm examples wherein two or more works identical in appearance have entirely different meanings depending on such things as the intentions of the artist and the historical entry of the work. Danto's insights are valuable for understanding modern and postmodern art, and most of his examples are drawn from these. (He claims that his theory applies to all art, "every artwork is an example of the theory if it is correct."[14] But we feel that his

theory is less helpful when applied to many pre-modern and non-Western varieties.)

Art As Language To say that art is a language is not to define art in any strict sense, but simply to claim that it is, like verbal language, a symbol system. This is not a new idea. In the twentieth century, *semiotics*, the study of signs and symbols has captured the interest of people in many fields, including philosophers and aestheticians. (In Chapter 4, recall that researchers in child art prefer to think of child art as a symbolic domain.) Susanne Langer's *Philosophy in a New Key*,[15] which first came out in 1948, distinguishes between discursive symbols, that is, words, and nondiscursive symbols such as pictures. Since then, the semiotic position in aesthetics has received increased attention. Danto's theory, which is essentially semiotic, is a case in point.

The person who has perhaps done more than anyone to clarify the ways in which the arts function as languages is philosopher Nelson Goodman. Goodman's theory of art, which is detailed in his book, *Languages of Art*,[16] is too complicated to explain fully. Since we will be referring to his theory and its influence on arts education in future chapters, we must devote some space to two of its principles, or what he calls "symptoms of the aesthetic."

For the sake of illustration and comparison, imagine first of all a printed announcement of Shakespeare's play, *Romeo and Juliet*. Its expressiveness would depend entirely on the way in which its words are strung together. Nothing else—such as the size of the words, the style of typeface, even the colors of the print and the paper it is on—is really significant (so long as these choices do not interfere with the announcement's readability).

Now, imagine this time a poster announcement of Shakespeare's play. According to Good-man, one symptom of a visual symbol is *repleteness*, meaning that most, if not all, aspects of the symbol are significant. This time, the style and size of the letters—whether they are thin, thick, outlined, boldface, or in some fancy style—make a difference in the poster's expressiveness. If an image of the fated couple is to be included on the poster, its style, size, and placement would matter. Or if the title *Romeo and Juliet* were unaccompanied, its location and contrast with its

background would also matter. Virtually everything—the width of a line, the character of a color, even empty space—counts in a visual symbol.

Another symptom of a visual symbol is *exemplification*, that is, the qualities of such things as colors and textures express ideas or emotional states through *example*. To exemplify excitement, agitated lines are more effective than, say, gentle curved lines (of course, to exemplify serenity, the opposite would be true). The poster artist might decide to make the letters *Romeo and Juliet* bright red in order to suggest passion. Or perhaps it would be more appropriate to exemplify the tragedy of the play by means of a subdued blue. Obviously, all of the elements of the poster would have to be coordinated in order to consistently exemplify an idea or set of feelings appropriate for such an announcement.

We used a poster as an example of a visual symbol. Of course, for artworks such as Van Gogh's *Fourteen Sunflowers in a Vase* (see, Fig. 5–1, **color insert** #1) the symptoms of repleteness and exemplification are not only more complicated but much more subtle in terms of their symbolic interactions.

Goodman's explanation of expression, which is more technical than that of traditional expression theories, resembles language in at least one other respect. Language is learned. In order to "read" colors and brushstrokes we need to learn more about the visual elements and how they function symbolically. Over time we acquire certain understandings and expectations about these things. Would *Fourteen Sunflowers in a Vase* express the same sense of *elan vital*, for example, if the colors were gray? Would it be the same if the brushwork were completely flat and smooth? Bright colors, visible brushwork, and flower images, thus, are pictorial *conventions*—-just as language itself consists of conventional symbols—that are expected to evoke certain kinds of ideas.

Palaeoanthropsychobiology Finally, there is even a theory of art based on theories of biology and human evolution. The chief exponent of this approach, Ellen Dissanayake, describes her discipline as *palaeoanthropsychobiology*. Unlike philosophical aesthetics, Dissanayake's is a scientific approach—although with a hybrid methodology—that tries to locate art in basic human nature.[17] She has identified a core behavior called

"making special," which fulfills a basic biological need—not unlike survival or sex—in this case, the need to enhance or embellish our material and psychological environment in some way. More will be said about Dissanayake's provocative ideas on cultural diversity in Chapter 12.

Where We Stand: An Aesthetic Eclecticism

Are you thoroughly confused by now? So many different, seemingly irreconcilable theories! Don't feel bad. Those of us in the arts are often confused. We have learned to live with pluralism and paradox. However, regarding this condition, are art and aesthetics really that different from other late twentieth-century institutions? What about the partisan wrangling in politics, the rival claims to truth in religion, the litigious battles between industry and consumer organizations, and, even, the intense bickering over what education should be? By comparison, the pluralism and contradictions in the art world are not that unusual. Moreover, certainty in questions about the arts is neither to be expected nor necessarily desirable.

An Eclectic Position Eclecticism means borrowing from different sources. Plato, Tolstoy, Bell, Dewey, Weitz, Dickie, Danto, Langer, Goodman, and Dissanayake are all correct, but also they are all wrong. There is something useful in each, up to a point. We will try to identify what is good and useful in order to arrive at a rational, albeit eclectic, position.

Contextualism, because of its inherent relativism, is probably the best overall approach to explain the aesthetic domain in a pluralistic world. It accommodates Dickie's institutional insight. Few can argue with the notion that art is essentially a social institution now, and always has been. Before the French revolution, art galleries (along with critics, curators, and art historians) hardly existed. Art was under the aegis of such institutions as the courts, the aristocracy, and the clergy, not Dickie's artworld. In non-Western societies, art was (is) under the aegis of priests, shamans, chieftains, temple elites, and so forth. While none of these examples resembles a modern art world *a la* Dickie, they nevertheless support the notion of art being a social institution.

Until recently, aestheticians have been preoc-cupied with investigating the aesthetic experience as a special kind of responding. This concern originated with the concept of disinterested satisfaction and was reflected in the expressionistic theories in the nineteenth century and formalist theories in this century. Even Dewey felt that having *an* experience, that is, a vivid aesthetic experience, was the best thing that could happen to a human being.[18] In Dewey's mind, such an experience was not limited to responding to art; it could occur with anything, anywhere. Recent writers on the subject prefer to limit the discussion to the nature of art and to link aesthetics with cognition, particularly with regard to the relationships between art and meaning. This brings us to the concept of art as language. For help in this regard, both Langer and Goodman are good resources.

Up to now, we have not referred to judgment. Our position is that no single standard or set of standards exists that one could use to judge all art. In this regard, we agree with Weitz. He compares art to games; we suggest comparing it to eating out. Just as there is no single standard in art, there is none for judging the merits of Mexican cuisine versus Italian versus Thai versus French, and so on. However, we all know that some restaurants are better than others.

In the art world, judgment goes on all the time: curators screening works to include in a collection, critics selecting works to review in their articles, textbook authors choosing works to include in the pages of a book, and so on. But a single standard for all this judgmental activity is elusive. Evaluation in art and education is a very complex subject involving many variables. Some of these variables will be broached in Chapter 7 (with regard to planning an art program), in Chapter 8 (with respect to art criticism), and in Chapter 10 (in connection with evaluating student work).

Meanwhile, if you are interested in ways to identify models of excellence in art, one way is to seek writers who specialize in certain kinds of art. For insights on what is important in art prior to the nineteenth century, one should consult the literature on Classical, Medieval, Renaissance, Baroque, or Neoclassical art. The theory of mimesis may apply to some degree here, but we do not necessarily recommend Plato. If one is especially interested in an analysis of the development of realism in painting, we recommend reading E. H.

Gombrich.[19]

Tolstoy's theory of expressionism is helpful for understanding the motives behind romantic art and literature. Also there are a number of art historians who specialize in romantic art. Formalism, despite our gainsaying of this position in earlier paragraphs, is helpful for recognizing excellence in a great deal of twentieth century art. We recommend not only Bell, but his British colleague, Roger Fry,[20] for late nineteenth-century and early twentieth-century art.

For postwar abstract painting, Clement Greenberg[21] stands out. For late modern and postmodern developments, Danto, as well as a number of current art critics, is especially good. Finally, there are authorities for the various kinds of non-Western art, but, as a general field, this one is less well developed.

One of the best sources in support of an eclectic position is Harry S. Broudy, whose ideas about art and aesthetics are a blend of formalism and contextualism. Broudy's 1972 edition of *Enlightened Cherishing* became a handbook for advocates of aesthetic education (see Chapters 2 and 3).[22] His writings since then have contributed to the formation of disciplined-based art education (Chapter 2). We will have even more on Broudy in Chapter 8.

Again, our purpose is not to suggest that you run to the library, but to clarify the way an eclectic position on aesthetics works.

CHILDREN AND THE AESTHETIC DOMAIN

What has all this aesthetic stuff have to do with children? Well, consider how children respond aesthetically to the *non*art aspects of their environment—situations that might be defined as the aesthetic domain of everyday experience. Children respond aesthetically whenever they appreciate an experience for its own sake.

Experiencing something for its own sake is a form of disinterested satisfaction. A number of examples come to mind. Some, like seeing, hearing, and feeling the approach of a thunderstorm, are dramatic (the kind Dewey referred to as *an* experience). Others, like idly watching seeds blown from a dandelion ball slowly descend, are more homely. Young children, especially, often seem to be absorbed in experiences such as the latter—smelling flowers, feeling an animal's fur, observing the shifting colors of a shiny rock, and so on. They appear to be completely engaged by something with no thought of personal reward other than the experience itself.

As children mature, they lose some of this aesthetic innocence and become increasingly interested in style, that is, the style of clothes, music, slang, almost anything. By the time of adolescence, their preoccupation with style emerges as a desire to be "cool," to be accepted. Their obsessions may seem anything but disinterested. Nevertheless, adolescents' devotion to style, their ability to discriminate between "what's in" and "what's out," does have an aesthetic dimension.

You can easily see that the concept of disinterested satisfaction seems to characterize the aesthetic behavior of young children. Can you also see that the behavior of older children tends to resemble that of arts professionals who, as part of their job, often have to make judgments on the basis of style? By adolescence, children have developed the ability to make critical judgments. Adolescents' appreciation of style is a more sophisticated form of aesthetic behavior, even though it may be based on standards only they find significant.

If we assume that one of the goals of art education is to foster aesthetic growth and that students are, by definition, already aesthetically engaged, what is there for us to do as educators? The details of what we can and should do are addressed in Chapter 8. Meanwhile, here are some generalizations.

With regard to younger children, their blissful interest in shapes and colors should be respected. But this is not to say that we should not expose them to art. Experiences with art would endow their natural aesthetic impulses with more meaning, as well as provide a foundation for these impulses to mature. Done with care such a program should not destroy their aesthetic innocence. Further, it should be remembered that this innocence is not going to last.

With regard to adolescents, their tastes, as we all know, are often narrow, truncated, and immature. This is a normal, peer-driven state of affairs, but one that can be self-altered given a good art program and sufficient motivation.

Mainly, motivation would consist of exposure not only to fine art but also to aspects of the popular culture that are more substantive and challenging than those adolescents usually encounter. More important, you should encourage your students to reflect on their aesthetic experiences and give them ample opportunity to do so.

Response Studies

What is needed for fostering aesthetic growth is an age and stage-sensitive program that provides continuity through the grades. Insights about this kind of continuity can be gleaned from research literature on how children react to art. Response studies did not become pervasive until the 1960s and 1970s, when interest in aesthetic education burgeoned. Now, given the current impetus for teaching aesthetics and art criticism, the need for such studies is more important than ever. Unfortunately, research in this area is not as well developed as it could be.

There are studies of art preference using norm-based published tests that purportedly measure such things as art attitude or design judgment. (As with multiple-choice tests, a subject is asked to choose the "correct" composition or pattern.) While these tests may be quite reliable, they are not deemed to be very valid, that is, measuring what they are supposed to measure.

The studies that will be reviewed in this chapter employ actual art or art reproductions as stimuli. The object is not to rate the children but to determine how they typically respond to paintings across several dimensions: subject matter, style, color, or combinations thereof. The children might be asked to compare a group of pictures and rank them, to select a favorite picture, to rate each picture on a like-dislike scale, to respond to questions of an interviewer, or to recognize and classify pictures by style. Several of the studies include follow-up questions to determine their reasons for making a choice. Again, the object is to discover age-related responses to differences in such things as style or subject matter. Sometimes subject matter is controlled (for example, all landscapes) to test the effects of style; sometimes style is controlled (all realistic works) to test the effects of different subject matters.

Results of Some Response Studies

Betty Lark-Horovitz's research, which started in the late 1930s, spanned nearly four decades (Chapter 4 dealt with her research on drawing). In general, Lark-Horovitz's findings indicated that subject matter was the most important reason for choosing a picture with children of ages 6 through 8, but that it decreased with age. The factors of realism and technical proficiency, on the other hand, increased with age. Color, which was important to young children (especially if one's "favorite" color was in the work), dropped off at adolescence.[23]

A 1960s study of middle class French boys by researcher Pavel Machotka confirmed Lark-Horovitz's findings to some extent. Color and subject matter accounted for most of the choices at age 6, while realism became important at age 8 and increased with age. Machotka also found that the reactions of younger children to pictures were often personal and naive ("father has a hat like that").[24] Those of 12-year-olds were more global, related to the atmosphere or character of the whole work. Machotka, who equates his findings to Piaget's developmental theories, characterizes this trend as a decrease in egocentrism.[25]

This trend was echoed in the findings of art educator Barry Moore. Moore's research was also conducted in the 1960s, but with American children. The results suggested younger children attended primarily to the things depicted in the subject matter, while older ones attended more frequently to the work as a whole, its style and/or theme.[26]

Howard Gardner, the developmental psychologist who researched children's drawings (Chapter 4), also conducted many studies of children's responses to art. In one of these, using a clinical method like Piaget's, Gardner divided his young subjects into two groups not only by age but also by the level of the maturity of their responses. Gardner's interviews revealed the same trends of growth discovered by Machotka and Moore, but from a different perspective. When asked, some from the youngest group thought art could be made by animals as well as humans: "A tiger puts a pen in his mouth, an elephant uses a trunk to write."[27] By contrast, the oldest group appreciated art as a form of human

imagination and self expression. Gardner also found trends regarding the relative importance of color, subject matter, and realism similar to those reported by Lark-Horovitz and Machotka. Interestingly, the youngest children often preferred abstract works over realistic works because of their "pretty colors" or "nice design."[28]

Art educators George Hardiman and Theodore Zernich tested the assumption that younger children were limited in their abilities to recognize and classify pictures by style characteristics.[29] Studies such as Machotka's had cited Piaget's centration principle (preoperational-level children "center" on a dominant feature) to explain why young children classify works on the basis of subject matter. Hardiman and Zernich showed that preschool children could classify paintings on the basis of style without special training and that they did not center exclusively on subject matter. The researchers conceded, however, that this ability increased with age and cited studies which indicated that training improved performance.

While the studies do not agree across the board, they are consistent regarding broad age-related trends: Subject matter, according to the research, affects children's preferences at all age levels, but much more so at the younger levels. Preference for realism asserts itself around age 8 and increases with age, mirroring the same trend in children's drawings (Chapter 4). Of the art elements, only color seems to be a major factor influencing preferences, and this at only the youngest level. Knowledge of the artistic process and notions regarding color and subject matter are especially naive at the youngest level. However, children at this level can classify paintings according to style.

Michael Parsons's Theory of Aesthetic Development

Based on the theories of Piaget and Lawrence Kohlberg (who investigated moral growth), various response studies, and his own interviews of children and adults, Michael Parsons crafted what he calls a "developmental account of aesthetic experience."[30] The five stages of this developmental theory are not so much age-related as they are levels of increasing sophistication acquired in a certain sequence.

Stage 1 This stage is characterized by an egocentric relationship to art. Here, for instance, the child is nonjudgmental; to him or her almost all paintings are good. She takes delight in its colors and patterns, just as he would the colors and shiny shapes of a toy tractor. He also tends to identify with a subject in a picture such as a favorite animal, or a figure that reminds him of a favorite hero. If the painting is abstract, the child will read his or her own subject into it, as in reading clouds or ink blots. The production of art, like that of most goods in our environment, is not necessarily associated with people, that is, artists. Paintings could just as well come from stores, or as in Gardner's study, be produced by animals.

Stage 2 This stage represents a move away from egocentrism. A picture is *about* something, a something that has an existence independent of the child. At this stage, for instance, the child expects the painting to depict physical things clearly, and these should be beautiful and interesting. A painting is good if (1) it has a beautiful subject, and (2) the subject is pictured realistically. As in mimesis theory, a painting is a window on the world. Attention is drawn to the subject matter and not to the medium or the form. The less these things obtrude, the better. Stage 2 children are aware of the existence of artists but have very naive concepts about the motives of artists and the workings of the art world.

Stage 3 The importance of expressing an emotion or mood emerges at this stage. The subject matter is seen less as a representation of physical things than as an expression of a theme. Realism is still important, but no longer an unquestioned good. An unpleasant subject is no longer an unquestioned bad. Instead of the beauty of the subject being important, it is the beauty of the expression, the quality or intensity of the experience that a work can evoke. A stage 3 viewer assumes the existence of an "inner state" of the artist, and that this can be expressed or conveyed to the viewer. The emphasis on subjectivity functions at both poles of the artistic enterprise: the artist and the viewer. This often leads to a relativistic attitude: The quality of the work matters little; what matters is its effect on the viewer, an effect that is private and subjective. At this stage, interpreters often give vague reasons for their

tastes (although Parsons does not explain whether this is because of naive viewing or poor powers of communication). Although more sophisticated than their stage 2 predecessors, stage 3 interpreters still do not recognize style as a product of culture, or of a time and place.

Stage 4 Form, medium, and style are concerns at this stage. The viewer is much more conscious of how the factors of form, medium, and style mediate meaning. The stage 4 viewer is also more aware of the workings of the art world and recognizes that an artwork is a public object subject to the conditions of its own sociohistorical context, whose meaning is further mediated by on-going public discourse. Reaction to a work is no longer just a subjective event but can be checked against the "facts" of a work's medium and form, and also by consulting the public discourse. Stage 4 types tend to accept the values of the art world uncritically This stands in radical contrast to the aesthetic values of stage 2 children who are largely unaware of the existence of an art world and who insist on realism. Parsons feels that our high schools should foster stage 4 understandings.

Stage 5 Stage 5 interpreters are so sophisticated that they question "politically correct" traditions and norms. They do not, as do stage 4 viewers, accept the values of the current art world uncritically. Individuals at this level have achieved intellectual autonomy. "At stage 5 we make judgments on our own authority and not on that of tradition. We are independent judges in that we can question the ideals and categories of the community."[31] Of all the stages, this one is the most reflective and introspective: the individual not only participates in the discourse but constantly examines and adjusts one's own values and attitudes.

Parsons's theory has come under criticism by a variety of educators: First, some criticize it because of the limitations of his research design. The stimuli, for example, consisted of only paintings and the sample consisted of only 300 respondents drawn from a homogeneous population living in Salt Lake City, Utah. Beyond stage 2, many of Parsons's interviewees were adults: college students, teachers, and college faculty. Second, according to David Feldman, Parsons's stages are not truly developmental because they do not meet the criterion of hierarchical organiza-

tion. After stage 2, advancement seems to be accomplished by adding dimensions rather than reorganizing and building on previous ones. Third, Feldman also indicts Parsons for not distinguishing between universal and nonuniversal developmental domains. While stage 1 may be universal, stages 2 and 3 are doubtful, and stages 4 and 5 clearly are not.[32] Fourth, Parsons's hierarchy of stages may send the wrong message to teachers who try to use it as a guide. Art educator Margaret DiBlasio is especially concerned about the implication of stage 4, namely, that children in the lower grades are not ready to understand the variables of form, medium, and style.[33]

Another concern centers around the identities of Parsons's stages. Stages 2, 3, and 4 resemble, respectively, the theories of mimesis, expressionism, and formalism. Stage 5, meanwhile, resembles the thinking of postmodernism. It is curious that a theory describing individual aesthetic growth would parallel so closely the historical unfolding of philosophical aesthetics. Also, the implication that formalism is inherently better than expressionism and that these two are superior to mimesis is troubling. Again, these trends may have been skewed by Parsons's use of undergraduate and graduate art majors as interviewees for the upper stages. Many of those in stage 5 were art or education faculty. The use of so many educated and professional people in Parsons's study raises questions about its generalizability and educational usefulness.

Still, we welcome his recognition that aesthetic growth is cognitive and is a philosophical process as much as anything else. To build his theory, Parsons drew from the literature of philosophical aesthetics as well as cognitive developmental psychology. We also feel that his insights regarding the aesthetic behavior of very young children are helpful. These not only corroborate the findings of researchers, they extend those findings into workable descriptions about how the largely untutored child would be expected to respond to pictures.

Parsons's insights about sophisticated responding, on the other hand, seem to describe approaches that would be affected by cultural conditions (what Feldman calls *nonuniversal regions*). But this observation does not necessarily say that these descriptions are invalid. Regarding stage 3, the notion that an adolescent or young

adult values self expression seems plausible. It has become conventional wisdom in the popular culture that artists (including rock musicians) are self-expressive all the time. Regarding stage 4, the notion that an art major in high school or college would focus on formal aspects and accept uncritically the standards of the art world is also plausible. However, we would have to acknowledge that this represents the outcome of a specialized form of indoctrination. Parsons does indeed suggest this as an ideal outcome for high school graduation. Meanwhile, stage 5 seems to apply only to those who are avid readers of *Art in America* or *The New York Times*.

SUMMARY

This chapter began with an overview of philosophical aesthetics. We described four traditional theories of art: mimesis, expressionism, formalism, and contextualism. We also explored several recent art theories: Weitz's open concept, Dickie's institutional theory, Danto's metaphorical interpretation, Langer's and Goodman's work on art as language, and Dissanayake's theory of art called palaeanthropsychobiology.

Traditional philosophies and theories of art, such as mimesis and formalism, are no longer adequate for illuminating a complex, pluralistic,

TABLE 5–1 Five Schemes Representing Developmental Stages

Piaget's stages	Gardner's stages, *responses to art*	Parsons's stages	Generic styles of drawing	Feldman's levels
			Scribbling ages 1–3	
Preoperational ages 2–7		*Stage 1* *egocentric*	*Preschematic* ages 3–5	*Universal domain*
	Immature ages 4–7			
			Schematic ages 5–8	
Concrete operations ages 7–11		*Stage 2* *mimetic*	*Transitional* ages 8–11 or older	
	Intermediate ages 8–12			*Cultural domain*
Formal operations ages 11 to adult		Stages 3, 4, and 5	*Cultural realism* Average children and those not interested in advancing in drawing may never reach this stage Above average children or those committed to art may reach this stage in middle school or junior high	
	Mature ages 14–16			*Discipline-based* (talented adolescents, possibly)

and, at times paradoxical art world. To argue for a single standard or even a single set of standards by which to identify and judge all art is no longer tenable. The authors recommend an eclectic position that recognizes multiple perspectives and multiple standards.

To be somewhat conversant with aesthetics and children's aesthetic development is necessary if you are going to incorporate aesthetic inquiry in some way or other into your art classroom. But let us not get ahead of ourselves here; that is a subject for Chapter 8. Knowing a little about aesthetics also provides a backdrop for understanding the ways in which children develop aesthetically. Admittedly, these ways are only beginning to be investigated. We already have some information about trends in responding to pictures. We also have at least a provisional developmental theory.

Table 5–1 is an attempt to show the relationship of five different schemes for representing developmental stages: Piaget's, Gardner's, Parsons's, generic styles of drawing (Chapter 4), and Feldman's (Chapters 2 and 4). Take, for example, the span of ages that includes the majority of elementary school children, 8 to 11. That age group falls within, respectively, Piaget's stage of concrete operations, Gardner's intermediate stage (this chapter), Parsons's stage 2 (this chapter), the transitional style (Chapter 4), and pieces of both Feldman's universal and cultural levels (Chapters 2 and 4). For the most part, there is a remarkable consistency among the descriptions of child development within these individual growth domains.

There is one final point to think about with regard to your students. Only a very small percentage will become professionals in art. Of the rest, some may advance in their skills in drawing, but most will not advance beyond a certain point—the point at which their formal art education usually ends. (Of course, how far they advance depends on the quality of their art experiences in school—the subject of this book.) The largest percentage of your students, on the other hand, will not pursue art professionally. Nevertheless they, like all of us, have a stake in the visual heritage. We are obligated to see that they achieve at their highest potential in Parsons' stages of aesthetic growth.

NOTES

1. The National Art Education Association. (1990). *Quality art education: Goals for schools.* Reston, VA: Author.

2. Dewey, John. (1938/1958). *Art as experience.* New York: Capricorn Books.

3. Tolstoy, Leo. (1896). Art as the communication of feeling from *What is art?* In G. Dickie and R. J. Sclafani, (eds.) (1977) *Aesthetics: A critical anthology.* New York: St. Martin's Press, p. 66.

4. Bell, Clive (1914/1949). *Art.* London: Ghatto and Windus, pp. 8–9.

5. Ibid., p. 21.

6. Bell, op. cit., pp. 8–9.

7. Dewey, op. cit., p. 82.

8. Harris, William T. (1898). *Psychologic foundations,* New York: D. Appleton and Co., p. 368.

9. Weitz, Morris (1962). The role of theory in aesthetics. In J. Margolis (ed.), *Philosophy looks at the arts* (pp. 48–60). New York: Charles Scribner's Sons, p. 52. (Original work published 1956.)

10. Dickie, George (1974). *Art and the aesthetic: An institutional analysis.* Ithaca, NY: Cornell University Press.

11. Blocker, Gene H. (1979). *Philosophy of art.* New York: Charles Scribner's Sons, p. 210.

12. Danto, Arthur C. (1981). *The transfiguration of the commonplace: A philosophy of art.* Cambridge, MA: Harvard University Press, p. 144.

13. Ibid., p. 94.

14. Ibid, p. 172.

15. Langer, Susanne K. *Philosophy in a new key: A study in the symbolism of reason, rite, and art* (3rd ed.). Cambridge, MA, Harvard University Press, 1957.

16. Goodman, Nelson. (1968). *Languages of art: An approach to a theory of symbols.* Indianapolis: The Bobbs-Merrill Company.

17. Dissanayake, Ellen. (1992). *Homo aestheticus: Where art comes from and why.* New York: The Free Press (Macmillan).

18. Dewey, John. (1939). In Joseph Ratner (ed.). *Intelligence in the modern world: John Dewey's philosophy.* New York: Modern Library, pp. 962–970.

19. Gombrich, Ernst H. (1960). *Art and illusion: A study of pictorial representation.* New York: Pantheon Books.

20. Fry, Roger. (1920). *Vision and design.* London: Chatto and Windus.

21. Greenburg, Clement. (1961). *Art and culture.* Boston: Beacon Press.

22. Broudy, Harry S. (1972). *Enlightened cherishing: An essay on aesthetic education.* Urbana, IL: University of Illinois Press.

23. Lark-Horovitz, Betty, Lewis, Hilda, and Luca, Mark (1966). *Understanding children's art,* 2nd ed. Columbus, OH: Charles E. Merrill Publishing, pp. 209–230.

24. Machotka, Pavel (1966). Aesthetic criteria in childhood: Justifications of preference, *Child Development*, 37: 883.

25. Ibid., P. , p. 883.

26. Moore, Barry (1973). A description of children's verbal responses to works of art in selected grades one through twelve. *Studies in Art Education*, 14 (3): 27–34, reported in Salome, Richard A. (1991) Research on perceiving and responding to art, *Translations: From Theory to Practice*, 1 (2), pp. 1–5.

27. Gardner, Howard, Winner, Ellen, and Kircher, Mary (1975). Children's conceptions of the arts, *Journal of Aesthetic Education*, 9 (3): 66.

28. Ibid., p. 70.

29. Hardiman, George, and Zernich, Theodore (1985). Discrimination of style in painting: A developmental study, *Studies in Art Education*, 26 (3): 157–162.

30. Parsons, Michael J. (1987). *How we understand art.* Cambridge, MA: Cambridge University Press, p. 10.

31. Ibid., p. 136.

32. Goldsmith, Lynn T., and Feldman, David H. (1988). *Symposium, Journal of Aesthetic Education,* 22 (4): 83–93.

33. DiBlasio, Margaret K. (1988). Symposium, *Journal of Aesthetic Education*, 22 (4): 103–107.

6
Thinking
Without Words

A work of art may be a window on the world, but it is also a window through which we can look into the mind of the artist. Unless we are aesthetically literate, looking inward tends to be obscured by our own reflection. Until we can discern the artist's thinking more clearly, we will not truly understand art or artistic invention.

Making art is a matter of thought more than of manual skill. Artistic thinking is highly abstract, even though art—in process and after completion—is an object we can see and touch. Although artists who lived long ago and those who live today would choose different words to describe their efforts, all have shaped their ideas by shaping their art.

Let us listen to two artists, the late twentieth-century American landscape painter Harold Gregor and the early twentieth-century Belgian surrealist painter René Magritte, to see what they can tell us about the inventive process. How do these artists describe their work? What do they intend it to say?

HAROLD GREGOR

Illinois Landscape #125 (1993) (Fig. 6–1) (see **color insert** #2) depicts a pastoral landscape near Gregor's home in central Illinois. While the loca-

tion is recognizable, Gregor's painting also conveys a timelessness that characterizes good art. It has a sense of lush, serene, unspoiled natural beauty. It is time present, yet reminds us of times past, displaying well-ordered fields and meandering streams that evoke countless rural environments through countless centuries the world over. The painting speaks of contentment and perhaps sadness that such a perfect world may always be beyond our reach.

To Gregor, perceptual processes are important. He began his career in the 1950s as an abstract expressionist working with color-formed space. What motivates him to choose landscape as a subject? What does he think of as he paints?

Recently, I visited a major exhibition of paintings by Titian, the great sixteenth-century Italian master [Fig. 6-2] (see **color insert** #2). Despite a distance of four centuries, I felt a direct kinship with Titian and his art. I was thrilled by the connectedness I felt, as though his paintings made manifest a mind I could engage and enter as an equal partner in a brotherhood of expressive understanding. How remarkable! It was as though a living force spoke to me, and we shared an aesthetic "high." I was profoundly moved by the experience.

When I am painting a landscape like "Illinois Landscape #125," my decisions are concerned

with light, metaphorical suggestion, and viewer impact. Early on I realized that my biggest challenge was to address landscape not from a nineteenth-century viewpoint, but in twentieth-century American terms. To this end I explored compositional possibilities offered by the golden section format, a way of dividing the space on my canvas known since the Greeks, and later by the panorama, a landscape format far longer than it is high that seems to duplicate the real world.

The more I paint, the more I become convinced of the existence of something called the "universal mind" or perhaps a "generative force for good." I feel assured that paintings, and probably all the arts, are vehicles through which this force may be made manifest. Titian speaks to the future because his paintings reveal timeless verities, an ongoing order, and a clarity of purpose that confirms ourselves as contributing, worthwhile beings. I hope my own efforts, even in a small way, become linked to this discourse.[1]

RENÉ MAGRITTE

Magritte, a Belgian surrealist painter, was more concerned with symbols than with perceptual processes. His works, too, are metaphors. Magritte preferred to call himself not an artist but a thinker, whose means of communication was paint.

Magritte's 1935 painting *Time Transfixed* (Fig. 6–3) shows a steam locomotive emerging from a wall surrounded by a fireplace mantelpiece. On the mantel is a clock. The locomotive is a symbol of energy and motion. The clock is a symbol of time. The fireplace is a symbol of transformation where the release of energy turns logs (one form of matter) into ashes (another form). *Time Transfixed* thus becomes a visual metaphor for Einstein's theory of relativity, a contemporary scientific development of which Magritte was apparently unaware.[2]

Magritte described how he came to make *Time Transfixed* as follows:

> I thought of joining the locomotive image with the image of a dining room fireplace in a moment of "presence of mind." By that I mean the moment of lucidity *that no method* can bring forth. Only the power of thought manifests itself at this time. . . .

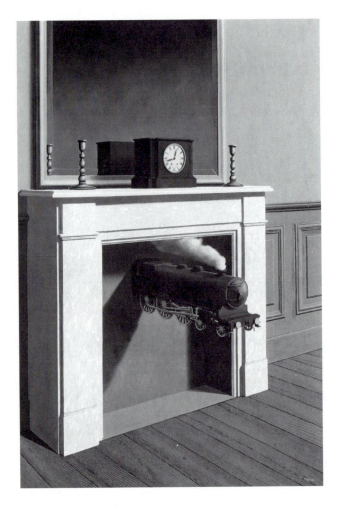

Figure 6–3 René Magritte, *Time Transfixed*, (1938). The Art Institute of Chicago, The Joseph Winterbotham Collection, 1970. 426.

(Courtesy of The Art Institute of Chicago, #E9028)

> The word *idea* is not the most *precise* designation for what I thought when I united a locomotive and a fireplace. *I didn't have an idea;* I only thought of an image After the image had been painted, we can think of the relation it may bear to ideas or words. This is not improper, since images, ideas, and words are *different* interpretations of the *same* thing: thought.[3]

ARTISTIC EXPRESSION

Gregor tells us about his deliberate arrangement of light and space so that his canvas recreates the beauty he finds in farmland. Magritte describes his ideas as mental images, later images on

canvas. Although Gregor appears to speak more to the perceptual aspects of painting and Magritte more to the symbolic, their paintings contain both. Perception and symbolism are two sides of the coin called *artistic expression.*

While you may have been using *self-expression* and *artistic expression* as synonyms, try now to think of self-expression as a generic activity that can take many forms and artistic expression as having a more particular meaning. Self-expression is a reaffirmation of one's own being, and it is not unique to the visual arts. Artistic expression, in contrast, refers to communication—the transmission of thoughts from one individual to another—through making art.[4]

We call Gregor's landscape representational art because it depicts particular trees and fields from a real place that we might visit. Magritte is a surrealist because his painted image transcends reality. When we look at these paintings, we can see that both express more than a literal interpretation. Both artists tell us that they intend more: they think of their paintings as metaphors that take us far beyond physical features to universal truth. How are they able to do this?

COGNITION

Let us look for an answer at artistic thinking, a part of what psychologists call cognition.[5] Cognition is described as the process of how people obtain and use knowledge. Four aspects of cognition have great meaning for artistic thinking: *intelligence, symbol systems, aesthetic perception,* and *artistic problem solving.*

Intelligence

The Swiss psychologist Jean Piaget (Chapter 4) was fascinated by the *mental operations* by which knowledge is acquired. Piaget's discoveries about mental development[6] are consistent with the approaches taken by many art educators, including Viktor Lowenfeld (Chapter 1). Piaget believed "that people are not recorders of information, but builders of knowledge structures."[7] Piaget's view of learning as a constructive process is now widely shared by cognitive psychologists.

American psychologist Howard Gardner is the major contemporary spokesman for children's artistic development. He draws from the work of Piaget and also from twentieth-century philosophers such as the German Ernst Cassirer, the American Suzanne Langer, the British Alfred North Whitehead, and the American Nelson Goodman. Goodman defines the primary purpose of art as a search for knowledge, "the urge to know," "cognition in and for itself."[8,9]

Many people believe that cognition has something to do with what we call *intelligence*—the faculty that allows us to acquire knowledge and use it to think and reason. Most psychologists assume that intelligence is a general intellectual ability found to a greater degree in some individuals than others. Certainly the conventional wisdom is that some people are "smarter" than others.

Gardner defines intelligence as "the ability to solve problems, or to create products, that are valued within one or more cultural settings."[10] He believes that problem solvers are "hunters, fishermen, farmers, shamans, religious leaders, psychiatrists, military leaders, civil leaders, athletes, artists, musicians, poets, parents, and scientists."[11] The diversity of their activities the world over shows that human problem solving occurs under many different circumstances.

Recently, Gardner has suggested a radically new theory of intelligence that he calls *multiple intelligences*: not one general intellectual ability, but a number of them. Gardner reviewed literature on anthropology, brain damage, child development, and psychometrics (the scientific measurement of human abilities like visual perception). He concluded that when fishermen, psychiatrists, athletes, and poets solve problems, each one requires a correspondingly different kind of intelligence that is independent of the kind (or kinds) needed by others.

Traditional theories of intelligence suggest that if intelligence is a general intellectual ability, then a "smart" individual should exhibit highly intelligent behavior in many different activities. In fact, extensive testing indicates that this is the case. Standardized tests of intelligence, for example, are good predictors of academic achievement. Tests on thousands of individuals have determined an "average" intellectual performance level for each age. An *intelligence quotient,* or "IQ," is a measure that compares an individual's intellectual ability to this average figure.

Gardner agrees that standardized intelligence tests can predict success in school, but he rejects the idea that they can measure all facets of intelligence; individuals around the world exhibit too wide an array of activities and achievements. Gardner believes there are seven human competencies that are independent of one another, all of which are kinds of intelligences: *linguistic* intelligence, *musical* intelligence, *logical-mathematical* intelligence, *spatial* intelligence, *bodily kinesthetic* intelligence, and two personal intelligences, the *intrapersonal* and the *interpersonal.*

The kinds of intellectual skills to which Gardner's various intelligences refer to have been recognized for almost a century. Testing shows that many of these intellectual skills correlate with one another. *Correlation* means that an individual who scores high on a test for one set of skills also scores high on a test for another set, suggesting that the two tests are measuring the same or closely related skills. Correlated scores support the theory of general intelligence.

Gardner discounts test results that suggest his multiple intelligences may not be independent on the grounds that most tests of intelligence ask verbal and mathematical questions. He expects that individuals who are gifted in the use of words and numbers will do well on these tests; conversely, those without such gifts will be at a disadvantage. Gardner further surmises that these tests do not measure the kinds of skills (like those used in art) that do not lend themselves to being tested in this way.

Also, Gardner is concerned about individual intellectual behavior. Traditional IQ tests only tell us about people on average, that is, people in the aggregate. What they cannot tell us is why individuals, each of whom has an infinitely varied combination of skills and talents, perform the way they do in any given set of circumstances. Individual differences also concern us as teachers, particularly when a student who seems gifted in art may perform poorly in mathematics.

Gardner's theory of multiple intelligences thus is beginning to revise our old idea of *talent.* The concept of talent has gained wide acceptance among art educators, who generally think of talent as an inherent aptitude for art above and beyond skills developed through education. They invoke talent to account for the fact that some people seem drawn to mathematics while others choose art. Gardner prefers to say that individuals have different kinds of intelligences.

All psychologists seem to agree that visual thinking processes information differently from linguistic or mathematical thinking. Gardner proposes spatial intelligence as the vehicle for visual thinking. He observes that logical-mathematical intelligence, although grounded in observation of the world, becomes increasingly abstract, while spatial intelligence "remains tied fundamentally to the concrete world, to the world of objects and their location in the world."[12] Concrete intelligence seems to account for only part of the thought processes of artists like Gregor and Magritte, however. Some of their processes—by their own accounts—are highly abstract.

Symbol Systems

If art is a language, it can reveal to others the thoughts within an individual's mind. Some conveyors of meaning are called *symbols.* Visual symbols can be *icons* (objects or configurations), as they are for Magritte, but the color and light that fascinate Gregor have symbolic properties as well. Goodman is the originator of a general theory of how symbols function in works of art (described more fully in Chapter 5).[13] He considers a symbol to be "any entity (material or abstract) that can denote or refer to any other entity."[14]

We cannot fully explain how languages or other symbol systems convey meaning. We know that each culture develops mutually agreed upon patterns of symbol use, however. Everyone in the culture understands these symbol systems. They are languages couched in speech, numbers, writing and other notation, music, visual art, dancing, and other forms of expression.

Symbol systems allow their users to communicate with others who understand them. We use symbols to write business letters and children's stories, to calculate how long it takes to get to the moon, to compose a lithograph, or to build a bridge. In art, the iconic symbols young children draw seem to be universal, but as children grow up in any given culture they learn to use its distinctive symbol systems (see Chapter 4). All symbol systems are complicated, including those in art, and we cannot understand their more intricate aspects without a good deal of effort, that is, education.

Children can learn to use aesthetic properties in symbolic ways just as artists do. Gardner used the term *expressiveness* to describe how children construct symbols "in such a way as to make a drawing that is 'lively,' 'sad,' 'angry,' or 'powerful.'" He used the term *repleteness* (after Goodman; Chapter 5) to mean lines in a drawing that varied in "thickness, shape, shading, and uniformity [that] contribute to the work's effect." Gardner reported that although older children could manipulate media for artistic expression better than younger ones, children acquired what he called *aesthetic sensitivity* during their elementary school years (Fig. 6–4).[15]

All cultures establish schools to assist their members in undertaking the journey from beginner to the highest levels of symbolic proficiency they wish to or are able to achieve. Eventually, some individuals become so proficient in using these symbol systems that they may even extend

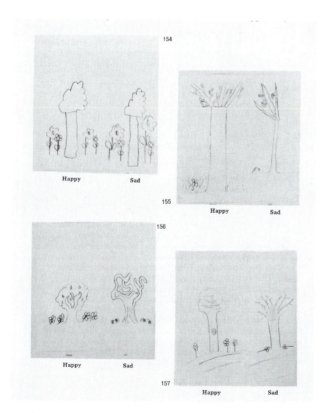

Figure 6–4 Expressiveness in children's symbols: "happy" and "sad" drawings by children of various ages.

(From the book, *Artful Scribbles* by Howard Gardner)(Courtesy of Basic Books, Inc.)

the system itself. In Chapter 2 we describe the levels of involvement individuals pass through as they become more adept at using the symbol systems of art.

Aesthetic Perception

Perception is a useful, everyday cognitive process that occurs spontaneously and invisibly. It is the way we "make sense" of an essentially neutral or sometimes even chaotic world. Perception depends on information obtained through our five senses—taste, touch, smell, hearing, and sight—and it does not depend on words. From sensory information we form mental images or mental pictures that correspond to objects in the real world.

Aesthetic perception is what we call making sense of art. There are properties in art—things like color and texture, for example—that we can perceive apart from the green trees and grassy hillsides that an artist may depict. We may organize areas of color and texture into objects, because we are experienced in perceiving objects in the real world, but we can also see them separately. Studying art teaches us to see how artists use them in their work.

For example an art historian, analyzing the portrait of *Mrs. Kirk* by the artist Anthony Van Dyck (Fig. 6–5) (see **color insert** #2) would most likely begin by describing the woman as though she were standing before us. Notice her posture and her presence, the historian would say; notice the way she holds her hands; notice the quality and style of her dress; notice her dog by her side; notice the room in which she stands; notice the many things in the picture that tell us, either literally or symbolically, about her position in life, her lifestyle, her social status, and the world in which she lives.

Only after spending a great deal of time discussing these "real-world" features of the painting might the art historian call our attention to the way Van Dyck applied paint in order to simulate the satin in Mrs. Kirk's skirt, the heavy brocade in the draperies, the hair of the dog, or the vegetation in the landscape. The historian might point out that Mrs. Kirk's figure is quite tall relative to the size of her head, and that the edge of her skirt, continuing the edge of the wall separating interior and exterior spaces, creates a vertical column

from the top of the painting almost to its bottom, forming a strong, solid visual element that suggests the stability of Mrs. Kirk's world.

The symbolic aspects of these perceptual features—and we could find many more in this single painting—indicate that the artist's choice of colors, placement of shapes, use of diagonals, creation of illusions of shallow and deep space, and manipulation of a host of additional aesthetic components contribute significantly to the meaning we derive from this painting. Their symbolic information exists in addition to any information that the art historian gleaned from the objects that the painting depicts. In fact, paintings that do not imitate the real world at all can express meaning through the things we call their formal aspects (inherent in their form rather than their subject). An art historian may

consider them of secondary importance, but an artist considers them essential to understanding art.

A familiar story about Henri Matisse concerns a well-meaning visitor to his studio, who undertook to point out to the artist that the proportions in his painting called the *Pink Nude* (Fig. 6–6) were incorrect. When the visitor observed that one of the woman's arms was too long, Matisse reminded the visitor that she was not looking at a woman, but at a painting—an image—of a woman. The misunderstanding that separates nonartists from artists, or the aesthetically illiterate from the aesthetically literate, the misunderstanding that Matisse addressed in his response to his visitor, is the difference between object and image, visual perception and aesthetic perception, the real and the symbolic.

Figure 6–6 Henri Matisse (1869-1954), *The Pink Nude,* (1935.) Baltimore Museum of Art.
(Courtesy of The Baltimore Museum of Art, BMA 1950.258)

If children are to become knowledgeable in art, bridging this perceptual gulf between nonartists and artists is essential. Giving children the means to do so is the most important service art education can provide them. Only by bridging it can anyone in our society achieve genuine aesthetic literacy.

PERCEPTION AND THINKING

Trying to understand the principles on which perception works is like trying to learn the rules of football by watching the game as it is played. It is hard to do. We observe that adults operate perceptually in a more efficient way than children, which allows us to infer that perceptual ability is learned. Perceptual learning is related to other cognitive processes such as remembering, using language (or symbol systems, as Gardner calls them), and forming concepts. In the late 1960s the American psychologist Eleanor Gibson noted that perceptual learning produces an increasing ability to extract information from the environment. Physical skills such as skill in throwing a football increase with practice, and so do perceptual skills.[16]

Teachers may acknowledge the usefulness of perceptual skills in art—we often say we are teaching children to "see"—but we may not recognize perceptual images as the basis for artistic thinking. Gibson's husband, psychologist James J. Gibson, considered perception to be an active, not a passive process.[17] We look, we do not merely see; we listen, not just hear. We form images and can recall them to mind.

There are two kinds of mental images, *particular* and *generic*. Particular (or *eidetic*) images—complete in every detail—are rare and are believed not suited to artistic thinking. Most mental images are generic, that is, representations of things out of context and qualities abstracted from objects. Our minds capture noteworthy features of objects, rather than the whole.

Can you think of a smile without a face, or a feeling of roughness without the bark of a tree? The mind captures ideas such as *liberty*, *heroism*, or *fear*. It combines parts of images in "imaginary" collages, as it "imagines" centaurs, griffins, unicorns, and art. Generic images are the building blocks of art. Psychologists speculate that the incomplete quality of our generic images allows us the freedom to think.

We all experience visual thinking every day. If you were to tell me how you go from home to your place of work, would your words describe a mental image of some kind? Before giving me directions, would you first imagine yourself walking or driving a car or riding a bicycle along certain streets, past certain landmarks? Would you see yourself stopping at certain traffic lights, turning right or left at certain corners? If so, you are experiencing a process of imagining that is essential to the making of art.

German-born Rudolf Arnheim, an American psychologist in the Gestalt tradition, observed that most words are labels for mental images, some of which are quite abstract. We have words, and corresponding images, for abstract concepts such as *patriotism* and *love*, as well as for concrete concepts such as *chair*, *woman*, and *skyscraper*. Arnheim noted that a cat named Yoshi, a specific individual, can also be a domestic cat, a feline, a mammal, and an animal depending on the increasing levels of abstraction with which we think about him.[18]

Arnheim suggested that thought is not limited to words but can also use mental imagery depending directly on sensory information. If everyday perception uses information available in the real world, then let us agree that aesthetic perception uses information available in artistic images. We can then speak of the aesthetic properties in a work of art as *aesthetic concepts*. Artists use these sensory and formal aesthetic concepts (the elements and principles of art) when they make artistic images; historians, critics, and aestheticians use them to interpret, admire, and evaluate art.[19]

Imagine these aesthetic concepts as the generic mental images we were just talking about—incomplete, out of context, and able to provide us with the means to think: concepts such as *redness*, *depth*, *diagonal*, *contrast*, and *smoothness*. A concept exists whenever two or more distinguishable objects or events have been grouped or classified together and set apart from other objects on the basis of some common feature or property characteristic of each."[20] Concepts seem to exist in all of the sensory modes—visual (having to do with sight), auditory (with hearing), kinesthetic (with touch), olfactory (with smell), and gustatory (with taste). Who can forget the taste of homemade bread or the smell of lilacs in the spring?

TEACHING WITHOUT WORDS

Have you ever tried to describe a work of art down to its last detail? Giving a name to an aesthetic concept helps to distinguish it from others, but more likely than not you will soon be at a loss for words—there are many more concepts than there are names for them. We can perceive some 10,000 colors alone, but have names for only a handful! Moreover, most concept names fail to convey their visual characteristics. It is little wonder that teaching art is a challenge.

Some visual aesthetic concepts are simple, but others are complex. Artistic style, for example, is a complex concept for which you can have a number of mental images, each of which is difficult to describe in words. Style refers to the way in which something is said or done, as distinguished from its substance. In art you quickly recognize styles by how they "look."

The Greek style looks different from the style of the Chinese; the Baroque style different from that of the Renaissance; the Benin style different from the Yoruba; the style of Matisse different from the style of Van Gogh. You can recognize artistic styles that differ from one civilization to another, from one historic time period to another, from one country or part of a country to another, or from one artist to another. Yet you can learn the characteristics of one sculptor's style so well, for example, that you can recognize a work by that sculptor you have never seen before. You can even tell whether it was made early or late in the sculptor's career.[21]

Formal instruction in the visual arts has incorporated three main strategies to teach aesthetic perception, which may be viewed to some extent in chronological order.[22] The earliest strategy was *imitation*. When all arts were considered trades, each master of each craft taught his apprentices to imitate the procedures he used to make an art object. As each apprentice could demonstrate skill at increasingly high levels, more freedom was allowed to initiate and complete projects until the apprentice could design and complete a work of art.

A strategy close to imitation was *copying*. During the nineteenth century it was common to see both men and women art students sitting in the Louvre and other European museums, copying paintings of the old masters. Teachers often

asked their students to draw the human figure from plaster casts of classical Greek sculptures, which were considered to embody ideal human form, as Van Gogh did (Fig. 6–7). By copying solutions to aesthetic problems found by acclaimed artists of the past, students learned the compositional principles that allowed them to create their own masterpieces.

The third teaching strategy was *drawing from life*, an approach still used today. Rendering nature would seem pretty straightforward, but early in the twentieth century this strategy took an unexpected turn. As scientists like Freud and Einstein began to uncover the subconscious and to revise our conceptions of space and time, artists like Picasso, Braque, de Chirico, and Duchamp felt able to represent more than an optical resemblance to the real world. The changes in artists' understanding of "life," whether fueled by science or intuition, opened the doors to cubism, surrealism, futurism, and other twentieth century styles of abstract art.[23]

Artists such as Walter Gropius, Wassily Kandinsky, and Josef Albers began to teach students to understand, and then apply, the aesthetic concepts now called *visual elements* and *principles of design* (described in Chapter 14). Most teachers now seem convinced that teaching elements and principles fosters children's cognitive skills. They associate those skills with being creative. It is often difficult to determine what concepts children are learning from the various projects they commonly encounter (or should encounter) in art class, however; this is the job of a good curriculum (see Chapter 9).

ARTISTIC THINKING AS PROBLEM SOLVING

Watching a clay-spattered ceramicist throwing a pot, or a sculptor with helmet and torch welding a steel sculpture, or a painter in frayed blue jeans at work in an untidy factorylike studio can give making art the aura of a technical, hands-on, blue-collar kind of trade. The reality of the visual artist as one who thinks abstractly and solves theoretical problems during a fascinatingly technical art-making process is less apparent. Only people familiar with the inventive nature of the art disciplines are likely to recognize the cognitive aspects of artistic activities: perceiving information, form-

Figure 6–7 Vincent van Gogh, *Study of a Plaster Cast,*
(light blue background). Van Gogh Museum,
Amsterdam, #F216h.

ing concepts, finding problems, reasoning, solving problems, and using the solutions to find new artistic challenges.

American painter Maurice Brown agrees that making art involves rational thought:

> Neither reason nor any of its tools are in necessary opposition to creativity. The judgment that guides scholarly research is not greatly different from the judgment that guides the artist's daring, and ultimately, skill. The scholar's typically high interest in the truth and the preservation of memory against the fog of lies, myth, forgetfulness, and even the treachery of language strikes a responsive chord in me and is not, I think, foreign to the attitudes of the painter.[24]

Art teachers like to refer to making art as a problem-solving activity because portraying it as a cognitive process helps to justify the educational value of their school programs—and so it should.

The term *problem solving* itself comes from the sciences; it is also called the *scientific method.* Incorporating problem-solving activities into art lessons demonstrates that making art is not accidental, but requires serious study. If asked, however, many art educators, including the authors, would find it difficult to explain what an artistic problem is and when a student has solved one.

The scientific method has several phases: perceiving a problematic situation, making educated guesses about its cause, predicting the results of attempts to resolve the perceived difficulty, carrying out the prescribed action, and then verifying its effect.[25] Once the problem has been identified and its cause inferred, the problem solver's thought process might be described as, "If I do this, then that is likely to happen." This educated guess is called a *hypothesis*. Scientists form and test hypotheses until they are able to verify their predicted consequences by direct observation.

Artistic Reasoning

Although we think of artists as primarily solving qualitative problems[26] and scientists as solving quantitative ones, both are able to perceive problems, diagnose the cause, form hypotheses, test them, and judge whether or not they work. The process of forming hypotheses involves conjecturing what will happen, inventing mental images or concepts of something that is not real and present, but of something that might be. In thought without words it has a special name and special meaning that comes directly from the images used: *imagination.*

Imagination frees us from the here and now. To test the strength of your imagination, give yourself some simple problems. For example, write down a description of the route that you follow from home to work. As you travel it in your mind's eye, what do you "see"? What landmarks do you recall? What building is on the corner where you turn? What building is next to it? What color is it? Can you see its details clearly?

Teaching children to be inventive in art means teaching them to use their imaginations to solve problems. You can give your students opportunities to find and solve problems that they would not otherwise find by themselves. In doing so, you can exercise their imaginations and prepare them for the day when they will be independent artists.

Problem solvers in art use both inductive and deductive reasoning. *Inductive reasoning* means working from the specific to the general: first examining specific instances and then making inferences about the principle or theory. If you find that the paintings of several artists all display similar characteristics of broken color, for example, you could infer that these artists have a common aesthetic goal. You might discover that they all wish to approximate the shimmer of light on surfaces of objects. Eventually you give their style a name: Impressionism.

Synthesis is an inductive process. It is a process that combines parts or separate elements to form a new and coherent whole. Creating art (art production), documenting an unknown monument from a bygone age (art history), interpreting a contemporary painting (art criticism), and building an aesthetic theory (aesthetics) are common inductive processes.

Deductive reasoning means working from the general to the specific: first examining the theory or principle and then, on the basis of its character, coming to conclusions about whether specific instances display it. If you know that all Impressionist paintings display certain characteristics of broken color, for example, and you encounter a painting you have never seen before with those kinds of color characteristics, you can deduce that it must be an example of Impressionism.

Analysis is a form of deductive reasoning. It is a process of examining components of a work of art within the context of the completed whole. Attribution of a work to an artist on the basis of its style (art history), formal analysis (art criticism and art production), and analysis of an object in order to determine if it is art (aesthetics) are all deductive processes you will encounter in later chapters.

The way in which any artist, critic, historian, or aesthetician uses knowledge is the heart of any art discipline. Inventive activities in aesthetics, history, criticism, and art production require both inductive and deductive reasoning. You can teach these processes to children.

Classroom Reasoning in Art

Imagine that you have given your students some studio assignments. They could reason as follows:

Induction—Perceiving the Problem, Forming the Hypothesis

My contour line is too light; it doesn't convey a sense of solidity. If I make it darker, perhaps it will make the figure seem more solid. (This is reasoning about sensory and expressive properties.)

The lower right-hand corner of my painting is dull. Perhaps it needs more energy. That blue next to the red in the upper left-hand corner makes both of them really vibrate. If I use that combination in the lower right as well, it might balance the two areas and give my painting more life. (This is reasoning about formal and expressive properties.)

My burin lines on my woodblock are all the same width, and they are narrow. They look

too similar and nothing stands out. If I use a wider burin and more pressure, I might get stronger lines in some places and perhaps better emphasis besides. (This is reasoning about technical and expressive properties.)

Deduction—Knowing the Theory, Forming the Hypothesis

Blue and yellow are supposed to make green. What would happen if I mix blue and yellow? Would I get green? If I put just a little blue in the yellow will I get yellow green? (This is reasoning about sensory properties.)

Shading produces the illusion of volume. Could I create a sense of volume if I add shading to my line drawing? I think it would make the objects look roundest if I put all the shadows on the same side. (This is reasoning about formal properties.)

Holding the burin correctly and pressing firmly should produce wide, even lines. Wide, even lines ought to make my woodblock stronger, the mood more intense. (This is reasoning about technical and expressive properties.)

Testing Classroom Hypotheses

In the art production part of any lesson or unit, you will assign your students the kinds of aesthetic problems that assist their artistic growth. They will be couched in everyday art projects: drawing a shoe, painting a vase of flowers, designing an album cover, making a necklace. As a way of presenting problems, you will state them as hypotheses your students should test. To identify useful problems, you will draw from what we call *warranted assertions.*[27]

Warranted assertions are credible hypotheses that have been tested over and over again by artists until they are commonly accepted as being true. *You can mix green from yellow and blue* is a warranted assertion. Some warranted assertions are one dimensional, as this one is, but others are not.

Imagine that you are teaching a third-grade art unit built around painting a vase with flowers in tempera paint (Fig. 6–8) (see **color insert** #2). It contains problems in each kind of aesthetic property: sensory, formal, expressive, and technical. Your students will test four hypotheses. (The ones we

are using as examples are deliberately simple, in order to be easily understandable. They could, of course, be much more complicated, depending on the age and previous experience of your students.)

Here is what you might say:

1. If you vary the pressure on your brush, sometimes pressing hard and sometimes gently, then your resulting line will vary from thick to thin. (This is an hypothesis about sensory properties.)
2. If you color a small area in one part of your picture a bright warm color, then you can achieve balance with a larger grayed area in another part. (This is an hypothesis about formal properties.)
3. If you use short, choppy brush strokes, then your paint will have a texture that looks like Van Gogh (Fig. 5–1). (This is an hypothesis about technical properties.)
4. If you make the edges of your shapes rough and jagged, then the mood of your painting will be livelier than when the edges are round and smooth. (This is an hypothesis about expressive properties.)[28]

You introduce your unit concepts by example or demonstration, because you cannot adequately describe them in words—although you try. You require your students to use these designated concepts in a work of art. You suggest hypotheses so students can put these concepts to work. When your students are finished, both you and they can tell, by observing the completed artworks, that they have acquired your designated concepts.

Finding Individual Solutions

When your students build the concepts you designate into an art work, your designated concepts are not the only ones they use. Each student work will contain many more concepts than the ones you designate—concepts of the students' choosing. These will form what we shall call a conceptual *context* in which are embedded your relatively few unit concepts.

In fact, all problems except the most elementary ones require students to use more than your designated concepts. For example, referring to the painting of the flowers, there are many ways to use a brush besides making lines that vary from thick to thin. Balance can be achieved by color, but other elements must also contribute to it.

Students most likely will use short, choppy brushstrokes in certain areas but not in others. They will make some shapes rough and jagged, but not all of them. They will decide where on the page to put the vase and flowers, whether they will be large or small, what colors to use, and so on. The list is virtually endless, even for third graders.

In other words, in every student's painting there will be a multitude of contextual concepts that you did not specify in your lesson. Each student's conceptual context will be different. If you structure lessons that allow this kind of creative latitude (remember, it is hard not to), you encourage your students to find and solve their own subsidiary problems.

When your students address a number of different problems within the same painting or drawing, they will find many different artistic solutions, even though instructions for everyone are the same. Each of twenty-five students who are painting the same still life can produce an individual statement that differs from all of the others in the class.

Such contextual diversity is often called *evidence of creative thinking*, although perhaps it would be more accurate to call it *evidence of selective problem solving*. For example, if some students testing hypothesis 3 paint on paper that is damp but others paint on paper that has puddles of water, the characteristics of the paint will vary. One technique is not necessarily more inventive than another; it depends on how it contributes to the artwork as a whole.

Child art made in school should display whatever concepts you have built into their class problems. These designated concepts will produce a visible conceptual consistency among child art from the class. Conceptual consistency does not mean that all of the students' art works look alike.

SUMMARY

The paintings of two artists, Harold Gregor and René Magritte, illustrate that making art is a visible reflection of artistic thought. Children also think as they make art. In making art, thinking can occur without words. (This bears repeating because so often thinking seems to depend on the mental equivalent of speaking.)

We have looked at artistic thinking from two points of view. First, we learned that children's cognitive development is revealed by their changing use of iconic symbol systems as they grow older. Second, we examined the symbolic nature of aesthetic concepts and their use in artistic problem solving.

Iconic symbols and the symbolic capacities of aesthetic concepts are two interdependent aspects of artistic thinking. Icons are configurations that stand for something else; sometimes we call them "subject matter." Artists modify the expressive quality of their icons by how they use color, line, shape, or balance. These aesthetic properties can convey optimism, fear, energy, and other moods and dynamic states. Sometimes, in art that has no subject matter, the sum of its aesthetic properties becomes its meaning.

We may perceive one figure as friendly and an identical figure as downcast based simply on the kinds and qualities of line the artist has used, for example. We may consider a painted landscape inviting or forbidding depending on the shapes of the trees, the color of sky and vegetation, and the dynamic tension of the painting's composition, if all else were equal. Both icons and aesthetic properties represent concepts (or mental images, or ideas). Artists use both icons and aesthetic properties to communicate their ideas to us, their viewers, by means of the images that we call art.

We have spent a good deal of time making a case for thinking without words. Let us not forget those people in art who think with them. Historians, for whom documentation and verification of each work of art is important, generate theories based on original art or documents (primary data). This parallels what scientists do. Critics are closer to artists in their approach to art; their interest in facts about the work hinges on what they reveal about its message. Aestheticians are philosophers who debate the nature and meaning of art and the creative process. Each of these activities present problems to solve much like those that face artists, and each needs to understand the language of art in order to be a skilled translator. Teaching children art means teaching them to think with both images and words.

NOTES

1. Gregor, Harold. (1995). Conversations with the artist.

2. Schlain, Leonard. (1991). *Art and physics: Parallel visions in space, time and light.* New York: William Morrow, p. 233.

3. Ibid.

4. See the theories of expressionistic art presented in Chapter 5.

5. *Metacognition* is the term for thinking about thinking.

6. Piaget, Jean. (1955). *The language and thought of the child.* New York: Meridian.

7. Resnick, Lauren B., and Klopfer, Leopold E. (eds.). (1989). *Toward the thinking curriculum: Current cognitive research; 1989 yearbook of the Association for Supervision and Curriculum Development,* Alexandria, VA: ASCD, pp. 1–2.

8. Goodman, Nelson. (1968). *Languages of art: An approach to a theory of symbols.* Indianapolis: Bobbs-Merrill.

9. **Harvard Project Zero.** In 1967, Goodman founded Project Zero at the Harvard Graduate School of Education. He intended it to be a place where scholars could examine issues basic to the arts and education. According to David N. Perkins and Gardner, now codirectors of Project Zero, the purpose of the Project is interdisciplinary research in human symbolic development. We have discussed some of the educational implications of Project Zero research in Chapters 4 and 5.

 Although Project Zero began existence as an ivory tower "think tank," considerably removed from the day-to-day concerns of public school teaching, its studies of cognitive development gained arts educators' interest. Today they recognize Project Zero as the leading American facility for empirical research in the arts. Project Zero's well-known developmental studies of children's symbol use in writing, music, and the visual arts provide valuable information for teachers.

10. Gardner, Howard. (1983). *Frames of mind: The theory of multiple intelligences.* New York: Basic Books, p. x.

11. Ibid., p. ix.

12. Ibid., p. 204.

13. Goodman, op. cit.

14. Ibid., p. 301.

15. Gardner, Howard. (1980). *Artful scribbles: The significance of children's drawings.* New York: Basic Books, p. 133.

16. Gibson, Eleanor J. (1969). *Principles of perceptual learning and development.* New York: Appleton-Century-Crofts.

17. Gibson, James J. (1966). *The senses considered as perceptual systems.* Boston: Houghton Mifflin.

18. Arnheim, Rudolf. (1969). *Visual thinking.* Berkeley and Los Angeles: University of California Press, p. 238.

19. In general, those who consider themselves fine artists have slightly different ideas about what aesthetic concepts are important than those who consider themselves applied artists or craftsmen. The approach to art contained in this book values the contributions of both fine and applied artists to the educational studio experience. We will attempt to circumvent this internal professional schism by noting that certain basic aesthetic properties are recognized by all artists, whether fine artists or craftspersons, and that these are the ones to be found in the books about "beginning design" or similar subjects. They are explained at greater length in Chapter 14.

20. Bourne, Lyle E. (1966). *Human conceptual behavior.* Boston: Allyn and Bacon.

21. Rush, Jean C. (1979). Acquiring a concept of artistic style. *Studies in Art Education, 20* (3): 43–51.

22. Dorn, Charles M. (1994). *Thinking in art: A philosophical approach to art education.* Reston, VA: The National Art Education Association.

23. Shlain, op. cit.

24. Brown, Maurice, and Korzenik, Diana. (1993). *Art making and education.* Urbana, IL: University of Illinois, p. 14.

25. Kemeny, John G. (1959). *A philosopher looks at science.* New York: Van Nostrand.

26. Ecker, David W. (1966). The artistic process as qualitative problem solving. In Elliot W. Eisner and David W. Ecker (Eds.), *Readings in art education* (Waltham, MA: Blaisdell), reprinted from *The Journal of Aesthetics and Art Criticism,* XXI /3, Spring 1963.

27. Broudy, Harry S. (1987). *The role of imagery in learning.* Los Angeles: The Getty Center for Education in the Arts.

28. Mack, Stevie, and Christine, Deborah. (1985). *Expressions of a Decade: CRIZMAC Master Pack.* Tucson, AZ: CRIZMAC Art & Cultural Education Materials.

7
Planning an Art Program

Amy is beginning her first year as a second-grade teacher. She is responsible for covering language arts, math, science, social studies, and health, all of which have state goals and learning outcomes and two of which (reading and math) have textbooks. She is on her own in art, if she wants to try it, but Amy feels relieved that an art specialist comes once a week. Her principal asks her to turn in lesson plans for the following week each Friday afternoon. Amy struggles to complete these plans, which demand some detail. They take a lot of time, although it gives her a feeling of self-confidence to know she is prepared to meet her students on Monday morning. Amy has mixed feelings about the plans, but she knows it is good to make these decisions before the last minute.

Amy's principal asks all of the teachers in his school to submit lesson plans, partly so that if he calls a substitute, the "sub" would know what to do. The principal likes to see art in the hallways because it is colorful, but doesn't ask his teachers to plan art lessons—that is the domain of the art specialist. He pays particular attention to Amy's lesson plans because she is new. He wants to keep track of her performance, in case she needs any help. Amy's credentials indicate that she has promise, but her principal doesn't know Amy as

well as some others he has worked with for several years. He scarcely glances at Catherine's plans, for example. He knows she has the routine down pat.

Catherine has been a fifth-grade teacher for 20-some years. She is regarded as one of the best teachers in the school, if not the district. Catherine prepares carefully for class, but spends almost no time on lesson plans. In fact, she is apt to change her plans at the last minute in response to some unanticipated event, in order to offer her students a more timely lesson than the scheduled one. She dutifully submits plans each week, but they are often vague or copies of plans made last year. Catherine likes art, and she works it into many of the academic subjects required in fifth grade.

Nicole is an art specialist with 8 years' experience. She is working on her master's degree at the state university. Nicole visits the district's two elementary schools and teaches over 600 students each week, kindergarten through sixth grade, seeing each child once during that time. She plans what she will teach independently from the classroom teachers and, because she is not supervised by the school principals, seldom writes down anything more than notes to herself. Nicole confers with the district curriculum coordinator once in a

while, who pretty much lets her decide the content of her lessons.

Nicole values spontaneity and individuality among her students and looks for art projects that can "turn on" her students; in return, they are enthusiastic about art class. Nicole sometimes decides on lesson content on the spur of the moment, and for that reason does not use textbooks or a sequential curriculum. Several years ago the state developed goals and learning outcomes for art like those for the academic subjects. Neither the state department of education nor the district requires Nicole to report students' performance on achievement tests at the end of the year, as they do teachers of other subjects. Rumor has it that *accountability* in art (some measurement of learning by means of test scores) is not far off, however.

The state board of education also has recently adopted the National Standards for arts education based on the *Goals 2000* initiative.[1] Anticipating statewide testing in art, the district superintendent has appointed a committee of teachers from the two elementary schools to develop a curriculum in art that will meet the national standards as well as the state goals and outcomes. She strongly suggests that the district adopt art textbooks and asks the committee to think of other ways to involve classroom teachers in day-to-day art activities. Amy, Catherine, Nicole, and two classroom teachers from the other elementary school will work on the art curriculum committee with the district's assistant superintendent for curriculum and instruction and at least one of the two elementary school principles.

The superintendent most likely will choose her committee members on the basis of several criteria, according to education professor Allan Glatthorn:

- Knowledge of the subject area for which they are responsible,
- Ability to produce work on schedule,
- Knowledge of the district's curriculum development processes, and
- Influence with classroom teachers.[2]

The superintendent expects the curriculum committee to produce a curriculum guide that can be implemented in elementary classrooms within 3 years. She envisions some kind of document that will organize program goals, concepts, and classroom activities according to grade level, but will leave actual lesson planning to each teacher. She intends to ask all elementary classroom teachers to use it. Committee members believe their art curriculum framework will benefit children in the district by increasing the amount of art education they receive.

You can see from the foregoing scenario that planning is an integral part of teaching. All teachers plan what to teach, and how, and when, and for how long, whether someone asks them to or not. It is part of being a thoughtful teacher, and the teacher's role in planning is a crucial one. Amy, and Catherine, and Nicole have different styles of planning, and each one takes it seriously. We can call each one a successful planner, because each is a successful teacher.[3]

DISTRICT CURRICULUM PLANNING

All teachers plan lessons every day, but planning can also take place over months or years. Planning can be individual or by committee, formal or informal, written or unwritten. A number of lesson plans considered as a group becomes a unit, and a number of units becomes a curriculum. Just as every teacher has lesson plans, whether or not they are written down, every teacher has a curriculum—if only in retrospect.

Curriculum is a word we use often and indiscriminately, and perhaps for that reason alone deserves a closer look. It can refer to plans for a few lessons, or to all of the courses of study offered by a school, or to an outline of a particular course of study in one subject, or to learning outcomes issued by a state department of education, or simply to a series of studio projects long enough to get through 9 weeks of seventh-grade art. A curriculum can be written or unwritten, actual or intended, hidden or highly visible.[4]

District curriculum planning, in the sense that our teachers Amy, Catherine, and Nicole are undertaking it, is the key to strengthening an art program. Backing of the district administration is essential to any curriculum innovation. The better the planners and the more teacher input they receive, the better their final product will be, because there are fewer curricular models for art than in other subjects.

Let us walk through what our teachers and principals will need to do when they meet with their assistant superintendent. Their first activity will be to list their projected activities as a curriculum committee. Their list will look something like the following one.

Our committee will have to

- decide how much time to spend on the project, on each part and in total (see *Scheduling*);
- discuss the purposes of the art curriculum (see *Educational philosophy*);
- study curricular precedents and resource materials (see *Literature review*);
- determine what art concepts are important for children in the district to learn (see *Curriculum content*);
- determine how students might best learn them (see *Classroom activities*);
- organize this content and these activities into a certain order over some period of time ranging from 9 weeks to several academic years (see *Sequencing*);
- ascertain who might best teach from them, and when (see *Articulation*);
- describe them so unambiguously and in such detail that teachers can use them easily (see *Formatting*); and
- assure teachers and school administrators that the curriculum materials provide the content that the district and state expect (see *Evaluation*).

Scheduling, philosophy, literature review, content, classroom activities, sequencing, articulation, formatting, and evaluation: These are the seven components of successful curriculum planning. Our committee members face some difficult decisions.

Does the district have curriculum goals? Do they match the state learning outcomes? Should the committee change the content of the present program? Given all of the factors to be considered, what kind of format should they use for the guide itself? Will textbooks help or hinder teachers? Which published materials, if any, will meet their needs? Furthermore, will teachers be able to use their new art curriculum? This chapter will follow our hypothetical committee as they address the task before them.

Scheduling

The superintendent wants a 3-year planning and implementation cycle. The first phase of the cycle will be production of the curriculum guide itself. Following that, the assistant superintendent will ask some classroom teachers to teach from the guide for several months to see where its weak spots are. Afterward there will be a period of revising and rewriting the curriculum guide before the superintendent distributes it district wide.

The first thing our curriculum committee will want to do is create a detailed schedule that covers all steps from planning to classroom use. Their schedule will have at least seven categories: organizing the committee (*Plan*), development of background knowledge (*Organize*), writing curriculum materials and selecting published resources (*Produce*), pilot testing (*Pilot*), evaluation and revision (*Evaluate*), and implementation of the finished curriculum (*Implement*).

The committee could show these on a long-term planning chart. Here is a sample:

Sample Long-Term (3-Year) Planning Chart[5]

1997–98	Summer 98	1998–99	Summer 99	1999–2000
Plan		Pilot		Implement
Organize		Evaluate		Evaluate
Produce		Revise		

The members of our curriculum committee may participate in planning, organizing, producing, piloting, evaluating, and revising; this is a formidable task. Working out the details will cost our teachers a lot of meetings after school, consuming at least the school year. They will almost certainly go without overtime pay; perhaps the superintendent can fund one of them to do the actual writing during the summer. They can ask a few teachers to try it out in the fall and let them know what needs adjusting. Counting time spent on rewriting and presenting it to teachers, Amy, Catherine, and Nicole are looking at a 2-year time commitment, at the least; perhaps three.

Educational Philosophy

Purpose In the best of all educational worlds—the teacher on one end of the log and the student on the other—each teacher would plan a curriculum for each child. In the world of the public schools, however, a curriculum most often governs what many teachers do in their classrooms, not just one. A curriculum furthers the aims of schooling. We can characterize these as *intellectual* (conveying wisdom of the ages), *social* (preparing good citizens), and *personal* (developing individual potential).[6] We have already discussed two of these (the intellectual and the personal) in Chapter 2.

Expectations The purposes of curriculum planners reflect a variety of expectations regarding what a curriculum will teach. Art educator Elliot W. Eisner has identified five kinds of expectations. Planners expect that a curriculum will

- "help children learn how to learn and . . . strengthen the variety of intellectual faculties they possess" [a personal purpose];
- lead children to study a subject because it is "a special case of a more general and powerful paradigm of human understanding" [an intellectual purpose];
- build on children's interests so that "the child will, without coercion, find what he or she needs in order to grow" [a personal purpose];
- identify needs of society and provide children with the kinds of skills that meet those needs (adapt to society) or even "become aware of the kinds of

ills that the society has and become motivated to . . . alleviate them" (reform society) [a social purpose];
- provide a kind of structure that permits accountability, in which "each teacher would have specific, measurable goals for each subject" so that teachers and students could recognize when they achieve them [both a social and a personal purpose].[7]

Teaching Styles Amy has recently taken a semester-long course in art education for the elementary grades, but it is her first art course since eighth grade. Catherine's teacher-preparation program did not include a course like that, but because of her interest in art she has studied nineteenth-century art history—through modern art—at a local community college. Nicole was an art major in college and still is an active painter during her spare time. She visits museums whenever she travels to a major city, and she belongs to the National Art Education Association in order to keep up on teaching art; she reads their journals and attends national meetings as often as she can afford to go. Each teacher who plans a curriculum brings different classroom skills and experiences to the task that will affect the outcome of the planning.

One of the most important of these experiences is teaching style, or the way teachers interact with their students.[8] Evaluator Liona Bresler finds that one of three distinct educational postures is likely to predominate in any art curriculum: rote (teacher-centered), open-ended (student-centered), or cognitive (higher order thinking-centered).[9] She associates rote learning with a curricular structure found most often in academic subjects, which seems to correspond to a didactic teaching style. A *didactic* teacher is highly prescriptive and a didactic learner is a passive recipient rather than a user of knowledge.

Bresler links the open-ended approach (a desire to improve traditionally structured subjects by adding more self-expressive activities) with a philetic teaching style. *Philetic* teachers are "child-centered" because they are reluctant to give direction in art and value children's expressions of feeling. They love their charges and want to do what is best for them, and students love them in return.

Teachers who take a cognitive approach to curriculum generally favor active learning (or "discovery" or "inquiry-based" learning) and generally have an heuristic teaching style. An *heuristic* teacher wants students to solve problems and use knowledge in other ways that involve "higher order" thinking (see Chapter 6). Their goal is not the memorization of knowledge but its use. The cognitive approach, sometimes called the *constructivist* approach[10] because children construct meaning for themselves, is the one most favored by educational theorists today.

While all of the distinctions Bresler makes are helpful, they are generalizations. Every good teacher is child-centered, and no real curriculum is as one-dimensional as any of the ways in which we have characterized those described. Most of us, as teachers, have eclectic educational philosophies. Any elementary art curriculum will be open-ended to some extent. Each elementary art teacher will find some occasions for which rote teaching is appropriate.

A curriculum designed to encourage thinking is not an easily achievable goal. It demands the most from elementary teachers and is farthest from familiar classroom practices. Successful innovation takes patience and the desire for change, plus two things we are about to consider: familiarity with existing curricula, and an acquaintance with the ideas of experts.

Literature Review

Curricular precedents are a great help to planners. As Amy, Catherine, and Nicole begin their creation of a curriculum guide, they will want to look at materials already in existence. Elementary art is known for home-made, individualized curricula and a lack of standardized teaching materials. Where can our teachers look for guidance?

District Materials Once their timetable is established and their educational philosophies explored, our committee members will find help close to home—in their district's curriculum policy, educational goals, and criteria for excellence. Is there a statement of district educational philosophy? If not stated explicity, it nevertheless exists in practice; the committee will need to spell it out. Does Nicole have a curriculum that can serve as a starting point? If not, perhaps a neighboring district does. Are there curriculum guides in subjects other than art? Perhaps one of those can serve as a model for the one to be written in art.

State Materials Fortunately our district is in a state that has a curriculum framework, which specifies learning outcomes for art. (Sometimes learning outcomes are also called *goals*, or *content objectives*, or *exit skills*.) The state learning outcomes are important references for our district committee. Not all states have curriculum guidelines in art, but states that do not are moving toward them. If our teachers were in a state without them, they could examine those of other states; our teachers may want to do that anyway. The more broadly they are informed, the easier their task will be.

National Materials Recently the Consortium of National Arts Education Associations[11] developed sets of learning outcomes in theater, music, art, and dance education, under the guidance of a National Committee for Standards in the Arts.[12] The Consortium acted in response to a federal law called *Goals 2000: Educate America Act*. You will recall from Chapter 1 that *Goals 2000* is the first time the federal government has considered the arts as important as the traditional "academic" subjects. Each association appointed a task force with six members to write the outcomes.[13] The National Standards, as they are called, represent a consensus of thinking on arts education. These National Standards are voluntary, however.

The arts Standards are general, not specific. They cover grades kindergarten through twelve. They set out performance levels that students should achieve, grouped according to grades: K to 4, 5 to 8, and 9 to 12 (for more detailed examples, see Chapter 10). They do not say how those levels should be reached, in order not to intrude on the prerogatives of local teachers like Amy, Catherine, and Nicole.

Nevertheless, when states and districts adopt the standards, they are announcing their intention to support excellence or rigor and have a way to define it. The Standards also assume the generative role of arts knowledge, in the sense that we have discussed it in Chapters 3 and 6. Arts educators believe the Standards will encourage students to seek new knowledge as they move

towards higher levels of achievement and artistic expertise (the kind of advance in levels of mastery you read about in Chapter 2).

The bodies of knowledge in each of the arts are quite different; "arts" education is not one entity. The Standards encourage interdisciplinary learning both within and among different art forms. They imply that teachers should help students to make connections between concepts from one arts discipline and those of others, and to see relationships between the arts and those subjects we call "academic." This kind of integrated learning is especially appropriate in elementary schools; it is discussed further in Chapter 11.

The Standards stress that understanding the arts must be global in scope. Its framers recognized that American students should be as knowledgeable in the arts as students from other countries are. They also acknowledge the many cultural traditions within the United States as resources for teaching art. The distinct character, history, and monuments of our many art forms provide compelling evidence of our artistic diversity on the one hand and the shared traditions that bind us together on the other. Chapter 12 treats these in more detail.

The Standards place the arts face-to-face with technology and the challenge of electronic media today (see Chapter 15). The graphic designer, film animator, and others who use electronic tools need to be artistically knowledgeable. Computers and interactive video "can also have a significant impact on the development of creative thinking skills."[14] Inventiveness in art does not depend on these new media, but an inventive person can use them to advantage in the creation of as yet unimaginable works of art.

The Standards suggest that there are qualitative distinctions in student performance in the arts: some things are right and some wrong, some problem solutions better and some worse; and knowledgeable people can distinguish excellence from mediocrity. The framers of the Standards realize that without assessment, teachers cannot know that students have reached the levels Standards recommend. Assessment thus becomes an important skill for every art teacher; the whole of Chapter 10 is devoted to it, and sets out the organization of the Standards in detail.

National Standards Because schools are a public concern, the expectations of many people besides teachers affect what happens in classrooms. The obligation of public schools to parents and the rest of society means that all children are expected to reach a standard acceptable to this greater body. Put another way, all children deserve to have the same opportunities as those afforded to the most privileged.

The National Standards spell out what students should be able to do by the time they have completed secondary school. They leave it to curriculum planners like Amy, Catherine, and Nicole to put their elementary equivalents into specific classroom contexts in each art form:

- *They should be able to communicate at a basic level in the four arts disciplines*: dance, music, theatre, and the visual arts. This includes knowledge and skills in the use of the basic vocabularies, materials, tools, techniques, and intellectual methods of each arts discipline.
- *They should be able to communicate proficiently in at least one art form*, including the ability to define and solve artistic problems with insight, reason, and technical proficiency.
- *They should be able to develop and present basic analyses of works of art* from structural, historical, and cultural perspectives, and from combinations of those perspectives. This includes the ability to understand and evaluate work in the various arts disciplines.
- *They should have an informed acquaintance with exemplary works of art from a variety of cultures and historical periods*, and a basic understanding of historical development in the arts disciplines, across the arts as a whole, and within cultures.
- *They should be able to relate various types of arts knowledge and skills within and across the arts disciplines*. This includes mixing and matching competencies and understandings in art-making, history and culture, and analysis in any arts-related project.[15]

Textbooks Art is a difficult subject for many teachers. For that reason, the superintendent thinks classroom teachers in all grades, kindergarten through eighth, should use art textbooks. Textbooks typically offer a series of lessons in one subject sequenced over a school year, usually accompanied by a volume of instructions for its use called a teacher's guide. Textbooks in art also contain color photographs of art, and a number of

them also reproduce the same works of art in large format for classroom use.

Our classroom teachers Amy and Catherine like the idea of textbooks; Amy thinks they will relieve her of the difficult task of planning art lessons, and Catherine thinks they will enable her to give her students more substantial art information and skills. Nicole, our art specialist, finds the idea of textbooks restrictive, however. She already has an arsenal of workable projects, and wants the flexibility to adapt her lessons to what she perceives as the needs of her students. Do the advantages of textbooks for Amy and Catherine outweigh the disadvantages of Nicole's reduced ability to respond to students?

The influence of textbooks on the content of elementary curricula can scarcely be overstated.[16] Every elementary curriculum in an academic subject that uses a textbook closely follows that text. In other words, the textbook becomes the curriculum. Amy and Catherine, like all classroom teachers, teach some of their academic subjects from textbooks and rely on their sequences of concepts and skills. They would appreciate having the same kinds of help when they teach art.

Planning a curriculum for each subject in elementary school is too time consuming for each classroom teacher to undertake, the results too uncertain when measured by standardized achievement tests. Art textbooks also save classroom teachers from spending a lot of time accumulating visual materials and explanatory materials to support them. In many ways textbooks in art help classroom teachers present programs of much higher quality than they have time to prepare without one. Moreover, any art textbook series adopted and used district wide ensures children in all elementary schools the same opportunities to study art.

The use of textbooks is growing rapidly among classroom teachers and even among art specialists. Although classroom teachers have always liked art textbooks, art teachers have not used them much. Prior to the 1980s, and to a great extent even today, art specialists routinely considered curriculum planning part of their job. The discipline-based approach and the desire to meet the National Standards encourage textbook use.[17]

There have been textbooks on drawing and art appreciation from the late 1880s, but the first modern series dates from 1973. It was called *Art: Meaning, Methods, and Materials,* written by Indiana University art educators Guy Hubbard and Mary Rouse, and a revised version is still in print (now called *Art in Action*).[18] Art textbooks provide conceptual structure as much as textbooks do in other elementary subjects. They contain valid information about art compiled by experts.

After the introduction of discipline-based art education another textbook series (*Discover Art,* written by art educator Laura Chapman)[19] and a number of supplemental resource materials became available. The increased demand encouraged major publishers to produce textbooks and related materials such as "art prints" (color reproductions), slides, lesson plans, flash cards, and so on. These new materials incorporate the comprehensive content consistent with the National Standards and have user friendly teacher's guides. (You can find a list of many of them in Appendix 2.)

Nevertheless, there are also some disadvantages to using textbooks. One of them is their cost; textbooks are expensive. Textbooks work best when each child has one. Some schools can only afford to provide teachers with one for the entire class; in this case the textbook becomes another resource, but cannot function as it was intended to. Some teachers also may use texts less regularly than recommended. If textbooks are being used, they should be available to all of the children and used consistently.

Another drawback to textbooks is their specificity or prescriptiveness. Nicole is typical of art specialists in valuing spontaneity and individuality among her students. She wants the same spontaneity for herself in planning what to teach. For a long time, art educators in the Lowenfeldian tradition considered the inventive nature of their subject ill suited to textbooks, tests, and even sequential planning. Many art specialists still consider even district-wide curricula, published or unpublished, as too restrictive on their ability to respond quickly and intuitively to creative "happenings" in the art class. When art specialists use textbooks, they generally teach lessons out of order.[20]

Other Curriculum Materials There are many kinds of curriculum resources for art teachers besides textbooks: sample lessons, statements of

educational philosophy, art history books, technical manuals for various art media, videotapes, art games, computer software, and similar materials. In the professional art education journals, particularly those published by the National Art Education Association,[21] leading authors discuss curriculum excellence within the context of current research on art learning. Professional journals in other areas of education also publish the results of research on teaching, learning, and child development.

There have been some notable art curriculum projects in the recent past that our committee might wish to explore. The Penn State Seminar, mentioned in Chapter 1, sparked a number of attempts to improve art education curriculum.[22] All have in common the broadening of content to include the understanding and appreciating of art as well as making it.

Curriculum Content

District, state, and national standards deal with ends, not means. It is undoubtedly helpful to have these aims toward which to work. By reviewing all of the literature discussed—district, state, national, commercial, and professional—our committee members will ensure that their curriculum content stands on a sound foundation of practice and research. But Amy, Catherine, and Nicole still have to decide on the specific content of their curriculum.

Some art content is important because it contains the major concepts and skills that define the arts disciplines. All students therefore need to learn them. Other kinds of information are less important.

For example, knowing the names of major artists associated with Post-Impressionism (Cezanne, Van Gogh, Gauguin, and Toulouse-Lautrec) would seem to be important for all elementary students. Knowing the details of these artists' lives would seem to have low importance. Knowing how to paint a picture with tempera paint is a skill of high importance in elementary school. Knowing how to mix the powder and water to produce the paint is one of low importance.

Some content is more structured than others. Students seem to learn it better when teachers present it in a structured way. According to Glatthorn, highly structured content is

- manifested in specific objectives
- clearly articulated
- well coordinated and sequenced
- carefully assessed
- explicitly taught.[23]

For example, understanding the principles of pictorial space requires structure; it must be explicitly planned, taught, and tested. But developing aesthetic awareness seems to be less structured learning; it should be nurtured continuously and less formally. In the case of a less structured skill like aesthetic awareness, Glatthorn finds, "the learning objectives can be more general, coordination and articulation are not crucial, sequence is unimportant, assessment is not necessary or practical, and no explicit teaching seems required."[24]

A curriculum that has high importance and high structure is called a *mastery* curriculum or a *core* curriculum. We will assume that our committee is planning such a curriculum. A mastery curriculum

> requires high-quality curriculum guides, standardization across the district, scope-and-sequence charts, and excellent assessment. Note also that the mastery curriculum requires careful planning and explicit teaching. Students will not "pick up on their own" the elements of the mastery curriculum.[25]

Our committee wants its curriculum guide to incorporate rigorous standards and at the same time relate to the experiences of their children. They know they must select knowledge about art from its four disciplines. They realize that this knowledge base will include processes as well as information (refer back to Table 3–1 in Chapter 3). Two terms you may encounter for these two kinds of knowledge are *declarative knowledge,* for information, and *procedural knowledge,* for processes.[26]

Content Objectives But what specific knowledge and processes should our committee use? They might wish to spell them out in lists of content objectives. (Other names for content objectives are educational goals, learning outcomes, or

exit skills.) Lists in each district could differ. As an example, here is one list of broad content objectives for all grades devised by art educator Phillip Dunn.

What may be called the intermediate aims and objectives of the curriculum include

- Developing cognition in its broadest forms.
- Enhancing visual perceptual skills.
- Augmenting verbal skills.
- Honing fine and gross motor control.
- Providing for individual differences in social, cultural, gender, and learning styles.
- Encouraging children to develop a level of technical mastery and control over the materials they are asked to manipulate.
- Allowing children to express themselves visually, verbally, and in written form in ways that are meaningful to them.[27]

Content objectives are more useful in the classroom when they indicate what students are expected to do. Let us look at more specific content objectives for grades 3 and 4 that relate to the first item on the previous list, *developing cognition in its broadest forms*. The first objective is general:

Imagination: Memory and fantasy

- Form mental images of real or incongruous objects and events.[28]

Even content objectives like the one above should be expanded by means of subgoals. The more specific these subgoals are, the more useful they are in the classroom. Elaborating on the general content objective above (forming mental images of real or incongruous objects and events), conceptual subgoals might be as follows (perhaps with reference to Figs. 6–1 or another realistic painting and 6–3 or another example of Surrealism):

Identify, discuss, and use in your own artwork the following characteristics of images of real and incongruous objects and events:

- proportion and disproportion
- real space, pictorial space, and spatial distortion
- real time and imaginary time
- realism and symbolism
- specificity and ambiguity.

Behavioral subgoals may imply concept learning without indentifying specific art concepts. As long as the teacher understands the concepts to be taught, behavioral subgoals serve an important function in planning classroom activities. The following examples from an Arizona curriculum guide are subgoals for the content objective above (forming mental images of real or incongruous objects and events):

Creative art expression

- Make a costume for a world on another planet.
- Make a monoprint of a dream.
- Draw a wished-for object or event.

Aesthetic assessment

- Discuss current fantastic or surreal art used in films and books.
- Identify kinds of art elements used to make fantasy-inspired artworks.
- Talk about dreams and wishes, the possible and the impossible.

Art in cultural heritage

- Recognize the style called Surrealism.
- Discuss motives for making a work of art.
- Discuss mood in a work of art.[29]

Generative Uses of Knowledge The National Standards call for children to *communicate* in an art form, *define and solve artistic problems, develop analyses* of works of art, *understand and evaluate* art and its historical development, and *relate* various kinds of art knowledge to one another (refer back to page 93). Educational theory from the 1940s through the 1970s placed great emphasis on teaching as the modification of behavior rather than the posing of problems. Teachers encouraged children to acquire knowledge by means of practice and rewards. When Benjamin Bloom organized his six-level hierarchy of educational objectives in the cognitive domain,[30] he considered knowledge acquisition to be the forerunner of thought. Bloom placed the acquisition of knowledge on the lowest level of his hierarchy and various kinds of thinking skills on higher ones.

Moreover, notes psychologist Lauren Resnick,[31] Piaget and the Gestalt psychologists (Chapter 6) seemed to advocate the learning of thinking skills independently from (or in prefer-

ence to) the learning of subject matter that takes place in schools. Their work suggested that teachers might even stand in the way of children's natural development. Believing they might impede children's development caused teachers of all elementary subjects concern, not only those teaching art. It was hard to provide fundamental science concepts, for example, when Piagetian theory emphasized hands-on activities.

Today educators see things differently than Bloom did; they regard thinking as the means by which knowledge is acquired. Chapter 6 describes the connection between knowledge acquisition and thinking in art. We see that connection especially when we observe children solving artistic problems. One of the most positive changes in general education today is the desire to build thinking skills into all elementary school curricula from the beginning.

Classroom Activities

Amy and Catherine encourage children to think by giving them opportunities to put their knowledge to work, that is, to solve problems and create meaning. This approach to curriculum has become known in schools as constructivism.[32] Teachers using a constructivist approach make sure that children are not only given problems, but also given help with strategies for solving them. Some strategies are generic, while others vary according to the subject or discipline. Students solve problems best when they know how to "gain access to and use a body of knowledge."[33]

There are many activities during which students can use thinking processes to acquire knowledge. Those that apply to academic subjects apply as well to art. These kinds of classroom activities convey curriculum content to students. Glatthorn cites some classroom activities that can be vehicles for thinking in all subjects:

- Listening to the teacher present information
- Guided discovery
- Guided discussion
- Interviewing experts, parents, and others
- Learning from peers
- Reading texts and other print materials
- Using computer software
- Viewing television
- Using other media.[34]

The last activity, *using other media*, could be expanded as follows with reference to art. These classroom activities convey curriculum content specifically about art:

- Making art
- Analyzing art
- Putting art into its historical context
- Evaluating art
- Appreciating art, including
- Asking aesthetic questions.

Research bears out the benefits of asking students to create meaning by using what they already know. Studies of chess, which requires highly complex decision making, have allowed educational researchers John Bransford and Nancy Vye to compare the performance of highly skilled individuals with those who are less skilled. Knowledge of the game resulted in thinking that was qualitatively superior to thinking displayed by players who were less knowledgeable. In other words, highly skilled players did not try more solutions but instead made better choices.

Comparisons of college students who did not play chess and children who did (whose average age was 10) found that when asked to remember number strings (7208419385), college students could perform better. When asked to remember chess pieces placed strategically on a chess board, however, children who played chess performed almost twice as well as the college students who did not. These experiments indicate that" 'memory ability' is not some general propensity for storing information. Instead, our abilities to remember depend strongly on the nature of information we have previously acquired."[35]

Learners need to be active participants in the construction of new knowledge. Teachers cannot simply convey information to students and expect that they will become knowledgeable by memorizing it. This does not mean that teachers should not teach. It does suggest, however, that children themselves must use the information that art teachers and textbooks provide. Bransford and Vye conclude that children who do not practice using new knowledge, in school, often remember only inert facts tied to specific contexts. They are unable to use them to solve new problems.[36]

Inert information that has been memorized is not effective in constructing new knowledge;

children do not use inert information in new situations even though it may relate to them. It is possible to teach children how to use inert knowledge, but "many traditional approaches to instruction do not help students make the transition of 'knowing that' something is true to 'knowing how' to think, learn, and solve problems. In 1929, [Alfred North] Whitehead made the sobering claim that schools are especially good at producing inert knowledge."[37]

One effective way for students to gain expertise by solving problems is through a technique called *coached practice*. When teachers act as coaches, they oversee students' problem solving so that students encounter real problems. Real problems allow students to experience the joys and frustrations of the process, and the teacher's job is to keep problems from being either too difficult or too easy. Difficult problems that are too frustrating can cause students to doubt their ability to solve problems altogether. Those that are too easy can give students an inaccurate sense of what problem-solving strategies are required (if, for example, they use memorized information in order to "solve" the problem instead of using reasoning).

Sequencing

Sequencing is ordering the presentation of content over time. An ideal curriculum would present children with learning opportunities in such a way that their age and prior experiences prepare them to comprehend new concepts and skills. For example, second grade students who understand that they can "see into" a picture even though it is flat could learn that objects close to them appear larger than objects that are farther away. Following that, they are ready to understand the concepts of foreground, middle ground, and background. Ideally any sequence of appropriate learning opportunities should take into account students' maturational levels, their level of prior knowledge, and the complexity of the tasks (see Chapters 4 and 5).

When we think about the kinds of concepts in art, such as pictorial space in the example given, we find no fixed linear sequence as we do in some other elementary subjects. For example, we teach spatial concepts to both second graders and to university graduate students. The differences that we see between the two groups comes primarily from their abilities to apply them. An effective art cur-

riculum revisits the same concepts over and over, each time adding layers of meaning.

Eisner suggests two metaphors for sequentially organized curriculum, a staircase and a spider web.[38] The staircase provides the more structured image, with a student climbing purposefully ever upward toward a higher and more knowledgeable goal. The spider web shows us a student following ideas wherever they might lead, darting back and forth to explore problems encountered by chance as much as by intent. In staircase learning, curriculum designers provide a set of steps that the teachers help their students climb. In the spider web, students initiate learning and teachers challenge them to explore areas in which they show interest.

The writers of the National Standards present us with a metaphor that seems to combine features of both: a spiral staircase. Students who learn a basic vocabulary of texture, for example, can convert textures felt by the hand into those seen by the eye. By doing so, students have opened up new possibilities that challenge them to take further steps up the staircase of competency. "The Standards are meant to reinforce this continual dynamic of climbing and exploring."[39]

A sequenced curriculum is one whose designers envisioned it as a whole, from start to finish. Their vision is a bond that connects all of the curriculum components. It becomes what we call a *coherent* curriculum.[40] A common characteristic of unsequenced elementary art education is what Andrew Ahlgren and Sofia Kesidou call "activity-to-activity incoherence—one activity follows another with no rhyme or reason."[41] When teachers and students can understand the wholeness of a curriculum, it becomes more meaningful to them (as you will see when we discuss conceptual consistency in Chapter 9).

For Ahlgren and Kesidou, sequencing requires two things:

1. gaining a deep understanding yourself of the ideas that you want students to learn, including major connections among them, and
2. imagining the steps of increasing sophistication by which students would come eventually to understand those ideas[42]

In practice, sequencing will require our curriculum committee to review all art concepts to be

learned from kindergarten through eighth grade, including how one builds upon another. Following that review they can choose appropriate learning activities that would best help children to develop in the desired direction.[43] Sequencing is more than accumulating concepts and activities and placing them at appropriate grade levels. It requires a coherent rationale.

Articulation

Who will teach what in the new art program? How will concepts be linked from grade to grade? If classroom teachers and art teachers work together, responsibilities for each will have to be explicitly defined. What about others who contribute to art programs: artists, librarians, museum educators, parents? Our committee will need to consider roles for all of these.

You will recall that Chapter 3 contains a model for collaborative teaching in an elementary art program. Applying it to our scenario here, all of our teachers would share responsibility for teaching art, and each would have a specific function. Amy and Catherine would be responsible for basic day-to-day art instruction. The textbooks they would use would coordinate linkages between grades. The district curriculum guide would reinforce and amplify the textbooks. Nicole would elaborate on the basic program when she visits each classroom.

In addition, volunteers from the community would serve as resource people to enrich the school program. Community volunteers would include artists, museum educators, librarians, state arts council staff, and others. Nicole would also serve as coordinator for their activities (see Chapter 3).

Formatting

Art teachers who set out to write a curriculum need advice from people who have specialized in the study of educational curricula as well as from those who specialize in art. The advice of curriculum experts can be particularly useful when the process is intended to result in a formal, written plan for teaching. Much of the effectiveness of a curriculum is the result of the organization of material to be taught.

Eisner wryly observes that "the process of curriculum development, like the process of doing quantitative empirical educational research, appears much neater and much more predictable in textbook versions of curriculum development and research than it is in practice."[44] While this is undoubtedly the case, there are certain organizational formats that Amy, Catherine, and Nicole might find helpful. Two of these are a *scope and sequence chart* and a *content × behavior grid*.[45]

We have already discussed content and sequence in elementary art. Two other terms associated with curriculum formatting are the following:

> *scope:* inclusion of content and purpose
> *content × behavior grids:* how content and purpose are related.[47]

Scope and Sequence Chart

A scope and sequence chart organizes content and may specify when it should be introduced and even how much time should be spent on each item. Events in the state of Arizona will illustrate the uses of a scope and sequence chart. In the early 1980s classroom teachers became responsible for art just as they were for American history, arithmetic, Arizona history and Constitution, civics (U.S. Constitution), geography, handwriting, health, language, literature, music, reading, science, spelling, and world history.

The Arizona Department of Education asked members of the Arizona Art Education Association—art specialists in elementary and high schools and art educators in universities—to prepare materials that would help classroom teachers get their art programs started. The Association members wrote a series of *scope and sequence charts* for elementary school art.

Table 7–1 shows one of these Arizona scope and sequence charts.[47] It presents a set of color concepts. There are similar charts for other visual elements and principles of design. The color chart groups content objectives under the three components of art learning specified by the state curriculum guide: *productive*, *critical/appreciative*, and *cultural/historical*.

The Arizona scope and sequence charts refer to basic aesthetic concepts. The charts have three broad skill levels: grades 1 and 2, grades 3 and 4,

and grades 5 and 6. They show teachers the grade level at which to introduce, amplify, and reinforce each color concept. Classroom teachers used the scope and sequence charts in lieu of textbooks to plan art programs, but they clearly needed additional materials for this demanding task.

Content × Behavior Grid A content × behavior grid shows how content and behavior are related.[48] Behaviors can signal the acquisition of concepts. Shortly after distributing the scope and sequence charts, the Arizona Department of Education appointed a statewide committee to devise a new, *sequenced* curriculum guide for distribution to all elementary classroom teachers throughout the state.[49]

The Arizona guide consisted of two large content × behavior grids that complemented the

TABLE 7–1 A Scope and Sequence Chart Format for Elementary School Art[a]

COLOR

Definition

Color is our perception of light wavelengths when light is refracted by a prism or reflected from a surface. Color has three dimensions: *hue* (the color name), *value* (lightness or darkness), and *intensity* (saturation or purity).

	Grade/Ability Level		
	1–2	3–4	5–6
Productive			
Use the three primary colors.	•	••	•••
Use the three secondary colors.	•	••	•••
Mix at least six tertiary colors.		•	••
Mix complementaries to obtain neutral colors.		•	••
Mix tints and shades of one color.		•	••
Use warm and cool colors.	•	••	•••
Use analogous colors.		•	••
Use color to create a mood.		•	••
Create color contrasts between objects or shapes.			•
Demonstrate the use and care of color materials and tools.	•	••	•••
Critical/appreciative			
Discuss the primary colors.	•	••	•••
Discuss the secondary colors.	•	••	•••
Discuss the tertiary colors.		•	••
Discuss the complementary colors.		•	••
Discuss shades of primary and secondary colors.		•	••
Discuss warm and cool colors.	•	••	•••
Discuss light and pigment of color theory.			•
Discuss analogous colors.		•	••
Respond to color in built or natural environments.	•	••	•••
Give a personal response to colors used in an art work.	•	••	•••
Cultural/historical			
Identify how artists use the emotional quality of color.	•	••	•••
Identify how color affects built and natural environments (advertising, architecture, clothing, etc.).	•	••	•••
Identify the symbolic use of color in our culture and in others.	•	••	•••
Identify how color is used in careers (television, interior design, movies, clothing design, advertising).			•

• Introduced •• Amplified ••• Reinforced

[a]Rush, Jean C. (ed.). (1982). Art in elementary education: What the law requires. *In: Perspective: The Journal of the Arizona Art Education Association*, 1 (1): 6–11, 24–28. In Walker, Decker, *Fundamentals of Curriculum*.

scope and sequence charts. The charts contained two kinds of content objectives. The first set of objectives (Part I) covered six content categories: art elements and principles, media, techniques, observation, imagination, and perception. The second set of objectives (Part II) treated each of the elements and principles of art (sensory and formal aesthetic properties) separately.

There was a content × behavior grid for each of three skill levels: Grades 1 and 2, grades 3 and 4, and grades 5 and 6. Headings across the top of each grid specify three dimensions of art learning. (The committee intended these three dimensions to refer to all four art disciplines.)

Creative Art Expression refers to art production. *Aesthetic Assessment* may include both aesthetics and art criticism. *Art in Cultural Heritage* may include aesthetics, art criticism, and art history.

Table 7–2 is a content × behavior grid for grades 3 and 4 from Part I of the Arizona sequenced curriculum guide.[50] Notice that headings in the vertical column on the left spell out categories of content objectives and their definitions. The first category addresses art elements and principles; it is later expanded into Part II. Subsequent categories in Part I have to do with *observing*, *imagining*, and *perceiving*—the kinds of thinking activities discussed in Chapter 6.

TABLE 7–2 A Content × Behavior Grid Format for Elementary School Art: General Art Learning Objectives[a]

Visual arts sequenced curriculum guide
Grades 3 and 4

Visual Arts is a specific discipline, a body of knowledge that is a part of basic education. Art education includes instruction in three domains: creative art expression, aesthetic assessment, and art heritage. Visual Arts education is essential to the quality of our nation's culture and is necessary in developing fully literate citizens.

Creative Art Expression	Aesthetic Assessment	Art in Cultural Heritage
Creative Art Expression is hands-on art activity motivated by a lesson that will produce as many visually unique art products as there are children in a classroom.	Aesthetic Assessment is the ability to appreciate, view, consider, and evaluate artworks created by oneself and others, and to communicate one's perception verbally.	Art in Cultural Heritage is the study of art and artists within the context of past and present cultures.

Part I: General art learning objectives

Categories and Definitions	Creative Art Expression	Aesthetic Assessment	Art in Cultural Heritage
Art Elements and Principles			
Components of art such as line, shape, value, color, texture, mass, and space, that are combined to produce compositional unity through rhythm, balance, contrast, and dominance.	Use at least seven of the ten basic art elements and principles (listed in Part II) in combinations of two or more to produce compositions.	Recognize, name, and use appropriately at least seven of the ten basic art elements and principles (listed in Part II). Observe them in representational, abstract, and nonobjective student and adult artwork. Analyze completed student work in terms of two or three elements and principles in combination.	Recognize, identify, and indicate the location of at least seven of the ten art elements and principles (listed in Part II) in contemporary and historical works of representational, abstract, and nonobjective art. Examine the function of each element and its contribution to the entire composition. Note how different artists have different styles or ways of using art elements and principles.

[a]Rush, Jean C. (ed.). (1982). Art in elementary education: What the law requires. In: *Perspective: The Journal of the Arizona Art Education Association*, 1 (1): 6–11, 24–28.

TABLE 7–2 A Content × Behavior Grid Format for Elementary School Art: General Art Learning Objectives[a] (continued)

Media (singular, Medium)

Materials and tools used by artists to create the visual elements in a work of art.	Expand the kinds of two- and three-dimensional art media and tools used in the classroom (for example, colored chalk, watercolor paint, clay, wood, fabric or fiber, linoleum, papier mache, printing and other inks, large white and colored paper, and small brushes).	Name each medium used in class and describe its specific performance traits (transparency, fluidity, plasticity, matte finish). Recognize skillful use of these media in representational, abstract, and nonobjective student and adult artwork.	Identify a range of art media in a variety of art. Note how different artists use media differently. Examine the contribution of each medium to the form of an artwork.

Techniques

Skillful and appropriate ways of using art media.	Demonstrate improved skills in handling familiar art media, and ability to use and understand related but unfamiliar media. Learn techniques of contour drawing, watercolor painting, printmaking, weaving, and ceramics.	Name each technique used in class and recognize it in representational, abstract, and nonobjective student and adult artwork. Analyze techniques according to their individual sensory properties.	Recognize sensory characteristics of contour drawing, watercolor painting, printmaking, weaving, and ceramics. Identify different techniques used with the same media by different adult artists.

Observation: Natural Environment

Look at natural objects and events, including animals.	Look at and draw magnified insects, seashells, or flowers. Paint a still life. Construct a found-object sculpture from natural objects.	Observe, compare, and contrast shapes, colors, and masses that occur in nature and those that occur in art. Find different sizes of the same shape in images. Become familiar with structures of desert plants, animals, birds, and rocks.	Identify biomorphic shapes and observe their variety. Note symmetries in shapes; discuss shading to produce an illusion of three dimensions. Recognize the aesthetic influence that the natural world has upon our life, art, and environment.

Observation: Oneself and Others

Look at human beings.	Look at a person and draw the entire figure. Draw a person who is happy, angry, or sad. Look at and draw a portrait of a friend. Look at yourself in a mirror and draw what you see.	Become familiar with the structure and color of human beings. Discuss different sizes and proportions of body parts. Recognize how posture and face convey mood.	Identify different kinds of people whom artists have portrayed. Discuss stylization of the figure in Egyptian sculpture and New Guinea masks.

TABLE 7–2 A Content × Behavior Grid Format for Elementary School Art: General Art Learning Objectives[a] (continued)

Observation: Constructed Environment

Look at objects and events created by people.	Make something useful, like a clay container, a woven belt, or a poster. Abstract geometric or mechanical shapes from familiar products. Make a collage from magazine photographs using geometric or mechanical shapes.	Observe how a collection of manufactured objects becomes a constructed environment. Relate the organization of buildings and cities or the design of objects to the quality of their inhabitants' or users' lives.	Define applied art, identify such art objects, and describe their utilitarian function. Recognize geometric abstraction in the style of painting called Cubism. Understand the purpose and scale of large public or architectural murals. Become familiar with designs of fabrics, tools, and stationery.

Imagination: Memory and Fantasy

Form mental images of real or incongruous objects and events.	Make a costume for a world on another planet. Make a monoprint of a dream. Draw a wished-for object or event.	Discuss current fantastic or surreal art used in films and books. Identify kinds of art elements used to make fantasy-inspired artworks. Talk about dreams and wishes, the possible and the impossible.	Recognize the style called Surrealism. Discuss motives for making a work of art. Discuss mood in a work of art.

Imagination: Anticipation

Form mental images of future objects and events.	Imagine the future: What will technology do to life in the next century? How will cities look? What kind of vehicles will there be for transportation? Will we travel to other planets, and how? How will we dress? What will we eat? What will we do for fun?	Discuss changes occurring now as a result of high technology. Explore how changes happening today will affect the lives of people living in the future. Consider possible ways to express these changes visually.	Recognize how modern items (light bulb, telephone) were designed and produced and suggest changes to adapt them for the future.

Perception: Personal

Experience objects and events directly (the way to view all works of art).	Respond through art media to personal visual and tactile encounters with materials, objects, and events in the everyday world. Describe personal feelings about direct experiences from the near past.	Discuss how personal responses (and the differences these imply) to environment or personal perceptions form the basis for, or the content of, visual art. Look at paintings of the same subject by different artists.	Respond to ways sensory properties are organized within an art object by identifying the character of its formal (form-related) properties. Discuss the extent to which each art element is necessary, how elements vary, and how a sense of unity is maintained. Note how different artists express the same thing.

TABLE 7–2 **A Content × Behavior Grid Format for Elementary School Art: General Art Learning Objectives[a] (continued)**

Perception: Historical

Experience objects and events of the past.	Make art objects whose design is based on traditional American craft styles (hex designs, weaving, table utensils).	View historical craft objects and analyze their art elements, media, and techniques. Discuss their usefulness at the time they were made.	Recognize hex designs, early American weaving, and the work of Paul Revere. Identify materials from which different craft items are made. Discuss the use of symmetry.

Perception: Ethnic or Cultural

Experience objects and events of another race or culture.	Make art objects that explore ethnic or cultural themes particularly meaningful in the immediate environment (Black, Chicano, Eskimo, Native American Indian, Vietnamese, and so on).	Identify and name special technical and aesthetic qualities used in ethnic and cultural arts selected for study. Compare and contrast the artistic approach of different races and cultures.	Look at specific art objects from the ethnic group or culture selected for study. In the case of Navajo weavings, for example, discuss aspects of pattern: distinguish between straight and wavy lines, symmetrical and asymmetrical balance, geometric and biomorphic shapes, large and small scale, depth and flat pattern. Recognize examples of Navajo weaving and the materials from which they are made.

Perception: Contemporary Art and Artists

Experience artwork, the artistic process, and the people who create art.	Create visual or verbal statements as a result of seeing a working artist or an original work of art either in the school or on a field trip to an artist's studio, an art museum, or an art gallery.	Listen to an artist explain to students the responsibilities and demands of his or her job. Have a museum person explain how artwork is selected for the collection and how exhibitions are assembled and hung.	Recognize the work of at least four living artists, two of whom live and work in Arizona (preferably in the students' community). Know what kind of education and discipline is required to become an artist, and what an artist's workday is like. Understand how an artist prepares his or her work for exhibition before the public. Name and know the location of at least four art museums, two of which are in Arizona.

Table 7–3 is a content × behavior grid from Part II of the Arizona guide.[51] Part II is an amplification of the first category of Part I. It refers entirely to making art. The art specialists who wrote it intended to help any classroom teachers without an art background understand the conceptual content necessary to encourage students to think without words.

TABLE 7–3 A Content × Behavior Grid Format for Elementary School Art: Learning Objectives from Art Elements and Principles[a]

<div align="center">

Visual arts sequenced curriculum guide
Grades 3 and 4

</div>

Creative Art Expression	Aesthetic Assessment	Art in Cultural Heritage
Creative Art Expression is hands-on art activity motivated by a lesson that will produce as many visually unique art products as there are chidren in a classroom.	Aesthetic Assessment is the ability to appreciate, view, consider, and evaluate artworks created by oneself and others, and to communicate one's perception verbally.	Art in Cultural Heritage is the study of art and artists within the context of past and present cultures.

<div align="center">

Part II: Learning objectives derived from art elements and principles

</div>

Categories and Definitions	Creative Art Expression	Aesthetic Assessment	Art in Cultural Heritage
Line			
The continuous mark made by a pencil, brush, or other tool.	Use different kinds and qualities of lines in a variety of media (pencil, pen and ink, brush and ink, chalk, watercolor) to suggest movement (diagonals, corkscrews), suggest mood (calm, excitement), and define shapes (draw an object). Make nonobjective compositions.	Name and identify different properties of line (movement and mood) and associate them with different line qualities (thick, thin, straight, curved, wavy, jagged, broken). Analyze how line quality may differ according to the parts of a shape and the kinds of shapes it describes. Look at representational, abstract, and nonobjective student and adult artwork.	Recognize, identify, and indicate the location of different properties of line (movement and mood) and associate them with different line qualities (thick, thin, straight, curved, wavy, jagged, broken) in works of art. Analyze how line is used in the entire composition. Look at the different ways three artists or cultures use line by looking at three works each by a different culture (see Perception: Personal, Part I).
Shape			
An area distinguishable from the space around it because of a definite boundary	Look for different kinds and complexity of shapes in the natural and constructed environments. Make images of objects in a variety of media (pencil, pen and ink, brush and ink, chalk) while looking at real objects. Abstract shapes from objects and use them in abstract or nonobjective compositions (tempera paint, watercolor, cut or torn paper).	Analyze biomorphic and geometric shapes in terms of detail distinguishing between simple and complex shapes. Look at shapes in representational, abstract, and nonobjective images made by students and adults.	Recognize, identify, and indicate the location of simple and complex, open and solid, biomorphic and geometric shapes of various sizes in works of art. Analyze how shape is used in the entire composition. Look at the different ways three artists or cultures use shape by looking at three works, each by a different artist or from a different culture (see Perception: Personal, Part I.)

[a]Rush, J. C. (ed.). (1982). Art in elementary education: What the law requires. In: *Perspective: The Journal of the Arizona Art Education Association,* 1 (1): 6–11, 24–28.

TABLE 7–3 A Content × Behavior Grid Format for Elementary School Art: Learning Objectives from Art Elements and Principles[a] (continued)

Value

The degree of lightness or darkness (whiteness or blackness) of a surface.	Make monochromatic value scales in a variety of media (tempera paint, watercolor, ink, colored paper) with seven clearly contrasting values of one color other than black or white. Define the edges of shapes in nonobjective compositions by contrasting values rather than by using line.	Understand how real objects in the natural and constructed environments are distinguished from one another on the basis of changes in value. Find examples where contrast is great, and examples where it is scarcely noticeable. Look for subtle value changes in representational, abstract, and nonobjective student and adult artwork.	Recognize, identify, and indicate the location of light, dark, and five middle values in a work of art. Analyze how value is used in the entire composition. Look at the different ways three artists or cultures use value by looking at three works, each by a different artist or from a different culture (see Perception: Personal, Part I).

Color

A perceived property of a viewed surface that varies according to the wavelength of light reflected from it.	Mix and use primary and secondary hues in a variety of media (felt pen, watercolor, colored chalk, fiber, colored paper) to create tertiary hues (red-orange, yellow-orange, blue-green, yellow-green, and so forth). Mix a hue with black and white to make a composition with a range of monochromatic values. Make one composition with a complementary color scheme and one with an analogous color scheme. Introduce the concept of color intensity.	Find and name tertiary hues in the natural and constructed environments. Find and name them in representational, abstract, and nonobjective student and adult artwork. Follow similar procedures for monochromatic, complementary, and analogous color schemes, and for intense and dull colors.	Recognize, identify, and indicate the location of primary, secondary, tertiary, complementary, analogous, monochromatic, warm, cool, intense, and dull hues in a work of art. Analyze how color is used in the entire composition. Look at the different ways three artists or cultures use color by looking at three works, each by a different artist or from a different culture (see Perception: Personal, Part I).

Texture

The surface character of material as perceived by the sense of touch, or a visual imitation of it.	Make a found-object relief sculpture with a variety of artificial, natural, invented, and simulated surface textures. Create artificial surface textures in a variety of three-dimensional media (clay, wood, fiber). Simulate actual texture on a two-dimensional surface in a variety of media (pencil, chalk, watercolor). Produce two-dimensional invented texture from repeated pattern.	Distinguish among artificial, natural, simulated, and invented textures, and between actual and simulated textures in representational, abstract, and non-objective artwork by students and adults. Describe sensory properties of each kind of texture.	Recognize, identify, and indicate the location of natural and artificial actual textures, simulated texture, and invented texture in a work of art. Analyze how texture is used in the entire composition. Look at the different ways three artists or cultures use texture by looking at three works, each by a different artist or from a different culture (see Perception: Personal, Part I).

TABLE 7–3 A Content × Behavior Grid Format for Elementary School Art: Learning Objectives from Art Elements and Principles[a] (continued)

Mass

The physical bulk of a solid body of material.	Use additive (building) and subtractive (carving) sculpture and printmaking techniques with a variety of materials (clay, wood, linoleum, cardboard, papier mache, fiber) to create different kinds of three-dimensional compositions.	Distinguish between additive and subtractive sculpture and printmaking techniques in representational, abstract, and nonobjective artwork by students and adults.	Recognize, identify, and indicate the location of natural and built masses and additive and subtractive techniques in a work of art. Analyze how mass is used in the entire composition. Look at the different ways three artists or cultures use mass by looking at three works, each by a different artists or from a different culture (see Perception: Personal, Part I).

Space

The interval or measurable distance between two points or shapes.	Understand the concept of two- and three-dimensional negative space; that is, shapes visible in the spaces between shapes created in compositions (cut paper and clay). Introduce the concept of the illusion of depth on a two-dimensional surface. Learn and apply principles of aerial perspective (color intensity and value changes, size changes, placement, overlapping) in a variety of media (tempera paint, watercolor, chalk, cut paper).	Distinguish between positive and negative two- and three-dimensional shapes in the natural and constructed environments, in architecture, and in two- and three-dimensional artwork by students and adults. Identify and describe elements that embody principles of aerial perspective in two-dimensional representational student and adult artwork.	Recognize, identify, and indicate the location of a variety of two- and three-dimensional positive and negative spaces, as well as elements that embody the principles of aerial perspective in a work of art. Analyze how space and depth are used in the entire composition. Look at the different ways three artists or cultures use space by looking at three works, each by a different artists or from a different culture (see Perception: Personal, Part I).

Rhythm

A feeling of flowing or recurring movement achieved by repeating visual elements at regular or irregular intervals.	Make rhythmic compositions that display mood (joy, boredom, excitement) by using seven or more repeated, similar or related, and deliberately varied shapes that flow across a page (cut paper or fabric; pencil; tempera paint). Create rhythm with changes in line quality (pencil or ink).	Discuss differences between simple and complex rhythms, and among rhythms with repeated, similar, and different elements. Find examples of these kinds of rhythms in representational, abstract, and nonobjective art by students and adults.	Recognize, identify, and indicate the location of elements that embody the principle of fast, slow, simple, and complex rhythms achieved by using repeated, similar, and different elements. Analyze how rhythm is used in the entire composition. Look at the different ways three artists or cultures use rhythm by looking at three works, each by a different artist or from a different culture (see Perception: Personal, Part I).

TABLE 7–3 A Content × Behavior Grid Format for Elementary School Art: Learning Objectives from Art Elements and Principles[a] (continued)

Balance

A feeling of equality of weight among the visual elements within an artwork, which may be arranged symmetrically or asymmetrically.	Understand the concept of radial balance in nonobjective compositions (pen and ink, cut paper). Use each of the three kinds of balance (radial, symmetry, asymmetry) in separate realistic, abstract, or nonobjective compositions (pencil, chalk, watercolor, clay, fiber).	Find examples of radial balance in the natural and constructed environments. Look for examples of symmetrical, asymmetrical, and radial balance in representational, abstract, and nonobjective student and adult artwork. Describe elements used by artists to achieve each one.	Recognize, identify, and indicate the location of elements that embody the principle of symmetrical, asymmetrical, and radial balance in a work of art. Analyze how balance is used in the entire composition. Look at the different ways three artists or cultures use balance by looking at three works, each by a different artist or from a different culture (see Perception: Personal, Part I).

Contrast-opposition and Dominance-subordination

Visual interest and focus of attention derived from differences in scale or character of art elements, such as between light and dark, thick and thin, or smooth and rough.	Understand the role of the viewer's attention in responding to art and the visual contrasts that attract it. Make compositions using two or three of the other art elements and principles listed on this chart to create a variety of contrasts (large smooth and small rough shapes, dark solid and light open shapes, small bright and large dull shapes, and so forth).	Discuss the importance of the viewer to the work of art in terms of looking at various features of the composition. Understand the concepts of dominance (red attracts more attention than gray) and center of attention. Describe how contrasts create visual interest.	Recognize, identify, and indicate the location of elements that embody the principle of contrast-opposition and dominance-subordination and the concept of center of attention in a work of art. Analyze how contrast-opposition and dominance-subordination are used in the entire composition. Look at the different ways three artists or cultures use contrast-opposition and dominance-subordination by looking at three works, each by a different artist or from a different culture (see Perception: Personal, Part I).

The more organization a curriculum has, the more useful it is. Nevertheless, as Nicole has already observed, the way any curriculum is organized will affect how much freedom teachers have when they use it. The more organization, the less freedom. All curriculum planners make tradeoffs between effectiveness and teachers' desires to plan classroom activities.

Course, Unit, Lesson, and Project Plans Every scope and sequence chart, every content × behavior grid is divided into smaller components. Planners of a coherent curriculum work from the global to the specific. The content and purpose of each smaller part depend on the structure of the whole.

A *syllabus* is a plan for a course. It covers a

9-month school year or a 16-week half year (a semester) or a 9-week quarter year. Elementary teachers write syllabi less than secondary teachers do, but some find it useful. A syllabus is more global than a unit plan.

Every year-long or semester-long or quarter-long course is subdivided into units. A *unit* is a learning situation of shorter duration than a semester or quarter but longer than one class period. Units are subdivided into lesson and projects. A *lesson* generally covers one class period. A *project* is a lesson plan in studio art. Unit, lesson, and project plans all use similar formats.

Units are organized according to general concepts (contour drawing, for example), or themes (the paintings of Van Gogh), or aesthetic principles (the illusion of space by means of linear perspective). A unit is more than a random collection of lessons. Unit plans, like more global plans, generally couch classroom activities in behavioral terms. Buried within these activities is conceptual content.

Although scope and sequence charts and content × behavior grids present essential long-term information, they leave many teachers wondering about what specific activities to use, in what order, in day-to-day classroom interaction. Unit plans provide that information. Table 7–4 is an example of a unit plan for third-grade art (see Fig. 6–8 **color insert** #2).[52] It is similar to what many schools use. The format for an art lesson or

TABLE 7–4 **Planning a Conceptually Focused Studio Art Project**[a]

Topic: Vincent Van Gogh	**Grade:** Grade three

OVERVIEW (TEACHER'S INTENTION):

Students will use acrylic paint to compose a recognizable still life that incorporates compositional and technical characteristics of Vincent Van Gogh's painting style.

CONTENT OBJECTIVES:

Visual Analysis	**Art Production**	**Critical/Historical/ Aesthetic Analysis**
On completing this lesson each student will be able to:		
Identify in a real or painted still life incorporations	Paint a still life incorporating	Identify art concepts in eight paintings by Van Gogh and in three paintings by Monet
Simplified shapes	Simplified shapes	
Center of interest	Center of interest	
Active, expressive brush strokes	Active, expressive brush strokes	
Texture	Texture	
Analogous colors	Analogous colors	
Dominant color	Dominant color	
Tints and shades	Tints and shades	

VISUAL ANALYSIS:

VOCABULARY WORDS: (see Demonstration, below)

Still life	Texture	Impressionism
Simplified shapes	Analogous colors	Claude Monet
Center of interest	Dominant color	Postimpressionism
Active, expressive brush strokes	Tints and shades	Vincent Van Gogh

VOCABULARY IMAGES:

Van Gogh:		**Monet:**
Potato Eaters	Bedroom at Arles	Regatta at Argenteuil
Portrait of Artist	Red Gladioli	Waterlillies
Self-Portrait w/ Bandaged Ear	Sunflowers	**Real objects:**
	Irises	Floral still life

ART PRODUCTION:

MATERIALS:

12″ × 18″ white paper	Acrylic paints, brushes	Paper plates
Pencil, eraser	Water containers	Paper towels

TABLE 7–4 **Planning a Conceptually Focused Studio Art Project**[a] **(continued)**

DEMONSTRATION:

The teacher uses the materials described above to demonstrate ways to produce the following visual concepts:

1. Make a drawing with lines that describe a) simplified shapes of petals, flowers, leaves, stems, vase; b) a center of interest (more detail, larger shape unusual shape), while looking at a real still life of flowers.
2. Prepare a paper plate palette containing three analogous colors of acrylic paints, plus black and white.
3. Make a recognizable painting of the still life containing a) a center of interest; b) texture produced by active, expressive brushstrokes; c) a limited palette (three analogous colors, a dominant color, and tints and shades).

CLASS ACTIVITY:

Children use prescribed art materials (see Materials, above) to make an image that will display the characteristics listed in Evaluation of Artwork (see below).

EVALUATION OF ARTWORK:

Each student makes a painting that contains:

1. A recognizable still life of flowers.
2. Shapes that touch or extend off the paper on at least two sides.
3. A center of interest.
4. Texture produced by active, expressive brush strokes.
5. Three analogous colors.
6. A dominant color.
7. Tints and shades of each color mixed by adding black and white.

CRITICAL/HISTORICAL/AESTHETIC ANALYSIS:[b]

ART IMAGES:

The large color reproductions of paintings by Van Gogh and Monet used as vocabulary images also serve for critical analysis.

aAdapted from Stevie A. Mack and Deborah R. Christine, *CRIZMAC Master Pack* (1985).

bNote: The art history component of this plan has been omitted in order to emphasize teaching of aesthetic concepts. This planning format is adapted from a form used at Western Australian College of Advanced Education, Mount Lawley, W.A., Australia, Australia, 1985.

an art project would be similar. Note that a unit plan does not specify the kinds of instructional strategies or teaching styles. These vary from teacher to teacher.

Curriculum planners sequence units based on level of difficulty (easy to difficult); on knowledge needed to build concepts; on ways to integrate concepts and problems with other disciplines in a coherent curriculum. Planners allow a certain amount of time for each unit; the older the child, the longer the unit. A shorter unit might have one or two objectives, a longer one three or four.

Units come first, lessons afterward. When a unit is well planned, it shapes the lessons within it. Planners couch art concepts in activities for children, but organizing the concepts necessary for inventiveness is their primary concern at the unit level. The right format can be a big help. Chapters 8 and 9 examine unit and lesson plans in greater detail.

The third-grade painting unit described in Table 7–4 is organized according to aesthetic concepts. In this unit, classroom activities follow from the concepts. The concepts allow teachers a good

deal of flexibility in terms of possible alternative activities, if the teacher so desires; activities can always be changed as long as those substituted for them teach the same concepts. Critical and appreciative activities are not planned as completely in this example as the making of art, although they certainly would be in a unit designed to emphasize them.

Chapter 8 will expand on some kinds of classroom activities that fall into the appreciative, critical, and historical realms. Chapter 9 will expand on studio art activities similar to those in Table 7–4 in more detail, explaining how concepts without words can be organized in order to create opportunities for problem solving. It is important to understand the principles involved in planning for concept acquisition, because they set up classroom conditions that encourage artistic thinking.

Evaluation

Our committee members have already made informal judgments about their present art cur-

riculum. Amy and Catherine regard the quality of Nicole's program as high, suffering only from not having enough time with the children. Nicole has purposefully built her program around the state learning outcomes. All three teachers doubt that adopting the national standards could improve the quality of children's art experiences in their district, but it might mean that children would receive art instruction more frequently.

Our teachers know their state department of education is building standardized tests around the state learning outcomes. Adopting national standards has reinforced the state's resolve to assess student performance in art. Our teachers want to have their new art curriculum in place before the state begins testing all public school students within the next few years. The superintendent also wants students' scores in her district to compare well with others in the state. The assessment of student achievement is the topic of Chapter 10, so we will defer our discussion of it until then.

The curriculum committee will need to evaluate its work during pilot testing, in the second year of their project. They will also be evaluating textbooks and other curriculum materials before they recommend them for district use. Textbooks, unit and lesson plans, and other curriculum materials based on teaching concepts in all four art disciplines become conceptually complex. It can be almost as difficult to choose appropriate materials like textbooks as it is to plan how they will be used.

Disciplines × Components Grid A disciplines × components grid format can help to make the evaluation of curriculum materials easier and less time consuming. When completed, the grid provides a way to see the strengths and weaknesses of curriculum materials at a glance. Table 7–5 is an example of a discipline × components grid that describes a lesson selected from a hypothetical art textbook.

Table 7–5 shows curriculum planners at a glance whether each discipline is represented and whether all lesson components have been addressed. It spells out whether all disciplines and unit components convey the same (or similar) concepts; if so, the unit (or lesson or project) has coherence, or what we call in Chapter 9 *conceptual focus*. If not, planners know where to rewrite and teachers know where to supplement the materials when they use them in their classrooms.

The column of headings on the left contains each of the four art disciplines. The row of headings across the top spells out instructional components: goals (general content objectives), concepts to be taught (specific objectives), teacher-directed classroom activities (opportunities for building knowledge), student classroom activities (opportunities for thinking, that is, using knowledge to create meaning), and evaluation criteria (by which to assess student learning). The grid provides a box in which to record the level of occurrence of each instructional component for each discipline.

At the end of the row for each discipline and again at the end of the column for each instructional component is a box entitled Conceptual Focus. In these boxes the evaluator can sum his or her assessment of curricular coherence and assign it a number on the accompanying rating scale. Conceptual focus can be assessed for each discipline, across instructional components, and for each instructional component across disciplines. A global evaluation for the entire set of materials can then be derived, if desired.

Scoring the Grid The rating scale for scoring is as follows:

- **5** **Conceptually consistent** (generally indicates art curriculum materials that are discipline or concept based);
- **4** **Fairly consistent** (often indicates art curriculum materials that are discipline-related or activity based, rather than concept based);
- **3** **Occasionally consistent/occasionally inconsistent** (usually indicates traditional art curriculum materials that are media based);
- **2** **Mostly inconsistent** (indicates art curriculum materials based primarily on creative self-expression or the desires of individual students);
- **1** **Conceptually inconsistent** (art curriculum materials based on trial and error).

SUMMARY

Following Amy, Catherine, and Nicole through curriculum planning gives you a good idea of some of the issues involved in such a long and complex process. If we accept the validity of having national standards in art that all schools nationwide are expected to meet, as all of the

TABLE 7-5

FRAMEWORK FOR EVALUATING CONCEPTUAL FOCUS IN ART CURRICULUM MATERIALS

NAME _____

CURRICULUM/TEXTBOOK/RESOURCE _____ GRADE _____ UNIT/LESSON _____ PAGE _____

INSTRUCTIONAL COMPONENTS

CONCEPTUAL FRAMEWORK	GOALS (General) (Objectives)	CONCEPTS (Specific)	TEACHER DIRECTIVES (Visual Analysis) (Demonstration) (Problem Setting) (Critique)	STUDENT ACTIVITIES (Aesthetic Scanning) (Tutored Images)	EVALUATION CRITERIA (Student Achievement)	CONCEPTUAL FOCUS (Conceptual Consistency)
Aesthetics						
Criticism						
History						
Production						
Conceptual Focus (Conceptual Consistency)						

5-Conceptually Consistent Discipline Based (Concept Based)
4-Fairly Consistent Discipline Centered (Activity Based)
3-Occasionally consistent Traditional (Lowenfeld) (Media Based)
2-Mostly inconsistent Creative Self Expression (Individual Based)
1-Conceptually Inconsistent No Instruction (Trial & Error)

Figure 6-1 Harold Gregor, *Illinois Landscape #125* (1993). Oil on canvas. Richard Gray Gallery, Chicago, IL. (Courtesy of Harold Gregor) (Photograph by Harold Gregor)

Figure 6-2 Titian (Tiziano Vecelli), *Venus of Urbino* (1538). Galleria degli Uffizi. Florence, Italy, (Courtesy of Firenze/Scala/Art Resource, #500005714)

Figure 6-8a Second-grade painting of a vase of flowers. (Courtesy of Deborah Christine)

Figure 6-8b Third-grade painting of a vase of flowers. *(Courtesy of Stevie Mack)*

Van Gogh lesson, *Expressions of a Decade,* CRIZMAC Master Pack, Tucson, AZ: CRIZMAC Art & Cultural Education Materials.

Figure 8-3 Mary Cassatt, *The Boating Party* (1893/94). Oil on canvas, 35 1/2 × 46 1/4" (90.2 × 117.5 cm). National Gallery of Art, Washington, D.C. (Chester Dale Collection #1963.10.91)

Figure 6-5 Anthony van Dyck, *Anne Killigrew, Mrs. Kirk.* The Huntington - San Marino, CA. (Courtesy of Super Stock Inc., #1060/284/N/PG, A)

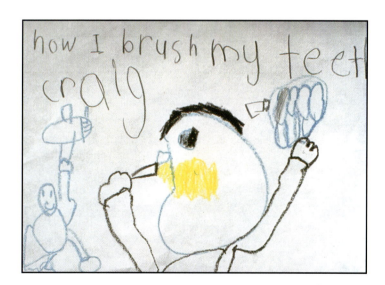

Figure 9-3 First-grade drawing. "How I Brush My Teeth." (Photograph by Jean Rush)

Figure 8-5 Joseph Albers. *Homage to the Square* (1950). Oil on masonite panel, Unframed: 20 5/8 × 20 1/2″ (52.3 χ 52.0 cm). Framed: 28 7/16 × 28 5/16″. Yale University Art Gallery, New Haven, CT. (Gift of Anni Albers and The Josef Albers Foundation, Inc.)

Figure 9-2 Sixth-grade painting, after Kandinsky. Unit on nonobjective art, CRIZMAC Art & Cultural Education Materials, Tucson, AZ. (Courtesy of Stevie Mack)

professional arts organizations have done, we already agree that one-teacher curricula are becoming things of the past. National standards for art education imply a radical departure from the traditional pattern of curricula that are tailored by individual art specialists for specific schools and children.

Art is one of the areas still dominated by individual curricula, but only because art has held a marginal place in elementary education. The *Goals 2000* initiative has changed the playing field for art in elementary education by making art as important as any other subject. In gaining recognition, elementary teachers will now be held as accountable for their students' pro-gress as they are in language arts, or science, or mathematics.

Under these circumstances, a once-a-week, 40-minute lesson from the art specialist will not be enough to ensure high student learning and high performance on standardized tests. More exposure is needed. To provide more art instruction, classroom teachers will need to become part of a team approach, and the team will need a common curriculum.

Amy, Catherine, and Nicole can resolve their dilemma in choosing between structure and flexibility if they recall that all of the materials, including textbooks, refer to artistic concepts. If they see these materials as resources in building a conceptual framework, around which teachers will generate the classroom activities to implement them, then a curriculum becomes a help, not a crutch; a tool, not a restrictive instrument. Teachers can use the curriculum's conceptual structure, but change the ornaments on the conceptual tree to suit their own desires and their children's needs.

Our teachers bring individual perspectives to their planning. Whatever solution they find, it will be a compromise necessitated by planning by committee. Amy, Catherine, and the superintendent will get their textbooks, if the district can afford them, and they will be happy to have this resource. Nicole will find her role enlarged to include more work with classroom teachers. The teachers in our schools will adopt a cooperative teaching model like the one portrayed in Chapter 3, dividing responsibilities for the art program and perhaps sharing them with resource people in their community.

In our scenario, change came about because the nation, the state, the district, and then the teachers came to feel that a more rigorous art curriculum was worth pursuing. Everyone in turn saw the wisdom of this idea, gave it the time and money needed to plan, and in the end accomplished their goals. The real world is seldom so neatly appointed, but the image is valuable nonetheless.

Now put yourself in the place of Amy, or Catherine, or Nicole. Even when you have decided to pursue an art program of higher quality than your present one, you will still have many questions about how to proceed. These are natural and valuable. Change as far-reaching as we have described cannot occur overnight. It requires study, practice, and patience. What specifically will go on in my classroom? What will I do every day? Your questions about specifics need good answers. The following chapters, 8 and 9, address those concerns.

NOTES

1. Consortium of National Arts Education Associations. (1994). *National standards for arts education,* Reston, VA: Music Educators National Conference, pp. 9–10.

2. Glatthorn, Allan A. (1994). *Developing a quality curriculum.* Alexandria, VA: Association for Supervision and Curriculum Development.

3. See Eisner, Elliot W. (1979). *The educational imagination: On the design and evaluation of school programs.* New York: Macmillan.

4. Ibid.

5. Adapted from Glatthorn, op. cit., p. 14.

6. Walker, Decker (1990). *Fundamentals of curriculum.* New York: Harcourt Brace Jovanovich.

7. Eisner, op. cit., pp. 55–69.

8. See Broudy, Harry S. (1976). Three modes of teaching and their evaluation. In: W. J. Gephart (ed.), *Evaluation in teaching,* Bloomington, IN: Phi Delta Kappa, pp. 5–11.

9. Bresler, Liona. (1994). Imitative, complementary and expansive: Three roles of visual arts curricula. *Studies in Art Education,* 35 (2): 90–104.

10. Brooks, J. G., and Brooks, M. G. (1993). *In search of understanding: The case for constructivist classrooms.* Alexandria, VA: Association for Supervision and Curriculum Development.

11. There are four national professional associations in the arts: the American Alliance for Theatre and Education, the Music Educators National conference, the National Art Education Association, and the National Dance Association.

12. The National Committee had thirty-two distinguished members representing all segments of the arts and education, from the American Federation of Teachers to the Spoleto Festival to the United Negro College Fund. Only two were identified as public school teachers, and one more as an elementary principal.

13. The Visual Arts Task Force, assembled by the National Art Education Association, contained two art specialist teachers, two state department of education staff members, two university professors, and the president of the National Art Education Association.

14. Consortium of National Arts Education Associations, op. cit., p. 14.

15. Ibid., pp. 18–19.

16. Apple, Michael W. (1985). Making knowledge legitimate: Power, profit, and the textbook. In: Molnar, Alex (ed.), *Current thought on curriculum* (1985 ASCD Yearbook). Alexandria, VA: Association for Supervision and Curriculum Development.

17. Lampela, L. (1994). A description of art textbooks use in Ohio. *Studies in Art Education, 35* (4): 228–236.

18. Hubbard, Guy. (1987). *Art in action: Levels 1–6.* San Diego, CA: Coronado.

19. Chapman, Laura H. (1985). *Discover art: Levels 1–6.* Worcester, MA: Davis.

20. Ibid.

21. *Art Education and Studies in Art Education.*

22. The CEMREL (Central Midwestern Regional Educational Laboratory) *Aesthetic Education Program;* guidelines for elementary art instruction by television and some TV programs offered through the National Center for School and College Television; Laura H. Chapman's curriculum planning model; Stanford University's *Kettering Project;* the SWRL (Southwest Regional Educational Laboratory) *Elementary Art Program; the Aesthetic Eye Project.* Efland, Arthur. D. (1987). Curriculum antecedents of discipline-based art education. *Journal of Aesthetic Education,* 21 (2): 57–94, later published as Ralph A. Smith (ed.). (1989). *Discipline-based art education: Origins, meaning, and development.* Urbana, IL: University of Illinois Press.

23. Glatthorn, op. cit., p. 27.

24. Ibid., p. 27.

25. Ibid., p. 28.

26. Davis, J., and Gardner, Howard (1993). The arts and early childhood education: A cognitive developmental portrait of the young child as artist. In: B. Spodek (ed.). *Handbook of research in early childhood education,* cited in Bresler, op. cit., p. 99.

27. Dunn, Phillip C. (1995). *Creating curriculum in art,* Reston, VA: National Art Education Association, p. 20.

28. Rush, Jean C. (ed.). (1985). *Visual arts sequenced curriculum guide, grades 1-6;* Part I: General Art Learning Objectives, grades 3 and 4 General Art Learning Objectives, Phoenix, AZ: Arizona Department of Education p. 2.

29. Ibid.

30. See Bloom, Benjamin S. (1954). *Taxonomy of educational objectives. Handbook I: Cognitive domain.* New York: Longmans, Green.

31. Resnick, Lauren B., and Klopfer, Leopold E. (eds.). (1989). *Toward the thinking curriculum: Current cognitive research* (1989 ASCD Yearbook), Alexandria, VA: Association for Supervision and Curriculum Development, pp. 1-2 .

32. Brooks, Jacqueline Grennon, and Brooks, Martin G. (1993). *In search of understanding: The case for constructivist classrooms.* Alexandria, VA: Association for Supervision and Curriculum Development.

33. Glatthorn, op. cit., p. 101.

34. Glatthorn, op. cit., p. 103.

35. Bransford, John D., and Vye, Nancy J. (1989). A perspective on cognitive research and its implications for instruction. In: L. B. Resnick and L. E. Klopfer (eds.), *Toward the thinking curriculum: Current cognitive research,* Alexandria, VA: Association for Supervision and Curriculum Development, p. 177.

36. Bransford and Vye, op. cit., p. 188.

37. Ibid, p. 193.

38. Eisner, op. cit., p. 122.

39. Consortium of National Arts Education Associations, op. cit., p. 12.

40. See the Association for Supervision and Curriculum Development. (1995). *Toward a coherent curriculum.* Alexandria, VA: Author.

41. Ahlgren, Andrew, and Kesidou, Sofia. (1995). Attempting curriculum coherence in Project 2061. In ibid., pp. 45–47.

42. Ibid., p. 45.

43. Ibid., p. 45.

44. Eisner, op. cit., p. 273.

45. Walker, op. cit.

46. Ibid., p. 18.

47. Rush, Jean C. (ed.). (1982). Art in elementary education: What the law requires. *In: Perspective: The Journal of the Arizona Art Education Association,* 1 (1): 6–11, 24–28, cited in Walker, op. cit., p. 19.

48. Walker, op. cit., pp. 18, 21.

49. Rush (1985), op. cit.

50. Ibid., pp. 7–9.

51. Ibid., pp. 10–12.

52. Adapted from Stevie A. Mack and Deborah R. Christine, *CRIZMAC Master Pack* (1985) Tucson, AZ. CRIZMAC Art & Cultural Education Materials.

8

Thinking, Talking, and Writing About Art

This chapter is about talking in the art classroom. By this we do not mean the disordered, random talk that unfortunately encroaches on the art lesson now and then, but thoughtful, reflective talk about the subjects of aesthetics, art criticism, and art history. The adjectives "thoughtful" and "reflective" suggest that this chapter is about thinking. This chapter involves not only thinking about art, but also, one might say, the *art of thinking*.

If this strikes you as something totally different from making art, you have already forgotten the content of Chapter 6, which was all about the thought that goes into the creative process. Thinking while *making* art and thinking *about* art may have different purposes, but to a great extent they share a common vocabulary. It is said that critics, art historians, and even aestheticians who know how to make art can talk about it better. Conversely, artists who know how to think and talk about art can make it better.

Indeed, we recommend the integration of making, thinking, talking, and writing about art, or, in other words, practices associated with studio, aesthetics, art criticism, and art history. As we have stressed earlier, it is not wise to teach any of them in isolation from one another. Still, there are important things to know about each, along with certain strategies to use for teaching each. Thus, the next several pages are about teaching concepts and processes selected from just three art areas—aesthetics, art criticism, and art history.

As we deal with teaching each of these three bodies of knowledge, we will depend on insights and principles drawn from philosophy, language arts, history, and, at times, even the sciences, particularly critical thinking. Thinking, talking, and writing about art also touch on three of the seven intelligences theorized by Howard Gardner (reviewed in Chapter 6): *spatial*, the capacity to perceive and deal with the spatial world, relates to art; *linguistic*, the capacity to function with words and language, relates to language arts; and *logical-mathematical*, the ability to handle long chains of reasoning, relates to both philosophy and art criticism.[1]

Some readers (mostly you classroom teachers) may be more comfortable with language activities than with teaching studio projects. Others (mostly you art specialists) are very much at home with studio activities but may be unaccustomed to conducting class discussions. All, however, when seeking to stimulate a discussion about art are apt to be met with a roomful of complaints: "Why aren't we doing art?" Art educator Louis Lankford advises starting "art talk" in the earliest grades. Meanwhile, you can move older students (those accustomed to studio production) by increments into broader based conceptions of art.[2]

Teaching children to reflect on art is well suited to the elementary level because school subjects at this level are rarely compartmentalized as they usually are from the ninth grade up. Often, an elementary teacher is responsible for all, or nearly all, of the subjects in that particular grade level (in which case education is naturally integrated, or should be anyway, in the thinking and practices of the individual teacher). Even in schools with specialists for certain subjects, such as art, the lines between subjects can easily be crossed if the need arises (an idea pursued in Chapter 11, *Integrating Art with Other Subjects*). In any case, it is highly recommended that the art teacher coordinate with the classroom teacher, the language arts specialist, and so on, and vice versa. Just as in the real world art is not separate from the functions and concerns of society as a whole, in the elementary school art need not be isolated from the other subjects.

If you are a classroom teacher, you will discover that art is better than most subjects for stimulating discussion and fostering critical thinking. One aspect of thinking about art, in which general questions are raised and pondered, is expansive and creative. Other aspects, in which students are called upon to defend their claims, is rigorous and disciplined. Both can be encouraged by discussions about art that relate to aesthetics, art criticism, and art history.

Aesthetics As Philosophical Inquiry

In 1967, a small bronze fifth-century B.C.E. Greek horse in the Metropolitan Museum of Art in New York (Fig. 8–1) was determined to be a modern fake and removed from the Museum. Prior to its removal, the author of a leading art textbook had called the horse "superb" and praised its unknown artist's sensitivity "to bronze as a material and to its use in rendering natural forms controlled by abstract order."[3] If the horse was a work of art while it was in the museum, was it one after it was removed? Was the horse less than superb or the artist less sensitive because it was made in the twentieth century rather than in the fifth century B.C.E.? (The techniques of lost-wax bronze casting remain the same today as they were then.) Some years after the horse was removed from the Metropolitan, three scientists at Washington

Figure 8-1 *Statuette of a Horse*, Greek fifth century B.C.E. or fake. (Line drawing based on a photograph.)

University announced that it was authentic after all![4] Now what do you think about the nature of art?

Aesthetics deals with *ontological* questions such as these (the nature of art, the nature of beauty, basic principles, and so on). To many people, aesthetic inquiry sounds too advanced for youngsters, a subject perhaps to be deferred until students are "mature enough" to handle it. In the new four-sided approach to art, teaching aesthetics is the least tried and, allegedly, the most dreaded. Contrary to this tide of opinion about aesthetics, we feel that (1) aesthetic inquiry is accessible to children, even those at young ages, and (2) if anything, aesthetic inquiry should precede rather than wait on instruction in art history or criticism.

According to philosopher and educator Matthew Lipman, children are natural philosophers because of their sense of wonder, curiosity, and constant inquiry about things adults take for granted. To capitalize on these tendencies Lipman has developed classroom materials in the form of vivid novels in which philosophical issues are embedded in the context of everyday situations.[5] Each novel is accompanied by a teacher's manual filled with discussion ideas and exercises. The purpose is to promote critical thinking through a

community of inquiry. "Philosophy, according to Lipman, "is attracted by the problematic and the controversial, by the conceptual difficulties that lurk in the cracks and interstices of our conceptual schemes."[6] He could very well be describing the art world (Chapter 5).

Art educator Sally Hagaman apparently concurs. Using Lipman's program as a model, Hagaman has developed and field-tested stories for elementary-age children that prompt thinking in the aesthetic domain.[7] Hagaman asks children to read aloud, round-robin, a story in which a paradoxical scenario or two is embedded. The teacher fields questions from the class about the story and writes these on the board. Discussion continues on one or more of the questions raised.

In a similar vein, Margaret Battin and others have compiled an "aesthetic casebook" full of art-world scenarios covering a whole range of aesthetic issues. Some have actually occurred, some are hypothetical; for example, "The Louvre is on fire. You can save either the *Mona Lisa* or the injured guard who had been standing next to it—but not both. What should you do?"[8]

Art educator Marilyn Stewart advocates the use of a "Big Question Chart" for display of ontological questions such as the following: "What is art? What does it mean to say something is beautiful? Can something be both beautiful and ugly? How is the (good) experience we have when we view a painting like the (good) experience we have when we read a book? Is the meaning of a work of art what the artist intends it to be?"[9]

Roger Messersmith, who has put into practice many of Stewart's ideas, has his fourth-grade students record on cards any art-related questions they derive during the course of a class discussion or studio project. These are pinned to a board, categorized, compared, and used for discussions. Messersmith says there are no bad questions; it is just that some are "bigger" than others.

Also, there are no "right" responses in aesthetic discussions; but some responses are better than others. Lipman's, Hagaman's, Battin's, and Stewart's real and hypothetical scenarios are quite plausible. A child, in responding to these aesthetic problems, "is to give a reasoned argument for the course of action he or she thinks appropriate."[10] And we should add, the quality or "rightness" of a response depends on how well the student uses logical arguments to support his or her answer.

Aestheticians use both inductive and deductive reasoning (described in Chapter 6). Let us suppose that children look at a display of objects (or photographic reproductions), some of which are art and some are not, without knowing which are which. The display includes unconventional examples of art such as Warhol's *Brillo Boxes* (See Chapter 5, Figure 5–3) and Christo and Jeanne-Claude's Environmental temporal work "Wrapped Coast" (Fig. 8–2). In order to decide which examples are art and which are not, they would use inductive reasoning.

Using the inductive method, the students would search for shared features, if any, among the various objects. Would the presence of a certain set of features, by itself, be sufficient evidence on which to declare some objects art, and some not? Eventually the class may arrive at a definition of art that all will accept—or they may not. They may even conclude that in today's world one cannot always identify an artwork based on *visible* features. If so, they would have independently arrived at the same insight as Arthur Danto! (See Danto in Chapter 5.) If so, you should give each one an 'A.' Be prepared to welcome *any* outcome in inductive reasoning—so long as it was arrived at in good faith, and based on available evidence.

On the other hand, suppose a child brings a bicycle to class, wrapped in a bedsheet tied with a length of clothesline. If students attempt to decide whether or not the wrapped bicycle fits any particular definition of art (see, again, Fig. 8–2)—either one developed in class or one by an aesthetician like Danto or George Dickie (see Chapter 5)—they are using deductive reasoning. Children's arguments must progress logically from the conditions established in the definition of art to the features of their particular wrapped bicycle. Under some definitions the bicycle will be art, but under others it will not.

STRATEGIES FOR THE CLASSROOM

Lankford suggests nine strategies for fostering a community of inquiry: form small groups, make sure students are prepared, encourage creativity, keep them on task, use students' ideas, encourage ownership of ideas, help bring discussions to closure, maintain order, and, if at first you don't

Figure 8-2 Cristo *Wrapped Coast*, Little Bay, Sydney, Australia, 1969. Cloth and rope, 1,000,000 square feet. Copyright: Cristo 1969.

(Photograph by Harry Shunk)(Courtesy of Christo and Jeanne-Claude)

succeed, try again.[11] Since there is no "right" answer in an aesthetic inquiry, as stated earlier, each child's response deserves serious consideration as long as (1) it is offered in good faith (smart-aleck or attention-getting responses are always inappropriate), and (2) the student reasons logically from observable evidence or an art theory.

There are many ways to get your students involved in aesthetic inquiry. You may allow the class to select or vote on a single issue or an agenda of issues. Each student could write a "big question" or an aesthetic issue on a card; you, like a talk-show host, could draw cards to read at random (or a student may act as the talk-show host). A round-robin policy for contributing to discussion rather than volunteering may be a better way to get everyone involved, especially for those who are shy. However, no one should be forced to respond when his or her turn comes up; it is O. K. to "pass." In any case, the teacher should try to provide opportunities for those who are shy or reticent.

You can invent your own case studies or scenarios. You can find scenarios to illustrate big questions in the everyday predicaments reported in newspapers, magazines, and television news.[12] You can either print them for the class to read or narrate them orally. Better yet, you can ask students to invent their own scenarios. Remember, scenarios should be open-ended so children can argue for or against any of the issues they raise. Consider disagreements as a valuable part of the process; remember, no question has a "right" answer.

When interaction is spirited because children are caught up in the excitement of debate, be prepared for disagreement. Encourage children's open-mindedness, curiosity, reasoning skills, and confidence in their own judgment. Neither encourage nor discourage consensus, but do look for an understanding of the philosophical issues involved.

Finally, children below the level of fourth grade—while they are very open-minded and

enthusiastic—may, in your judgment, lack both the verbal skills and the knowledge of art needed to engage in meaningful dialogue. Indeed, Lankford thinks they should first acquire some art vocabulary and concepts.[13] His point not withstanding, we believe that beginning discussion of aesthetic issues with younger children could be feasible and would be educationally valuable—provided, that is, such dialogue is conducted with sensitivity and common sense.

We have developed some aesthetic scenarios for classroom use. Table 8–1 suggests some case studies, role playing, and other activities along with pump-priming questions for stimulating a community of inquiry on aesthetics. The scenarios fall into four groups: *What is art? How do we interpret art? What is aesthetic value? When do art values and other values conflict?* These correspond roughly to the descriptive, interpretive, and evaluative processes set out in Chapter 3.

Art Criticism

Art criticism is one of the best tools currently available for fostering thinking skills. Developmental psychologist David Perkins (Chapter 4) offers several reasons for this; two are worth mentioning here. The first is *sensory anchoring*—the advantage of having something physical to focus on as the class thinks and talks. "This comes naturally with art, which can be present either in the original or in reproduction." The second is *instant access*—the advantage of being able to point to that "muted yellow" in the process of describing a sensory quality, or to the facial expression of someone in the picture in the process of arguing a point about interpretation. "Works of art are made to draw and hold attention," Perkins writes, "This helps to sustain prolonged reflection around them."[14]

TABLE 8–1 Aesthetic Scenarios for the Classroom

Allow children to argue for or against any of the following questions. Get as many children involved as possible. There is no "right" or "wrong" answer for any question. But each child *must* give reasons in defense of his or her position. Reasons should derive logically from the evidence and/or stated criteria.

Children's discussion may stray from the original question, and this is to be expected. However, even though there are no right or wrong answers there are strong or weak arguments. Yes or no responses, and responses given facetiously or without reference to the constraints of the issues at hand, are inappropriate.

Be prepared to accept disagreement. Children will probably not arrive at a consensus by the end of their discussion. But neither do aestheticians. Look for curiosity, open-mindedness, reasoning skills, risk taking, confidence, understanding of philosophical issues, and similar behaviors.

1. What is art?

1. **Question:** *Is this art?*
 Display reproductions of some objects that are artworks and some that are not (these need not be in color; black-and-white photocopies will do), without revealing which ones are considered art. Include a mix of conventional examples (regular paintings and sculptures), unconventional examples such as Warhol's *Brillo Boxes* (see Chapter 5, Fig. 5–5), Christo and Jeanne-Claude's *Wrapped Coast* (see again Fig. 8–2), Marilyn Levine's *H.R.H. Briefcase* (see again Fig. 8–4), and performance pieces (see Chapter 1, Fig. 1–3), and ordinary objects. Some students are bound to misclassify the unconventional examples, and to raise questions about them when they learn that they are considered art.
2. **Question:** *What is art?*
 Have students develop their own definitions of art (including, if possible, some necessary and sufficient conditions for each). These could be collected, displayed, compared, and voted on as a class. (Who knows? Some students may arrive spontaneously at definitions similar to those reviewed in Chapter 5.)
3. **Question:** *Is this art?*
 Have students bring objects (family artworks or ordinary household utensils) from home and make a case for whether or not each object is art, based either on the class definition of art or children's individual definitions.
4. **Question:** *Suppose you wrapped your bike in a bedsheet tied with a length of clothesline and called it "Wrapped Bike." Would anyone take "Wrapped Bike" seriously as a work of art?*
5. **A hypothetical case scenario:** A famous contemporary sculptor submits a piece of driftwood to a gallery and titles it *Driftwood #1*. There, resting on a pedestal, the artist's "found object" is highly admired for its natural beauty.
 Question: *Is this art?*
6. **A hypothetical case scenario:** Suppose you know what beach the artist frequents and you find a very similar piece of driftwood there and place it on your mantel.
 Question: *Is your driftwood art?*

7. **A real case scenario:** A jury chose an abstract watercolor for a show of works by professional artists to be hung in the Manchester Academy of Fine Arts (Manchester, England) unaware that it was painted by a 4-year-old.[a]
 Question: *Are all paintings by children art?*
 Question: *Did the status of the watercolor change from child art to "real" art after it was entered in the show?*
8. **A real case scenario:** A small bronze horse (see Fig. 8–1) in the Metropolitan Museum of Art in New York was determined to be a fake and removed from the museum in 1967.[b]
 Question: *Was the horse a work of art before 1967?*
 Question: *Was it a work of art after 1967?*
9. **Role playing:** Children may be interested in role-playing the part of a gallery director or curator to argue some of these cases.

2. How do we interpret art?

1. **General Question:** *How important is it to know the subject matter of a work of art?*
 Much modern art is difficult to understand by the average person without some indication of the artist's intent or knowledge of the subject.
 Even very realistic traditional art is not readily accessible. Take, for example, *The Maids-in-Waiting* by Diego Velàsquez (see Chapter 2, Fig. 2–6). This is both a portrait of the Spanish royal family and a self-portrait of Velàsquez in the process of doing their portrait (notice the artist and his canvas on the left). The central figure is the little princess being fawned over by her maids. Her "pets"—the dog and dwarfs—are on the right. Behind them are other servants, including the chamberlain in the doorway. But where are the king and queen? Did you notice the mirror on the back wall? There, the king and queen stare at us from their reflections—as if one of them were you, the viewer. Now, you know why Velàsquez is looking at you.
 Question: *Was the title,* The Maids in Waiting, *a sufficient enough clue to help you understand the work? Or did you need to have the subject matter explained?*
2. **A real case scenario:** Often the title of an art work is of little, or no, help. Even many adults who visit museums are not familiar with royal families, or classical mythology, or passages from literature to which titles often refer.
 Question: *Do you think that in order to interpret and appreciate a work you need to know what its subject is?*
 Show children an abstract or a nonobjective work of art. Some viewers of art who have a definition of art called *formalism* (Chapter 5) contend that information such as that provided by the title or the subject matter is unimportant. They believe that a work of art should stand on its aesthetic merits.
 Using art reproductions with their titles covered from view, have students invent titles for them. See how different titles affect meaning. Compare the children's titles with the artist's title. (Refer to the use of titles and other label information in the section on art criticism.)
3. **A real case scenario:** Some of today's art is provided by the discoveries of archaeologists. Unfortunately, for prehistoric art there are no titles, names of artists, or even written records to aid in explaining its content (see prehistoric painting in Chapter 2, Figs. 2–1 and 2–2).
 Question: *Imagine you are an archeologist in the year 2995 and you came across a twentieth-century landfill (such as the one in your hometown); what, if any, objects would you save to put in a museum?*
 Question: *Would you know their names (their "titles")?*
 Question: *Would any of these be considered art?*
 Archaeologists, anthropologists, art historians, and other scholars acting as a team pore over what evidence does exist—for example, carbon dating, indications of technology and diet, analogies with present-day cultures, and so on—in order to speculate about the meaning of a prehistoric object or image.
4. **Role playing:** Have students team together as archaeologists, anthropologists, or art historians to speculate about the meaning of an old photograph or an unknown object found in someone's attic.

3. What is aesthetic value?

1. **A real case scenario:** A jury chose an abstract watercolor by a 4-year-old to be hung with works by professional artists. We have already discussed whether or not this work should be considered art.
 Question: *Did the aesthetic value of the watercolor increase when it was selected for admission to the show by the jury?*
 Question: *Did its monetary value increase?*
2. **A real case scenario:** In 1959 the author of a leading art textbook called the small bronze horse in the Metropolitan Museum of Art "superb" and praised its sensitivity "to bronze as a material and to its use in rendering natural forms controlled by abstract order" (see Fig. 8–1).[c] The sculpture was subsequently determined to be a fake.
 Question: *Although the bronze horse did not physically change in 1967 when it was determined to be a fake, did it nevertheless become less "superb"?*
3. **Same real case scenario:** Some years later three scientists at Washington University announced that the bronze horse was authentic after all![d]
 Question: *Did the horse return to being "superb"?*
 Question: *Do you think this would affect its monetary value?*
4. **Real case scenario:** For years a neglected statue of Cupid stood atop a fountain in a New York embassy. In 1995 an art historian determined that the statue was a Michelangelo that had been missing since 1902.

Question: *Now, even though nothing has changed about the statue except for its being attributed to Michelangelo, is it a better sculpture than it was in 1994? Did its monetary value change? Did its aesthetic value change?*

5. **Hypothetical case scenario:** Minnie Molart, geometric abstractionist, is very interested in color interaction. She has decided to continue the *Homage to the Square* series started by Josef Albers (Fig. 8–5) (see **color insert #2**), but without duplicating the color combinations of any work within that series. When her paintings are compared with Albers's, experts—not knowing which are which—cannot tell them apart, and—after learning which are which—agree that Molart's are at least as subtle and original with regard to new color combinations as his. Yet her work is not accorded special recognition nor is it found in any of the major museums. Art critics and museum directors say that while Molart's colors may be as good as, if not better than, Albers's, her work is still derivative of his and therefore not as deserving of attention. Albers, after all, started doing this kind of thing back in 1947.

Question: *Do you agree with the critics, or do you think that Molart, because of the quality of her color harmonies, deserves as much recognition as Albers?*

6. **Hypothetical case scenario:** Harold Edge, like Molart, is a skilled geometric abstractionist interested in color. However, knowing that any painting in the Albers *Homage* series would command very high prices in the art market, Edge decides to produce some fake *Homages*. Through a complex web of deceit, he manages to convince art dealers that he "discovered" some heretofore unknown *Homages*. Art critics rejoice in the new paintings saying that the color combinations in these are even better than those in earlier members of the series, and Edge becomes a millionaire.

Question: *In your opinion, are the fake "Homages" equal to the genuine "Homages"?*

7. **Role playing:** To facilitate an argumentative atmosphere, have students role-play the parts of gallery directors, art critics, and art historians—people who might be involved in adjudicating situations like the ones described under the headings "What is art" and "What is aesthetic value."

4. When do art values and other values conflict?

1. **Hypothetical case scenario:** In the town of Normington is a city park dating to the Civil War. The park and the houses surrounding it, all built in the nineteenth century, have been designated by the state historical society as historical landmarks. In the interest of preserving the original appearance of the block, the state has offered grants for redecorating the exterior of each home with the stipulation that the style conform to nineteenth-century standards and tastes. One homeowner refuses the grant and to comply with the stipulation, insisting that it is his house not the state's.

Question: *Which should take precedence—the rights of a property owner or the aesthetic integrity of a historical landmark?*

2. **Real case scenario:** In 1933 Leni Riefenstahl was commissioned by Adolph Hitler to make documentary films of Nazi party rallies. Although not a Nazi herself and disinterested in German politics, Riefenstahl accepted the commission as an aesthetic challenge. One of her films, *Triumph of the Will*, won a number of awards and is recognized to this day as an outstanding, innovative example of the documentary category.[e] It also glorifies the rise of Hitler and the Nazi Party—the forces that eventually led to the disasters of World War II and were responsible for the Holocaust.

Question: *Should a film that is antidemocratic and racist be considered a great work on the basis of its artistic merits only?*

Question: *Are the aesthetic values and ethical values of a work of art related, or can they be considered separately?*

Question: *If a work of art conveys hate of democracy or individuals, is it all right to censor the work (prevent people from seeing it)?*

3. **Role playing:** Again, students may role-play, this time, perhaps, as a censor and/or a member of the American Civil-Liberties Union.

[a]Bloomington IL, *Pantagraph* (2/10/93)
[b]Bloomington Pantagraph (date unkown)
[c]Crosby, Sumner M. (1959). *Helen Gardner's art through the ages.* New York: Harcourt Brace and World, p. 121.
[d]Bloomington IL, *Pantagraph*, ibid. (date unkown)

Compared to aesthetic inquiry, which is open-ended and unpredictable, art criticism, at least in its early stages, deals with facts. Aesthetics encourages *divergent* thinking; art criticism is somewhat more academic and *convergent*. Art criticism depends on aesthetic perception, introduced in Chapter 6, and aesthetic perception is fundamental to the other three disciplines as well. Now is a good time to get acquainted with some effective ways of teaching this useful skill to children.

There are two popular procedures for teaching perceptual and interpretive skills that work well. One, developed by Harry S. Broudy,[15] is called *aesthetic scanning*. The other, often called simply the *Feldman method*, is part of an approach to art criticism developed by art educator Edmund Burke Feldman (not to be confused with the David Feldman mentioned in earlier chapters). Scanning is a three-step process and the Feldman method contains four, but Feldman's

first two steps also embody a scanning procedure in combination with a description of subject matter. Broudy does not address subject matter at all.

It should be understood that Feldman's system does not necessarily replicate *professional* criticism, the kind published in newspapers, news magazines, and the art press; nor does Broudy's replicate the approach of the artist. In principle, both incorporate processes used by art professionals. But in practice, professional critics and artists do not always progress through each of the four stages in any particular order, let alone give them equal emphasis—nor will you, when you become more familiar with them. Both of these approaches are systematic methods of examining and talking about works of art that are useful in teaching.

Aesthetic Scanning

Scanning is a classroom application of the perceptual activity that artists use when making art, and that connoisseurs use when contemplating it. "What kinds of shapes can you see in this painting, Jerry? Round ones? Yes! Can you show us where they are? Point to them—that's good! Do you know what this shape is called? *Amorphous.*—that's a new word for us. Kristin, where else can you see an amorphous shape? Good for you! Where else? Can anyone else see one? Anita? O.K.! I think we have found them all." First graders have just begun to look closely at a work and describe what they see in it.

Teaching children to make informed aesthetic responses by means of aesthetic scanning has all the excitement of a treasure hunt. The hunters are the children and their teacher. Their tools are a pair of sharp eyes. The treasures they seek to discover are the sensory, formal, expressive, and technical properties of works of art.[16] Aesthetic scanning should occur at three times during the course of a comprehensive art lesson or unit: when children are viewing objects or images in preparation for art production, when they are examining their completed artworks, and when they are analyzing exemplary works of adult art (acting as art critics).

When scanning, children are called upon to see and identify the following in a given artwork: *sensory properties*—kinds of visual elements such as line, shape, color, and texture (short, long, curved, and diagonal lines, for example), and also

their qualities (fuzzy, hard, soft, or mechanical); *formal properties*—the principles of design, including such things as balance, rhythm, and contrast, and their respective qualities (fast, slow, syncopated, or stately rhythm, for example); *expressive properties*—the way in which the combined qualities of the visual characteristics just described elicit moods, convey dynamic states, or represent ideas (ideals). Broudy's scanning may also include *technical properties*—characteristics of the art medium itself, and their aesthetic contribution to the work.[17]

Sensory properties are separate visual elements (see Chapter 14). Scanners should save any reference to ways that these elements relate to one another for their examination of formal properties. A discussion of color would appropriately fall under an examination of sensory properties; references to rhythm or other compositional devices would not. (Formal properties are often called *principles of design* because they are ways that artists achieve unity and balance; see Chapter 14.)

The aesthetic scanning treasure hunt has only one guiding principle: the aesthetic property must appear in the work of art, where it can be observed by others. You invite students to identify the observed property by describing it, or pointing to it if their art vocabulary is rudimentary. Your role is that of referee rather than scanner. You are the final authority on such things as whether or not a property exists, whether or not the child identifies it correctly, and whether or not the child's interpretation of the work is consistent with its aesthetic properties.

Other than that, you can let children do the talking. To lead the search for aesthetic properties, you should be able to place them into their correct categories, that is, to identify them as sensory, formal, expressive, or technical. Beyond that, a student's resource is the work of art itself, as distinguished from any historical or critical facts about it. This allows you to obtain careful observation from children successfully, even if you are a beginning teacher of art.

You may wonder how to elicit children's responses to art. Aesthetic scanning lends itself well to a question-asking approach. Some questions are more difficult than others, (see Table 8–2). Leading questions are the easiest to answer: "This painting has a lot of red, doesn't it?" Some, slightly more difficult, ask for a choice: "Is the

TABLE 8–2 **Questions to Initiate Aesthetic Scanning**[a]

The following initiating questions are presented in the order of how difficult they are for children to answer. Leading questions would be useful with young children and beginning scanners of all ages. Phrase your questions carefully, using words children understand.

Pause before asking a question, to demonstrate that thought is needed to ask good questions. After asking a question, wait long enough to allow children time to think before responding. Wait at least 3 seconds after a child's response before asking another question; waiting demonstrates the importance of the student's response. Remember, their answers are more valuable to you than your questions!

Encourage total student participation. Ask several children to answer a given question; this demonstrates that there is no "right" answer; many questions have alternative or multiple answers. Involve less verbal children by asking them questions that are narrow in focus or that require shorter answers; then prompt these same children to extend their answers using the questions in Table 8–3.

Kind of question	Aesthetic properties	Sample questions
Leading (Agreement, disagreement)	Sensory	This painting has a lot of red, doesn't it?
	Formal	The balance in this fabric pattern is symmetrical, isn't it?
	Expressive	Don't you agree that the smooth shapes in this sculpture convey a feeling of peace?
	Technical	You can feel how rough the surface texture of this ceramic vase is, can't you?
Selective (Choice)	Sensory	Do you see more red or blue in this painting?
	Formal	Is the balance in this fabric pattern symmetrical or asymmetrical?
	Expressive	Do the shapes in this sculpture convey peacefulness or anxiety?
	Technical	Is the surface texture of this ceramic vase rough or smooth?
Parallel (Additional information)	Sensory	Can you find other colors in this painting besides red?
	Formal	Is there another kind of balance in this fabric pattern besides symmetry?
	Expressive	What else besides peacefulness might these smooth sculptural shapes suggest?
	Technical	Are there other kinds of surface texture on this ceramic vase besides rough ones?
Constructive (Specific new information)	Sensory	What colors can you find in this painting?
	Formal	Can you tell me the kind of balance in this fabric pattern?
	Expressive	How many different shapes can you find in this sculpture, and what mood do they evoke?
	Technical	How has the artist treated the surface of this clay vase?
Productive (General new information)	Sensory	How would you describe any one of this painting's sensory properties?
	Formal	Can you tell me about the formal properties in this fabric pattern?
	Expressive	What kind of message does this sculpture express, and how?
	Technical	What medium and techniques did the artist use in constructing this ceramic vase?

[a]Adapted from Hewett, Gloria J., and Rush, Jean C. (1987). Finding buried treasures: Aesthetic scanning with children. *Art Education*, 40 (1): 41–43.

surface texture of this ceramic vase rough or smooth?" Some, more difficult still, ask for additional information: "Is there another kind of balance in this fabric pattern besides symmetry?"

The level of difficulty depends on how many clues each question holds to the correct answer. Ask the easiest questions first. Starting with the easiest ones builds confidence and vocabulary. As children become used to looking at art and talking about aesthetic properties, they will give longer, more detailed descriptions of them. You can then ask more open-ended, difficult questions. The most difficult questions ask the students to produce all of the vocabulary and concepts about the work themselves.

Even first graders enjoy the give-and-take of group scanning. Once started, it may be hard to keep up with them. It is important to respond in a positive manner; even a "good" or "that's right" gives children encouragement to go on. If one child runs out of ideas, you can ask questions that will widen the circle of respondents: "Would anyone else like to add to that answer?" Perhaps the child is searching for words: "Can you state your

TABLE 8–3 Questions to Continue Aesthetic Scanning[a]

The following continuing questions are presented according to their function, which relates to levels of difficulty presented in Table 8–2. Once children begin to scan, these continuing questions can maintain the momentum of their responses.

Question	Sample questions
Redirect	Good! What else? Right! Would anyone else like to add to that answer? O.K.! Does anyone else have a comment?
Rephrase	You're on to something, but your answer wasn't clear. Can you rephrase it? I don't think you understood my question—I'm asking you to explain the Can you state your answer another way?
Prompt	You're not answering my question—why don't you try again? You're on the right track—can you keep going? Have you left anything out?
Clarify	Can you tell me your answer more clearly? Can you say it more accurately? Can you explain what you mean? Can you help me understand your point better?
Elaborate	What else do you see? Can you tell me more about it? Can you find other examples? What else can you add to that? What else? What else?

[a]Adapted from Hewett, Gloria. J., and Rush, Jean. C. (1987). Finding buried treasures: Aesthetic scanning with children. *Art Education*, 40 (1): 41–43.

answer another way?" You may not understand the child's intent: "Can you explain what you mean?" One of the simplest responses is, "What else do you see? Good! What else?" Refer to Table 8–3 for additional questioning strategies.

In any case, your questions should be phrased well and used with sensitivity. In responding, students report only direct observations of the work. In addition, there *are* right answers in scanning, and they are easily verified by looking. You should insist on them. However, wrong answers should not be a source of embarrassment to those who offer them; they give you, the teacher, the opportunity to elicit clarification, elaboration, or rephrasing. Also, keep in mind that young children tend to approach pictures egocentrically and naively (recall the research on this subject in Chapter 5).

The Feldman Method

As early as 1967 art educator Feldman published a method of art criticism based on four stages—*description, formal analysis, interpretation,* and *judg-*

ment (see Table 3–1).[18] Since then, countless teachers have adopted his method and it has become something of a classic.

Feldman's method, like Broudy's, is *inductive,* proceeding from the particular to the general—from statements of facts to, eventually, inferences about the work's meaning based on those facts. If followed thoughtfully, this kind of examination prevents a student from coming to premature conclusions before all the evidence is in, and enables him or her to explore the artwork in depth. For purposes of illustration, *The Boating Party* (Fig. 8–3) (see **color insert** #2), painted in France by American artist Mary Cassatt, will be the centerpiece of our trial art criticism.

Description The object of this stage is to identify and record individual facts about the work. Part of these facts will have to do with sensory properties, and this part of Feldman's process could also be called aesthetic scanning. Art critics need other information, however, so subject matter also receives careful scrutiny and is generally given first attention.

The name of the artist (or culture, if the name is not available), title, medium, dimensions, and date can be quickly gleaned from the label information. The descriptions of the subject matter and form are more challenging. *Objectivity* is very important. Interpretative statements such as "the baby is wiggly," "the woman is impatient," or judgmental statements as, "it's a pretty scene" are usually inappropriate at this stage. All statements must stand the test of general agreement among a group of people seeing the same thing.

> *Note*: As a classroom exercise, you may ask the students to take a few minutes to write what they observe on paper. Then, in round-robin fashion, call on them to name two or three items from their list until the description phase is completed.

Because *The Boating Party* contains relatively few items of subject matter to inventory, it may strike older students as an exercise in the obvious. But any fact, no matter how insignificant or obvious, may have a bearing on the eventual interpretation. Such an inventory would take into account the people, including details of costume, and what they are doing. An advanced student might observe that none of the people is showing any particular emotion (such a statement would be considered sufficiently objective if others in the class could agree). A very observant student might add that the face of the infant is partly shadowed by her hat; the face of the mother is entirely shadowed. These data, together with the brightness of the colors, suggest the sun is shining. The water seems calm. Additionally, something should be said about the locations, spatially, of the boat, the people, and other items in the scene.

Description does not end with the subject matter, however. It should take into account the shapes—the large shape of the man, the shape of the woman and child, and the shape of the boat and its sail which are cut off by the edges of the picture. Older students might refer to the character of a given shape—whether it is organic or geometrical, closed or open. The shore in the distance, for example, is a narrow rectangle parallel with the top edge of the picture. In addition, students should be expected to describe individual colors and where they are located, and the textures. Younger children will use more familiar and generic terms for the colors, for example, pink, yellow, blue, and so on. Older children should be able to discriminate the particular kind of yellow in the boat (muted lemon yellow), or the kind of blue in the water (an intense blue green with dashes of dark blue). Older children should also be using sophisticated terminology referring to the different properties of color.

> *Note*: During the description phase, responses should avoid relationships such as comparisons. If any do involve these, you might request that the student look again for single items to describe, and save insights about relationships for the next stage. Also, a round-robin recitation might pass through a whole class before completing the description phase, that is, if each student were to read off only one or two items.

Formal Analysis The object of formal analysis is to identify relationships. Perhaps the first thing one sees in Fig. 8–3 is the way in which the man, an almost solid black silhouette, dominates the right side of the picture. His shape contrasts starkly with the warmer, lighter colors and broken patterns of the boat and the mother and child. His shape, large as it is, is nevertheless balanced by the many items of interest—the mother and child, the oar, the sail, and others—on the left. All three people, together with the boat, overlap a mostly green-blue background consisting of little detail other than the distant shore. Muted yellow is repeated in the boat seats, the oar, the sail, and the woman's hat; light red is repeated in the clothes of the child and woman, and in a few spots in the distance. Because they occupy such a large part of the visual field, together with the low eye level, the people seem very near. Advanced students might observe that the shape of the boat (which is something like a pointed arch) is repeated in the larger triangle formed by the boat, the man, and the woman (with the woman's hat at the apex).

Using the information from the description stage, especially that which pertains to the visual elements, a student would also identify the ways in which shapes, colors, and so forth have been organized and interrelated. These include similarities, contrasts, continuities, and overall qualities. Are colors and shapes repeated? Are some things vividly different in size, shape, color, or light and dark? Are there rhythms or continuities? Is there

anything significant about the spatial relationships—is the space shallow or deep, are nearer shapes more colorful than farther ones, is the eye level high or low?

Interpretation The object of this stage is to arrive at the meaning or content of the work. What feelings, ideas, or emotions does it evoke? This is the most creative part of the critical process. Feldman suggests that the student-critic *hypothesize* a meaning, and then try to support his or her hypothesis by referring to information on both subject matter and aesthetic properties obtained in the previous stages. Similar to aesthetic inquiry, the interpretation stage requires the student to defend his or her answers. But in the case of criticism, the defense is grounded in *evidence*. Most of this evidence is perceptual, *internal* to the work (and brought to the surface in the description and analysis stages). But some evidence is not perceptual and is *external* to the work (see Chapter 5). As with aesthetic inquiry, there are no definitive "right" statements in this stage. Some are better than others, of course, depending again on the quality of the arguments.

Younger children are apt to provide simple, obvious interpretations: "It's a nice day." "The people are happy riding in a boat." Of course they must indicate what the evidence is for these interpretations, for example, the sun is shining, the water is calm, riding in a boat (under these conditions) is pleasant, and so on. Because of their egocentric tendencies (Chapter 5) young children are also apt to submit story-telling answers: "The mommy and daddy wanted to take their little girl for her first ride in a boat." Since these are younger children, the teacher should probably accept the assumption that the two adults are married. However, the assumption that the two "wanted to take their little girl for her *first* ride" should be challenged because this cannot be determined by looking at the painting.

Older children should be expected to plumb deeper. In addition to the obvious nice-day, pleasant-activity interpretations, some students might observe that the three are well-dressed—a fact that might strike American children as odd, especially for people out in a boat. Others might observe that because of the size of the man and the fact that the boat extends beyond the edges of the picture the viewer is close enough to be riding

in the boat. This, together with the woman holding a child, suggests a degree of intimacy. But despite the mood of pleasantness and intimacy, the people do not seem overtly happy, that is, no one is smiling, they seem so "matter-of-fact," almost detached.

At this point, the teacher could introduce a new word, *sentimental*, and discuss the fact that this picture does not seem to be very sentimental. (With regard to art, the term often refers to an obvious or overstated display of tender emotion.) Whether or not any of the students spontaneously use the word sentimental is not as important as the fact that they pick up on this idea in their own words. Another interpretation, based on the dramatic difference in size and color between the man and the other two figures in the boat, might lead to the notion of there being something different or even sinister about the man. But since this notion is contrary to the overall mood, it would have to be defended with more information.

> *Note*: The interpretation stage can end at this point. Whether or not you or your students care to extend this stage by bringing in external evidence is optional. The following is an example of how external evidence can be used.[19]

So far, the process has depended mostly on things visible in the picture, that is, *internal* evidence. Interpretation can be extended or altered at any time by the introduction of valid *external* evidence. For example, when it was observed that the people in the boat were well dressed, the teacher could introduce information about the costumes and lifestyles of the French middle classes in the late nineteenth century. Knowing this would not only explain the costumes but could enlarge on the interpretation. When the term sentimental was introduced, the teacher might point out that Cassatt's work, though unusual for its use of mother-child subjects, is rarely sentimental. This evidence would not only confirm that the work is not sentimental but could lead to further discussion about the role of sentimentality in art.

The man's being sinister would also call for some kind of external evidence. If none were available, however, such an interpretation probably should be rejected. Still, the idea may not be entirely invalid. The term *ambiguity* could apply

here, together with the fact that many works of art, especially serious works, are ambiguous, like life itself. Or, as Lipman explains, ambiguity "readies the child not only for the puns, equivocations, and double entendres of everyday discourse but also for . . . the double binds of human relations."[20] Finally, the fact that Cassatt was a woman working in a male-dominated profession (as it certainly was in the nineteenth century) suggests that her work bears a uniquely "feminine perspective." It might also motivate the girls in the class to research the artist's life and to engage in a discussion about the role of women as artists.

In the interpretation phase, judgments are out of order. Whether or not any of the following are good things—the absence of sentimentality, the presence of ambiguity, or the fact that Cassatt may have brought a female perspective to art—is an assessment that should be reserved for the next stage.

> *Note*: While the above interpretations are valid they are not the only ones. Those generated in a real classroom might be very different, but equally valid. Go with the flow. The unexpected is what makes art criticism so exciting. Remember: Children must defend whatever they say.

Judgment The object of judgment is to determine the quality of a work of art. This is the most "iffy" stage of the Feldman method and may be omitted. Nevertheless, we have provided the following illustration to show you how the judgment phase could be played out.

There are at least three kinds of judgments typically made: the extent to which a work is significant when compared to others of its kind; the extent to which a work has influenced others during the course of history; and the extent to which a work is well organized and conveys its message well. Measuring one work of art against others requires a fairly extensive knowledge of art. Determining a work's influence requires some knowledge of art history. The younger the child, the more restricted such judgmental activities will be—not to mention the limitations you, as the teacher, may feel with regard to this kind of knowledge. That leaves the third kind of judgment, the one about the work's powers of organization and communication.

Initially students may judge a work by their personal preferences. There is no reason to be dishonest or to conceal one's feelings about art. But there is a difference between personal feelings about a work and the public value of that work based on recognized standards. It is certainly possible—and legitimate—to like a bad artwork, or to dislike a good one.

This brings us to the question of criteria. What are the criteria to judge art? (This is perhaps the most difficult question in the world.) Chapter 5 reviewed several theories of art, one of which is formalism. This is a theory of art whose counterpart in education consists of the principles of design, which brings us back to the formal analysis phase. Under that heading statements were made about such things as contrast, balance, color, repetition, and dominance. Without going into detail about all the principles of design, we think you would agree that Cassatt's picture is very well organized and has visual impact. Indeed, because its shapes are so crisp and the design so strong, *The Boating Party* provides an excellent opportunity for students to engage in formal analysis.

This kind of judgment is based entirely on internal evidence. Some art educators, favoring a contextualist position, believe that students should be allowed to use external evidence—even if it is based on limited knowledge. Still other art educators recommend *eliminating the judgment stage altogether*. We consider this a viable option. The Feldman method is still a valuable system even if you choose to use just three stages—description, formal analysis, and interpretation.

ART HISTORY

We have already seen the importance of art history to aesthetics and art criticism. For example, how can one recognize the conundrums of Warhol's *Brillo Boxes* (see Chapter 5, Fig. 5–3) or Marilyn Levine's ceramic *H.R.H. Briefcase* (Fig. 8–4) without knowing something about the history of recent twentieth-century art? How can one adequately analyze Cassatt's *The Boating Party* without some knowledge of French Impressionism? Meanwhile, a person would be even more frustrated trying to analyze a non-Western piece without knowing about the culture and art traditions from which it came.

Figure 8-4 Marilyn Ann Levine (b. 1935), *H.R.H. Briefcase*, 1985. Clay and mixed media, hand built (slab construction), 16" x 17 1/2" x 6 1/4" (14 x 44 x 17 cm).
(Courtesy O.K. Harris Works of Art, New York.)(Photograph by D. James Dee)

But what if your background in art history leaves something to be desired? Some external information is not art historical and can in some instances be provided without the need to consult sources. Appropriate adjectives such as "ambiguous" or "sentimental"—not typically a part of a fifth-grader's lexicon—are familiar to you. Not all relevant historical information requires research. Many teachers, for example, would have no trouble elaborating in a general way on the costumes seen in Cassatt's *The Boating Party*.

Even those of you who majored in art and spent many hours in darkened classrooms looking at slides are not always sure about what you remember. Those who did not major in art must be even less secure. Still, even if your training in art history was wonderful and it turned out to be your favorite subject, you would not necessarily want to teach it by lecture as it was taught to you. And this brings us to another dilemma: Should you go for depth or for coverage? Should you stimulate individual inquiry or be satisfied with group instruction?

At this juncture, we should clarify some things. First, we need always to be sensitive to what students are ready to learn at a particular level and what ways are most effective in prompt-

ing that learning (some of the research and theory reviewed in Chapter 5 is relevant here). Second, there is no reason why you and your students cannot learn together—even if you are already fairly knowledgeable about art. Third, art history does *not* need to *precede* learnings in aesthetics or art criticism—either for the student or you. Indeed, we feel that it is better the other way around. If you know little about art history, you can initially focus on just the internal evidence—what is visible in the work—right along with your students . Then, as questions arise, you and the class together can ferret out some of the facts behind and beyond the picture.

If, for example, you show a group a reproduction of Warhol's *Brillo Boxes*, the students would probably raise questions about Warhol's definition of art or his intentions as an artist. At this point the students could look for the answers themselves. In such a quest they may never replicate Warhol's definition or discover his intentions, but they would nevertheless learn something about Pop Art and how this art movement related to postwar art in general. If students were to analyze *The Boating Party*, they—especially the girls—might want to know something about Mary Cassatt. Along the way, they would also become

acquainted with Impressionism and late nineteenth-century art.

To summarize, we feel that knowing a little art history *well* is preferable to being merely exposed to a lot of it. By actively ferreting out knowledge, as opposed to passively receiving it, students are more likely to come into genuine ownership of it. Indeed, lest you be tempted to lecture, it may be better if you, the teacher, do *not* know much art history. Moreover, perhaps the best approach to art history is by an indirect route—through aesthetic investigation, art criticism, or the study of history.

Note: Except for only the most recent developments in art, knowledge about art and artists is readily available in any standard art text or even an encyclopedia found in the school library. The following approaches to art history can apply whether a teacher provides most of the information, sends students to the library, or a combination thereof.

Approaches Related to Content

Integrated Approach (History and Art History)
According to art educator Mary Erickson, leaders in social studies education and art education now recognize that the two fields are mutually supportive.[21] If you are a classroom teacher, art is a golden opportunity for you to enliven your lessons in history and social studies. Or, if you are an art teacher, you can tap into the regular history curriculum to enrich your lessons in art history. This integration can take many forms depending on the subject. The focus may be on a single culture, such as Indians of the Northwest Coast; or a time period such as the Middle Ages; or a particular overview of American art, say from the Revolution to the twentieth century. All that is required is some coordination between art teacher and classroom teacher. (See Chapter 11, which discusses in more detail methods of interdisciplinary integration.)

Thematic Approach
Select a subject that interests students, perhaps horses, and see how artists of different times and places (Paleolithic, Chinese, Persian, and Renaissance European will get you started) have represented that same subject. Other appropriate subjects are people (portraits and self-portraits), plants, and landscapes—the last two, perhaps, involving the integration of art and science (biology, geography, or earth science). More sophisticated themes that could be explored by older students: images of authority (portraits of rulers from Constantine to Stalin), images of war and political unrest (art history is full of these), or story-telling art (from Egyptian murals to Japanese woodcuts to modern comics). The possibilities of themes and their integration with other subjects are infinite.

Polarized Approach
Art history is full of polarities, many related to style (see following). But some have to do with function, such as the differences between art and craft, between fine art and applied art, or between fine art and popular art. Still other polarities involve content. Older students, for example, could examine the contrast between Asian and European attitudes toward nature by studying these cultures' landscape paintings; or they could get a sense of the polarized political conditions in eighteenth-century France through contrasting the paintings of French rococo artists with those of Jacques Louis David.[22]

Approaches Related to Style

Sorting Approach
According to a study by Hardiman and Zernich, preschool children are able to classify paintings on the basis of style (cited in Chapter 5). A young subject successfully recognized the style of a particular artist after being shown one example.[23] This suggests that young children, given a random collection of works, could sort artworks according to polarities of realistic and abstract, soft-edged and hard-edged, shallow space and deep space, or almost any reasonably distinguishable characteristic. Older children might be able to classify works according to different periods of art—such as baroque, rococo, and neoclassical—or discriminate subtle differences—such as those between analytical (facet) cubism and synthetic cubism—on the basis of style. Such discriminations would provide good practice in aesthetic perception as well as exposing children to a variety of art. The success of this, of course, depends on not only the available resources—color reproductions, filmstrips, slides, CD Rom disks. (You will want to encourage your school to establish a good collection of visual art resources; see Chapter 18.)

Sorting-Thematic Combined Approach
Again, take a single subject or theme and have children sort an array of works depicting that subject or theme by style. You would not necessarily need to tell the students the characteristics they are supposed to see beforehand, or the name of a particular art style. Instead they would discover the distinguishing characteristics on their own, and perhaps even supply their own name for the style. A final benefit of this process could be to see the ways in which style and medium affect students' reaction to content.[24]

The Inquiry Process

Art history inquiry, like aesthetic inquiry, is inductive learning at its best. Art history inquiry calls for the students to do what real art historians do: construct historical narratives by working with the raw materials, including not only artworks but documents of all kinds.[25, 26] One high-school art history project that could be adapted for junior high involved students researching the local arts and crafts of Calgary, Canada. Students interviewed the artists (or people who knew the artists) and collected bills of sale, photographs, newspaper reviews, exhibition catalogs, letters to or from patrons, and other such sources.[27] Students' processing and interpreting of the information was guided by the following kinds of questions: What is it? Who made it? When? Why was it made? Who asked for it? and so forth. Students were encouraged to develop further questions as they moved through the inquiry. The capstone consisted of the students presenting their findings (either in written or verbal form) and reflecting on their research.

While these students may not have learned anything about the great monuments of Western art history,[28] they learned something perhaps more valuable: what it is like to be a historian and what history really is. As Tom Holt explains:

> History, after all, is past human experience recollected. Thus our own everyday experience is the substance of history: our individual life cycles, our family's or community's stories, the succession of generations. To construct coherent stories about this collective experience—something we all do—is to create histories.[29]

While the Calgary project may need to be modified for sixth graders, let alone younger students, this is not to discredit the inquiry process for elementary children. Younger students, including first graders, can ferret out information about the arts and crafts in their own homes (especially those created by friends or relatives). As a class project, older students can research their own school—not only when it was built but its principle of construction and style relative to contemporary architectural styles. Almost every community harbors at least a few homes or public buildings of historical interest. As a resource, the local museum, library, or historical society is a good place to start.

SUMMARY

As proposed in this chapter, aesthetics involves fostering a community of inquiry, an inquiry often stimulated by the paradoxes of the art world itself. Open-ended discussion is encouraged, tempered only by the need to give reasons or criteria. Needless to say, any classroom discussion can be converted to a written assignment, especially for older students.

Art criticism consists of a disciplined method starting with observable facts and ending with either interpretation or judgment. Art history can take many forms: questions raised in the course of studying aesthetics or art criticism, an integrated approach with history or social studies, a means of classifying styles, or actual historical research. Written assignments are appropriate and often used for these activities.

A thread running throughout this chapter was that of integration—integrating aesthetics with philosophy, art criticism with language arts, art history with history and social studies—but also integrating aesthetics, art criticism, and art history with one another. (Chapter 11 discusses in some detail different models of integration.) Further, all of these pursuits drew upon the principles of critical thinking. Elementary education, because of its traditional divisions by grade levels rather than by subject areas, uniquely allows for such kinds of interdisciplinary coordination—whether by the individual classroom teacher or by some form of teamwork.

Notes

1. Armstrong, Thomas. (1994). *Multiple intelligences in the classroom.* Alexandria, VA: The Association for Supervision and Curriculum Development.

2. Lankford, Louis. (1992). *Aesthetics: Issues and inquiry.* Reston VA: The National Art Education Association, p. 61.

3. Crosby, Sumner M. (1959) *Helen Gardner's art through the ages.* New York: Harcourt Brace and World, p. 121.

4. Bloomington, IL, *Pantagraph* (date and page unknown).

5. Lipman, Matthew. (1974). *Harry Stottlemeier's discovery.* Montclair NJ: Institute for the Advancement of Philosophy of Children.

6. Lipman, Matthew. (1988). *Philosophy goes to school.* Philadelphia: Temple University Press, p. 33.

7. Hagaman, Sally. (1990). Philosophical aesthetics in art education: A further look toward implementation. *Art Education,* 43 (4): 33.

8. Battin, Margaret, Fisher, John, Moore, Ronald M., and Silvers, Anita (1989). *Puzzles about art: An aesthetic casebook.* New York: St. Martin's Press, p. 149.

9. Stewart, Marilyn (1989, Summer). Presentation at the Improving Instruction in Visual Arts Education (IVAE) Conference, Pasadena, CA.

10. Battin et al., op cit, p. vii.

11. Lankford, op. cit., pp. 52–61.

12. For example, the recent discovery that a three-foot statue of Cupid which had stood atop a fountain in the French embassy's cultural center in New York city could be by Michelangelo (see *Newsweek,* February 5, 1996, p. 62).

13. Lankford, op. cit., p. 41.

14. Perkins, David N. (1994). The intelligent eye: Learning to think by looking at art. Santa Monica, CA: The Getty Center for Education in the Arts, pp. 5 and 83–84.

15. Broudy, Harry S. (1983). *The uses of schooling.* New York: Routledge.

16. Adapted from Hewett, Gloria J., & Rush, Jean C. (1987). Finding buried treasures: Aesthetic scanning with children. *Art Education,* 40 (1): 41–43.

17. Note: The basic rationale for aesthetic perception is in Chapter 3. Art terminology such as the visual elements and principles of design is *not* reviewed until Chapter 14, "The Language of Art." You may

elect to review some of those basics now; however, rest assured that you will not need them in order to understand the pedagogy covered in this chapter.

18. Feldman, Edmund B. (1967). *Art as image and idea.* Englewood Cliffs, NJ: Prentice Hall.

19. See Feldman, Edmund B. (1994). *Practical art criticism.* Englewood Cliffs, NJ: Prentice Hall.

20. Lipman (1988), op. cit., p. 103.

21. Erickson, Mary (Ed.) (1992). *Lessons about art in history and history in art.* Bloomington, IN: ERIC:ART and Santa Monica, CA: The Getty Center for Education in the Arts, p. vii.

22. Perhaps the most pervasive polarity in the arts of the West, one that is constantly discussed by scholars, is that between *classicism* and *romanticism.* An example of this in the popular arts is the contrast between cool jazz and rock music. Such an examination would be appropriate only for older students and only if the teacher feels comfortable doing it.

23. Hardiman, George, and Zernich, Theodore. (1985). Discrimination of style in painting: A developmental study. *Studies in Art Education,* 26 (3): 158–159.

24. For more ideas on sorting see Hurwitz, Al and Madeja, Stanley S. (1977). *The Joyous Vision: Source Book.* Englewood Cliffs, NJ: Prentice-Hall, pp. 63–77.

25. Erickson, Mary. (1983). Teaching art history as inquiry process. *Art Education,* 35 (5): 28–31.

26. Korzenik, Diana. (1985). *Drawn to art: A nineteenth century American dream.* Hanover, NH: University Press of New England.

27. Calvert, Ann. (1992). Art around here: Avenues of acquaintance. In Mary Erickson (ed.), op. cit., pp. 107–111.

28. More than likely, these students learned something about art beyond the limits of Calgary. Paintings made there during the 1930s, for example, probably would bear some signs of the influence of Regionalism, a realistic school of art that flourished between the wars.

29. Holt, Tom. (1990). *Thinking historically: Narrative, imagination, and understanding.* New York: College Entrance Examination Board, p. 9.

9

Problem Solving in Tutored Images

Jeff has just completed a careful line drawing of his own shoe. It is an athletic shoe. Jeff's drawing is extremely detailed: laces, holes, decoration, creases. He has used a contour line that is sensitive to the bumps and wear. It is Jeff's shoe, without a doubt; no other (see Fig. 9–1).

Jeff is five years old. Some five-year-olds draw tadpole figures, a far cry from what Jeff has produced. Some ten-year-olds do not observe the environment about them as carefully as Jeff has. Is Jeff gifted in art? But look over there! Jeff's classmate Carin has also drawn a shoe that seems advanced for a five year old, and so have Michael and Jamie and, in fact, almost all of the 17 children in the kindergarten class.

These are ordinary children from a racially diverse, urban, public school kindergarten classroom. They are not considered "advantaged," far from it; they live in what is sometimes described as the "inner city." These children did make their drawings at the urging of their teacher, however. Any differences between the kind of drawings Jeff, Carin, Michael, and Jamie produced in school from the kind they might have produced outside of school—-the kind of drawings we might expect after learning about the developmental norms discussed in Chapter 4—can be credited to the teacher's influence.

WHAT ARE TUTORED IMAGES?

Jeff and his classmates are making *tutored images*. A tutored image is the product of teaching that produces significant art learning. An *untutored image* would be one that a child initiates spontaneously, independent of adult intervention that affects its outcome. Neither term implies anything about the aesthetic, inventive, self-expressive, or artistically expressive nature of these images. Each refers only to whether or not a child makes the image in response to some suggestion from an adult in the role of teacher—-art teacher, classroom teacher, mother, father, or friend—whose intent is to help that child become more knowledgeable about making art.

The term *tutored image* does imply, however, that children should learn to express their ideas in more inventive ways than can be determined by maturation alone. We have called inventiveness the ability to be imaginative and to solve artistic problems. Learning to be inventive and acquiring artistic knowledge go hand in hand.

You can observe children's spontaneous acquisition of knowledge in art production by tracking the development of their untutored images—that is why knowing something about children's developmental stages or styles is help-

Figure 9-1 Kindergarten drawing of a shoe. (Photograph by Jean Rush)

ful to art teachers. Children's ability to organize their artistic statements in ever more complex and inventive ways normally increases with age, but spontaneous learning is too unpredictable for use in schools. When you teach art production, you aim to create classroom situations that will guide many children through the developmental styles in a steady and beneficial way, and in general more rapidly and with greater proficiency than might otherwise happen.

Tutored images are solutions to authentic art problems that are posed by teachers. Elementary art programs have sometimes interpreted "artistic freedom" in a laissez-faire manner, giving children few art problems and thus little opportunity to become more knowledgeable about making art. Academic schooling, on the other hand, while committed to imparting knowledge, has earned a reputation for placing more emphasis on rote learning and right answers than on flexible thinking and inventiveness.

The approach to elementary teaching now called *coaching* is closest to what should take place in teaching children studio art. A teacher who is a coach gives students opportunities to solve authentic art problems. Children who make tutored images as a result of their teacher's coaching are making the kinds of art that help them become more knowledgeable—and the kinds they might not have made without being coached.

If problem solving sounds too academic and dull, try to remember the excitement that artists feel when they face the challenges of expressing their ideas in paint, clay, or computer graphics. Making tutored images can generate that feeling for children (see Fig. 9–2) (see **color insert #2**). Terms like *problem solving* and *aesthetic concepts* should not suggest a lackluster classroom experience. On the contrary, if children are not energized by participating in the inventive process, something is amiss.

Might tutored images be too prescriptive for elementary children? All teachers face the challenge of wondering how much help to give their students. What is too much and what is not enough?

Your expectations of tutored images should always be appropriate to your students' levels of maturation. Children should not and cannot imitate adult artists. On the other hand, children with good art instruction often perform above the developmental stage that is normal for their age. If your expectations match their abilities, making tutored images will give your students the opportunity to become young artists, with all of the excitement that implies.

For you, the teacher, posing authentic art problems does not have to be the intimidating mandate it may seem. You pose problems for your students whenever you ask them to use specific aesthetic concepts to make a print, a drawing, a sculpture, or a ceramic vase. All student artworks produced as a result of your teaching, containing aesthetic concepts unlikely to appear without your intervention, will be tutored images.

Children learn more about art when you pose authentic art problems than they would through trial and error, particularly when you and your school colleagues all follow the same art curriculum. If you see children making the same kinds of pictures in elementary school that they make at home, you can regretfully conclude that no art teaching is taking place. Asking your students to make tutored images can prevent that unfortunate situation in your classroom.

THE IMPORTANCE OF THE STUDIO EXPERIENCE

Child art looks different than art made by adults, but children and adults share the ability to distinguish between narrative (or subject)—describing

the features of their experiences—and composition (or form)—organizing their visual statements. The pattern of children's artistic development shows an increasing ability to think separately about these two aspects of art. As they grow older, children create images that are increasingly complex and, to adult eyes, more compatible (for the most part) with our adult aesthetic.

Most artists believe that unless people learn to make art at some level, their understanding of art is not complete. Psychologists concur, in this sense: unless children or adults can put their knowledge to work, they cannot have a *genuine understanding* (a disciplinary understanding)[1] of art. Children might acquire facts about art, but without the ability to use them their knowledge remains rote or "academic."

Most of us want children to further their knowledge of art by making it in an authentic way. We might like our students in elementary school to emulate the conditions artists face in their studios, if that were possible. Since it is not, we want children to act as much like artists as they can when they make images in school.

What do artists think children should learn about making art? The same kinds of things that they themselves have had to learn: how to use tools and to manipulate different materials with care and skill, in order to create a silver necklace, or woven fabric, or a finely handcrafted wooden chair; how to draw an image of a three-dimensional object on paper so that it looks "real"; how to compose a photograph or a sculpture that may not look "real" at all. Most important, artists learn how to perceive the real world in new ways; and how to imagine *what might be* when faced only with *what is*.

Artists believe they can perceive ordinary objects and events from a point of view that is extraordinary, and that their gift can help the rest of us find heightened meaning in our own lives. They ask themselves, "What would happen if I did *this*? I wonder if it would be *that*?" And then they make a drawing or a jewelry design or a relief print to see if their prediction was right. School art experiences, therefore, should offer children opportunities to do those kinds of things. When children learn to perceive and imagine, to find and solve problems in a way that expresses meaning, their inventive activities in the classroom parallel what adult artists do.

Those who consider the studio experience essential to art learning generally regard it as a catalyst for acquiring art concepts used in aesthetics, art criticism, and art history as well. Some art educators in recent years, in particular Vincent Lanier, have argued that elementary school art does not necessarily have to include making images in order to teach those concepts. Lanier observes that making art, as practiced in most elementary schools, does not teach children to understand either art or their own aesthetic responses.[2]

We agree with those teachers who say that making art can be essential to elementary education, and also with Lanier when he says that it is not always so. Your challenge will be to teach art production in a meaningful way. The key is to emphasize aesthetic concepts.

TEACHING AESTHETIC CONCEPTS

Traditional studio art instruction in elementary schools emphasizes technical mastery of tools like crayon, paintbrush, and burin when children draw, paint, print, and so on. This is the artistic equivalent of mastering pencil, pen, and computer when children write. Learning to make art, like learning to write, requires more than techniques; it also requires learning to perceive the aesthetic properties (the visual elements, principles of design, and "big ideas") contained in artistic images.

Aesthetic properties are kinds of aesthetic concepts that artists use; all textbooks in art fundamentals illustrate them (see Chapters 6 and 14). For example, all variations of form called *visual elements* are concepts. All of the many ways of combining these elements to organize a composition, called *principles of art*, are concepts. Further, all of the techniques with which artists treat materials (mixing, applying, shaping, refining) are concepts.

All of the messages that art can express are also concepts. Art can express *moods* (joy, sadness, satisfaction, anger, fear, pleasure, pain), *dynamic states* (action, inertia, motion, speed, energy, calm, frenzy) and *ideas*, both large and small (liberty, patriotism, racial tolerance, feminism, love, family support, religious freedom, inducements to buy commercial products, and a host of social injus-

tices). Children can use these concepts in making tutored images.

Think of teaching children to make art the way you teach them to write stories. You ask children to master the rules of grammar so they can write coherent essays; you can also ask them to master the "rules" of aesthetic structure so they can create coherent images. The message of art (its expressive character or content), like that of literature, depends upon more than the story it tells (its *subject matter*); its message also needs to be stated well (its *form*).

Elementary art teachers often suggest topics for student compositions: "What I did on my summer vacation." "Our trip to the fire station." "My family's Thanksgiving." "How I brush my teeth" (Fig. 9–3) (see **color insert** #2). Topics like these provide opportunities for storytelling, and part of the picture's meaning is intended to reside in the narrative. If teachers assume that the form of students' art should be each child's artistic prerogative, however, they stop short of giving children a full art-making experience.

While children of four or five may not distinguish between the subject of their art ("my summer vacation") and the way they represent it, older children will, with or without art instruction. In other words, children *learn* to distinguish between subject matter—describing experience—and form—organizing visual elements—just as adult artists do, even though child art looks different than art made by adults. The older children are, and the more complete their art education, the better they become at making this distinction.[3]

A good elementary classroom strategy for venturing beyond narrative is *aesthetic scanning* (introduced in Chapter 8). When properly done, scanning can guide even young children to appreciate the expressive qualities of form. Combinations of visual elements and principles of art convey powerful aesthetic messages that imbue subject matter with meaning. All professional art schools teach students to distinguish between subject matter and form; they call it *aesthetic perception*. It is an essential artistic skill.

Aesthetic perception has three traditional uses within the professional studio experience that should be incorporated into teaching elementary art production. The first is before students make art; students should always look at images in order to form the aesthetic concepts they will be using to complete their art projects. This activity constitutes a *visual analysis*.[4] We call this preliminary analysis a *focused scanning* because students focus their attention on concepts taught in the unit.

The second use of aesthetic perception is during the art production itself. Students should analyze their works in progress to make sure they are using the artistic concepts learned during the visual analysis, and using them well. This perceptual activity, another form of scanning, is unspoken and is an inherent part of the creative process.

The third use of aesthetic perception or scanning is after children have completed their projects, when you and they should examine them. This *critique*, as it is called, also focuses on unit concepts. Both you and your students look to see whether the aesthetic concepts taught during visual analysis occur in the resulting art; if they do, you both know that learning has taken place. A critique gives you a chance to praise, evaluate, introduce new concepts, and if necessary, repeat your instructions to some children. It gives children the chance to realize their achievements and to anticipate extensions of them.

We propose that you consider children's art activity as *artistic expression* (the communication of ideas) rather than self-expression (the confirmation of one's existence; see Chapter 6). Recognize that children, like artists, can and do employ aesthetic concepts as well as subject matter to express ideas. From that perspective, even young children like Jeff and his friends can and should learn principles that govern the expressive process and practice using them when they make art.

THE NATURE OF CONCEPTUAL CONSISTENCY

Teaching that produces solid art learning must have conceptual consistency. *Conceptual consistency* refers to the way related conceptual strands from distinctly different art disciplines weave together within an effective art *project* (one art activity), or an art *lesson* (the amount of instruction at any one time), or an instructional *unit* (a series of related projects or units) to form a single, coherent learning experience whose product will be a tutored image.[5] To illustrate, imagine that

Why is each print considered an original art-work? If so, what about the reproductions—also prints—in textbooks? Why are hand-made methods accorded privileged status? What if an artist hires someone to do the actual printing? These and other questions are appropriate aesthetic inquiries that would interest students in the studio process they are about to explore.

As you begin your visual analysis, you might show contrasting examples of woodcuts—such as *Rain Shower on Okeshi Bridge* (1857; Fig. 9–4) by Japanese artist Ando Hiroshige and the *Head of Henry van de Velde* (1917; Fig. 9–5) by German Expressionist Ernst Ludwig Kirchner—explaining technical and expressive differences among their two styles. Hiroshige's art is a color *tour de force* of exquisite detail and technical virtuosity; Kirchner's work is a study in black and white wherein the marks of the artist's cutting tool or *burin* are clearly evident. The Japanese

Figure 9-4 Ando Hiroshige (1797-1858), *Rain Shower on Okeshi Bridge*, (Storm on the Great Bridge), Japanese. Color wood block on paper, 13⅞ × 9⅛".
(Courtesy of The Cleveland Museum of Art, #21.318)
(Gift from J. H. Wade)

you are teaching a sixth grade unit on relief printing that also includes concepts from aesthetics, art criticism, and art history.

Your unit might begin with a brief review of what a print is—that is, a single image reproduced numerous times in identical (or nearly identical) copies. Each copy is considered an original work of art, provided the print was made by one of the traditional hand processes (relief, intaglio, lithography, silkscreen, or combinations thereof). While your initial review will introduce this technique as the one students will explore, you might also introduce aesthetic inquiry at the same time.

Figure 9-5 Ernst Ludwig Kirchner (1880-1938), *Head of Henry van de Velde* (1917). Woodcut. Staatliche Graphische Sammlung, Munich.
(Courtesy of Straatliche Graphische Sammlung, #1950:158)

Figure 9-6 Käthe Kollwitz (1867-1945), *Memorial for Karl Liebknecht* (1919). Woodcut. (Courtesy of the Museum of Fine Arts, Boston, #53.148/E12961/EDA)

artist, through his composition and technique as well as his choice of subject, conveys a world of the past in which nature is both powerful and delicately balanced; the German, through his, a modern world of human anxiety and harsh immediacy in which nature is almost an afterthought.

You might mention that Japanese woodcuts (called *ukiyo-e*, "art of the floating world"), which are highly admired and exhibited in museums throughout the world, were used in the nineteenth century as wrapping paper by the Japanese. This could stimulate further aesthetic inquiry, but of course it is also art history as well as the beginning stages of art criticism. This kind of information about Hiroshige's work, while interesting, is not of immediate concern as your students prepare to make prints of their own. Depending on the time available, you could (if

you wish) defer it until a later time with no ill effects.

Your visual analysis might come to rest on a critical comparison of two black-and-white relief prints, a woodblock *Memorial to Karl Liebknecht* (1919; Fig. 9–6) by early twentieth-century German artist Käthe Kollwitz, and a relief print entitled *The Survivor* (1983; Fig. 9–7) by contemporary American artist Elizabeth Catlett. These two works of art appear to have much in common; both are social realism, and both are by women. Both show us the struggles of common people; Kollwitz shows us a group of people, while Catlett depicts an individual.

But wait—let us look further. Both prints reduce the figures to simplified shapes. Both contain great contrasts between black and white areas; grays are formed by the juxtaposition of

Figure 9-7 Elizabeth Catlett, *The Survivor* (1983). Linocut 11″ × 10″ (28 × 25.5 cm). Malcolm Brown Gallery, Cleveland, Ohio.
(Courtesy of **VAGA**)

bold, energetic white lines carved from a black ground. Both prints have straightforward compositions based on rigid verticals and horizontals that lend them a sense of strength despite the inevitability of sorrow and hardship. Each artist conveys her message of adversity by the way she uses the visual elements and principles of design (sensory and formal aesthetic properties) as much as by the subject she depicts.

When your students understand this, they are ready to try making a relief print themselves. You would like it to be a woodcut, but you settle for a linoleum block because those are available in the supply room. The technique is similar, easier for children to manage, and will accommodate the same aesthetic concepts. You realize that the use of these aesthetic concepts, not technique per se, is the objective of your unit.

The aesthetic concepts you will ask children to use will be taken from Kollwitz and Catlett: simplified shapes, high contrast, grays formed by juxtaposition of black and white lines, and compositions based on verticals and horizontals. You

specify that each print is to incorporate them in some way. These concepts become your students' objectives and your evaluation criteria. You leave the choice of subject matter up to each child, but expect each one to convey a serious mood and a sense of strength produced by its form as much as by the story it tells.

After your students have finished their prints—their tutored images—they will *critique* them (examine the extent to which they reached their objectives). As in aesthetic inquiry, there is no "right" answer, but some prints will display unit concepts better than others. Self-examination, with your help and input, is part of students' learning process. It allows them to acknowledge their progress, seek new challenges, or repeat difficult material as needed. If you work in a school where it is necessary to grade art projects, your students will understand your reasons for awarding the grades they receive (see Chapter 10).

Now that students' prints and critiques are completed, subsequent reexamination of Hiroshige, Kirchner, Kollwitz, and Catlett by the class can reveal ways in which students' tutored images look the same or different than these master works. Discussion of the works' expressive properties (the moods, dynamic states, and ideas conveyed by form as well as by subject) will help students to interpret their meaning. Students may discuss the works' meaning within the context of historical information about these artists, if you have not already covered this kind of material.

For example, you could explain that Kollwitz, the wife of a doctor whose patients were Berlin working people, saw the hardships of the poor at first hand. Although influenced by Expressionism she developed into the first of the German Social Realists, partly as a result of the death of her son in battle during World War I. Her forceful tribute to a fallen political leader, couched in stark contrasts between black and white, conveys a universal anguish that touches us deeply.

Catlett depicts the difficult life of the rural poor by showing us a single, ordinary woman; Catlett's print echoes the concerns of other artists associated with American social realism. Catlett's print closely resembles a photograph from Dorothea Lange's 1936 series about the plight of California's migrant families during the 1930s. The print also suggests the strength and endurance of many people who survived oppres-

sion in the antebellum South and their heroic struggles during the Civil Rights movement.

There is always time for a couple of questions before you leave this unit: What is a "floating world," anyway? What does "antebellum" mean? Was that before World War I? Was Germany on our side? Who knows; when all is said and done, sixth graders may just learn some things besides art—about Japanese culture, the first world war, the Civil Rights movement, and our nation's history.

PLANNING FOR CONCEPTUAL CONSISTENCY

The three-part model for producing tutored images that you saw in the preceding lesson on relief printing follows a pattern familiar to teachers in professional art schools, although perhaps less so to those in elementary schools. Teachers first show students examples of concepts to be learned, either real-world objects or art; students then engage in a studio activity (including a demonstration beforehand and a critique afterwards); and both teacher and students look for unit concepts in additional works by adult artists. Planning for conceptual consistency across these three unit components may seem rather difficult at first—especially when the concepts to be taught derive from four different arts disciplines.

We call the first component of this three-part unit *visual analysis*; it makes use of both *vocabulary words* and *vocabulary images*. We call the second unit component *art production*; it comprises a *demonstration*, a list of evaluation *criteria*, a *class activity*, and a *critique*. We call the third unit component a *critical, historical, and aesthetic analysis*; it contains *art information* and *art images*.[6] During visual analysis, children learn concepts; during art production they apply them to solve artistic problems; and during critical, historical, and aesthetic analyses they have opportunities to extend what they have learned to new situations, as well as to acquire concepts from beyond the studio discipline.

Achieving conceptual consistency among these three components is not as difficult as it may sound. What makes a unit like the one on relief printing effective is that certain aesthetic concepts recur consistently throughout all aspects of the unit. You emphasize the same sensory (visual elements), formal (principles of design), technical, and expressive properties in your visual exam-

ples, your scanning, your studio activities, and your critical and historical analyses.

If you want your students to make relief prints, for example, you show them relief prints. You do not show your students wood engravings, in which the printed lines (black areas) are cut away, and then ask them to make relief prints, in which the unprinted lines (white areas) are cut away. You do not show only black and white prints in a unit on color, although the reverse might be possible.

You do show children more than one example of each visual concept so that they can distinguish the concept from the artistic context (the work of art) in which it is embedded. If you had showed beginning students only one print by Kollwitz, for example, they would have had difficulty thinking of other ways to use line and shape to compose a picture. Most likely they would have copied Kollwitz's print—copying both her concepts and their context (as described in Chapter 6) because they had no way of separating the two. Instead, we want students to extract the unit concepts from the art in which they are embedded, and then to invent new contexts for them by making their own, original artworks.

To construct a conceptually consistent unit, therefore, you will be planning more than what you expect your students to *do*; you are also designating what *concepts* you expect them to learn. Most schools ask teachers to use some kind of standard format for planning instruction (see Table 9–1).[7] As you complete your planning form, you are planning the logical unfolding of students' concept acquisition, problem solving, and transfer of learning to new situations. Using a planning form is also a way to self-instruct and self-check, and be confident you have not omitted any crucial unit components.

In teaching art no planning "formula" can serve all situations, however. The format suggests a certain functional sequence for teaching concepts. Think of any planning format as flexible enough to accommodate your individual skills and preferences. Do not interpret it as a mandate for only one sequence of activities or only certain projects to teach those concepts. As you become more familiar with the nature of conceptually consistent instruction, you should alter the sequence and the projects of any "unit plan" if a different one would better suit your own interests and teaching style. Table 9–1 is a blank planning format for you to copy and use if you wish.

TABLE 9–1 **PLANNING A CONCEPTUALLY FOCUSED STUDIO ART UNIT**[a]

TOPIC:

GRADE: **DATE:** **TIME/PLACE:**

OVERVIEW (Teacher's intention):

CONTENT OBJECTIVES:
VISUAL ANALYSIS ART PRODUCTION CRITICAL/HISTORICAL/AESTHETIC ANALYSIS
On completing this unit each student will be able to:

VISUAL ANALYSIS:
VOCABULARY WORDS: (see Demonstration, below)

VOCABULARY IMAGES:

ART PRODUCTION:
MATERIALS:

DEMONSTRATION:
The teacher uses the materials described above to demonstrate ways to produce the following visual concepts:

At the same time, the teacher presents the **evaluation criteria** upon which the completed artwork will be evaluated (listed under Evaluation of Artwork, below). These are also the teacher's **content objectives**.

CLASS ACTIVITY:
Children use prescribed art materials (see Materials, above) to make an image that will display the characteristics listed in Evaluation of Artwork (see below).

EVALUATION OF ARTWORK:
Each student makes a drawing that contains:

CRITICAL/HISTORICAL/AESTHETIC ANALYSIS:
ART IMAGES:

ART INFORMATION:

AESTHETIC INQUIRY:

[a]Adapted from Rush, Jean C. (1987). Interlocking images: The conceptual core of a discipline-based art unit. *Studies in art Education*, 28 (4): 206–220. This page may be photocopied.

In the projects that follow, you could substitute different studio activities and visual examples, expand or combine any of the three components, or otherwise reconfigure the units. Remember how the unit on relief printing integrated many ideas in an informal way? In other words, you could personalize each unit according to your own interests, time constraints, or spontaneous responses from your students. What you cannot do, if you wish to maintain conceptual consistency, is combine unlike concepts; that would produce a conceptual mismatch that would jeopardize students' learning.

CONCEPTUAL CONSISTENCY IN A CONTOUR DRAWING PROJECT

Let us look at a conceptually consistent eighth-grade unit containing two projects: one on contour drawing and a following project in which students add chiaroscuro to create volume.[8] Imag-

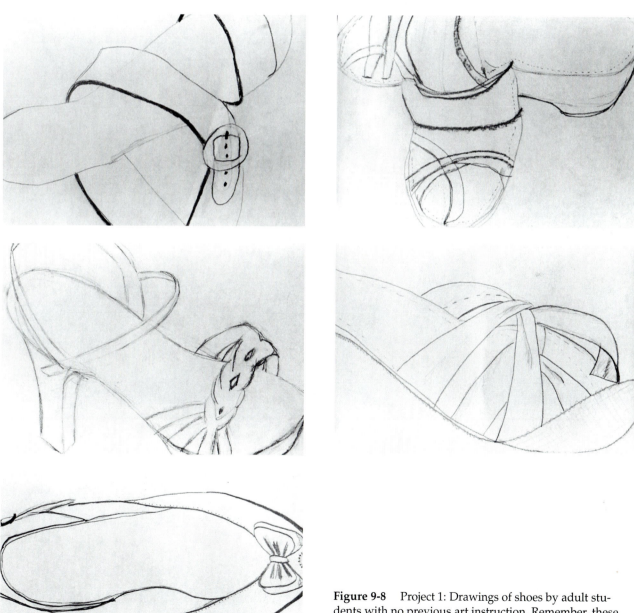

Figure 9-8 Project 1: Drawings of shoes by adult students with no previous art instruction. Remember, these students draw much like seventh and eighth-graders (see Chapter 6).

(All photographs by Jean Rush)

ine that you are preparing to teach this unit. In Project 1 you will be asking your students to make contour drawings (line drawings) of their shoes. Figure 9-8 shows you how they might turn out.

You can find the outcomes of Project 2, showing the addition of shading, in Figure 9-9, although we will not discuss this second project at length. The two projects are sequenced according to their complexity (see Chapter 7), with the simpler drawing task first. We chose these two widely used projects as examples of art instruction in hopes that their familiarity might allow us to attend to the matter at hand, that is, planning for conceptual consistency.

Projects 1 and 2 are examples of group instruction. Elementary art depends on group

Figure 9-9 Project 2: Drawings of shoes by adult students with no previous art instrustion.

(All photographs by Jean Rush)

instruction because of the number of children and the relatively short periods of instructional time available. Group instruction is a departure from the way most of you learned studio art in high school and college, which was primarily on an individual (one-to-one) basis with your teacher even when you were in a studio art class.

Adults made the drawings in Figures 9-8 and 9-9, although the level of difficulty for Projects 1 and 2 is seventh or eighth grade. This level of instruction is often used in introductory units for adults without previous art experience, because that is the level of their art ability. These units have been adapted for use with children as young as five-year-olds; you have already seen the results in the drawings of Jeff and his friends.

The time required for adults to complete each project is 2 to 3 hours of uninterrupted time. In an elementary school, this project would consume a number of 20-minute lessons spread out over the course of several weeks. With eighth graders in junior high school, a couple of 40-minute periods per project might be enough.

Let us walk through the planning format of the "shoe unit" together, beginning at the top of Table 9–2 (found on page 144):

Topic

Notice that the description of the topic of Project 1 refers to describing shape with line, using the contour drawing technique. In other words, it describes the artistic problem you are asking your students to solve, not the media activity.

Overview

As you start to plan this art learning situation, you will find it helpful to state your general expectations of what students will make as they work on their projects. For Project 1, you expect your students to make contour drawings of their own shoes. Each student will make a drawing with a soft drawing pencil on a 9 × 12 white paper.

You expect that your students' drawings will display the concepts you plan to teach. You state your expected outcomes in terms of things you can see in their completed work. It is impossible to observe learning directly—we cannot see what goes on inside of someone's head—so

your alternative is looking for visible evidence, from which you can infer that learning has occurred.

Content Objectives

You now want to be a little more specific about what you expect students to learn during the three unit components of *visual analysis* (concept acquisition), *art production* (problem solving, constructing new knowledge), and *critical/historical/aesthetic analysis* (transfer of concepts learned in one context to another context). Under the subheading *visual analysis* you will list specific aesthetic concepts each student should be able to identify in art or the real world. Under *art production* you will list specific concepts each student should be able to apply as they make art. Under the heading *critical/historical/aesthetic analysis* you will list a few artists students will study in the context of those same concepts (there is not enough room for all of the artists you might use).

The idea of conceptual consistency means that you integrate a number of discipline concepts to teach a conceptually complex studio art project.[9] Your choice of concepts to teach in any one unit or project will depend upon the curriculum, or long-term instructional plan, that you follow. Without a curriculum, choosing the concepts for each project would be extremely difficult, as you learned in Chapter 7. Whenever you introduce aesthetic concepts and behaviors in any component of your unit, you elaborate on your previous objectives. Once you have stated your content objectives, you do not introduce concepts unrelated to them at a later time.

Visual Analysis

Visual analysis should precede all studio activity. Visual analysis is a scanning activity (Chapter 8) used selectively to teach aesthetic concepts students will use in making their art projects. They also give these concepts verbal labels, which become your vocabulary words.

When your students analyze visual images, they obtain the information they need to form the aesthetic concepts you have chosen as your content objectives. You and your students can analyze real objects, photographs, adult art, or student artwork

from previous classes. Recognizing aesthetic concepts is a form of critical thinking artists use during the creation of their own work (see Table 3.1).

Your content objectives contain a number of artistic concepts:

- kinds and qualities of line
- how line describes the contours or edges of shapes, including internal and external contours
- the way that overlapping shapes produce the illusion of shallow space
- the difference between positive and negative shapes
- how artists use positive and negative shapes to break up the flat area of the picture plane as they compose the picture
- how a variety of sizes and shapes creates visual interest.

Remember, this is an eighth-grade project; you might want kindergartners like Jeff to concentrate only on lines and the way they spell out contours. You will adjust the project's conceptual complexity to fit your students' abilities (Chapters 4 and 5 can help you know what to expect.)

You will lead your students through a visual analysis before they begin to draw, in order to prepare them to use the unit concepts in their own art. The images you choose for your visual analysis should relate directly to the coming art production activity. The degree to which students acquire unit concepts will affect the form of the images they will subsequently make and the expressive properties the works will have. Later, when children have finished their art projects,

TABLE 9–2 PLANNING A CONCEPTUALLY FOCUSED STUDIO ART UNIT[a]

TOPIC: **Project 1: Describing shape with line (contour drawing).**
(Project 2: Describing volume with shading; continuing project 1).

GRADE: Eighth/Adult **DATE:** **TIME/PLACE:**

OVERVIEW (Teacher's intention):
Project 1: Students will make a contour drawing of a shoe in pencil on 9″ × 12″ smooth white drawing paper.
(Project 2: Students will add shading to imply volume.)

CONTENT OBJECTIVES:
On completing this unit each student will be able to:

VISUAL ANALYSIS	ART PRODUCTION	CRITICAL/HISTORICAL/AESTHETIC ANALYSIS	
1	**2**	**3**	**4**
Identify	**Use pencil to make**	**Identify art concepts in line drawings by**	
Contours	Contour lines		
Lines	Kinds of Lines		
Shapes	Qualities of lines	Matisse	(Van Der Werff)
Overlapping	Expressive lines	Kuhn	(Passrotti)
Proportion	Overlapping shapes	Kanemitsu	(Unknown Artist)
Space	Large, medium, and small shapes	Landacre	(Redon)
		Picasso	(Salvioni)

The objectives in columns 1, 2, and 3 are for **Project 1.** Those in column 4 are for **Project 2:**

VISUAL ANALYSIS:
VOCABULARY WORDS: (see Demonstration, below)

Project 1:				(Project 2:)
Contour	Line	Shape	Space	(Shading)
Edge	Short/long, etc.	Positive/negative	Shallow	(Value)
External	Thick/thin, etc.	Overlapping	Contrast	(Cast shadow)
Internal	Straight/rigid, etc.	Proportion	(Volume)	

VOCABULARY IMAGES:
Line qualities; photographs of shoes; diagram of overlapping shapes; line drawings.

ART PRODUCTION:
MATERIALS:
6B pencil, eraser, 9″ × 12″ smooth white drawing paper.
DEMONSTRATION:
The teacher uses the materials described above to demonstrate ways to produce the following visual concepts:
1. Kinds of lines: short, long, curved, straight
2. Qualities of lines: thick-thin, hard-soft
3. Expressive lines: straight-rigid, diagonal-exciting, horizontal-restful, vertical-dignified, undulating-energetic
4. Line describing an external edge: external contours
5. Line describing an internal edge: internal contours
6. Shallow space: Overlapping lines and shapes
At the same time, the teacher presents the **evaluation criteria** upon which the completed artwork will be evaluated (listed under Evaluation of Artwork, below). These are also the teacher's **content objectives.**

TABLE 9–2 PLANNING A CONCEPTUALLY FOCUSED STUDIO ART UNIT[a] (Continued)

CLASS ACTIVITY:
Children use prescribed art materials (see Materials, above) to make an image that will display the characteristics listed in Evaluation of Artwork (see below).

EVALUATION OF ARTWORK (CRITQUE):
Each student makes a drawing that contains:
1. Shoe touching two edges of paper
2. Interior/exterior contours
3. Thick-thin/soft-hard/dark-light lines
4. Small/medium/large/overlapping shapes
5. Expressiveness/specificity

CRITICAL/HISTORICAL/AESTHETIC ANALYSIS:
ART INFORMATION:
Names of artists, their countries and lifespans; titles of drawings, dates, media, sizes.
Historical periods in which artists lived.
Expressive properties (mood, dynamic state, ideas), that is, meaning of the work.
Project 1: Additional visual analysis concepts of shading to imply volume, in preparation for Project 2.
ART IMAGES:
Project 1: Line drawings by Matisse, Kuhn, Kanemitsu, Landacre, Picasso.
Project 2: Shaded drawings by Van Der Werff, Passrotti, Unknown Artist, Redon, Salvioni.
(See Content objectives, above).
AESTHETIC INQUIRY:
Project 1: "Big questions" about art. Examples: Should a drawing be considered a finished work of art? If an artist makes a sketch in preparation for an oil painting, is the drawing considered art if it is a stage of a longer process? Is an artist who makes only drawings a "complete" artist?

[a]Adapted from Rush, Jean C. (1987). Interlocking images: The conceptual core of a discipline-based art unit. *Studies in Art Education*, 28 (4): 206–220.

they will be able to identify unit concepts in their own images and in images made by their classmates.

Vocabulary Words During visual analysis you and your students will talk about aesthetic concepts as well as look at images containing them. Vocabulary words designate concepts in the normal jargon of art classrooms; that is why it is so important for students to learn vocabulary. Your vocabulary list (with their definitions) may contain more concepts than you have space for on the planning format, but they should be consistent with your initial ones.

During visual analysis activities, described later, students associate these labels with visual images. You will want to illustrate each vocabulary word with more than one *vocabulary image*. This is not as cumbersome as it sounds, because most images will display several concepts at once.

Vocabulary Images In order to make art, students need a vocabulary of images more than they need a vocabulary of words. Vocabulary images may be real objects such as a still life. They may be real-world images such as documentary photographs, clipped from newspapers or magazines.

They may be works of art, either real ones or reproductions of them. The vocabulary images for Project 1 include examples of line quality, line that describes objects, line drawings by artists, photographs of shoes, and paintings of shoes.

Sample Visual Analysis As you show your students the vocabulary images, imagine yourself pointing to the aesthetic properties or visual concepts you want your students to understand, and explaining them somewhat as follows:

- Line is the path left by a moving point; lines can be short or long, straight or curved, thick or thin, hard or soft (Fig. 9–10).
- Different qualities of line can produce different expressive effects: for example, straight lines seem rigid; diagonal lines cause your eye to move more quickly within the drawing, causing excitement; horizontal lines seem restful; vertical lines seem stable and dignified; and undulating lines move back and forth, and so they seem energetic.
- Lines do not occur naturally in nature. We perceive the edges of objects because of a contrast in value or color; we call the edge of an object, such as the edge of this walking shoe, its contour (Fig. 9–11). Every object has internal and external contours, just as this shoe does.

Figure 9-10 Line as the path left by a moving point.
(Photograph by Jean Rush)

Figure 9-11 Photograph of walking shoes.
(Photograph by Jean Rush)

- You can describe the contours of your shoe by drawing a line, just as the artist does in this picture of a boy (Fig. 9–12). The best kinds of lines for contour drawings reflect all of the subtle changes we observe in the contours of our faces or our shoes. Run your finger over your shoe; how many small bumps and curves do you feel? Your pencil will work just as the arm of a seismograph does; every time you see a bump, your pencil will jiggle up and down and record it on the paper.

- When we describe the contours of an object with line, we have drawn a shape. Here is a diagram of some simple geometric shapes—a cube, a pyramid, and three spheres. There are small, medium, and large shapes in nature.

- Shapes that sit behind other shapes seem to be farther away from the viewer than the ones that overlap them. When we overlap shapes (indicates the diagram), we create an illusion of depth, even though our paper is flat. The space created by the overlapping shapes can be shallow or deep; the space in this image is shallow.

- In any composition, such as this photograph of work boots, there are positive and negative shapes (Fig. 9–13). A shape that we pay attention to is called a positive shape; the shapes around it are the negative shapes. In this photograph, negative shapes are just a varied as the positive ones.

- Both positive and negative shapes contribute to the drawing's composition. In this photograph of sandals, you can see negative shapes within each shoe because you can see through it (Fig. 9–14).

Figure 9-12 Matsumi Kanemitsu, (American; 1922-1992), *Head, 20th Century.* n.d. Ink on paper, 10¼ x 7½" (26.0 x 19.0 cm).

(Collection of The University of Arizona Museum of Art, Tucson, AZ. (Gift of the Artist, #58.17.2)

Various kinds of shapes (regular, irregular; geometric, biomorphic) and sizes of shapes (small, medium, large) of both positive and negative shapes creates visual interest.

Figure 9-13 Work boots.

(Photograph by Jean Rush)

Figure 9-14 Sandals.

(Photograph by Jean Rush)

• Look at this painting of shoes by the artist Van Gogh (Fig. 9–15). Are they new shoes? Old shoes? Dress shoes? Work shoes? What are some ways the artist expresses the character or "shoeness" of each pair of shoes? How can you use contour line, composition, and depth in your own drawing in order to convey the character of your own shoe?

Students must see examples of these concepts in order to learn them; your words direct their attention to the concepts, but they do not adequately describe them. Students can identify these concepts during visual analysis, but using them is critical to understanding and remembering them. Think about how much easier it is to

Figure 9-15 Vincent van Gogh (1853-1890), *A Pair of Shoes*, Paris, 1886. Oil on canvas, 37.5 x 45 cm.

Amsterdam, Van Gogh Museum, #F255.) (Vincent van Gogh Foundation)

find your way to an unfamiliar location if you have previously driven the car there yourself, instead of having been a passenger.

Art Production

Demonstration Before your students begin to work with art materials, they may need to learn some additional vocabulary words related to technique. Concepts of skill, like concepts of aesthetic properties, seem better learned from observation. You convey these concepts in the course of making one or more images using the media and tools to be used by students. During your demonstration, you will attempt to put into practice as many concepts as possible that you discussed during visual analysis.

Sample Demonstration Your demonstration models both aesthetic properties and processes, as follows:

- O.K., everyone! Take your practice paper and a 6B pencil and do what I do. Swing your arms! Loosen up! Let's draw some different **kinds** of lines—try some short lines (like this); now long lines (like this); try some curved lines; now straight; make some broken lines, and continuous ones; go on. Put energy into them. Good!

- Now let's make some lines that have different **qualities:** Can you draw dark lines? (Press hard.) Light lines? (Barely touch the paper.) How would you make fat lines? (Use the side.) Thin ones? (Use the point). That's the idea!

- Now experiment—try rigid lines; soft lines; smooth ones, fuzzy ones, mechanical ones, energetic ones. Look—each line also expresses something: straight lines express rigidity, and therefore strength; diagonal lines express rapid movement, so they say "excitement;" horizontal lines express inertia, which conveys restfulness; vertical lines express stability, and therefore dignity; undulating lines express changeability, and thus energy; and so on. What would happiness look like? How about anger? Good, you've got it!

You may also wish to draw a series of shapes to demonstrate external and internal contours and how to create shallow space by overlapping lines and shapes. You could draw part of your own shoe to model how to describe contours with line, especially the kind of sensitive line associated with contour drawing. If you draw your shoe on a piece of paper in several different ways, producing a different arrangement of positive and negative shapes each time, you can explain the unit

concepts in several different contexts. This allows students to learn the concepts independently from the images; it keeps them from thinking there is only one "right" way to do what you are asking.

Content Objectives/Evaluation Criteria While you are demonstrating media skills for your students, before they begin their drawings, you will also want to tell them your content objectives for your art project. You state your objectives as separate sensory (visual elements), formal (principles of design), expressive, and technical features to be incorporated into your students' artworks. For students, however, you will call your objectives *evaluation criteria*. Evaluation criteria define the artistic problem you ask students to solve. (We discuss evaluation criteria further in Chapter 10.)

Your evaluation criteria spell out selected aesthetic concepts your students' art projects should contain when they are completed. In everyday language, your evaluation criteria describe what students' completed art projects should look like. The number of your evaluation criteria will be too few to specify all of the aesthetic dimensions of their projects, but they should include all of the new concepts that you want them to learn.

You should make sure that a list of your evaluation criteria is visible to all students, perhaps on the chalkboard or bulletin board, as they generate ideas for the project and throughout the entire time they are working on it. Because you review the criteria with your students during your demonstration and before they begin to work, you can make sure they understand the problems to be solved. Your review also gives them the means to evaluate themselves both during and after their art-making experience.

You will assess your students' completed artworks on the degree to which they incorporate your evaluation criteria. For this reason, the list should be relatively short and expressed in as few words as possible. For adult learners, five items are enough. For younger learners, two or three are sometimes sufficient. The brevity of the list means that you will leave out some of your most obvious expectations. (In Project 1, for example, the most obvious unspoken criterion is that the artwork will be a contour drawing of the student's shoe or shoes.)

The way you state evaluation criteria will depend on your own way of identifying aesthetic

concepts, using words your students can understand. After a thorough visual analysis, your list becomes a kind of shorthand, as you see below (the boldface type). We have added a longer explanation as a kind of "teacher's guide" to illustrate how the process works. In the classroom, you would write the "shorthand" version on your chalkboard; you would deliver the explanation orally as you introduce the unit and as you and your students review the criteria prior to beginning to draw.

List of Content Objectives/Evaluation Criteria
In the case of Project 1, given the list of concepts taught during visual analysis and the demonstration, you want to remind your adult students that each of their drawings should contain the following things:

1. **Shoe touching two edges of paper.** Parts of the drawn shoe should touch at least two edges of the paper. This criterion helps students create a variety of positive and negative shapes, avoiding the inclination of beginners to float the positive image in a sea of undifferentiated background space. It helps them to organize their 9 × 12″ format as they begin to draw.

2. **Interior and exterior contours.** This criterion encourages students to draw more than just the outline of the shoe. It helps them to achieve a greater variety of shapes. It sets up opportunities for creating an illusion of shallow space by incorporating overlapping shapes, part of criterion 4.

3. **Thick-thin, soft-hard, and dark-light lines.** Students' lines should display qualitative transitions from thick to thin, soft to hard, dark to light. This criterion reminds students to use their pencils in a way that is sensitive to the objects being drawn, a characteristic feature of contour drawing. Various qualities of line are also essential to achieving criterion 5.

4. **Small, medium, large, and overlapping shapes.** A variety of shape sizes helps to create "visual interest" in students' compositions. It seems to make students more inclined to vary the kinds of shapes they draw as well. Overlapping shapes, either within one shoe or from placing one shoe on or in front of another create an illusion of shallow space.

5. **Expressiveness and detail.** This criterion reminds students that they are drawing a specific shoe. The pencil lines and the shapes they create are intended to convey information about a specific shoe to the viewer of the completed work. It encourages students to use their powers of observation and media skills for expressive effect.

Class Activity Students make contour drawings of their shoes. By asking your students to incorporate certain aesthetic concepts into Project 1, you have posed authentic art problems for them to solve. By posing problems, you are asking your students to make tutored images.

Recall from Chapter 6 that when artists solve problems, they pose and test hypotheses. Although you may not have thought about it in this way (and there is no reason that you should), you have based your unit on a number of artistic hypotheses. As the children begin their drawings, they will be testing these hypotheses in order to solve your problems.

If we were to spell out these artistic hypotheses, just as an academic exercise, these are what we would find:

- some balance between positive and negative shapes helps to organize the composition
- inclusion of both interior and exterior contours increases variety in kinds of shapes
- varying the line quality makes it more expressive
- variety of shape sizes provides more visual complexity
- some combination of expressive lines, irregular shapes, placement of shapes can convey a message about the shoe.

Stating these hypotheses, even to yourself, is unnecessary and impractical in the everyday world of the elementary classroom. The advantage of a conceptually consistent approach to art production is that when you ask children to learn and apply aesthetic concepts, you can be sure that a problem-solving process will occur even though you don't—or can't—put the artistic hypotheses into words. Your evaluation criteria reflect these unspoken hypotheses.

Evaluation of Artwork (Critique) Your critique of students' completed drawings, whether with an individual or an entire class, should always refer to your evaluation criteria. In a group critique, you will display the work of all children simultaneously. You might ask students to identify projects that do an especially good job of demonstrating each criterion. Or you could ask students in turn to discuss the criteria with reference to their own work.

Negative criticism from you or other children is unnecessary and in general counterproductive. Because you have stated your criteria clearly, students will know whether unit concepts appear and how well each completed project makes use of them. Simply providing children with an opportunity to see all of the completed class projects together will, within the context of expectations provided by the evaluation criteria, provide a powerful incentive for meaningful art criticism.

Sample Evaluation of Artwork (Critique)

Here is a taste of a group critique based on the criteria above. Remember, you may critique this work for other purposes as well.

What an impressive group of drawings. Isn't it exciting to see them all pinned up together? You've done extremely well on this assignment!

Let's discuss the first criterion. Can anyone show me a good use of negative space? O.K., let me be more specific: Where does the shoe create a variety of shapes when it touches the edges of the paper?

Rhonda, how about you? Go up to the front of the room and point out some negative shapes that you think are well done, so we all know exactly which ones they are.

Good! I agree with you! What makes those shapes particularly interestintg? That's right!

Thinking about our criteria, Rhonda, what else do you notice about this drawing? Yes, you're right! Does anyone else have anything to add?

Thank you, Rhonda; you can sit down, and we'll get someone else to show us the next criterion.[10]

A critique traditionally is an interactive session during which you can give students feedback about their performance and suggest avenues for future growth or, if necessary, suggest remediation. Students can demonstrate their conceptual vocabulary. They learn to estimate their degree of success. They may wish to elaborate on their sources of inspiration and on the meaning of their work. Critiques can be opportunities to plan future work on related problems, or to decide to redo the project in order to achieve at a higher level.

In a class of 15 to 20 (or more) students, experience shows that completed art projects fall into three easily recognizable categories: projects that meet the objectives, projects that do not, and

projects that go beyond them by presenting unusual or unexpected outcomes, perhaps by transferring concepts to a new context or by introducing new ones. Particularly in group critique settings, students learn to recognize these categories as well as the teacher. The last category can be helpful in illustrating extensions for those advance individuals who might want to take a project further.

With respect to conceptually consistent learning, a critique gives you a chance to determine the extent to which your students have attained your unit objectives. You can easily rate student performance on a three- to five-point value scale, either assigning a global rating to the whole work or rating each criterion item in turn, summing the ratings at the end (see Chapter 10). If you assign grades, your ratings give you a way to do it objectively and fairly. When evaluation criteria are clear, students can take responsibility for meeting (or not meeting) them; "success" is defined as mastery of unit concepts, and "failure" is no disgrace as long as a student is willing to try again.

If you have asked students to create an illusion of shallow space (by overlapping shapes, for example), every drawing in the class should contain it. If all student drawings should fail to show shallow space or other concepts designated in your evaluation criteria, an unlikely event, it means students do not understand them. Have you communicated your evaluation criteria clearly? When you have, you will find that all student drawings contain some of the concepts you have designated—some drawings will have more than others, of course, because some students will understand them better than others—but a few drawings may contain them all.

Differences in students' rates of concept acquisition at any grade level are to be expected. Moreover, if a student should vary other aspects of your assignment, such as subject matter or media, you might find that he or she transferred the designated concepts to another artistic problem sooner than you had anticipated. If such a drawing contains designated unit concepts, it could be a desirable outcome despite its unorthodox nature because it alerts you to above-average understanding.

Look at the drawings from Project 1 to see how they differ. Their differences occur along con-

ceptual dimensions that the evaluation criteria did not designate. Some of these differences are as follows: kind of shoe; size of shoe; placement on the page; ratio of thick to thin and soft to hard lines, and small to large shapes; and expressive quality. You could find more.

When any studio task contains areas in which differences can occur as a result of artistic choices among undesignated concepts, problem solutions will vary among individuals. You should always plan a project to allow for diversity of this kind. Most art teachers consider it desirable, and so do we.

Critical, Historical, and Aesthetic Analysis

Art Information After students have critiqued their own and one another's artwork, you will want to give them an opportunity to strengthen their concept acquisition by learning to recognize unit concepts in other contexts. It's always a good idea to follow a student critique with a critique of additional works of art by adult artists. The primary value of looking at historical art images, for teaching art making, is the opportunity students have to see unit concepts employed by professional artists.

You will ask your students to base their interpretations on what they can actually see: a work's subject matter and its sensory and formal properties (Fig. 9–16). Arriving at features of art in a studio-oriented context parallels activities described in Chapter 8. These can be spoken group activities or individual written work. Art educator Nancy Walkup[11] uses the format in Figure 9–16 to elicit students' observations.

Students will interpret what we have called the work's expressive properties—moods, dynamic states, and ideas. Students learn two things from these activities: first, that artists use the same aesthetic concepts in the real world of art as students do in the classroom; and second, that they can identify their unit concepts in many different

Figure 9-16 Art Criticism: Compare/Contrast. (Work sheet by Nancy E. Walkup, Project Coordinator, North Texas Institute for Educators on the Visual Arts)

contexts (transfer of learning). This activity is more closely related to art criticism than to art history.

You may accompany these additional works of art with information of a historical nature if you wish, as we did in our example of the unit on relief printing. You can also refer to historical information to give students some ideas about why the artists would want to convey the kinds of messages they did. Remember, *how* they conveyed messages is a studio-related inquiry; *why* they conveyed them is historical.

In Projects 1 and 2 of the shoe unit, historical information would include such facts as titles, sizes, dates, and location of all works shown; artists' names, dates of lifespans, countries of origin; and whether each image was a sketch or a finished work. Additional historical analysis could uncover other information about the artist, culture, subject matter, symbolism, and style (see Chapter 8). Understanding why certain historical art objects are considered landmark works can also enlarge students' appreciation of critical judgment.

Critical, historical, and aesthetic activities occur throughout the printmaking unit and the shoe unit to inform the studio process. We have deemphasized them within the present context of a studio art project only in order to point out other, equally important, features of conceptually focused art learning. If Projects 1 and 2 were part of a longer unit of study, you would also need to evaluate student learning of critical, historical, and aesthetic concepts as well as you did the concepts related to art production (see Chapter 10).

Art Images In Project 1, the first five art images you would show as part of critical and historical activities are line drawings by five different artists: Matisse, Kuhn, Kanemitsu, Landacre, and Picasso (Fig. 9–17). They illustrate the unit's line and shape concepts in dissimilar media and styles.

Five line and wash studies by five additional artists (Van Der Werff, Passrotti, an unknown seventeenth-century artist, Redon, and Salvioni, Fig. 9–18) present some concepts from Project 1 but more related to the content of Project 2, the conversion of line into value. These latter five images provide a transition to Project 2, in which students use chiaroscuro to produce volume. Using line alone precedes using line with chiaroscuro, because your conceptual sequence moves from simpler to more complex.

You would direct students' attention to these art images in the same way you used scanning to introduced the vocabulary images during visual analysis. All critical analysis begins with aesthetic perception (see Chapters 6 and 8). In fact, many teachers prefer to use works of art during visual analysis instead of the kind of real-world images or diagram used in Project 1. This is a substitution that any teacher could effectively make with no ill effects—at least, as long as both art and real-world images contain the same artistic concepts, including those of meaning. Remember, teaching visual elements and principles of design by themselves is not enough.

Aesthetic Inquiry Students are apt to raise any number of issues at any time during an art project that might properly be called aesthetic in nature. Because the emphasis in Project 1 is on the studio experience, you might wish to wait until after the drawings are completed to introduce additional aesthetic discussion, perhaps as you are looking at historical images. You might wish to consider some questions such as the following:

- Should a drawing be considered a finished work of art?
- What if a drawing is preliminary to something else, like a painting or sculpture? Can the drawing be independent of the later work?
- If an artist makes a sketch in preparation for an oil painting, is the drawing considered art at all if it is a stage of a longer process?
- Can a drawing be as expressive as a painting? Can it be more so?
- Can a drawing be as valuable as a painting? Monetarily? Artistically?
- Is an artist who makes only drawings a "complete" artist? (Does painting, or sculpture, or printmaking, or glass blowing require more comprehensive knowledge of art than drawing?)

ROLE OF CRITICAL, HISTORICAL, AND AESTHETIC ANALYSES IN STUDIO ART

Your opportunity to draw from several disciplines within a conceptually focused art unit shows students how discipline concepts interrelate. You

Figure 9-17 Five line drawings by different artists (All figures from the Collection of The University of Arizona Museum of Art, Tucson):
(K) Henri Matisse, (French; 1869–1954) *Woman at Table (Girl with Gold Necklace),* 1944. (Gift of Edmund J. Gallagher, Jr. 55.7.7)
(L) Walt Kuhn, (American; 1880–1949) *Woman in Clown Costume,* 1928. (Gift of C. Leonard Pfeiffer, #46.8.2)
(M) Matsumi Kanemitsu, (American; 1922–1992) *Head, 20th Century* n.d. (Gift of the artist, #58.17.2)
(N) Paul Landacre, (American; 1893–1963) *Meadowlark,* c. 1939. (Given Anonymously, 81.4.26)
(O) Pablo Picasso, (Spanish; 1881–1973) *Petit Clown à Cheval,* 1954. (Gift of Edmund J. Gallagher, Jr., 58.1.2)

could teach style characteristics as either historical or critical activity, for example. Much that is central to art history—the documentation of a work from the past—stands outside of the process we call the artist's vision, but knowledge of an artist's life often enhances our appreciation of his or her work. If the emphasis in another unit were on art history, the reverse would be true: a critical under-

standing of a work of art enhances students' perception of the artist's personal and cultural style and other features of historical interest.

Images made by children in an art class are rarely ends in themselves; a comprehensive approach teaches students to appreciate their own work within a larger frame of reference. The critical, historical, aesthetic processes that support their studio activities leads children to perceive similarities and differences between their own artwork and that of their peers as well as of adults. Their own studio involvement makes the aesthetic, historical, and cultural aspects of adult art (its concepts, techniques, and social contexts) "real" for them. All of these together will build the background knowledge that eventually will distinguish these children as artistically educated adults.

INDIVIDUALITY AND AESTHETIC VALUE IN TUTORED IMAGES

Child art displays aesthetic qualities highly valued by adults for the unstereotyped view of the world that it offers. In that respect it is similar to the best adult art. Many artists have expressed the wish that their own work could achieve the candor and naivete of a child's "innocent eye." Art produced by children under traditional art education, the kind often described as teaching toward self-expression, displays this kind of ingenuousness. So, we might add, do most tutored images.

Self-expressive artwork is also thought to differ from one child to another in the same way that work of one adult artist differs from that of another, and that in this individuality lies both the aesthetic and educational value of the self-expressive approach. What tutored images show us, however, is that aesthetic value and educational value are two different things. Some self-expressive art, whose aesthetic value teachers may rate as high, has little educational value.

Conversely, some art problems having educational value (the kinds of work made for practice rather than finished art) do not lend themselves to solutions with high aesthetic value. Also, all tutored images by different children are bound to show some degree of similarity because they will contain the same set of unit concepts. As a result, they may not always have the kind individuality that we have come to expect.

Nevertheless, a tutored image is quite different from child art that is copied or caused by rote learning. In those cases, both unit concepts and all contextual concepts (see Chapter 6) are determined by someone other than the child. The child artist makes no independent artistic decisions.

Aesthetic concepts are worth teaching because children can use them to generate new ideas, the ultimate evidence of individual thinking. Artistic expression requires individual inventiveness, but self-expression does not. Children who study diverse expressive options are able to develop a truly distinctive artistic style that can extend into adulthood.

Ingenuousness and individuality alone are unreliable measures by which to judge the success of art education, therefore. If children's images produced as a result of conceptually focused instruction were consistently "fresh" and diverse, would it indicate that more or better art learning had taken place? Of course not. Unless the images of every student were also to display specific, designated, identifiable unit concepts, they would still be invalid examples of art learning even though they contained aesthetic features that many art educators judge aesthetically pleasing.

Tutored images produced in a solid educational environment can give us a new and more artist-related standard than "universal" developmental styles for what child art can look like at various ages. You will be able to measure your success in studio instruction by comparing the quality of your students' images—aesthetically satisfying and conceptually advanced—to untutored images of other children the same age. And looking at the characteristics of your students' art is absolutely the right way to evaluate yourself.

SUMMARY

Tutored images are child art that show evidence of significant art learning. Children acquire knowledge about making art spontaneously as they grow older, but the purpose of schooling is to guide children through their artistic development more rapidly and to a greater level of proficiency than if left to their own devices. The approach to elementary teaching called coaching comes closest to the kind of teaching used to educate professional artists.

Figure 9-18 Five line and wash drawings by different artists (all figures from the Collection of The University of Arizona Museum of Art, Tucson):

(P) Adriaen Van Der Werff (Dutch; 1714–?) (Attributed to), *A Scene from Roman History*, n.d. (18th century) (Gift of Reuben Guterman, 79.36.9)

(Q) Bartolomeo Passrotti (Italian; 1520/1530–1592) (Attributed to), *Portrait of an Emperor*, (Probably Augustus) n.d. (16th century) (Gift of Reuben Guterman, 79.36.17)

(R) Unknown Spanish artist, *Saint Francis*, (17th century) (Gift of Reuben Guterman, 79.36.11).

(S) Odilon Redon, (French; 1840–1916) *Tete en Profile à la Fenetre*, n.d. (late 19th century) (Gift of Edward J. Gallagher, Jr., 57.1.5)

(T) Saverio Salvioni (Italian; 1755–1833) (Attributed to), *Allegory of Defeat*, n.d. (19th century) (Gift of Reuben Guterman, 79.36.3)

The experience of making art can also help children acquire and apply concepts central to aesthetics, art criticism, and art history. One of these is the distinction between the subject of art and its form; the content or message of art depends on both. Distinguishing between the two is the function of aesthetic perception, and a good art education will teach children this essential artistic skill.

A unit on art production that can produce tutored images will have conceptual consistency, an interweaving of separate conceptual strands from art production, art criticism, art history, and aesthetics. These concepts are interwoven throughout three basic unit components: visual analysis (concept acquisition), art production (solving art problems, constructing new knowledge), and a critical/historical/aesthetic analysis (transfer of learning). This structure for art learning is used in the education of professional artists, and is just as appropriate for elementary students.

Adults value the aesthetic character of child art, particularly art by children eight or under, for its freshness of vision and its apparently individual character. Teaching children to use aesthetic concepts in making art gives children the opportunity to make genuinely fresh, individual statements because they can use them to generate new concepts. Teaching art production in a conceptually consistent way will give you a new standard for what child art can and should look like in a sound educational environment.

NOTES

1. Gardner, Howard. (1991). *The unschooled mind: How children think and how schools should teach*, p. 9. New York: Basic Books.

2. Lanier, Vincent. (1991). *The world of art education*. Reston, VA: National Art Education Association.

3. For a good discussion of the way children learn to compose paintings, see Nancy R. Smith (1983), *Experience & art: Teaching children to paint*. New York: Teachers College Press.

4. Generic visual analysis as described here is a standard part of studio art lessons at any level of schooling.

5. Rush, Jean C. (1989). Coaching by conceptual consistency: Problems, solutions, and tutored images. *Studies in Art Education*, 31 (1), 46–57.

6. The terms *visual analysis, art production*, and *critical, historical, and aesthetic analysis* to describe parts of an elementary art unit come from *The SWRL Elementary Art Program*. Bloomington, IN: Phi Delta Kappa (1977).

7. Adapted from a planning form used at the Western Australian College of Advanced Education, Mount Lawley, Western Australia, 1985.

8. From Rush, Jean C. (1987). "Interlocking images: The conceptual core of a discipline-based art unit." *Studies in Art Education*, 28 (4), 206–220.

9. The vocabulary used on this page and following pages referring to various visual elements and principles of design is explained in Chapter 14. Those of you without backgrounds in art may wish to consult that chapter.

10. Remember that a studio critique is a form of aesthetic scanning. You will find the initiating and continuing questions for scanning in Chapter 8, pages 123 and 124, helpful for encouraging classroom discussion.

11. Walkup, Nancy E. (1996). Personal communication.

10
Accounting for Learning

Let's rejoin Amy, Catherine, and Nicole, our elementary curriculum planners from Chapter 7. They have written their art curriculum guide by now, and are preparing to account for its effectiveness. In doing so, they are collecting evidence about it. They are sitting in classrooms and watching teachers as they try it out. They are observing students as they participate in art lessons. Their evidence will be drawn from teacher behaviors, their perceptions of classroom events, samples of child art (tutored images), children's paper and pencil tests, and the results of teacher assessments of student achievement.

Catherine is visiting the classroom of Lou, a fourth grade teacher. Lou is using the curriculum guide to present an integrated unit on Pompeii. Children are studying Roman mosaics as the art component of his unit. To determine the degree of students' art learning, Lou uses a performance assessment task that asks students to make a paper mosaic similar to the floor mosaics in Pompeii.

Making the paper mosaic is the children's art project as well as an assessment task. It is an authentic art problem. Lou explains in advance which aspects of the mosaic he will evaluate and the rating system he will use. Lou has three standards for each aspect: "terrific," "OK," and "needs work."[1] He shows students examples of

previous student artwork that illustrate each of his three standards.

WHAT IS ASSESSMENT?

For both our curriculum planners and for Lou, *assessment* is the process of evaluating evidence in order to estimate both the extent of curriculum effectiveness or of student achievement. Evidence is information that you can verify by observing objects or events. What students and teachers do, what they say, and what work they produce are all evidence.

When you record your observations of the evidence you generate data. *Data* are records of your observations that can be organized for analysis and interpretation; each recorded observation is a *datum*. You can organize your data in a number of ways; for example, some data can be easily converted to numbers. We will discuss recording your observations later on.

Evidence is neutral. In order to interpret your evidence—to know what it means—you must assign it some value based on a standard of measurement. Evaluation completes the assessment process. Some educators use the terms assessment and evaluation to refer to different practices, depending upon whether they are talking about curricula, students, or programs, but in

fact the purpose of each is to estimate the worth of something.

Curriculum Assessment

Our curriculum planners will collect evidence from other classrooms besides Lou's. They will record their observations of student performance, or the appropriateness of their curriculum for the grade level, or the level of teacher approval. They may rate some of the things they observe, as Lou did, although they may use a more discriminating scale—perhaps a five-point scale ranging from 5, *meets all objectives* to 0, *No observable effect*. They (and Lou) may simply record whether or not some other behaviors or conditions are present.

Our planners can account for their art curriculum only on the basis of evidence whose meaning they can interpret. "Are the problems suitable for children of this age? Can a teacher have easy access to the materials the way they have been designed? Do the tasks take longer than was expected?"[2] Amy, Catherine, and Nicole are testing their curricular hypotheses. Whatever they find out about their curriculum will help them to improve their original ideas.

Student Assessment

The finished paper mosaics provide evidence of what Lou's students' know about art. He examines them carefully. Are the children learning what he wants them to? To what extent does each one understand the concepts involved? How much help does each child need? Lou also gathers evidence of learning from the way students approached the making of their mosaics, from what they said about it during the class critique, and from what they have said and written about the Roman mosaics they studied.

Lou generates evidence by assigning children an art project and examining their finished products. Paper-and-pencil testing is the traditional way of generating evidence of learning in a classroom, but there are many others. You might ask children questions about art that require a reasoned response and listen to their answers. You might conduct a class critique and ask students to talk about their work. You might observe group activity, both directed and undirected, and record what they say and what they do.

Different teachers may value the same evidence differently. Value judgments about the evidence depend on the standards (the expectations or frame of reference) of the person who examines it. Lou may value any given mosaic more highly than you might. One of the biggest advantages of a district-wide curriculum guide, for example, is the likelihood that many teachers will share the same standards for evaluating work from the art program.

Lou can use the evidence from his student assessments for many purposes. Knowledge of outcomes provides *summative* (summed up or final) information on which to base student evaluation and grading. Knowledge about processes provides *formative* information (capable of forming or developing) for diagnosing and improving student behavior. Formative information provides *feedback* to students in counseling sessions, written evaluations, or parent-teacher consultations. When decisions about school funding or life-altering decisions about students (such as promotion, retention, or placement in special classes) depend on assessment outcomes, it is called *high-stakes* assessment.

Accountability

Lou, Amy, Catherine, Nicole, their principal, and their superintendent all assess different things for different reasons. What they share is their sense of responsibility for the effectiveness of their work. For that reason, Lou wants to know the extent to which his students are learning. Amy, Catherine, Nicole, and their principal want to know whether students taught from the guide will acquire the expected art concepts and skills. The district superintendent wants to demonstrate that children in her district are learning art.

Furthermore, the public holds Lou, Amy, Catherine, Nicole, their principal, and their superintendent legally and ethically responsible for the quality of their teaching and curriculum. *Accountability* is their ability to demonstrate that they are acting responsibly. If each of them can provide evidence of what happens in their classrooms or schools or districts, they can account for what they teach and how well they teach it.

We have only to recall the National Standards discussed in Chapter 7 to realize that accountability is one of the chief aims of school

reform. Accountability can be summative or normative. Knowledge of learning outcomes shows parents, the school board, and the public the extent to which their school has fulfilled its community responsibilities. For Amy, Catherine, Nicole, and their principal, knowledge of outcomes provides information necessary for student evaluation, grading, promotions and retentions, and placement in special classes.

Elementary teachers also track students' progress throughout the school year. Teachers want to account for student achievement, that is, the degree to which students attain educational objectives as a result of participating in each art learning situation. Teachers use their knowledge about students' performance to give them *feedback*. Feedback can take the form of a pat on the back, test scores, student counseling, evaluation, or parent-teacher consultations, among other things. For students, knowledge of their progress makes it possible to learn even more.

Evaluation

The term *evaluation* used by itself is more often applied to programs than to student achievement. Program evaluation is a broad undertaking that may rely on evidence more varied and sometimes less well defined than that used for curriculum or student assessment. Part of the evidence in an evaluation of program effectiveness might be the results of a curriculum assessment such as Amy, Catherine, and Nicole are undertaking. Other evidence might be the results of student assessments such as Lou's. A program evaluation might include evidence from assessments of facilities, materials, equipment, and teacher preparation. It might also include undocumented assumptions, perceptions, and holistic conclusions of the evaluator.

Program evaluation is the subject of considerable scholarship in art education. Much of it emphasizes approaches that differ from the evaluation of academic subjects. In 1975, educator Robert Stake coined the term *responsive evaluation*. Responsive evaluation was "an attempt to respond to the natural ways in which people assimilate information and arrive at understanding."[3] It was a subjective alternative to more conventional and precise forms of measurement unsuited to the arts.

Stake saw program evaluation, particularly by an outside evaluator with numbers of observers, as helpful to art teachers when the evaluator's frame of reference was what the teachers themselves were trying to accomplish. On the other hand, he believed that evaluators who judged art programs on the basis of predetermined criteria or expectations were unable to address the subtleties of artistic learning, and their evaluations were therefore irrelevant to the real purpose of art programs.

Art educator Elliot W. Eisner saw a need for evaluation that could define program quality with reference to classroom environments. Eisner sought evidence that provided a more holistic and colorful picture of classroom life than we can get from test scores and counting the number of times a teacher reinforces a student's behavior. He adopted the kind of qualitative inquiry found in art, specifically in art criticism. He called it *educational inquiry* or *educational connoisseurship*.[4]

Kinds of Student Assessment

From this point on we will focus on the assessment of student learning, leaving program evaluation for a later time. We will return to it in Chapter 18, when we discuss the learning environment. Now let us examine two kinds of student assessment, the conventional approach and alternatives to it.

Conventional Assessment

For years, teachers of academic subjects have assessed learning by giving students paper-and-pencil tests of various kinds. In general, conventional assessment is based on tests that require students to select answers rather than generate them. Tests that ask for a true-false or matching response, multiple-choice tests, and some kinds of short-answer tests are example of *selected-response* (also called *forced-choice*) testing. Conventional assessment procedures tell us whether or not students can recall learned (memorized) facts—what Alfred North Whitehead called inert knowledge (see Chapter 7).

Scoring conventional tests saves teachers time; in fact they could score conventional tests by machine, although elementary teachers seldom have large enough class sizes to warrant doing so. Despite this attractive feature, elementary teach-

alternative assessment is based on some kind of active learning; learning and its assessment are one process. Alternative assessment requires students to perform real-life (authentic) tasks. Students perform tasks that depend on "prior knowledge, recent learning, and relevant skills."[9] In 1991 the U.S. Department of Labor reported that students need the following com-petencies in order to enter the workplace. These competencies also define an authentic performance task:

* creative thinking
* decision making
* problem solving
* learning how to learn
* collaboration
* self-management.[10]

Effective performance tasks are those on which students can work for an extended period of time. They are "layered" tasks from which children draw increasing insights over a period of two or more weeks.[11] In art, the following tasks could include all of the competencies listed.

* documenting art objects (art history)
* keeping a journal (all disciplines)
* making and exhibiting student artworks (studio art)
* critiquing finished student artwork or adult art objects (art criticism)
* making and defending aesthetic judgments (aesthetics)
* restoring works of art (art history)
* keeping a portfolio of documents created in class (in studio art in particular, but students can also build portfolios that include documents developed for art history, art criticism, and aesthetic reasoning).

Teachers no longer expect students to respond passively to instruction. They expect students to participate actively by constructing meaning for themselves. Teachers look less for simple, isolated facts and more for multidimensional knowledge used in a way that means something. They still assess students, but they also expect students to be able to assess themselves. Teachers still assess individual performance, but also include collaborative projects that allow them to evaluate students as they work and play together.

Art teachers have always relied on perform-ance-based procedures to assess art making. It is no surprise to art specialists that classroom teachers have borrowed some of their assessment practices such as analyzing artwork, keeping portfolios, and class critiques. These are standard procedures in studio art that require reflection and critical thinking.

Making art has never lent itself to conventional assessment techniques, partly because of the visual nature of aesthetic concepts and partly because making art is a matter of solving problems. In an era of reliance on conventional assessment procedures, educators' inability to develop valid standardized tests in art seemed to demonstrate the inappropriateness of art for general education. (A test is *valid*—has *validity*—when it measures whatever it claims to measure.) With today's emphasis on teaching thinking skills, all of the arts are being appreciated for the problem-solving activities they are.

Nevertheless, we emphasize that there are many ways to accumulate information by which to evaluate students. Conventional assessment procedures remain appropriate tools in some circumstances. In some art learning situations, multiple-choice tests may be a good way to acquire information on students' mastery of basic facts and concepts. On the other hand, some kinds of paper-and-pencil tests qualify as performance tasks because they tell us how well students can put their knowledge to work. Teachers of a balanced curriculum will use both kinds of evidence when they evaluate student learning.

DEVELOPING ASSESSMENT PROCEDURES

What kinds of assessment procedures will you use? How will you develop assessment strategies and materials? Your school district will provide some. Commercial publishers can provide others. If you choose performance assessment—the approach most suited to art and most recommended by experts—you will also find yourself writing many of your own materials.

Common sense will help you organize your approach to assessing your students' learning in art. Here are some guidelines established by Robert Marzano, Debra Pickring, and Jay McTighe to collect evidence about their classroom perform-ance.

ers have become dissatisfied with conventional assessment practices in recent years and have turned increasingly to alternatives (Table 10–1). Their dissatisfaction reflects a change in philosophical emphasis throughout elementary education from modifying behaviors to teaching the kinds of cognitive skills we have discussed in previous chapters.

Conventional assessment is frequently associated with a behavioral view of learning. Behaviorism appeared in schools in the 1940s and influenced elementary education through the 1960s, leaving us with the useful practices of *reinforcement* and developing *behavioral objectives*. Behaviorists chose to modify children's behavior rather than to affect the way children think. Teachers reinforced (rewarded) desired behaviors and ignored undesirable ones. The cognitive (or constructivist) approach to teaching has largely supplanted behaviorism today (see our discussion of teaching styles in Chapter 7). Teachers now rely less on paper-and-pencil tests for assessment and more on problem solving.

Standardized Tests *Standardized* tests are so named because their questions refer to "standards" or "standard information" that all children in a particular group (with similar age and demographic characteristics) are expected to know. The format and scoring procedures of a standardized

test imply that no matter who gives it, to whom, at whatever time or place, the test will measure exactly the same things. A test's ability to measure the same things when being given at different times in different places by different teachers is called test *reliability*.

The only standardized test measuring student achievement in art to have been widely used is the Art component of the National Assessment of Educational Progress (NAEP), which tested students in a number of subjects. It was first given during the 1974–1975 school year and again in 1978–1979. The chief author of the NAEP in Art, art educator Brent Wilson,[5] included a variety of selected-response questions covering art appreciation, art history, art criticism, and making art in the attempt to test students' art knowledge and thinking. Wilson patterned his work on the cognitive taxonomy of Benjamin Bloom[6] discussed in Chapter 7. Reports published by the NAEP show the use of test items covering seven kinds of art processes or domains: perception, knowledge, comprehension, analysis, evaluation, appreciation, and production.[7,8]

Alternative Assessment

Alternative assessment, also called *authentic assessment* or *performance-based assessment*, asks students to construct a response rather than select one. All

TABLE 10–1 Recent Changes in Assessment[a]

Conventional (Behavior modification theory)	Alternative (Cognitive learning theory)
Observations of behavior	Observations of thinking outcomes
Multiple-choice tests	Problems to solve
Passive responses	Active responses
Selection of meaning	Construction of meaning
Memorization and recall	Thinking and inventing
Learning outcomes	Learning processes
Single-occasion observations	Cumulative observations over time
Observe individuals one by one	Observe individuals in groups
Evidence of single attributes	Evidence of multidimensional attributes
Simple skills	Complex skills
Facts out of context	Concepts in context (knowledge)
Accumulation of isolated facts	Application and use of knowledge
Technical skills	Cognitive and metacognitive skills
Single correct answer	Multiple correct answers
Private (local) standards	Public (national) standards
General intelligence	Multiple intelligences

[a] Adapted from Herman, Joan L., Aschbacher, Pamela R., and Winters, Lynn (1992). *A practical guide to alternative assessment.* Alexandria Association for Supervision and Curriculum Development. Figures 2.1 and 2.2, pp. 13, 19.

1. Specify the **content objectives** you expect students to reach.
2. Provide **tests and performance tasks** that would permit students to demonstrate these concepts and skills.
3. Extract the **concepts** that you expect students to acquire.
4. Identify the **criteria** that would allow you to evaluate their ask performance.
5. Link your rating scale to **standards** for judging student performance.
6. Develop a reliable **rating scale**.[12]

Each of these is important because they allow you to provide feedback to students or to inform parents and others about their progress. Remember, they help you know your students better. Let us go through the list item by item and look at each one in detail.

Content Objectives, Performance Tasks, and Concepts

To assess student achievement you must determine your general content objectives, the specific concepts to be learned by students, and the tasks that allow students to demonstrate their acquisition of them. Any single art learning situation can be viewed from these three aspects, and the three must have conceptual consistency (also called *conceptual coherence* by some educators; see Chapters 7 and 9). No matter with which aspect you begin your planning, you will always wind up with all three components at the end.

Content Objectives

Depending on the context, *content objectives* may be called *content standards, learning outcomes, exit skills,* or *educational goals* (see Chapter 7). Whether you find them in the National Standards or in district curriculum guides, they form the skeleton that gives shape to the assessment instruments that you make, either conventional or alternative. Content objectives will range from the general to the detailed.

Content objectives specify the kinds of concepts and skills students are expected to develop. You will look for evidence of these concepts and skills among your students. As you plan assess-

ment procedures, you and your colleagues will ask yourself a number of questions. What are our specific content objectives? Are they teachable? Are they testable? What is their relative importance? Which ones should be tested?

National Standards The National Standards for arts education are sets of content objectives or learning outcomes (although called *content standards* on this document) that cover grades kindergarten through twelve (see Chapter 7). They define what students should know by the time they have completed secondary school.

The Visual Arts component of the National Standards divides its content objectives (content standards), no matter what the grade level, into the following six categories:

1. Understanding and applying media, techniques, and processes;
2. Using knowledge of structures and functions;
3. Choosing and evaluating a range of subject matter, symbols, and ideas;
4. Understanding the visual arts in relation to history and cultures;
5. Reflecting on and assessing the characteristics and merits of their work and the work of others;
6. Making connections between visual arts and other disciplines.[13]

These categories denote general kinds of concepts and skills in art. Each category is subdivided into four groups by grade levels: *K-4, 5-8, 9-12 proficient,* and *9-12 advanced.* Within each grade-level group you will find additional art content objectives (content standards), in each category, that are stated more specifically. All of the objectives in each category for the elementary grades, K-4 and 5-8, are listed in Table 10–2.

Now let us look at the National Standards through the eyes of an elementary-school evaluator—someone charged with determining whether or not students achieve them. Examine in detail the objectives, both general and specific, for the groups that span the school years K-4 and 5-8. The letter in parentheses following each objective (or standard) allows you to compare the same objective at two different grade levels.

You will notice that even though the visual arts National Standards identify concepts and skills, all of the content objectives (content standards) for the elementary grades are written as

TABLE 10–2 Content Objectives in the Visual Arts for the Elementary Grades[a]

Grades K–4	Grades 5–8

1. Content Standard: Understanding and applying media, techniques, and processes

Achievement Standard: Students	**Achievement Standard:** Students
know the differences between materials, techniques, and processes (a)	select media techniques, and processes; analyze what makes them effective or not effective in communicating ideas; and reflect upon the effectiveness of their choices (a)
describe how different materials, techniques, and processes cause different responses (b)	
use different media, techniques, and processes to communicate ideas, experiences, and stories (c)	intentionally take advantage of the qualities and characteristics of art media, techniques, and processes to enhance communication of their experiences and ideas (b) (c)
use art materials and tools in a safe and responsible manner (d)	(same)————————————>

2. Content Standard: Using knowledge of structures and functions

Achievement Standard: Students	**Achievement Standard:** Students
know the differences among visual characteristics and purposes of art in order to convey ideas (a)	generalize about the effects of visual structures and functions and reflect upon these effects in their own work (a)
know the differences among visual characteristics and purposes of art in order to convey ideas (a)	generalize about the effects of visual structures and functions and reflect upon these effects in their own work (a)
describe how different expressive features and organizational principles cause different responses (b)	employ organizational structures and analyze what makes them effective or not effective in the communication of ideas (b)
use visual structures and functions of art to communicate ideas (c)	select and use the qualities of structures and functions of art to improve communication of their ideas (c)

3. Content Standard: Choosing and evaluating a range of subject matter, symbols, and ideas

Achievement Standard: Students	**Achievement Standard:** Students
explore and understand prospective content for works of art (a)	integrate visual, spatial, and temporal concepts with content to communicate intended meaning in their artworks (a)
select and use subject matter, symbols, and ideas to communicate meaning (b)	use subjects, themes, and symbols that demonstrate knowledge of contexts, values, and aesthetics that communicate intended meaning in artworks (b)

4. Content Standard: Understanding the visual arts in relation to history and cultures

Achievement Standard: Students	**Achievement Standard:** Students
know that the visual arts have both a history and specific relationships to various cultures (a)	know and compare the characteristics of artworks in various eras and cultures (a)
identify specific works of art as belonging to particular cultures, times, and places (b)	describe and place a variety of art objects in historical and cultural contexts (b)
demonstrate how history, culture, and the visual arts can influence each other in making and studying works of art (c)	analyze, describe, and demonstrate how factors of time and place (such as climate, resources, ideas, and technology) influence visual characteristics that give meaning and value to a work of art (c)

TABLE 10–2 **Content Objectives in the Visual Arts for the Elementary Grades[a] (Continued)**

Grades K–4	Grades 5–8
5. Content Standard: Reflecting upon and assessing the characteristics and merits of their work and the work of others	
Achievement Standard: Students	**Achievement Standard:** Students
understand there are various purposes for creating works of art (a)	compare multiple purposes for creating works of art (a)
describe how people's experiences influence the development of specific artworks (b)	analyze contemporary and historic meanings in specific artworks through cultural and aesthetic inquiry (b)
understand there are different responses to specific artworks (c)	describe and compare a variety of individual responses to their own artworks and to artworks from various eras and cultures (c)
6. Content Standard: Making connections between visual arts and other disciplines	
Achievement Standard: Students	**Achievement Standard:** Students
understand and use similarities and differences between characteristics of the visual arts and other arts disciplines (a)	compare the characteristics of works in two or more art forms that share similar subject matter, historical periods, or cultural context (a)
identify connections between the visual arts and other disciplines in the curriculum (b)	describe ways in which the principles and subject matter of other disciplines taught in the school are interrelated with the visual arts (b)

[a]Consortium of National Arts Education Associations, (1994). *National standards for arts education*. Reston, VA: Author, pp. 121–127.

behavioral objectives—things students are expected to know, describe, use, select, generalize about, explore, understand, identify, and so on. Are they teachable? If so, when and how? Are they testable? How? Which are the most important? Which least? The Standards, then, are only one aspect of art assessment, so let us look futher.

Dimensions of Learning Evaluator Robert J. Marzano and his colleagues suggest five dimensions of learning (content objectives or standards) in any subject that can be measured by performance assessment tasks. He calls them *lifelong learning standards*. They stress higher-order thinking skills and the use and communication of knowledge. They are compatible with the National Standards in art.

Marzano's five lifelong learning standards are as follows:

- Category 1: Complex thinking standards.
 Students should be able to use a variety of complex reasoning strategies:

 - Comparing
 - Classifying
 - Analyzing perspectives
 - Decision making

 - Induction
 - Deduction
 - Error analysis
 - Constructing support
 - Abstracting
 - Investigation
 - Experimental inquiry
 - Problem solving
 - Invention

- Category 2: Information processing standards. Students should be able to gather, interpret, and determine the value of information.
- Category 3: Effective communication standards. Students should be able to express what they have learned to others in a clear way.
- Category 4: Collaboration/cooperation standards. Students should be able to use interpersonal skills to contribute to group goals.
- Category 5: Habits of mind standards. These fall into three areas: self-regulation, critical thinking and creative thinking.
 - Self-regulation. Students are aware of their own thinking, respond to feedback, and can evaluate the effectiveness of their own actions.
 - Critical thinking. Students seek accuracy, are open-minded, and take a position when the situation warrants it.
 - Creative thinking. Students engage intensely in tasks even when answers or solutions are not immediately apparent

- They push the limits of their own knowledge and abilities.
- They generate, trust, and maintain their own standards of evaluation.
- They generate new ways of viewing a situation outside the boundaries of standard conventions.[14]

Performance Tasks

Some of Marzano's lifelong learning standards suggest behaviors or activities that a teacher could observe, such as gather, classify, abstract, employ, and interpret. But gather what? Interpret what? Other objectives stress knowing and generalizing—cognitive activities that we cannot observe directly. All of these objectives are purposefully left vague enough so that many teachers can use them in their own ways. Now we must select performance tasks that will demonstrate all of these objectives.

Let us use familiar material to illustrate a performance task. Think of the Grade 8 unit on drawing shoes, discussed in Chapter 9. The shoe unit is a performance assessment task, although we did not call it that. It is organized in a way that produces evidence. The unit incorporates many of the content objectives from the National Standards in Art and Marzano's lifelong learning standards.

National Standards Working from just one category of content objectives from the National Standards, the ones that concern *using knowledge of structures and functions,* let us see how the shoe unit would address them. Our first job is to define *structures* and *functions.* We look in the visual arts glossary that accompanies the National Standards:

> Structures: *Means of organizing the components of a work into a cohesive and meaningful whole, such as sensory qualities, organizational principles, expressive features, and functions of art.*[15]

The National Standards glossary does not define functions. We must do it ourselves. Turning to the dictionary, the most appropriate definition for function seems to be the one for grammar referring to the role or position of a linguistic element in a construction. Let us say that function in the sense used in *structures* and *functions* in the National Standards is as follows:

> Function: *The role or position of an artistic element in a work of art.*

The shoe unit asks students to make a drawing of a shoe. We ask them to use both sensory and formal aesthetic properties (elements and principles of art). We ask them to express the character of a particular shoe. We ask them to compose the drawing, or in other words to consider how the elements, principles, and expressive qualities work together in order to convey an idea about a particular shoe. To complete the drawing and critique it, students need to use and analyze structures and functions, as defined.

Lifelong Learning Standards As students look at real shoes, photographs of shoes, and other images during visual analysis, they exercise a number of cognitive skills. They compare, classify, and abstract the features of the images that allow them to form aesthetic concepts of line, shape, composition, and so on. Making the shoe drawing constitutes experimental inquiry that uses inductive and deductive reasoning, decision making, and invention. The subsequent critique of the completed drawing requires students to process information, interpret, evaluate, construct support, and communicate. If it is a group critique, we might even find it required collaboration.

Concepts to Be Acquired

With content objectives and a task for students in hand, the first hurdles to developing assessment procedures are behind you. Now it is time to attend to the specific concepts you will teach. The shoe unit again provides us with an example for teaching art production. The learning objectives indicate that students will recognize and use aesthetic concepts of contour, line, shape, overlapping, proportion, and space. (For a more detailed discussion of these concepts and how they figure in the unit, see Chapter 9.)

The artistic concepts embodied in the learning objectives are made visible to students by means of vocabulary words. The vocabulary words present specific concepts to students. These concepts become the students' objectives as they make a contour drawing. In the shoe unit students are to use the following concepts:

- Contour: edge, external contour, internal contour
- Line—kinds: short or long, thick or thin, straight or curved, etc.
- Line—qualities: rigid or relaxed, smooth or rough, mechanical or natural, etc.
- Shape: positive, negative, overlapping
- Space: shallow

These concepts become the focus of unit objectives related to art criticism, art history, and aesthetic inquiry as well as art production. We recognize that there can be others. Their identification and construction would follow this same pattern.

EVALUATION CRITERIA, STANDARDS, AND RATING SCALES

The end point of gathering evidence is its use in evaluating student performance. Evaluation requires human interpretation and judgment. Conventional assessments may call for either-or judgments (either right or wrong), but alternative assessments require more qualitative decisions. Teachers use three tools to keep the evaluation process as objective and as fair as possible: evaluation criteria, rating scales, and standards. These tools are helpful whether you are judging individuals or groups, products or processes, knowledge of facts or problem solving.

Evaluation Criteria

Evaluation criteria (sometimes called *scoring criteria*) identify distinct features or dimensions of student classroom performance. They designate the evidence of learning that you will examine in order to judge your students' achievement. Criteria also let others know what is being judged. If you do not establish evaluation criteria for students' classroom activities, they are simply activities—not assessment procedures.

Judy Arter, manager of the Evaluation and Assessment Program at the Northwest Regional Educational Laboratory (NWRL) says that "developing good criteria requires a change in approach for most teachers. . . . We tend to be better at designing meaty, rich, 'authentic' tasks than at developing the criteria we use to judge quality performance on the task," she says. "We are used to having assessment mean task, activity, project,

or problem, because that's the way it is on multiple-choice tests—you just score them right or wrong. "[16]

Appropriate Criteria Appropriate criteria, shared with students, are essential for good performance assessment. Perhaps you might ask your students to paint pictures describing something that happened during their summer vacations. After students have finished, if you evaluate their paintings according to how lively their color is, how much movement their figures display, and how well they filled up the page, you would be using inappropriate criteria. Why? Because you did not communicate these criteria to your students.

Let us say you want more from your students than a painted narrative. You also want their paintings to look "artistic," however you define it. You may hesitate to explain all of your criteria—lively color, movement, a well filled page, or whatever they might be—because you think they may infringe on your students' creative choices. In fact, the more clearly you communicate your standards for excellence, the more likely your students are to achieve them.

Evaluation criteria must represent your major content objectives. Think of evaluation criteria as the form in which you present your content objectives to your students. Their evaluation criteria—not your objectives—are what you discuss with your students. Criteria make your objectives real for your students, because the criteria become *their* objectives. Your performance tasks will not produce valid, useful information unless you use appropriate evaluation criteria.

Analytic and Holistic Criteria There are two kinds of evaluations, analytic and holistic. A teacher who looks at a student painting and rates color use separately from figure movement, and figure movement separately from filling the page, is taking an analytic approach. A teacher who looks at a work of art, or listens to a critique, or reads an art history paper and assigns it a single score is making a holistic evaluation. Each has advantages and disadvantages.

Analytic criteria provide more evidence about individual students' performances. They allow teachers to diagnose students' strengths and

weaknesses and to provide them with feedback that is helpful because it is specific. Most teachers who make "holistic" evaluations consider a number of more specific criteria in the process, like the one just described who assigned paintings of summer activities. If so, it is difficult to keep from applying them selectively. If a teacher who habitually uses "holistic" evaluations scores analytic criteria one-by-one and then totals them, the overall score—with each component weighted equally—is likely to be a surprise.

Evaluating student work by the holistic method takes much less time, however, and this a characteristic appreciated by every teacher. Teachers who know their students well are best able to make accurate holistic evaluations. Holistic evaluations are particularly suited for identifying students working above or below grade level; the teacher can then analytically evaluate those showing minimum competency in order to work with them further. Holistic criteria are also well suited to final evaluations at the end of a grading period.[17]

Criteria for an Art Project You will use criteria in the shoe unit (Chapter 9) that will allow you to make an analytic evaluation of completed student artwork. Each criterion will identify a dimension of the final drawing that is different from all of the others. You will write these criteria on your posters or chalkboard for all students to see as they work. The explanation following each criterion is what you might say to your students. The shoe unit is at an eighth-grade level, but these criteria can be understood by much younger children.

Addressing your students, you say, *Each of your drawings should contain the following things:*

- **Shoe touching two edges of paper.** Parts of the shoe you draw should touch at least two edges of the paper. This helps you create a variety of positive and negative shapes. Every artist is responsible for organizing the entire format—in this case your 9 × 12″ piece of paper. Your composition will be less interesting if your shoe "floats" in the middle of a blank page.
- **Interior and exterior contours.** Draw more than just the outline of your shoe. Notice the many shapes inside the shoe. Let your pencil "drift" along the contours; make it sensitive to even small bumps and changes of direction. Look and draw slowly; you will see more. Visual interest depends on variety.

- **Thick-thin, soft-hard, and dark-light lines.** Remember to let your lines vary from thick to thin, soft to hard, dark to light. How you use your pencil depends on what you see in your shoe. Press hard when the line goes away from you, lighten up as it comes closer. Variety in your line quality can express the character of your individual shoe.
- **Small, medium, large, and overlapping shapes.** When we talk about "interesting shapes," what do we mean? One thing is shapes of different sizes; shapes all the same size would be boring. Find places where shapes overlap, so you can create shallow space—either within one shoe or by placing one shoe on or in front of another in your composition.
- **Expressiveness and detail.** Remember that you are drawing a specific shoe. Your pencil lines and the shapes you create convey information about your specific shoe to people who will see your completed drawing. Make sure they recognize your shoe and not confuse it with someone else's.

Criteria for Basic Art Behaviors Art educator Carmen Armstrong identifies seven categories of art behaviors whose value for art learning many art educators recognize. These behaviors are *knowing, perceiving, organizing, inquiring, valuing, manipulating,* and *cooperating (interacting).*[18] These can become criteria by which to evaluate art learning and participation in classroom activities. Again, the criterion is printed in boldface type and the explanation following it is what you might say to your students (or to their parents).

Each of you (or your child) should be able to do the following things:

- **Know:** Knowing refers to recalling facts and concepts when asked, or otherwise demonstrating the retention and application of knowledge.
- **Perceive:** Perceiving refers to detecting and describing fine visual differentiations that contribute to the interpretation and creation of works of art.
- **Organize:** Organizing refers to forming concepts, applying concepts and principles, and making generalizations using ideas in speaking, writing, and artistic images.
- **Inquire:** Inquiring refers to problem solving, invention, risk taking, reflection, and other higher-order cognitive skills.
- **Value (art, self, own work):** Valuing refers to appreciating of art, making informed choices, moving from an egocentric value system to a concern for others, and showing self-confidence.

- **Manipulate:** Manipulating refers to using refined motor skills with tools and media in a way that contributes to intended meaning of artwork.
- **Interact/cooperate:** Interacting and cooperating refer to the exercise of self-discipline, responsibility, empathy, and leadership.[19]

Stating art criteria unambiguously is a skill worth learning for many reasons. Unambiguous criteria define dimensions of the product or process in question that are distinctly different from one another. Each criterion is short. Each is concrete. Three to five criteria are sufficient even for analytic assessment. When art criteria are well defined they are much more likely to be understood by students.

Having good criteria is even more important for those who are conducting a *high-stakes*[20] assessment. A high-stakes assessment is made to determine such things as school entrance, retention, graduation, program evaluation, and so forth. In high-stakes assessment, consistency in scoring becomes important—either from one testing occasion to the next, or when a test is given by more than one teacher. Scoring consistency is also called *reliability*. Unambiguous criteria can improve test reliability.

Standards

Criteria by themselves do not indicate how well or poorly a student performs. You determine the degree to which any student's work meets an evaluation criterion on the basis of some standard. Your *standard* is your general expectation of student performance. You may judge your students by either absolute or relative standards.

Absolute Standards Absolute standards rely on an idea of excellence inherent in each art discipline. In order to decide whether sixth-grade student Robert's critical essay on the similarities between Picasso and Braque is excellent, good, or inadequate, for example, we would turn to teachers of art criticism to specify what should be included in such an essay. Art teachers have had a difficult time establishing absolute standards because of the visual character of aesthetic concepts and individual nature of creating art.

An absolute standard in the classic sense (also called a criterion) is specific. Eisner cites John Dewey's 1934 definition of an absolute stan-

dard as grounded in a physical measurement such as weight or volume. Under this definition, to pass a test that is criterion-referenced you must meet the standard employed. For example, you must be four feet tall to ride unaccompanied on the roller coaster at the fair; if you are three feet and eight inches, you will be turned away. Child art and other products of art education do not lend themselves to being measured in this sense.[21]

In everyday use, a test that is called *criterion-referenced* measures what a student knows or does not know, although most teachers prefer to report the degree to which students meet the standard rather than simply whether they pass or fail. Even so, we have some idea of what constitutes a standard of excellence in art although we cannot always describe it with numbers. When we refer to an absolute standard in the context of assessment, this idea of excellence is what we mean. We cannot evaluate student achievement in art without referring to it now and then.

Relative Standards You will probably use relative standards more often than absolute standards. You are using relative standards when you compare the performance of one student to another, or one group of students to another group. Art teachers often compare the performance of current students to their idea of typical grade-level performance, which is based on their experience with past classes.

Standardized tests also use a relative standard. Standardized tests compare students to a national norm. A *norm* is a typical test score determined by testing many students with characteristics similar to the children in your class. A norm is "the score at the 50th percentile achieved by a national sample of students."[22] We call these kinds of tests *norm-referenced*.

Let us suppose you design a test to demonstrate students' performance on aspects of an art project that you have declared important. You spell these out in your evaluation criteria. The criteria are learning outcomes expected in a specific art learning situation, and your test is designed with them in mind. This kind of test is also called criterion referenced. However, you can evaluate students' performance using a relative standard of excellence.

If you compare this year's students to last year's, that is using a relative standard. If you "decide at the beginning of a class that the top

portion of students will get A's, the middle will get B's and the bottom will get C's or D's, with no further definition of what level of performance is expected for each grade, that is using a relative standard. This kind of relative standard merely ranks students."[23]

Relative standards pose some concerns. You might not want to give students "A" grades if they had not performed at that level in some absolute sense. It could give them an inaccurate perception of their abilities and be misleading in terms of taking later classes. On the other hand, what if most of the class performed exceptionally well? If you were grading "on the curve," you might have to give some of them lower grades—implying lower performance on an absolute scale. In practice all teachers reference their levels of performance to absolute or discipline standards to some extent. It is difficult to dispose of absolute standards altogether.

National Standards The writers of the National Standards in art tried to keep in mind that artistic creation is an individual achievement and therefore open to unlimited variety through personal choice. Nonetheless, the introduction to the National Standards suggests their writers' intention to represent an absolute standard of excellence. The introduction states that National Standards

> can make a difference because, in the end, they speak powerfully to two fundamental issues that pervade all of education—quality and accountability. They help ensure that the study of the arts is disciplined and well focused, and that arts instruction has a point of reference for assessing its results. . . . They will help our nation compete in a world where the ability to produce continuing streams of creative solutions has become the key to success.[24]

The National Standards in art are not absolute standards, however, either in Dewey's measurable sense or in the artistic sense of absolute excellence. Within the context of our chapter, the National Standards best fit the definition of content objectives. When you report the extent to which your students are able to "select and use the qualities of structures and functions of art to improve communication of their ideas," you must apply your own notion of excellence—

your standard with a small "s"—whether absolute or relative. When you wish to operationalize the National Standards (convert them into specific activities for classroom use), you must devise your own evaluation criteria for this purpose and then apply your standard of excellence to the work that students give you in response.

Rating Scales

Performance tasks do not have a single correct answer. Often, you will indicate the extent to which a student meets each of several criteria by a score on a rating scale. You can then place a value on each student's overall performance, guided by each of your evaluation criteria.

Your evaluation—your idea of what is excellent or less than excellent—will convey information to students that either encourages them to continue as before or to do something differently in the future. This is the reason that aspects of student performance selected as evaluation criteria should be characteristic of the underlying discipline. Remember, you always share your evaluation with students as they begin work on each performance task.

Other names for evaluation criteria include scoring criteria, scoring guidelines, rubrics, and scoring rubrics. A *rubric* (sometimes also called a *schema*) simply means a limited number of criteria that represent the entire performance task. "More specifically, a scoring rubric consists of a fixed scale and a list of characteristics describing performance for each of the points on the scale."[25]

Rating Scale Values A rating scale is a scale of values. It allows you to indicate the quality of each aspect of student performance. The scale may employ numbers (1–5), or letters (a–e), or adjectives (excellent–poor), or phrases (*offers accurate analysis of the information and issues—reiterates one or two facts without complete accuracy*[27]). No matter which kind of notation is used, each step on the rating scale stands for how well a student accomplishes a given task; it ranges from exceptional to minimal achievement."[27]

Scales for classroom use generally contain three to seven steps, depending on a teacher's needs. The number of steps should reflect the kinds of decisions teachers need to make, and whether they are diagnostic or descriptive. If you

want to identify fine distinctions among students, or if you are going to assign grades, you may want to use a five- or six-step rating scale. If you only want to identify low, medium, and high achievers, a three-point step will do. Here are some examples of rating scales:

Three-step rating scale
E Excellent
G Good
NI Needs Improvement
* * * *

Five-step rating scale
I Minimal achievement
II Rudimentary achievement
III Commendable achievement
IV Superior achievement
V Exceptional achievement
* * * *

Six-step rating scale
0 no response
1 no concepts/principles
2 one concept/principle
3 two concepts/principle
4 three concepts/principles
5 four or more concepts/ principles
* * * *

Seven-step rating scale
6 Exemplary response
5 Competent response
4 Minor flaws; satisfactory
3 Serious flaws; nearly satisfactory
2 Begins; does not complete problem
1 Unable to begin effectively
0 No attempt[28]

Teachers rate each student's performance with respect to each criterion. If a number of teachers will be rating students, they will need to agree on the description of each dimension to be rated and the value assigned to it. This is called *interrater reliability*, and achieving it is absolutely necessary if performance-based art assessment is to be taken seriously. Coming to a consensus may require in-service training. The longer the scale, the more difficult it will be to agree.

Checklists A checklist is a simple two-step rating scale for descriptive purposes only. Teachers check only whether or not they observe the behavior or skill; they do not indicate its quality. "Primary school teachers find checklists useful because they must often determine how students are developing according to some theory of skills acquisition. For example, current language acquisition theory suggests that this skill cluster supports a child's ability to read:

- Ability to draw or depict an idea.
- Ability to recognize sound-letter correspondence.
- Ability to recognize that words stand for something.
- Knowledge of left to right and up-to-down page orientation.
- Ability to recall and retell favorite stories."[29]

Fairness You want to construct your tests, performance tasks, learning objectives, and evaluation criteria in such a way that you do not inadvertently discriminate against any group of students. Pay particular attention to students from various gender, racial, or ethnic groups, or students with special learning or physical needs. Discrimination in this sense means that one group of students would have an advantage in answering test questions or completing a performance task because of the way it is structured.

One of the most overlooked forms of bias is language. Try to substitute neutral terms for those that might convey a meaning you did not intend: use *technical quality* instead of craftsmanship, for example, *hearing impaired* instead of deaf, *Asian* instead of Oriental. Make sure members of all groups have had opportunity to acquire concepts and skills to be assessed. Ask yourself whether any test items or evaluation criteria perpetuate stereotypes about any student's race, national origin, gender, or physical abilities.

Grading You may attach letter grades to your rating scale. For art projects, grades can correspond to the rating scale used to evaluate the project. In that case, each letter has specific descriptors. For a period of time like a unit or a semester, grades represent values that represent an average rating for a number of observations throughout the time period. Each letter grade will have an inclusive descriptor such as *A, Superior, B, Good, C, Satisfactory, D, Needs improvement, F, Unsatisfactory.*

Reporting grades Perhaps you would like to provide students and their parents with more feedback that a single letter grade offers. Art educator Carmen Armstrong gives us a useful model for a traditional report card based on her identification of seven categories of art behaviors (Table 10–3). It reports a set of subscores for a given time period rather than a global score such as a letter grade. A subscore is provided for each of the seven categories of art behaviors. The five-step rating scale for each behavior runs from *No Evi-*

TABLE 10–3 An Individual Report Card for Art[a]

			Name _____ Elda _____
Behavior	Weight		Sub-score comment
KNOW	1	Exemplary	Recalls over 85% of information taught.
PERCEIVE	1	Expected	Visually differentiates with accuracy.
ORGANIZE	2	Exemplary	Logical organization of thoughts, forms and images into a meaningful synthesis.
INQUIRE	2	Evidence	Curious. Considers illogical search procedures.
VALUE	2	Evidence	Subject interest in works of art. Insecure about own work.
MANIPULATE	1	Expected	Constructs, draws, models at age-appropriate level.
INTERACT/ COOPERATE	1	Exemplary	Self-disciplined. Peacemaker. Empathetic.

[a]Armstrong, Carmen (1994). *Designing assessment in art*. Reston, VA: National Art Education Association, p. 182.

dence (on the low end) through *Entry*, *Evidence*, and *Expected* to *Exemplary* (on the high).

A look at the rubric or schema behind the report card makes the grading system clear (Table 10–4). For each behavior there is a descriptive phrase that explains the criterion used. Teachers can quickly convert their numerical ratings into a report card that communicates information to parents that clearly describes their children's performance. Good communication between school and home benefits teachers, parents, and especially students.

FORMATS FOR PERFORMANCE ASSESSMENT

There are many kinds of assessment formats you may wish to use, providing many kinds of products to be assessed. Table 10–5 lists a number of these. Space permits us to take a closer look at just a few of them. They serve as examples only. For a lengthier collection, we refer you to Armstrong's book *Designing Assessment in Art*.[31]

We will look only at examples of performance assessment. These are of most current interest to elementary teachers. Keep in mind, however, that asking students for facts is a useful and acceptable assessment procedure, for which there is no substitute. Don't omit it from your assessment repertoire; use it in combination with performance tasks.

Paper and Pencil Tests

Not all paper and pencil art tests require passive responses from students. While some assess factual information, some assess students' ability to think and solve problems. Some tests, therefore, qualify as performance tasks.

You can see several examples of these kinds of tests for elementary grades in Tables 10–6, 10–7, and 10–8.[32] They require students to apply aesthetic concepts in much the same way they would apply them through making art or writing art criticism. For example, one test for the primary grades (Table 10–6) shows four photographs of real-world objects: a bird's nest, porcupine quills, melting patches of snow, and a sky scraper under construction. There are also reproductions of four paintings: Helen Frankenthaler's *Blue Atmosphere*, Adolf Gottlieb's *Brink*, Piet Mondrian's *Composition Number 2*, and Vincent Van Gogh's *Irises*. The question for students is, "In which works of art shown has the artist created an effect similar to one of the real-life photographs in the top row?"[32]

On the test, each real-world photograph is identified by a letter and each painting reproduction by a number. Students can answer this question by simply writing a number on an answer sheet or filling in a blank on a form for machine scoring. The answer is either right or wrong. The ease of scoring belies the high level or complexity of thought required to complete this kind of a test.

Art Projects with Rating Criteria

Learning and assessment always go hand in hand. Chapter 9 presents an art production unit organized in such a way that the finished project can be used as an assessment task. The act of drawing

TABLE 10–4 Rubric (Schema) for an Individual Report Card in Art[a]

Behavior	Sub-score weight	No evidence	Entry	Evidence	Expected	Exemplary
KNOW	1	Does not demonstrate art knowledge	Shows little retention of art information	Needs prompts to recall art information	Retains 70–85% of art information assessed	Recalls over 85% of information assessed
PERCEIVE	1	Apparently unaware of a visual world	Makes only obvious visual discriminations	Uses visual qualities appropriately in making art. Notices some specific qualities of works of art.	Visually differentiates accurately in viewing and creating. Notices particular qualities of work.	Makes fine visual differentiations that contribute to effectiveness in interpretation and creation of works of art.
ORGANIZE	2	No attempt to put concrete objects together as groups.	Arranges concrete items into groups	Shows some organization of images and ideas. Plans.	Relates ideas, images, or forms to communicate effectively.	Logical organization of ideas, images and form into meaningful syntheses.
INQUIRE	2	No inclination to search.	Conforming, impulsive. Does not question.	Curious, considers illogical search procedures.	Experimental, flexible. Uses reasonable search procedures.	Innovative, reflective, divergent questions. Moderate risks in searches.
VALUE ART, SELF, OWN ART WORK	2	No awareness of art. Self-value not	Disinterest and/or self-degrading about art.	Subject interest in works of art. Insecure, non-committal about own art.	Story interest in art works. Associates art with experience. Secure.	Unprompted appreciation. Interest in meanings. Self-confident
MANIPULATE	2	No use of tools. No evidence.	Gross motor control with tools and media.	Control with simple tools and media for age level.	Constructs, models, draws at age-appropriate level.	Refined motor control with tools and in media contributes to intended
INTERACT/ COOPERATE	1	No interaction with others.	Somewhat disruptive. Some inconsiderate acts.	Complies, tries, is accommodating. Cooperates.	Contributes. Helpful to others. Respectful.	Self-disciplined. Empathetic. Peacemaker. Leadership.

[a]Armstrong, Carmen (1994). *Designing assessment in art*. Reston, VA: National Art Education Association, p. 181.

TABLE 10–5 **Assessment Formats**[a]

Assessment processes	Products to be assessed
• Clinical interviews • Documented observations • Critiques (student explains degree to which project meets objectives/rating criteria) • Student learning logs and journals; portfolio review • Student self-evaluation (oral or written) • Critiques (debriefing interviews) about student projects, products, and demonstrations/investigations (student explains what, why, how; reflects on possible changes) • Behavioral checklists • Student think-alouds in conjunction with standardized or multiple-choice tests	• Essays *with evaluation criteria* • Projects (artwork, documentation of an art object, art criticism, aesthetic reasoning), *with evaluation criteria* • Descriptive, interpretive, and critical essays *with evaluation criteria* • Student portfolios *with evaluation criteria* • Untutored paintings, drama, dances, and stories, *with evaluation criteria* • Student demonstrations/investigations (expository or using the arts) *with evaluation criteria* • Attitude inventories, surveys *with evaluation criteria* • Standardized or multiple-choice tests, perhaps with section for "explanations" *with evaluation criteria*

[a]Adapted from Herman Joan L., Aschbacker, Pamela R. and Winters, Lynn (1992). *A practical guide to alternative assessent.* Alexandria, VA: Association for Supervision and Curriculum Development, Figure 1.3, p. 7.

TABLE 10–6 **Visual Quality-Matching of Object and Reproduction**[a]

[a]Armstrong, Carmen (1994). *Designing assessment in art.* Reston, VA: National Art Education Association.

demonstrates students' ability to apply aesthetic concepts taught earlier in the unit. The techniques for integrating teaching and assessment do not need repeating here. We wish to point out, however, that a completed art project is only one kind of evidence available from the shoe unit or any elementary art learning situation.

Remember that you can use more than one kind of assessment format in the same unit or to test students' command of the same concepts. You could use paper-and-pencil tests like those described above in the shoe unit, for example, either before or after students complete their art-work. You could also delay giving such a test for several weeks to gauge students' retention of these concepts.

You could (and should) evaluate students on their critiques of their own completed art projects during any unit. Can they put the aesthetic concepts into words? Can they communicate them clearly to their classmates? Can they identify them in works by adult artists? You could (and should) also evaluate students on their ability to identify historical information: associating artists' works with names, styles, and perhaps historical contexts, depending on grade level.

TABLE 10–7 Matching Reproductions and Clues to Interpretations[a]

Picasso's *Still Life with Antique Bust*	Van Gogh's *Sunflowers No. 2*
Objects around us are too special to look at in only one way.	The flowers are alive!
Goya's *Madame Sabasa Garcia*	Renoir's *Children on the Seashore*
Poised and elegant, but reserved and somewhat cool young woman.	Happy, but quiet time with older children caring for younger ones.

Blacken the number on your answer sheet (or circle the letter) of the clue that best fits the picture and its meaning. Each reproduction posted (or below) has a meaning written under it. Match the clues (what the artist did to make people arrive at that meaning) with the correct picture and its meaning.

____ a. the brightly colored shapes twist and turn.
____ b. soft colors, position, and proximity of subjects to each other.
____ c. value contrasts, erect posture, detail of lace, and fabric texture.
____ d. limited color, emphasis on shapes, different viewpoints of objects.

Matching modification. By asking students to supply a reason for their selection, the following example introduces a human judgment component to the matching item which is scored subsequently to machine scoring.

[a]Armstrong, Carmen (1994). *Designing assessment in art.* Reston, VA; National Art Education.

TABLE 10-8 Art Card: Definitions of Terms[a]

A R T

formal balance	foreground	pattern
movement	complementary colors	coil pottery
visual texture	value contrast	organic shapes

To play Art Card, students take turns drawing definitions from the draw stack. Art Cards can be made from paper the same size as individual blocks on the art card. If the definition fits a concept word on one's card, it is placed on top of the concept. If the definition does not seem to fit a concept on the card, it must be discarded. Drawing definitions continues in turn (reusing the discard pile) until the students have covered as many spaces as possible with correct definitions for the concepts underneath or time runs out. Empty spaces and/or incorrect matches between concepts and definitions subtract from the total score of 9.

Note: Arrangement of concepts on cards can be scrambled. There should be an art card and complete set of definitions made for all players. Crossword puzzles are another way to help students commit definitions to memory if that is a desired outcome.

[a] Armstrong, Carmen (1994) *Designing assessment in art.* Reston, VA: National Art Education.

Student Portfolios with Rating Criteria

Think of a portfolio as a way to track all of the kinds of work children might produce in art: sketches or sketchbooks, finished artwork, journals, tests, critical or historical studies, art reproductions or photographs they are using to generate ideas, vocabulary lists, or interpretive essays. A portfolio is a collection of work made on several different occasions over some period of time. Art teachers have used portfolio reviews as a way of evaluating student artwork for generations. Many elementary classroom teachers are discovering their advantages for other subjects.

One of the advantages of a portfolio review is being able to compare the results of more than one assessment task. A second is being able to see results of a variety of tasks. A third is being able to recognize the changes in one student's work with the passage of time. A fourth is being able to include examples for a number of reasons, which could differ at different times. A fifth is the active participation of students in the assessment process. This wealth of information allows you and your students to develop a more complete understanding of their performance than you can with fewer, sporadic, unrelated tests.

Arter and Spandel[33] summarize the kinds of concerns teachers should keep in mind when using portfolios or other comprehensive assessment systems:

1. How representative is the work included in the portfolio of what students can really do?
2. Do the portfolio pieces represent coached work? Independent work? Group work? Are they identified as to the amount of support students received?
3. Do the evaluation criteria for each piece and the portfolio as a whole represent the most relevant or useful dimensions of student work?
4. How well do portfolio pieces match important instructional targets or authentic tasks?
5. Do tasks or some parts of them require extraneous abilities?
6. Is there any method for ensuring that portfolios are reviewed consistently and criteria applied accurately?

The ARTS PROPEL curriculum project, operated at the middle (and high) school level in the Pittsburgh Public Schools by Harvard Project Zero,[34] emphasizes alternative assessment practices. One of their primary assessment tools is portfolio review. In order to characterize their use of portfolio review as a normative or diagnostic process, the Project Zero researchers call them *process-folios*. Process-folios exhibit all of the portfolio characteristics previously described.

Criteria for Portfolio Review We discuss the purpose and makeup of elementary art portfolios in greater detail later on in this chapter. Each item in a portfolio would carry with it a set of evaluation criteria based on its use in a learning experience (like the criteria mentioned for an art project). In addition, teacher and student would have a set of criteria by which to evaluate the portfolio as a whole. General evaluation criteria might touch on the following dimensions:

- **Developmental level**
 Look for such things as children's ability to represent figures and objects.
 Look for their degree of detail, and their accuracy of proportion and spatial relationships.
- **Perception**
 Look for children's ability to observe and interpret their surroundings.
 Look for organized essays and composed pictures.
- **Expressiveness**
 Look for clarity of ideas both visually and verbally.
 Look for variety of resources and techniques.
- **Inventiveness**
 Look for imaginative, novel, or original solutions to class problems.
 Look for degree of elaboration on ideas and images—the number of dimensions and degree of complexity.
 Look for initiative in finding additional information and tasks.
- **Critical thinking**
 Look for reference to internal and external evidence for interpretations of pictorial meaning (including ability to describe and use sensory and formal aesthetic properties).
 Look for ability to assess the value of information.
 Look for reflection on and evaluation of one's own artwork and that of others.
- **Historical understanding**
 Look for an awareness of other artists, countries, and times; other styles, themes, subject matters, and formats.
- **Aesthetic appreciation**
 Look for ability to address "big questions."
 Look for inductive and deductive reasoning.

TABLE 10–9 Portfolio Assessment Rating Scale[a]

Variety of art forms explored are consistent with problems addressed.

Use of processes, techniques, media at grade level of competence. Presentation.

Functional redirection, exploration, integration of influences.

Growth in complexity of ideas: depth with issue, form or concept.

Shows synthesis of art history or critisism experience.

Authenticity of problem(s) addressed.

Utilization of visual awareness for achiving goals.

Criteria of the problem are met.

Challenge, effort, quantity of work.

Aesthetic quality beyond criteria.

Individuality, originality.

Student + ^ -

Generic coding:
4 = commendable
3 = expected
2 = below expected
1 = remedial
0 = no evidence
* = exemplary initiative
+ = beyond experiences
 provided by the
 art curriculum
✓ = as provided by the
 minimum recommen-
 dations for art cur-
 ricula
- = below experiences
 provided by the
 art curriculum
0 = no evidence

Total
* / 4
+ / 3
✓ / 2
- / 1
o / 0

[a]Armstrong, Carmen (1994). *Designing assessment in art*. Reston, VA: National Art Education.

- **Technical quality**
 Look for adeptness with materials, tools, and techniques of presentation.
- **Overall growth**
 Look for change over time.

You might wish to use other criteria, depending on your reason for reviewing the portfolio. If you are using the portfolio in order to identify students in your classes with artistic "tal-

ent," for example, you may look for other things (or for some things and not others—see Chapter 13). All criteria may be formatted as a rating scale to simplify record keeping. An example of such a format may be found in Table 10–9.

Summative Portfolios In some educational contexts a portfolio is not a diagnostic tool. Portfolios used to determine entrance to a special school for the arts, for example, usually contain

examples of a student's best, most finished works. The works are the evidence used to make a summative evaluation, which is judged against particular standards for a specific purpose: the student either gains admittance or not. In this case several judges may review each portfolio. More often, a single art teacher will use portfolios to accumulate finished work throughout the duration of a class in order to document students' progress from beginning to end.

The contents of portfolios used to further elementary students' own understanding, as well as their teacher's, are quite different. They contain unfinished as well as finished work, and work in progress such as sketchbooks. Besides artworks, an elementary art portfolio might include examples of art criticism, Big Question aesthetic reasoning, evidence of library research, or whatever the teacher or student thinks is important. Portfolios "contain a range in variety and quality of works chosen to show the depth, breadth, and growth of students' thinking. . . . they are intended to document the evolution of new understandings over time and across many projects—those that were satisfying and those that were not."[35]

CHAT: Comprehensive Holistic Assessment Task

Participants at the Florida Institute for Art Education, one of six regional staff development programs supported by the Getty Center for Education in the Visual Arts,[36] have developed thematic, interdisciplinary units of instruction containing multiple performance assessment tasks. To date, development teams consisting of elementary classroom teachers, art specialists, and university researchers have written nine instructional units and field tested them throughout Florida. Institute participants call their assessment procedure CHAT, or Comprehensive Holistic Assessment Task. Their assessment goals relate directly to the Florida *Blueprint 2000* reform plan, whose art standards reflect the National Standards in Art.

The central theme of each unit of instruction comes from a work of art. The unit theme concerns "important questions/notions of the human condition and their relationship to the world."[37] Development teams arrive at each unit theme by discussing the meaning of the unit's focal art work. In order to explore the work's meaning in depth, each team also studies contextual material related to it, such as the culture from which the artist comes, what the artist says about the work, what art critics say about it, and pertinent aesthetic issues.

Throughout the unit, elementary students begin to uncover ("unpack") the meaning of the focal work of art by looking at it, describing it, and analyzing it during class discussions; interpreting it in written essays; and making related artworks themselves. Teachers guide students in exploring the unit theme as it interfaces with other classroom subjects (arts, language arts, social studies, science, geography, and math), emphasizing how knowledge is interconnected. These connections, in turn, bring students greater understanding of the focal work's relevance to human experiencing. Solving these problems gives students a chance to use their knowledge in a real-world way (see Chapter 7).

The CHAT model uses comprehensive or multidisciplinary art content with respect to art, combining aesthetics, art criticism, art history, and art making. The Florida Institute advocates a discipline-based approach to art education, which regards "art as a way of thinking and knowing, essential to the learning of every child."[38] Each CHAT unit integrates inventive and interpretive art learning experiences.

Lesson Content Let us look at a CHAT unit that focuses on *Tar Beach*, a story quilt artwork (there is also a book of the same name) by African-American artist Faith Ringgold (see Fig. 10–1) (see **color insert** #3) that describes "a little girl's dream of how she would like to live in a world she imagines for herself and others."[39] The unit organizes a series of related art learning experiences around this theme for children in Grade 4, but may be suitable for younger or older children depending on their developmental level and experiences in art. There are three unit content objectives.

1. Students will interpret the meaning of *Tar Beach* as the dream/imagination of personal and societal freedom (or other meanings associated with the work).
2. Students will create works of art that convey ideas and feelings about personal and societal freedom

(or other important meanings associated with the work).

3. Students will relate ideas of personal/societal freedom to other works of art and art forms that deal with the African-Americans' struggle for freedom (or other important meanings associated with the work).[40]

Each CHAT unit contains six to ten lessons (most of which last more than one class period) considered essential to achieving unit content objectives. Each lesson contains a written student performance task to be assessed. Lessons are designed to fit into a normal classroom schedule over a 4- to 6-week period, with at least two lessons each week to maintain continuity. Teachers who wish to extend a unit may add lessons, but may not substitute the new lessons for the initial six to ten.

Tar Beach contains 10 lessons, as follows:

1. Students give an initial response to *Tar Beach* by writing about the work as an art critic for the school newspaper. They also draw themselves flying to a place "they can only imagine—a place you can't get to any other way," like the girl in the Ringgold book *Tar Beach*.

2. Teachers read the story of *Tar Beach*. The book tells about Cassie, who believes she can provide a better life for her family by magically flying over obstacles to freedom, for example, over the union hall where her father and grandfather cannot get jobs because of their race. Teachers use questioning strategies to encourage students to interpret the book.

3. Students "meet" Ringgold by watching a videotape about her life and work.

4, 5. Teachers help students "unpack" the larger meaning of the work by connecting it to African-American history in the story "Follow the Drinking Gourd," which relates the experiences of slaves escaping to freedom 150 years ago through the underground railroad. Students listen to a Langston Hughes poem, sing spirituals, and listen to Martin Luther King's "I Have a Dream" speech. They make a pictorial time line of important events in the history of the civil rights movement.

6. Students compare the quilt "Springtime in Memphis: At Night, 1979" by African-American artist Michael Cummings to Ringgold's quilt. They compare subject matter, ideas, and aesthetic issues in a matching game. They consider what makes a quilt "art."

7. Students transfer the concept of personal freedom to societal freedom; they write a story and draw sketches of the "way they want the world to be."

8. Students select their best sketch and refine it into a paper collage "quilt square" for a class story quilt.

9. Students work together to create two large paper "quilts" and compare their own works to *Tar Beach*.

10. Students again write about the meaning of *Tar Beach*. They add information about the artist, historical influences, and symbols, and reflect on their own ideas about personal and societal freedom.[41]

Evaluation Criteria At the end of each lesson, each child completes a performance task in writing or by making artwork. These statements provide teachers with evidence on which to evaluate the extent of student learning (Table 10–10). Teachers also record their judgments of each stu-

TABLE 10–10 CHAT Student Performance Assessment Tasks, Lessons 1 and 2, *Tar Beach*[a]

Student Performance Assessment
TASK

I. **What I See:** Initial Journal entry (Lesson 1)
Student's initial written response to *Tar Beach* describes:
 *1. important ideas (meaning of artwork)
 2. evidence for important ideas, including:
 • people, objects, and/or symbols
 • a setting
 • time frame
 • actions
 • colors, lines, and/or shapes
 • organization; i.e., point of view, placement, size, repetition, balance
 • expressive qualities, i.e., feeling or mood
 3. a conclusion about the meaning of the artwork supported by statements of evidence
 *4. important questions he/she has about the artwork
Comments:

TABLE 10–10 CHAT Student Performance Assessment Tasks, Lessons 1 and 2, *Tar Beach*[a] (Continued)

TEACHER'S INFORMAL ASSESSMENT

The student's initial writing demonstrates that he/she was able to perform an inventory of the artwork, collection ideas for later expository and persuasive writing.

- Yes (+1 pt)
- No (-1 pt)
- Did not attempt (reason?) (0)

Comments

Student Performance Assessment TASK

II. Taking A Closer Look—Initial Drawing (Lesson 2)
Student's initial drawing depicts:
 *1. a main idea(s): ""Flying to a place in my imagination"
 2. evidence for main idea including:
 - people, objects, symbols
 - a place that reflects a specific time; i.e., past, present, or future and time of day
 - action
 - use of color, line, and shape to convey meaning
 - use of point of view, size, and placement to denote importance (orientation of figure to denote flying)
 - expressive qualities; i.e., feeling or mood (happy, sad, exciting)

TEACHER'S INFORMAL ASSESSMENT

The student's initial drawing demonstrates that he/she was able to transfer ideas and visual concepts from *Tar Beach* into his/her artwork.
 - Yes (+1 pt.)
 - No (-1 pt.)
 - Did not attempt (reason?) (0)

Comments:

The student completed a thoughtful assessment of his/her initial drawing using **Taking a Closer Look** journal page.
 - Yes (+1 pt.)
 - No (-1 pt.)
 - Did not attempt (reason?) (0)

Comments:

[a]The Florida Institute for Art Education. (1996). Unpublished manuscript.

dent's performance task for each lesson on a checklist (Table 10–11). Students will compile completed essays, drawings, quilt sketches, and quilt blocks, together with their teacher checklists, in process-folios.

Teachers also keep informal (called *anecdotal*) records (Table 10–12) of class activities and individual student behaviors and accomplishments for each lesson. These records of class discussions and student interaction lead to informal assessments that assist teachers in their formal evaluations. They may also document unexpected learning that occurs.

STUDENT SELF-ASSESSMENT

Most of this chapter talks about the nature of assessment in the context of how and why you, the teacher, will assess the extent to which your students reach the objectives you set for them. Before we end this chapter, let us recognize the role that students play in their own evaluation process. Alternative assessment practices are meant to teach students to assess their own performance. Self-assessment is an essential educational goal, because it allows students to become independent learners.

In performance tasks, students are always active participants in your assessment procedures. They use your evaluation criteria as guides for their problem solving. They can and must apply them to their own work in order to complete the project successfully. They critique their own finished work according to these criteria.

Students also employ other criteria from past lessons that have become part of their vocabulary of aesthetic concepts. They also develop criteria of their own. For the past ten years, at least, educators have recommended that students assess themselves. Students benefit from additional opportunities to reflect on the finished project, to

TABLE 10-11 CHAT Student Performance Checklist, Lessons 1 and 2, *Tar Beach*[a]

Student's Name _____ Teacher's Name _____
Grade _____ Dates of Instruction _____ to _____
School _____ District _____

Check off elements that are present.

TASK
I. What I See: Initial Journal entry (Lesson 1)

Student's initial written response to *Tar Beach* describes:
1. _____ important ideas (meaning of artwork)
2. _____ evidence for important ideas, including:
 _____ people, objects, and/or symbols
 _____ a setting
 _____ time frame
 _____ actions
 _____ colors, lines, and/or shapes
 _____ organization; i.e., point of view,
 _____ placement, size, repetition, balance
 _____ expressive qualities, i.e., feeling or
 mood
 _____ a conclusion about the meaning of the
 _____ artwork supported by statements of
 evidence
3. _____ important questions he/she has about the
 artwork
Comments:

TEACHER'S INFORMAL ASSESSMENT
The student's initial writing demonstrates that he/she was able to perform an inventory of the artwork, collection ideas for later expository and persuasive writing.
_____ Yes
_____ No
_____ Did not attempt (reason?)
Comments:

TASK
II. Taking a Closer Look | Initial Drawing (Lesson 2)
Student's initial drawing depicts:
1. _____ a main idea(s)
2. _____ "Flying to a place in my imagination" as evidenced by:
 _____ people, objects, symbols
 _____ a place that reflects a specific time; i.e.
 _____ past, present, or future and time of
 day action
 _____ use of color, line, and shape to convey
 meaning
 _____ use of point of view, size, and placement to denote importance.
 _____ expressive qualities; i.e. feeling or
 mood (happy, sad, exciting)

TEACHER'S INFORMAL ASSESSMENT
The student's initial drawing demonstrates that he/she was able to transfer ideas and visual concepts from *Tar Beach* into his/her artwork.
_____ Yes
_____ No
_____ Did not attempt (reason?)
Comments:

The student completed a thoughtful assessment of his/her initial drawing using **Taking a Closer Look** journal page.
_____ Yes
_____ No
_____ Did not attempt (reason?)
Comments:

[a]The Florida Institute for Art Education. (1996). Unpublished manuscript.

TABLE 10-12 CHAT Teacher Anecdotal Record, Lessons 1 and 2, *Tar Beach*.[a]

Lesson _____ Name _____

How successful was the lesson?

Did students demonstrate an understanding of the concepts, content and tasks in the lesson?

Difficulties:

Surprises:

Special mention:

Comments:

[a]The Florida Institute for Art Education. (1996). Unpublished manuscript.

compare it with those of classmates, and to draw conclusions about the nature of all of the projects above and beyond class criteria.

Many educators today believe that successful performance assessment depends on student self-assessment. They suggest that students can and should assess themselves on all content objectives, no matter how broad. While students are studying the motifs and symbols in *Tar Beach*, for example, teachers might ask them to rate their understanding of those concepts. Similarly, after completing their quilt squares, students might be asked to evaluate the extent to which it is a unique expressive outcome (Table 10–13).

Framing a Student Performance Task

Current thinking on assessment is that we should encourage student participation in choosing the performance assessment tasks themselves. Evaluator Joan Baron, an authority on performance assessment, believes that an authentic performance task will have the following five characteristics:

- The task is meaningful both to teachers and students.
- The task is framed by the student.
- The task requires the student to locate and analyze information as well as draw conclusions about it.
- The task requires students to communicate results clearly.
- The task requires students to work together for at least part of the task.[42]

Students will need help from their teacher in order to frame meaningful performance tasks. Evaluator Robert J. Marzano and his colleagues recommend a five-step process. These five steps will take you from generating an idea through designing assessment rubrics for students to use. The five steps are as follows:

- Step 1: Have students *identify a question* related to something in the current unit of study that interests them.
- Step 2: Help students write a first draft of the task that makes explicit one or more of the *complex reasoning* processes you wish them to use (comparison, error analysis, constructing support, decision making, investigation, or problem solving).
- Step 3: Help students identify standards from the categories of *information processing* (gathering and using information), *effective communication* (expressing ideas clearly), collaboration/cooperation (working toward group goals), and *habits of mind* (critical thinking, inventive thinking, and being aware of own thinking.
- Step 4: Help students rewrite the task so that it puts the *standards* identified in Step 3 into specific language of the task. (Example using *Tar Beach*: I'm going to find out what happened to people who used the underground railway after they got to the North and how they might have changed their own lives for the better. I will read what other people besides Faith Ringgold have written on this topic. I will work with two other people who have related topics and keep track of how well I can coordinate my information with theirs. After I have collected enough information, I will take a position and defend it, taking special care to express my ideas clearly.)
- Step 5: Help students write assessment rubrics for the standards that have been built into the task. (Example for effective communication standard:

 4 I have communicated my position clearly. In addition, I have provided support that is very detailed and very rich.

 3 I have presented my position clearly. I have provided adequate support and detail.

 2 I have presented some important information, but I have no clear position.

TABLE 10-13 CHAT Student Assessment Forms, Lessons 1 and 2, *Tar Beach*[a]

What I See	Taking a Closer Look
Name Date Teacher School Grade	Name Date Teacher School Grade
What are the main ideas in *Tar Beach*?	The main idea I tried to show in my drawing was:
What do you see that makes you think so?	To show my idea, I put the following things in my picture:
What questions do you have about *Tar Beach*? What do you wonder about?	I showed what was most important by:
	I think my artwork is successful because:
	The things I would like to change in my picture are:
	because:

a The Florida Institute for Art Education. (1996). Unpublished manuscript.

1 I have communicated only isolated pieces of information.[43]

Journals

Keeping a journal is another valuable experience for students and a way they can assess themselves. You can suggest directions for students to take by asking them to describe how well they have done something, or the extent to which they understand something. Students write their responses in their journals, which you can periodically review. Students can also note unfinished ideas in their journals—ideas for future development, isolated observations, insights of the moment. Journals form a good basis for the one-on-one conferences that you hold with students from time to time during the semester.

Journals are an excellent adjunct to portfolios. They have many of the same advantages. Journals grow over time. They present evidence of students' cognitive activities (higher-order thinking), and metacognitive activities (thinking about thinking). They document students' abilities to communicate effectively.

SUMMARY

As a teacher, you will be accountable to your students, your school, your district, and your state department of education for what happens inside your classroom. Accounting for student achievement is one of the most important things you will do. Whether you use conventional methods or alternative assessment strategies, you will find yourself collecting a great amount of information about how well your students perform. You cannot teach well without it.

Developing reliable and valid assessment instruments takes a good deal of thought and time, even several years. These activities are well worth the effort you will put into them if you do them well. Poorly constructed tests and performance tasks can be unfair to students and they may not assess the intended content domain. Well constructed ones can benefit students by making learning experiences more powerful than they would have been otherwise.

Performance assessment is particularly appropriate for art education. First, it is difficult to observe the outcomes of studio art learning by conventional tests. Second, the wide variety of performance tasks and the traditional participation of students in self-assessment in studio art offer more opportunities for increased learning than in some other elementary subjects. Assessment tasks will be more interesting and evaluation criteria more definitive if you can involve those who will be affected by the assessment results in their design—other teachers, students, parents, and school district administrators.

Instruction and evaluation, like teacher objectives and evaluation criteria, go hand in hand. One cannot exist without the other. Far from being a punitive process, accounting for learning challenges students to learn and teachers to structure classroom art learning situations in ways that meet the highest goals of their profession.

NOTES

1. See Cohen, Philip. (1995). Designing performance assessment tasks. *ASCD Education Update*, 37 (6): 1, 4–5, 8.
2. Eisner, Elliot W. (1979). *The educational imagination: On the design and evaluation of school programs*. New York: Macmillan.
3. Stake, Robert. (1975). *Evaluating the arts in education: A responsive approach*. Columbus, OH: Charles Merrill, p. 23.
4. Eisner, op. cit.
5. Wilson, Brent. (1971). Evaluation of learning in art education. In: B. Bloom, J. Hastings, and G. Madaus (eds.), *Handbook on formative and summative evaluation of student learning*. New York: McGraw-Hill. Cited in Armstrong, Carmen. *Designing assessment in art*. (1994). Reston, VA: National Art Education Association.
6. Bloom, Benjamin S. (1954). *Taxonomy of educational objectives. Handbook I: Cognitive domain*. New York: Longmans, Green.
7. National Assessment of Educational Progress in Art. (1978). *Knowledge about art*. Washington, DC: National Center for Educational Statistics, U.S. Department of Health, Education and Welfare, Education Division.
8. National Assessment of Educational Progress in Art. (1978). *Attitudes toward art*. Washington, DC: National Center for Educational Statistics, U.S. Department of Health, Education and Welfare, Education Division.
9. Herman, Joan L., Aschbacher, Pamela R., and Winters, Lynn. (1992). *A practical guide to alternative assessment*. Alexandria, VA: Association for Supervision and Curriculum Development.
10. Secretary's Commission on Achieving Necessary Skills. (1991). *What work requires of schools*. Washington, DC: U.S. Department of Labor.

11. Marzano, Robert J., Pickering, Debra, and McTighe, Jay. (1993). *Assessing student outcomes: Performance assessment using the dimensions of learning model.* Alexandria, VA: Association for Supervision and Curriculum Development.

12. Ibid., adapted from p. 8.

13. Consortium of National Arts Education Associations. (1994). *National standards for arts education.* Reston, VA: Author, pp. 121–127.

14. Marzano et al., op. cit. pp. 18–24.

15. Ibid., p. 83.

16. Cohen, P., op. cit., p. 4.

17. Herman et al., op. cit., p. 71.

18. Armstrong, Carmen. (1994). *Designing assessment in art.* Reston, VA: National Art Education Association.

19. Adapted from ibid., pp. 26–30, 35–37, 181.

20. Cohen, op. cit., p. 54.

21. Eisner, Elliot W. (1995, June). Standards for American schools: Help or hindrance? *Phi Delta Kappan,* pp. 758–759, 761–764.

22. Herman et al., op. cit., p. 109.

23. Ibid., p. 109.

24. Consortium of National Arts Education Associations, op cit., pp. 9–10.

25. Marzano et al., op. cit., p. 29.

26. Herman et al., op. cit., Fig. 5–1, p. 47.

27. Ibid., p. 45.

28. Ibid, pp. 46–47, 60, 62.

29. Ibid., pp. 64–65.

30. Armstrong, op. cit.

31. From Armstrong, op. cit.

32. Ibid., p. 90.

33. Arter, J., and Spandel, V. (1992). Using portfolios of student work in instruction and assessment. *Educational Measurement: Issues and Practice,* 11 (1): 36–44. Cited in Herman et al., op. cit., p. 120–121.

34. ARTS PROPEL. During Project Zero's early history its researchers focused less on art learning than on what children's artwork reveals about their cognitive processes. Its researchers viewed themselves as developmental psychologists instead of designers of model teaching strategies or public school curricula. Since the late 1980s, however, Project Zero associates have established a model educational program in the Pittsburgh public schools called ARTS PROPEL. PROPEL is an acronym for the kinds of cognitive skills to be taught: production (expression), perception ("thinking" artistically), and reflection (critical analysis and appreciation). ARTS PROPEL is a middle- and high-school program that puts research-gained insights into educational practice. From Gardner, Howard. (1989). Zero-based arts education: An introduction to ARTS PROPEL. *Studies in Art Education,* 30 (2): 71–83.

35. Zessoules, Rieneke, and Gardner, Howard. (1991). Authentic assessment: Beyond the buzzword and into the classroom. In Vito Perrone (ed.), *Expanding student assessment.* Alexandria, VA: Association for Supervision and Curriculum Development.

36. The Florida Institute for Art Education, directed by art educator Jessie Lovano-Kerr, The Florida State University, and Nancy Roucher, arts consultant, is supported by the Getty Center for Education in the Arts, the Jessie Ball duPont Fund, the Florida Department of Education, and the Florida Department of State, Division of Cultural Affairs.

37. Florida Institute for Art Education. (1995). Unpublished manuscript, p. A–1.

38. Ibid, n.p.

39. Florida Institute for Art Education. (1996). *Introduction to the CHAT instruction/assessment model for* Tar Beach *by Faith Ringgold.* Unpublished manuscript, p.x. Author.

40. Ibid., p. x.

41. Florida Institute for Art Education. (1995). op. cit., pp. B–2, B–3.

42. Marzano et al., op. cit., p. 31.

43. Ibid., pp. 32-34.

11
Integrating Art with Other Subjects

Antoine's sixth-grade students are discussing the painting *Blue Hole, Flood Waters, Little Miami River* by the nineteenth century American painter Robert S. Duncanson (Fig. 11–1) (see **color insert** #3). The school where Antoine teaches is in an urban neighborhood in Cincinnati. His students notice how the wooded scene is so different from the neighborhood surrounding their school, even though the setting of the scene is now a part of Cincinnati.

Only a few of Antoine's students have ever been outside of their own neighborhood. They know that the picture was painted a long time ago. Antoine explains that the scene is near the junction of the Ohio and Little Miami Rivers—a site well known at the time as an escape route for fugitive slaves. The painting looks so peaceful and quiet. Today, however, the junction of the rivers is near two highways, an interstate, and a municipal airport. Is the setting still that quiet?

Antoine is in the midst of a social studies unit that he has organized around the theme "Where I Live." Antoine wants his students to imagine what living in Cincinnati in the nineteenth century might be like—in order to see their own time and themselves in a fresh light. As a byproduct of this pursuit he expects them to learn something of their city and their city's art history. Duncanson, he explains, was a self-taught black painter who spent most of his career in Cincinnati, a largely abolitionist community on the edge of the slave-holding South.

Works of art can be compelling vehicles for encouraging children to think and to reflect on their knowledge and personal experience. (Recall the discussion on Perkins and the concept of sensory anchoring in Chapter 8.) Antoine's use of art in a social studies unit is an example of "informal integration"—which is one model of integration among many that we will be discussing later in this chapter.

In earlier chapters we built a case for an art education based on teaching children to use their existing knowledge to construct new knowledge. The visual arts are not the only subjects that we can teach in a generative way.

THE CASE FOR INTEGRATION

As you know, life is not neatly divided into math, English, art, and music. But this is often the message we send in school. Ask a first grader "what is art?" and the possible reply is "something we do on Friday afternoons."

According to Webster, the verb *to integrate* has two meanings:

1. to make whole or complete by adding or bringing together parts.
2. to put or bring (parts) together into a whole, to unify.[1]

These two definitions are subtly different. The first implies something that was once whole being restored to wholeness by bringing together the necessary parts or adding the missing parts. The second implies bringing parts together to create a new whole. Both interpretations are appropriate for the subject of integrated learning in the elementary school.

On the one hand, a team of teachers may be motivated to bring together separate subjects—each currently parceled into 40 minute time slots—to restore a certain amount of wholeness to knowledge. On the other hand, these teachers' motivation may not be that of restoring wholeness to knowledge but that of creating a new, unexpected whole—perhaps a new theme or a new slant on knowledge not thought of before.

Whatever the motivation, the task of integration in education is usually denoted by the term, *interdisciplinary*—the juxtaposing of two or more school disciplines. We have already said a great deal about both integration and the juxtaposing of disciplines. Chapter 2 addressed integrating the related disciplines of studio art, art history, art criticism, and aesthetics. Chapter 3 addressed the same topic but also discussed collaborative teaching strategies that went beyond the school to include resource people in the community. Chapter 8 described situations in which art teachers collaborated with classroom teachers, language arts teachers and social studies teachers to teach art history, art criticism, and aesthetics. This chapter will explore in more detail ways of collaborating and different models for integrating art with other subjects.

Subject Matter versus Skills Education

It has already been pointed out that elementary school is a comparatively friendly environment for integration because content areas there are not nearly so compartmentalized as they are in high schools and colleges (Chapter 8). Some educators have characterized high schools and colleges as *subject-matter* intensive, whereas elementary schools are *skills* intensive. Elementary schools

focus on the skills necessary to handle things such as history, literature, and science that students will have to face in high school.[2] We disagree with this characterization of elementary education. We contend that both knowledge (i. e., subject matter) and skills should be seen as a single entity under the heading of *content* (Chapter 3). In effect, we advocate a balance between subject matter and skills in elementary education.

But a skills emphasis does allow for an important kind of integration, that is, teaching the same learning skills in several subjects. A prime example is reading and writing, skills that can be, and often are, applied across the curriculum (including the arts disciplines). A less traditional example would be such skills as creativity and higher-level thinking which, theoretically at least, can be applied across the curriculum. Chapter 8 addressed the advantages of aesthetics for teaching thinking skills, art criticism for teaching both thinking and writing skills, and art history for teaching research skills.

Integrating subject-matter areas, on the other hand, is much more difficult than that of simply teaching a skill, say writing, across the curriculum. Perhaps the most obvious and least problematical example of content integration would be a combination of art and social studies, in other words, art history. But how does one integrate art with science? with geography? with physical education? These combinations are all possible, but certainly not obvious. Also you should be warned that integration, just for the sake of integration, is apt to produce artificial content, or an awkward product like Dr. Seuss's "elephant-bird" (Fig. 11–2). We have touched on one possible disadvantage of interdisciplinary combining. We will present some others under "Challenges and Problems," but first the pros of integration.

Arguments for Integrated Learning and Interdisciplinary Projects

One argument, already alluded to, is overcoming the fragmentation that typically besets a school curriculum. Educator Heidi Jacobs points out that "Only in school do we have 43 minutes of math and 43 minutes of English and 43 minutes of science. Outside of school, we deal with problems and concerns in a flow of time that is not divided into knowledge fields."[3] Integration not only

Figure 11-2 Dr. Seuss "Elephant bird."
Illustration from the book "Horton Hatches the Egg" of "Elephant Bird" by Dr. Seuss.
(Courtesy of Random House, Inc.)

restores wholeness to learning, it is, in a sense, more attuned to real life.

Another argument, also alluded to, is to provide a fresh view of existing knowledge—a different lens through which to look at the world. Obvious, but very valid, examples consist of studying American geography and American history through the lens of American art (see Fig. 11–1, and Fig. 11–3). A less obvious example might be to acquire fresh insights into the art of geometric abstraction by studying Euclidian geometry. Exploring new curricular territory—an adventure fraught with no small amount of risk—always adds a spark to learning.

Some fields of study, such as ecology, communications, or urban studies, are cross-disciplinary to begin with. The *only* way to access knowledge in these fields is through interdisciplinary approaches. However, the same case can be made for the study of art history, aesthetics, and art criticism. Taken out of its social-historical context, art history becomes simply a chronicle of changes in styles; without insights from philosophy, aesthetics is reduced to a list of design principles; and without the help of language arts, art criticism is apt to lapse into subjective reflection. Similar to ecology, these arts disciplines are naturally cross-disciplinary.

Admittedly, there are risks involved in merging disciplines—especially if you have to depend on the cooperation of colleagues. But look at it this way: If you are an art teacher and intend to conduct a session on art history, but without the help of a classroom teacher, you would probably have to research the history part of the lessons on your own. If you are a classroom teacher without an art specialist to help you, you may have to read up a bit on art. To do so in either case can certainly be personally rewarding and mind expanding. But help in managing the additional knowledge from someone who is more prepared in that knowledge than you are would obviously be welcome. The risks of collaboration are usually outweighed by its benefits. Furthermore, collaboration does not always have to entail team-teaching; it can take many forms, some requiring very little coordination. Several models of interdisciplinary collaboration are reviewed in this chapter.

Before embarking on an interdisciplinary unit, however, you should be aware of some of the challenges.

Challenges and Problems Regarding Interdisciplinary Projects

First and most obvious are the practical challenges. To mount a good interdisciplinary unit involves extra time spent in planning, organizing, writing, and prepping. Will you and your colleagues be compensated for this, or will it come out of "hide"? Extra money may be needed for printing, mailing, purchasing materials and equipment, and so forth. Can your school spare the extra cash? What about space and time? Often, combining disciplines means combining classes, resulting in large groups and block scheduling.

There are also political challenges. Does the new unit or course of studies have the support of

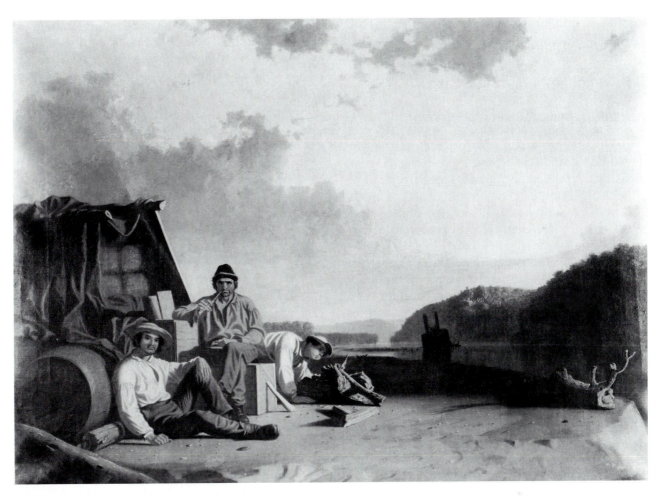

Figure 11-3 George Caleb Bingham, *Watching the Cargo*, 1845, Oil on canvas, 29″ × 36 1/2″. (Courtesy of The State Historical Society of Missouri, #SHS #006797)

colleagues, the administration, parents, community? Support of parents and community, or lack thereof, is especially important if the new course is unconventional.

There are pedagogical problems. Jacobs cites what she calls the *potpourri problem*—a poorly planned or misconceived interdisciplinary unit resulting in shallow samplings of knowledge from each of the disciplines.[4] Disciplinary structure is missing and knowledge depth is sacrificed. Or perhaps the discipline mix, while looking good on paper, does not make sense or creates an odd hybrid *a la* Dr. Seuss.

Related to this is the problem of evaluation— not just that of devising assessment instruments for new content, but evaluating untraditional learning in a traditional, subject-based environment. Or to put it another way, how can you give a letter grade in English based on a student's per-

formance in a unit on, say, "Cross-cultural nonverbal communication"? Can the success of such a unit be measured by the Iowa Test of Basic Skills?

Finally, there are personnel challenges. It is enormously difficult to find the right mix of faculty who will team without friction. Some teachers are territorial about their subject matters, others may not carry their load, still others are simply difficult to work with. And, who is to lead? Who is to be given the authority and responsibility to see it through? Likely, there is no "chain of command" established in your school for overseeing interdisciplinary units.

It should be pointed out that the seriousness of these problems is relative to the scope and nature of the interdisciplinary project itself. Some units require little more planning time than meeting with a colleague over coffee. Some are cost free, uncontroversial, educationally viable, and as

easy to coordinate as making a short phone call the night before.

DEVELOPING AN INTERDISCIPLINARY UNIT

Selecting an Organizing Center

Initially, an interdisciplinary project needs to be developed around an *organizing center* such as an idea, issue, problem, or theme. This center can be either skill oriented or content oriented.

As an example of a skill-oriented center, recall the project conducted by students in Calgary, Canada, involving collecting old photographs and newspaper reviews to reconstruct the history of arts and crafts in that community (Chapter 8). Imagine such a project conducted on a broader front—involving other cultural institutions besides art. Such a unit, say for seventh and eighth graders, possibly titled "Researching Calgary Culture," would be organized around the skill of research and draw on the services of other disciplines besides art: *language arts* for investigating Calgary's book clubs and for library research in general; *social studies* for archival research of newspaper or city records about cultural institutions; and *physical education* for investigating Calgary's sports culture.

As an example of a subject matter-oriented center, take a theme called "the North American river systems as factors in the early settlement of the United States." Social studies, of course, would be the principal resource here. However, think how you could enliven such a unit by showing students paintings of American river life by George Caleb Bingham, who lived during that time (Fig. 11–3). Language arts could introduce older students to selections from *The Adventures of Tom Sawyer* or *The Adventures of Huckleberry Finn*. It should be pointed out, however, that the paintings of Bingham preceded the novels of Mark Twain by more than a generation. This fact in itself is suggestive for the study of Mississippi lore). Finally, a music specialist could introduce the songs of Stephen Foster.

Criteria for Selecting an Organizing Center

David Ackerman identifies two kinds of criteria: practical and intellectual.[5] Practical criteria involve the things mentioned earlier as challenges: time, money, and space in addition to political support and personnel. As criteria, these parameters exist not only as challenges but also as potentials. If, relative to the project you have in mind, your school has the space and ability to block schedule, is willing to give you some time off for planning and prepping, has the support of the community, and so on, then the project is go. If not, you may have to modify the project or abandon it.

Ackerman outlines intellectual criteria as validity *within* the disciplines and validity *for* the disciplines. Validity within the disciplines means that the unit should be supportive of, and consistent with, the principles and concepts of each of the contributing disciplines. "Researching Calgary Culture" meets this criterion for each of the disciplines, assuming the proper research protocols are observed for each. The American rivers unit meets this criterion for art, provided that the works by Bingham are analyzed in their own right through the lens of history and not simply used as window dressing for the history lessons. In other words, to satisfy Ackerman's criteria for the discipline of art, a unit should invoke the principles of knowledgeable teaching (Chapter 3) and the goal of aesthetic literacy (Chapter 2).

Validity for the disciplines means that the juxtaposition of subject matters makes sense, that the disciplines involved are mutually supportive. We might add that they should also exhibit conceptual consistency (Chapter 6). The American rivers unit, *if handled correctly*, is a good example of how a combination of history, literature, art, and music can illuminate for students an aspect of nineteenth-century American life—something which could not be accomplished by any discipline alone.

Long-Range versus Short-Range Units

The Calgary unit and the American rivers unit would probably take up to a half semester each. Both, probably, are appropriate only in the upper grades. However, interdisciplinary units can be shorter range—from 1 to 5 weeks—and made appropriate for all levels of elementary.

Holiday themes easily come to mind. Yet, some art teachers are so put off by typical holiday art, for example, cutout pumpkins, hand-traced turkeys, snowflake doilies, and so on, that they

may even refuse to become involved. But holiday art need not be so stereotypical, and to refuse involvement is to miss an opportunity to capitalize on a situation full of artistic and interdisciplinary potential. Children, especially those in the lower grades, are spontaneously enthusiastic, and holidays themselves are redolent of history and colorful tradition.

Holidays ("holy days") are sacred observances common to all cultures (even civic holidays such as Thanksgiving and the Fourth of July have a sacred basis). The Festival (from the word "feast "), an event combining dance, music, and the visual arts—usually in the form of costumes, masks, and body painting—was the principal way ancient and medieval cultures celebrated important times on their calendars. (Modern survivals include Brazil's *Carnival*, Germany's *Oktoberfest*, and New Orleans' *Mardi Gras*.) The medieval European calendar, for example, was filled with feast days, not only Easter and Christmas, but such observances as Ascension Day, All Saints Day, and Epiphany, among others.

Within the elementary-school calendar, December, the month that includes both Christmas and Hanukkah, is probably the most exciting and most reminiscent of a medieval feast observance. Early childhood specialist Suzanne Krogh explains that it has become a tradition even in schools where the day-to-day curriculum is rigid: "No

matter what their feelings are the rest of the year, teachers seem to accept the idea that in December it is all right to plan learning around a theme."[6] Krogh illustrates this with a "curriculum web" (Fig. 11-4). As an organizing center, December brings together the disciplines of language, music, social studies, mathematics, art, and science.

The question becomes whether or not this theme as webbed by Krogh satisfies Ackerman's criteria of validity within and for the disciplines. At a glance, probably not for an upper grade unit. For a primary grade, however, the demands of discipline structure and knowledge depth are less strict.

Short-run units, of course, can be based on themes besides holidays. One of the authors of this book recalls the annual Parent's Night held in the school system where he once worked as art coordinator. This was a special event whereby parents throughout the district came to view their sons' and daughters' projects in science, social-studies, and art, and to see them perform in skits and musical reviews (usually in the lunchroom serving as an auditorium). Even the students' desks were organized. Each year was a different theme, sometimes patriotic, sometimes pedagogical, often with novel titles, such as "Jurassic Park" or "It's a Small, Small World," drawn from the popular culture. Much of the school work over a period of a month was coordinated with the

Figure 11-4 Krogh's curriculum web.

theme; most of the final week was devoted to rehearsal. Without question Parents' Night was an interdisciplinary boon for the arts, involving dance (P.E. specialist), music (music specialist), and art (art specialist), as well as some creative drama (usually the homeroom teacher). Teachers complained about the extra work, some even disparaged it all as promotional eyewash. But in retrospect, this annual event—held in a school district with high academic standards—provided the students with an immersion experience in planning and collaboration as well as a temporary respite from the routine curriculum.

Planning for an Interdisciplinary Unit

One drawback of the annual Parents' Night was that each year's theme, or organizing center, was chosen by the administrators not the faculty. But that was just the first step; the faculty had to figure out how to take it from there. Jacobs recommends a brainstorming process to explore the central idea from all discipline fields.[7] To aid in this, a graphic is helpful (Fig. 11–5). Described by Jacobs as a wheel with the organizing center as the hub and the disciplines as the spokes, it is the same thing as Krogh's web. Brainstorming yields ideas for perspectives relating to the central theme. Some will be good, some not so good. Through a process of screening, applying Ackerman's criteria, a working concept for an interdisciplinary unit begins to crystallize, for example, the American river unit (Fig. 11–6).

The next step—especially recommended for long and complicated units—is to develop a scope and sequence. Chapter 9 explained the rationale and the process for developing a scope and sequence for art instruction (the Arizona art curriculum guide served as an example of scope and sequence chart). Complicated integrated units, no less than single disciplines, need to have their structures defined this way. Jacobs recommends starting with guiding questions.[8] For the sake of illustration, we have listed some guiding questions for developing a scope and sequence for the American rivers unit.

In what ways did water transportation play a role in exploration, land settlement, and commerce in the early United States?

What effect did the opening of the Erie Canal (1825) have on American commerce? on American culture?

What is "manifest destiny" and what did it mean to American citizens in the early 1800s?

Recall that a form of nature-worship flourished at that time. Was this connected with the concept of manifest destiny? Explain. How was love of nature reflected in the nation's art and poetry?

Compare the paintings of the Hudson River School artists to the writings of people like Thoreau, Alcott, and Emerson. Are there any parallels in subject matter? in feeling?

Today, works such as *Blue Hole, Flood Waters, Little Miami River* by Duncanson (see Fig. 1–1) are included with the Hudson River School. But in the 1800s none of Duncanson's works were because he was black. What does this say about the nineteenth-century art world?

Figure 11-5 Jacobs' wheel.

Figure 11-6 Organizing chart for American River unit.

Compare the paintings of George Caleb Bingham to those of the Hudson River artists. Which ones are more "down to earth"? Which are more dramatic?

Describe the work of Bingham in terms of "art reflects life" and "life reflects art."

What is the relationship, if any, between Bingham's paintings and the novels of Mark Twain?

What themes central to American culture in the post Civil-War period are played out in *The Adventures of Huckleberry Finn*? How does the geography of the Mississippi River symbolize those themes?

Compare the mood of Stephen Foster's music to Bingham's *Fur Traders Descending the Missouri*, and to Duncanson's *Blue Hole, Flood Waters, Little Miami River*.

INTEGRATING ART WITH OTHER SUBJECTS

Interdisciplinary teaching arrangements can take many forms depending on the scope and complexity of the unit. But any arrangement is contingent to some extent on the type of art position(s), if any, that are in the district.

Types of Art Specialists in Various Districts

For good or bad, elementary education in America is heterogeneous. This is probably more true for the situation of art personnel (or lack thereof) than for that of any other kind of faculty. We are talking here not about individual art teachers' qualifications—which do vary of course—but

about job descriptions. The latter vary from districts that have no art specialists at all to those that have enough to cover every grade level in fully equipped special rooms.

In between the extremes are many arrangements that will be briefly described here (Chapters 18 and 19 discusses these, along with ideal arrangements, in some detail). The general rule is that art services become more available as the grade level ascends.

Typically, art teachers, usually with art rooms, are provided for junior-high classes, if not also for middle-school classes (although, in many situations, the students take art for no more than 100 minutes a week every other semester). The lower grades are lucky to have a "traveling art teacher" visit their rooms on a once-a-week, or less frequent, basis. While the ideal might seem to be an art teacher meeting with each class at least once a week in an art room, this arrangement does not necessarily bode well for teacher-to-teacher collaboration, especially if the homeroom teacher is not required to accompany his or her charges to that room.

The visiting teacher arrangement—even if intermittent—is potentially better. Call this person an art consultant, coordinator, or supervisor if you wish. Whatever the title, this person without a room should be available for any of a number of constructive tasks: visiting classrooms, meeting with teachers to plan units of instruction (both art and integrated), approving commercial materials,

writing local curriculum materials, and, in general, coordinating art activities throughout the building or district. (These kinds of services on the part of an art specialist are described in Chapter 3. Beyond these are the potential services available from resources in the community, such as libraries, art museums, and universities—also described in Chapter 3 in connection with a report on a recent Texas consortium.)

Finally, if your elementary building or district has no art specialist—not even a high school art teacher willing to lend a hand on occasion—this does not obviate your teaching art. As stated previously (Chapter 3), classroom teachers have primary responsibility for basic art instruction, in any case. Hopefully, you will have at your fingertips materials that provide a basic vocabulary of grade-appropriate art concepts contained in user friendly lesson formats. Since as a classroom teacher, you teach all the subjects, the problem of integrating art with any of these subjects should almost come naturally. More about this in the following section.

Models of Interdisciplinary Integration and Collaboration

As we have seen, the possible kinds of elementary art services across the spectrum of American education are numerous. And this makes the possible permutations of interdisciplinary arrangements endless. The balance of this chapter will try to make some sense out of this situation by presenting a few classic models of integration. The first and simplest is *informal integration* suggested by educator Allan Glatthorn.[9] The others are adapted from a continuum of design options suggested by Jacobs (Fig. 11–7): *parallel-discipline, multidisciplinary,* and *interdisciplinary.*[10] Each description will include an example or two to show how the model would be implemented in a situation in which art is one of the disciplines.

Informal integration: This consists of a teacher of one discipline occasionally bringing in content from another discipline.

Example: Recall Antoine's social studies unit called "Where I Live." To make the unit more interesting and also to provide the material with a degree of sensory anchoring while students think and talk about Cincinnati, Antoine has his students look at a painting by Duncanson (see Fig. 11–1). Antoine could also have his students look at photographs of local architecture, particularly historical buildings.

Example: You teach seventh-grade art and are planning a unit around the art of murals as a studio experience to be executed in small groups. To stimulate students' interest in this kind of art you intend to show them examples of WPA murals in your community. You realize that your students know nothing about the 1930s, the Great Depression, and the Roosevelt Administration, let alone the meaning of WPA. Accordingly, you introduce some facts about that era to provide a sociohistorical context for the art you intend to explain.

Parallel-Discipline: This is a situation in which two or more teachers of different disciplines teach their classes separately, but sequence their lessons to correspond to a single theme. Normally, little coordination is required.

Example: You teach eighth-grade art and have agreed with your colleagues in social studies, language arts, and music to focus simultaneously on the theme of "United States History and Culture from the time of Jefferson to the time of Lincoln" for a half semester. The social studies teacher normally covers that period of American history anyway; you agree to focus your art his-

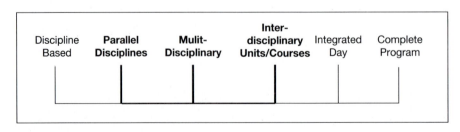

Discipline Based	Parallel Disciplines	Mulit-Disciplinary	Inter-disciplinary Units/Courses	Integrated Day	Complete Program

Figure 11-7 Jacobs' continuum.

tory lessons on mid nineteenth-century American painting, sculpture, and architecture; the language-arts teacher on selections of American literature; the music teacher on American composers.

Example: You teach first grade; the whole school has adopted the theme of "Jurassic Park" for upcoming Parents' Night. You, along with all the homeroom teachers, have agreed to focus your science lessons on dinosaurs (and/or pre-mammalian life in general) and the art teacher, who visits your room on a semiweekly basis, agrees to parallel this emphasis by leading your students in creating, firing, and decorating sculptures of dinosaurs out of fire clay. (The projects vary in difficulty for each grade level. Sixth-graders, for example, will construct a "life-size" tyrannosaurus out of wire and papier mâché in the lunchroom as a group project.)

Multidisciplinary Unit or Course: Unlike the parallel-discipline model, this model requires intense coordination and team teaching. Sometimes referring to this as *complementary discipline,*

Jacobs explains that this option brings together related disciplines "to investigate a theme or issue."[11] Disciplines that are easily melded together for this purpose are history, literature, and the fine arts.

Example: "The American rivers" unit previously described. Once again, you are an eighth-grade art teacher working with social studies, language arts, and music. This time, the four of you brainstorm, plan, and team together rather than simply coordinate your individual classes around a theme. However, your school does not have a large enough room for more than two classes, and your mutual schedules do not allow you to teach together as a foursome for a complete block of time. As a practical matter some compromises may have to be made. The first diagram (Fig. 11–8) tracks two eighth-grade homerooms in a traditional time schedule through three-periods (F, G, and H) at the end of the school day. The second diagram (Fig. 11–9) shows a plausible way in which the classes and periods are combined to form a three-period block. Here the social-studies

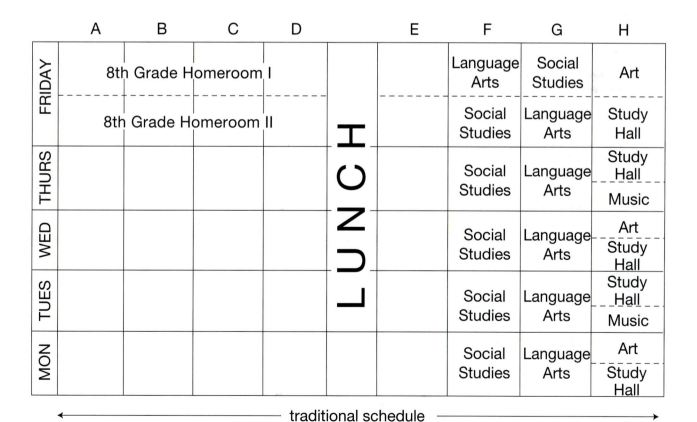

Figure 11-8 Eighth-grade schedule I.

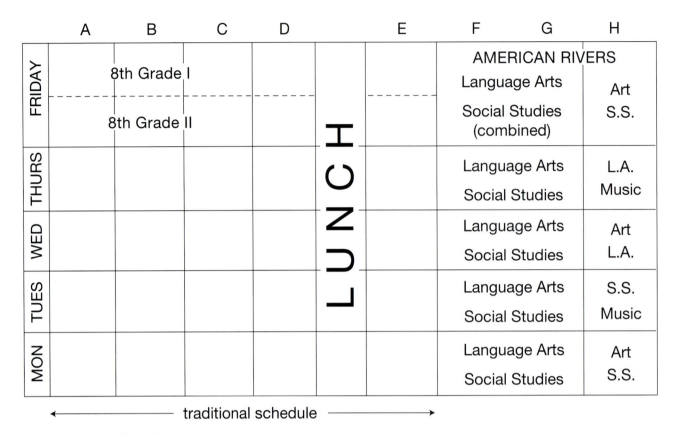

Figure 11-9 Eighth-grade schedule II.

and language-arts teachers team with the combined classes for two periods and share the third period with art and music on alternate days. Certainly not an ideal solution, but each of the teachers works with the others during some of the time. The students give up a study hall; each teacher gives up a free period or a study hall in order to join the team during part of the block.

Example: The whole school has adopted the theme "It's a Small, Small World" for this spring's Parents' Night—which has been extended this year into a Parents' *Week.* You are a sixth-grade teacher in a K to 6 unit. The agenda calls for immersion over a month's time in a particular country's culture. The capstone will be a display of projects—papers, readings, artworks—throughout Parents' Week, and musical performances during Parents' Night itself. The sixth-grade homerooms opt for Switzerland. You may have to do some research, particularly in those areas which fall within the purview of social studies and language arts. Of course some obvious things come to mind: Switzerland's unique geography, its political relationship to the rest of Europe, its

multilingualism. It also has a wealth of religious, political, and educational history to draw upon. Among others, Zwingli, Luther, Calvin, Rousseau, Voltaire, Lord Byron, Wagner, Tell, Pestalozzi, Mme. de Stael, and Piaget thrived there—either as natives, visitors, or refugees. You may want to narrow the focus, say, to William Tell, whose exploits make good stories; to Pestalozzi, whose relevance to you and your students is obvious; and perhaps to Heidi, a legendary mountain girl whose lifestyle influenced the Victorians. After doing some research, the art teacher learns that a number of significant modern artists were Swiss, as well as the fact that many others worked there throughout history. She decides to focus on twentieth-century Swiss crafts. For studio experiences, she is considering some Swiss folk arts: carving, lace making, and puppetry—although using materials appropriate for sixth grade. The music teacher agrees to amplify on Tell by playing orchestral selections from Rossini's opera, *William Tell.* Similar to the art teacher, he is considering a Swiss folk tradition: yodeling—which might be a hit on Parent's Night. Meanwhile, the art teacher

is leading all grade levels in the production of colorful travel posters—all closely geared to the respective countries.

Interdisciplinary Unit or Course: The term "interdisciplinary," as defined by both the dictionary and this chapter, means "the juxtaposing of two or more disciplines" and we have been using the term consistently throughout. As Jacobs outlines this model, however, it means the *full array* of school subjects: social studies, language arts, science, mathematics, industrial arts, art, music, P. E., drama, and so forth.

Since every lifelike picture or sculpture has a recognizable "subject," for example, dinosaurs, one might conclude that such an artwork can be correlated with that subject or any other. But as an example of interdisciplinary juxtaposition, this is rather superficial. Of course, the subject matter of art is not the only theme around which an interdisciplinary unit can be organized. The physics of color, the science of optics, linear perspective, geometric sculpture, and so forth, are viable instances of crossing art with science. In the field of music there exists the physics of sound and the mathematics of meter or pitch. Juxtapositions such as these are certainly fruitful, and should be considered.

Still, how does one bring together not just art and science or music and science, but all three, not to mention all the rest, around a common organizing center? We think an attempt to bring all, or even most of, the disciplines together for teaching a common theme at the middle-school or junior-high level is both impractical and philosophically unsound. If taken literally, this model is a good candidate for "potpourri."

A seventh-grade unit on print communication, for example, could involve as many as four disciplines: history (the history of written language), language arts (the study of various language systems), industrial arts (the development of paper and printing processes), and art (various ancient printing methods, including relief, intaglio, and lithography). The unit could start with the first written language (Ancient Sumeria) or the first use of paper and woodcuts (China) and end with word processing and computer graphics—or anywhere in between. A capstone project could be that of each student making a relief print, one that involved both images and words. (If a school has the right hardware and software, the final project could be a computer graphic.) It seems to us that to bring in more than these four disciplines—in a vain attempt to make such a unit interdisciplinary by Jacobs definition—would violate Ackerman's intellectual criteria, as well as lead to potpourri.

In the lower grades, the situation is different, however. There, discipline viability is less strict, and scheduling in self-contained classroom settings is much more flexible. Recall the Krogh example of marshaling together language, music, social studies, mathematics, art, and science around the theme of December. The interdisciplinary unit/course model, as defined by Jacobs finds a legitimate home in grades K to 3. (Indeed, the Parent's Week theme of "It's a Small, Small World" could be extended to incorporate all the disciplines in the K to 3 levels of our hypothetical school.)

In conclusion, we recommend the informal, parallel, and multidisciplinary models or combinations thereof for all grade levels, and the interdisciplinary option for only the lower grades. The first three are the most feasible and also the most viable with regard to discipline integrity—even for the upper grades. The fourth meets these criteria only in a K to 3 contained classroom setting where one person—though perhaps with the help of art, music, and other specialists—manages the interrelating of the disciplines.

SUMMARY

While previous chapters referred to some interdisciplinary possibilities, this chapter explored the subject in more detail. The focus of integration can be on skills, such as teaching higher-level thinking skills across disciplines, or on subject matter, such as juxtaposing art history and social studies. The reasons for integration and interdisciplinary approaches can be (1) to overcome fragmentation in the curriculum, (2) to discover new, unexpected knowledge, or (3) to examine old knowledge in a new light. Even so, there are good reasons not to integrate—depending on the scope of the the proposed new unit and the circumstances of the school setting. Some of these are practical, related to factors of time, space, money, and personnel. Some are philosophical, related to the need to maintain the integrity of the original disciplines.

The steps in developing an integrated unit include selecting an organizing center, brainstorming for ideas, establishing a scope and sequence for the new content, and coordinating efforts to team teach. The preferred models for content integration ranged from informal integration of two disciplines by a single teacher to interrelating the full array of disciplines by a team of teachers. The appropriateness of each model depends on the grade level. Generally, it is more feasible to organize learning around several disciplines (such as three or more) in the lower grades than it is in the upper grades.

NOTES

1. *Webster's New Universal Unabridged Dictionary*, (2nd ed.), p. 953.
2. Ackerman, David, and Perkins, David. N. In: Jacobs, Heidi Hayes (ed.). (1989). *Interdisciplinary Curriculum: Design and Implementation*. Alexandria, VA: Association for Supervision and Curriculum Development, pp. 79–93.
3. Jacobs, Heidi Hayes (1989). The growing need for interdisciplinary curriculum content. In: Jacobs (ed.) *Interdisciplinary Curriculum: Design and Implementation*. Alexandria, VA: Association for Supervision and Curriculum Development, p. 2.
4. Ibid.
5. Ackerman and Perkins, op. cit.
6. Krogh, Suzanne. (1990). *The integrated early childhood curriculum*. New York: McGraw-Hill Publishing Company, p. 80.
7. Jacobs, op. cit. pp. 55–56.
8. Jacobs, op. cit. pp. 60–65.
9. Glatthorn, Allan A. (1994). *Developing a quality curriculum*. Alexandria, VA: Association for Supervision and Curriculum Development, p. 91.
10. Jacobs, op. cit. pp. 13–24.
11. Jacobs, op. cit. p. 16.

12

Art for the Culturally Diverse Classroom

Because the issue of immigration gets so much attention in the press, we tend to forget the truism that this country was a nation of immigrants from the start. The irony of this fact is neatly capsulized in a political cartoon by Etta Hulme (Fig. 12–1). Indeed, cultural diversity began on this continent with Columbus. It began on the eastern shore of this country with the landing of the Mayflower.

Cultural diversity in the classroom also has a long history. One of the reasons Horace Mann introduced drawing into Massachusetts schools (Chapter 1) was to address the needs of a diverse population based on social class. While the privileged children of New England continued to study Latin and rhetoric, it was believed that poor and working-class children needed different knowledge and skills to prepare them for entry-level jobs in the new industries of the time.

A generation later, big-city schools throughout the new republic were forced to liberalize both the curriculum and teaching methods—this time because of an influx of non-English speaking immigrants. When dealing with such a heterogeneous student population, teachers simply could not keep order using the old methods of rote learning and recitation.[1]

At the turn of the century, the immigrant population in the schools consisted primarily of non-English-speaking Europeans: Germans, Poles, Russian Jews, Italians, and Scandinavians among others. The educational needs of Native-American and African-American children, meanwhile, were either totally neglected or given little attention.

Today, the immigrant population consists of a wide variety of non-English-speaking peoples—from Latin America, Asia, and the Near East, as well as Europe—a population mix that makes greater demands on the educational system than that of any of the earlier periods. Meanwhile, the education of Native Americans and African-Americans is no longer neglected as it once was. These groups, although non immigrant and English-speaking, are still, nevertheless, considered minority cultures.

But we may have to rethink the definition of "minority." In many places the minority has already become the majority. Half of all elementary and secondary students in California schools is Hispanic, Asian, or African in origin. In our large cities, the majority is also non-European (much of this as a result of internal migrations during and since World War II). It is estimated that by the year 2010, the majority of school-age children in California, New York, Texas, and Florida will be of non-European origin.[2]

Figure 12-1 Cartoon by Etta Hulme, "Sign the Petition for Proposition 1. . . . "
(Courtesy of Etta Hulme)

CULTURAL DIVERSITY AND YOU

Although our country's diversity is a source of political and cultural strength—for which we are all proud—it is also a source of concern to teachers. You may have asked yourself such questions as: How do I respond to cultural diversity? and How does this affect my classes in art?

An elementary teacher, Catherine Leffler, asked these kinds of questions on behalf of other teachers when she was invited to be a recorder at a Getty Center seminar on cultural diversity. In her notes, Leffler wrote that the teacher "must schedule approximately thirteen areas of instruction into 1 week, as well as deal with drug abuse, AIDS, abused and homeless children, the learning disabled, language problems, and the physically and mentally challenged." She also recorded the following questions with regard to the issue of cultural diversity:

1. What is art?
2. Does the cultural environment in a community and its school affect multicultural art education?
3. What cultures should be included in the curriculum and should these be the cultures in the school or in the nation?

4. How does one become "fluent" in a culture? How does one find bridges to reach this fluency?
5. Is it necessary to address the aesthetics that are unique to a particular culture[3]

We have solutions for Leffler's concern as well as answers to her five questions. We know that you will be interested in these. First, we must bring you up on the history of the multicultural movement in education and on the issues of cultural diversity.

THE HISTORY OF MULTICULTURALISM IN EDUCATION

Although terms such as *multiculturalism* and *cultural diversity* were not buzzwords in the 1960s as they are today, the ideas they refer to had their origins in the liberal environment of that decade. Whatever the final analysis may be about the substance of John F. Kennedy's presidency, there is no question it set in motion a spirit of change and idealism. The peace corps—a program aimed at solving problems in depressed areas around the world by use of American volunteers (mostly young)—is an example of this idealism as well as one with multicultural implications. Kennedy also

assisted blacks in attacking segregation and inequality.

The real momentum in this area—which came to be known as the Civil Rights movement—however, was the result of the work of black leaders. Martin Luther King, Jr., whose name more than anyone's came to symbolize the aspirations of blacks, received the Peace Prize in 1964. Interestingly, in 1963, the year King made his famous "I have a dream" speech in Washington DC, Betty Friedan published *The Feminine Mystique*. Her analysis of the historical inequities perpetrated against women helped to inspire "women's liberation." By 1970 this movement, now known as feminism, was in full swing.

As far as elementary school teachers were concerned, the immediate impact of civil rights legislation was to begin the process of integrating black and white students in classrooms. The long-range effect of both the Civil Rights movement and feminism was consciousness raising. Public awareness of the harmful effects of discrimination, not only toward people of non-European origins—Hispanics, and Native Americans as well as blacks—but also toward women, had increased dramatically. Out of this consciousness grew the concept of multicultural education.

During the 1970s, the concept of multiculturalism took on added urgency because of mounting immigration from a new source: "boat people" from Southeast Asia. Asians increasingly joined the non-European mix of blacks, Hispanics, and Native Americans in elementary classrooms, particularly in the state of California. However, this was not the end of multiculturalism's growing mandate. By the end of the 1980s there were pressures to extend it to include gays, lesbians, and groups discriminated against because of class and lifestyles. In addition, activist proponents called for more than just recognizing the needs of disenfranchised groups. They raised questions about the whole of American society, even suggesting education as a means of intervening in the problems of racism, sexism, homophobia, and other injustices. This more radical brand of multiculturalism is sometimes referred to as *social reconstructionism*. By the time of this writing, multiculturalism's mandate is so inclusive that a definition, or at least a sorting out, of the concept is in order. First let us see how art education fits into these developments.

Again, major changes in art education began in the sixties decade. At that time art educators in colleges and universities began to question the premises that art teachers had been working under since the end of the war. It was then that the inclusion of subjects such as art history and art criticism were first proposed. A leader in that overall ferment was June King McFee. In 1961 McFee published a text that stressed the sociological functions of art and the importance of viewing art education in the context of cultural differences.[4] She cited studies of child art in Siberia and of the Northwest Coast Indians, for example, to challenge some of Lowenfeld's contentions (Chapter 5). Although few art educators were aware of it then, her writings foreshadowed a multicultural direction in the field. Meanwhile, in response to the general cultural stirrings of the 1960s, the National Art Education Association (NAEA) appointed a committee devoted to minority concerns. By 1974 an affiliated women's caucus had been formed.

It took 20 years before the art-educational ferment of the 1960s percolated to teachers in the classrooms. The most important catalyst in this change was discipline-based art education (DBAE), which emerged in the mid 1980s. By the 1990s, many of its principles had been adopted by several state boards of education and by a number of school districts. Multiculturalism, meanwhile, had also emerged as a major force in art education. However, unlike discipline-based art education, multiculturalism has not as yet generated a coherent agenda. Its perspective is still not significantly reflected in official mandates nor in specific guidelines for teaching art.

SOME TERMS

At this juncture, we should pause to clarify some terms. The concepts of multiculturalism and its cognates are not always stable, and they can mean different things to different people.

Culture

We might begin with the term *culture* itself, which has at least two meanings—each symbolic of the two constituencies mentioned. Many discipline-based advocates favor the classical meaning in

which the metaphor "cultivate" applies, that is, a process of cultivating one's intellect through acquiring a body of knowledge that compresses civilization's noblest ideas (considered by some to be available in a literary canon of 100 "Great Books," as well as a canon of Great Works of Art). Although seen as having universal status, this ideal is actually rooted in the core values of one culture, Western civilization.

Multiculturalists, on the other hand, would invoke the sociological meaning of the term. Here, culture is conceived of as the whole way of life—material, intellectual, and spiritual—of a given society. Culture can mean the way of life, language, history, and traditions of a specific ethnic group, such as the Navajo, or a way of life defined by age and lifestyles such as the "youth culture," or even an entity defined by an institution such as the "public-school culture." The sociological definition is obviously relative and comparative and is not committed to any single culture. Whereas the classical meaning is inherently evaluative, the sociological meaning is value neutral.

In this chapter, we'll be illuminating the sociological definition. We cannot ignore, however, the classical definition since, as educators, we obviously value the "civilizing" influence of learning about the leading ideas and artifacts of civilization (not only Western civilization but many civilizations). As you may have already surmised, this book will attempt to steer a middle course between the classical definition and the sociological definitions of culture. To continue on this path we need to sort out more terms and concepts.

Cultural Pluralism

Cultural pluralism, as defined by educator James Banks, exists when various cultures and ethnic groups within a nation maintain their own identities.[5] Such identities can be expressed in several ways, for example, through religion, language, lifestyle, music, even geographical location. So long as these cultural manifestations do not conflict with the overarching values of the host society, they are legitimate—provided that the society is both democratic *and* committed to pluralism. (An extreme example of maintaining cultural identity might be the recent establishment of African-American immersion academies

designed to meet the specific needs of black males.)

As we have already seen, American society is affected by the perspectives of cultures from all around the world, not to mention the hybrid subcultures and regional variations that have grown up on American soil since the Civil War. And, because of a combination of legislation and consciousness raising since the 1960s, Americans have come increasingly to accept pluralism.

Few question that America today is culturally pluralistic, at least on the *macro* level. On the *micro* level, however, this is not always the case. America is a big country. If you were to examine a small piece of it, say a given rural community or a particular inner city neighborhood, you could easily discover a virtually homogeneous, *mono*-ethnic culture.

Cultural diversity—the term used in the title of this chapter—is simply a recognition of cultural pluralism. McFee has observed that cultural diversity exists in schools whenever a teacher from one cultural background attempts to teach children from another culture.[6] As pointed out earlier, the school population in many of our cities and in certain states has been culturally pluralistic for some time—although that diversity has often not been recognized. Nevertheless in some places, particularly in rural districts, the populations tend to be relatively homogeneous ethnically and culturally, and thus (assuming the teacher is of the same culture), there would not be much cultural diversity, but a high degree of cultural *unity*.

Assimilation versus Acculturation

Assimilation and *acculturation* are forms of interaction between two or more cultures. Assimilation occurs when ethnic groups within a society acquire the norms and values of the dominant culture of that society. The popular notion of the United States being a "melting pot," a place where diverse cultures blend into one unified culture, would be an example of assimilation.

Acculturation, on the other hand, presupposes the maintenance of cultural diversity. The process of acculturation occurs when cultures come into contact with one another and each influences the other and becomes modified, but each retains its individual identity. (Acculturation also applies to the process of a child acquiring the

values, beliefs, and customs of the culture in which it lives.)

Multicultural Education

Because multicultural education is an evolving concept, there is no hard and fast definition for it. *Multicultural education* has become the rubric for the whole debate over cultural diversity in education, including even the limits of diversity in the first place. Some educators go so far as to include identities based on class, sexual-preference, ability, and perhaps even age under the heading of diversity.

What this means to you, the individual teacher, depends on your perspective on the debate. A very broad interpretation of multiculturalism suggests that cultural diversity of some sort exists in every single classroom. It is simply impossible for a district not to have some class and ability differences, not to mention gender differences. Also, in cases where—according to one's definition of cultural diversity—problems of discrimination exist, there may be a need for reform of the school environment.

Extremists among the advocates of multiculturalism promote the concept of social reconstruction. If you accept this approach, you and your students would be enlisted to question the mainstream culture. Also, whenever and wherever possible, you and your students would actively foster changes in institutions that perpetuate racial, social, and gender injustices. Reform in this case would not be limited to just the school environment, and instruction would not be tailored to just the cultural mix of your local district. Even in districts with little or no cultural diversity, students would be engaged in analyzing inequality and oppression wherever it exists. Aside from the obvious difficulties of implementing such a program, social reconstructionism raises serious philosophical questions. More about this later.

Inclusion

The term *inclusion* is used in different, but related, ways in education. In the context of special education (see next chapter), the term refers to placing disabled students in regular classes.

In the context of multicultural education, inclusion refers to classifying a given population—such as women or gays—as culturally different vis-à-vis mainstream culture. Inclusion also refers to including a previously ignored topic—such as the art of Southeast Asia—in the regular school curriculum.

Global Education

The concerns of global education overlap those of multicultural education. But *global education* reaches beyond America's boundaries to comment on the ways in which nations today are inextricably linked.

Some of us can remember when imported goods were confined to a few food items such as bananas from Jamaica or coffee from Brazil. Manufactured products were usually made in the USA. Not so today. Similar to many Americans, one of the authors of this book owns several things made in Japan: his car (Toyota), his camera (Canon), his VCR (Sanyo), his tape deck (Sony), and his TV (Sears, but with Japanese components). Meanwhile his shirts were made in El Salvador, Malaysia, and Bangladesh; his pants in Korea; his Birkenstocks in Germany; his jacket in Taiwan; his bathrobe in Turkey. (Only his underwear was made in the USA.)

We hear a great deal about America's "trade imbalance"—suggesting that our country imports more than it exports in terms of dollar value. However, don't be misled into thinking trade is a one-way street. The United States exports an enormous amount of products, and American companies—Ford, MacDonald's, Kentucky Fried Chicken, and Toys "Я" Us, to mention a few—have significant overseas operations. With treaties like the North American Free Trade Agreement (NAFTA) and the General Agreement on Trade and Tariffs (GATT), this two-way traffic will only increase.

But trade is only one aspect of globalization. The world is linked by international organizations in health, education, research, religion, police, and such private transnational associations as Rotary, Scouts, Amnesty International, the Salvation Army, and Habitat for Humanity. Even visual arts education has its world association: the International Society for Education Through Art (INSEA).

While exponents of multicultural education dwell on the theme of diversity, global educators tend to emphasize the opposite. Lee F. Anderson explains that the "past half millennium has witnessed a marked *homogenization* of human culture"[7] (italics added). This global culture's second language is English; its common ideology is science. Indeed the most significant American export may, after all, lie in the area of culture—a fact that would tend to contribute further to this alleged homogenization of the world's peoples. Of particular note in this regard are Hollywood movies and popular music—a subject we will return to later in this chapter.

A REVIEW OF SOME PROPOSALS

Starting with the basic premise that American society is pluralistic—affected not only by factors of culture, ethnicity, and gender, but also by that of geography—the question is: How are educators to respond? The traditional way has been to temper this pluralism by assimilating students—regardless of race, creed or gender—into the mainstream culture by offering everyone what is deemed to be the best that that culture has to offer. It is the ideal of equal opportunity—what the Civil Rights movement was all about, at least initially. It is also reflected in the motto on the Great Seal of the United States, *e pluribus unum*, which means "one out of many." Bilingual education, for example, would be supported, but only as the quickest way for non-English-speaking Americans to become literate in English. In an art program it would mean providing all students with the best art available, what art educator Ralph Smith has called a "right to the best" or "beneficial elitism."[8] To some teachers, "best art" might mean only those works acknowledged to be great in the Western tradition.

But lately, many writers on multicultural education are rejecting the idea of assimilation in favor of preserving the integrity of ethnic groups as they are. Bilingual education in this view would not be a means to an end but an end in itself. Moreover, in this view the choice of art to use in school would be contingent on the culture(s) found in a particular class rather than on any single concept of "best art." As art is one of the most important agencies in embodying and transmitting culture, recognizing an ethnic group's

art in school would be a big step toward preserving that group's ethnic integrity.

Finally, some writers, believe that maintaining cultural pluralism, nice as it sounds, does not go far enough. Contending that the whole educational system is tainted with discrimination and injustice, they would call for radical reform known as social reconstruction.

School As a Microculture of Diversity

Banks, a respected writer on multiculturalism and one who believes in maintaining pluralism, identified a number of ways schools have addressed the issue. Initially these ways have taken the form of adding bits and pieces of ethnic history to instill "racial pride," or establishing compensatory programs (such as Head Start and English-as-second-language) to help disadvantaged students "catch up." Over time these strategies have become more multifactored.

Banks's own ideal is a system which conceives of a school as "a microculture where the diverse cultures of students and teachers meet." This microculture would stress not only instructional programs aimed at minorities, but in-service programs to help teachers and other members of the staff develop democratic attitudes and to ensure the maintenance of a racist-free atmosphere at all times. Acculturation would take place in this environment as various constituencies interact and absorb one another's views and perceptions in the spirit of mutual acceptance. His ideal—an interrelated whole—implies school reform, but does not go as far as social reconstruction. The components of Banks's system and how they interrelate are shown in Fig. 12–2.[9]

What do art educators propose for multicultural education and pluralism? McFee, for one, has recommended that the cultural study of art be added to studio, art history, art criticism, and aesthetics as a *fifth* content area.[10] Quite a few art educators, as we shall see in this brief review, are critical of Western culture and tend to favor a program of social reconstruction.

Multicultural Art Education As Critique

For starters, multiculturally inclined arts educators tend to focus on critiquing mainstream attitudes about art. Anthropologist Ellen Dissanayake

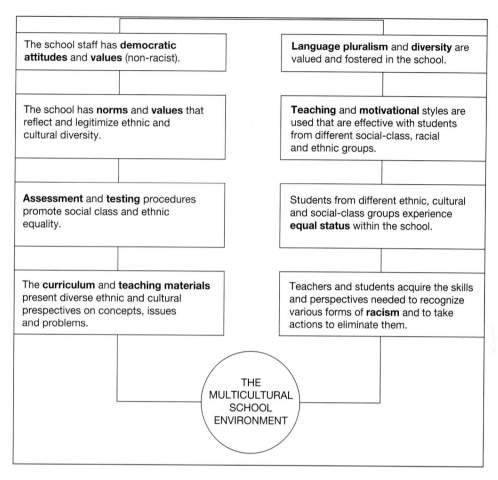

The school staff has **democratic attitudes** and **values** (non-racist).

The school has **norms** and **values** that reflect and legitimize ethnic and cultural diversity.

Assessment and **testing** procedures promote social class and ethnic equality.

The **curriculum** and **teaching materials** present diverse ethnic and cultural prespectives on concepts, issues and problems.

Language pluralism and **diversity** are valued and fostered in the school.

Teaching and **motivational** styles are used that are effective with students from different social-class, racial and ethnic groups.

Students from different ethnic, cultural and social-class groups experience **equal status** within the school.

Teachers and students acquire the skills and perspectives needed to recognize various forms of **racism** and to take actions to eliminate them.

THE MULTICULTURAL SCHOOL ENVIRONMENT

Figure 12-2 Banks's scheme.

(Chapter 5) explains that the concept of fine art is simply a Western notion, unprecedented in human history (before the eighteenth century), and unknown in hunter-gatherer, pastoralist, or agricultural societies.[11] Dissanayake suggests that all art theories (such as those reviewed in Chapter 5) contain hidden assumptions based in Western values and notions of art and are therefore tainted or, at least, inappropriate for understanding non-Western art. This line of thinking begins to discredit the vaunted institutions of art history, aesthetics, studio, and art criticism.

Some writers go beyond this sort of critique, however, to analyze the situation in strictly ideological terms. Feminist art educators remind us that what society has raised up as great art was made by "white, Western males." As such this art was, and still is, part of a system that "marginalized women as well as individuals of other cultures, races, and classes."[12] Other writers invoke the argument of "neo colonialism." Art criticism

and art history are seen as instruments of a Western world view and, therefore, have implicitly participated in "the domination of one group of people over another."[13]

These arguments obviously lean toward social reconstructionism. Among the most ardent spokespersons for a social-reconstructionist art education is Patricia Stuhr. Quoting writers who have outlined this position in general education Stuhr advocates that students in the art classroom be "taught to coalesce and work together across the lines of race, gender, class, and disability in order to strengthen and energize their fight against oppression."[14] Such a position is not only radical, but obviously impractical in an elementary education setting. It is also one that leaves little room, if any, for a discipline-based approach.

Some art educators are less strident, but are nevertheless critical of mainstream art. Karen Hamblen believes that a multicultural and a discipline-centered approach can coexist—but only if

the latter modifies its stance on what she perceives to be a single standard of cultural literacy, namely, Western. To Hamblen, cultural literacy should not be defined by a single standard, but instead be seen as a *process*. She favors a school environment wherein students become more aware of their own culture through learning about others. According to her, this would raise the whole concept of culture "to consciousness in terms of comparative and relative meanings."[15]

Graeme Chalmers, likewise, would "multi-culturalize" a discipline-based approach. Chalmers says that in teaching the four disciplines one should look beyond "formalist aesthetic qualities" and "embrace an anthropological and sociological perspective." He also says that a multicultural view is a contextual view.[16] (Recall in Chapter 5 the discussion of contextualism as a set of assumptions about the relationship between art and society.)

Unfortunately, multiculturalists, while strong in critique, are often weak in providing solutions. Hamblen promotes examining the assumptions of one's own culture—a good idea—but provides little in the way of specific methods.[17] Chalmers submits a "check list" (adapted from a "Cultural Sensitivity Self-test") which is helpful for assuming the right attitude in multicultural art education, but unhelpful in providing guidelines to teach it.[18]

SOME REFLECTIONS

Before coming to closure on what this book's position is on multiculturalism and ethnic diversity, we think it wise to reflect a bit on some different insights and points of view in order to put the whole issue in wider perspective.

We Have Met the Enemy, and It's Not Western Culture

For the reasons stated in the previous section, it is difficult to summarize precisely the position of multiculturalist art educators. But one thread running through all of their arguments is that the traditions and values of Western culture are at best, wanting, at worst, destructive. We question this. To stigmatize Western culture as the *bete noir* of

multicultural art education overlooks the fact that many *non*-Westerners—particularly Asians—are attracted to the arts of the West.

Take the case of concert music: An increasing number of Asians—Chinese, Indian, Korean, and Japanese—are now found in the ranks of top performers and conductors in the symphony orchestras of this country. Asian-American teachers of instrumental music are not at all uncommon in American universities. In Japan, Beethoven is so popular that performances of his Symphony No. 9 have become synonymous with their end-of-the-year traditions (not unlike the playing of Handel's *Messiah* among Christians in this country).

You may be surprised to learn that Chinese art majors are far better "drawers" than their counterparts in the United States. Why? One reason is because of the traditional education in the conventions of Oriental art, which is rigorous and demanding. Another reason is because much of Chinese professional art training is modeled on that of nineteenth-century European training—where students were obliged to spend many hours drawing nudes and still lifes. In Japanese junior high schools children do such things as draw and paint from nature (a traditional Western practice) and draw one another's portrait (also Western). The art reproductions that hang in art rooms are mostly of nineteenth- and twentieth-century Western works.[19]

Meanwhile, scholarly Japanese art education is heavily influenced by Western art education—and this was true even before World War II. Since the war, this influence has continued. As of 1984, *Creative and Mental Growth* by Lowenfeld (an Austrian-American) had gone through 40 reprinted editions. Just as in this country, Japanese art educators in the late 1960s reacted against the emphasis on creativity. In their case, however, the latter was replaced by an emphasis on *Bauhaus* design principles (a German import).[20] The reason for all this arts acculturation cannot be laid entirely to neocolonialism. Few would contend that such modern powers as China and Japan are currently under the spell of American domination—culturally or otherwise.

The denigrating of Western culture also overlooks the fact that the participation of minorities in the American art world has increased dramatically. Not all African-Americans, Hispanic-Americans, Native Americans, and women who

exhibit in New York or Los Angeles and are reviewed in major newspapers like to emphasize their minority status. To be sure, the content of their art often reflects, consciously or not, their ethnicity or gender. But what is important to these artists is that they are succeeding in the art world, a tough and highly competitive world, and they want to be respected as studio artists, not as minorities or women.

To return to the point about Asians appreciating Western music: Those who regularly play violin and listen to Schubert are undoubtedly a small percentage—though we don't have statistics on this subject. It is safe to say that the average citizen of Yokohama or Taipei is probably relatively oblivious of concert music. However, the same could be said about the average citizen of Youngstown or Tulsa! Western culture—if by that one means Beethoven, Shakespeare, Michelangelo, and Picasso (sometimes called the "high" culture)—is not a preoccupation of more than probably 5 percent of Americans. The central point is that popular culture—Hollywood, TV, sports, rock music—has *overwhelmed* the high culture. But it has also largely overwhelmed *traditional* cultures as well. (Traditional cultures are non-modern cultures native to various places throughout the world [sometimes called the "old world"]. Many of these are preserved by ethnic enclaves in this country as well.)

If we must identify a "neocolonialist" culture today—the enemy of cultural diversity—it would have to be American popular culture, not Western fine art. Nowhere is the global village more apparent than among the world's youth. It is not unusual to spot youngsters wearing *Raiders* T-shirts or *Sox* ball caps (often worn backwards) skate boarding in Paris, Tokyo, or Sydney. Or to hear the music of Michael Jackson or R.E.M. in Minsk or Recife. Or to see Madonna videos in Milan and Rambo movies in Beijing. Americans have also exported their professional sports: baseball to Mexico and Japan, basketball to places such as Italy, Croatia, and Venezuela, and football to places such as England, Germany, and Spain. Terms such as disco, rock, pizza, O.K., cool, and hamburger are international. Despite efforts, for example, on the part of the French government to stem the tide of American culture, the victory is complete. Popular culture, most of it bred in America, is now global culture. Thanks largely to the spread of American popular culture, English is becoming the world's second language.

This is not to say that all popular culture is bad; indeed some of it is excellent and should be taken seriously. Nevertheless much of it is trivial, and some of it is actually destructive. (Chapter 17 discusses popular art—rather than popular culture as a whole—and how it relates to fine art, and further how it can be accommodated in a comprehensive art education curriculum.)

All That Jazz

Up to this point the talk has been about the influence of American popular culture on other cultures. Acculturation, however, is not a one-way street. A good illustration of how acculturation proceeds in both directions is jazz, America's most original contribution to world culture. Jazz and its descendent, rock, are hybrids of many cultures, non-Western, minority, and Western.

Jazz's origins date to turn-of-the-century New Orleans, a diverse city of French, African, Creole (French-African), Spanish, Haitian, and, later, Anglo-American cultures (Fig. 12–3). The music itself grew out of two African-American musical traditions: blues (a mix of church music, African singing, work songs, and street vendor cries) and ragtime (European band music and African-American banjo playing). Over time, jazz continued to evolve, moved to Chicago, became national and, during World War II—the era of swing—became international.

During the 1950s, when jazz was becoming increasingly cool and intellectual, rock was just getting started. In addition to rhythm and blues—one of jazz's antecedents—rock brought together strains of regional music, particularly western swing and country. And, like jazz, rock continues to evolve and add more strains—folk, protest, Motown, soul, disco, raga, metal, new wave, punk, reggae, rap, and even classical. No better example of *e pluribus unum* exists in the arts than America's popular music.

Canon or Cannon

A nagging issue that always comes up in these discussions is what examples are appropriate, or stated another way, whose list shall we use? A

Figure 12-3 Photo of Louis Armstrong (1901–1971) seated at the piano with his Hot Five Band at the time of their first recording in 1925. *Left* to *right*: Johnny St. Cry, Johnny Dodds, Kid Ory, and Lil Hardin (Armstrong's wife). (Courtesy of Archive Photos, #334)

canon is an authoritative collection or list. (In religion, for example, it refers to the agreed-upon texts included in a holy book—such as the Torah, Koran, or New Testament.) In art the canon consists of those works typically reproduced and discussed in art history books—but it is definitely not a hard and fast list. While conservative art educators tend to accept this generalized canon, multiculturalists, as we have already seen, allege that it is too Eurocentric and exclusive of works by women artists. Radical multiculturalists seem bent on shooting it out of existence altogether. (If you were to base a canon on, say, tribal art, you would probably consult the experts in a particular tribe, but ironically you may also have to consult *Western* sources of connoisseurship and scholarly research.)

Must we choose between Eurocentrism and nihilism? Or is there something in between? The issue here is inclusion. First, any list of works used at the elementary level would need to be very limited in size—making the job of inclusion that much more selective. Second, what to include

is not just a matter of seeking some kind of cultural balance, but also of accommodating the students in your class. To do so, you should consider a number of factors, including your students' ages, abilities, ethnicity, and cultural backgrounds. We have some tips on this at the chapter's end.

Caveats from the Conservative Side

While we debate over such things as the proper balance of differing cultures in the curriculum, there exists another vocal constituency that opposes pluralism of any kind. Usually characterized by political and religious conservatism, this segment of the public is suspicious of any views that seem to differ from what they believe to be core American values. This camp insists that education should concentrate on those values in addition to teaching basic skills (That is, the three Rs). They are against English as a second language for any reason. They also oppose global education because they see a negative correlation between

Figure 10-1 Faith Ringgold, *Tar Beach* (1988). Story Quilt, (acrylic pieced and printed fabric), 74 × 69". Collection: Solomon R. Guggenheim Museum (c) Faith Ringgold, Inc.

Figure 11-1 Robert S. Duncanson, *Blue Hole, Little Miami River* (1851). Oil on canvas, 29 1/4" × 42 1/4". (74 × 107 cm). Cincinnati Art Museum, Cincinnati, OH. (Gift of Norbert Heerman and Arthur Helbig, #1926.18)

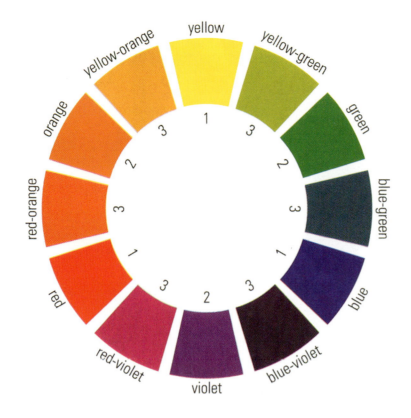

Figure 14-15 The traditional color wheel of pigment mixtures.

Figure 14-18 Gustave Caillebotte, *The Place de l'Europe on a Rainy Day* (1877). Oil on canvas, 83 1/2 × 108 3/4" (212.2 × 276.2 cm). The Art Institute of Chicago, Chicago IL. (Charles H. and Mary F. S. Worcester Collection, 1964.336/photograph #E30159 (c) 1996). All Rights Reserved.

Figure 14-17 Hans Hofmann, *Flowering Swamp* (1957). Oil on wood, 48 1/8 × 36 1/8″ (122.0 × 91.5 cm). Hirshhorn Museum and Sculpture Garden, Smithsonian Institution. (Gift of the Joseph H. Hirshhorn Foundation, 1966, #66.2482) (Photograph by Lee Stalsworth)

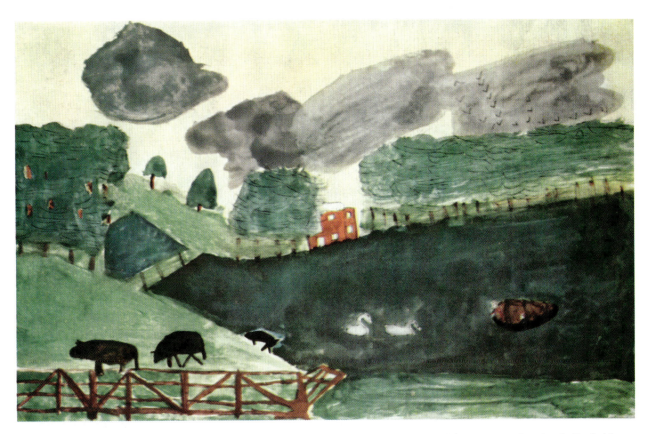

Figure 15-8 Mary E. Forsdyke (age 11) *Copy of Constable's "Wivenhoe Park"*, painted for Ernst H. Gombrich. Probably transparent watercolor paint on paper. (From the book *Art and Illusion: A Study in the Psychology of Pictorial Representation*, by E. H. Gombrich, Copyright (c) 1960.) (Reproduced by permission of Princeton University Press)

Figure 15-13 Wayne Enstice, *Escargot* (1994). Mixed media: carpet, cardboard, acrylic paint, and two frames, 26 1/2" high × 21" wide × 2" deep. (Collection of the artist.) (Photograph by the artist)

world cooperation and the maintenance of U.S. hegemony in world affairs.

The reality is that this conservative opposition is increasing, particularly in its influence in public affairs. One need only to consider the presidential elections of 1980 and 1984 and the congressional elections of 1994, in addition to the explosive growth of conservative radio talkshows over that same period. Steven Lamy, a professor of international relations, describes two "recessive" world views: the utopian right and the utopian left.[21] The first refers to the more extreme elements of the conservative opposition just discussed, the second refers to what we have been calling social reconstructionists—a minority among educators. Lamy points out that even the moderates among multicultural educators and global educators, though a majority within the schools and colleges of education, are usually among the minority in their own communities.

Caveats from the Classroom

Elementary educators—whether generalists or art specialists—are often caught in the middle: between students and administrators, between their schools and a public that is either indifferent or hostile, between their liberal teachers in colleges of education and conservative leaders in their own communities, and finally between practice and theory.

Early on in this chapter, we mentioned Catherine Leffler, the elementary teacher who was invited to a Getty Center seminar on cultural diversity. It is time now to address her concerns.

She lamented that she and her colleagues already had a full plate to deal with in the classroom, let alone taking on the issue of cultural pluralism. Relative to that lament she raised five pertinent questions which we will repeat here—but in a slightly different order (notice the placement of question 1 between questions 4 and 5):

2. Does the cultural environment in a community and its school affect multicultural art education?
3. What cultures should be included in the curriculum and should these be the cultures in the school or in the nation?
4. How does one become "fluent" in a culture? How does one find bridges to reach this fluency?
1. What is art?
5. Is it necessary to address the aesthetics that are unique to a particular culture?[22]

Leffler's concern and questions are addressed in the conclusion, the penultimate section of this chapter.

CONCLUSION

To indicate where we stand on multicultural education, we have boiled the issue down to a set of principles and a few suggestions. You will discover that our recommendations are practical and not nearly so daunting as those found in the some of the multiculturalist literature.

Personal Attitude

The most important element in a culturally diverse situation is you. Regardless of your curriculum, you the teacher mediate the messages and symbols and, therefore, consciously or unconsciously, mold its content. Banks advises all teachers to do a little self examination in order to "come to grips with their own personal and cultural values and identities."[23] The need on your part as the teacher to relate positively to students from various groups and to help them relate positively to each other is especially important if you teach in a culturally diverse situation. One of the points in Chalmers's checklist asks if you provide a "classroom atmosphere in which students' cultures are recognized, shared, and respected?"[24]

Decisions about Scope and Content of Cultural Diversity Should Be Local

Sometimes when reading the exhortations of writers on multicultural education, we forget the fact that schooling in this country is under the control of local school boards. The concept of local control is even more appropriate in a time of cultural pluralism. School populations differ dramatically, say, between the city of Chicago and downstate Illinois, or between Dade County, Florida and Davison County, South Dakota. Such differences should have a bearing on what materials are culturally appropriate, to say nothing about such issues as bilingual education. Therefore, the answer to Leffler's *question two*—about the role of the cultural environment of a community and school—is "yes." The obvious wisdom is simply

that one cannot make across-the-board generalizations about choices in multicultural education.

A Teacher Is Not Solely Responsible for Multicultural Education

Ideally, multicultural education is a school-wide project and not something that is expected to be successfully accomplished in a single classroom or by the art program alone—even in schools with ethnically diverse populations. You, the individual teacher, should have creative input, along with administrators, as part of a team, but you should not try to go it alone.

We reject radical reform—such as actively encouraging students to go out and combat oppression—as impractical and inappropriate for elementary education. The American system—flawed as it is—is still a leader, if not *the* leader, in the principles of equality and justice. Also, American society, of all societies in the world, probably has the best record of support for the rights of women. If anything, a serious study of other cultures and of other nations will demonstrate these facts. In the final analysis, we seriously doubt that you will ever encounter a philosophy of radical reform or "social reconstructionism" in your school system. If a school district is multiethnic, and the policy is to promote pluralism rather than assimilation, then we think a multicultural education modeled on Banks's paradigm is probably the wisest. Whatever the policy, it should be system wide.

Some Multicultural Education Is Appropriate Even in Classes That Are Not Culturally Diverse

If your classroom is culturally diverse, you are obviously obligated to meet this challenge in your classroom or art program in some way (again, within the limits of school policies, if any). If your classroom is *not* culturally diverse, you still have an obligation of providing an atmosphere in which such differences as ability, age, or gender are respected. But we also feel that you should develop one or two lessons with a non-Western or minority focus, nevertheless. One reason for this would be to foster empathy in your students for alternative points of view and an appreciation of the fact that culture is increasingly global. Another reason would be that studying a different culture helps students see their own culture more objectively—just as studying a foreign language helps one to understand English.

Don't Dilute the Content

This principle addresses Leffler's point raised about the pressures of scheduling in an elementary classroom (in addition to dealing with an array of students' personal problems). It also addresses *question three* about what and how many cultures to include. First, we do not approve of trying to include many cultures, for example, making toilet-paper-roll Kachina dolls this week (Hopi), Muslim paper mosaics next week (Islam), milk-carton totem poles the following week (Haida), and so on. Such an endeavor ultimately trivializes the very things that we are seeking to raise up for greater appreciation. It is an issue of breadth versus depth. We come down on the side of depth. An immersion experience in one or two cultures is much better than shallow experiences in many—even at the expense of not recognizing all of the cultures represented in your classroom in a given year. Remember, there are other school years. This is another reason for multicultural education being a school-wide project, in this case, a K to 6 or K to 8 plan to coordinate grade-level curricula to ensure that the cultures of all ethnic groups are given their due.

The point on immersion experiences partly addresses *question four*: How does one become fluent in a culture? How does one find bridges to reach this fluency? Achieving fluency in a culture is probably too much to expect. However, partial fluency or, more important, empathy and understanding, can be bridged by successful in-depth experiences.

Multicultural Education Is Multidisciplinary Education

An in-depth cultural study is best handled through marshaling together several disciplines—something we have talked about extensively in previous pages. Chapter 4 discussed ways of integrating aesthetics, art history, and art criticism in a well-rounded studio lesson; Chapter 8 suggested

integrating aesthetics with philosophy, art criticism with language arts, art history with history and social studies; Chapter 11 overviewed some specific strategies for integration and teacher collaboration. If at all possible, art teachers should coordinate their instruction with classroom teachers or specialists in history, geography, and language arts. Conversely classroom teachers may need to coordinate with the art specialist and, where possible and appropriate, with specialists in other subject areas.

A junior high school unit on Islam in Normal, Illinois is a good example of both interdisciplinary teaching and in-depth learning. Normal—a predominately white, middle class university town—has a smattering of Muslim households. But this was not necessarily the reason for the unit. A social studies teacher and a language arts teacher with a strong interest in art elected to team-teach world history organized around the theme of major religions, of which Islam is one. All of the instructions in the history of Islam, the geography of North Africa and the Middle East, Muslim literature, and Islamic art—took place in the combined social studies/English class. The unit even included a field trip to a Muslim community in Chicago where students and teachers toured a mosque. Of striking interest, especially to the girls, was the fact that many of the women there, including teenage women, wore the traditional *abaaya*, a black cloak that hangs over the head, and a veil to cover the face. Back in Normal, 20 students—girls and boys—volunteered to participate in an experiment that required them to dress and act like Muslims for the day. At one point they left their seats to face East and pray to Mecca. The girls, draped in bedsheets with only their hands and eyes showing (Fig. 12–4) had become objects of curiosity, and sometimes even ridicule.[25] Consider the multicultural implications of this unit: The students not only learned about a different culture and manner of life—in a way they'll never forget; they also experienced, albeit via role playing for a short period of time, what it is like to be a member of a minority.

Again, Stimulate a Community of Inquiry

Leffler's Questions one and *five*, "What is art ?" and "Is it necessary to address the aesthetics that are unique to a particular culture?" have already been

Figure 12-4 Chidix Junior High School students. (From Bloomington Pantagraph, Bloomington, IL.)

addressed in Chapter 8. Recall the recommendation for teaching aesthetics (which includes the question, "What is art?"). Instead of running to the library to check out philosophical tomes on the subject, you are urged to create a community of inquiry—sometimes by means of invented scenarios with pump-priming questions. For example, imagine the questions raised in students minds by the Islam unit just described. Of course many questions would be raised about Muslim attitudes toward, and treatment of, women. But a minimum of information about Arabian Islamic art traditions—such as the fact that their religion forbids portraying the human body—would stimulate questions about the connections between art and religion, between art and gender, and even between art and styles of dress. These sorts of connections are in the spirit of a contextual theory of art (discussed in Chapter 5) as well a mode of inquiry in aesthetics.

Different disciplines were utilized by the teachers in order to manage the information for the Islam unit. Meanwhile, the students, engaged

in the line of questioning described, are *thinking* in different disciplines—where lines between art, religion, sexual attitudes, and so forth, are traversed and retraversed at will. They are involved in an open interchange between their own values and those expressed in the culture and its art. We are not the least bit concerned over the possibility of the inquiry straying from the subject of art. Indeed we feel that such cross-disciplinary, creative thinking—wherever it leads—represents education at its best.

SUMMARY

This chapter overviewed the history of multicultural consciousness raising in this country since the 1960s—a development that led to the concept of multicultural education. The history of how this concept evolved in education and in art education was briefly traced.

Key terms, such as *culture, multicultural education*, and *global education*, were sorted out for clarification, but not defined. Proposals for the conduct of multicultural education, particularly the debate in art education, were then aired and analyzed. The writing in art education, as we saw, was often heavy on the side of critique, but light on the side of concrete suggestions.

This chapter attempted to rectify this omission to some extent by elucidating a set of principles. None of these principles are in conflict with any of the principles presented in other contexts in previous chapters. Indeed there is no conflict between multicultural education and a discipline-based art education, especially one that subscribes to a contextual view of art and eclectic approaches (Chapters 5 and 8).

Finally, we sincerely urge you to follow your own instincts with regard to meeting the challenges of cultural diversity. Also, go with the flow of opinion and policy in your own local district. If for example, it is not a major issue in your district, do not make it a false one on your own behalf, simply because of something you may have read. Do whatever is common sense and comfortable for you.

In the view of this book, a reasonable, practical approach to multicultural education need not be just another "add-on" to an already crowded elementary agenda. It can be an intrinsic part of a contextualist, integrated approach to art instruction.

NOTES

1. Logan, Fredrick. (1955). *Growth of art in American schools.* New York: Harper & Brothers, pp. 22, 23, 87.
2. Anderson, Lee F. (1991). A rationale for global education, *Global education: From thought to action.* Alexandria VA : The Association for Supervision and Curriculum Development (ASCD) Yearbook, pp. 28–29.
3. Leffler, Catherine. (1993). Elementary education. In: *Seminar proceedings: Discipline-based art education and cultural diversity.* Santa Monica, CA: The J. Paul Getty Trust, p. 105.
4. McFee, June K. (1961). *Preparation for art.* Belmont, CA: Wadsworth Publishing Co.
5. Banks, James A., and Lynch, James (ed.). (1986). *Multicultural education in western societies.* New York: Praeger, pp. 197–198.
6. McFee, June K. (1993). *Some perspectives from the social sciences.* In: *Seminar proceedings: Discipline-based art education and cultural diversity.* Santa Monica, CA: The J. Paul Getty Trust, p. 66.
7. Anderson, op. cit., p. 16.
8. Smith, Ralph A. (1986). *Excellence in art education: Ideas and initiatives.* Reston, VA: National Art Education Association.
9. Banks, op. cit. pp. 22–23.
10. McFee, June King. (1988). Art and society. *Issues in discipline-based art education: Strengthening the stance, extending the horizons.* Los Angeles, CA: The Getty Center for Education in Los Angeles.
11. Dissanayake, Ellen. (1992). *Homo aestheticus: Where art comes from and why.* New York: The Free Press (Macmillan Inc.).
12. Collins, Georgia, and Sandell, Renee. (1992). The politics of multicultural art education. *Art Education* 45 (6): p. 8.
13. Congdon, Kristin G. (1989). Multi-cultural approaches to art criticism. *Studies in Art Education* 30(3): p. 179.
14. Stuhr, Patricia L. (1994). Multicultural art education and social reconstruction. In: *Studies in Art Education* 35 (3): p. 176, quote from Grant C., and Sleeter, C. (1993) Race, Class, Gender, Exceptionality, and Education Reform. In James A. Banks and Cherry A. McGee Banks (eds.) (2nd ed.). *Multicultural issues and perspectives.* Boston: Allyn and Bacon, p. 57.
15. Hamblen, Karen A. (1988). Cultural literacy through multiple DBAE repertoires. *Journal of*

Multi-cultural and Cross-cultural Research in Art Education, 6 (1), pp. 89–90.

16. Chalmers, F. Graeme. (1992). D.B.A.E. as Multicultural Education. *Art Education* 45 (3): pp. 17–18.

17. Hamblen, op. cit., p. 95.

18. Chalmers, op. cit., p. 23.

19. Mason, Rachel. (1994). Artistic achievement in Japanese junior high schools. *Art Education 47*, (1), 8–19.

20. Okazaki, Akio. (1984). An overview of the influence of American art education literature on the development of Japanese art education. *Journal of*

Multi-cultural and Cross-cultural Research in Art Education, 2 (1).

21. Lamay, Steven L. (1991). Global education: A conflict of images. *Global education: From thought to action*. Alexandria VA : The Association for Supervision and Curriculum Development (ASCD) Yearbook, pp. 56–57.

22. Leffler, op. cit., p. 105.

23. Banks, op. cit., p. 17.

24. Chalmers, op. cit., p. 23.

25. Conversation with Steven Mintus, social studies teacher in Unit 5.

13
Teaching All Learners

In every school, some children perform well beyond our expectations and others are inordinately challenged by them. We call both kinds of students the exceptional ones. Exceptional students include those who have some kinds of disabilities as well as those who have special gifts. Both groups of students have special needs. Whether you are an art teacher or classroom teacher, you probably will be (if you are not presently) working both with gifted and with disabled students—even, in some cases, with those having relatively severe disabilities.

Teaching exceptional children can also carry its own certification in many states. Some art specialists pursue graduate study to earn these credentials. Others, also after graduate study, become art therapists, using art to diagnose and treat personality disorders. Neither of these specialized uses of art is your responsibility. We do not expect you to do the job of these special educators, particularly the art therapists. Our discussion to follow is designed to prepare you to help the exceptional children you may ordinarily expect to encounter in your classrooms.

CHILDREN WITH DISABILITIES

Among the children we consider to have disabilities we count those who are slow learners, who

have physical impairments, including chronic illnesses, who are emotionally disturbed, or who may need remedial instruction in language or other subjects. Although these children need extra time from you in an already full school day, all teachers need to realize "it's *our* kid—it's the school's child."[1]

Nearly 10 percent of all U.S. students receive special education services of some kind.[2] In the past, most of those with mental or physical disabilities were taught in settings separate from regular schools. This practice was challenged in 1975. The U.S. Congress passed legislation (PL 94-142) requiring that all children, regardless of disability, receive an education in "the least restrictive environment" to the maximum extent appropriate.

"Least restrictive environment" has been interpreted to mean offering a variety of special education services, but whenever possible integrating students with disabilities with their age peers. The implications of this provision raise a number of questions, some of which are treated in the following section. One consequence is that children with special needs are already being included in regular classrooms—both elementary homerooms and art rooms.

Since the 1975 law, later amended and renamed the Individuals with Disabilities Education Act (IDEA), placements in regular classes steadily increased. In 1987, 29 percent of students

214

with disabilities spent from 60 to 100 percent of their time in regular classes. In 1991, 33 percent did.[3] Looking at this development from another angle, around two-thirds of all art teachers interviewed in a 1992 survey said that they had taught exceptional children in integrated classes, while as many as 84 percent reported working with them in either integrated, segregated, or combined settings.[4]

Kinds of Settings for Teaching Children with Special Needs

Art therapist David Henley identifies these three basic types of settings for teaching children with special needs: *individual, self-contained groups,* and *inclusion.*[5] He notes that these kinds of services can be mixed, as well. That is, exceptional children in regular classes may be pulled out for part of a day in order to receive more intensive instruction in group or individual settings.

Individual An individual setting calls for intensive, one-on-one involvement, a maximum of adaptation of the art activity, and close monitoring of the child's responses and behaviors. This level of service is often the result of a referral by a teacher or a multidisciplinary team, and is usually reserved for children with particular problems needing special intervention.

Self-Contained Groups A group setting is for children who are able to function in a group but who still need a more structured and sheltered environment. Class sizes are usually small, and the people in the class share the same disability. The self-contained setting—whether in a special room in a public school or in a separate school—is the traditional way of educating those with disabilities. Because of its homogeneity and segregation from the normal population, however, this level of service is deemed to be in conflict with the least-restrictive environment mandated in PL 94-142.

Inclusion Intended to address the spirit of least restriction, inclusion (sometimes called *mainstreaming*) involves placing students with mild or moderate disabilities in regular class settings for most, if not all, of the school day.[6] A concept that emerged in response to the Individuals with Dis-

abilities Education Act, inclusion has assumed the proportions of a movement and, in its extreme forms, is controversial. To some inclusion advocates, special education itself is an obsolete concept, especially for children with moderate disabilities.

The Pros and Cons of Inclusion

To understand the advantages of inclusion, let us look first at the *problems* of special education. Many of these are inherent in the concept itself: the stigma of the "special" label, isolation from neighborhood life, lack of contact with every-day culture, lack of regular role models, and low expectations bred of special treatment. Traditional special education is even accused of being bureaucratic—given to things such as vested interests, mismanagement, and in-born conservatism. Special education is "dysfunctional and overgrown" according to inclusion advocates.[7]

Inclusion, the inverse of special education, seems to be the natural answer to these problems. Minimizing one's special status, goes the argument, brings both social and academic rewards. Inclusion, by decentralizing the services for the child who has a disability into regular classrooms, supposedly addresses the bureaucracy problem. Finally, the argument is made that inclusion also benefits those without disabilities who, by interacting with a child who has a disability, come to appreciate human differences.

Conversely, to see the disadvantages, let us review the benefits of traditional special education: intensive small-group instruction; instruction adapted to the child's disability; a predictable, structured environment; specially trained professionals. These benefits, traditionalists argue, are at risk if the concept of inclusion is interpreted too literally. Also, there is the regular classroom teacher (or art teacher) who not only feels ill-equipped to handle exceptional children, but who already has more than enough students.

Art therapist Frances Anderson asks, "How appropriate is it to include children with severe disabilities in regular education classes when there are already too many students in the class (say, 35 to 40) and the teacher has no support staff?"[8] Further, disrupting the pace of learning, the possible lowering of expectations, and perhaps, even, changing the curriculum are bound to

affect negatively the education of the regular students. Finally, the potential benefits of integration for the child with disabilities may be offset by the anxieties of being removed from his or her usual sheltered environment.

Cost factors are even a point of debate. Inclusion advocates argue that savings will accrue from eliminating such things as busing, maintaining special facilities, and bureaucratic overload. Inclusion critics claim that inclusion will cost more, not less. In order to provide truly appropriate education, they say, new teachers and teacher's assistants will have to be added to the payroll. We feel that, given the current fiscal situation in most schools, this is not apt to happen.

COPING WITH INCLUSION

Should you find exceptional children in your classes, you should be able to teach those with disabilities without disruption to you, your schedule, or your regular art agenda. (Some of you may also be assigned to teach art in segregated self-contained groups.) The following discussion of inclusion covers *philosophy, preparation, setting limits, lowering student ratios, verbal activities,* and *resources* as they relate to inclusion.

The Philosophy of Inclusion

Inclusion advocates refer to *normalization,* a belief that integrating children with disabilities into regular classrooms fosters behaviors similar to those of other children the same age. This suggests that you treat the child who has a disability just as you would any other child of that age. You would abstain from what art educator Douglas Blandy describes as the *medical model,*[9] which would deemphasize art *content* in favor of art *therapy.* Whether you are an art teacher or classroom teacher, you should not sacrifice content when working with children who have disabilities.

But does this mean, then, that your teaching agenda would be entirely unaffected by the presence of students with disabilities in your class? Each kind of disability has different requirements. At times the presence of students with disabilities calls for little adaptation, and providing too much—such as dictating a theme or helping the child with the composition—would do more harm than good. Henly comments on a spastic cerebral palsied child in a class doing mixed-media paintings:

> Perhaps all that's needed is a thicker paintbrush or precut collage materials. Spasticity has little bearing on a child's depth of imagination or vitality. Implementing unnecessary adaptations . . . will only repress the child's potential and, in the long run, will make the child more dependent.[10]

At other times, however, trying to achieve a least restrictive environment may call for a great deal of adaptation. In the following case, intervention is necessary to create a least-restrictive environment, that is, one in which the child can function successfully. Consider the needs of a child whose disability is mental retardation, who may not be able to

> walk in the door unless given clear, concise directions. The child may need assistance in finding a seat, accepting art materials, sequencing the steps of the art process, using the medium appropriately, or following the simplest clean-up regime.[11]

In summary, whether or not you have students with disabilities, you should "stay the course," that is, continue to teach substantive, age-appropriate art lessons without compromising standards. Nevertheless, if you do have such students, you may have to take some measures to help a student overcome some particular difficulty. We stress that your role is *not* therapy. If a child has a serious problem, or is unusually disruptive, that child—whether with or without disabilities—should be referred to an appropriate professional for help.

Preparing for Inclusion

Wise preparation in a school situation always applies. Chapter 9 discussed the subject of organizing an art lesson, Chapter 18 covers organizing an art room. Here, the discussion focuses on a few tips for handling a mainstreaming situation.

Anticipating Problems There is no substitute for experience. No matter how much your methods teachers tell you or how much we say in these pages, you will not completely appreciate the nuts-and-bolts aspect of teaching until you have had some experience. An experienced teacher almost instinctively anticipates and prepares for potential problems.

Some problems are purely logistical: the passing out and handling of materials, safety hazards, cleanup procedures, and so forth. Some involve difficulties students have in sequencing through a technical process (especially a complex one). Some are motivational—lulls in concentration that can lead to discipline problems.

Finding Solutions Have art materials ready for distribution, perhaps at convenient supply points. Have directions and motivational strategies well organized and even rehearsed. Anticipate times when additional instructions or interventions are needed to overcome difficulties or motivational lulls during the course of the lesson. Provide printed guidelines geared to reading level—either on paper or on the chalkboard. If you take your time and think through the whole lesson, your imagination and common sense will provide you with workable solutions for problem situations.

Setting Limits

By "setting limits" we mean "not spreading yourself or your art lesson too thin." Recall in Chapter 9 the explanation of the *conceptually consistent* lesson, wherein each art lesson teaches a limited number of concepts. Also, you learned that despite this limitation, individual results of a *conceptually consistent* lesson tend to be as varied as those of an open-ended lesson.

In an integrated art classroom, it is wise to have all students using the same materials and tools. A single-medium lesson reduces the time needed to give technical instructions before and during the process of executing a project. Also, like the *conceptually consistent* lesson, a single-medium project enables the teacher to aim motivational strategies and instruction toward just one or two goals. In short, both limiting the parameters and maintaining a focus reduce stress, not only on your students, but more importantly, on you.

Lowering the Student-Teacher Ratio

The ideal way to teach exceptional children is one in which a special education teacher is assigned to your room—either on call or on a regular schedule with four or five other rooms. Together, you and the special teacher would develop an Individualized Education Program (IEP) for each exceptional child, and he or she would assist you whenever special intervention is called for. This model would be the best of both worlds—full inclusion plus individual instruction when needed.

Short of the ideal, your school might lower the student-teacher ratio by recruiting parents, retired people, college students, and self-employed artists from your community.[12] Volunteers can clean brushes, check kiln temperature, fill paint jars, and so forth. If a volunteer works with a child who has disabilities, the nature of the intervention must be specific and carefully defined.

Finally, if other adults are not available, the job of lowering the ratio may have to be accomplished internally by means of *cooperative learning*. Cooperative learning refers to organizing your class into small groups of mixed abilities. You would intentionally disperse throughout the groups not only those with disabilities, but also those students identified as artistically average, below average, and above average. Students who are potentially disruptive should be dispersed as well. The idea is that in each group the responsible students will assist others as needed, either spontaneously or by teacher direction.

Verbal Activities

The previous examples imply the handling of art materials, but lessons including aesthetics, art criticism, and art history also involve verbal activities. Ostensibly they are less awkward to manage, but verbal activity has its own hazards. Lacking the advantages of sensory anchoring and concentrating the mind that a good studio activity provides, verbal activity can tend toward either underinvolvement (for example, apathy and boredom) or the opposite—getting out of control. Children who have disabilities or who feel insecure are prone to become underinvolved, while some of their peers may talk too much.

Bear in mind first of all that those who do not participate are not necessarily languishing. The minds of those who listen may be just as active in reacting to points raised and following a line of argument as those who do the talking. Also, as mentioned in Chapter 8, no one should be forced to respond when his or her turn comes up in a round-robin discussion. It's O.K. to "pass."

Those who, for whatever reasons, have difficulties speaking in front of a class can contribute by writing—such as submitting written questions for the "Big Question Chart" or scenarios for aesthetic inquiry. It might be easier for a child who is shy or has a disability to contribute in a small group (such as a cooperative learning group described earlier). When the groups are reassembled into a plenary session, the child's contribution can be given voice by the designated leader of that group.

Finally, verbal activity is not always group related. Growth can take place in verbal activity between just student and teacher. Opportunities for individualized exchanges exist during studio activity when the rest of the class are absorbed in their own projects.

Critiquing a student's work often provides the pretext for this exchange, an exchange that should be conducted in a secure, nonjudgmental atmosphere. This kind of contact helps develop vocabulary, understanding of art concepts, thinking ability, and self confidence. One art therapist describes the amazement of visitors watching a class of students with severely limited speech referring to this or that "element" in their "piece" during a group critique.[13]

Resources

The bibliography for this chapter includes books about teaching those with disabilities. Anderson's *Art for All the Children: Approaches to Art Therapy for Children with Disabilities* provides lists of characteristics of the various disabilities along with suggestions for adaptations.[14] Henley's *Exceptional Children: Exceptional Art* provides a wealth of useful insights and suggestions, many of which have been cited in this chapter.[15]

In addition to the texts, there is the *Federal Register* of the Individuals with Disabilities Educa-tion Act (IDEA), which defines the various disabilities. The American Association of Mental Retardation (AAMR) provides information about children with mental retardation—the disability that you will encounter with the greatest frequency. We recommend these and the others, but with a caveat: do not try to use their diagnostic procedures and suggestions for therapies, which all of these books include to greater or lesser degrees. We repeat, art therapy is *not* your responsibility.

CHILDREN WITH SPECIAL GIFTS

Children who have special gifts are considered exceptional students not because they have disabilities, but because they have superior abilities. Giftedness, whether in adults or children, is a high level of performance compared to one's peers, particularly as measured by a standardized I. Q. test. Unlike most disabilities, which affect an individual throughout life, giftedness is not always a permanent quality. A child considered gifted at 5 years of age may not fulfill the criteria for an exceptional student as an adolescent.

Unlike those with disabilities, students with special abilities do not enjoy the protection of federal and state educational mandates, have no army of certified professionals assigned to work with them, and are not represented by whole curricula in colleges of education. Also, rather than being celebrated, those with special gifts are often objects of latent hostility. This is because of two notions that run deep in the American idea of democracy: commitment to egalitarianism and suspicion of elitism. Democracy in this context—practiced as inclusion—serves to *level* differences, not foster them. The upshot of all this: during times of hardship, programs for the gifted are among the first to go.

The historical practice has been to segregate children who have disabilities, and only lately to integrate them. For those with gifts, on the other hand, the standard practice has been integration all along—though due more to neglect than to stated philosophy. Now, the debate is over whether or not to segregate.

Ironically, the winners in the debate seem to be inclusion advocates who make the same case

for those with special gifts as they do for all other exceptional students. But not everybody agrees. Studies indicate that the gifted do *not* benefit from being placed in mixed-ability groups, such as, for example, cooperative education sessions.[16] Currently, advocates for those with gifts are floating a number of proposals for separating them within the schools. Some recommend teaching them in segregated schools.[17]

Different Kinds of Gifts

We call children with special gifts in making art *talented*. Talent in arts education was given official imprimatur in 1972 by a report to Congress (*The Marland Report*) which used the word *talented*, and which listed the "visual and performing arts" as one of six areas of superior performance to be recognized in education. Thus, the arts gained a place at the table of public discourse, and the talented became provisionally defined as those who show superior performance in one of the arts.[18]

Traditionally, we have considered talent to be a congenital aptitude for art possessed by a few individuals, who may or may not score high on conventional I.Q. tests. Education was thought to discourage some individuals from making full use of their talents, but it was considered unable to instill high artistic ability in any individual unlucky enough to be born without it.

Thinking of artistic talent as a personal attribute with which a child is born, however, may be a mistake. According to psychologist Mihaly Csikszentmihalyi, talent "is a relationship between culturally defined opportunities for action and personal skills or capacities to act."[19] Thus, once adults recognize superior artistic abilities in a child, they *can* nurture them through education.

As you learned in Chapter 6, Howard Gardner's theory of multiple intelligences has shed new light on the way we think about talent. Now we are beginning to regard the talented as having an artistic intelligence (some combination of Gardner's multiple intelligences). We consider artistic intelligence different in kind but not necessarily different in giftedness from the faculties all children possess. We believe that talented children need instruction in art just as much as their peers do in other subjects.

Current Methods of Identifying Talent

There are two principal ways of assessing talent, just as there are for any student achievement: observing products and observing performance. Both of these should be done as part and parcel of your normal assessment procedures for the whole class (refer to Chapter 10). Indeed, there may be no exceptionally talented students in your room.

Determining whether any of your students has artistic talent differs from assessing student achievement in only one respect. Ideally, your standard of measurement should lie outside of your classroom. You would gain the most reliable determination of talent if you could compare the performance of your student to the typical performance of many other students of the same age and educational level.

Most of us are not that experienced, however, so we do the next best thing. Whether your own experience in art is limited to your school, your district, or your state, you compare the level of your best student's work with that of all other children of the same age that you have seen (and you can refer to the guidelines in Chapter 4 for confirmation, if you need to). Think of what you are doing as similar to an I.Q. test in this respect: if a child's products and performance are consistently superior to excellent examples of objects and performance by children who are the same age, you can declare the child to have special abilities in art.

Identifying Talent Through Portfolio Review
A portfolio review for identifying talent is to the visual arts what an audition is to the performing arts. For discovering artistic giftedness, obviously, a portfolio consists of artworks, but also, depending on the purpose, it might include written examples of art criticism, answers to Big Questions of an aesthetic nature, evidence of library research, or whatever the assessor requires (Chapter 10). If the purpose of identifying talent is to decide on admission to a special school for the arts, the portfolios under review might contain the best examples of a student's artwork collected by a parent or teacher over several years of elementary school. If the purpose of identifying talent is in order to place the child in special classes, or to determine whether the child might benefit

from advanced work (the most likely scenario), the portfolios might be those routinely kept by all of the children in your class.

Assessing superior performance in art is basically the same as judging a competition in Olympic figure skating. In both cases, it is a matter of *rating*. In your classroom, you are probably the only rater. However, in the case of an art competition—say, to screen candidates for admission to a special school for the arts—the ratings of several judges may be used, just as in the Olympics.

In looking for talent, you can respond to single works in sequence, as judges of Olympic contests or judges of art exhibits often do, or as you do yourself when you are assessing tutored images that result from class assignments. You can also make a summative evaluation of the collection of artworks as a whole, as art critics often do when they review an art exhibit for their newspapers. Both kinds of approaches are necessary.

Dimensions of Superior Work In looking for talent, you are looking for consistently superior artwork. Superior artwork is defined as work that is above what would normally be considered excellent performance by a student of that age. Superior work is consistent if it occurs repeatedly throughout the portfolio.

Table 13–1 illustrates an individual rating scale to use when looking at a portfolio of student art. Its criteria represent six distinct aesthetic dimensions: *realism, visual elements, design principles, technical skill, expression,* and *invention*. Each dimension refers to a different set of characteristics to look for in each work (and in the series of works as a whole).

Let us examine the criteria one by one.

- **Realism:** Under realism, you would look for such things as a student's ability to represent figures and to indicate spatial relationships.
 - Do the figure drawings have accurate proportions?
 - Does a landscape contain an illusion of pictorial space?
 - Can a sculpture be considered complete from all sides?
 - Is there linear and aerial perspective, foreshortening, and perhaps chiaroscuro?
- **Visual elements:** Look for repleteness (as defined in Chapters 5 and 6).
 - What is the character of the lines?
 - What is the aesthetic quality of the color?
 - What is the expressiveness of the shapes, and so on (see Chapter 14)?
- **Design principles:** Look for such aesthetic properties as balance, repetition, and movement that produce a sense of unity within the composition (Chapter 14).
 - How well did the child make use of the entire page (the artistic format)? Is there a center of interest?
 - Do the figures and shapes fit comfortably within the edges? Can you identify positive and negative shapes?
 - Does it have unity?
- **Technical skill:** Look to see how successfully the student handled media.
 - How many media are represented? At what level of skill were the technical processes in each one?
 - Was technique used in order to express a mood or idea, or simply for its own sake?
- **Expressiveness:** Look for the effectiveness of the work's communication.
 - Does it have impact (due not just to the design, but to the idea as well)?

TABLE 13–1 Individual Portfolio Rating Scale for Identifying Artistic Giftedness (Talent)

	Realism	Visual elements	Design principles	Technical skill	Expressiveness	Inventiveness
5 Superior						
4 Excellent						
3 Very good						
2 Satisfactory						
1 Poor						
0 No observation						

- Does it make a statement?
- Can it be said to arouse an emotion or convey an idea?
- **Inventiveness:** Remember that inventiveness or originality is a relative term; something that is inventive at age six may be a cliché by age ten. Divide inventiveness into four subsets:
 - originality of subject matter (narrative)
 - originality of form (use of visual elements and design principles)
 - originality of technique
 - originality of expression.

You can give the dimensions in Table 13–1 different weights for different kinds of art products. For example, to rate a drawing you might give greater weight to realism, visual elements (especially line quality), design principles, expressiveness, and inventiveness, and lesser weight to technique. For a ceramic jar, you might give the greatest weights to clay technique, visual elements (especially shape and texture), and design principles, lesser weight to expressiveness, and no weight at all to realism. You can and should devise your own rating system to represent whatever dimensions of student art that you consider important.

Portfolio Review for Program Screening and Other Competitions Art educator Al Hurwitz has judged literally thousands of high school students' works for all kinds of competitions and screening purposes. Hurwitz developed a list of assessment criteria for screening that are geared more for high school portfolios than for elementary portfolios. Nevertheless his list is a good example of other functional dimensions, consideration of which can help you spot excellence in children's studio art.

Hurwitz's list of criteria is as follows:

- verisimilitude (another term for realism)
- compositional control
- complexity and elaboration
- memory and detail
- sensitivity to art media
- random improvisation.[20]

Remember, all students should keep portfolios, and you may use them to assess not only art products but other student projects, such as art criticism and art history research. It is possible that your classroom harbors a gifted future aesthetician or art critic. Portfolio screening should be designed to find these kinds of students as well.

Identifying Talent Through Observing Performance Observing children's performance or behaviors is also a good way of screening for superior abilities. We make use of the following general and art-related behaviors: *intelligence, work habits, inventiveness (general behaviors); attitude, school record, and studio behaviors (art-related behaviors).* Some behaviors relate directly to art, and others are tangential to it.

Table 13-2 presents these behaviors in the form of a rating scale. It lets you measure how often you observe these general and art-related behaviors. You can observe performance behav-

TABLE 13–2 Individual Performance Rating Scale for Identifying Artistic Giftedness (Talent)

	General Behaviors			Art-Related Behaviors		
	Intelligence	Work habits	Inventiveness	Attitude	School record	Studio behaviors
5 Compelling						
4 Highly evident						
3 Evident						
2 Occasionally evident						
1 Seldom evident						
0 Not evident						

iors that identify talented individuals either directly, in your classroom, or indirectly through test scores and other school records.

General behaviors

- **Intelligence:** Not all intelligent people are artistically talented, but most talented people—although not all—have above-average intelligence, as measured by their performance on a standard I.Q. test.
- **Work habits:** An unfortunate myth exists that students who do well in art do poorly in academic subjects—a myth perpetuated by the common practice of counseling problem students into art classes in high school. Talented students may sometimes become obsessed with art to the point of neglecting other subjects, but talented students generally do better than average work in most subjects.
- **Inventiveness:** Look for signs of invention in children's work. Is the student an independent thinker? Exhibit a rapid turnover of ideas? Generate ideas more original than the average?

Art-related behaviors

- **Attitude:** Does the student have a passion to make art? Is the student a self-starter? Show a desire to improve without prompting? Identify himself or herself as an artist or show interest in an art career?[21]
- **School record:** Biographical information about a particular student may be helpful. Is there any record of interest in art at an earlier age? Has the student received excellent grades in other subjects? Have earlier teachers taken special note of this student's artwork?
- **In-progress art production behaviors:**
 - Does the student work at an advanced level for his or her age (see Chapter 4)? Have a strong preference for a particular medium? Deal successfully with the challenges of representing or composing?
 - Does the student have a preferred style? Hurwitz suggests that, contrary to conventional wisdom, talented students may be more dogged than creative. "Because gifted students have invested a great deal of themselves in developing mastery in a certain idiom, they are unwilling or unable to experiment in new areas"[22]

Teaching the Talented

Olive Jones has a math whiz in her third grade; Nora is always the first to finish her regular assignments. Jones, therefore, is compelled to create "enriched" assignments for her so she doesn't get bored. On the other hand for Dave, the talented painter in the class, Jones is less apt to have this problem. Talented students generally have more opportunities for self-initiation and sustained interest. Also, they are more likely to stick with an artistic problem and be the last, not the first, to finish.

This is not to say that you or Jones are off the hook in coming up with ideas for your talented students. Remember the sequenced learning activities in Chapter 9 that call for step-by-step mastery of specific concepts and art processes? A talented student, who has already mastered these or who will do so rapidly, will need different assignments—not just to keep from being bored, but in order to continue moving toward extended unit-related goals.

There are additional concepts and skills to learn in art criticism, art history, and aesthetics. While these relate to making art, they differ because they have verbal components. To this extent, talent in these disciplines crosses with giftedness in language arts. In search of a term to describe this kind of giftedness, Hurwitz came up with *critical sensitivity*,[23] which is similar to our *aesthetic literacy* (Chapter 2).

Talent, like giftedness, can emerge in grades K to 2 (although researchers are skeptical about the degree to which this aptitude is sustained into maturity). If and when unusual art ability does appear, you should record it in some way and communicate your discovery to the child's parents in case they are not already aware of it. But we advise you *not* to identify the child and publicize this talent in class.

Primary (K–2) youngsters, as indicated before (Chapter 4), are spontaneously creative in art. Children become self critical all too soon as it is—though usually not until half way through second grade. They will soon spot the talented artist in their midst by themselves without your help.

Strategies for Teaching the Talented in the Classroom

You can apply some methods for teaching your students with special gifts to teaching the talented. Let us look at a few of them. They are generally referred to as *compacting the curriculum*,

learning contracts, tiered assignments, independent projects, and *cluster grouping.*

Compacting the Curriculum Compacting means allowing students to take and pass a pretest in order to be excused from a lesson and still receive credit for it. By so doing, the individual earns time, but must spend that time doing work related to the content of the original lesson, though at an advanced level. Meanwhile the rest of the class does the regular lesson.

In the context of art, for example, you could excuse Jamie from doing the regular lesson in color theory if she demonstrates beforehand that she has mastered the concepts. The extra time she earns can be spent on some color activity that she chooses in consultation with you—perhaps doing a series of designs of different color harmonies. Todd can take a pretest to excuse himself from a lesson on art criticism so that he could write a review of a local art exhibit that he saw over the weekend.

Students who have mastered material that the rest of the class has yet to learn should be rewarded with assignments adapted for their needs. Bear in mind that they are to receive credit only for a regular assignment, not "extra credit." As the teacher, you should keep records of pretests and portfolio examples as well as the results of the differentiated assignments.

Learning Contracts *Contracts* are agreements between teacher and student about the nature and amount of class work to be done. Contracts are generally written, are more structured than compacting, and apply to ongoing situations such as progressing through chapters in a book or progressing through lessons in an individual chapter. Eligible students work with the class off and on depending on the terms of the contract. A specimen contract for a book chapter, designed by former classroom teacher Susan Winebrenner, is shown in Table 13–3.[24]

Initially, the teacher administers pretests, either self-designed or from the teacher's edition of the text. Students passing one or more of the tests are given a contract filled out in a way that requires them to work with the class on some concepts (those that are checked) and to be released from others in order to engage in enrichment options (see specimen). There should be enough options to give the students some leeway of selection. The working conditions are specified and the contract is co-signed by teacher and student. Winebrenner recommends meeting with students on contract on a regular basis and basing their grades on an average of the text work, not on the enrichment activities.[25]

Tiered Assignments *Tiered assignments* allow gifted students to work with the rest of the students studying the same content, but they take more difficult examinations on that content. In other situations they may be expected to complete more elaborate projects than the other students, yet based on the same assignment.

Nick, who is gifted in his other studies and likes art, participates with the class in a unit on art history. At the end of the unit, however, the teacher devises a special test for him composed of more difficult questions than those on the regular test. Wanda, a talented student in art who has never done ceramics, learns the techniques of hand-formed pottery and preglaze decoration with the rest of the class. But she is expected to complete more projects than the other students, and also projects that are more complex than theirs.

Independent Projects Independent work usually involves major projects or assignments extended over relatively long periods of time. For independent work it is advisable to devise a contract with a student, in order to clarify objectives and expectations. Perhaps you can "sign off" on the contract when the project is completed.

For example, if Arthur is an obviously capable but nevertheless bored student in class, you should talk to his parents. Arthur may be deeply involved in a challenging project at home, while appearing apathetic and lazy at school. In that case, suggest that he bring some of that work to school. Or you might develop a special, long-range assignment that relates to his particular passion. Perhaps you can find a private space where Arthur can work alone, apart from the rest of the class.

Sally has a pony at home. Also, she has drawn horses since she was a preschooler, and continues to draw them at home. Sally's teacher,

TABLE 13–3 **Teaching Gifted Kids in the Regular Classroom**

<div style="border:1px solid">

LEARNING CONTRACT

CHAPTER: _____

NAME: _____

✓	Page/Concept	✓	Page/Concept	✓	Page/Concept
___	_____	___	_____	___	_____
___	_____	___	_____	___	_____
___	_____	___	_____	___	_____
___	_____	___	_____	___	_____

ENRICHMENT OPTIONS: _____

Special Instructions

YOUR IDEA:

WORKING CONDITIONS

Teacher's signature _____

Student's signature _____

</div>

after consulting with her parents, assigns Sally to do a library search for examples of horses in art. She discovers, to her amazement, horses painted on caves at Lascaux and on walls of Egyptian tombs, horses carved in both Syrian and Greek reliefs, horses painted by Rubens and Marc, horses drawn by Chinese artists, and by Degas and Picasso. Partial completion of the project involves a bibliography developed out of the search. The rest involves Sally's copying some of the art in the books directly, then drawing her own horses but in the style of some of the art, and finally making a capstone piece—a large composition of horses done in a medium and style of her choice.

The advantages of an independent project include strong self-motivation and the student's experiencing both the frustration and rewards of sustained effort. The disadvantage is that a project

can take up too much of a student's time and energy. If so, it can deprive the student of content to be learned from the regular art curriculum.

Cluster Grouping *Cluster grouping* consists of placing high-ability students in the same group, in order to challenge them. This of course runs counter to the practice of mixed-ability grouping, currently a politically popular method for including children with disabilities. Advocates of children with special gifts claim, however, that making bright students be mentors to everyone else is unfair to them, depriving them of their own learning needs. Research shows that the gifted benefit when grouped with students of similar ability. In a cluster group students with special gifts are not only challenged, they may be humbled—especially those who come from a school environment in which they were always ahead of their classmates.

A school with three classrooms at each grade level may have around five or six children with special gifts per grade—as identified, say, by achievement or I.Q. tests. If so, this cluster could be assigned to one of the three teachers (who could rotate the responsibility on an annual basis). The definition of talent in the visual arts is more vague, so the number of artistically talented students could be greater or lesser than the number of children with other kinds of gifts.

Options for the Talented Outside the Regular Classroom

Options outside the regular classroom may or may not be available in your district or community. They include special classes, magnet schools, residential schools, summer schools for the arts, and community professionals.[26] These options are usually competitive. Therefore, the records you keep—such as rating forms, portfolios, pretest results, and so on—to identify your talented students will come in handy at application time. Students may have to submit their artwork to a judge or a panel of judges, depending of course on how competitive the option is.

Special Classes Larger school systems may have special classes for talented students in each building or in a single building. Some have after-school programs. In communities where colleges exist, gifted and talented students are frequently admitted to actual college classes on a part-time basis, even as early as seventh and eighth grade. In some communities, colleges offer Saturday art classes for children taught by preservice art teachers. Community art centers and recreation programs in parks also offer Saturday art classes.

Magnet Schools *Magnet schools* for elementary students are usually middle schools, usually available only in areas of large cities where voluntary racial integration is a district objective. Each school specializes in a particular discipline cluster, such as the sciences or the arts. Students attending such an arts magnet school would receive a standard curriculum in all the subjects except for the one that is specialized. In that one, the instruction is intense, accelerated, and taught by highly qualified teachers. The magnet school is probably the most salutary environment for both the gifted and talented.

Residential Schools *Residential* programs are either private or state supported schools that involve living away from home. With intense programs for talented high school students and sometimes also for junior high students, these schools are designed to prepare talented youth for entrance into art schools or academies at the college level. Because they entail tuition and residential costs, and are available in only a few states, these schools are inaccessible to many students.

Summer Schools for the Arts Many states offer intensive summer programs, often called "the Governor's School (or Institute) for the Arts" or something similar, for students interested in art, music, dance, and theater. Varying in length of time from 2 weeks to 6 weeks, and often sited on university campuses where the students live and eat in dormitories, these schools provide immersion-type experiences directed by well qualified teachers. Some are for high school students only, some are for both junior and senior high school. The visual arts curriculum is usually organized around studio processes.

Community Professionals Finally, there is the possibility of help within the community. The collaborative-teaching model discussed in Chapter

3 invokes the services of museum personnel, college professors, art teachers, and other arts professionals. These may be willing to work with talented youngsters either on a volunteer or part-time basis. On college campuses, undergraduate (and some graduate) art and art education students also are sometimes willing to volunteer in schools.

SUMMARY

In art, teaching all learners means working with two special populations: those with disabilities and those with special gifts that we call talent. Perhaps the most important single development in teaching students with disabilities is inclusion, the practice of integrating exceptional students with their age peers. It is believed that this integration minimizes special labels, fosters socially normative behaviors, and fosters greater understanding of reality.

Another effect of integration, however, is the placing of greater responsibility for educating students who have disabilities on art teachers and regular classroom teachers who may not be trained to address their needs. Yet in keeping with the principles of inclusion, this should not mean that your curriculum would be altered in any way or that you would have to treat a student with disabilities differently than a student without disabilities. In addition to recommending that you hew to these principles, we also offered suggestions regarding advanced preparation, setting limits, ways of lowering student ratios, and resources.

Although identification of the talented resists the standardized testing used to find the gifted, you can spot artistically talented students in your classes by means of portfolio reviews and observing their performance. Programs suggested for teaching the talented within a regular school situation included compacting the curriculum, learning contracts, tiered assignments, independent projects, and cluster grouping. Contrary to the recent trend of integrating those with disabilities, the debate over educating children with special gifts emphasizes ways of segregating them from their peer age groups. But given the fiscal restraints of school districts and states, segregated programs will probably remain in the debate stage for some time to come.

NOTES

1. Malarz, Lynn. (1994, October). Cited in Willis, Scott, Making schools more inclusive. *ASCD Curriculum Update*, p. 8.

2. According to government statistics published in 1992 by the National Association of State Boards of Education. Cited in Willis, Scott (1994, October), Making schools more inclusive. *ASCD Curriculum Update*, p. 1.

3. Guay, Doris M. (1994). Students with disabilities in the art classroom: How prepared are we? *Studies in Art Education 36* (1), p. 44.

4. Guay, ibid., p. 44.

5. Henley, David. (1992). *Exceptional children: Exceptional art. Teaching art to special needs*. Worcester, MA: Davis Publications, pp. 28–32.

6. In the context of multicultural education (Chapter 12), inclusion refers to including students in public schools who are regarded as part of a minority culture.

7. Willis, op. cit., p. 2.

8. Anderson, Frances. (1994). *Art-centered education and therapy for children with disabilities*. Springfield, IL: Charles C. Thomas, p. 4.

9. Blandy, Douglas. (1989). Ecological and normalizing approaches to students with disabilities and art education." *Art Education 42* (3), p. 10.

10. Henley, op. cit., pp. 26–27.

11. Henley, op. cit., pp. 26–27.

12. Henley, op. cit., pp. 32–33.

13. Henley, op. cit., p. 35.

14. Anderson, op. cit.

15. Henley, op. cit.

16. Rogers, Karen B. (1992). The relationship of grouping practices to the education of the gifted and talented learner. *Translations: From Theory to Practice*, 2 (1).

17. Herrnstein, Richard J., and Murray, Charles. (1994). *The Bell Curve: Intelligence and class structure in American life*. New York: The Free Press.

18. The Marland Report. U.S. Department of Education (1972) *Education of the gifted and talented: Report to Congress*. Washington D.C.: U.S. Government Printing Office.

19. Csikszentmihalyi, Mihaly, and Robinson, Rick. E. (1986). Culture, time, and the development of talent. In: Robert J. Sternberg and Janet E. Davidson, (eds.). *Conceptions of giftedness*, Cambridge, England: Cambridge University Press, p. 264.

20. Hurwitz, Al. (1983). *The gifted and talented in art: A guide to program planning*. Worcester, MA: Davis Publications, pp. 23–27.

21. A word of caution: Self-identification is not a particularly valid indicator of talent in the primary grades, since just about all young children like making pictures. In the intermediate grades, however, where interest in making pictures begins to flag, self-identification may be a good indicator of talent.

22. Hurwitz, op. cit., p. 20.

23. Ibid., p. 28.

24. Winebrenner, Susan. (1992). *Teaching gifted kids in the regular classroom*. Minneapolis: Free Spirit, p. 24.

25. Ibid., p. 25.

26. For detailed information about special arrangements and schools for the artistically talented, see Clark, Gilbert A., and Zimmerman, Enid. (1984). *Educating artistically talented students*. Syracuse, NY: Syracuse University Press.

14
The Language of Art

We are using language here in two senses: (1) the vocabulary and terminology employed by art critics to describe an artwork, and (2) the visual elements and the principles by which artists employ them to compose an artwork (generally called the *principles of design*). We most often think of words as the basic components of language, but actually there are smaller units. The visual elements are more analogous to morphemes and phonemes— the available structures and sounds of a given language—than to words.

This chapter has two objectives: first, to bring the nonart majors and classroom teachers among our readers "up to speed" on material that should be common knowledge to those of you who are (or were) art majors; second, to suggest for all our readers some age-appropriate ways for applying this material in the classroom. However, with regard to the second objective, we have opted to provide you with some general ideas or, so to speak, "food for thought" instead of detailed recipes.

THE VISUAL ELEMENTS

The visual elements—the abstract components of a work of art—are listed in this book as *line, shape* (two-dimensional and three-dimensional), *texture,* *value, color,* and *space.* Each one represents a perceptible dimension of an art object, and all of them play significant roles in our interpretation of an object's meaning because they have symbolic potentials. Visual elements can convey moods, or dynamic states, or sometimes even ideas. A shape may appear "sad," for example, a line "active," or a color "strong." You recall from Chapters 5 and 6 that Nelson Goodman called one of the ways by which the visual elements express meaning *exemplification.*

Not all lists of visual elements are exactly the same as this one; some divide the element of shape into shape and form, some collapse value into color, some include movement, some distinguish between real space and pictorial space, and so on. Indeed, not everyone uses the term *visual elements.* Harry S. Broudy refers to the elements of art as *sensory properties* (see aesthetic scanning in Chapter 8). But all of us are talking about the same things, no matter how we classify them.

Line

Line, perhaps the most economical of the visual elements, is also one of the most versatile. A *line* is simply a thin mark made by a tool such as a pencil, marking pen, or brush (or, on a computer, a row of pixels). We—and the children we work

with—encounter lines most often on paper: printed words, numbers, diagrams, cartoons, notations, and scribbles, among others.

The first lines used by an infant to form rudimentary patterns—what Howard Gardner calls "first-order symbolic knowledge" (Chapter 4)—signify a turning point in the cognitive development of that child. By the same token, the first lines ever made by humans that formed images or symbols signified a major turning point in the development of human culture. Perhaps, the earliest lines were those engraved on the walls of a southern Australian cave by Aborigine ancestors around 50,000 years ago. Anthropologists Donald and Lenora Johansen have this to say about them.

> How paradoxical that the most striking archeological signature of the full-blown emergence of our own human species . . . turns out to be not new and better hand axes but symbolic art.[1]

It is not only the impulse to make lines but the impulse to interpret them that is so significant. In the 50,000 years since then, the use of lines—whether to make diagrams, or maps, or artistic images—has become so commonplace that we tend to take this kind of human behavior for granted.

Lines in art can represent figures and objects by defining their edges—what we commonly call outlines. Children, as we know, use outlines. Cartoonists use outlines to create imaginary or satirical characters; illustrators sometimes use outlines to describe objects or figures in the simplest way possible. The resulting imagery, though quite readable and perhaps adequate for an entry in a dictionary (Fig. 14–1), is lacking in both depth and visual interest.

In the hands of artists, lines tend to be much more complex and expressive. Usually called *contour lines*, when used in realistic images such as the *Portrait of Docteur Robin* by J. A. D. Ingres (Fig. 14–2), lines are capable of describing both the outside and inside edges of objects (their *contours*), while at the same time revealing many nuances of direction and detail. Sometimes they are used less realistically, but just as effectively in expressing the substance of a figure, as in Rico Lebrun's vigorously penned *Seated Clown* (Fig. 14–3). Notice that in the first example the pencil lines are rather delicate; in the second, the ink lines are quite bold.

Figure 14-1 Illustration of a horse.

In both works, the lines are interesting and beautiful in their own right.

Closely spaced, parallel lines are called *hatching*; if crossed, they are called *cross hatching*. Artists use hatched lines to represent shadows or the shaded side(s) of an object or figure (Fig. 14–4). The technical word for shading is *chiaroscuro*. (A softer version of chiaroscuro, lightly applied with pencil or chalk rather than by hatching, is evident in the drawings by Ingres and Lebrun.) We will return to the subject of chiaroscuro a bit later (see p. 238).

Many other kinds of "lines" are not marks from a pencil or pen, but nevertheless exist by implication. If one of two adjoining shapes is light and the other dark, for example, we may call their mutual boundary an implied line. Indeed, any edge, contour, or boundary in a picture (or sculpture) implies a line. Additionally, lines are implied by the paths along which people in a picture seem to be looking (called "sight lines") and by the directional forces of a composition (see under "Principles of Design"). In common language, we speak of the lines of a car, of a building, or of a slender fashion model. We refer to coastlines, a line of scrimmage, or a waiting line. All of these of course are implied—as opposed to literal, visible—lines.

Returning to visible lines: Lines have expressive potential in their own right. This is

Figure 14-2 Jean-Auguste Dominique Ingres
(1780–1867; French) "Docteur Jean-Louis Robin."
Pencil, 11" × 8 3/4".

(Courtesy of the Art Institute of Chicago, # E22265)

Studio activities with line, any age level

- Discover how many different kinds of lines you can make with available tools. By varying pressure and/or the speed of the stroke, you can make them thicker or thinner and darker or lighter. (Teacher: A matrix is good for showing how different tools make lines under different conditions—see Fig. 14–5).

- Create a number of lines, each with a different "personality" and a name such as "loud," "calm," "nervous," "bold,"and so on, to go with it.

- Exchange your lines with other students (Teacher: Or you can post them). Keep the names secret, however. How closely do others agree with you about your lines' personalities?

Line activities, upper grades

- Select a favorite picture you made earlier. Redo the picture two or three times using a different kind of line each time (perhaps by using a different tool).

- Compare the first and second pictures. Does the meaning change because the line quality has changed?

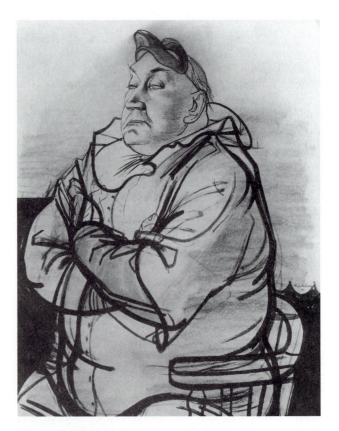

Figure 14-3 Rico Lebrun (b. 1900); American-Italian "Seated Clown." Ink and wash, red and black chalk, 1941, 39 1/2" × 29".

(Courtesy of the Santa Barbara Museum of Art, #1942.1.2)

obviously the case with lines found in abstract or nonobjective art, since there is no representation to begin with. In representational art, lines express qualities independent of the subject. Usually, however, there is close agreement between what the lines express and what the picture expresses—as in the lightly drawn, "genteel" lines of Ingres's solemn young doctor in Fig. 14–2, and the robust, yet capricious, lines of Lebrun's clown in Fig. 14–3. In both works, lines vary from thick to thin, from light to dark, and from short to long.

Finally, with regard to this visual element and your students: It is not that children need encouragement to use lines—they use them all the time in their own work—but that they need to be made more conscious of lines and how they can manipulate them for expressive effect. Here are some suggested classroom activities, framed in statements directed at your students.

Figure 14-4 Box.

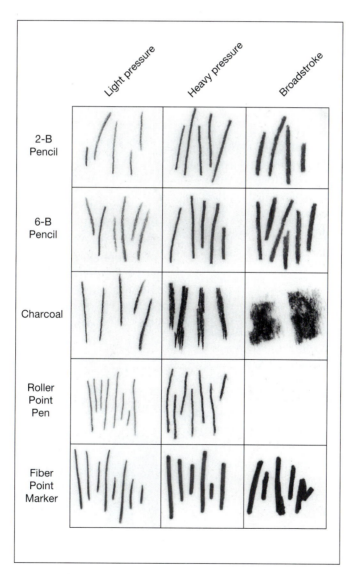

Figure 14-5 A matrix showing different lines with different tools.

- Look at drawings by famous artists. Describe the characteristics of a particular line. Are some lines darker than others? Do some have more variety from thick to thin? (Teacher: Keep going; these are only a few examples of the questions you can ask about the kinds of lines.)
- What quality does each kind of line express? (Teacher: Ruled lines seem mechanical; brush lines seem soft; pen lines seem scratchy; and so on.) How does the line quality affect the message of each drawing?
- Select a favorite soft object, such as a cap, hat, handbag or old sneaker, and make a careful contour drawing of it. Observe and draw the inside contours as well as outside ones. Keep your eyes fixed on the object rather than your paper. Pretend the tip of your pencil is touching each contour as you draw it. Take your time. (Teacher: This is called a "blind" contour drawing.)

Shape

Two-Dimensional Shape We live in a three-dimensional world surrounded by real space and filled with real objects. But as we saw earlier with lines, in daily life we constantly interact with two-dimensional images, whether as diagrams, maps, illustrations, or art. When lines enclose an area—as in an outline on a piece of paper—it is called a *shape*. Of course, a shape does not have to be enclosed by lines; it can exist as a solid color.

There are as many kinds of shapes as there are lines. Art professionals find it useful to classify shapes in dichotomous terms: *organic* or *geometric*, *rectilinear* or *curvilinear*, *closed* or *open*. Organic shapes have irregular contours, and are associated with things in nature (sometimes these are called *amorphous* or *biomorphic*). Geometric shapes have regular contours, and are associated with manufactured things (although some natural things, like crystal formations, are also geometric).

We have names for the geometric shapes: circles, squares, rectangles, triangles, parallelograms, and so on. But we are at a loss for names for nongeometric shapes. We call them amorphous, biomorphic, or even "free forms" because they are irregular or remind us of natural objects. (Because these shapes do lack specific names, when you talk about them with your students, you may have to point them out to make sure your students know exactly which shapes you mean.)

Prior to this century the dichotomy of organic and geometric shapes would not have been an issue. Virtually all premodern art was organic: paintings about saints, nudes, still lifes, or landscapes; or monumental sculptures about kings and heroes. But today, geometric abstraction is a very valid kind of art. In earlier chapters, we saw a geometric painting by Albers (Chapter 8, Fig. 8–5, see **color insert** #2), as well as examples of traditional African sculpture (Chapter 1, Fig. 1–4 and Chapter 5, Fig. 5–2), an art which is relatively geometric.

Shapes, no less than lines, have expressive potential. A shape can be "graceful" or "bold." Nongeometric shapes have the most expressive potential, and these are the ones artists most often use. Notice the complexity of the shapes with which Ingres portrays Dr. Robin (see again, Fig. 14–2); do they help to convey a "genteel" feeling, as do his lines? Are the shapes in Lebrun's clown (see again, Fig. 14–3) similar to those of Ingres or do they have a different character? Are they more robust, perhaps, like Lebrun's lines? It is difficult, however, to regard a shape independent of the thing it represents, and many art critics find it impossible to separate the two. For example, is the stout shape of Lebrun's clown an attribute of the clown or of the shape itself?

Figure and Ground A basic principle of perception is the tendency of viewers to divide a visual pattern into two kinds of shapes—a figure and its background (Fig. 14–6). We pay attention to the shape of a figure, but we tend to ignore the shape around it. A figure appears to be "on top of" and surrounded by a ground; conversely a ground appears to be underneath and surrounding a figure. Artists also call a figure a *positive* shape and the ground a *negative* shape.

Viewers can choose to reverse the figure and ground. For example, in the face-vase illustration, you can see this figure either as a white vase on a

a b

Figure 14-6 Face-vase graphic.

black field or as twin black faces on a white field. According to Gestalt psychologists, you cannot see it both ways simultaneously—although you can switch from one perception to another in less than a blink. By so doing you can almost feel it "flip" in your eyeball as one image advances and the other recedes. A much more interesting example of reversal is *Circle Limit IV* by M. C. Escher (Fig. 14–7). Initially, you probably saw the bats. If so, look for the angels (or vice versa).

Whether or not a work of art is completely reversible like Escher's, the relationship between figure and ground (between positive and negative shapes) is an important factor in art and, therefore, of concern to artists. Negative shapes are as important to a composition as positive shapes are, and in a good composition they are just as interesting. Often, one can also find interesting posi-tive-negative relationships in the daily comics, particularly the adventure-comic variety (some of these are discussed in Chapter 17).

Let us look at some classroom activities for two-dimensional shape. The following ones, like those for line, are framed in statements directed at the student. Each statement is brief and sketchy, designed mainly to prime your idea pump.

Studio activities with two-dimensional shapes, any age level

- Create a repeat design in two colors. Try to maintain a balance between shapes in such a way that either color could be positive or negative.
- Funny cutouts: Divide a 12 × 18 sheet of paper into two sheets, each with a random, meandering edge (Fig. 14–8a). Look for an image in one of the halves and "complete" it by adding a few details with pencil or crayon. Do the same for the other half.

Figure 14-7 M.C. Escher, *Circle Limit IV*, 1960. Woodcut in two colors, diameter 13 1/2" (417 cm). Copyright 1989 M.C. Escher Heirs/© 1996 Cordon Art, Baarn, Holland. All Rights Reserved.

(Courtesy of Cordon Art B. V.)

- Compare the two (Fig. 14–8b). Turn both over and realign their edges. Which side is figure and which is ground? Next time, exchange cutouts with your neighbor. (Teacher: In a primary grade, you probably should cut the sheets yourself.)
- Make your own reversible figure-ground illustration. Try something besides a face-vase.

Three-Dimensional Shape.

Three-dimensional shapes, in contrast to two-dimensional shapes, take up real space. They also have real weight, density, and bulk (sometimes called *mass*). Most three-dimensional artworks are classified as sculptures. However, this century has seen the appearance of numerous hybrid forms—such as assemblages and performance art—not ordinarily called sculptures. Chapter 16 will acquaint you with the many classifications and subclassifications of three-dimensional art.

Geometric three-dimensional shapes, unlike their two-dimensional counterparts, are called cubes, cylinders, spheres, and pyramids (rather than squares, rectangles, circles, and triangles). The principle of figure and ground, or positive and negative, also applies to three-dimensional shapes. But instead of figure and ground, it is more customary to refer to this relationship as solid shape and empty space, or mass and volume. The alternation between solid and void is a primary factor in one's understanding of Henry Moore's *Recumbent Figure* (Fig. 14–9). Moore intentionally injected openings into his earth-goddess sculptures for symbolic reasons (in this case, allusions to both the vagina and caves), but also to emphasize the aesthetic potential of positive and negative in a sculptural context.

Three-dimensional shapes, no less than two-dimensional shapes, have expressive potential. With abstract art, such as Moore's *Recumbent Figure*, it is easier to speak of the quality of the shapes in their own right. Already mentioned, for example, was the sculpture's contrasting solids and voids. We could also speak of its shapes as curvilinear and undulating, yet appropriately massive and weighty for a symbol of the mythic earth mother.

Meanwhile, in the realm of public sculpture, geometric shapes are more popular than you might realize. Works of welded metal, such as

Figure 14-8 (a) Length-wise cutouts. (b) Cutouts with detail.

Figure 14-9 Henry Moore (1898–1986), *Recumbent Figure,* 1938. Stone 4'4" long. The Tate Gallery, London.

(Courtesy of Art Resources, #S0101152)

Alexander Calder's Flamingo (Fig. 14–10), stand in the plazas of major institutions and corporations throughout the country. Calder's geometric sculpture consists of mostly curvilinear shapes, and is a good example of *open* sculpture. Moore's organic sculpture, on the other hand, consists entirely of curvilinear shapes, and except for the penetrations, its forms are mostly closed.

Studio activities with three-dimensional shapes, any age level

- Mold a figure of an animal or person out of a single ball of clay. Try not to add pieces to the figure.
- Mold a partially abstract figure of an animal or person out of clay. After the clay becomes leather hard, carve out one or two openings. Place each opening strategically, so that it emphasizes the solid quality of the rest of the figure.
- Create an open sculpture out of sticks—such as toothpicks, swab sticks (with the cotton removed), or tongue depressors.

Texture

The term *texture* refers to the surface qualities of things—for example, the smooth hard feeling of an egg shell or the nubby feeling of wool. Texture is *tactile*, that is, it appeals to our sense of touch. But we don't always have to literally touch a texture to grasp its quality; we can do this vicariously by looking at it.

All of us are critically aware of textures in everyday life—in the clothes we wear, the furniture we use, even the food we eat. Our tastes (literally and figuratively) are based on texture preferences more than we realize. We like leather to be supple, not dry and brittle; we like toast to be dry and brittle, not supple; and so on. Yet we—not to mention our students—seldom use the word texture, and seem to be almost oblivious of it as a concept.

In Chapter 1, we stated that crafts were useful objects. With regard to modern crafts, however,

Figure 14-10 Alexander Calder, steel painted red, *Flamingo,* 53 × 60 ft., 1974, in the Federal Center Plaza, Chicago.

(Photograph by Jack Hobbs)

it is more accurate to say that this art involves the making of *precious* objects, in which appearance is more important than function. And fundamental to that appearance is texture. The delicate finish of Fred Danforth's hand-spun pewter *Lily Vase* (Fig. 14–11), for example, attracts us as much as its classic shape. Compare the texture of Danforth's piece with the more "earthy" textures of Karen Karnes's ceramic jar (Chapter 1, Fig. 1–2).

Sculpture, according to art historian Herbert Read "is an art of *palpation*—an art that gives satisfaction in the touching and handling of objects."[2] Read, of course, is talking about texture. We respond naturally to a sculpture's surface quality—be it stone, bronze, or wood. The fact that Moore's *Recumbent Figure* is stone symbolizes its link to nature. But the stone medium is also important because, in this case, the sculpture's grain and coarse finish express a sense of warmth and earthiness that would be absent in metal.

If you were to touch a painting, you might feel a slick, bumpy surface (depending, of course, on the type of painting). Van Gogh's *Fourteen Sunflowers in a Vase* (Chapter 5, Fig. 5–1) (see **color insert** #1) is an example of a work that actually flaunts its paint surface—the thicker and oilier, the better. However, not all paintings are the same as Van Gogh's in this regard. Some are smooth, but there is no question that all two-dimensional works have texture—whether it be paint on canvas or dusty chalk on paper. They are, after all, material objects.

However, in many two-dimensional works, the real texture is not what counts. What counts is *simulated texture*, the textures of the things represented in the picture. In Titian's *Venus of Urbino* (Chapter 6, Fig. 6–2) (see **color insert** #2), for example, the operative textures are such things as velvet (the curtain behind Venus) silk (the bedsheets), fur (the dog), hair (Venus) and, especially, female flesh. These simulated textures, though vivid, cannot be physically touched, of course. The touching is in the imagination.

Studio activities with texture, any age level

- Produce different textures in damp slabs of clay; use your fingers or clay tools, or press objects into the clay. If you have clay slip that is a different color than the slab, apply a coat of the slip, then scratch through the coat. Potters call this *sgraffito*.

- Make a collage consisting of real textures. These can be cut from scraps of any flat material: cloth, wall paper, leather, rug, veneer, and so on. Make a collage of simulated textures taken from magazine pictures (see Hockney collage, Fig. 15–24 (see **color insert #4**) in Chapter 15). Make a collage consisting of both types of textures. Add some invented textures, if you wish. Study collages by such artists as Picasso, Braque, Schwitters, or Rauschenberg.

- Make a texture "rubbing." Lay a sheet of thin paper over a textured surface—tree bark, weathered wood, brick, cement, etc.—and rub across the sheet with the side of a crayon. Do several rubbings, each of a different texture. Make a collage with them.

- Invent some textures by crosshatching, stippling, repeating patterns, and so forth. Cut shapes from your textures and use them in a collage.

Figure 14-11 *The Lily Vase.* (6 1/2 " high) 1995. From Danforth Pewterers.

(Courtesy of Danforth Pewterers)

Verbal activities for texture, all grades

- Artists use the adjectives *mat* and *glossy* to refer to the textures of paints, varnishes, or ceramic glazes. Look these up in the dictionary. Identify some mat textures; identify some that are glossy. Make up your own adjectives for textures.

- Every thing has a texture. Do liquids have textures? For example, is there a difference between the textures of skim milk and cream? Explain.

Verbal activities, upper grades

- Discuss the paradox of textures in a realistic picture being illusions—as opposed to textures in an abstract painting being real. The expression "willing suspension of disbelief" refers to the attitude of a movie viewer who follows the action as if it were true, yet knowing it is fiction. Is this your attitude when watching a scary movie? If so, is this attitude conscious or unconscious on your part? Explain. Is the expression, "willing suspension of disbelief," an appropriate one for viewing realistic art? Explain.

- Much of Marilyn Levine's art consists of "false objects" such as a briefcase that looks like leather but is actually ceramic (Chapter 8, Fig. 8–4). According to Webster, an illusion is "a misleading image presented to the vision." Compare the use of illusion in referring to Levine's work with its use in referring to a realistic picture (see the work by Gregor, Chapter 6, Fig. 6–1) (see **color insert #2**).

Value

Value refers to different degrees of lightness and darkness. Imagine the full range of light and dark in the world: One extreme might be looking at bright sunlight reflected from snow; the other might be experiencing the black void of a deep cave. The extremes of light-dark in the context of a black-and-white art medium, like pencil or charcoal or lithography, while perhaps not quite as dramatic, range from dazzling white to velvety black. Value, however, is also a property of color, as we shall discuss soon. Perhaps as we use the term here, we should call it *achromatic* value (value without color).

Black and white are what you see at either end of a continuum called a *value scale* (Fig. 14–12). Between the extremes of white and black are *middle* values. Those closer to white are called light values, those closer to black are dark values. Since at this point color is not involved, the values

Figure 14-12 Nine-step value scale. Gray Scale.

between black and white consist of different shades of gray. Henceforth, we will use the word value whenever referring to the lightness or darkness of something.

Surfaces of objects have different values depending on how directly light strikes them. Yet, we tend to perceive objects as having a single value regardless of changes in reflected light. This is a perceptual phenomenon called *value constancy*. Normally, we think of a cue ball as being a uniform off-white all around—the value we know it to be. Yet, if we look at the image of a cue ball in this photograph (Fig. 14–13), we see that it consists not of a single value but of a continuum of values from light to dark. The technique for representing this value continuum in a black-and-white medium like pencil or charcoal is called *chiaroscuro*.

Objects such as boxes, which have flat sides instead of curved surfaces, also display value differences. When the artist uses chiaroscuro to represent light reflecting off the surfaces of a box, the

result is quite different (see again, Fig. 14–4). Here, instead of a transition from light to dark we see three distinct planes, each with a slightly different value. We can see these same kinds of value changes in the real world if we look for them.

As indicated earlier, the term *illusion* is sometimes used to refer to the ways in which two-dimensional art represents three-dimensional objects. One of these ways is chiaroscuro—which helps to create an illusion of three-dimensional volume. Indeed, chiaroscuro seeks to reproduce the patterns of light and dark we see when we look at real objects. Now, to reproduce the patterns of light and dark on a geometric surface (like a cue ball or a box) is one thing. It is much more difficult to do this with a figure of a person. Observe, for example, how successfully Charles White defined the figure and clothes of a preacher (Fig. 14–14) by means of chiaroscuro—even in such minute areas as the knuckles of a finger and the wrinkles in the palm of a hand.

Value, similar to all of the visual elements, can act in a symbolic way within a work of art. Compare the Ingres portrait of Dr. Robin (see again, Fig. 14–2) with White's preacher. The value of the Ingres is light, contributing to the sense of restraint and gentility that the portrait conveys. The value of the preacher is dark and forceful, conveying to us that this is a man of power who deserves our attention.

Studio activities in value, any grade level:

- Make a value scale with several steps (Teacher: Start with three or five steps for younger children) the same as the one in Fig. 14–12. Try maintaining an equal "distance" in value between each square.
- You might try painting your different values of gray in patches on a sheet of paper. Then you could cut them into squares. and arrange them into a value scale. If two values look too much alike, you can make another patch.
- Test your ability to achieve different values with charcoal or black crayon on paper by varying the pressure.
- Make a picture using only black and white and different values of gray.

Value activities, upper grades:

- Set up a still life consisting of mostly geometric solids, such as cubes and cylinders (or boxes and

- Make a collage consisting of real textures. These can be cut from scraps of any flat material: cloth, wall paper, leather, rug, veneer, and so on. Make a collage of simulated textures taken from magazine pictures (see Hockney collage, Fig. 15–24 (see **color insert** #4) in Chapter 15). Make a collage consisting of both types of textures. Add some invented textures, if you wish. Study collages by such artists as Picasso, Braque, Schwitters, or Rauschenberg.
- Make a texture "rubbing." Lay a sheet of thin paper over a textured surface—tree bark, weathered wood, brick, cement, etc.—and rub across the sheet with the side of a crayon. Do several rubbings, each of a different texture. Make a collage with them.
- Invent some textures by crosshatching, stippling, repeating patterns, and so forth. Cut shapes from your textures and use them in a collage.

Figure 14-11 *The Lily Vase.* (6 1/2 " high) 1995. From Danforth Pewterers.

(Courtesy of Danforth Pewterers)

Verbal activities for texture, all grades

- Artists use the adjectives *mat* and *glossy* to refer to the textures of paints, varnishes, or ceramic glazes. Look these up in the dictionary. Identify some mat textures; identify some that are glossy. Make up your own adjectives for textures.
- Every thing has a texture. Do liquids have textures? For example, is there a difference between the textures of skim milk and cream? Explain.

Verbal activities, upper grades

- Discuss the paradox of textures in a realistic picture being illusions—as opposed to textures in an abstract painting being real. The expression "willing suspension of disbelief" refers to the attitude of a movie viewer who follows the action as if it were true, yet knowing it is fiction. Is this your attitude when watching a scary movie? If so, is this attitude conscious or unconscious on your part? Explain. Is the expression, "willing suspension of disbelief," an appropriate one for viewing realistic art? Explain.
- Much of Marilyn Levine's art consists of "false objects" such as a briefcase that looks like leather but is actually ceramic (Chapter 8, Fig. 8–4). According to Webster, an illusion is "a misleading image presented to the vision." Compare the use of illusion in referring to Levine's work with its use in referring to a realistic picture (see the work by Gregor, Chapter 6, Fig. 6–1) (see **color insert** #2).

Value

Value refers to different degrees of lightness and darkness. Imagine the full range of light and dark in the world: One extreme might be looking at bright sunlight reflected from snow; the other might be experiencing the black void of a deep cave. The extremes of light-dark in the context of a black-and-white art medium, like pencil or charcoal or lithography, while perhaps not quite as dramatic, range from dazzling white to velvety black. Value, however, is also a property of color, as we shall discuss soon. Perhaps as we use the term here, we should call it *achromatic* value (value without color).

Black and white are what you see at either end of a continuum called a *value scale* (Fig. 14–12). Between the extremes of white and black are *middle* values. Those closer to white are called light values, those closer to black are dark values. Since at this point color is not involved, the values

Figure 14-12 Nine-step value scale. Gray Scale.

between black and white consist of different shades of gray. Henceforth, we will use the word value whenever referring to the lightness or darkness of something.

Surfaces of objects have different values depending on how directly light strikes them. Yet, we tend to perceive objects as having a single value regardless of changes in reflected light. This is a perceptual phenomenon called *value constancy.* Normally, we think of a cue ball as being a uniform off-white all around—the value we know it to be. Yet, if we look at the image of a cue ball in this photograph (Fig. 14–13), we see that it consists not of a single value but of a continuum of values from light to dark. The technique for representing this value continuum in a black-and-white medium like pencil or charcoal is called *chiaroscuro.*

Objects such as boxes, which have flat sides instead of curved surfaces, also display value differences. When the artist uses chiaroscuro to represent light reflecting off the surfaces of a box, the

result is quite different (see again, Fig. 14–4). Here, instead of a transition from light to dark we see three distinct planes, each with a slightly different value. We can see these same kinds of value changes in the real world if we look for them.

As indicated earlier, the term *illusion* is sometimes used to refer to the ways in which two-dimensional art represents three-dimensional objects. One of these ways is chiaroscuro—which helps to create an illusion of three-dimensional volume. Indeed, chiaroscuro seeks to reproduce the patterns of light and dark we see when we look at real objects. Now, to reproduce the patterns of light and dark on a geometric surface (like a cue ball or a box) is one thing. It is much more difficult to do this with a figure of a person. Observe, for example, how successfully Charles White defined the figure and clothes of a preacher (Fig. 14–14) by means of chiaroscuro—even in such minute areas as the knuckles of a finger and the wrinkles in the palm of a hand.

Value, similar to all of the visual elements, can act in a symbolic way within a work of art. Compare the Ingres portrait of Dr. Robin (see again, Fig. 14–2) with White's preacher. The value of the Ingres is light, contributing to the sense of restraint and gentility that the portrait conveys. The value of the preacher is dark and forceful, conveying to us that this is a man of power who deserves our attention.

Studio activities in value, any grade level:

• Make a value scale with several steps (Teacher: Start with three or five steps for younger children) the same as the one in Fig. 14–12. Try maintaining an equal "distance" in value between each square.

• You might try painting your different values of gray in patches on a sheet of paper. Then you could cut them into squares. and arrange them into a value scale. If two values look too much alike, you can make another patch.

• Test your ability to achieve different values with charcoal or black crayon on paper by varying the pressure.

• Make a picture using only black and white and different values of gray.

Value activities, upper grades:

• Set up a still life consisting of mostly geometric solids, such as cubes and cylinders (or boxes and

jars covered with white paper) near a window. (The room lights may need to be turned off.) Notice how the light from the window reflects off the objects and helps to define their shapes. Draw the still life on gray paper using both black and white chalk. Practice the technique of chiaroscuro.

• Set up a still life illuminated by a single source of light (either from a flood lamp or a window). (Teacher: Perhaps set up two or more still-life stations so that the class can be divided into smaller groups.) Place geometric solids in the still life (see above), but mix these with more complicated shapes. Try emphasizing the three-dimensionality of the objects by means of chiaroscuro.

Color

Think of your response to Van Gogh's painting of *Fourteen Sunflowers in a Vase* (Chapter 5, Fig. 5–1) (see **color insert** #1) compared to, say, Duncanson's *Blue Hole, Flood Waters, Little Miami River* (Chapter 11, Fig. 11–1) (see **color insert** #3). The color of the two paintings is dissimilar, and that dissimilarity accounts for much of the difference in your responding. Because color moves people, color has been studied more than any of the other

visual elements. It is the most fascinating of the elements, and also the most puzzling. To understand the role of color in art and vision, we must analyze it in terms of three properties: *hue, value,* and *intensity*.

Hue In a famous experiment, Isaac Newton separated a beam of sunlight (white light) into a *spectrum* of colors—all the colors of the rainbow—by passing the beam through a prism. Each color that we can see has a separate, measurable wave frequency, which can be determined precisely by scientific instruments. For reasons still not fully understood, only this small fraction of the total electromagnetic spectrum (which also includes x-rays, radio waves, and infrared and ultraviolet light) is visible to the human eye without the aid of instruments.

We can perceive over 10,000 different colors. Many have names, such as *green* or *blue*, that help us to distinguish one from another. This aspect of color is known as *hue*. Either term—hue or color—is appropriate to use, however, when referring to these differences.

To show how colors are related, Newton arranged the spectrum colors in a circular chart, the

Figure 14-13 Photo of cue ball.
(Photograph by Jack Hobbs)

Figure 14-14 Charles White, *Preacher*, 1952. Ink on cardboard 21 3/8″ × 29 3/8″.
(Courtesy of the Whitney Museum of American Art, New York, #52.25.) (Photograph by Geoffrey Clements)

predecessor of today's twelve-place color wheel (Fig. 14–15) (see **color insert** #3). The color wheel is a tool for studying the hue aspect of color. It helps us to identify color groupings: *primaries, secondaries, tertiaries, complementaries* and *analogous* colors.

The primary colors of pigments (the coloring matter used in things like paints, dyes, inks, and glazes) are red, blue, and yellow.[3] Theoretically, with just these three, we can create all the other colors we need except white or pure black. Equal amounts of red and blue make violet; yellow and red make orange; blue and yellow make green. The three new hues—violet, orange, and green—are called *secondary colors*. On the color wheel, these lie midway between the primaries.

By combining a secondary color with either of its neighboring primary hues, we can produce a *tertiary color*, that is, red-violet, violet-blue, blue-green, and so on. On the wheel, each of these lies between a secondary and a primary. Between the tertiaries and secondaries there could be any number of *intermediate* hues, depending on how many times a color wheel is subdivided, but the English language (or any language) does not have names for all of them. Artists often use colors we are unable to name.

Finally, there are the *complementary* and *analogous* colors. Complementaries are easily identified because they are opposite one another on the wheel, for example, yellow opposite violet, red-orange opposite blue-green, and so on. Analogous colors are any group of hues that are next to one another on the color wheel. Many analogous colors seem closely related because they may have a

primary hue in common; for example, red-violet, red, red-orange, orange, and yellow-orange all contain the color red.

Complementaries are also opposite each other in a more fundamental way than just location. Violet, composed of red and blue, for example, does not share any of its optical characteristics with yellow. The unequal mixing of two complementaries produces a dull hue—rather than a bright one like those on the wheel. For example, a touch of green added to red results in a dulled or "brick" red. A very small amount of violet added to yellow produces a "yellow ocher." The mixing of complementaries in equal amounts theoretically produces gray. Colors such as gray, white, black, or very dull browns, are often called *neutrals*. More on dull colors and neutrals in the discussion of intensity.

Value Value was discussed earlier—in association with white, gray, and black—as a separate element. The extent to which colors can be light and dark is also called value—just as it is for the grays in a value scale. Blue, for example, can range in value from pale sky blue to deep navy blue; red, from light pink to burgundy, and so on.

Every hue has a normal value that is shown on the color wheel. Note that yellow along with its neighboring hues, yellow-green and orange-yellow, are the lightest, while violet and its neighbors tend to be the darkest. Values lighter than the color on the color wheel are called *tints*, values that are darker are called *shades*. With *opaque* paints, such as tempera, acrylic, and oil paints, tints are made by adding appropriate amounts of white to a color; middle values come straight from the jar, and shades are made by adding black. With *transparent* paints such as watercolors, tints are made by diluting a color (so that the white of the paper shows through), middle values are made with little or no diluting, and darker shades by adding black. Adding white or black to a color dulls it.

Intensity Intensity refers to the relative purity—the level of brightness—of a color. All of the colors on the wheel are bright (as bright as printing ink can make them). The most intense colors in a painting are usually those that come straight from the jar (or tube). If an artist dabbles very much, especially mixing complementaries (or more than two of the primaries at a time), the colors lose their brilliance.

However, there is good reason for intentionally dulling colors. Most colors in nature are less than brilliant. If all the colors in a painting were intense, the same as an environment in which all the sounds were loud, the result would be overkill and ultimately boredom. Many paints, particularly "earth" colors such as browns, red-browns, golden yellows, and others, are not bright to begin with (just as in a large crayon box not all the hues are bright). Besides selecting colors—both bright and dull—already formulated by the manufacturer, artists control the intensity of their own colors by mixing complementaries. Again, very dull colors—such as blacks, whites, and grays—that cannot be identified with any of the spectrum hues are called *neutrals*.

Color and Expression Layman and professional alike agree that color—particularly the hue aspect of color—has an impact on people's feelings. Indeed color has been the subject of numerous psychological studies. Under certain conditions, it has been said, color can raise or lower blood pressure, reduce eyestrain, and improve one's ability to concentrate. However, artists are less interested in color's alleged psychological and physiological effects than in its aesthetic effects.

Artists tend to divide the domain of color into *warm* and *cool* (as, earlier, shape was divided into organic and geometric). Reds, oranges, and yellows (the colors on the left side of the wheel) are considered warm colors. Blues, greens and violet (those on the right) are considered cool colors. (Yellow-green and red-violet are borderline; where they fall depends on which color predominates.) Perhaps this distinction is based on both natural and cultural associations. The color red reminds us of fire, blood, or danger; the color yellow is associated with the sun; the color blue with sky or water, and so on. Whatever the reasons, the use of warm colors in a design is likely to evoke warmth or excitement, while cool colors are likely to have a quieting effect.

There is no one-to-one relationship between colors and people's responses. Most colors have

cultural significance. In Asia, for example, white is the color of mourning, while in Europe and the United States it is black. But given a list of colors to match with a list of psychological states, people would probably agree more than disagree. For example, if asked to identify a "sad" color, most would probably choose blue rather than yellow, a dull color rather than a bright one, or a dark value rather than a light one (or the reverse if one had to match the same colors with "cheerful").

Studio activities with color, any age level

- Using tempera paint, make some patches of primary colors straight out of their jars on a blank piece of white paper.

- Practice mixing secondary colors on the same paper; don't mix them in the jar. You will soon discover that "equal" portions do not always produce a satisfactory secondary color. Equal amounts of yellow and blue, for example, produce a deep bluish-green. To make a true green, use a small amount of blue. You may have to use similar proportions in making orange and violet.

- After making satisfactory secondaries, go on to mix tertiaries. Use one primary and one secondary color.

- You may want to cut your color patches into uniform squares and arrange them in a six-place color wheel (primaries and secondaries) or a twelve-place wheel (primaries, secondaries, and tertiaries).

- Try inventing new colors: an "off shade" of one of the secondaries, a subtle hue between a tertiary and a primary, a slightly dulled pink, and so on. Try making silver or gold. Create exotic names for your new colors.

- Make a monochromatic picture or design, that is, one that has the whole range of values but only one hue. You can also use black and white.

- Make a picture or design with analogous hues, using all warm colors plus black and white. Then, make the same picture or design using cool colors. Which do you prefer? Do you react differently to each?

Color activities, upper grades

- Paint a design with a complementary color scheme. Use only two complementary hues, plus black and white. Use at least five values of each hue.

- Make a painting using only two complementaries and no black or white. Make all of your grays by mixing complements together. Notice whether this painting looks brighter or less bright than the preceding one. (Teacher: Adding white or black to a color will reduce its intensity.)

- Invent more new colors. This time, focus on making interesting soft colors by mixing complementaries. Paint a fall landscape in order to imitate colors from nature: hues such as forest green, olive green, leaf gold, leaf red, or terra cotta.

- Bring to school a patch of color—from any source: a paint chip, a piece of a leaf, a piece of material, a chip of wood, a section of tile or brick, or so forth. Study the color and attempt to match it with paints. (Teacher: This will entail careful manipulations of all three properties of color.)

- Try to mix equal values of two different primary hues. Test your results by making a photocopy of each color. If your color values are the same, the two photocopies will be the same value of gray.

- Make a series of squares, each enclosing a smaller square. Fill in each inner square with the same yellow. Fill in each outer square with a different color; make one orange, one violet, one green, and so on. The two colors in each square will interact with one another. For example, does a yellow square look brighter inside a violet square or inside an orange square?

- Experiment not only with different hues, but different values and different intensities. (Teacher: Joseph Albers made a series of paintings called *Homage to the Square*—see Chapter 8, Fig. 8–5 (see **color insert** #2). Study some of the works in that series to determine the interaction of Albers's colors.)

Verbal activities for color, upper grades

- Imagine explaining color to a friend who has been unsighted since birth. Of the three properties of color—hue, value, and intensity—which would be the most difficult to explain to your unsighted friend? (Teacher: The answer is hue. The easiest to explain would be value, because you can compare the properties of color to the properties of musical sounds that also form a continuum, such as pitch or the loudness and softness of a tone.)

- How would you describe a hue, such as red, to your unsighted friend? A value? Intensity?

- Look up the word analogy. Could you compare the properties of color to those of music?

- Look up the term continuum (plural, continua). Which two of the three color properties are continua having opposite ends? Could you compare either of these with pitch or dynamics in music? Explain.

Space

Ordinarily we think of space as empty and invisible. Recall that Moore intentionally penetrated his

massive earth goddess with openings (see again, Fig. 14–9) and Calder gave as much attention to the open spaces as he did the steel when making his imposing *Flamingo* (see again, Fig. 14–10). So, why is it considered one of the *visual* elements?

First, space is not empty. Space (with the exception of outer space) consists of various gasses, water vapor, and even particles of matter. Secondly, it is not always invisible. To the extent that it contains gasses and matter, space can be seen under certain conditions—and painters are able to depict it. Under most conditions, however, space is relatively transparent.

Nevertheless, space can be described and measured and experienced visually by its boundaries and limits. The size of a room, for example, is defined by the planes of its ceiling, floor, and walls, and also by the objects it contains. The size of an interior space is always determined by how large or small it is compared to the viewer.

Outside, the ground is a plane that stretches to the horizon. We use the ground plane, and the objects on it, to perceive distance. In a realistic picture, we determine depth and distance in much the same way.

Architects are in the business of organizing space. When given the task of renovating the lobby of a Chicago office building, Frank Lloyd Wright animated the space with a variety of stairways, planters, and light fixtures—all of this beneath an array of exposed iron beams (Fig. 14–16). In addition, Wright had it finished in gold and ivory. Thus, this commercial lobby—appropriately called the light court—bears the kind of opulence and visual excitement one expects to find in a Baroque palace.

But physical space, the kind that architects and sculptors obviously have to deal with, is only one kind of space in art. Artists who work with paint, or pencil, or engraving tools, also use the

Figure 14-16 Frank Lloyd Wright, renovated lobby (1905) of the Rookery Building, Chicago. (Photograph by Jack Hobbs)

term *space* to describe an illusion of three-dimensionality that exists in their two-dimensional representations. Their paper or canvas—the *picture plane*—becomes, so to speak, a "window" on a three-dimensional world.

Sometimes *shallow* space is used to describe an imaginary undefined depth, particularly in abstract paintings, like that in Hofmann's *Flowering Swamp* (Fig. 14–17) (see **color insert #3**), in which abstract forms seem to float. Shallow space is virtually synonymous with ground (as in figure-ground), in this case referring to the "negative" areas around shapes and colors. The real depth of Hofmann's painting is probably no more than a centimeter—or the thickness of the heaviest layer of paint. What we're talking about here, however, is a spatial *effect*, not physical space.

Two-dimensional pictures can also have *deep space*, or illusionistic space. Take for example, a picture whose deep space is occupied by urban strollers, namely, *The Place de L'Europe on a Rainy Day* by Gustave Caillebotte (Fig. 14–18) (see **color insert #3**). Caillebotte, a contemporary of Mary Cassatt (Chapter 8), endowed each stroller and umbrella with three-dimensional depth by means of chiaroscuro, a technique discussed earlier. Caillebotte also made the strollers and objects appear nearer to or farther away from the viewer. Let us look at some of the techniques he used for achieving spatial depth.

Space in Pictures

Size One device for creating spatial depth is relative *size*, that is, making objects in the distance smaller than those in the foreground. Notice that the couple in the distance on the left are not even as large as the umbrella held by the near couple on the right. We, nevertheless, perceive the couple on the left as people of normal stature. The fact that we do this is because of a perceptual phenomenon called *size constancy*. In the real world we constantly (and unconsciously) determine distances of things by their relative sizes. Because of size constancy, however, we do not think of them being smaller or larger, but being farther or nearer.

High or Low Placement One of the most obvious devices of pictorial space is the *placement* of things high or low on the picture plane,

depending on their distance. Some children, even in elementary, have learned to place distant objects higher in a picture (transitional style, Chapter 4). In the boulevard scene, for example, the people in the farthest distance are higher in the picture than those in the middle distance. Those in the middle distance are higher than those in the foreground on the right. Indeed, the people in the foreground are so far down that we are unable to see their feet.

Overlapping Another spatial cue the artist manipulates is *overlapping*—placing one thing in front of another. In Caillebotte's painting, overlapping is abundant: people overlapping the street or sidewalk, people or umbrellas overlapping people, people in front of buildings, buildings in front of buildings, and so forth.

Aerial Perspective Still another device, sometimes called *aerial perspective*, simulates the effects of atmosphere. Remember that we said space is not empty? Under certain conditions air is visible, such as in the case of smoke, pollution, or just plain haze. (An example of hazy atmosphere can be seen in the background of Bingham's *Watching the Cargo* [Chapter 11, Fig. 11–3]). With *The Place de L'Europe on a Rainy Day*, obviously, it is rain. Caillebotte did not show rain drops, but he did simulate a rainy atmosphere by blurring the outlines of things in the background as well as by subduing their colors. Notice the lack of detail and diminished value contrasts in the buildings in the background. And to heighten the effect of rain, Caillebotte cleverly included reflections on the street and sidewalk. (The colors of distant things in a full-color picture—as well as in real life—tend to be bluer in hue, lighter in value, and less intense, while the colors of near objects maintain their original hue, value, and intensity.)

Gradient of Detail Caillebotte's use of *gradient of detail* can be seen in the pavement stones, which progressively decrease in size and become less distinct in detail as they advance toward the buildings in the distance. (The windows in the distant triangular building on the left also decrease in size and detail, the farther away they are.)

Linear Perspective The most traditional spatial device used in Caillebotte's painting is *linear*

perspective, a system developed by Renaissance artists and architects in the fifteenth century (and one that was used in just about all pictorial art until this century). Because linear perspective is difficult to explain in a paragraph or two, we have devoted a whole section to it.

Linear Perspective

One-Point Perspective The situation of a road or railroad tracks Fig. 14–19) going off in the distance is often used to illustrate *one-point* perspective. Notice that the *diagonal* lines, those moving away from the viewer, converge at one point—the *vanishing point*. Specifically, they are the lines composed of the tracks and the eaves and ridge of the roof, as well as an imaginary line connecting the tops of the poles. (The slanted lines of the gable roof are exceptions.) A second set of lines is *horizontal*: the pole crossbars, railroad ties, front and back of the platform, and shed siding. The third set of lines is *vertical*: the telephone poles and the vertical sides of the shed.

Besides the vanishing point, the other element of perspective is the *eye level*—meaning, literally, the level of the viewer's eyes. Generally, the eye level and horizon line are the same. (Often, the horizon line is invisible, being obscured by such things as trees, hills, buildings, or walls.) In Fig. 14–19, the viewer is elevated above even the height of the tall poles. If this picture were a photograph, we would have to assume that the photographer was floating in the air, or in a helicopter. Notice that all the converging lines lead *up* to the vanishing point.

The only thing altered in the second version of the scene (Fig. 14–20) is the eye level. Now the viewer (or photographer) is standing on the ground. Other than the eye level, nothing, not

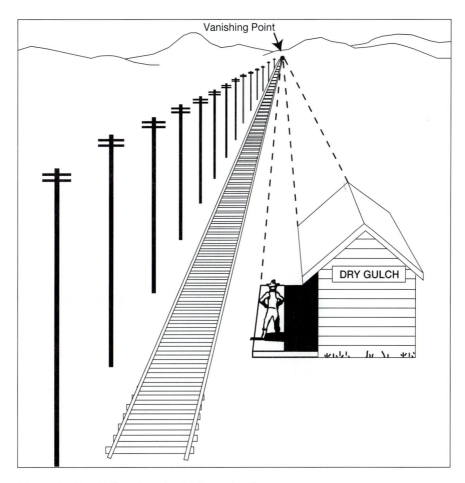

Figure 14-19 Railroad tracks (high eye level).

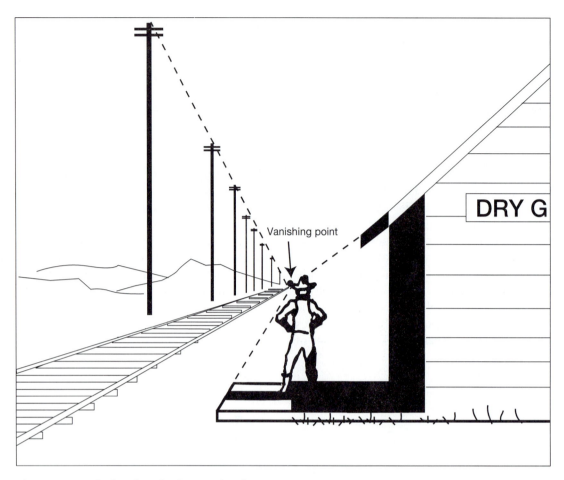

Figure 14-20 Railroad tracks (low eye level).

even the distant hills, has changed. But notice the dramatic difference in the effect, especially with regard to the size and shape of the railroad tracks. The vanishing point—which happens to be obscured by the cowboy's head—is at the level of a standing person. This, of course, also represents the eye level. The vertical and horizontal sets of lines have not changed. Some of the converging lines, the tracks and the left edge of the platform, still lead up to the point—but not nearly so steeply. The tops of the poles, however, lead *down* to the point. Which of the two versions, Fig. 14–19 or Fig. 14–20, do you think is the most natural? Which of the two is more successful in drawing you into the scene?

Two-Point Perspective The single-point system of perspective works for scenes in which the horizontal things—in this case, the pole crossbars,

railroad ties, front and back of the platform, and siding—are parallel with the edges of the picture. In cases where there are no horizontals, two vanishing points are necessary (sometimes more than two, if not all things are at right angles). The box in Fig. 14–4, used for illustrating chiaroscuro, was drawn with two vanishing points (Fig. 14–21)—both points being outside the limits of the Fig. 14–4 picture. Notice that only the vertical lines are parallel with the edge of the page. The nearest part of the box is the near corner. Imagine that the box is a building, and compare it with the railroad shed in Figs. 14–19 and 14–20. Notice that the nearest part of the shed is a side, not a corner.

Foreshortening Foreshortening is related to a paradox of vision called *shape constancy*—the tendency to perceive an object as unchanging in its shape regardless of changes in its position

relative to the viewer. Imagine a real box rotating in our view. We would perceive it as having the same shape despite the fact that the optical image actually changes as it rotates. The drawing (Fig. 14–22a, b, c) approximates that of a changing image in three different positions. Notice that the near side is transformed from a virtual square to a very narrow trapezoid (while the other visible side becomes more rectangular). Ordinarily, though, we are unconscious of these "distortions"; indeed, without these so-called distortions, the box would not look so "real." When an artist alters the shape of something to create the effect of depth, it is known as *foreshortening*.

Foreshortening is simply a ramification of linear perspective, but on a smaller scale (or, it could be said that linear perspective is foreshortening writ large). Look again at the illustration of the railroad tracks and shed (Figs. 14–19 and 14–20). Notice in 14–19 the foreshortening of the roof; notice in 14–20 the foreshortening of the left side of the shed and of the platform on which the cowboy stands.

So far we have looked at examples of foreshortening applied to the representation of simple geometric objects. Needless to say, these are less challenging than representing, say, an active human being such as White's preacher as seen from the front pew (see again, Fig. 14–14). Study

this drawing closely, particularly the man's face, arms, and hands. Notice the radical foreshortening in these parts of his body, especially in his right forearm.

And what about the size of the hands, especially his right hand? Have you noticed that they are very large in proportion to the rest of his body? Of course the reason is that the preacher's hands are closer to us. (We are sitting in the front pew, remember?) This is another example of size constancy (see previous discussion of strollers in *The Place de L'Europe on a Rainy Day*). Because of size constancy, the preacher's hands appear *not* to be abnormally large, but rather, to be unusually close. Finally, the principles of linear perspective can be, and are often, violated—as Caillebotte did to some extent in his rainy scene. John Maxon, an art historian, refers to this work as having "condensed perspective."[4] Nevertheless, the principles of linear perspective are important to any artist seeking to imitate optical reality, even to a small degree. It is difficult, however, to demonstrate them in complex spatial situations such as Caillebotte's boulevard, in which the buildings do not lie at right angles to one another.

The best kind of illustrations for showing the workings of linear perspective are simple pictures, such as, for example, that of the railroad tracks and the box. Each of these pictures

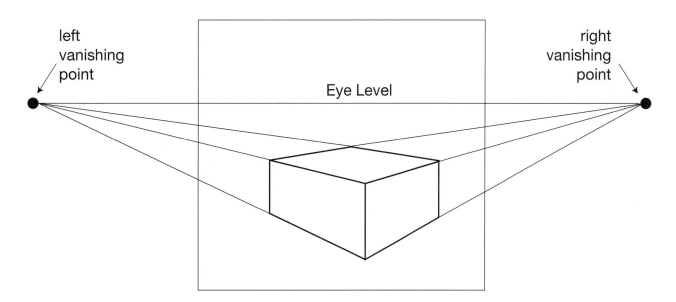

Figure 14-21 Same box used in Fig. 14-4 showing vanishing points.

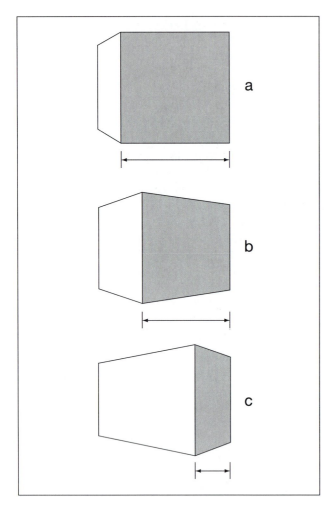

Figure 14-22 Progressive foreshortening of one side of a box shape, (a), (b), and (c).

presupposes a level environment in which all objects are square and at right angles to one another. We cannot always count on such an environment, either in real life or in pictures.

Studio activities for space, any age level

- Using boxes of different sizes, organize an architectural space. If this is a class project, the boxes can be medium to large (like the size of computer-paper boxes, for example). If this is an individual or small group project, the boxes should be small (perhaps the size of floppy-disk boxes). Pretend the space to be organized is a commercial district of a city; each box would represent a building. What would you place in your ideal city? How would you organize these things in terms of beauty and patterns of traffic?

Or pretend the space is the inside of a school, an office, or a home; each box would represent a piece of furniture or equipment. Give careful thought to this kind of organization as well. You could paint your boxes or wrap them in a neutral color of paper.

- Take a blank sheet of paper. Think of the surface of the paper as "space." Somewhere in the middle of this space, place a cutout image of a house. This becomes a "frame of reference." Now take a cutout of an animal or person and observe how that image looks small when placed below the frame of reference and large when placed above it. What accounts for this "magical" effect? (Teacher: The answer is size constancy.)

- Extend the above activity by cutting out different sizes of animals of the same kind, such as horses or cattle. Also cut out different sizes of objects of the same kind, such as fence posts or telephone poles. Arrange these on a large sheet of paper in such a way that all the cutouts seem to be the same (or correct) size. If this is to be a mural or a group project, then images of people and other animals or objects can be added. See that each cutout when placed in the mural appears to be correct in size.

- Cut some parallelograms, trapezoids, and ellipses out of stiff paper. Paste these onto drawing paper and transform each into a drawing of a box or cylinder shape (Fig. 14–23).

Space activities, upper grades

- Try locating the principal vanishing point in *The Maids-in-Waiting* by Diego Velàsquez (see Chapter 2, Fig. 2–6). (Hint: follow the lines formed by the edge of the ceiling and the frames of the paintings on the right; Fig. 14–24).

- Where is that point? (Answer: somewhere behind the head of the infant princess.) Where is the eye level?

- Would the lines of Velàsquez's easel lead to the same vanishing point? Explain.

- Perhaps you and a few other students can take drawing equipment out of class to draw a hallway. Position yourself in the middle at one end of the hallway. Notice the dramatic one-point perspective. If you are sitting down, would the eye level be high or low? Be sure to place your vanishing point accordingly. After locating the point, commence drawing. Ensure that the lines thrusting away from you—such as the tops and bottoms of lockers or light fixtures or floor tiles—converge on the vanishing point.

- Using a camera, look for a good "one-point" scene. Make sure that the horizontal parts of the scene are parallel with the bottom and top edges of the view finder.

Figure 14-23 Making solid shapes out of cutout shapes. Parallelograms converted into cubes, ellipses into cylinders.

- Using your own photograph or another one that is a good example of one-point perspective; make a drawing based on the photograph.
- Typically, a photograph of a building is taken from one of the corners of that building and shows two sides of it. Therefore, the photo is a good example of two-point perspective. Mount a photocopy of the photograph (reduced in size, if necessary) in the middle of a large sheet of paper. Locate the two vanishing points. (If one or both points end up beyond the edges of the paper, reduce the Xerox even more.) Extend the picture beyond its original boundaries by drawing your own additions, using the vanishing points.
- Look for pictures in newspapers or magazines. Locate the vanishing point(s) of a picture by laying a ruler (or any straight edge) along the converging lines to see where they meet.
- If a window in your classroom looks out over rectangular objects, such as buildings, sidewalks, or a street, you can trace some of these directly on the glass. Use an overhead projector pen. Keep your body, especially your head, in the same position relative to the glass at all times. If the scene is extensive enough, you should be able to see it terms of linear perspective. Can you locate vanishing points? Can you determine the eye level?
- Create your own two-point perspective picture from imagination. Locate the points at either edge of a horizontal 12 × 18" sheet of paper. (You may want to confine the picture itself within a 9 × 12" rectangle inside the paper.) Imagine a futuristic city with overhead avenues, monorails, and floating buildings.

THE PRINCIPLES OF DESIGN

Now that you are familiar with the visual elements, you will be able to see how these elements work together as a team. The result of this teamwork is called *composition* (literally putting together). As Caillebotte was composing *The Place de L'Europe on a Rainy Day* (see again, Fig. 14–18), he had at least two objectives: (1) that the picture be a convincing illusion of Parisians on a rainy day, and (2) that it have visual impact. To address his first objective, the artist employed the visual elements, including foreshortening, chiaroscuro, aerial perspective, and linear perspective—all the things just reviewed. To address his second objective, Caillebotte depended on the *principles of design*. While Caillebotte himself may not have used that term, he certainly was conscious of various ways of manipulating the visual elements to produce a striking composition.

The principles of design, as we list them here, are *variety; unity; movement, stability*, and *rhythm*; and *balance*. Similar to the visual elements, the principles of design come in different labels, depending on whose list you use. Broudy, for example, refers to them not as principles of design, but as *formal properties* (see *aesthetic scanning* in Chapter 8). To review the principles of design, we will see how they are used in both

Caillebotte's painting and Hofmann's *Flowering Swamp* (see again, Fig. 14–17).

Variety

Variety refers to differences or contrasts among the visual elements or among features in the subject matter. A picture might contain a variety of lines ranging from thick to thin, or light to dark, for example. It might contain a variety of shapes in a number of sizes, ranging from small to large, or from geometric to biomorphic. Variety of line, shape, texture, value, color, and space contributes to its visual interest.

In Caillebotte's picture, for example, there is obvious variety in its subject matter. There are people, umbrellas, paving stones, buildings, a lamppost, and a carriage. Among the people are both men and women. The variety in the subject matter is enhanced by the variety among the visual elements. Notice the differences in value (the dark clothes of the people set against the lighter values of the rain-soaked street), in shape (the organic people and the geometric buildings), and in simulated textures (silken umbrellas, woolen clothes, and slippery stones). The most interesting contrast, however, is spatial—between the crowded right half of the picture and the somewhat empty left half. Notice that the lamppost is in the exact center.

Variety in abstract art, such as *Flowering Swamp*, is owing entirely to things such as shape, color, and texture, since it has no subject matter beyond its form. All of the shapes in Hofmann's work are organic and undefined, except for two rectangles—one red and one green. The textures—in this case *real* textures—vary from the thick, bumpy layers of paint over most of the canvas to

Figure 14-24 Schematic of Velàsquez painting showing fate lines.

the relatively smooth surface of the two rectangles. Color variety is rampant. In the upper one third there exists a riot of hues and values, while in the lower two-thirds there seems to be a duel between mostly reds and greens.

As a third example of variety, let us look briefly at Escher's *Circle Limit IV* (see again, Fig. 14–7). There are only two kinds of shapes, although they vary in size. Were it not for the artist's clever game of figure-ground reversal, it could be said that this endless repetition of bats and angels is lacking in variety. The ambiguous figure-ground relationships, however, are a source of endless fascination.

Unity

Lack of variety, as in a forty-piece orchestra playing the same note over and over, leads to monotony. The same orchestra playing forty different tunes would have variety but sound chaotic. Both situations are disagreeable. *Unity* describes a state of being whole, or a condition of *harmony*. In music, accomplishing this with twenty different instruments is the job of the conductor. In a painting, it is the job of the artist.

Proximity Grouping One strategy for accomplishing unity is *proximity grouping*, that is, grouping some things close together to reduce the number of focal points. (You do this, for example, when you group books, papers, and art tools in different places to make your classroom look "tidier.") There are relatively few focal points in Caillebotte's Paris scene, principally the threesome on the right, the isolated couples and singles in the distance, and a few clusters of buildings. Proximity grouping is harder to identify in *Flowering Swamp* because of its less defined forms. Still, we can see this in the color explosion that seems to circle around the red square versus the lone green rectangle beneath that activity.

Similarity Similarity is a way to connect things without grouping them together (just as in coordinating a room, you use similar colors in things not close together such as carpet and drapes). Similarity of shape is evident in the umbrellas that link the right and left halves of the Paris picture, as is similarity of value seen in the uniformly dark clothes of the upper-class people. Throughout

Hofmann's painting is similarity of texture, seen in the thick, roiling brushwork. A less obvious example is color similarity found in the light green of the rectangle which is echoed, though faintly, by two strokes of light green at the top of the canvas.

Emphasis *Emphasis* or *dominance* is still another strategy for unification. For example, the dominant feature unifying a classroom is the teacher. The teacher is the *center of interest*. Works of art also have a center of interest.

Visually, dominance is a function of size, brilliance, location, and contrast with surroundings. Psychologically, it is a function of what seems to be the most important emotionally. In the Caillebotte, the building on the left stands out partly because of its isolation, but mostly because it is the only triangular shape in the entire picture. The near couple on the right stand out because of their size and their psychological weight—of all the features, we identify most easily with them. (Meanwhile, neither the building nor the couple is favored by central location.) Weighing everything, we think the couple is the most dominant. Years from now, if you remember this painting, your memory image will no doubt be dominated by their presence.

In *Flowering Swamp*, the green rectangle stands out because of its light value (against dark surroundings) and unique shape. The little red square is favored because of its brilliant hue, shape, and central location. Yet, the red square tends to get lost in its reddish surroundings. The brushwork in the painting attracts our attention because it is highly charged. Which of these things dominates? It is hard to say. Perhaps the tension between them is the dominant feature.

Meanwhile, in Escher's woodcut, repetition and regularity unify his composition. The center of interest falls in the exact center of the image where the feet of Escher's devils and angels meet. It provides the one point of stability in the fascinating and ever changing figure-ground relationships.

Continuity Still another way of fostering unity is *continuity*, a line or shape or series that continues—as a "flow of vision"—throughout a large part of the composition. Since there are no literal lines in either painting, continuity has to be inferred from either a large shape or a series. Such

a series in the Caillebotte is the eye-level line— composed of umbrellas, the foot of the triangular building, and figures on the left, and continued on the right by, literally, the eyes of the couple. That horizontal is intersected by the vertical of the lamppost, starting at the top and continued below by its reflection on the sidewalk. Interestingly, these continuities divide the composition into four parts (Fig. 14–25). Meanwhile, continuity in the Hofmann consists mostly of the flow of vision from the green rectangle in the lower left through the lively brushwork to the upper right.

Movement, Stability, and Rhythm

Movement and *stability*, like variety and unity, are necessary opposites. Absence of movement in a work is stasis; absence of stability is endless restlessness. The goal is to harmonize the two, although every artwork tends to emphasize one or the other.

Movement First, it should be acknowledged that the artworks under discussion, like most artworks, are static. Relatively few kinds of visual

art, that is, kinetic sculpture, film, and video (see Chapters 16 and 17), actually move. What does move is our attention as our eyes scan the image to examine its various components.

The visual elements, again, play a roll in guiding the scanning of our eyes and also in suggesting movement. Diagonals, because they are perceived to be "unstable," evoke movement more than do verticals and horizontals. Brilliant colors, especially in combination—say, red juxtaposed with blue-green—generate more visual energy than do duller colors. Strong contrasts— whether between values or hues—create more energy and movement than do weak contrasts.

Caillebotte's picture suggests movement in large part by the subject matter which preserves a moment in time. The walking figures are stopped in action, implying a relationship to both time and movement. The visual elements also play their part. The diagonal direction of human shapes from lower right to upper left and the regression of the pavement stones from lower left to upper center, both of which thrust into the distance, impart a definite sense of movement. The odd linear perspective—reminiscent of a photograph taken with a wide-angle lens—produces a

Figure 14-25 Four-part composition of the Caillebotte.

special kind of tension, thus adding to the sense of movement.

Movement in the Hofmann depends entirely on the visual elements. And there is scarcely a better example of movement produced by tensions between colors and shapes than this one. Previously, the colors were likened to a riot or an explosion, and the textures were described as unruly, roiling, charged, and animated. The only thing to add is the observation that such undisguised brushstrokes as Hofmann's can be seen as records of his physical movements when making the painting.

Stability *Stability*, like movement, is a function of both the visual elements and subject matter in a painting such as Caillebotte's. Vertical directions tend to suggest strength, and horizontals seem to be at rest. The most stable shapes, therefore, are rectangles. Stability in the Caillebotte is augmented by the four-part rectangular structure which is, as pointed out earlier, a product of the vertical line of the lamppost intersected by the eye-level line. Stability is also suggested by the relatively subdued colors as well as by a relative lack of animated texture. Finally, as to subject matter: We can easily see that *The Place de L'Europe* is a relatively quiet intersection (which today would be filled with the sights and sounds of cars and buses). The people are calm; no one seems to be in hurry.

In *Flowering Swamp*, on the other hand, the two rectangles are the only areas of calm in a universe of restless movement. As a result, the eye tends to connect the rectangles—as though they were being drawn together by some magnetic force. This relationship produces another kind of movement, perhaps even a dominant one. Clearly Hofmann's work emphasizes movement. Caillebotte's seems to keep movement and stability in a kind of equilibrium.

Rhythm In some lists, *rhythm* is treated as a separate principle. But in fact, rhythm is a part of movement. Rhythm is the repetition of identical or similar units in a series. Just as rhythm in music (such as a foot-tapping beat) stipulates and controls the tempo of a song, rhythm in art controls the tempo of movement in a picture or design. A good example of rhythm is the repeated devils

and angels in Escher's *Circle Limit IV*. Rhythms in Caillebotte's work derive from such things as the repeated shapes of paving stones, the repeated shapes of the umbrellas and perhaps of the people, and the repeated verticals of windows in the buildings. The repeated brushstrokes in the Hofmann are an example of a more informal kind of rhythm.

Balance

Balance refers to equilibrium—a subject that tends to evoke images of balance scales or see saws. However, art is not about physical equilibrium (except in the case of mobiles, Chapter 16), but about the *appearance* of equilibrium.

Symmetry *Symmetrical* works—which are similar in some respects to geometric objects—are inherently balanced. Escher's *Circle Limit IV* is an example of *radial symmetry*. Like a Ferris wheel or a sunburst, it has similar parts distributed equally around a central axis. Most public architecture consists of *bilateral symmetry*—that is, having identical, or mirror image, parts on either side of a vertical line in the center. Similar to a balance scale with equal weight on each side, a symmetrical building or painting has equal visual weight on each side of its axis. An example of symmetry in painting is Albers's *Homage to a Square* (Chapter 8, Fig. 8–5) (see **color insert #2**).

Asymmetry But the vast majority of artworks are not symmetrical—either radially or bilaterally; they are *asymmetrical*. A painting that is balanced asymmetrically has equal visual weight on either side of its axis, but the visual elements producing it are not identical. Thus, achieving *asymmetrical balance* is the same as trying to equalize the weights of a father and a daughter on a see saw. In a picture, this can be explained in terms of balancing *visual weights* and *psychological weights*. The factors of visual weight are similar to those of dominance: size, brilliance, and contrast with surroundings. Psychological weight—which applies only to pictures with recognizable subjects—involves things of human interest.

The Paris scene, as indicated earlier, is divided into two parts that are equal in size, but

nonidentical. On the right are two large umbrellas and three large figures—including the couple facing us (determined earlier to be the dominant feature). On the left are some anonymous people in the middle distance and some (very small) in the far distance, plus pavement stones and a triangular building. The right side seems to be the "heaviest" in terms of both visual weight and psychological weight. However, there is one other datum of psychological interest: Both the man and woman are looking toward the left—drawing our attention in that direction. Imagine how the picture would be affected if they were looking the opposite way, say, at the shops on the right. Whether the direction of their gaze is enough to restore equilibrium is hard to say. In the final analysis, Caillebotte's picture is fascinating partly because of these unresolved tensions.

Hofmann's painting displays a similar two-sided conflict, in this case between the green rectangle at the lower left and the light values and animated brushwork in the upper right. Between these lies the red rectangle. Any psychological weights to consider will come from our responses to color (for example, warm versus cool) and the other visual elements. In our judgment, the visual weights at either end tend to cancel each other out and, therefore, the painting is balanced. Indeed, the general feeling when looking at *Flowering Swamp* is that of balance (this feeling may be a better test than that of adding up all the visual weights and comparing the two halves of the picture). A canvas with such volatile colors and brushwork needs this feeling of balance to provide it with some stability.

Activities

As indicated in Chapter 4, children ages 6, 7, and 8—because of a natural inclination for repetition—often have a natural sense of composition. Studio exercises aimed at teaching design concepts should be age-appropriate. Also, when you teach design, be sure that each lesson is sufficiently narrowed and conceptually focused (Chapter 9). In any case, you should not expect students always to observe all the principles of design in their studio work. In other words, the principles are guidelines, not rules that can be

applied the same way in every case or followed unthinkingly.

Studio activities for design principles, any age level

- Fold a paper in two, and begin cutting. When done, open it up. What kind of balance do you see?
- Take a square sheet of paper and fold it into fourths. Then from the closed corner, fold it again to form a triangle; begin cutting. What kind of balance did you obtain this time?
- Cut out a few abstract shapes of different sizes and colors. These could be either geometric or "free-form" shapes. Using these shapes, make an asymmetrical design that is balanced.
- Make a picture of an athletic team in action—any sport: soccer, volleyball, softball. Are all the players wearing the same colored jerseys? If so, are they united as a team? As a composition? What kind of unifying strategy is this called?
- Make a picture consisting of several figures and objects, but with one figure or object that is clearly dominant. What are the factors that cause it to be dominant? Is size the only way to make something dominant? Try making something dominant because it differs in some way from all the other things in the picture.
- Try a picture in which the dominant feature is off to the side. What can you put on the other side to balance it?
- Using one of several simple relief printing methods (prints from vegetables, odds-and-ends, cardboard cutouts; see Chapter 15), create a simple shape or a symbol. Print the shape repeatedly as a series; this is called a *motif*. Use more than one motif alternately. See what kind of rhythms you can create. Look for examples of rhythm in art, architecture, interior design, and product design.
- Study works by artists. Discover the strategies they used
 - to unify a picture (such as similarity, dominance, continuity)
 - to endow a picture with movement and/or with stability
 - to balance a picture (visual weights, psychological weights).
- Study examples of advertising art. Identify ways in which the visual elements, in combination with design principles, were used to sell a product. For example, is the product name or logo usually the dominant feature? What ways were used to attract your attention?

Older students can do similar activities, though perhaps with added challenges. You prob-

ably have ideas of your own. You should use the principles of design as criteria for critiquing these activities only if they are part of ongoing lessons in which you present the criteria to students clearly in advance (see Chapters 7 and 10).

Verbal activities for design principles, upper grades

- Study works by artists. Look for any strategies related to the visual elements or the design principles that may have been used by an artist to express a feeling or an idea.
- Which do you think is the dominant feature in Cassatt's *The Boating Party* (Chapter 8, (Fig. 8–3) (see **color insert** #2)—the mother (with a child) or the man rowing? Do the two figures compete for attention? Explain. Contrast the two in terms of value and color? Does this contrast imply anything about feminine and masculine? Explain.
- Identify other strategies used by Cassatt to unify and balance her picture.
- Study works by twentieth-century artists. Discover how often some of these artists violated the principles of design. Identify instances in which one or more of the principles is completely missing. Would such an instance diminish a work's aesthetic value? Explain.

SUMMARY

Recall in Chapter 5 our discussion of theories of art. One of those was *formalism*—a theory stating that the essence of an artwork lies in its arrangement of formal elements—such things as colors, lines, and shapes. Some of the more extreme defenders of the theory dismissed the importance of subject matter altogether (a position with which we, obviously, disagree). During this century, formalism was a dominant philosophy among critics and aestheticians, particularly in the 1950s and 1960s when various abstract movements held sway in the art world. Recently, formalism has fallen out of favor, at least as a dominant theory.

Regardless of the fortunes of formalism as an aesthetic theory, however, the issues of color and texture and design will continue to be referred to in the language of artists, critics, art historians, and aestheticians. Such language is obviously necessary to articulate *what is seen* in a work. In many ways the vocabulary of visual elements and principles of design—the terminology we have used in this chapter—is the pedagogical equivalent of formalism.

This chapter is not the first time we have used the language of elements and principles. In Chapter 3 we examined various processes within the art disciplines. Common to all four disciplines is formal analysis which depends on being able to perceive the way the visual elements, as organized by the principles of design, express meaning in a work of art. While it may be difficult at times to see the elements and principles independently from a work's subject matter, it is easy to see that they literally "color" our interpretation of the subject in many ways. Chapter 8, as you recall, explained the techniques of aesthetic scanning and the Feldman method of criticism, both of which call for describing the elements and analyzing their relationships.

As we said at the opening of this chapter, one objective was to bring those of you without art backgrounds up to speed on the language and knowledge of the elements and principles; the other was to suggest age-appropriate applications for their use in the classroom. We hope that, for you, both of these were accomplished. However, for your benefit and to augment the second objective, we have included in the bibliography for this chapter a number of texts on art and design, some of which include details on presenting studio projects.

NOTES

1. Johanson, Donald and Lenora, and Edgar, Blake. (1994). *Ancestors: In search of human origins.* New York: Villard Books, p. 303.
2. Read, Herbert. (1961). *The art of sculpture* (2nd ed.). Princeton: Princeton University Press.
3. The primary colors in colored lights are different. It is unlikely, however, that you and your students will be doing projects with colored lights.
4. Maxon, John. (1970). *The art institute of Chicago.* New York: Harry N. Abrams, p. 95.

15
Processes in Two-Dimensional Art

Some art, such as sculpture, exists in real space. Other art, such as drawing, can convey the illusion of space on a two-dimensional surface. This chapter is devoted to the latter. It is called *two-dimensional art* (or *2-D* for short). Three-dimensional forms of art (3-D) are the subject of the following chapter (Chapter 16).

The most common two-dimensional art forms may be loosely grouped as drawing, painting, printmaking, still photography, and computer-generated art, which now includes much of graphic design (advertising art) and industrial design. Two-dimensional art, except for design, is categorized primarily according to the medium used. Some artists use mixed media—media from more than one group—and designers make use of all media.

Two-dimensional art activities are popular in elementary classrooms. One reason is that many of them use inexpensive materials familiar to everyone able to write: standard school manilla paper and pencils, crayons, ballpoint pen, magic markers. Another is that drawing, if not painting, is familiar to most children even in the earliest grades; children learn to draw long before they learn to write.

Let us explore the most common two-dimensional art forms used by adults and look at related

kinds of two-dimensional projects you can use with your own classes. Exactly what you teach will depend on your students' capabilities, however; you may have to simplify or extend the activities described. They are only examples, in any case, to guide you in your search for others.

DRAWING

All of us have drawn as long as we can remember, and before. Yet many people, when asked to take pencil in hand to make a work of art, respond, "I can't draw!" Drawing is at once a familiar and an intimidating artistic process.

Perhaps that is because drawings are personal statements. Drawings reveal our thought processes and our aesthetic expertise, or lack of it. Drawing is the closest art form to thinking. Some drawings appear effortless; in others, the battle for expression seems hard fought.

Over the centuries, some drawings have been considered unfinished works; the term *sketch* denotes such a drawing, made for later use as an aid to the artist's memory or a study for a more complete statement in a medium such as paint or stone. Others are works of art in their own right. No matter which kind we look at, when we look

at drawings we are closest to the mind of the artist.

In Europe, the use of drawings for exploration and drawings as ends in themselves dates from the introduction of the Chinese skill of paper making in the early fifteenth century. Using paper proved much cheaper than the traditional vellum or wooden panels covered with *gesso*, a smooth, white mixture of glue and chalk or plaster of paris. With paper, artists such as Leonardo da Vinci were able to record their observations of the world like the natural scientists they were.

Today there are many drawing media. Some are dry—pencil, chalk, charcoal, crayon. Others are wet—pen and ink; a simple stick with ink; a magic marker; a brush with ink, or ink thinned with water (called a *wash*), or water-based paint, or oil paint. Some drawing tools (called *burins*) cut into the surface drawn on.

Some surfaces on which we draw are rough, some smooth; some hard and impervious to liquids, some soft and absorbent; some paper, some cloth or wood or metal. Each combination of marker and surface has different characteristics, producing some visual effects but not others. Even so, the expressive possibilities of each combination are almost limitless.

Some drawings like that by Jean Auguste Dominique Ingres (Fig. 14–2) depend on beautifully refined line; others are coarser and more heavily worked. Gestural drawings represent energy (Fig. 15–1); contour drawings describe external and internal shapes of objects (Fig. 9–16). Representational drawings show us an artist's response to the natural world (Fig. 15–2); abstract drawings reveal an artist's inner world (Fig. 15–3).

Teaching Drawing

Teaching children to draw amounts to giving them a reason to look closely at the world. Drawing things seen in the real world builds a visual vocabulary. Children use this vocabulary when they draw from imagination; but students' imaginations can be only as inventive as their level of visual understanding—or as the quality of the images in their memories—will allow (see Chapter 2).

Some kinds of approaches to drawing are used by teachers at all levels:

Figure 15-1 Thirty-second gesture drawing. Charcoal on paper.

(From the book "The Art of Responsive Drawing" by Nathan Goldstein. Courtesy of the Prentice Hall College Library)

- **drawing with expressive lines:** line quality can be structural, descriptive, or calligraphic,
- **gesture drawing:** quick drawings to capture movement, in contrast to shape or volume or detail,
- **contour drawing:** drawings that use slow, sensitive line that describes the fluctuation of edges (both internal and external) of positive shapes,
- **drawing with light and dark:** drawings that use shading (gray areas) to duplicate the effects of direct light on objects, including the shadows they cast, in order to produce an illusion of volume,
- **drawing negative shapes:** drawings of the spaces between objects (or through them),
- **drawing in perspective:** using aerial and linear perspective to create an illusion of space on a two-dimensional surface,
- **representational drawing:** recording observations of nature in illusionistic or pictorial space,

Figure 15-2 John Constable, *Fishing in "Wivenhoe Park"* (1816). Pencil on paper.
(Courtesy of the Victoria and Albert Museum, London, #P.602)

- **abstract drawing:** creating the dimensions of a pictorial space extracted from nature, but governed by the artist's rules of order,
- **nonobjective drawing:** creating a pictorial space without reference to nature.

Student Drawing Activities

Children draw spontaneously from their early years (see Chapter 4) with anything that makes a mark on any available surface, including walls and furniture. Virtually all of them will be familiar with using pencils and crayons by the time they enter school. Drawing materials are readily available, inexpensive, and widely used in classroom art.

The activities that follow relate to looking carefully at things in the immediate environment.

Young children (from the age of 2 or so) may be encouraged to look carefully, and to visualize what they remember, by asking them to notice particular features of objects they may wish to paint. Art educator Nancy R. Smith suggested some kinds of questions that can encourage children to develop symbols. Whatever answer a child might volunteer would be right. Smith refers to paint here, but for young children paint is also a drawing medium.

"What kind of a house do you live in?"
"Is it tall?"
"Do several families live in it?"
"Is there a tree near it?"
"What special parts does it have?"
"Does it have a pointed roof?"

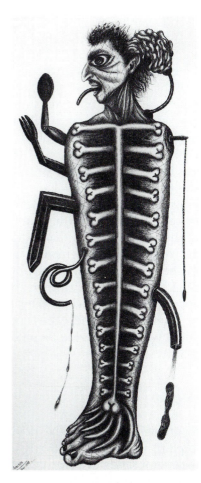

Figure 15-3 Luis Cruz Azaceta, *Self-Portrait: Mechanical Fish*, 1984. Colored pencils, conte crayon on paper, 103 × 44″.

(Courtesy of George Adams Gallery, #4385) (Photo: eeva-inkeri)

"What shape are the windows?"
"How will you make them with the paint?"
"Will you start with the ground or the house?"
"What is the very first thing you are going to paint?"[1]

You might like students to keep sketchbooks or portfolios in which they record things they see, ideas they have, preliminary solutions for problems you assign them. If you ask students to keep sketchbooks or portfolios, be sure to look at them regularly with each student, discussing their contents in ways that will give your young artists helpful advice. Some beginning drawing activities follow:

- **Expressive lines:** Give children a soft (6B) drawing pencil and several 9″ × 12″ pieces of paper. Ask them to make thin lines, thick lines, light lines, and heavy lines. Then ask for lines that express feelings—happy lines, angry lines, quiet lines, sad lines, and so on. Make a "happy picture," an "angry picture," and so on; the lines themselves become the subject matter. Later, have the class guess which is which.

- **Gesture:** Children can benefit from making quick gesture drawings of a figure in movement. One child can be a model while the others draw. Give students only 30, 60, or 90 seconds to capture the pose. Change models often. At first, ask children to assume the pose themselves before they draw to capture the feeling (Fig. 15–1).

- **Contour:** Even kindergarten children can make contour drawings (see Fig. 9–1). Ask them to look carefully at the object they are drawing and to fill up the 9″ × 12″ paper.

- **Contour extension:** Modify the sample lesson in Table 9–2 to fit a variety of ages and objects to be drawn (Fig. 15–4). Use 9″ × 12″ paper for young students, larger paper for older ones.

- **Contour and composition:** Ask older students to cut a 3″ × 4″ frame from paper and move it around their first contour drawing until they find a good composition; then enlarge that part of the drawing to make a new 9″ × 12″ (or larger) drawing (Fig. 15–5).

- **Volume:** Have students use pencil or black chalk to make a contour drawing of an inert object or group of objects (a still life) illuminated by a desk lamp shining directly on it. Add shading (from

Figure 15-4 Fifth-grade contour drawing. Pencil on paper.

(Photograph by Jean Rush)

Figure 15-5 Fifth-grade contour drawing, enlargement of a section of Fig. 15-4. Pencil on paper.
(Photograph by Jean Rush)

light grays to the darkest grays or blacks possible) to the drawing to create a sense of volume; include shadows cast on the table top. Add shading until the lines disappear. Use 12″ × 18″ paper or larger, depending on students' ages. When using chalk, remind children to shake off the dust gently rather than blow it (see Chapter 18).

• **Negative shapes:** Direct students' attention to shapes made by the spaces between one object and another, or spaces "inside" an object like a chair or a bicycle. Have them draw negative shapes, and let the positive ones "appear" by themselves.

PAINTING

In China and other Eastern countries, painting, drawing, and writing are interrelated. Artists use the same brushes and inks for all three. Paintings often include poems, and dexterous brushwork defines calligraphic skill as much as a calligraphic aesthetic defines painterly art (Fig. 15–6).

The study of Western painting is not so much the study of technique as it is the study of light and color. Painting and drawing are siblings, but painting is more than drawing in color (that is, more than using line to define shapes). In paintings, areas of color can define shapes rather than line. The painter distinguishes these areas from one another by giving them different hues, values, and intensities.

The painter reproduces on paper or canvas the play of light that we all see on the surfaces of objects in the real world, or invents new ones. In the process, shapes emerge in illusionistic or abstract pictorial space. Some artists have tried to reproduce natural light faithfully (Fig. 3–10), while others have been more interested in inventing new worlds (Fig. 2–3).

Painting has a long, rich aesthetic tradition. More than any other art form, painting is the medium of the old masters. If many drawings are studies and incomplete statements, most paintings are finished ones. Drawings may be informal, but paintings are formal. Paintings make their subjects appear real even when they are imaginary. They immortalize landscapes, people, and everyday objects. They provide us with our standards of beauty.

Painting Media

In general, artists do not use the kinds of paint you use to paint your house (although some do). Artists use several kinds of paint that we identify according to the kind of material (called the *vehicle*) in which the *pigments* or coloring agents are dissolved. Some paints are water based, some are oil based, and some are plastic based.

Water-Based Paints One kind of water-based paint is called *transparent watercolor* because the color is translucent enough to allow the white of the paper to reflect through it. Watercolor is a favorite of artists because of the subtle colors they can achieve by applying the paint in thin layers or *washes* (Fig. 15–17). Transparent watercolor requires a deft hand; the medium is unforgiving of mistakes. Learning to become a skillful watercolorist takes many years.

Opaque water-based paints are thicker and cover the paper completely, although they may be diluted by adding more water. Opaque paints are considered easier to use because mistakes can be painted over, and so are more suitable for beginners. One kind of opaque water-based paint, called *tempera paint* or "poster paint," is widely used in elementary schools (Fig. 15–8) (see **color insert** #3).

Figure 15-6 Wu Chen, *Bamboo*, Yuan dynasty (A.D. 1350). Album leaf, brush and ink on paper, 16″ × 21″ (41 × 54 cm). Taipei, Taiwan, Republic of China.
(Courtesy of The National Palace Museum, #4A1H)

Another kind of tempera paint is called *egg tempera* because it uses egg yolk to create an emulsion that binds the pigments to a surface, generally a wooden panel. Egg tempera was the forerunner of modern oil paint; it was used from early Egyptian, Greek, and Roman times through the Middle Ages (Fig. 15–9). Only a few artists today use egg tempera because modern oil and acrylic paints are more convenient, but it is a durable medium. Many egg tempera paintings have retained their clear colors for centuries without darkening.

Oil-Based Paints European artists have used oil paint since the fifteenth century. The earliest oil paintings were made on gessoed wooden panels, but by the eighteenth century most artists painted on tightly stretched canvas. Oil paint can be either opaque or transparent, depending on the amount of linseed oil it contains. In oil paint a thin coating of color, similar to a wash in watercolor, is called a *glaze*.

Until the nineteenth century, each artist used natural substances like earth, rocks, vegetation, insects, and even semiprecious gemstones to color oil paint. By painstaking collecting and grinding the artist or his assistants could convert these substances to pigments. The consistency of early oil paint was thin, and the colors soft. Earth tones predominated (being most readily available); they cost the least, while hues of red, and blue, and gold were extremely expensive.

The industrial revolution during the nineteenth century gave artists brightly colored oil

Figure 15-7 Winslow Homer, (1836–1910), *Sloop, Nassau* (1899). Transparent watercolor paint on paper, 15″ × 21 1/2″. (Courtesy of The Metropolitan Museum of Art, N. Y., #10.228.3)

paints made with coal-tar dyes (see Fig. 5–1). These new paints were inexpensive and were mass-produced industrially, rather than made by each artist. The consistency of these manufactured paints was thick, like toothpaste; they were packaged in tubes, and they were always ready for use. For the first time, artists could put their paints in their knapsacks and paint landscapes directly from nature, out of doors rather than in the studio from sketches (Fig. 3–10).

Oil paint has remained substantially the same to the present day (Fig. 14–17). Oil paints dry slowly, so that artists have time to think about their work, revise it where necessary, and refine their ideas. Despite these advantages, oil paint is not suitable for elementary children because the colors and solvents can be hazardous, and they are difficult to clean up.

Acrylic-Based Paints The twentieth century has seen the invention of paints based on polymer plastics. Acrylic paints have many characteristics similar to those of oil paints: they are thick, come in tubes, have permanent colors, and can be either opaque or transparent depending on how they are thinned. They are water based, and therefore easy to clean up in either a studio or a classroom.

Acrylic paints dry quickly. As far as scientists can determine, their colors will last a long time without darkening or yellowing. Many contemporary artists use acrylics (Fig. 15–10) (see **color insert** #4). Middle-school children ready to explore the subtleties of paint can benefit from using acrylic paint with appropriate supervision. Acrylics pose few health hazards (see Chapter 18) and are almost as easy to clean up as tempera paint.

Other Painting Media *Encaustic* is an ancient painting medium in which hot wax is used as a vehicle for the pigments. Some artists such as Jasper Johns (Fig. 15–11) still use it today, but it is not recommended for elementary students. *Fresco*, another ancient technique, is a way of painting on fresh plaster; the effect is similar to transparent watercolor. The lime in the plaster binds the pigments to the wall. Fresco has been used in both Asia and Europe for thousands of years; perhaps the best known and best preserved Western examples are Michelangelo's paintings on the ceiling of the Sistine Chapel in Rome.

Collage is not a painting medium per se, but its two-dimensional forms have aesthetic properties similar to those of paintings. A two-dimensional collage is an image that contains shapes made from wallpaper, newspaper, string, or other common materials pasted on its surface instead of, or along with, paint (Fig. 15–12) (see **color insert** #4). Collage is a form of *mixed media*, a way of working that may combine a number of two-dimensional media and often two- and three-dimensional techniques (Fig. 15–13) (see **color insert** #3).

Collages may also be three-dimensional. In this case they are sometimes called *assemblages* and are considered found-object sculptures (see Figs. 16–22 and 16–23, Chapter 16). Collage is an excellent elementary medium and should be a part of every child's classroom experience.

Teaching Painting

For young children, from preschool ages up to second or third grade, drawing and painting may be considered the same activity—primarily describing shape with line (see Chapter 4). Many children do not have paints at home, so their first

Figure 15-9 Gentile da Fabriano, (1370–1424), *The Adoration of the Magi* (1423). Egg tempera paint on wood panel, approx. 9'11" × 9'3" (300 x 202 cm). Florence, Italy: Galleria delgi Uffizi.

(Courtesy of Art Resource, #S0040438) (© Photograph by Erich Lessing/Art Resource, NY)

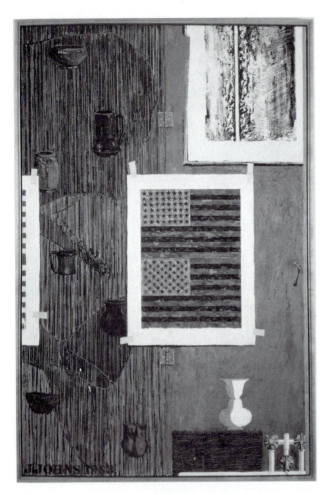

Figure 15-11 Jasper Johns, *Ventriloquist* (1983).
Encaustic on canvas, 75 × 50".

(Courtesy of VAGA) (©1997 Jasper Johns/Licensed by VAGA, New York, NY.)

contact with this medium is when they come to school. Even children able to make figures with pencil or crayon may revert to scribbling when introduced to paint for the first time, but this is no cause for concern; as they master this new medium they will resume schematic activity.

Learning to use tempera paints gives children the chance to study color: how to define it, how to mix it, and how to apply it (see Figs. 6–8 and 9–2). Children in the early grades often paint at an easel from containers of primary and secondary colors, plus black and white, each of which has its own brush. If left to their own devices they tend to mix colors experimentally on the paper, often continuing until they reach a state of "mud."

Young children have difficulty controlling dripping paint when working on an easel, particularly if brushes are left in the paint container. Unwanted drips frustrate older children. Painting

on tables, flat desks, or the floor solves this technical problem. Art educator Lila Crespin suggests having a "color place" for each brush not in use.

> Designate on the newspaper that covers the table that the red brush has its own red place next to red paint. . . . If you are using an extended palette (3 or more colors) each color should have its own brush and each brush its own color place. If you are using a limited palette and mixing colors, you do not need more than 1 or 2 brushes, and probably no color place as well.[2]

You will want your older students to take only primary hues straight from the jars, using them to mix their secondary and tertiary hues. Unless students learn to mix paints, they remain unaware of the range of color available to them in the standard red-yellow-blue-green sets. In addition, the perception of color is relative, that is, a yellow (or any other hue) will appear to differ when hues next to it vary. A yellow that appears dark in the mixing pan will look quite light on the painting, for example.

Colors also create spatial effects. Warm colors appear to reach out to the viewer; cool colors recede into the pictorial space. Colors create moods: warm colors are more positive than their cooler cousins, which can convey (literally and figuratively) the darker side of life.

The painter Josef Albers (see Fig. 8–5) devised some strategies for teaching students to perceive color differences that have become standard at all levels of teaching art.[3] Albers's students matched and contrasted shapes cut from colored papers, but his principles can be adapted to color mixing. Albers's students also analyzed color schemes used by painters of the past in order to discover their color dynamics.

Cleanup requires special attention with painting. Take time to rehearse your students in cleanup procedures before they begin, including what to do in case of accidental spills. Brushes need careful washing and shaping in order to dry in a reusable condition. For detailed painting cleanup procedures, see Chapter 18.

Student Painting Activities

Most of the following activities suggest ways to explore the medium. Remember that any medium serves the expression of ideas, and color, in partic-

ular, conveys emotion. Many elementary teachers spend considerable time prior to painting in developing themes designed to evoke emotions.

- "When you feel dreamy, how do you sit or stand? What kinds of things are you thinking about?"
- "Do animals have families? How do they feel about their children?"
- "What is something frightening that happened to you? What is something brave you have done?"[4]

Color study is most effective when students use color in a composition of some kind. Avoid asking them to mix colors for the sake of mixing, as in making a color wheel or a value chart. Assign activities that engage their imaginations. The complexity of each activity and the time needed to complete it will depend on the ages of your students.

- Ask students to make a design using only the three primary hues (colors) plus black and white. Paint the background (the negative shapes) as well as your design (the positive shapes).
- In the first design or a subsequent one, mix black and white with the primaries to produce tints and shades of each hue. Paint every area on the painting.
- Make a design with two overlapping shapes; use one primary hue for each shape, mixing the appropriate secondary hue where the two overlap (Fig. 15–13). Paint every area on the painting.
- Make a design with three overlapping shapes. Use one primary hue for your main shape and a second for your two overlapping shapes, creating secondary hues where they overlap. Add black and white to both primaries to create a range of tints and shades (Fig. 15–14).
- Repeat the exercises above without using black and white. Create a range of hues by mixing complementary hues together to form grays.
- Paint one or more still life objects illuminated by a direct light. Indicate volume as you did in drawing, that is, by adding shading and shadows. First, mix tints and shades to make grays; next, mix complements to make grays.
- Make paintings using a limited number of hues (color schemes) to help unify your composition. Three common color schemes: any two complementary hues; two or three analogous hues (next to each other on the color wheel); or a hue triad (equal distances on the color wheel; red-yellow-blue is a primary hue triad, orange-green-violet is a secondary hue triad). You can add black and white to any of these color schemes to increase

Figure 15-14a Adult student art (sixth-grade level): Mixing secondary hues; tempera paint on white paper.
(Photograph by Jean Rush)

Figure 15-14b Adult student art (sixth-grade level): Mixing tints and shades of secondary hues; tempera paint on white paper.
(Photograph by Jean Rush)

the range of tints and shades you can mix. You will be surprised to discover how many different "colors" you can make.

- Students can also make all of the preceding exercises using collage. Have them cut areas of color from photographs in magazines and paste these onto a rectangle of black or white paper.

PRINTMAKING

Drawing and printmaking are even more closely related, at least in the West, than drawing and painting. The technique of printing—the ability to make multiple copies—had been known in China

since the ninth century. Early fifteenth century explorers introduced Europeans to printing at the same time as paper making. Printing with movable type on paper quickly replaced the tedious and expensive practice of hand lettering books on vellum. Printmaking developed in response to the need for illustrations for this new industry.

Many artists—the German Albrecht Dürer, the Dutch Rembrandt van Rijn, the French Henri de Toulouse-Lautrec, among others—were both painters and printmakers. Nowadays each print that is made by hand, either by the artist or under the artist's supervision, is considered an original work of art. Each is signed and numbered by the artist, who generally also indicates the total number of prints made of that particular image (for example "10/85" indicates the tenth print out of a total edition of 85).

We often hear the term "art print" used to refer to photographic reproductions of drawings or paintings; museum gift shops often sell these large color reproductions of the works in their collections. Reproductions are mass-produced and are not made by hand. They are not considered original works of art, even though they may be framed well and have good color quality.

Printmaking Techniques

Some printmaking techniques are quite complex, although others are simple enough for elementary school children to practice successfully. In general, there are four kinds of printing processes: relief printing, intaglio printing, lithography, and screen printing. Relief printing dates from ninth century China, intaglio printing from fifteenth- and sixteenth-century Europe, and lithography from nineteenth-century Europe. Screen printing is a contemporary form of an old process, stencil printing, originally used on fabric. All of these can be hand processes used in making art, although each has its commercial mass-produced counterpart.

Relief Printing The term *relief*, in both sculpture and architecture, refers to the projection of figures or forms from a flat background. In relief printing, the surface of a block of wood, linoleum, or some other workable substance is cut away around the areas that are to print, leaving them in

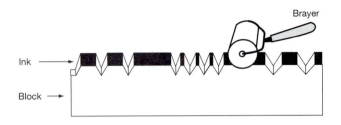

Figure 15-15 Cross section of a block from which a relief print is made.

relief. The artist rolls ink onto the relief surfaces with a *brayer* (Fig. 15–15), presses them against a piece of paper, and transfers the image—reversed, as in a mirror—to the paper.

In a relief print, in other words, the printmaker's cut lines become the white areas in the picture (the areas without ink) rather than the dark ones (the inked areas) (Fig. 9–4). Carving a relief print is the same as drawing in reverse. Relief printing is a popular technique in elementary schools, and one from which students can learn a great deal about art.

Another kind of relief print often used with children is called a *collograph*. The surface of a collograph is raised by the addition of layers of cardboard and other materials, much as a collage is constructed, rather than being cut away. It is printed in the same way as a traditional relief print.

In the nineteenth century, Japanese artists used blocks of wood to create multiple-color relief prints that became an inspiration for printmakers around the world (Fig. 9–4). The printing of each color required a separate block; lighter colors were printed before the darker ones. Each block, inked with its own color, had to be placed precisely on top of the dry image of its predecessor to ensure a clear final print. This process of lining up all of the blocks is called *registration*.

Intaglio Printing An intaglio print called a wood *engraving* can be made on the end grain of a block of wood (Fig. 15–16), rather than on the softer side used for relief printing, but most often engravers use plates of soft metal such as copper or zinc. Again the artist uses a *burin* or carving tool to cut away the surface of the wood or metal plate. The Italian world *intaglio* comes from the verb *intagliare* (to cut into).

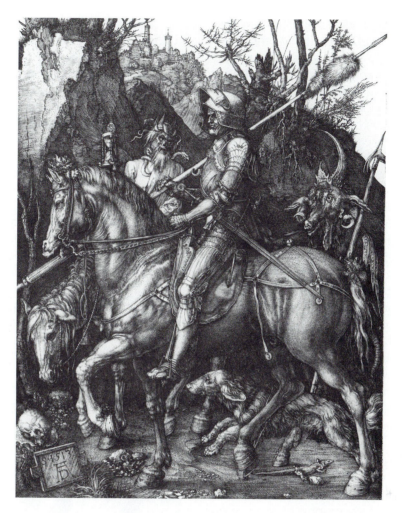

Figure 15-16 Albrecht Dürer (1471–1528), *"The Knight, Death and the Devil,"* 9 5/8 × 7 3/8. Engraving on wood, printed on paper. (Harris Brisbane Dick Fund, 1943)
(Courtesy of The Metropolitan Museum of Art, #43.106.2/MM, 14997)

An engraving differs from a relief print in this respect: the portion of the metal plate that prints—the portion that forms the dark areas of the image—is the portion that the engraver cuts away, rather than the surface that the artist leaves (Fig. 15–17). In the sense that the burin line will leave a dark mark in the final print, engraving is like drawing. Our paper currency and wedding announcements are two everyday examples of engraving we have all encountered.

An *etching* is another kind of intaglio print. Instead of a burin, the printmaker uses acid to etch away the surface of a metal plate. Most often the etcher covers part or all of the plate with a varnish compound or *hard ground*, which acid cannot penetrate, later using a penlike stylus to scratch lines through it. The varnish-covered plate

is then immersed in a shallow pan containing acid—an acid "bath," allowing the acid to contact the metal exposed by the scratched lines. If the printmaker scratches lines directly into the metal plate without using a ground or acid, the technique is called *drypoint*.

The engraved line and the etched line have noticeably different qualities: the edges of an

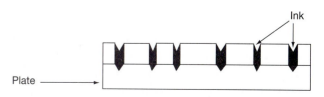

Figure 15-17 Cross-section of an engraved and inked metal plate used in intaglio printing.

engraved line are smooth and crisp; those of the etched line softer and slightly fuzzy. An engraver must create areas of gray by crosshatching or stippling, or otherwise juxtaposing many dark lines. Etchers can also make grays with small dots by sprinkling grains of powder rosin on the plate and then heating it, a process called *aquatint*. (See Figure 15–20.) The rosin melts, leaving small spaces between each grain for the acid to work (contemporary etchers sometimes use spray paint). A *soft ground*, usually varnish containing asphaltum and grease, allows the printmaker to create grays by impressing textures from cloth or similar materials through it and etching them onto the plate.

To print an intaglio plate, the printer first covers the entire printing plate with ink, later wiping the surfaces clean but leaving ink in the engraved or etched depressions. Printing both etchings and engravings requires a mechanical press that can exert a good deal of pressure on the paper and plate. The bed of the press passes between two heavy metal rollers, which force dampened paper into the depressions on the plate where it absorbs the ink. If you feel the surface of an intaglio print, you can feel raised lines of inked paper.

Lithography Lithography differs from relief and intaglio printmaking in that the printing surface remains flat; creating the image does not raise the surface or cut it away. Lithography makes use of the fact that oil and water do not mix. A lithographer draws with a black grease pencil or crayon on a block of limestone, ground until its surface is as fine-grained and as flat as a piece of good drawing paper, or paints with *tusche*, a black oil-based ink.

When the drawing is completed, the lithographer hardens the grease by applying a mixture of gum arabic and acid. The printer then saturates the block of limestone with water and rolls a layer of grease-based ink over its surface. The greasy ink will adhere to the grease in the artist's image, but will not adhere to the wet limestone. When paper is applied to the stone with modest pressure, a mirror image of the artist's drawing will result.

Lithography is much faster and less labor intensive than intaglio printing. Lithographs also look similar to drawings; sometimes it is difficult to distinguish the two. Nineteenth-century commercial printers welcomed the directness and cost-effectiveness of the process, particularly for posters

and handbills. Toulouse-Lautrec made over three hundred lithographs, many of which were memorable posters for Parisian cabarets (Fig. 15–18).

Offset lithography is the process most used by commercial printers today. Everything from colored newspaper comic strips to high-quality fine art reproductions can be printed by this process. Offset lithography uses thin plates of aluminum and high-speed presses that can print thousands of images per hour. These images are not considered original art.

Screen Printing For centuries, artisans all over the world have used simple stencils to apply decorative designs to fabric. Screen printing uses a kind of stencil that is covered by a delicate screen, originally made from a piece of silk, to print areas of flat color on paper, fabric, or other surfaces. Screen (silk-screen) printing used to make art is often called *serigraphy*.

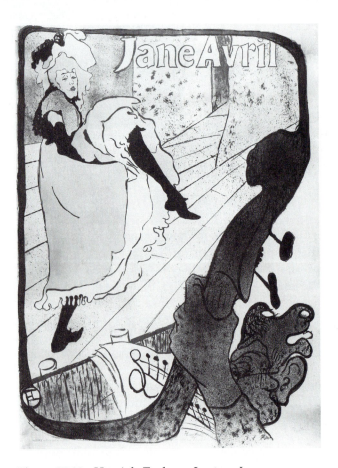

Figure 15-18 Henri de Toulouse-Lautrec, *Jane Avril* (lithographic poster), 1893.
(Courtesy of The Museum of Modern Art, #S-15, 327)

Screens used for printing consist of a rectangular wooden frame covered by tightly stretched silk or other finely woven synthetic material. A gelatin film adhered to the screen prevents ink from passing through it in areas that are to remain uncolored. Placing the screen directly on the paper, the printmaker applies a viscous ink to its surface with a rubber-tipped scraper called a *squeegee*. The squeegee pushes the ink through the unblocked areas of the screen to apply it evenly to the paper below (Fig. 15–19).

Screen printing on fabric is widespread in the United States. Many of the currently popular T-shirts with designs and inscriptions are screen printed. Some designs are made by reproducing photographic images on light-sensitive gelatin attached to the screen.

Teaching Printmaking

The magic of the mirror image is one of the best reasons for including printmaking in an elementary school art curriculum. Seeing the discrepancies between a "frontwards" and a "backwards" image teaches a new way of looking at the world. How much do we know about our own features, when we have only seen them in a mirror?

Relief Printing Relief printing, both block printing and collography, is a technique that is used successfully with elementary school children. Preschool and kindergarten students can make relief prints with a variety of everyday objects like cut vegetables and household utensils on paper and also on cloth. Papers printed with repeated shapes can be used for wrapping gifts, decorating things such as notebook covers or neckties, or as backgrounds for bulletin boards.

In the primary grades, the small styrofoam trays used by your supermarket to package meat (or other styrofoam packing material) make inexpensive surfaces for relief prints. Students can emboss a linear design on a tray with pencil or ballpoint pen and print it by rolling ink on its surface. Art supply houses manufacture a variety of easily carved materials for relief printing (the traditional linoleum block and others) suitable for students in the upper grades. Be sure to use water-based inks (see Chapter 18).

Intaglio Printing Despite its versatility, the intaglio process is technically inappropriate for most classrooms. It requires expensive equipment, and it uses extremely hazardous materials. It is not suitable for the kind of group instruction found in elementary schools. Where individual children can work in controlled settings, however, with an adult to prepare the plate and work with the acid, they can draw on a copper plate as well as on a piece of paper (see Fig. 15–20).

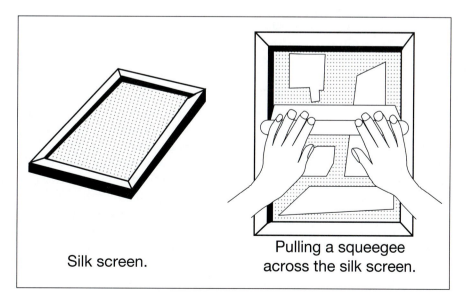

Silk screen.

Pulling a squeegee
across the silk screen.

Figure 15-19 The silk-screen printing process.

Figure 15-20 Etching by an 8-year-old boy. (Original artwork.)

(Photograph by Jean Rush)

Lithography Lithograph stones are heavy, expensive, and breakable. A lithograph press is different from an etching press, but just as large. The process requires special sinks for preparing the stones. Lithography is therefore another process that is unsuitable for elementary school classes, although children with access to an artist's private studio could undoubtedly learn the techniques.

Screen Printing Screen printing has been popular in middle and high schools for many years. The best effects are obtained with oil-based inks, but these require solvents to remove them from the screen. As we have become more aware of the negative effects on health of volatile solvents, oil-based screen printing has fallen out of favor. In any case, water-based inks should always be used even with older students (see Chapter 18).

Student Printmaking Activities

- **Preschool:** Ask children to print shapes made from cut vegetables such as potatoes, apples, mushrooms, celery stalks, and so on, or sponges, leaves, sticks, spools, buttons, and other household items; spread tempera paint on a cookie sheet or other smooth surface so they can dip these items in paint and apply them to paper. Make patterns all over a piece of paper by repeating and alternating shapes; use several colors for variety.

- **Primary grades:** Draw images on styrofoam surfaces with a pencil, ballpoint pen, large nail, or table knife; roll with tempera paint; place a piece of paper on the inked surface and rub with your hand or the back of a spoon. Print either as a single design or make repeated patterns. Students can also print from bars of soap or slabs of wet clay, which are easy to carve.

- **Intermediate grades:** Using a linoleum block or similar surface that permits more detail than styrofoam, go beyond a linear design; make images that include areas of gray made by stippling, cross hatching, or parallel lines cut close together. Print with water-based printing ink.

- **Collograph:** Glue shapes cut from cardboard and made from string onto a rectangle cut from cardboard. Tear off the surface of corrugated cardboard to expose the ridges. Add leaves and other materials if desired. Apply tempera paint or printing ink with a brayer, place paper on top, and print the block by rubbing with your hand or a spoon.

- **Monoprint:** Paint a picture with tempera paints on a formica table top, a cookie tin, or a sheet of glass. While it is wet, cover it with a sheet of absorbent paper and pat gently and evenly over the entire surface. When you remove the paper, the picture will be transferred from the table top to the paper.

STILL PHOTOGRAPHY

The still camera dates from the middle of the nineteenth century, although artists had known of a device the Italians called a *camera oscura* since the sixteenth century. A *camera oscura* was initially a dark chamber or room, as the name implies, but later became smaller in size. It is a pinhole "camera" in the photographic sense of the term: an enclosed box (dark inside) with a small hole in one side through which light, reflected from real objects, passes to form an image of the objects that is upside-down, on the opposite side of the box (Fig. 15–21).

The modern camera simply records these reflected images on strips of light-sensitive plastic film. These photographic images represent the

Figure 15-21 Cut-away drawing of a sixteenth-century camera oscura. The earliest camera oscura was large enough for an artist to stand inside.

three-dimensional world in a visually accurate way. From the beginning, photographic realism became a standard of excellence against which the public measured art.

The earliest photographers tried to make their photographs look like the painted portraits and still lifes with which they were most familiar (Fig. 15–22). But the camera could see things the eye could not—it could stop movement, for example—and gradually artists of the time began to incorporate the visual characteristics of photographs into their paintings. Painters such as Edgar Degas began to show figures cut in half, looking or striding out of the picture, as though caught by the artist in an instant of movement.

At first photography was considered simply a technique, not an art form. It was used to document rather than enhance the world; it instantly replaced the artist as a recorder of physical reality. During the last hundred years photography has become an incomparable tool for scientists, engineers, journalists, and others. However, in addition, photographers discovered that photographs reflect the artistic eye behind the lens as well as the world in front of it. Photographers who compose well, are inventive in their choice of subjects, and are adept in their technique are now called artists.

The photographer whose work exhibits the aesthetic properties necessary to make it art needs

Figure 15-22 Mathew Brady, *President Abraham Lincoln* (1860).

(Courtesy of the Library of Congress, Washington, D.C.)

to be as well trained in art as a draftsman, a painter, or a printmaker. The same visual elements and principles of art that apply to making drawings, paintings, and prints apply also to making photographs. Photographs by the American photographer Paul Strand make this observation abundantly clear (Fig. 15–23).

Early photography lacked color, and some contemporary photographic artists still prefer to make black-and-white images. Today color photography dominates technical and popular photography. Cameras and film developing are so readily available and inexpensive that it is difficult to imagine that anyone does not own a camera for taking colorful snapshots of family, friends, and favorite vacation spots. Many artist-photographers, too, explore the expressive possibilities of color. Some artists use color photographs as visual resources for reassembled works similar to collages, called *photocollages* or *photomontages*, as David Hockney does (Fig. 15–24) (see **color insert #4**).

Teaching Photography

Children can easily understand the principles of photography. A camera is simply a box that can admit a brief flash of light from a small opening, or *aperture*, in one side. The light passes through a glass *lens* that focuses it on the side of the box opposite the aperture, which is covered by the *film*. The *shutter* controls the duration of the exposure.

The photographer can control the amount of light that enters the camera by changing the aperture and shutter speed. Too much light means the image will be faint or *overexposed*; too little, dark or *underexposed*. The width of the aperture can also determine *depth of field*, or the amount of the area being photographed that will be in focus. A wide aperture can photograph close objects clearly; but a small aperture can bring both closer and more distant objects into focus.

The portion of photographic film exposed to light darkens; when it has been *developed*, or rendered insensitive to light, we call the resulting picture a *negative* because it is the reverse of the *positive* image that we call a photograph. The photographer can make a print from the negative by either placing it directly onto light-sensitive paper (a *contact print*) or projecting it through an *enlarger*. The transparent areas of the negative allow light to reach the photographic paper while dark areas of the negative prevent it. The areas of photographic paper exposed to light darken, just as film does, when placed in a bath with the proper chemicals, thereby reversing the image yet again and producing a positive print.

Student Photographic Activities

The cost of teaching children photography does not have to be prohibitive. Your students can make some kinds of photographic images without cameras at all, as indeed the photographer William Henry Fox Talbot did (Fig. 15–25). The artist Man Ray also used this technique; he called the results *rayograms*.

- Children can arrange one or more ordinary objects like a leaf, marbles, paper clips, and other items found in your classroom on photographic paper.

Figure 15-23 Paul Strand (1890–1976), *Porch Shadows (Porch Abstraction)* (1916). Photograph, satista print, 13 × 9″ (33.2 × 23 cm).
(Courtesy of The Art Institute of Chicago, #E24204)

By exposing the collection of objects to light, you can create compositions with an endless array of black, white, and gray shapes.

- Young children can watch the image develop as you treat the paper in its various baths—one to darken the image, one to stop the darkening process, and one to fix it (to render the image permanent). These are available at your local photo stores.

- Older children, with proper safeguards (see Chapter 18), can learn to develop the image themselves. You will need to darken your classroom completely, or work in a windowless area (be sure it has adequate ventilation). You can buy an ordinary red light bulb for a "safe light" while you work.

- Your students can also make and use pin-hole cameras with black-and-white film. You can either develop the film yourself, or have it done quickly (and inexpensively) at a local photo shop. Children can then make small contact prints themselves. Larger ones will require an enlarger.

- Polaroid cameras, although more expensive, are also ideal for classroom use because the results

are immediately available. Polaroid cameras yield color images.

- Ordinary color film is the most expensive of all, both to buy and to process. It is difficult to process in the classroom, which makes it impractical for the average elementary teacher to use.

COMPUTER-GENERATED ART

The successor to still photography, in terms of a technological step forward, is art generated on the computer, even though the imaging processes of a computer is as dissimilar from photography as photography is from painting. The computer forms images by converting them to numbers or digits; thus, we say that it *digitizes* them. A computer software program controls the arrangement of pixils or points on its monitor screen to make art in the same way it would to produce letters or numbers. Computer images are no longer the art medium of the future; the future is already here.

Figure 15-25 William Henry Fox Talbot, *Heliophila* (1839). Photogenic drawing. Salted paper print photograph's drawings 17.0 × 17.3 cm.

(Courtesy of The Metropolitan Museum of Art. Harris Brisbane Disk Fund, #36.37MM/20440B)

Software programs for image making and image enhancing, and the works artists produce with them, are becoming increasingly sophisticated. Some software lets users "draw" or "paint" somewhat as they would on paper (Fig. 15–26) (see **color insert** #4). Artists can then print these computer images from floppy disks onto paper or canvas to display in an art gallery, or make them into transparent slides for use in public lectures or in the elementary classroom.

Artist David Humphrey tells us about the images in his computer-generated work (Fig. 15–26) (see **color insert** #4), which he transferred to paper to become a limited-edition print. Humphrey derived his images from one frame of a film called *The Dark Half*, which he scanned directly into his computer. By coincidence, the film was partially shot in the house in which Humphrey grew up. He tells us,

> Using photoshop software, I excised everything from the film still that did not correspond to my memory of the place. Those blanks then became opportunities to plug in material from my own image repertoire, like my own family. . . . It was a crazy opportunity to mix and hybridize material from mass culture, memory, and my imagination.[5]

Artistic uses of the computer are rapidly forging into areas far beyond the aesthetic restrictions of conventional media. Much computer imaging takes advantage of the computer's ability to make forms appear to move. Television station logos are fascinating examples that we see every day. Special effects in motion pictures are another. Sculptors, architects, and urban designers now can "construct" their work on the computer and view their designs from all angles before committing themselves to actual steel and concrete.

The most recent practical use of computer imagery with yet-unrealized artistic promise is to create *virtual realities*, interactive environments available through special headgear containing monitors that substitute computer images for the viewer's visual field. Virtual reality has been used to teach golf, train airline pilots, and play games. Imagine what artists will be able to do with such technological capabilities!

Virtual reality (or virtual art) will only be as inventive as its creators, however; the computer cannot replace the human mind. It is important to remember that the computer is a tool, just like a camera. Once artists master any software program, they will follow the same artistic principles as their low-tech drawing, painting, printing, and photographing colleagues. At present it is a tool whose aesthetic limits will be unknown for many years; we should welcome the new creative opportunities it presents.

Graphic Design

Graphic design or advertising art employs images and words in an aesthetic way primarily in order to sell manufactured goods. Many of these combinations of visual and verbal messages are the advertisements seen on television, in newspapers and magazines, and on billboards, postage stamps and posters for concerts and motion pictures. In advertising agencies, a team of people—perhaps a designer, a writer, and a photographer—may work together on one project.

Graphic designers also make traffic signs and typefaces, greeting cards and menus. Designers are particularly associated with company trademarks, called *logos* or symbols, by which many companies and institutions are easily identified. General Electric, IBM, Apple Computer, McDonald's, and AT&T have widely recognized trademarks.

Graphic design has always incorporated all of the two-dimensional media discussed in this chapter and Chapter 17. Today, the computer has revolutionized practices in the field of graphic design. Gone are the tedious chores associated with making layouts, paste ups, color separations, typesetting and so on by hand.

Even gone to a large extent is the need for preliminary drawings and color renderings, formerly created by hand during the process of visualizing ideas. The computer provides unlimited flexibility in trying out alternative compositions. A designer working on a computer can enjoy changes of mind without hours of wasted effort, can create trial compositions easily, and can transmit finished work to the print shop instantaneously as camera-ready copy or, in some cases, as ready to print.

Industrial Design

Someone designed every manufactured thing that we use in our daily lives. *Industrial design* is the

process of applying aesthetic principles to the planning of utilitarian objects. Earlier in the industrial revolution an artistic style called *art nouveau* affected the design of many utilitarian objects. Today's aerodynamic automobiles, as well as household furnishings and machine tools, are designed with their functions in mind. Even so, designs also change according to fashion, just as art does; for example, the function of chairs, electric fans, lunch boxes, or the windows in our homes has remained the same for the last 50 years while their designs have changed radically.

As the industrial revolution surged into the twentieth century, designers of products as diverse as telephones, beauty products, and dental equipment sought (as well as architects) to improve the beauty and usability of their products. Designers have also influenced the evolution of building interiors, both public and private, and textile patterns. Interior design and textile design are both important design fields. The computer aids all of these designers today.

Teaching Art on the Computer

Children are able to make computer images almost as soon as they are able to draw. Art or animation programs are fun and educational at the same time. Even though children may consider these activities games, they learn to imagine, explore, and build foundational computer skills. Most elementary schools now have computers available for instruction, and you will be able take every opportunity to introduce your students to making computer art.

The rapidity of technological change means that software (computer operating systems) popular today will either be improved on or forgotten tomorrow. Consider any program mentioned, therefore, as an illustration only. Take time to research available software programs[6] and then to familiarize yourself with the program you plan to teach, in order to work through those frustrating moments when things go wrong before you find yourself facing a roomful of eager children.

Student Computer Activities in Art

Each software program for making art will have different procedures, and you will need to give your students time to familiarize themselves with the program you have selected before expecting them to produce advanced results. As with any other medium, begin with simple tasks. Choose assignments that will let students explore many facets of the program.

Computer As Tool Preschool children can learn to use programs such as *Kid Pix 2* (ages 3–10; published by Broderbund) for drawing and painting. They can add color to their own or predrawn shapes or "stamps," and they can erase the images in imaginative ways (as though dynamiting it in a explosion of different colors). *Kid Pix* also lets children add letters, numbers, and sounds to their computer images. The computer can pronounce the name of each letter and numeral as it is used, for example. Children can print the final image, many times if desired.

Flying Colors (5–12; Davidson) offers "cycling colors" that move and sparkle and "building-block" stamps—ready made components for constructing buildings, people, space ships, and so on. *Kid Cuts* (3–8; Broderbund) provides craft projects—making puppets, "paper" dolls, masks, hats, circus animals, party decorations, and the like.

If you have a CD-ROM drive in your computer, you can use *Kid Pix Studio* which in addition to the basics lets children animate stamps, black-and-white photos, and hand-drawn images. *Art Explorer* (8–12; Adobe/Aldus) is similar to *Kid Pix* but more sophisticated, which will satisfy children until they are adept enough to handle adult software. Its images and sound effects are tailored to preadolescent tastes, and its capabilities are close to professional.

Some seventh and eighth graders, such as Edward whom we introduced in Chapter 1, will be ready for adult software. These program have no predrawn shapes, and artists can "read in" photographic or other images with a scanner and then edit them. *Adobe Photo Shop* (Adobe/Aldus) is a program designed specifically to manipulate photographic images. There are also programs that teach basic art skills including beginning drawing, figure drawing, painting, cartooning, and animation.

Computer Games Don't overlook the advantages of playing computer games as a way to children's art education. Some of the most compelling

computer imagery can be found in computer games, particularly those on CD-ROM, as well as visual puzzles such as *Sim City Enhanced* that require children to sharpen their strategic-thinking skills.

Summary

Children can convert their thoughts into aesthetic images by using a variety of media, just as artists do. This chapter introduces you to some processes for making two-dimensional art. Some are more familiar than others, but common to all of them is their potential to create an illusion of space on a two-dimensional surface.

Drawing, painting, printmaking, still photography, and computer-generated art (including graphic design and industrial design) are the major forms of two-dimensional art taught in schools. You can involve your students all of these processes in your elementary classroom. The more you know about them, the better teacher you will be.

You could also combine these media. Many contemporary artists do. Artists today work in "mixed media," combining several two-dimensional media and often two- and three-dimensional techniques.

The examples of art activities for children in this chapter are generic. They are illustrative only. There are many good books on teaching each of these techniques. We recommend you add several to your teaching library.

Last but not least, remember that teaching these art forms is not an end in itself. The end, as we all know, is to convey a message. Each of these art forms should be part of a complete learning experience as described in Chapters 7 and 8.

Notes

1. Smith, Nancy R. (1983). *Experience & Art: Teaching Children to Paint*. New York: Teachers College, Columbia University.
2. Crespin, Lila. (1987). *Managing materials and children with art activities*. Unpublished manuscript written for Phi Delta Kappa, Bloomington, IN.
3. Albers, Josef. (1963). *Interaction of color*. New Haven, CT: Yale University.
4. Smith, op. cit., p. 78.
5. Humphrey, David. (1996). Personal communication.
6. Miranker, Cathy, and Elliott, Alison. (1995). *The computer museum guide to the best software for kids*. New York: Harper Collins.

16

Three-Dimensional Art

After reading Chapter 15 you may be thinking the art world is full to the brim with different kinds of media. Well, you've seen only half of it—the two-dimensional half. The amount of variety in three-dimensional (3-D) art is at least as great as it is in two dimensional art.

Some of this variety is a result of advanced technologies in metals, plastics, and fabrication that have added to the possibilities for new kinds of sculpture. However, much of the proliferation in 3-D media is because of the modern movement—which not only broadened the definition of art, but helped to legitimize the art and artifacts of non-Western cultures (see Chapters 1 and 5).

The twofold objective of this chapter is (1) to acquaint you with the range of 3-D art that exists today, and (2) to indicate some of the types of 3-D projects that elementary-age children can do. Many of the examples of 3-D art will be drawn from works shown in earlier chapters. All of the illustrations of children's 3-D work, however, are new to this chapter.

In this chapter, the whole domain of 3-D art will be considered under the following main headings: *Sculpture, Environmental and Performance Art, Crafts,* and *Architecture.*

Following the discussion under each heading or subheading, there will be suggestions for activities, both verbal and studio. Although most of these will be addressed to the student, there will be some directed to the teacher as well. You may already know that three-dimensional projects are more demanding in terms of materials and supplies than 2-D projects—not to mention the issues of time and safety. While a few elementary schools may have fire clay and kilns, very few have such additional things as plaster, liquid latex, wire cutters, pliers, looms, safety goggles, and so forth. Depending on your budget, you can obtain these things from commercial dealers—and we will mention some of these as we go along. However, in most situations, 3-D activities are augmented by odds and ends and scraps brought to school by the student. Finally, the issue of health and safety when using tools and materials—a perennial concern in the art classroom—will be addressed in detail in Chapter 19.

SCULPTURE

Initial Considerations

The traditional term for three-dimensional art is *sculpture.* That term probably makes you think of a bronze or stone statue on a pedestal in a park.

Well, your mental image would not be wrong; there are many things like that still around, and there are artists who still make statues of stone or bronze. But sculpture today consists of so many things unlike that mental image that the meaning of the word, sculpture, seems to have been stretched beyond the limit. Nevertheless, it continues to be used for any work of art carried out in three dimensions.

Three-dimensionality, however, is relative. Unlike a painting or drawing, a sculpture supposedly can be viewed from several different vantage points—providing a different shape (or silhouette) for the eye to see at each vantage point (Fig. 16–1a, b). The number of available vantage points depends, though, on whether the piece is *in the round* or *in relief*. An in the round sculpture is an independent, freestanding (or free-hanging) object capable of being viewed from all points of the compass. A relief sculpture is made in such a way that its forms protrude from a background, and

therefore can be seen only from a limited number of vantage points.

The metal sculpture in Fig. 16–1 is in-the-round (as are the examples in previous pages of this book, such as the African sculpture in Chapter 5 and those by Moore and Calder in Chapter 14). The faces carved by John Gutzon Borglum and his son on Mount Rushmore, on the other hand, are in relief (Fig. 16–2). While the head of George Washington is almost in the round, those of the others, particularly Theodore Roosevelt's, are definitely embedded in the granite. (These heads, even Roosevelt's, are in *high* relief compared to the portraits of Confederate leaders on Stone Mountain, GA—also by Borglum—which are in *low* relief.)

Sculpture can be divided into the following classifications: *carving, modeling, casting, metal sculpture, construction, kinetic art,* and *mixed media.* (These classifications apply to works whether they are in-the-round or in relief.)

Figure 16-1 (a) Martin Faulkner, *Untitled* (1975). Stainless steel 13' × 4' × 8'. (b) Martin Faulkner, *Untitled* (1975) Stainless steel, 13' × 4' × 8'. Illinois State University, Normal, IL. (Views of a metal sculpture on I. S. U. campus) (Photographs by Jack Hobbs)

Figure 16-2 John Gutzon Borglum and Son, *The Presidents* (1927-1941). Carved granite Mount Rushmore National Monument.

(Photograph by Jack Hobbs)

Carving

The 60-foot-high heads on Mount Rushmore were carved from granite with the aid of pneumatic hammers and explosives. A tourist shrine, the Mount Rushmore sculpture attracts people from all over the world. It is appreciated not only because of its magnitude, but also because of its difficult execution. It is indeed a tour-de-force.

The use of carving to make images is as old as human culture itself. Sometimes referred to as the subtractive process, carving involves the use of gouges or chisels to remove material from a block of wood or stone. Obviously, the artist must have a well-defined idea of not only what the image is supposed to look like, but also of knowing exactly when to stop cutting. A mistake, that is, subtracting too much material in any one place—is irreversible.

Tour-de-force, incidentally, is not necessarily a criterion of artistic excellence. The only other example of stone carving in previous pages is Moore's *Recumbent Figure* (Chapter 14, Fig. 14–9). Although physically smaller and less ambitious than the Mount Rushmore carving, the Moore is, on the basis of its aesthetic and expressive qualities, probably as highly regarded today by critics and historians as the presidential carvings.

Student activities, carving

- Imagine that Borglum set an explosive charge in the wrong place and accidentally blew off Washington's nose. Would the whole project have to be scrapped and begun anew?
- Try carving a relief sculpture out of soft material.
- Try carving an abstract in-the-round sculpture out of soft material. Think of the work of Henry Moore. Consider cutting openings into your piece.
- Try carving a person or an animal in-the-round. Be sure to rotate the piece as you carve. Notice how difficult it is to make the four legs of an animal!
- Teacher: Of all the sculpture media, carving may be the least practical to do in elementary school. For reasons of security and safety the use of knives may be out of the question. (Even dull paring knives may be inappropriate even for the older children in your school.) Then, there is the problem of getting soft enough material to carve. Traditional materials have been bars of laundry

soap or blocks of Styrofoam. Blocks of plaster (formed by pouring liquid plaster into 1/2 gallon milk cartons) are also common. (The plaster is sometimes mixed with insulating material, such as vermiculite, to make it easier to cut.) In addition there are commercial products consisting of carving blocks that are initially soft and which harden over time.

Modeling

The opposite of carving is modeling—sometimes called the *additive process*. Modeling consists of forming three-dimensional shapes out of a pliable material such as clay or wax. The artist can easily manipulate this material with bare hands or, if need be, with simple tools such as wooden paddles and knives. With this medium, obviously, there is no fear of a "fatal" mistake as there is with carving.

Modeling is probably as ancient as the discovery that mud could be formed into shapes or images. Archaeologists have found figures of buffalo modeled by stone-age artists over 10,000 years ago. In later periods, sculptors used clay or wax for the same purpose that painters use drawing tools and paper—to make preparatory "sketches" for their finished works. This fact points to the major disadvantage of clay or wax: Anything made with this material is not permanent and therefore not satisfactory for finished works.

Clay, however, can be changed into a relatively hard material called *ceramic* by baking it at a high temperature in a special oven called a *kiln* (a process that probably goes back to the discovery of fire). Perhaps the most remarkable examples of ceramic sculpture consist of the life-size tomb figures, the *Soldiers of the Imperial Bodyguard* (Fig. 16–3), made in the third century B.C.E. for the

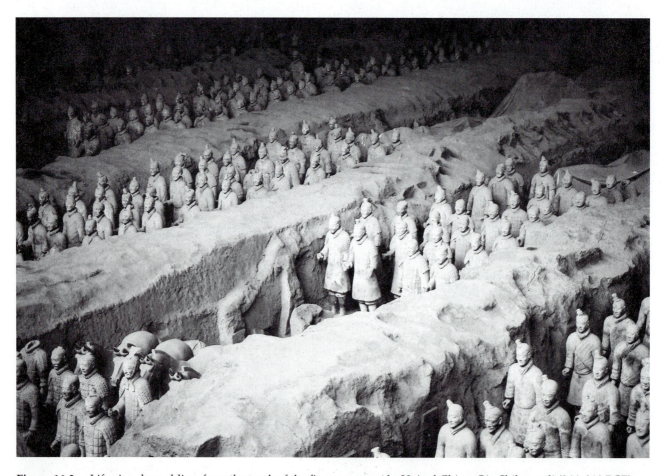

Figure 16-3 Life-size clay soldiers from the tomb of the first emperor of a United China, Qin Shihuangli (246–210 BCE) discovered in 1974. Three different sites around the tomb hill contain some 8,000 infantrymen, cavalry, archers, charioters and officers archaeological site, Xian, China.

(Courtesy of Art Resource, #S0073447) (Photograph by Erich Lessing)

Figure 16-4 Glazed-fired ceramic sculpture, student work, seventh and eighth grade, Woodrow Wilson Junior High School, Decatur, IL.

(Photograph by Donald Gruber, Clinton, IL)

Chinese emperor Shih Huang Ti. Discovered in 1947, this collection—consisting of more than 6000 figures—is understandably considered to be one of the greatest archaeological finds of the twentieth century. Another example of ceramic sculpture is Sherrie Levine's illusionistic (and whimsical) *H.R.H. Briefcase* (Chapter 8, Fig. 8–4). Although made of baked clay, it looks for all the world like leather.

Student activities, modeling

- Model an animal out of oil clay or fire clay. Try to form the whole animal out of a single lump rather than adding parts.
- What is an armature? (Answer: a framework to support a figure being modeled in a pliable material such as clay.)
- Try modeling a standing person. (In order to help it stand, you may have to reinforce it with a wire armature.)
- Try to think of interesting, colorful subjects for glaze-fired sculpture, such as items of food (Fig. 16–4).
- What other materials available in your school can be used for modeling? (Answer: papier mache' and plaster modeling tape.)

- Make a papier-mâché mask using either clay or wadded paper for an armature (Fig. 16–5). (Be sure to coat a clay armature with liquid soap so that the mâché releases.)
- Make a papier mâché fish (Fig. 16–6) (see **color insert** #4) or an animal using two pieces of cardboard mounted on a cardboard base for an armature.
- Make a papier mâché sculpture using various scrap materials for an armature (see *Student activities, constructions*).
- Teacher: Modeling materials available from commercial suppliers include synthetics that harden over time, synthetics that harden when baked in ordinary low-temperature ovens, play dough, and oil clay. (Oil clay can be recycled and used over and over, but it cannot be baked.) Plaster modeling tape, which comes in roles, is relatively inexpensive, and excellent for final-coating of large papier mâché projects.

Casting

Images made in both clay and wax can be translated into a more durable material by a technique called *casting*. Although casting can be done in several ways, the basic steps are as follows: the

Figure 16-5 Papier mâché mask, student work, seventh grade, Clinton Junior High School, Clinton, IL.
(Photograph by Jack Hobbs)

artist covers the original clay or wax form with plaster. The plaster hardens and, when it is removed, becomes a mold. The inside of the mold consists of a negative shape that corresponds to the positive shape of the original wax or clay image. Into this cavity, a substance such as molten metal, cement, plaster, or polyester is poured or pressed. After the filler hardens, the mold is removed, leaving the finished image.

The most pervasive method of casting bronze sculptures—used not only in the ancient world, but even today—is the *lost wax* process. The basic concept is the same as that mentioned but with the following exceptions. A layer of wax of the same thickness desired for the metal itself (no more than three-eighths of an inch) is applied to the inside of the mold. The wax-coated cavity is then filled with a plaster core and the whole mold is heated. The wax melts and runs out, leaving a thin channel to receive the molten metal. When

the bronze hardens, the result is a *hollow* image. Although still heavy, the image is, of course, much lighter than a solid image.

One example of the lost-wax process is the bronze horse in Chapter 8 (Fig. 8–1) which is either a piece of fifth-century B.C.E Greek sculpture or a fake. Although the little horse may not be truly Greek, it is truly a bronze casting.

Today, some artists cast in bronze, but many prefer to cast in other materials—particularly synthetic materials such as vinyl or polyester resin. These materials are versatile, strong, and far less costly than bronze. Polyester resin is a heavy, syrupy liquid before it is hardened by the addition of a catalyst. While the resin is hardening the artist reinforces it with flexible sheets of fiberglass. Do you own a canoe? It was probably made with the same materials. Or consider the body of your car, particularly the bumpers, part of the fenders, and the panels below the doors. Like auto makers and canoe makers, some artists—but not all of them—recognize the advantages of new technologies. Other materials used in casting—although not quite so new—include plaster and cement.

Student activities, casting

- Have you ever cast in sand? Make a negative impression in moist sand, then pour liquid plaster into the impression. A reinforced shoe box can serve as a container for the sand; the finer the sand, the better.

- Older students: carve a negative shape into a flat block of plaster. (Include a channel for pouring the liquid metal.) To complete the mold cover the block with another plaster block, and secure the two blocks with strong rubber bands. Heat some metal, such as pewter, that has a low melting point, and pour into the mold. Allow to cool before undoing the mold and removing the metal casting (Fig. 16–7 a, b, c). **Warning:** Use extreme caution when working with molten metal! Do so only under the supervision of your teacher.

- Teacher: Like carving, casting is largely impractical for elementary art, except at the junior high level, and there it should be closely supervised. We do not approve of ready-made rubber or latex molds because they obviate the child's creativity. Liquid latex, used in making molds from scratch, is available, but expensive and complicated to use. Polyester resin (mentioned earilier) is also available, but not recommended because it is not only complicated to use, but highly toxic.

Figure 16-7 Scott Stanton, eighth grade, Clinton Junior High School, Clinton, IL. (a) Heating pewter in crucible. (b) Pouring molten pewter into the mold. (c) Removing the casting.
(Courtesy of Denny Stanton.) (Photograph by Jack Hobbs)

Welded Metal

Much newer than bronze, but not quite so new as polyester resin, is *welded metal*, that is, creating a sculpture by joining pieces of metal with heat. Julio Gonzalez, a friend of Picasso, began making sculptures this way in the 1920s. At that time, it was a radical departure from traditional sculpture. Instead of modeling a work from a lump of clay or carving it from a mass of stone, Gonzalez pieced it together around empty space with scrap iron, rods, and nails. He introduced not only a new medium, but a new concept of 3-D art—*open sculpture*.

Today, welded sculptures have become almost commonplace—whether in parks, public squares, or in the plazas and lobbies of the home offices of corporations. Two examples in previous pages include Calder's *Flamingo* (see Chapter 14, Fig. 14–10) and the welded sculpture in Fig. 16–1.

Construction

Some recent sculptures are neither carved, modeled, cast, nor welded. They are constructed—hence the category, "construction." Philip Hitchcock crafted a "sound piece" (Fig. 16-8) out of wires and radio parts, and encased these in a clear plastic tube. When plugged in and touched by human hands, Hitchcock's art emits sounds—depending on the temperature and dampness of the person's hands. Mounted on a living room wall, the sound piece is a great "conversation piece" for guests and visitors—some of whom not only wonder what it is, but are brave enough to "fondle" it. At the same time, Hitchcock's work is an elegantly simple piece of construction sculpture. Finally, constructions can involve any material or combination of materials, but unlike assemblages (see following), they generally consist of forms and materials that do not provoke or clash visually.

Figure 16-8 Philip Hitchcock, *Soundpiece* (1970). Plastic 4 1/2 × 39 1/2″.

(Jack A. Hobbs art collection.) (Photograph by Jack Hobbs)

Student activities, constructions for younger ages

- Using toothpicks or swab sticks and balls of clay, make an open sculpture (Fig. 16–9).
- Make paper sculpture out of sheets of construction paper. Begin with geometric shapes (Fig. 16–10). Later, make more complicated shapes by bending, cutting, overlapping, curling, and so forth (Fig. 16–11). Try making people, clowns, animals, birds, and so forth out of paper.
- Make sculptures using scrap materials brought from home: toilet paper cores, paper towel cores, oatmeal boxes, plastic bottles, match boxes, Styrofoam scraps, and on on (Fig. 16–12). Embellish these with scraps of construction paper, cloth scraps, recycled buttons, toothpicks, Styrofoam balls, and anything you can think of.
- Instead of embellishing your sculptures, use them as armatures for covering with papier mâché or plaster modeling tape. Think big! Have the whole

class get in on the fun, and produce a Mesozoic monster (Fig. 16–13). (Also, see *Student activities, modeling*).

Student activities, constructions for older ages

- Make open sculptures with sticks and glue (Fig. 16–14 a, b). (Make sure that the glue has the seal of approval of the Art and Craft Materials Institute; most rapid-drying glues are toxic.) If glue is slow drying, use various means of joining sticks (such as tying with thread) or propping them until glue dries. Anchor the sticks in a cardboard or Styrofoam base. Try using reed or sticks that bend easily. (Sticks can also be soaked in water to make them more bendable.)
- Make paper sculptures using more complicated shapes. (see Fig. 16–11). For very sophisticated methods of manipulating paper, thin paper, rather than construction paper, is recommended. Try using origame methods (i. e., the Japanese art of folding paper).
- Make constructions out of scrap materials (Fig. 16–15).
- There are many things, such as retablos (Fig. 16–16) (see **color insert** #4) (Fig. 16–17 and 16–18), that can be made with ordinary corrugated cardboard. Finish the construction by painting with tempera and coating with polymer varnish.
- Using stove-pipe wire or another appropriate lightweight, soft wire, make a *wire sculpture* (Fig.

Figure 16-9 Toothpicks stuck into balls of clay.

Figure 16-10 Simple forms of paper sculpture, using construction paper.

Figure 16-11 More complex forms of paper sculpture.

Figure 16-12 Imaginary animal made from odds and ends.

16–19 a, b, c) Teacher: Glasses or goggles should be worn to protect children's eyes from stray wire ends.

• Teacher: Construction sculpture may be a new medium in the fine arts, but in the elementary classroom it is a commonplace for 3-D projects. Also, almost all of the projects described are, by definition, "mixed media" (see later, *Mixed media*). It would be virtually impossible to do 3-D work in elementary school without the use of a wide assortment of cheap materials, usually scraps brought from home.

Kinetic Art

Kinetic art is the name applied to sculptures that move—whether by mechanical means, such as motors, or by random means, such as currents of air. The most familiar example is the *mobile*—essentially a lightweight open sculpture with unmotorized movable parts. The term was originally coined by Marcel Duchamp (Chapter 6) to describe the works of Alexander Calder—whose mobiles can be found in museums and offices around the world. Typically, a Calder mobile, similar to the one hanging in the East Building of the National Gallery (Fig. 16–20), consists of rods and metal vanes that slowly move with shifting currents of air. The continual drifting of the abstract shapes—while barely perceptible at any given moment—continually transform the sculpture's appearance.

Figure 16-13 Armature consisting of styrofoam, wire and wood scraps covered with papier mâché and plaster modeling tape. Student work, seventh and eighth grade, Clinton Junior High School, Clinton, IL. (Photograph by Jack Hobbs)

b) reeds (or straw) and straight sticks

Figure 16-14 (a) Straight sticks. (b) Reeds (or straws) and straight sticks.

Figure 16-15 Construction, using a variety of scraps. Student work, seventh grade, Woodrow Wilson Junior High School, Decatur, IL.

(Photograph by Donald Gruber, Clinton, IL)

Figure 16-17 Unfinished hinged retablo, cardboard, papier mâché. Student work, Clinton Junior High School, Clinton, IL.
(Photograph by Jack Hobbs)

Figure 16-18 Anna Overleese, eighth grade. Making a retablo, using a corrugated card board base, Clinton Junior High School, Clinton, IL. In Hispanic cultures a retablo is a portable altar.
(Courtesy of Rose Overleese.) (Photograph by Jack Hobbs)

Student activities, mobiles

• Make a mobile using coat hanger wire or dowel rods, string, and pieces of cardboard. The cardboard can be cut into free-form shapes reminiscent of a Calder mobile, or into stylized figures of birds or fish, and so forth. Start from the bottom and work up. Make sure each element and each level of the mobile is balanced as you work your way up (Fig. 16–21 a, b, c, d). Teacher: Even small mobiles take

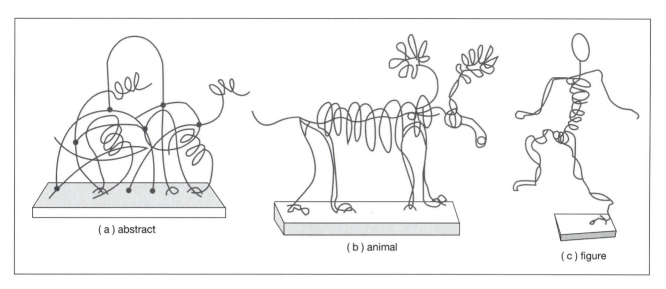

Figure 16-19 (a) Abstract; (b) Animal; (c) Figure.

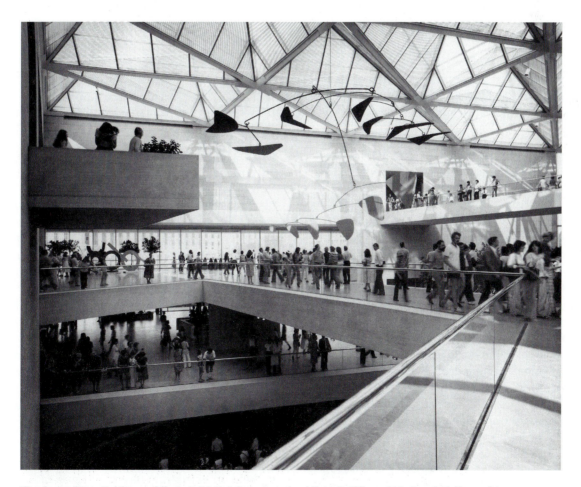

Figure 16-20 Calder mobile in I. M. Pei (interior view) *East Building* of National Gallery of Art, Washington, D.C. The East Building was designed by I. M. Pei and completed in 1978. It houses contemporary art collections, including a large mobile by Alexander Calder in the central lobby. (Courtesy of Esto Photographics, Inc.) (Photograph by Ezra Staller)

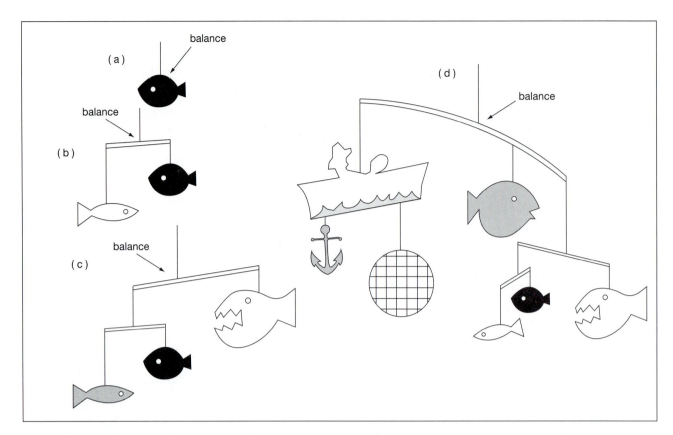

Figure 16-21 Making a mobile. Start with the lowest elements, such as the fish in A, and balance each element or combination of elements as you work your way up to the single strand that holds the whole mobile (B, C, D).

up space. Because of this and mobiles' inherent awkwardness to make, they are probably best executed in small groups (producing 5 or 6 mobiles in a class of 25 students).

Mixed Media

It could be said that mixed media refers to any artwork in which two or more media are combined. Technically speaking, Hitchcock's piece, which combines three or four kinds of material, is an example of mixed media—just as in the two-dimensional realm a drawing, say, combining charcoal, pencil, and marking pen, would be an example. Both are fairly rational examples of mixing two or more media. But in the context of contemporary art, the mixed-media classification usually refers to media combined in less rational, indeed *incongruous* ways.

Assemblage: In the 3-D realm, assemblage is the counterpart of collage. Both are twentieth-century inventions and both comprise a particular niche in the mixed-media category. Whereas collages tend to use "found images" (see Enstice

work, Fig. 15–13, **color insert** #3), assemblages use "found objects," that is, ready-made objects collected by the artist rather than created by him or her. As the name implies, assemblage calls for assembling objects (found or otherwise) with glue, staples, nails, or any other means. There is no limit to the kinds of things eligible for incorporation in an assemblage or the ways they can be combined. Robert Rauschenberg is well known for madcap creations such as *Monogram* which, in this case, combines a stuffed goat and an old tire mounted on a collage-covered canvas and spattered with paint. By employing familiar objects in novel combinations, an assemblage can provoke viewers not only to see those objects in a fresh way but also to make new connections and draw new meanings about our everyday world.

Student activities, assemblages

- Find an object, any object, and make it into an art object. How you do this is up to you—limited only by your imagination.
- Have you ever heard of "cool shoes" (Fig. 16–22)? Would you want to wear a pair?

Figure 16-22 Scott Stanton working on a "Cool Shoe," eighth grade, Clinton Junior High School, Clinton, IL.

(Courtesy of Denny Stanton.) (Photograph by Jack Hobbs)

- Is this a chair (Fig. 16–23) or a work of art?
- What is postmodern art? (Answer: There is no clear definition of postmodern art. Generally, it refers to recent art—such as assemblages, environments, and performances pieces—that challenge traditional concepts and definitions of art).
- Teacher: In terms of child art, the difference between a construction made with scrap materials and an assemblage is moot. Any mixed-media work that is especially original, unusual, and/or whimsical, can be called an assemblage, if you wish.

ENVIRONMENTS AND PERFORMANCES

A great deal of recent art is basically three-dimensional. But much of it, especially the experimental kind, is so different from anything we have seen so far that it defies classification as sculpture. For the purpose of this review, we have lumped it all under two headings—environments and performances—while at the same time realizing that by so doing we have not truly accounted for all its variety and complexity.

Environment

A relatively new term in art, *environment*, refers to projects that first emerged as experiments in the late 1950s and 1960s to literally bring the spectator

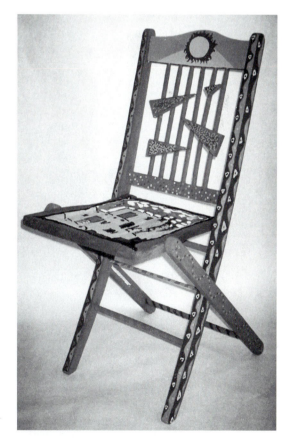

Figure 16-23 Kristin Douglas, "Chair," eighth grade, Clinton Junior High School, Clinton, IL.

(Photograph by Jack Hobbs)

into the work. Rather than hanging on a wall or resting on a pedestal, an environment (sometimes called an *installation* or *site art*) either surrounds, or in some way shares the same space with, the viewer. A corollary characteristic is that most environments are not permanent. Although the term, environment, is new, the concept has precedents in such traditional areas as theater and landscaped gardens.

In 1959, Allan Kaprow invited viewers to a series of events called *18 Happenings in six parts* (Fig. 16–24). Held in a New York art gallery, this first *happening* was an environment spatially divided by plastic partitions and furnished with Christmas lights, slide projectors, tape recorders, and assemblages of junk. Kaprow's friends, who read poetry, played musical instruments, spoke double talk, and performed other similar acts, were stationed in strategic places in the gallery. Gallery visitors navigated through this potpourri, becoming in a sense part of the work. "Happening" became a generic term in the 1960s and 1970s for almost any kind of improvisational event—whether planned or unplanned—intended as an

artwork. Because of the involvement of people, the happening also was the forerunner of performance art (see following section).

On a larger scale is *earth art*, an environment writ large that first emerged in the late 1960s. Earth artists specialize in landscapes, but used earth-moving equipment as their brushes and the landscape itself as their canvas as they go about digging or building enormomous trenches or mounds. Most earth art is vulnerable to the erosions of time and the elements of nature. After so many years, the only visible remains of such projects are photographs.

Even more transitory are the works of Christo. His *Wrapped Coast* (see Chapter 8, Fig. 8–2), for example, had to be soon unwrapped. In this respect, and because Christo usually recruits an army of young volunteers to help him, his projects are more reminiscent of happenings. Christo has wrapped buildings in this country and bridges in France, erected a 24-mile fence in California, and surrounded islands with plastic sheets in Biscayne Bay, Florida. Unless you were at those places at the right time, the only way you can

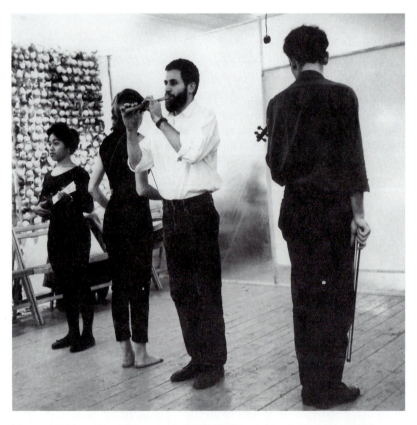

Figure 16-24 Allan Kaprow, (b. 1927) *18 Happenings in six parts* (1959).
(Courtesy of Fred W. McDarrah, #326) (Photograph by Allan Kaprow)

experience a Christo work is through photographs.

Performance Art

If environments have tended to depreciate the notion of permanence, performance art has tended to depreciate the art object itself. Performance art involves an artist or a small group of artists who present a partially scripted activity or carry out some form of experiment. As the term suggests, performance art bears some resemblance to theater. However, unlike theater, performance art is rarely practiced on a picturelike stage and almost never has a plot or focused structure.

Among the better known practitioners of performance art are Gilbert and George (Gilbert Proesch and George Passmore). Their *Underneath the Arches* (see Chapter 1, Fig. 1–3) appeared in an earlier chapter, again, to make a point about the variety of media in today's art world. The performances of Gilbert and George, who perform as living sculptures, are akin to a variant of performance art called *body art*.

There are a number of permutations of environmental and performance art that could have been discussed here, but space does not permit it. If one were to stir into this media mix the technologies of film, video (see Chapter 17), and computers (see Chapter 15), the possibilities would become endless and the stew even richer. Our main goal here was to give you just a taste.

Student activities, environments and performance art

- As a class project, obtain boxes of varying sizes (such as recycled boxes from supermarkets or computer stores), and paint them one color, preferably white, or cover them with paper of one color Arrange them to create an interesting space, a space for walking through or among the boxes, or for just looking at.
- Help your teacher put up an art show. Consider the spatial environment when you arrange stands for 3-D work, and how these relate to the walls or boards holding 2-D work.
- Pretend you are a work of art. Select a famous picture, such as Caillebotte's *Place de L'Europe on a Rainy Day* (see Chapter 14, Fig. 14–18) (see **color insert** #3), and imitate the people in that picture. You could costume and pose as the people, while remaining perfectly still. Have you heard of the term "tableau vivant"? As a class project, you and your classmates could select different pictures to imitate and see if the rest of the class

can guess what the pictures are. Have you heard of the game of "charades"?
- How about something more challenging? Select a picture, and pretend it is a moving picture or a play. Act out a scenario of what the people would be doing next.
- Even more challenging? Imitate a work of art *without* people. How would you imitate, for example, Van Gogh's *Fourteen Sunflowers in a Vase* (see Chapter 5, Fig. 5–1) (see **color insert** #1) or Hofmann's *Flowering Swamp* (see Chapter 14, Fig. 14–17) (see **color insert** #3). Imitate a color wheel or a metal sculpture.
- Teacher: Having students do performance art may call for integrating art with creative drama. (Often, the only specialists in creative drama are language arts teachers.)

CRAFT ART

Craft art, or *crafts,* refers to useful handmade objects such as pottery or fabrics. As we learned in Chapter 1, at the turn of the century people continued to yearn for handmade objects that heretofore had been produced in the home or cottage industries—this, despite the fact that the new methods of mass production had made daily goods more available and much less expensive. As a result of this yearning, together with the inspiration of the *Arts and Crafts* movement (Chapter 1), the crafts were given new life, and eventually came to be considered a special category of the fine arts.

It should be noted that at about the same time that crafts were becoming recognized as members of the fine arts, so too were many non-Western objects. Prior to the twentieth century the Bayeux Tapestry (Chapter 2, Fig. 2–4) and the Navajo rug (Chapter 15, Fig. 15–1) probably would not have appeared in an art book. The same could be said of the African sculpture (Chapter 5, Fig. 5–2) and the African mask (Chapter 1, Fig. 1–4)—which, incidentally, were seen by their original African makers as "useful" objects (used for ritual purposes) rather than art.

Just as today every university art department has as part of its curriculum courses in the crafts, every major museum has a collection of crafts—both Western and non-Western. Crafts media can be divided into the following classifications: *ceramics, glass, metals and jewelry,* and *fiber*.

Ceramics

The term ceramic refers to the process of converting clay to a hard, permanent substance by baking

in a kiln. *Ceramics* refers to the art of making pottery and related products this way. Of all the crafts media, ceramics is probably the most popular and best known—as attested to by the fact that many college students, both art and nonart majors, are drawn to courses in ceramics. In those courses students make pottery or ceramic sculpture using many of the same hand building methods invented by the ancients and still used today by ceramic artists. These methods can also be employed by elementary-aged children.

For small forms such as cups and bowls, a potter can use the "pinch" method: progressively pressing and extending the form from a fist-sized ball (Fig. 16–25 a). For larger forms such as jugs, pitchers, vases, and jars, the "coil" method can be used: rolling clay into ropelike coils and then winding the coils from the base to the top of a form (Fig. 16–25 b). Cylindrical and rectangular forms can be made by joining slabs of clay—previously beaten flat by hand or with a rolling pin (Fig. 16–25 c). All of these except the rectangular forms, can be made more uniformly and quickly with the aid of a potter's wheel. The latter, which requires great skill in keeping the clay "centered" at all times, is called "throwing" (Fig. 16–25 d). Throwing on a potter's wheel, incidentally, is beyond the reach of most elementary-age children.

While hand-built pottery (that is, variations of the pinch, coil, and slab methods) dates to the earliest of neolithic cultures, the potter's wheel did not appear until around 3000 B.C.E. This technology was used by cultures in Africa, Asia, and Europe, as well as by craft artists today. Although it is essentially a manual type of technology, the potter's wheel enabled a level of production that—by ancient-world standards—can be called mass production. (Mass production of pottery today relies on the use of molds; ceramic artists, however, continue to throw on the wheel.) Karen Karnes's jar (Chapter 1, Fig. 1–2) is a twentieth-century example of wheel-thrown pottery.

Glass

Glass objects, similar to ceramic objects, are hard and nonresilient, and use high temperatures in their manufacture. Glass, in the form of beads and solid shapes, first appeared around 3000 (about the time that the potter's wheel emerged). Glass vessels, made by wrapping layers of glass around a sand mold, appeared around 1500 B.C.E. The invention of the blow pipe (for blowing glass) between 200 and 100 B.C.E. enabled the production of hollow vessels on a mass basis.

For centuries, glass objects had been made almost exclusively in large furnaces with teams of workers (just as commercial glass objects are made in large furnaces today, though by less labor-intensive methods). Glass art—as a pursuit for the individual artist—was virtually nonexistent until the 1950s when Harvey Littleton, a potter, began to develop a technology for producing glass in the private studio. Aided by other potters and technicians, Littleton was so successful that, by the 1970s, many university art departments were offering studio courses in glass, along with those in ceramics.

Functional glass forms are similar to those of pottery. Indeed, the natural shape of blown glass, similiar to that of thrown pottery, is symmetrical and ovoid—an ideal kind of shape for such things as bowls, vases, ewers, and pitchers. And just as clay is pliable and therefore manipulable before baking, glass is pliable when in the molten stage. The primary difference is that glass objects can assume qualities of transparency and translucency.

Glass blowing is out of the question for an elementary school, but having children use pieces of glass to create such things as mosaics or stained glass windows is possible and appropriate—given, of course, the wise use of safety precautions (see *Student activities, crafts*).

Metals and Jewelry

Unlike sculptors who weld (see *Welded Metal*), artists who specialize in *metals* and *jewelry* deal with metal on a small-scale, typically producing vessels like Fred Danforth's *Lily Vase* (see Chapter 14, Fig. 14–11) or jewelry. Even more than pottery and glass, metals and jewelry have a "precious" connotation. To early cultures, such things as shells, bones, stones, seeds, and animal hairs were precious items. When people learned to mine and smelt ores these things were replaced by metals, principally, gold—the most sought after metal throughout time—for making precious objects.

In addition to being mined and smelted, metal is manipulated in many ways—casting, annealing, soldering, electroforming, and so forth, that are obviously inappropriate for young chil-

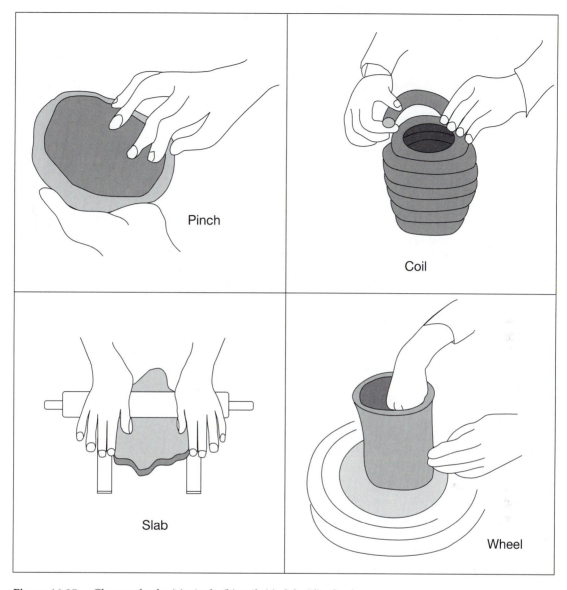

Figure 16-25 Clay methods: (a) pinch; (b) coil; (c) slab; (d) wheel.

dren. Danforth's metal vase, for example, was cast in a bronze mold, welded to a spun base, and spun on a lathe. Spinning metal vases or casting gold rings may be beyond the reach of children; nevertheless, there are some technologically simple projects for children to do in the realm of jewelry (see *Student activities, crafts*).

Fiber

Fiber refers to any substance that can be separated into threads or threadlike structures. When fiber art is mentioned, people usually think of weaving. However, although loom weaving is the principal construction method of fiber craft, the medium also includes plaiting, braiding, crocheting, macrame, knotting, and knitting. Far from being limited to blankets or shawls, fiber entails a range of products—from quilts, baskets, and dolls to handmade paper, wall hangings, and even fiber sculptures.

Quilt making—a lost art since the nineteenth century—experienced a revival during the nation's bicentennial celebrations in the mid

1970s. Back in the days of the colonies and the early republic, houses were drafty and blankets were scarce; thus, Americans needed quilts to keep warm. However, quilts were also admired for their beauty; "quilting bees" were held for people to compare one another's creations and to inspire the production of ever more beautiful quilts. Now, many fiber artists are again making quilts—but as wall hangings, not to keep warm.

Student activities, crafts

- *Pottery*, younger students: Try making pottery using the pinch or coil method. When your piece is completely dry, paint with tempera and finish with two coats of clear polymer.
- *Pottery*, older students: If your school has fire clay and kiln(s), you may be able to make ceramic pottery. You should know, however, that there are proper ways to handle clay, maintain dampness of projects, fire a kiln, and glaze. This technology is a shared responsibility of you and your teacher.
- The pinch method is suitable for what kinds of pottery? Coil method? Slab method? (Answers: see earlier section on *Ceramics*.)

- Have you considered embellishing a coil pot with coils on the top (see Fig. 16–26)?
- Have you considered "draping" a slab (Fig. 16–27)?
- *Glass art*, younger students: Make a stained glass window out of different colors of tissue paper or cellophane. Strips of black construction paper can serve as the "leading" (lead strips used to hold real pieces of stained glass in place) to separate the various colored shapes.
- *Glass art*, older students: If appropriate tools and safety goggles are available, you may try making a stained glass panel. One method is to cut shapes of colored glass and glue them to a clear piece of plate glass. When the glue is dry, press black window putty into the spaces between the shapes. **Warning:** Use extreme caution when handling pieces with jagged edges!
- *Jewelry*: Try making jewelry or ornaments completely from objects found in nature: rocks, pebbles, feathers, leaves, straws, reeds, and so on. (If necessary, you may use manufactured string as well.)
- Try making jewelry completely from odds and ends: buttons, paper clips, safety pins, recycled beads, recycled necklace chains, and so forth.
- *Jewelry*, older students only: If your classroom has the proper equipment, you may be allowed on an

Figure 16-26 Student art, Johns Hill Junior High School, Decatur, IL.
(Photograph by Donald Gruber, Clinton, IL)

Figure 16-27 Glazed ceramic tray, student art, eighth grade, Clinton Junior High School, Clinton, IL. The base is a cylinder made from a clay slab. The top is a slab that was draped in a cloth, and allowed to dry.

(Photograph by Jack Hobbs)

individual basis to cast metal jewelry ornaments (see Fig. 16–7 a, b, c, *Student activities, casting*).

- *Fiber art*, younger students: Make a paper weaving with strips of two different colors of construction paper. Use one color for the *warp*, and the other color for the *weft*. Try introducing other materials, such as straws, reeds, or raffia, into your paper weaving.

- *Fiber art*, all ages: Make a mixed-media quilt—using a variety of fabrics either sewn on or appliqued. If need be, use acrylic paints as well. Such a quilt could be a large one with a single theme, perhaps as a group project by the whole class.

- *Fiber art*, older students: If looms (Fig. 16–28) are available in your classroom, you may try loom weaving with yarn, thread, or even beads. Similar to ceramic pottery, loom weaving is a technology that requires skill and care.

- Teacher: The activities described are but a few of the possible crafts that can be made successfully in elementary school. Whether or not you do a particular craft depends on the maturity of your students, the availability of appropriate materials and tools, and your own comfort level with that craft. If one of these conditions is lacking, then that activity is probably out of the question. Above all, observe safety precautions.

ARCHITECTURE

There is very little literature on either the content or methods of teaching architecture at the elementary level. Yet of all the visual arts, architecture is probably the most visible in terms of people's everyday lives—especially for those living in urban areas. Therefore, we believe that it should not go unaddressed.

Architecture is often associated with mechanical drawing. While we do not recommend teaching mechanical drawing *per se*, we do think that there is value in having older children make imaginary floor plans—perhaps even to scale. We will have more to say about studio exercises in architecture as well as some suggestions for approaching architecture from the standpoints of history, aesthetics, and criticism at the end of this section.

Our twofold objective here—as it has been all along—is (1) to acquaint you with the subject, and (2) to indicate some projects for students to do.

Figure 16-28 Looms for the classroom. Reading clockwise from top left: Heddle frame loom, open frame loom (larger), open frame loom (smaller), inkle loom, bead loom, card loom.
(Photograph by Jack Hobbs)

Principles of Construction[1]

While buildings have taken many forms throughout history and across cultures, the ways of erecting them can be boiled down to a few major principles of construction: *post and lintel, corbeled arch, arch, frame, ferroconcrete,* and *geodesic dome.* The first three pertain to structures built from ancient times to about the middle of the nineteenth century, the last three to buildings in our own era. However, before reviewing these principles, we should point out some terms.

Load carrying refers to a building in which the walls, posts, columns, or piers support the weight of the ceiling. It might strike you as common sense that this is always the case, but in fact, in just about all modern buildings it is *not* the case—which leads us to the next term.

Nonload carrying refers to a construction in which the walls do not support the weight of the ceiling but are attached to a frame. All frame and geodesic constructions and most ferroconcrete constructions have nonload bearing walls.

Masonry refers to such materials as stone, brick, adobe, concrete, and cement-block—as opposed to wood or metal.

The examples of architecture in the following review are major public buildings, the kind that usually come with the label, "architecture," if not "architectural monument."

Post and Lintel

The oldest and simplest method of construction, post and lintel (Fig. 16–29), consists of vertical members (posts, columns, or walls) supporting horizontal members (lintels or beams). The oldest buildings still-standing are of masonry post and lintel.

Although there are stone temples and tombs in Egypt older than the Fifth-century B.C.E.

Figure 16-29 Post and lintel.

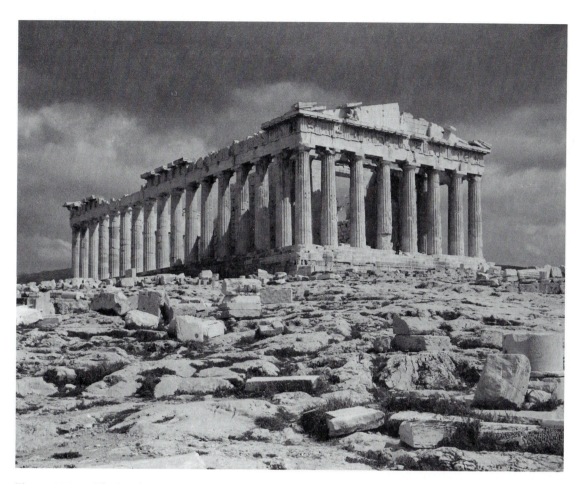

Figure 16-30 The Parthenon, Greek Architecture. View from the northwest, 448–432 B.C.E.
(Courtesy of D. A. Harissiadis Photograph agency, #X63-85-16) (Photograph by Stergios Svarsaas)

Parthenon on the Athenian Acropolis (Fig. 16–30), this one will do for our example of post and lintel. Perhaps the most famous architectural shrine in the world, the Parthenon symbolizes not only Athens' moment of glory in the midfifth century (following her victories over the Persians at Marathon and Salamis), but the whole of our classical heritage. For all its symbolic importance, the Parthenon today is in a state of ruin—as you can plainly see. However, this is not a result necessarily of inherent inadequacies of post and lintel nor even of poor engineering on the part of its designers, but of history. Over the past 2500 years, the temple has endured a number of abuses—the worst was in the sixteenth century when it was serving as a storehouse for gun powder and received a direct hit from a Venetian cannonball. (Presently, its Pentelic marble is slowly eroding because of exposure to acid rain and pollution.)

Nevertheless, there is a major drawback to post and lintel. A masonry lintel (whether stone or concrete) lacks *tensile strength*, that is, it is unable to withstand stress from a force perpendicular to its main axis (Fig. 16–31). Therefore a masonry lintel much longer than 20 feet will crack of its own weight from the force of gravity. Notice how close together the Parthenon's exterior columns are; this, just to support the lintels of the entablature around the outside of the building. The supports

Figure 16-31 Tensile strength, post and lintel.

on the inside (most of which are missing), however, were less closely spaced and with thinner walls or columns. Why? Because the interior lintels and beams were made of wood —which is lighter in weight and has much more tensile strength. However, wood, unlike stone, tends to rot over time or to catch fire. Therefore, the Venetian cannonball notwithstanding, the ceiling of the Parthenon, as well as all other wood fixtures, would probably have vanished anyway by now.

Corbeled Arch

The corbeled arch—which employs masonry only—spans an opening by means of laying rows of stones in such a way that each row projects inward until they meet at the top (Fig. 16–32). Used in some early Greek buildings and especially in the temples of the Maya, Aztec, and Toltec cultures of pre-Columbian Mexico, the corbeled arch has the advantage of employing short stones—as opposed to longer lintels—to span a space. This advantage is especially important in construction sites where large stones are unavailable or quarries are distant. Nevertheless, the corbeled arch is probably the least efficient of the building methods—since it requires so much material to span such a small area.

Arch

Like the corbeled arch, the arch and its variations employ only masonry—whether stone, brick, or poured concrete. In contrast to the corbeled arch, however, the arch is very efficient and versatile. The Romans, who exploited the possibilities of arch construction more than any other ancient people, were able to create a great variety of structures including some that spanned spaces of up to 145 feet in diameter.

Basically, an arch bridges a space by means of a series of wedge-shaped masonry blocks arranged in a curve (Fig. 16–33). Because of their shape, the blocks press against one another rather than falling. During construction, the stones are supported by a temporary wooden framework until the top stone, the "key stone," is inserted. The downward force of gravity is thus diverted outward toward the sides requiring that an arch be given extra strength or buttressing along its sides.

The arch in Fig. 16–33 might serve as a gateway or, if multiplied into a series of arches, as an aqueduct—a type of plumbing used extensively by the Romans to channel water to the cities. But to serve as a shelter, to protect you from the rain, an arch must be cast in other configurations. A *barrel vault* (Fig. 16–34 a)—an arch extended in depth—is one of those configurations, in this case, to cover a rectangular area. However, because of the problem of outward pressure, a barrel vault requires heavy walls along its entire length (think how dark the inside of a barrel-vaulted building would be). A *cross vault* (Fig. 16–34 b), formed by two intersecting barrel vaults, is an improvement because—as the support is focused at just four points—it is more open than the barrel vault. Still another variation is the *dome* (Fig. 16–35) which is simply a radial form of the arch to cover a circular or octagonal area. Finally, it should be pointed out that all of these configurations could be, and were, realized by the Romans in poured concrete as well as in stones. (The principle of an arch being much stronger than a horizontal lintel applies whether the material is stone or concrete.)

The Colosseum—started under the emperor Vespasian and dedicated by Titus—is a virtual textbook of Roman construction methods (Figs. 16–36, 16–37). Using stone, brick, and concrete, Roman builders exploited all the variations of the

Figure 16-32 Corbeled arch.

Figure 16-33 Arch.

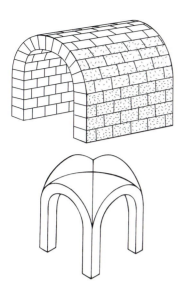

Figure 16-35 Dome.

Figure 16-34 (a) Barrell vault,
(b) Cross vault.

arch (except the dome) to create a multileveled stadium with both cross-vaulted and barrel-vaulted corridors leading around the perimeter and toward the arena—all enclosed by three levels of arcades (repeated arches). During the Colosseum's heyday, its vaulted corridors served as the infrastructure for seating 50,000 people—impressive even by the standards of today's football stadium. Again, similar to the Parthenon, the Colosseum is a ruin. And again, this was not because of faulty construction, but because of history—specifically, the Christians who used the Colosseum as a quarry for material to build churches.

Christian builders in western Europe did not become proficient in masonry construction until much later. However, by the thirteenth century

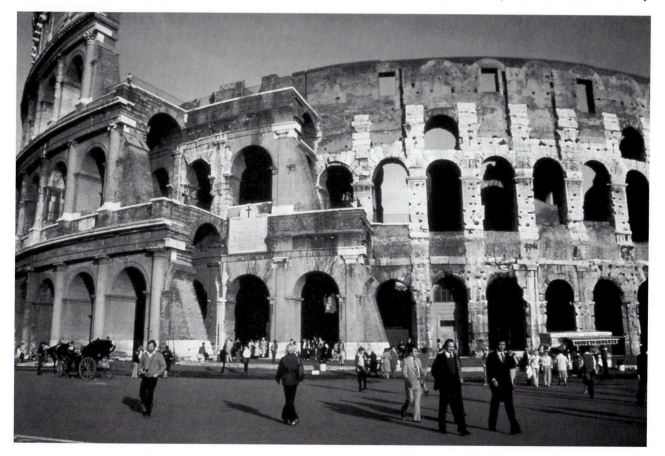

Figure 16-36 Colosseum, Rome ca. 70-82.
(Photograph by Jack Hobbs)

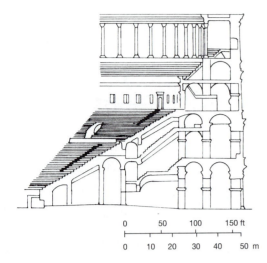

Figure 16-39 Pointed cross vault.

Figure 16-37 Diagram of Colosseum.

they had surpassed even the Romans in their development of a unique kind of arch construction for building cathedrals and churches. Called *Gothic* architecture, this construction made maximum use of the *pointed arch* and the *flying buttress*.

The pointed arch allows for more flexibility than its round counterpart. Since a round arch is a semicircle, its height is strictly governed by its width. Therefore, round vaults over a rectangular area cannot be of the same height. A pointed arch, on the other hand, is more like a triangle (Fig. 16–38); it allows the ratio of width to height to vary simply by changing the angle of the arch. This, in turn, allows intersecting vaults of different widths to have the same height (Fig. 16–39). Moreover, the pointed arch is more stable than the round. Its sharper angle focuses the thrust of gravity downward more than outward.

The flying buttress, a half arch extending from a narrow masonry pier to the upper part of the church, is intended to support the church at its weakest point—specifically, where the downward thrust of the ceiling vault presses against the outside wall (Fig. 16–40). As seen in this view of Chartres Cathedral (Fig. 16–41), flying buttresses surround the building similar to a giant exoskeleton. Their effect on the inside of the cathedral is even more dramatic. Flying buttresses, together with pointed arches and vaults, eliminated the need for thick walls and massive piers, which in turn opened the interior space as well as permitting large window openings (Fig. 16–42) (see **color insert #4**). Of all the masonry methods, Gothic is the most efficient. The interior of a Gothic cathedral would be

Pointed arch.

Figure 16-38 Pointed arch.

Flying buttresses.

Figure 16-40 Flying buttresses.

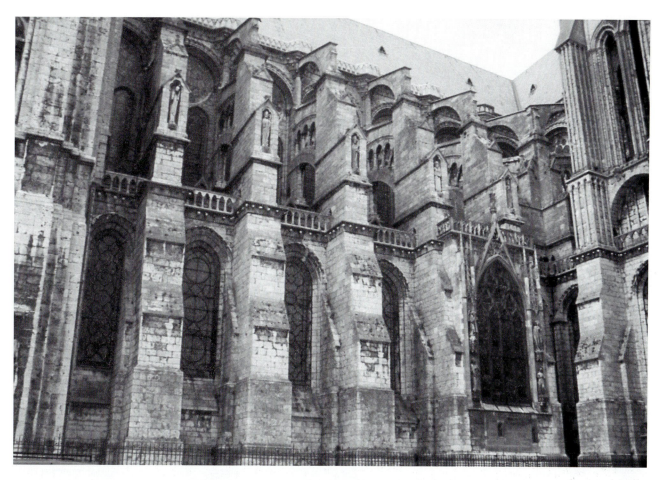

Figure 16-41 Chartres Cathedral, south side, France (1194–1260).
(Photograph by Jack Hobbs)

flooded with light were it not for the fact that the windows are typically filled with stained glass.

The final stop in our survey of arch construction is Florence—the symbol of the fifteenth-century Renaissance, that great cultural transition between medieval and modern times. Between the fall of the Roman Empire and the Renaissance only a few small domed structures had been built in western Europe. Therefore, when the large pointed dome (Fig. 16–43) on the Cathedral of Florence—designed by Filippo Brunelleschi—was dedicated in 1436, an architectural landmark was born. One hundred forty feet in diameter and 300 feet high (351 feet to the top of the "lantern"), the Florence dome is an impressive sight even today, not to mention how it looked in 1436. Because it is pointed like a Gothic arch, the Florence dome is more stable than previous domes, or any other round dome. Brunelleschi's design served as the precursor of major domed buildings thereafter—

including, among others, St. Peter's Basilica in Rome, St. Paul's Cathedral in London, and our nation's capitol in Washington, D.C.

Interestingly, almost all of the domed structures in Europe are cathedrals or churches whereas, in the United States, almost all are government buildings—including most state capitols and many county court houses. It should also be noted that nearly all of the U.S. buildings are reinforced with metal—which leads us to the next principle of construction.

Frame

A new method, frame construction, arose in the nineteenth century to challenge existing methods—some of which had been around for thousands of years. Up to this time, virtually all public buildings, and most houses too, were of the load-carrying type, that is, ceilings and roofs were supported by

Figure 16-43 Cathedral of Florence (1296–1436). Dome by Filippo Brunelleschi, 1420–1436.
(Photograph by Jack Hobbs)

walls, posts, columns, and so forth (see *Principles of Construction*). Frame construction, on the other hand, is nonload carrying, since it consists of joining thin, relatively lightweight members to form a rigid framework similar to a cage. Walls are added to the cage as needed; since they are nonload bearing, these walls may be of any material, even glass.

Prior to the nineteenth century, wood houses, such as those in the American colonies, were typically constructed of heavy rough-hewn beams supported by large wooden posts and masonry hearths (located either at the center or at the ends of the buildings). In the 1830s, wooden houses called "balloon frames" began to appear on the American frontier. Capitalizing on mass-produced nails and precut lumber (two-by-fours, two-by-sixes, etc.), the balloon frame was an early example of nonload-carrying construction. The ancestor of today's wood frame, the balloon frame was not

only quicker to build but stronger than the typical post and beam house made up to that time.

The first significant metal-frame construction was the Crystal Palace—built in 1851 to house the first world's fair. Designed by Joseph Paxton, a London engineer and botanist, the Crystal Palace was essentially a vast framework of iron rods and panes of glass. Despite its enormous size—covering 800,000 square feet (74,000 square meters) of floor—the Crystal Palace was erected in less than 6 months. To the fairgoers the building itself was the main attraction, outshining all the new machines and marvelous artifacts displayed beneath its transparent roofs.

Despite the Crystal Palace's success, traditionalists—who believed real architecture should be made of stone, not iron pipes and panes of glass—declared it unworthy of the term architecture. Still, no one could ignore the obvious advan-

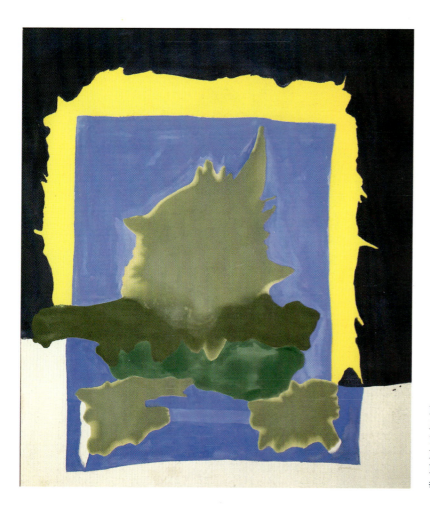

Figure 15-10 Helen Frankenthaler, *Interior Landscape* (1964). Acrylic on canvas, 104 7/8 3 92 5/8″ (266.4 3 235.3 cm). San Francisco Museum of Modern Art, San Francisco CA. (Gift of the Women's Board, #68.52) (Photograph by Don Myer)

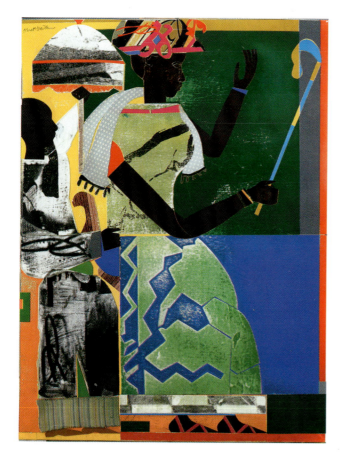

Figure 15-12 Romare Howard Bearden, *She-Ba* (1970). Collage on composition board, 48 3 35 7/8," Wadsworth Atheneum, Hartford, CT. (The Ella Gallup Sumner and Mary Catlin Sumner Collection Fund. Courtesy Estate of Romare Bearden, Romare Howard Bearden Foundation, #1971.12)

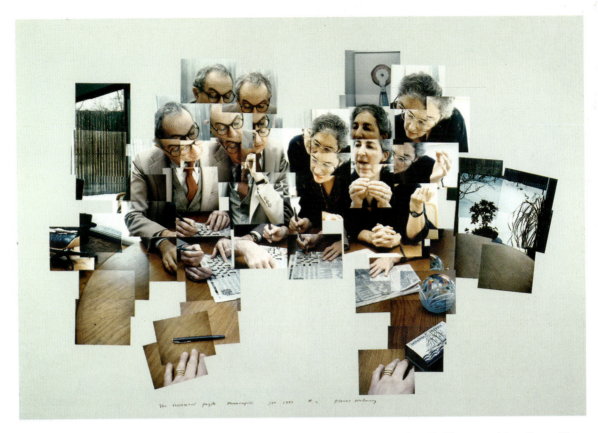

Figure 15-24 David Hockney, *The Crossword Puzzle, Minneapolis, Jan. 1983* (1983). Photographic collage, 33 3 46" (83.8 3 116.8 cm). (c) David Hockney. (Courtesy of David Hockney, Trustee)

Figure 16-6 Kristin Douglas, papier mâché fish, student work, eighth grade, Clinton Junior High School, Clinton, IL. (Photograph by Jack Hobbs)

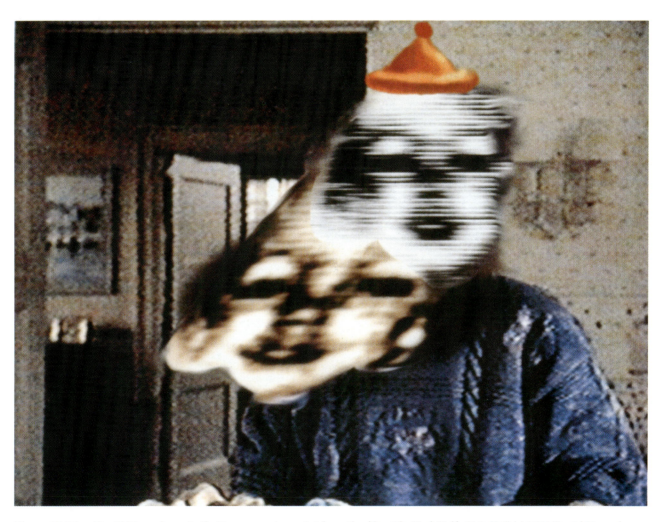

Figure 15-26 David Humphrey, *In the Nursery,* cactus print from the film, *The Dark Half,* 53 3 59." (c) 1994 David Humphrey.

Figure 16-16 Carrie Turney, eighth grade, "Retablo" cardboard relief. Cardboard, papier mâché, tempera, polymer medium. (Clinton Junior High School, Clinton, IL.) (Photograph by Don Gruber)

Figure 16-42 Notre Dame, Paris, began c. 1215. Interior, north arcade, and side aisle. (Photograph by Jack Hobbs)

Figure 16-44 Alexander Gustave Eiffel, Eiffel Tower 1889, Wrought iron, 984 ft. high. Paris, France.

(Photograph by Jack Hobbs)

tages of frame construction. As the century progressed, builders would use it increasingly for many kinds of structures, from ordinary factories to the Eiffel Tower (Fig. 16–44). The principle of frame construction was here to stay.

Our review of architecture now leads us to the end of the nineteenth century and the city of Chicago. There, a building boom was in progress in the wake of the great fire of 1873. Several factors combined to encourage architectural innovation: the building boom itself, high prices of downtown real estate, the new technologies of metal-frame construction and passenger elevator, and finally, the lack of old architectural conventions to inhibit the use of bold solutions. Chicago builders pioneered a new concept of architecture, one that took advantage of the inexpensive space

in the air as opposed to the costly space of the ground: the *skyscraper*. Among the leaders of this architectural revolution, referred to, now, as the "Chicago School," were Louis Sullivan, Daniel H. Burnham, and Frank Lloyd Wright (Sullivan's apprentice at the time).

Recall in Chapter 14, a picture of a dramatic lobby designed by Wright (Fig. 14–16) which was used to illustrate the ways in which architects organize space. The building housing Wright's lobby is known as the Rookery, a combination of masonry and metal frame designed by Burnham and John W. Root and finished in 1886. The exterior walls along La Salle and Adams streets consist of heavy granite columns on the first level, continued by brick piers and surmounted by a one-story cap of small windows and brick masonry (Fig. 16–45). The rest of the building— the exterior walls along Quincy Street and an

Figure 16-45 Daniel H. Burnam and John W. Root 1886, Rookery Building, Chicago.

(Photograph by Jack Hobbs)

alley, the court walls, the interior walls, and the floors—is entirely metal frame. Some of the earlier Chicago School buildings were metal frame throughout; almost all of the later ones were. While these buildings were unpretentious, functional, and relatively free of earlier architectural styles, they nevertheless were covered with outer walls of masonry. There seems to have been a psychological need to make a building appear heavy and solid in spite of its metal skeleton.

Indeed, the designs of the Chicago School fell out of favor in the 1920s because they did not resemble masonry buildings enough. After World War I, downtown buildings were often made to resemble Renaissance palaces or Gothic cathedrals. Though this practice was new for skyscrapers, invoking the past was common in the nineteenth century, especially for the designs of official buildings and churches. Think of all the "neoclassical" courthouses and post offices—not to mention all the architecture in Washington, DC—with columns reminiscent of those on the Parthenon. Think of all the "neo-Gothic" churches with spires and pointed arches. Yet just about all of those buildings are masonry on the outside, frame on the inside.

It was not until the early 1950s that architects felt free to design steel frame buildings that looked frankly steel frame. This acceptance of metal was inspired in large part by the work of a former director of the Bauhaus: Ludwig Mies van der Rohe. (The famous German art school was discussed in Chapter 3.) In 1933, when the Nazis came into power, the Bauhaus closed, and Mies fled to Chicago. There, Mies not only resumed his architectural practice; more important, he spread his ideas through teaching architecture at the Illinois Institute of Technology. He came to be identified with a style of architecture completely devoid of superfluous ornament and detail. Chicago's Daley Plaza (Fig. 16–46)—a simple monolith of unpainted steel and glass—though not designed personally by Mies himself, is a classic example of his style.

Mies's motto, "less is more," embodies a philosophy of architecture that enjoyed a large following, affecting the looks of high-rises all over the world. The most successful solutions of this philosophy are found in downtown Chicago where "less is more" has been employed most imaginatively, and where recent metal-frame examples reflect the zest of the earlier Chicago School. But unfortunately, in many cities it has led to glass-coated monotony and architectural boredom.

Figure 16-46 C. F. Murphy and Associates; Loebl, Schlossman, and Bennett; Skidmore, Owings and Merrill 1965, Daley Plaza, (Civic Center), Chicago. (Photograph by Jack Hobbs)

Ferroconcrete

Concrete, which had been a lost art since the Romans, was rediscovered in the nineteenth century (with the invention of Portland cement). Still, similar to its Roman predecessor, modern concrete is a form of masonry and therefore weak in tensile strength (see *Post* and *Lintel*). However, this handicap can be overcome by embedding stretched rods or cables into the material, a combination called *ferroconcrete* or reinforced concrete (Fig. 16–47). The dual advantage of plasticity and

Figure 16-47 Ferroconcrete: steel bar embedded in concrete.

strength makes ferroconcrete an extremely versatile medium of architecture.

A contemporary of Mies van der Rohe and the architect most associated with postwar ferroconcrete is Le Corbusier (originally Charles Edouard Jeanneret). Similar to Mies, Le Corbusier has seen his influence spread throughout the world. But because he exploited the special characteristics of ferroconcrete, Le Corbusier provided an alternative to the Miesian glass box. To demonstrate this, compare Boston's City Hall, a Le Corbusier-influenced building (Fig. 16–48), with Chicago's Daley Plaza. Both are rectilinear, but there the similarity ends. Rather than a single, simple solid, the City Hall is a complex of solids—overlapping, intersecting, and even terraced. Rather than having windows on the same plane as the wall, the City Hall's openings are deeply recessed. Rather than a surface of glass and metal, the Boston building flaunts a surface of unadorned concrete. "Sculpturesque" is an adjective often used to describe Le Corbusier's own designs as well as those inspired by him.

Geodesic Dome

The geodesic dome could be seen as another architectural alternative to the Miesian box. This method of construction, however, has not as yet generated a significant following. Invented by Buckminster Fuller, a man who combined the attributes of Yankee tinkerer and visionary, it is essentially a frame method. But instead of square modules, it employs triangular or hexagonal modules which, when connected, form a shell, as opposed to a plane. The simplest demonstration of Fuller's dome and the principle behind it is a climbing-gym (Fig. 16–49).

Figure 16-48 Kallman, McKinnell, and Knowles, City Hall, Boston, 1963.
(Courtesy of Esto Photographics, Inc., #119D:15/WS, 962743) (Photograph by Jeff Goldberg) (©Jeff Goldberg/Esto)

Figure 16-49 Climbing gym. A hexagon is formed by combining 6 triangles. (Photograph by Jack Hobbs)

A more dramatic example is the *Climatron* in St. Louis (Fig. 16-50). Constructed of aluminum rods, the hexagonal modules of this dome are clearly visible—just as they are in the climbing-gym—but in this case each module is doubled and reinforced with a system of internal cables. The Climatron—the home of 11,000 different species of tropical plants—is essentially an enormous greenhouse—70 feet high, 175 feet in diameter, and enclosing 24,000 square feet.

The geodesic dome's potential is great, as it is probably the most efficient construction method to date; specifically, it can enclose more space in less time with the least amount of material. The Climatron, for example, is as large as any court house or a library, but was built in much less time with only a fraction of the weight of those kinds of buildings. Yet, because Fuller's invention seems to be limited to a shell configuration, it is also limited as a style. In addition to housing botanical gardens, the dome has been used effectively for world's fair pavilions, military radar installations, and swimming pools. It remains to be seen whether it will ever play as significant a role in architecture as steel-frame construction (of the rectangular variety) or ferroconcrete.

As of this writing, the designs of Mies and Le Corbusier and their followers are seen as passé. While these styles are being replace by "postmodern" styles (see Chapter 5 with regard to postmodern art), the principles of metal frame and ferroconcrete continue to be the major ways of making modern buildings.

Student activities, architecture

- As you did in the class project for making an environment (see *Student activities, environmental art*), obtain some store boxes of varying sizes. But this time do not necessarily paint the boxes the same color. Pretend they are features of an architectural environment—either an urban complex or the inside of a building, perhaps a school—and decorate them accordingly. (Look for ideas under *Student activities, constructions for older ages*.) Arrange them to create a space that is both functional and interesting.
- If the class project is not practical, do the same thing on a smaller scale, using such things as matchboxes or floppy-disk boxes.
- Make a floor plan of your architectural environment.
- Older students only: Make floor plans for an imaginary house or office. Using a ruler, make the floor plans to scale, that is, $1/4'' = 1'$.

- Realize your floor plans in a scale model house (Fig. 16–51) out of cardboard or any suitable stiff material. **Warning:** Use extreme caution when cutting cardboard with a knife!

- What are the meanings of the suffix "neo" and the terms "revival" and "eclectic" in the context of architectural styles? (Answers: "Neo" means new, thus "neo-Gothic" means, literally, "new Gothic." "Revival" is any style based on an earlier style; for example, "neo-Gothic" could be called "Gothic revival." "Eclectic" means borrowing from many sources; thus, an eclectic style is one that revives the styles of two or more historical periods.

- Do a survey of public buildings in your community or neighborhood. If you live on the east coast, some of those structures might be pure masonry, using mostly arch methods of construction. If you live in the Southwest, some may be masonry, some may be adobe (i.e. sun-dried brick), some may be a combination of masonry and adobe. The rest of the buildings, and virtually all of the public buildings in the rest of the country contain some degree of metal in their construction—even though they may appear to be masonry.

- Buildings designed prior to World War I are likely to be *neoclassical*, *Romanesque Revival*,[2] or *neo-Gothic* in style. Decorations on pre-World War I buildings are apt to be in the style of *Art Nouveau*.[3] Buildings erected between the wars are likely to be *neoclassical*, *neo-Gothic*, or *Art Deco*.[4] Those built since World War II are likely to reflect styles inspired by Mies van der Rohe or Le Corbusier. Of course, in your survey, you may find other styles, or discover that some buildings do not fit any particular style. Select an example from each era and write a commentary about each example and how it differs from the others in terms of style. Who were the architects? How does each building reflect its era?

- Select a particular public building, determine its style and the name of the architect, and analyze the way it was built. If it is a historical landmark, you may be able to get answers to these questions directly as well as obtain a great deal of information about the building's history.

- Does your community or neighborhood have a local historical society? If so, ask that organization for information about houses which have been designated as historical landmarks or that are recognized for their historical value. Do some research on one or two of these houses. You may discover styles with interesting labels, such as *Georgian Revival*, *Italianate*, *Queen Anne*, or *Victorian Eclectic*—depending, of course, on what part of the country you live in.

- Teacher: If you travel to Europe, study and photograph masonry buildings made prior to the nineteenth century. Notice particularly the interiors with either vaulted or domed ceilings. Churches and cathedrals usually have pamphlets of information about their structures. Your students will be fascinated by your discoveries and your pictures.

Figure 16-50 Climatron, a geodesic dome, in St. Louis. Climatron houses an acre of reconstructed rain forest.

(Courtesy of Seattle Filmworks)

Figure 16-51 Student work, eighth grade, Clinton Junior High School, Clinton, IL.
(Photograph by Jack Hobbs)

SUMMARY

By now, you should have no illusions about the visual arts being limited to just paintings and statues. You should also know that the review of media in this chapter touched on only the high points of three-dimensional art. Those were as follows: sculpture (subdivided into carving, modeling, casting, welded metal, construction, kinetic, and mixed media), environmental and performance art, crafts, and architecture.

In keeping with the twofold objective of this chapter, the discussion of each medium was followed by suggestions for age-appropriate 3-D projects in the elementary grades. If the review and description of 3-D media was limited, it was even more so for the discussions of the student projects—both quantitatively and qualitatively. (It would require an encyclopedia to provide recipes for all the 3-D projects available to children.)

Obviously, there are many things in the 3-D realm that professional artists do that are inappropriate for use in the elementary school. One reason, of course, is because children lack some of the necessary skills; another is concern for their health and safety. But mostly, elementary children cannot do many of those things because of the proverbial shortages of space, time, and money that exist in elementary education.

NOTES

1. Much of the following material has been derived from Hobbs, Jack A., and Duncan, Robert L. (1992) *Art, ideas and civilization.* Englewood Cliffs, NJ: Prentice Hall.

2. Romanesque, a medieval style characterized by round arches and thick walls, flourished in Europe before Gothic was developed. Romanesque revival was a popular style of architecture for public buildings and private mansions in this country during the late nineteenth and early twentieth centuries.

3. Art Nouveau was a decorative style featuring extreme curvilinear and undulating lines. Popular in the late nineteenth and early twentieth centuries, it was found in the graphic arts, but its florid lines also pervaded furniture, doorways, staircases, balconies, and gaslight fixtures.

4. Art Deco, the "streamlined" descendent of Art Nouveau, was popular in the 1920s and 1930s. Unlike the earlier style, Art Deco featured rectilinear lines and shapes, in an attempt to imitate the dynamic forms of industry and machinery.

17

The Art of Sequence and Movement

The two previous chapters barely scratched the surface of the kinds of fine-arts media available today. Despite this immense diversity, however, there is one thing that almost of all of these media have in common: they consist of single static objects.

This chapter will look at a different kind of media, the art of sequence and movement. Comic strips involve sequence, although they don't move. Movies and television involve both sequence and movement (technically, they involve the *illusion* of movement). Comics, movies, and television, the media considered in this chapter, are classified, as you know, as popular art.

O.K., but should we be discussing popular art in the context of education? In Chapter 2 Harry Broudy recommended teaching just fine art. Children, Broudy reasoned, can easily learn about popular art on their own, whereas they cannot understand fine art—which is more difficult and inaccessible—without the help of teachers. Further, of all the visual arts, Broudy would argue, fine art is the most inventive, noble, and meaningful. A backward glance at the art examples used in the foregoing chapters demonstrates that, so far, we have gone along with Broudy.

The issue of fine art versus popular art probably would not even exist if art education had not recently moved away from emphasizing just stu-

dio production. With the addition of aesthetics, art criticism, and art history the question arises: What art should we bring into the classroom for study? Broudy says fine art only. Some would emphasize popular art. Others argue for a mix of the two but with the greater weight on fine art.

The authors of this book are among the third group. We favor the use of mostly fine art in a comprehensive art program, but we also think there is definitely a place for popular art. In this chapter we intend to show that a study of popular art—especially that which is appropriate for and accessible to children—can (1) build bridges to the enjoyment of the fine arts and (2) develop a mature perspective that will foster discriminating consumers of everyday art. We also intend to show that some popular art, like fine art, is inventive, noble, and meaningful.

POPULAR CULTURE AND ART EDUCATION

Brief mention was made in Chapter 1 about "Art for Daily Living," a 1930's depression-era idea. A small town, Owatonna Minnesota, became the object of a unique experiment in art education. Adults attended classes in art appreciation and crafts. Children of all grade levels learned about color and principles of design, and then applied

this knowledge in actual hands-on projects in the school and community. It was a populist kind of art education that reflected the spirit of community formed in the crucible of the Great Depression. The promoters of the Owatonna project probably would have scoffed at Broudy's commitment to fine art and the high culture.

The experiment was cut short by the war and never was revived or emulated by other communities. After the war, the idea of art for daily life was replaced by that of art for personal expression (due largely to the influence of Viktor Lowenfeld). Now, some four decades later, after another ideological shift and a revival of thinking about popular art, will we see another Owatonna? We think not.

In the 1930s, the focus was *design*-oriented— the premise being that learning about product and urban design would improve daily life. Now, the focus is on *meaning*—the premise being that recognizing the ways in which popular culture shapes our realities and influences our lives can hopefully enable us to master it rather than vice versa.

As you know, the entertainment industry has come under fire with regard to its responsibilities in the cultural marketplace. Hotly debated are such issues as the causal relationship, if any, between fictional violence and real violence; the proper balance between censorship and free expression; and the moral responsibility in general of the media. All of these are relevant to the lives of children and all could be discussed in the classroom in age-appropriate ways. Equally relevant are issues centering around cultural pollution in general—the eroding of not only moral, but of intellectual and aesthetic standards by a constant barrage of mind-numbing, inane material. This is not to say, however, that all popular art is inane. Some is superb—as we shall see. Thus, another benefit of studying popular art would be to provide students with appropriate analytical tools to help them separate the gold from the dross.

The Relationship Between Popular Art and Fine Art

Precedents for Popular Art in the History of Fine Art

The idea of fine art being intended just for aesthetic pleasure (or "disinterested satisfaction"; Chapter 5) is a notion that did not emerge until the eighteenth century. Prior to that, art had served a variety of *non*-aesthetic functions, mostly related to glorifying either religion or the state through story-telling. For various reasons during the twentieth century, story-telling (or "narrative" art) was thought to be beneath the dignity of true art. Indeed, formalist art critics such as Clive Bell (Chapter 5) even declared subject matter to be irrelevant. Thus, the function of story telling was left to popular art, the vast majority of which—whether comics, movies, or television—tells stories.

In the ancient world almost all art was of the story-telling variety. The legends of gods and goddesses graced the walls of temples; the stories of heroic battles were carved on monuments. In the medieval and renaissance periods, art was utilized to impart stories from the Bible. Giotto's series of the life of Christ in the Arena Chapel and Michelangelo's story of Genesis on the ceiling of the Sistine are but two of many examples of this kind of art.

All of these examples are serious—serving religion, the state, or some combination of the two. By the eighteenth century, however, some artists dared to satirize various social institutions instead of glorifying them. William Hogarth is a good example of an artist who liked to poke fun. For instance, his *Marriage a la Mode*, a six-part story, lampoons the cynical eighteenth-century English custom of using marriage to bargain for title or wealth. In one scene (Fig. 17–1) a nobleman (shown with the family tree) cuts a deal with a wealthy merchant to marry off his son (shown in the background with his back to the bride).

What we have just discussed are historical precedents for popular art. All of the examples are story-telling, both serious and humorous. Knowing the analogy between historical art and modern popular art can help students bridge the gap between their own culture and that of the past as well as lead them to better understand their art heritage.

The Crossover Phenomenon

Sometimes the difference between fine art and popular art is simply a matter of time and circumstance. Many items of popular, applied, and folk art in the past have since crossed over the line into the fine arts: the posters of nineteenth-century artist Toulouse-Lautrec (see Chapter 15, Fig. 15–18); many nineteenth-century photographs;

Figure 17-1 William Hogarth (1697–1764), *The Marriage Contract* from *Marriage a la Mode* (c. 1745). Oil on canvas, approx 28 × 36″ (71 × 91.5 cm). National Gallery, London.
(Photographed by Bildarchiv Foto Marburg/Art Resource, N.Y.) (Courtesy of Art Resources, #S0004688)

Charlie Chaplin films; turn-of-the century sky-scrapers in Chicago's loop (see Chapter 16); and the paintings of Grandma Moses; to name but a few examples.

In mid-nineteenth-century Japan a kind of picture known as *ukiyo-e* ("the art of the floating world") drew its subject matter from popular entertainment and sight-seeing, and catered to the tastes of the merchant class. Some of it was even bawdy. *Ukiyo-e* woodcuts were so lowly regarded and also so plentiful that the Japanese used them to wrap their exports. On the other side of the globe, the French Impressionists recognized their unique qualities and avidly collected them. Eventually Japanese woodcuts came to be so highly valued that an original print by Hiroshige (Chapter 9, Fig. 9–9), for example, is found only in the most distinguished art collections, and is frequently reproduced in art books.

Popular art and fine art have commonalities in both content and function and have been historically intertwined more often than people realize. The rest of this chapter will demonstrate how the popular arts of comics, film, and video can be fruitfully employed in a comprehensive art program.

THE COMICS

Comics have a number of advantages for teaching art. They are readily available. Instead of going to the library, or ordering slides or reproductions, you can clip them out of a newspaper and make transparencies of them to show on an overhead projector, or slides to show on a slide projector. (Three or four rows of strips can fit on a transparency or slide.) Comics, needless to say, are

popular. Both children and adults like to read them. The spontaneous drawings that children do out of school (or sometimes, illegally, in school) are often based on cartoon imagery. Finally, as a medium, comics are not unlike what children do all the time in art class: making line drawings on paper. Comics involve pencils, pen and ink or brushes, colored inks or paint, and paper—commonplace tools and materials in every art room.

Besides their convenience as a medium, comics also lend themselves very well to teaching art history, aesthetics, and art criticism.

Comics History

In addition to having precedents in art history—as we saw earlier—comics have an interesting history of their own. Most popular-culture historians agree that this art had its beginnings in the humorous satires of a Swiss illustrator, Rodolfe Topffer, who published his own series of lithographed pictures and prose—in some respects, a predecessor of today's comic book—in the early nineteenth century.

The American beginnings of the comic-strip date to *The Yellow Kid* printed in New York newspapers as early as 1895. Initially, *The Yellow Kid* appeared in single panels depicting humorous anecdotes in the slums of New York. Eventually, these anecdotes were extended into horizontal series of panels. When dialogue "balloons" were added, the comic strip as we know it today was born.

Some of the best comics of all times date to the early twentieth century. One of those was Windsor McCay's *Little Nemo In Slumberland*. Nemo—a character based on the artist's own son—made weekly visits to slumberland on the pages of The *New York Herald*. Elegantly penned in Art Nouveau style, a page of McCay's art (Fig. 17–2) can be appreciated for its abstract beauty of line and composition—especially with regard to its keen relationships of black and white (or positive and negative). At the same time, McCay's ingenious imagery makes the world of dreams almost palpable. His comics have so impressed the art community that they have been exhibited in New York's Metropolitan Museum of Art.

Adventure comics appeared in the 1920s. Comic-art historians cite *Wash Tubbs* as the first of the genre. Starting as a humorous strip, *Wash Tubbs* added a hard-boiled drifter named Captain Easy and eventually took on the latter's name as well an adventure focus. *Little Orphan Annie*, probably the most venerable of adventure strips, had the least likely of heroes: a little girl and her dog. Daddy Warbucks, Annie's rich, avuncular guardian, made an entry only now and then, but always in time to rescue his ward from a desperate situation.

Milton Caniff, the creator of *Terry and the Pirates*, was one of the more successful of adventure-strip artists to use a realistic style. Terry, a young and merry drifter in the 1930s, grew up in time to join the Army Air Corps in the 1940s. He and his buddies—who were fighting the Japanese in the Pacific—spoke a free wheeling citizen-soldier argot that helped to convey the story line (Fig. 17–3). The drawing style consisting of bold combinations of black and white, yet without any loss of necessary detail and texture, was equally important, however. And reminiscent of the movies, each panel employed unusual "camera angles" and striking jump cuts from scene to scene.

The comic book, a single-hero magazine in comic-strip format that also emerged in the 1930s, brought together elements of pulp fiction, movies, and radio-show serials. It was the launching pad for famous super heroes: Superman (1938), Batman (1939), and Captain Marvel (1940). Patriotism and decency were strong themes as these masked avengers relentlessly attacked crime and corruption. In the immediate postwar era, however, these themes gave way increasingly to obsessions with violence, gratuitous sex, and even sadism. In the 1950s, the contents of comic books came under scrutiny by a psychiatrist who published a book suggesting a connection between fictional depravity and juvenile crime.[1] This inspired a moral crusade (not unlike the one today with regard to the entertainment industry) which led to a Senate hearing, the establishment of the Comics Code Authority, and serious damage to the whole comic-book business.

Not all comic-book art was depraved or intellectually stultifying. One artist, Will Eisner, created heroes with masks, but who also had complex personalities and functioned in a complex world. Later, Eisner penned serious comics, particularly a collection of short stories titled *Contract with God* which includes, among others, *Hamlet on*

Figure 17-2 Winsor McCay (1867–1934) panel from *Little Nemo* (February 23, 1908).
(Courtesy of the University Press of Mississippi)

Figure 17-3 Milton Caniff (1907–1988), *Terry and the Pirates*, 1943.
(Reprinted by permission of the Tribune Media Services, Inc., Copyright (1970-1974). World Rights Reserved.)
(Courtesy of the Tribune Media Services, Inc.)

a Rooftop, a series based on the soliloquies of Shakespeare.[2]

Robert Crumb was the acknowledged pioneer of underground comics—a genre trafficking in mockery and the obsessions of hippies that emerged in the 1960s. His satire, however, was aimed not at just middle-class hypocrisies, but at those of everyone, including the hippies themselves. Similar to Eisner, Crumb has recently branched out into illustrating serious literature, specifically, a book-length version of the writings of Franz Kafka. Highly admired now by the mainstream press and critics, Crumb's work, unfortunately, is often too scatological to use in the elementary classroom.

Art Speigelman, another talent involved in underground comics, published in 1986 a book-length comic-strip called *Maus: A Survivor's Tale*. As told by his father, *Maus* (German "mouse") chronicles the elder Speigelman's ordeals during the Nazi Holocaust (Fig. 17–4). It is partly autobiographical, as Speigelman himself appears as the son interviewing the father. In addition to the tragic unfolding of the Holocaust events, the story is also about the ambivalent relationship between father and son. This kind of content invites comparison with that of serious literature. And indeed *Maus* has won many awards, including a *Pulitzer Prize*, and has been translated into over a dozen languages. That a comic strip would transcend its idiom this way is all the more surprising since *Maus* employs a typical funnies' convention: animals as characters—in this case, mice as Jews, pigs as Poles, and cats as Nazis.

This is a very thin historical sketch ending in the mid 1980s, with very few examples and without any mention at all of today's familiar comics. It is perhaps more important for students, especially older ones, to be aware of some of the earlier developments in comics history—since they already know some things about contemporary comics. (For your benefit in this regard, consult the bibliography for this chapter at back of the book.)

As to methods of teaching this history, we remind you of the suggestions in Chapter 8. But apropos teaching comics history, here are a few more.

Integrated Approaches Art and social studies teachers can team together to investigate, for example, the ways in which strips have reflected the conditions of their times, such as the Great Depression (e. g., *Little Orphan Annie*), World War II (e. g., *Terry and the Pirates*), the Cold War (e. g., *Steve Canyon* [another creation of Caniff's]), and growing up in the Postwar era (e. g., *Peanuts* and *For Better or Worse*).

Thematic Approaches Look for themes in the comics and compare those with similar themes in fine art or in literary masterpieces.

Sorting by Content Given a random collection of comics, have students sort and classify according to genres—humor, adventure, situation comedy, detective, science-fiction, and so on. Or have students sort according to themes—childhood, the growing family, the working girl, the military, human relationships, horror, the lone hero, and so on.

Figure 17-4 Cartoon from the book, *Maus: A Survivar's Tale* by Art Spiegelman.
(Courtesy of Random House, Inc., Pantheon Books)

Sorting by Style Given a random collection, have students sort them on the basis of stylistic differences. Some are relatively realistic, some are much less so. Some are basically outline, some include varying degrees of chiaroscuro, and so forth.

Polarities Take two comics similar in style, e. g., *Beetle Bailey* and *Peanuts*, and have students investigate the ways they differ in content. (Older students should go far beyond the simple observation that one deals with children and the other with soldiers.)

Inquiry Art historians involved in research classify works by style, subject matter, use of symbols, or any clue that betrays something about a work's

sociohistorical contexts. With regard to a comic strip: in addition to its graphic style, it also contains such signs of the times as language, social behavior, style of dress, interior design, and so on. What are some signs in Calvin and Hobbes (Fig. 17–5), for example, that place it in the culture of the mid 1990s? Comics like *Cathy*, *For Better or Worse*, *Peanuts*, and even *Garfield* might provide even richer lodes of contemporary signs. Ask students to imagine they are art historians in the year 2090 who do not know the dates of any of these comics. What would they look for?

Cull through collections of old comic books or newspapers. Based on this evidence, students may reconstruct a simple history of comics (or a particular genre of comics) showing the ways they have changed over time. Characteristics to look for: graphic style, story-telling devices, major themes, and so forth. Again, do not overlook such signs of the times as costumes, hairstyles, manners, and interior design.

Indeed, the possibilities for using comics as sources for learning about American history, popular culture, and art are endless. These are just a few suggestions. We hope these are successful in priming your pump of imagination.

Aesthetics

Again, we refer you to the suggestions in Chapter 8 for teaching aesthetics, particularly the use of a Big Question Chart and the puzzling cases approach. Some things inherent in comics lend themselves to aesthetic inquiry. Why are comics not considered art, a la *fine* art? Or conversely, why are some comics, such as Speigelman's *Maus* and McCay's *Little Nemo* considered art? Are there any objective criteria to determine that a particular strip is or is not art? Assuming that you find none clearly articulated in the literature, students can develop their own criteria, either collectively or individually. Students may bring examples of their favorite comic to class and make a case for its being art (or not). Either way, a student must defend his or her judgment based on evidence and criteria.

More questions to ponder: What is the difference, if any, between art and entertainment? If there is a difference, where do you draw the line? Can the term *comics* itself be defined in any conclusive way? Is this term easier to define than the

Figure 17-5 Calvin and Hobbes (Sliding Pond) © 1992 Watterson Dist. by UNIVERSAL PRESS SYNDICATE. Reprinted with permission. All Rights Reserved. (Originally in color, this Calvin and Hobbes strip is printed here in black and white.) (Courtesy of Universal Press Syndicate)

term *art* (see Chapter 5). Students may endeavor to develop a list of necessary and sufficient conditions with which to define comics. What are some ways to determine the quality or aesthetic value of a comic strip? Students may develop their own criteria for doing this, but their criteria should be sound (see following). They can rate a number of comics using these criteria. This endeavor can also be done as a part of art criticism.

Art Criticism

Because comic strips are so popular and accessible, you may want to use them *prior* to examples of fine art for the purpose of practicing art criticism. But be choosy. Obviously, many comics are inappropriate for the classroom—not only on grounds of morality and taste, but also because they have little to offer besides entertainment.

Some, like *Calvin and Hobbes*, however, are not only in good taste, they provide enough substance to explore in a critical analysis.

The reader is asked to recall the (Edmund) Feldman method and its four stages—*description, formal analysis, interpretation,* and *judgment*—as described in Chapter 8.

Description Generally, a single picture of a comic has far less visual information than a painting. But there are more of them. In describing the *Calvin and Hobbes* strip (see again, Fig. 17–5), students should take it panel by panel. The first two panels show Calvin running to and climbing some steps. In succeeding panels he pauses on the steps to survey the landscape beneath him, climbs into the clouds, and finally reaches the top of what turns out to be an enormous, stratospheric slide. By now, Calvin is above the atmosphere. There he

pauses again, nervously moistening his lips, before plunging toward the earth, miles below. Students should not fail to notice the curve of the horizon and recognize the Great Lakes as shown in the large panel. In the final panel, the only one with dialogue, Calvin is seen hesitating at the top of a four-foot slide as his father tries to reassure him.

In addition to the actions, students should also describe the relevant visual elements—the colors, lights and darks, lines, and shapes. They can also describe the graphic style(s). Is some of it realistic? Is some of it relatively abstract? (Any comparing or contrasting of these elements, however, should be reserved for the next stage.)

Analysis In comparing and contrasting the elements in *Calvin*, students might observe that the panels vary in size, style, and even eye level. The small panels containing just Calvin or Calvin and his father overlap the large ones, which contain much more visual information. The figures of Calvin and his father are rendered in typical cartoon style—simplified, flat shapes—while the aerial scenes are rendered more realistically with a greater variety of color, shape, and line. The progress of the story, as well as the drama, is conveyed by contrasting eye levels: the figure of Calvin in the smaller panels is seen at regular eye level and in the larger panels at high eye levels—except for one which shows Calvin from below.

Interpretation The third phase involves looking for meaning(s). Students may observe that, as in nearly all of the *Calvin and Hobbes* strips, the action switches back and forth between different states of consciousness—in this case between reality and Calvin's vivid imagination. Ironically, the most realistically rendered scenes represent the state in which Calvin is most out of touch with reality. The obvious meaning of this strip is that of a little boy who, because of an overactive imagination, is afraid of sliding down a small slide.

So far, the analysis has stuck to *internal* evidence, those things visible in the strip. Recall from Chapter 8 that it is acceptable to bring in *external evidence*, but only in the interpretation stage and only after dealing adequately with the internal evidence. External information about the popular culture, politics, or life in general is especially appropriate for this kind of art, and can be introduced by either the teacher or the students.

Students should be encouraged to relate the information they uncover to their own lives. Some of the younger children—those around Calvin's age—will probably relate the story literally to their fear of slides. Older children should be able to, or at least encouraged to, see it as a metaphor of irrational fear or insecurity in general. Obvious examples would be such things as learning to ski for the first time, diving off a high board, riding a horse, learning to dance, and so forth. More subtle ones, especially for young adolescents, might involve insecurities typical of their age group, such as trying to be accepted, trying to make it in sports, impressing the opposite sex, being cool, knowing what to wear, and so on. Older students may be inspired to discuss the differences between perception and reality.[3] Finally, you may be surprised and fascinated by the kinds of interpretations your students come up with. Similar to art itself, interpretation is always unpredictable.

Judgment We feel that this stage of criticism, the most complex and controversial of the stages, is optional. In other words, the educational benefits from doing this may not outweigh its costs in terms of time and frustration. On the other hand, you and your students may, for whatever reasons, be motivated to engage in judgment. One good reason would be that of providing them with a further tool for separating good from bad in popular art.

Recall that there are at least three kinds of judgments typically made in the field of art: the extent to which a work is significant when compared to others of its type; the extent to which a work has influenced others during the course of history; and the extent to which a work is well organized and conveys its message well. It was stated in Chapter 8 that only the third one of the three kinds of judgments was available to children because of their lack of art knowledge. In the case of comics, however, children have a greater knowledge base and would be able to do the first kind, for example, to compare *Calvin and Hobbes* with other similar comics.

For both the first and second kinds of judgment, students should use sound criteria—even though these may have been developed in class. We suggest basing criteria on principles spelled out in earlier chapters: 8, 10, and 14, in particular.

Production

Creating comics requires the same skills needed in making pictures: being able to draw people and objects and handling spatial relationships. Students in preschool, kindergarten, and first grade, who are still in the preschematic stage, are not yet ready to relate their drawings to a rectangular format in consistent ways. (This is because of their characteristic use of random space and floating images; see Chapter 4.) Therefore, a comic-strip project would probably not be successful with this age group. Students in first and second grade (and many in third grade) generally employ schematic imagery which lends itself very well to to the rectangular formats of comics. As you may recall from Chapter 4, these children are spontaneous with regard to their creative expressions and will take up the challenge readily with little direction. Whatever their products may lack in polish, they more than compensate for in charm and boldness.[4]

For older students, expect a little more sophistication—depending of course on general maturity, natural ability, and previous instruction. To varying degrees, these children can draw the human figure with reasonably good proportions, and maybe even use foreshortening, chiaroscuro, and perspective—though to limited degrees and without consistency. Also they should have received some experience in composition, particularly in manipulating and balancing positive and negative space. Unlike younger children, older ones are ready for some special instruction in comic strip art. Much of this involves both you and the class observing examples of that art. A practice session or two may be devoted to the each of the following skills:

- adjusting drawings to the scale of, say, 5″ × 5″ panels (on 12″ × 18″ sheets cut horizontally), and fitting talk balloons into the panels without interfering with the drawings,
- lettering readable dialogue and getting it to fit in the talk balloons,
- trying to show people and objects from different eye levels; previous experience with still photography (Chapter 15) is relevant here.
- trying to keep compositions simple and bold. Previous experience with balancing positive and negative space is relevant here.
- practicing caricature and developing their own characters. Discourage the use of stock characters, e. g., *Batman*. (Nevertheless if one is used, it must be transformed by being placed in a new context developed by the student.)
- employing comic-strip conventions: speed lines, worry sweat, swearing symbols, silhouettes for closeup or distant figures, and so on.

Some Strategies One way to initiate a unit on comics is to have students "complete" commercial funnies in which the final panels, the ones containing the "punch line" or final action, have been removed. After a student is finished, he or she is then allowed to see the original artist's solution. Sometimes the student's solution is as funny or funnier than the original. (All you have to do, as the teacher, is to xerox a number of black and white daily comics and clip off their final panels.)

Mike Mosher, who taught comics at a summer school (mostly to children in grades three through six), found the following technique to be successful when students were at a creative standstill. Each was prompted to draw a single panel in just 2 or 3 minutes, and then pass the paper to the next child, and so on, until an eight-panel strip was finished by eight different artists. Though at first resisting having to think so swiftly and share their creations, "they soon got the idea, picked up the rhythm, and bought into the game," according to Mosher.[5]

The term "mixed-ability" in the context of education does not necessarily mean differences on a *vertical* scale of academic ability. It could just as well refer to differences on a *lateral* continuum (i. e., Gardner's multiple intelligences). An upper elementary grade contains a rich mix of nascent abilities in different fields. While some children are good at math and verbal skills, others are known to be good at such things as humor, storytelling, writing, drawing, using pen and ink, and leadership. Thus, you could organize your class into cooperative learning groups or into teams that include these different specialties—namely, writers, sketchers, penners, idea people, and leaders—to create a comic strip. While a responsible leader oversees the project, a penner takes the roughed-out product of the writers and artist and makes a finished, polished version of the strip. If time permits, a successful team might even be inspired to make a short comic book.

Finally, don't overlook the option of allowing each student to create his or her own individual comic strip (Fig. 17–6). According to Mosher, "Kids are by nature witty, sharp, and Huck Finn-

Figure 17-6 A. J. Brown, sixth grade, Lincoln Junior High School, La Salle, Illinois.
(Photograph by Jack Hobbs)

inventive."[6] There usually is no problem with students being eager to make comics. Indeed, they may be too eager. You may have to slow them down a little, and coach them on the fine points of making comics as well as drawing in general (perhaps, even, having them do two or three drafts before the final inking).

Comics is a wonderful outlet for this creative energy. They sometimes elicit hidden drawing talent (see the sophisticated, though exaggerated, treatment of the human body in the work of a seventh grader: Fig. 17–7). Teachers who have directed classes in comics have found them to be popular and amazingly free of discipline problems.[7, 8]

FILM AND VIDEO

In ordinary parlance we speak of movies and television. In the art world, these are usually called *film* and *video*. Although different in their technologies, film and video are similar in terms of their expressive possibilities. Also, both have similar disadvantages regarding their use in the elementary classroom. Although many schools are stocked with movie projectors and TV monitors, few have cameras and camcorders, and fewer still have them for the use of students. Obviously, these things are costly, but they are also very unfamiliar as art media and even intimidating to most teachers, let alone their students. Don't let any of these caveats prevent you from trying either film or video. No doubt, there are teachers out there—some, perhaps, reading these pages—who have had success using one or the other even as low as the primary grades.

Film and Video As Media

A movie camera is the same as a still-photography camera, except that it is motorized to draw film

Figure 17-7 Isaiah Sanders, seventh grade, Clinton Junior High School, Clinton, Illinois. Although Isaiah's style effectively emulates that of hero and science fiction comics, he makes up his own drawings and stories.
(Photograph by Jack Hobbs)

through its chamber in a rapid stop-and-go motion. A single frame is pulled into position behind the shutter, the film stops, the shutter opens, and a single image is exposed. This is repeated twenty-four times a second, the standard rate of sound film.

The filmmaker, like the still-photographer (Chapter 15), must contend with such things as available light, point of view, and composition within the frame, but also with movement within the frame, and sometimes with the movement of the frame itself.

There are two basic elements of film: the *shot*, an unbroken segment of a scene or action, and the *sequence*, a series of shots. In making a shot, a camera can remain in a fixed position or it can pivot, follow an action (or track), or move closer or farther from an object (or zoom). If a film were made

of the sequence of *Terry and the Pirates* in Fig. 17–3, for example, the first two shots would be from fixed cameras in the cabins of Terry and his friend; the third and fourth would probably be tracking shots. Each shot would last no more than 5 or 6 seconds (or no longer than the conversations in the talk balloons).

After a film is shot, it must be edited: cutting and splicing segments of film to compose the final array of shots and sequences. In many respects, editing is as important in creating the final product as the shooting.

Similar to photography or film, video transforms light into images—but by electronic means rather than by mechanical and chemical means. Instead of a black box with a lens in front and light-sensitive film in back, a video camera is a tube with a lens aiming light reflected from a subject at a photosensitive electronic plate. The light is converted into electric signals that are transmitted through the air or carried by cable to a television receiver—basically a tube with a screen in the front that reads the signals and converts them back to an image of the original subject. Television signals can also be stored on magnetic tape and played back at any time.

The same variables of working with film—lighting, point of view, composition within a frame, and movement—apply to video. The elements of the shot and sequence are also the same. At one time, video cameras and recording equipment were too awkward and expensive for anyone to use but commercial television crews. Now, small *camcorders*—hand-held units with camera and recorder combined—are readily available, inexpensive, easy to operate, and capable of producing remarkably good images. Therefore, video has become more popular than film for individual use, whether art, hobby, or family. It is also more practical for use in school.

Implications for Teaching History, Aesthetics, and Criticism of Film or Video

Public acceptance of film as an art form began in the late 1950s. By the 1970s, film had received the imprimatur of higher education and museums. Today, there are few universities that do *not* teach film; some even offer degrees in the discipline. The Museum of Modern Art in New York has a

permanent film curator on its staff; the Cleveland Museum of Art offers workshops on film animation. Some of this acceptance was the result of changing perceptions among audiences—a consciousness-raising about a medium that had heretofore not been taken very seriously. Some of this was because of the industry itself responding not only to more discriminating audiences, particularly among the young, but to the need to compete with television (aka video) which had displaced a big share of the weekly and biweekly movie-going market.

For a period of time the "art film" label was limited to films produced only by distinguished directors, mostly foreign, such as Ingmar Bergman, Federico Fellini, Ahira Kurosawa, and so forth. For the most part these films were made for and appreciated by a select audience. Now, many older mass-audience American films, particularly those by Charlie Chaplin, Alfred Hitchcock, and John Huston, to name a few, are taken seriously by critics and film historians. Similar to some comic strips mentioned earlier, these have crossed over from the realm of entertainment into that of art. Additionally, numerous current American films, including those that are huge box-office successes, enjoy the status of being appreciated for their artistic merits as well as for their entertainment value.

Meanwhile, film criticism has become very visible in American culture. Previously available only in major-city newspapers, film criticism is found in just about all city newspapers—some of it by excellent writers. More important, film criticism can be seen in our living rooms on a regular basis. Every major TV network has a resident film reviewer; many individual stations do. Some critics, such as Gene Siskel and Roger Ebert, are as celebrated as the films and actors they talk about.

In the 1960s, when film was becoming recognized as an art form, a number of visual artists—some of them famous as painters or sculptors—experimented with the medium. Unlike directors in the film industry, however, these artists did not have the help of actors, camera persons, musicians, and technicians, to mention a few of the army of professionals involved in making movies. With hand-held cameras, serving as their own directors and camera technicians, sometimes prevailing on friends to be actors, these intrepid artists created films, sometimes very original

ones, on a shoe string. Recently, artists have turned to video. It might seem that these artists and their works would be models for use in the elementary art classroom. With few exceptions, however, their products, whether on film or video, are largely experimental or avant-garde, and therefore are not very available for viewing nor very age-appropriate for the elementary level. One exception consists of the works of performance artist Laurie Anderson whose multimedia mix of film, electronics, costumes, songs, and stories are not only very inventive but also reasonably accessible to general audiences.[9]

Commercial films, on the other hand, are very available (as video rentals) and, if carefully selected, age-appropriate. Network or cable video programs are also very available—either as live broadcasts or on tape. These should also be screened for age appropriateness—particularly music-video productions. While industry-produced films or videos are preferred over artist-produced ones for school use, they have the disadvantage of being somewhat removed from the realm of the traditional visual arts. In addition to the visual elements and the film elements of the shot and sequence, commercially produced films and videos typically must account for the elements of theater, such things as character development and plot. In most universities, for example, film studies are located in theater/drama departments. This suggests that successful teaching of film or video would call for the kind of interdisciplinary mixes discussed in Chapter 11—in this case, art and drama or art and language arts. (In the case of music video, however, the mix would obviously be art and music.)

The approaches for teaching history, aesthetics, and criticism would not differ from those discussed in Chapters 8 and 11 for teaching art history, or in this chapter for teaching comics history. A bibliography of introductory books on film is included at the end of the book for your convenience in this regard.

However, you do not need to be literate in either film or video to teach them. It is a matter of your fostering historical research, aesthetic inquiry, and criticism on the part of your students. Thanks to VCR technology and the presence of video rental stores, you and your students are able to play and replay films as well as to record and play back television programs. Given these

resources, appropriate films and videos can be brought into the classroom for engaging in history, aesthetics, and criticism.

History As with comics, students can classify film and video productions as to style, genre, or content, or compare past with present, and so on. Have Westerns changed in style and content since the 1930s? If so, in what ways? Students can explore the relationship between the 1920s surrealistic movement in art—particularly works by Salvador Dali (Chapter 2, Fig. 2–3) and René Magritte (Chapter 6, Fig. 6–3)—and the recent phenomenon of music video.

Aesthetics The artistic status of film or video raises questions similar to those raised about comics? Is film art? Is video art? Or are only some films (video productions) art? If so, what are the distinguishing characteristics of those considered art? Students can argue on behalf of their favorite film or television show being classified as art (or not).

Art Criticism Finally, there are ample models of professional film and video criticism out there. While Gene Siskel does not use Feldman's method, he does nevertheless base his interpretations and judgments on evidence, evidence grounded in description and analysis. You and the students could observe the ways in which he does this (especially when he has to defend his interpretations and judgments before Roger Ebert, or vice versa). Because of the time involved in studying feature-length films, you may want to make film criticism an out-of-class assignment. Also because there are more parameters to consider in critiquing a film or video than in critiquing a single painting, a student may have to limit the description phase to just some aspects of the film or video. Other than that, the method of criticism would not be basically different.

Producing Films or Videos

The following are suggestions—not detailed recipes—for film or video-related activities.

Story Boards A story board is a series of pictures resembling a comic strip. Each picture corresponds to a single shot; each series of pictures, to a sequence. Film directors use story boards to *previsualize* a sequence before the actual shooting, especially for action-packed scenes. Students may enjoy making story boards without having them realized in an actual film or video production. In addition to the illustrations, students may desire to include information about the camera, its location, whether it is stationary or tracking, and the running time for each shot. They may also add script.

Producing a Film or Video For reasons previously stated, we recommend camcorders instead of movie cameras. The actual filming or taping of a story based on a student-generated story board—especially if the subject is science fiction or something equally exotic—may seem to present insurmountable problems in terms of staging and special effects. However, you should realize that students can be very forgiving of the final results, no matter how crude. The reward here consists of the fun, not to mention the educational benefits of doing such a project in the first place.

Time-Lapse Animation Some camcorders have animation features, one of which is an automatic time lapse. For example, a camera can be set to expose 1 second of running time at 15-second intervals. This might be appropriate for taping the gradual opening of a *four o'clock* flower, in this case, an hour's worth of unfolding petals revealed in 4 minutes of time-lapse animation. The same method can be used for taping the movements of clouds. In both cases the camcorder should be stabilized on a tripod.

Animation Animation relies on a phenomenon known as persistence of vision, the ability of the brain to synthesize individual images into a continuum of movement. Some camcorders allow for exposures as short as 1/4 of a second—equivalent to six frames of movie film. (However, these bursts—short as they are—may not permit the smoothness of motion that can be acquired with the single frame shooting of a film camera.)[10]

For animating graphic work, the camera should be mounted on a copystand directly over the graphic work (which is resting on a flat surface). We suggest using cutout figures instead of line drawings. The cutouts can be moved slightly between each exposure. Limbs can be attached separately so that they can be moved as needed. It is suggested that an animation project be preceded by a unit on comic strips or story boards so

that students would have some previously developed characters and stories to use.

For animating sculptures, the camera should be mounted on a tripod and aimed at a created environment inhabited by movable sculptures. We suggest using oil clay which is very malleable for the sculptures. Oil clay lends itself well to changeable facial expressions. Children may enjoy making heads with faces that change or even metamorphose. With imagination they can enjoy, for example, transforming heads into alien creatures and back again.

Painting Directly on Film This kind of animation—which consists of painting or drawing directly on film—requires neither a camera nor a camcorder. All you need is some film, marking pens and/or food colors, and a projector. As to the film, it may be exposed film leader or exposed film in which the images have been removed with bleach. (You may want to retain some of the imagery for a special effect.) Consult the high school athletic department—which uses reels and reels of film to study games—for obtaining old film. Other than orienting students to what is up and down and front and back on the film, let them create at will.

Most of these projects lend themselves to group work. Students may be assigned or self-assigned to certain specialties in each group (not unlike the division of labor we suggested earlier for making comic strips). Finally, before trying any one of these projects on a class, you should first experiment with it.

Summary

Comic strips, film, and video, all of which involve story-telling to greater or lesser degrees, are considered popular art—art that is accessible to, and enjoyed by, the general public. Because this art is so pervasive in a modern society, it belongs in a comprehensive art program if for no other reason than to equip our students, the future consumers of popular culture, with better tools of discrimination. Because the functions of popular art resemble those of fine art, especially premodern art, a study of the former can foster appreciation of the latter. And finally, some popular art is as deserving of our attention and appreciation as fine art.

Of the three media reviewed, comic strips are the most practical for elementary. They can be xeroxed from new or old newspapers and comic books. They are also to be found in many scholarly books. (*Make certain that your use of these resources does not violate copyright laws.*) Just as with reproductions of paintings or sculptures, these can be studied in the classroom from the standpoints of history, aesthetics, and art criticism. Creating comics in the classroom draws on basically the same materials and skills that studio work in drawing and painting do.

Accessing examples of film and video is more complicated than accessing comics. But given the technology of VCRs and the existence of rental film stores—and assuming you have a modest budget and VCR and television monitors in your school—these media can also be brought into the classroom. Like comics, they can be studied from the standpoints of history, aesthetics, and criticism—although the time involved in viewing and describing feature-length films is a disadvantage. Producing films or videos in the classroom obviously poses more problems and requires more equipment than producing comics, but it can be done. Suggestions, but not detailed recipes, are contained in this chapter and refer to such activities as making story boards, producing an actual film or video based on a student-generated story board, time-lapse animation, animation, and painting directly on film.

Notes

1. Wertham, Fredric. (1954). *Seduction of the innocent.* New York: Rinehart.
2. Eisner, Will. (1985). *Comics and sequential art.* Forestville, CA: Eclipse Books, pp. 112–121.
3. Hobbs, Jack A. (1995). Comic Relief Is in the News *Learning, 24* (1), Aug. '95 pp. 48–9
4. Ibid.
5. Mosher, Mike. (1994). On Teaching Kids Comics. *The Comics Journal, 170* (August), p. 89.
6. Ibid.
7. Ibid.
8. Hall, Justin. (1994). Contrasting Experience. *The Comics Journal, 172* (November), p. 8.
9. Viz. Anderson, Laurie. (1986). "Home of the Brave", which recently aired over the Bravo network.
10. Erhlich, Linda. (1995). Animation for children: David Ehrlich and the Cleveland Museum of Art Workshop. *Art Education, 48* (2), 24.

18

Classroom Protocols in Art

"Miss Young, I need help—quick!" "What's the matter, Billy?" "My paint is running down my picture!" (Frantically blots the paint with a paper towel.) "It's ruining it!"

"Miss Young, look at my dress! My mother told me to keep it clean. Does this color come out? (Kendra begins to cry.) Can I go wash it in the restroom?"

"Hey, Miss Young!" (Frank smiles happily). I finally got the paint out of the carpet in your classroom."

"Miss Young, our custodian found finger marks on the walls in the hall and paint spattered all over the restrooms. Not to mention your carpet." (Mr. Martinez, the principal, frowns.) "Please try not to let that happen again."

We know you think teaching art is important. But is it worth the hassle? Your room may not be equipped for art—it may not even have a sink.

Your worst nightmare may be that you are unable to control either the media or your students, or both—these scenarios are, unfortunately, real ones. Some teachers solve this problem by avoiding art altogether. There is no way to teach art without encountering these kinds of predicaments now and then—or is there?

MANAGING ART MATERIALS

Managing classroom art materials requires your attention, no matter whether you are a classroom teacher or an art specialist. Teaching students skills with art media is an important part of teaching art. Lila Crespin, a former classroom teacher, art specialist, and elementary principal, suggests that all teachers should have certain expectations for their own and their students' behaviors when handling art materials. These expectations can ease the trauma of elementary art-making activities.[1]

Expectations of Behavior

Teacher Expectations of Student Behavior Crespin has found from experience that if you show children how to use art media properly, and then consistently reinforce responsible behavior, you will be able to manage art-making activities successfully (Table 18–1). She asks students to act out appropriate behaviors—technical procedures, care of tools, and so on, including how to clean up—before they begin their art-making activity, even though this takes a little time away from making art. Crespin also shows students in

TABLE 18-1 Managing Materials and Children: Expectations That Teachers Must Teach and Live By[a]

1. I expect to show all of my students the appropriate way to work with art materials and how to clean up those materials.
2. I expect all of my students to dramatize (yes, "act out") appropriate behavior, and to know the consequences for inappropriate behavior, BEFORE I give them any art media.
3. I expect to show my students how to self-correct any errors made with art media (no one child is perfect —I can be sure of that!).
4. I expect to enforce and reinforce appropriate behavior consistently whenever my students are performing with any art media.
5. I expect my students to have good attitudes and actions toward other students who are learning and performing in art; in other words, they will mirror MY attitude!

[a]Adapted from Crespin, Lila. (1987). *Managing materials and children with art activities.* Unpublished manuscript written for Phi Delta Kappa, Bloomington, IN.

advance what to do in case something goes wrong, so that they can correct their mistakes by themselves.

Student Expectations of Their Own Behavior You can also shape children's expectations of their own behavior when they are learning about art (Table 18-2). If art is to be a serious subject, students should maintain a classroom atmosphere conducive to learning. Teaching an attitude of seriousness is necessary because most children associate art with extracurricular (or recreational) activities. Children's attitudes determine whether an art activity is active learning or play.

Expectations of Time

Allowing enough time to complete art-making activities can also reduce your "art anxiety." In deciding how much time to allow for any activity, you should consider the students' ages (levels of maturity), their levels of prior experience, and the complexity of the activity they will undertake. If you have only a small amount of time available on a given day, divide the art activity into two or more parts rather than trying to hurry through it.

Be sure to leave enough time for the three major segments of your lesson: visual analysis, art production, and critical/historical/aesthetic analysis (see Chapter 9). Students will take each part only as seriously as you do. Each contributes certain thinking opportunities that are crucial to the art making process, so to slight any part because you are short of time jeopardizes your students' learning in two ways: they have less exposure, and they consider art to be less important.

Some children will complete their assigned work faster than others. Your job is to make sure that those who do are productively occupied for the entire working time available. Your have a number of options: you can ask students to reconsider certain aspects of the assignment, and keep

TABLE 18-2 Managing Materials and Children: Expectations That Children Must Perform and Live By[a]

1. I know what my teacher expects of me.
2. I expect to do my art work well and with serious intent.
3. I expect my teacher to show me how to work with any media he or she gives me, what to do if I make a mistake, and how to clean up after I have completed the activity.
4. I expect my teacher to praise me for good behavior and media use, not just correct me for poor behavior and media use.
5. I know I will be quickly excluded to a predetermined place if my behavior is not appropriate for learning about or producing art (my teachers IS consistent about this).

[a]Adapted from Crespin, Lila. (1987). *Managing materials and children with art activities.* Unpublished manuscript written for Phi Delta Kappa, Bloomington, IN.

working on it; you can ask them to redo the project; or you can assign them additional work to extend the project. You will base your decision on the outcome of each individual's project.

Leaving ample time for students to clean up their work spaces and themselves properly is also important. You want students to be responsible for themselves. Treat this as part of the learning process.

Evaluation of Expectations

Crespin suggests that you and your students periodically evaluate classroom media managing to find out which procedures are working well and which ones need to be improved. Examine aspects such as your and your students' behavior, the requirements of the media you have used, the requirements of the projects attempted, and whether or not time allotments have been realistic. If this self-evaluation occurs periodically throughout the quarter or semester, your teaching can be more responsive to the needs of your current group of students. Next quarter's or next year's group may have different working patterns and different needs.

Media Tips

Chapters 15, 16, and 17 describe a variety of art techniques suitable for elementary classrooms.

Each art medium needs different management skills. Billy's problem with running paint, for example, occurred because his desk was slanted; a flat table would have made a better workplace. Kendra's came from standing too close to her desk; standing behind her chair would have kept her at a safe distance from her painting (thank goodness you were using nonpermanent colors). The children's paint containers were too large for their desks and one of them fell off (baby-food jars are just the right size and the lid can hold the water). Instead of blotting the carpet with paper towels until it was dry, the anxious student tried to wash the paint out—adding water and in the process making more paint.

Children left finger marks in the hall because their only sinks were in the restrooms down the hall. Crespin suggests that children who have paint on their hands, from finger painting or by accident, make a "hand sandwich" by wiping their hands dry on a paper towel and then holding it between their hands in a "praying" position. As they travel to the sink, whether it is in the room or down the hall, they will not touch other objects as long as their "sandwich" is intact (see Table 18–3).

ENCOURAGING RESPONSIBLE CLASSROOM BEHAVIOR

Every teacher knows that some classroom environments are more conducive to learning than

TABLE 18–3 Cleanup Techniques for CHILDREN After Using Tempera Paint[a]

1. The only time you should have paint on your hands or arms is when you finger paint or if you have had an accident.
2. When there is paint on your hands or arms, you pat, blot, and wipe it off with your paper towel. Refold your towel when it is full of paint in order to use a clean side. Keep folding and using clean sides UNTIL YOU ARE COMPLETELY DRY. (You will not be clean—you will still see paint stains—but you will be DRY.)
3. When you finish your painting, raise your hand. When I give you a signal, carry it to the drying place (rack, shelf, floor along the wall), and then return to your desk.
4. Leave your brushes and paint jars and lids (containing water) on the newspaper covering your desk. I will choose some students to collect and close the jars. I will choose others to collect the brushes in the newspaper, and carry them to the sink. I will choose two students to wash and rinse brushes in the sink.
5. Wipe your hands dry so that no more paint will come off on your towel. Make a "hand sandwich" by holding your paper towel between your hands in a "praying" position. Your position tells me you are "praying" that I will let you go wash off the stains.
6. You do not have permission to go wash or do anything until I give you a signal. When I see that your "hand sandwich" is ready, I will let you go. When you leave for the sink (or the bathroom), keep your "hand sandwich" INTACT until you get there.

[a]Adapted from Crespin, Lila. (1987). *Managing materials and children with art activities.* Unpublished manuscript written for Phi Delta Kappa, Bloomington, IN.

others. Art by its nature is more interesting for your students than some other subjects. In fact, how to respond to their natural enthusiasm may be more of a concern than overcoming apathy or dealing with other behavioral problems. You will want to channel your students' natural energy and curiosity.

Many of your students may come from homes that contain no original art. Perhaps their previous experience has been to regard art as recreation, and therefore as inconsequential. There are a number of things you can do to create an environment in which children will study art seriously:

- Decorating your room with artwork, making it a pleasant and aesthetically stimulating environment.
- Starting your art lesson on time, not ending early; making the entire experience "quality" instructional time.
- Spending a small amount of time (2 to 13 percent) on setting up equipment and materials.
- Spending a good deal of time (65 to 85 percent) in interaction with the entire class rather than with individuals.
- Showing your students acceptable art behavior, including what to do in case of accidents before they occur.
- Making clear what the consequences of inappropriate behavior will be.
- Consistently maintaining your expectations of serious behavior by your students.
- Praising your students for work in the classroom and arranging for them to receive recognition at school art exhibits, assemblies, and other public functions.[2]

Teaching children to act responsibly in the art classroom is compatible with the kind of active learning that we value in art. Responsible behavior encourages critical thinking and the ability to make decisions, and vice versa. Students learn to make choices and to recognize the results of their actions.

Your expectations for students' behavior during art lessons reflect your own principles governing classroom interaction. You can state these explicitly if you wish and discuss them with your students. These might be some of your principles:

- Be respectful of others.
- Be courteous.
- Be prepared.
- Treat others as you wish to be treated.
- Try your best at all times.[3]
- Acknowledge your mistakes.
- If you are not satisfied the first time, try again.

MEDIA AND CHILDREN'S HEALTH

The media discussed in Chapters 15, 16, and 17 are safe for elementary children (Table 18–4 for a list of basic art supplies), but not all art materials are benign. Twenty years ago the toxic properties of many materials were not widely recognized. Even 10 years ago, health hazards expert Michael McCann found teachers in preschools and elementary schools still using hazardous art materials. Children have the right to attend school in a safe environment.

Some kinds of media and techniques are toxic to human beings and must be used by artists with great care. They can produce both short-term and long-term effects including dermatitis, lead poisoning, silicosis, liver and kidney damage, nerve damage, carbon monoxide poisoning, and cancer.[4] These toxic art materials are too hazardous for children under 12 years of age to use. Unfortunately, you may still find some of them in your supply closet.

You should be able to recognize symptoms of toxicity, even though some of them may not appear until long after exposure. Symptoms include headaches, dizziness, fatigue, blurred vision, nausea, nervousness, chronic coughing, loss of appetite, skin problems, irritability, breathing difficulties, and similar problems.[5] It is your responsibility to keep toxic substances out of your classroom.

Routes of Entry

Toxic materials can enter the body in three ways: through the skin, by breathing them in, and by mouth. The most frequent way is through the skin. Many substances, such as organic solvents, peroxides, and bleaches, can destroy the skin's protective coating, causing various kinds of dermatitis. Some solvents, such as turpentine (used with oil paints), benzine, toluene (found in permanent markers and enamel paints used on

TABLE 18–4 Basic Art Supplies for an Elementary Classroom

The best time to order your art supplies is in the spring, so you will have them when school begins in the fall. In order to estimate the amounts you will need with any accuracy, you should know in advance what lessons you plan to teach. The list below will get you started. Buying them in bulk is less expensive and will stretch your supply budget.

These supplies are generic. As you develop your own catalog of art projects, you will undoubtedly discover a need for others that are more specialized. Remember, do not use adult art supplies. Buy materials that carry the Certified Product (CP) or Approved Product (AP) stamp of approval from the Arts and Crafts Materials Institute.

Clay

Earthenware (low-fire ceramic clay)
Canvas or masonite work pads
Garbage can with lid for clay storage
Modeling clay (nonceramic)
Plastic trash bags for clay storage
Rolling pins
Quarter-inch wood strips
Wire clay cutter

Drawing and Painting Tools

Brushes
Chalk
Charcoal
Colored pencils
Conte crayons
Crayons (wax)
Erasers (art gum or kneaded)
Felt-tip markers
Graphite sticks
Inks (black and colored)
Pencils
Pens (straight)

Fibers

Burlap
Muslin
Thread
Yarn

Found Objects

Cardboard rollers (paper towels, etc.)
Cloth scraps
Egg cartons
Ice cream sticks

Jars and lids
Magazines
Newspapers
Plastic bags
Rags
Still-life objects
Styrofoam meat trays
Tin cans
Wallpaper samples
Wood scraps

Miscellaneous (for your students)

Glue (glue sticks, library paste, white glue)
Paper towels
Plastic wrap
Pipe cleaners
Rubber bands
Rulers
Scissors
Sponges
String
Waxed paper
Yardsticks

Miscellaneous (for you)

Clamp lights
Clothespins
Mat knife
Stapler
Tape (paper, masking, scotch)
Thumb tacks
Xacto knife

Papers

Brown wrapping paper
Butcher paper

Cardboard
Construction paper (colored)
Corrugated paper
Manilla paper
Mat board
Newsprint
Tag board
Tissue paper (colored)
White paper

Paints

Colored inks
Finger paint
Laundry starch
Tempera paint
Transparent water colors

Printing Materials

Brayers (rubber rollers)
Cookie sheets
Linoleum blocks
Linoleum carving tools
Printing ink (water based)
Rubber gloves

Sculpture

Carving tools
Papier-mâché (flour and water paste, newspaper)
Plaster of paris
Plaster-impregnated bandage
Pliers (with wire cutters)
Sawdust
Tongue depressors
Toothpicks
Wire
Wood scraps

model airplanes), and methyl alcohol (wood alcohol), can even enter the bloodstream through the skin and affect other parts of the body.

The second most frequent way for toxic materials to enter the body is by inhaling them. Materials such as glacial acetic acid (a "stop bath" used in photographic developing) or sulfur dioxide gas from ceramic kilns can immediately damage the sensitive linings of the airways and lungs.

Substances that can be dissolved in the blood may travel beyond the lungs to affect the rest of the body.

The third way for toxic substances to enter the body is through the mouth. If children's hands touch their mouths or food or other objects placed in the mouth during art class, they are apt to swallow small amounts of art materials. This can be a problem especially for young children.

Risks for Children

A given amount of a toxic substance might not harm an adult but could injure a child. Children are more susceptible to toxic materials than adults because they are still growing. Their metabolisms are higher, they absorb toxic substances faster, and the effects of those substances (on the brain, nervous system, and lungs) is quicker and stronger. Children's body weight is low in proportion to their exposure; the less they weigh, the more they are at risk.

The toxic effects of some materials may be enhanced in classrooms that do not have adequate sinks or ventilation. Many elementary schools, even "newer" ones, have ventilation systems that are inadequate for art. Even some art classrooms are improperly ventilated for equipment such as ceramic kilns.

The degree to which toxic materials affect individuals depends on a number of factors. Someone who is exposed to a small amount for a few minutes each day is obviously less at risk than someone who uses a large amount for several hours at a time. Some materials are more toxic than others, so a small amount of those may be as injurious as a large amount of others that are less toxic. Some materials have a synergistic effect; they cause more damage when encountered simultaneously.

Materials Unsuitable for Elementary Art

Solvents and Aerosol Sprays *Solvents and aerosol sprays have no place in an elementary school.* Most organic solvents can cause dermatitis and are poisonous if students swallow or inhale enough of them. Even alcohols, which are anesthetics, irritate skin, eyes, and upper respiratory tract. As little as two tablespoons of methanol (wood alcohol), if ingested by a child, can have serious toxic effects—perhaps blindness. More could cause death.

Aromatic hydrocarbons such as benzol, toluene, and styrene are some of the most dangerous solvents. They are found in paint and varnish removers, silk-screen washup, lacquer thinners, and aerosol spray cans, among other things. In a worst-case scenario, they can cause damage to bone marrow and sometimes lead to leukemia, liver, and kidney damage.

Chlorinated hydrocarbons are also toxic. Carbon tetrachloride (what children formerly euthanized butterflies with), one of the most toxic, can be absorbed through the skin. Severe liver and kidney damage can result from exposure to even small amounts. Chlorinated hydrocarbons are so dangerous children should never be exposed to them.

Petroleum distillates are less toxic than other solvents, but nevertheless can cause lung inflammation and peripheral nerve damage. Rubber cement contains natural rubber dissolved in low-boiling petroleum distillates. Without good ventilation, exposure can cause nerve damage. Spray rubber cement is especially hazardous because it can be inhaled. *n*-Hexane, gasoline, benzine, mineral spirits (odorless paint thinner turpentine substitutes), and kerosene are petroleum distillates used in paint thinners, rubber-cement thinners, and so on. Avoid them.

Turpentine is commonly used to thin oil paint and varnish. It can irritate and be absorbed through the skin, and some kinds may cause severe kidney damage. If swallowed, turpentine is extremely poisonous; even one tablespoon may be a fatal dose for a child.

Metals and Enamels Work with metals that involves casting or soldering is too risky for elementary children. Inhalation of metal fumes is the greatest risk. Soldering silver in particular can be hazardous because some silver solders contain cadmium. Cadmium fumes can cause chemical pneumonia, and there is at least one documented death from brazing with a silver solder as a result of inhaling cadmium fumes.

Most of the enamels used on copper are lead based. Lead is one of the most dangerous substances for children, and its negative effects are well known. Other hazardous metals found in enamels are nickel, manganese, chromium, and cobalt.

Stained Glass Lead poisoning is also a hazard in making stained glass, if the process involves soldering with lead and tin solders.

Acceptable Art Materials and Precautions for Use

Glue Library paste, flour-and-water paste, glue sticks, or white glue are benign and suitable for elementary children.

Felt-Tip Markers Washable markers are generally benign.

Note: *Permanent markers are toxic.* They contain hazardous solvents (toluene) that can be absorbed through the skin or inhaled. Do not use permanent markers in your classroom.

Water-Soluble Paints The water-soluble tempera paints used in elementary classrooms are generally benign, although some hazardous pigments are found in adult water-based paints.

Water-based acrylic paints are less suitable than tempera. They contain a small amount of ammonia and formaldehyde, which can cause throat, nose, and eye irritation under conditions of poor ventilation. Acrylic colors are permanent and will stain clothing.

Note: Many inorganic pigments used in oil paints are hazardous, and they require the use of solvents for thinners. This is good reason why *oil paint is not a suitable medium for children.* House paints, enamels, automotive paints and the like can contain toxic solvents and you should not use them without first making sure they are benign.

Printing Inks Water-soluble printing inks for relief printing are generally considered benign.

Note: Other printing inks can contain the same hazardous pigments as oil paints do. Silk-screen printing, if solvent-based inks are used, present unacceptable hazards for elementary children. Although silk screen is often taught in high school, its health risks can be high. Intaglio and lithography are complex techniques whose risks from inks and acids also suggest they are better left for older students.

Charcoal and Chalks Buy chalks that are labeled nontoxic.

Note: *Use all charcoal and chalks with care.* Charcoal contains carbon black, and chalks and pastels can contain hazardous pigments. The dust that accumulates as students use these materials constitutes a hazard if children inhale them. Be sure the chalks you use are specifically for children; do not use artists' pastels. Even so, make sure that your students do not blow charcoal or chalk dust off of their papers and into the air, or shake their drawings to dislodge the dust. Have them wash their hands thoroughly when they finish work.

Clays and Glazes Workable (mixed) clay is benign. Buy ready-mixed glazes labeled nontoxic.

Note: Powdered clay is hazardous. Buying ready-mixed clay is preferable to buying clay in powdered form. If dry clay is mixed in the classroom, inhalation of clay dust can cause silicosis, whose symptoms may not develop for years.

Powdered glazes also contain free silica. Many glazes also contain toxic metals such as lead, barium, lithium, chromium, manganese, cadmium, and chromates. Lead frits (vitreous substances used in making glazes), often assumed to be safe, can dissolve in stomach acids. Some ready-mixed glazes may not carry warning labels.

Wood Working with wood is safe in elementary schools as long as power tools are not used.

Note: Power saws and sanders create unacceptable levels of airborne sawdust. Even a high noise level, such as made by some power tools, can damage children's hearing. Power tools are hazardous in any case. They do not belong in your classroom.

Styrofoam and Other Plastics Polystyrene foam sheets or blocks are often used for sculpture because they are easy to carve or cut and are safe for children to use.

Note: If you are cutting or sawing large amounts of styrofoam, however, you can release a colorless, odorless gas (methyl chloride) that is toxic. Some styrene cements used with the foam may be toxic also.

Note: Fiberglass, often used for laminating, irritates the skin, and the dust, when sanded, irritates the lungs. Fiberglass does not belong in your classroom. Teflon is safe as long as it is not heated to the point that it decomposes.

Plaster Plaster of paris (calcium sulfate) in liquid or hard form is benign.

Note: When plaster sets, it becomes hot. There are cases of severe burns of children and adults making plaster casts of body parts. McCann recommends that this process not be done with children. Plaster-impregnated gauze used for making medical casts is less hazardous

Plaster of paris in powdered form can irritate the eyes and the respiratory system. You should mix plaster in an area away from students. If children carve plaster, it should be in a well ventilated room.

Batik Beeswax and paraffin, a petroleum wax, do not pose health risks in a solid or warm state. (Chlorinated waxes sometimes used in foundry casting are extremely hazardous; do not use these under any circumstances.)

Note: Wax is flammable and should never be heated on an open flame or a hot plate with an exposed element, or overheated. Use an electric frying pan or a hot plate with a good thermostat.

Overheated wax can decompose and vaporize into substances that can damage the lungs. Overheating can also occur during ironing of fabric to remove wax. Do not use solvents to remove wax, however; send the ironed material to a dry cleaner.

Fibers Most processed yarns and commercially woven cloth are benign.

Note: Dust from processing fibers such as spinning can cause respiratory irritation and allergies. Imported animal fibers such as wool or yarn can carry spores of anthrax, a serious bacterial disease. Be sure that you buy decontaminated wool.

Certain dyes can also carry hazards. Some dyes are skin irritants and may cause allergic responses. Longer term hazards are assumed to exist, but have not been studied thoroughly. Wear protective gloves when making tiedyed and batik designs.

Photography Using cameras to take photographs does not pose health risks.

Note: Developing film requires caution. The developing process involves many chemicals that can cause skin problems and sometimes lung irritation. The greatest risk is to you, during the handling of concentrated solutions in preparing the various developing and fixing baths. It is necessary to wear goggles and protective gloves. When developing, use tongs to avoid putting your hands into the developer. Make sure you have a sink available to wash your hands if chemicals do contact your skin.

Minimizing Risk

Using toxic materials safely requires students to know and follow safety procedures. Children under 12 years of age are not dependable in

this regard. Young children habitually put objects such as pencils and paintbrushes into their mouths. Several children have died as a result of accidentally swallowing turpentine or paint thinner, some of which had been stored in soda bottles or juice containers.

Children of middle-school age can use more hazardous tools and materials than younger ones. It is your responsibility to teach them to take appropriate precautions. Never use highly toxic materials such as asbestos, lead, mercury, and cadmium even though you have complete confidence in your students' maturity.[6]

Here are some suggestions for minimizing risk to your students from art materials.

- Buy art materials that carry the Certified Product (CP) or Approved Product (AP) stamp of approval from the Arts and Crafts Materials Institute. They are presumably safe for children even if swallowed.

- Do not use adult art materials for classroom projects. A material whose label does not carry a warning is not necessarily safe. Many materials whose label identifies them as "nontoxic" have not been tested for long-term toxic effects.

- Use glues, paints, and inks that are water based. Make sure that they do not contain lead, cadmium, chromium, or other toxic pigments. Do not use solvent-based materials of any kind.

- Prepare materials when your students are not present. You can mix clay or plaster with water before class begins, for example, preferably in a preparation room separated from the classroom.

- Always spray-fix chalk or charcoal drawings out of doors unless you have a specially vented spray booth. Do not spray in hallways where building ventilation can circulate fumes to other classrooms.

- Keep your room clean. In a clean room, children cannot inhale dust from clay, plaster, charcoal, chalk, and other substances.

- Make sure that hand washing—with soap—is a regular part of cleanup. Children with open sores or cuts on their hands should not use some art materials. Your room should have a sink not only for cleanup, but in case children should accidentally get a foreign substance in their eyes. Children should not eat in the art room or art area, in order to prevent ingesting art materials.

- Locate your ceramic kiln in a separate room with ventilation designed especially for it. Fire your kiln after school hours, if possible. If the kiln room adjoins the classroom, leave the connecting door closed during firing.

The Classroom Art Environment

Although you have learned what supplies to order and what to avoid, does making art require a better equipped classroom than the one in which you may teach? Your school may have an art room, or it may not. You may have unlimited art supplies, or you may not. You may have a classroom with an art area, or you may have a classroom without a sink. You may have a media center, or you may be unable to darken your windows to show slides. If you have limited facilities, can you still teach art?

You can teach some kind of art anywhere. You can teach major art concepts with the simplest of materials, as well as the most complex. The more space you have, and the more equipment your school can afford, the greater variety of media and techniques you can offer to children. Technical variety is certainly desirable, but conceptual variety is more important. You are bound to have conceptual variety if you follow the guidelines set out in Chapters 8 and 9.

The Art Room

In real life art rooms range from a remodeled broom closet with no windows to light-filled areas whose facilities are specially designed for the art teacher (Fig. 18–1). Having said that you can offer significant art instruction with a minimum of means, it might be helpful to know what an ideal art room looks like. Perhaps your district is considering upgrading its school buildings. You may be asked to give the architects some advice.

In any case, let us consult the design standards for school art facilities published by the National Art Education Association (Table 18–5).[7] In the best of all worlds, art rooms should be larger and more specialized than other kinds of classrooms. Adequate storage space is essential, as well as room for some bulky equipment. Work areas should accommodate the traffic patterns created by active students. Windows provide natural light and walls serve to display completed art work.

An elementary art room should accommodate no more than 28 students at one time and 24 at the middle school level (Fig. 18–2). There should be one art room for every 400 to 500 students in an elementary school. Each student needs

55 square feet of net floor space, not counting storage space, the kiln room, computer facilities, library, or the teacher's office.[8] Elementary art projects are often large.

An art room is best located on the first floor, near a patio or outdoor work space and with a delivery entrance nearby. The first floor is more convenient for scheduling outdoor student activities such as sketching or building sculptures. A convenient delivery entrance simplifies obtaining art materials in bulk. Student art is most often displayed in first floor hallways, offices, and other public rooms. A location near performing arts areas can make interdisciplinary activities easier to undertake. Students with physical impairments need easy access.

At least one wall should be covered with cork wallboard for displaying student work, and well lighted. Shelving for storage and display of three-dimensional work is also desirable. Artificial lighting should enhance or duplicate natural lighting so that color relationships are accurate; the light fixtures should be located so there are as few shadows as possible. There should be a wall-mounted screen and a way to darken the room in order to show slides or films, or perhaps an adjoining lecture room for this purpose.

An elementary art room should contain certain essential equipment, some of which is large (Table 18–6). Drying racks are essential. Large work tables are better than individual desks. There should be a six- to twelve-foot chalk board. Storage cabinets for small tools need to have locks. At least one third of the students should be able to use the sinks at one time, from more than one side; the sinks should have easily cleaned sediment traps for clay and paint.

Rooms for Storage and Preparation of Materials and Equipment

A separate storage and preparation room, with its own sink, can simplify storage and handling of potentially hazardous materials. An electric ceramics kiln needs 45 square feet and special wiring; it should be placed in an adjoining room with its own ventilation system that exhausts directly to the outside. Any clay and glaze mixing also needs special ventilation. Lockable display cases in school hallways will prevent damage to student art works.

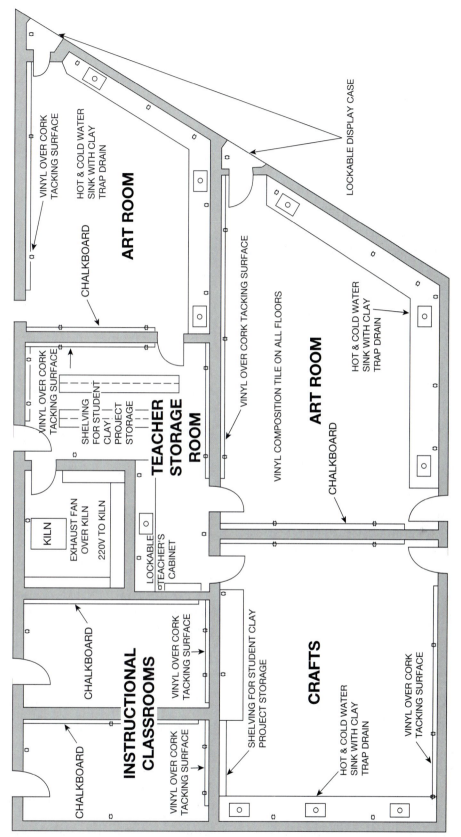

Figure 18-1 Specialized art classroom complex from Doerre Intermediate School, Klein Independent School District, Klein, TX. From *Art Education: Planning for teaching and learning*, Texas Education Agency. In Goodwin, Mac Arthur (ed.). (1993). *Design standards for school art facilities*. Reston, VA: National Art Education Association, p. 7.

TABLE 18–5 **Features of an Elementary Art Facility**[a]

Art Classroom

- Space adequate for class discussions, small group work, critiques, viewing slides, large two- and three-dimensional art projects, and working on computers.
- Adequate work space per student (about 55 square feet, excluding storage).
- Adequate space for storage, display, and equipment.
- Flexible space; easy access to equipment and tools.
- Natural lighting; artificial lighting that duplicates natural light; minimum shadows.
- Track lighting for display areas
- Capability for darkening room to show slides, films, or videos during the day.
- Electrical outlets conveniently located throughout the art room.
- Built-in AV screen and chalkboard.
- Sinks accessible from several sides at heights appropriate for elementary children and children in wheelchairs.
- Sinks equipped with hot and cold water, sediment traps, and acid-resistant drains.
- An outsize entrance door for installation of bulky art equipment.
- Acoustical buffering to minimize noise.
- Adequate ventilation.

Special Areas

- Special areas for ceramic kilns, photographic developing, plaster mixing, and other processes that require specialized ventilation.
- Securable space for storing equipment and supplies, some of which may be hazardous.
- Special areas for computers, photographic equipment, and other equipment that require a dust-free environment.
- Adequate teacher office space and work stations.
- Securable display areas central to the flow of school traffic.
- An area in the school dedicated to films, slide collections, and other instructional materials.

[a]Adapted from Goodwin, Mac Arthur (ed.). (1993). *Design standards for school art facilities.* Reston, VA: National Art Education Association.

A separate room for computers, slide projectors, slides, floppy and CD-Rom disks can keep this sensitive equipment dust free. If the school has a computer lab or media center, art students can work in that space on occasion, but there should be a computer work station in the art room as well. The media center could house the school's main slide and computer disk collections, software, books, videotapes, and so on.

No school has the perfect art room. Each room reflects the way someone teaches, and you will have your own "wish list" of supplies, equipment, and space. These specifications will give you some ideas for improving your own situation, an opportunity you will undoubtedly have at some time during your career.

DISPLAYING CHILDREN'S ART

Nothing is more heartwarming to someone entering an elementary school than the sight of children's artwork decorating its hallways and classrooms. It is more than seeing decoration on what may be (in older schools) drab institutional walls. The building seems alive with the energy and enthusiasm of its inhabitants so clearly evident on every side.

Decoration is certainly one reason for displaying child art. All adults and children respond positively to it. Your hallways, your cafeteria, your public spaces in your elementary building should be overflowing with artwork by its students—all of its students. Don't display only the "good" pieces—include everyone's efforts.

But decoration alone is not the only reason for displaying student artwork. Artwork in a school's public places testifies to the learning that takes place in the classrooms. When you display a completed project for your public—other teachers, other students, and their parents—be sure to accompany it with an explanation of what your students learned by making it. Ask viewers to share your and your students' respect for the difficulty of the artistic problem, your wonder at the variety and invention of the solutions, and your pride of accomplishment.

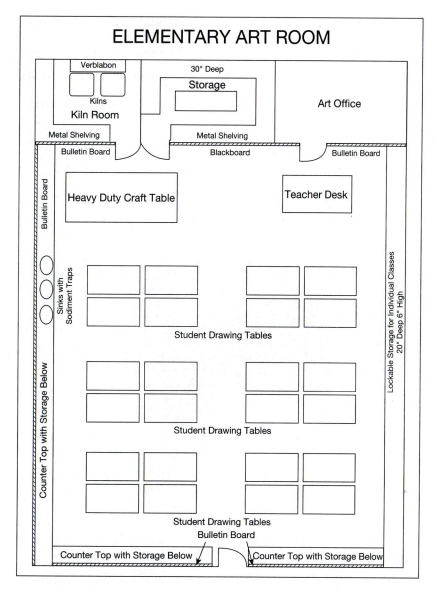

Figure 18-2 Generic elementary art classroom. From Goodwin, Mac Arthur (ed.). (1993). *Design standards for school art facilities.* Reston, Va: National Art Education Association, p. 8.

TABLE 18–6 Large Equipment for Elementary Art

Ceramic kiln
Drawing tables
Drying racks
Garbage cans with lids (clay storage)
Painting easels
Paper cutter
Slide projector and screen
Storage shelves
Work table (large)
Vise

Explanations are even more important when you display completed artwork in your classroom for important occasions such as parent-teacher conference days. Remember, many of your students' parents are less well-educated artistically than their children—particularly now that their children are seriously studying art. In art, the number of your students is often larger than you imagine—you may be teaching art indirectly to their parents as well.

Some child art is more suitable for public display than others—some looks more "finished"

than others. You should display two kinds of art inside your classroom on a daily basis, work from completed units and work from lessons that are part of units in progress. Work from some lessons may be a step on the way to a more complex composition. In addition, whenever you set a problem for your students to solve, you will temporarily display the results (for purposes of critique) no matter how "unfinished" it may look.

You may also be asked to provide children's artwork for an art exhibit. Some elementary schools establish "art galleries." Sometimes districts collect work from a number of schools to display in the administration building or to the public in the local shopping mall. Sometimes community business establishments enjoy displaying child art. The National Scholastic Art Awards is a competitive exhibition that occurs each year; the jurors are usually local artists or art educators. Artwork selected for local awards competes with child art from other communities at the state level, and then work selected at the state level goes to a national competition.

Display Areas

Displaying student art can be as easy as taping a picture to a wall or as difficult as framing it under glass. No matter which you are doing, be sure to leave enough space between artworks. An inch or two of wall space—or more, if you have it—will isolate the images from one another enough that viewers can concentrate on each one without being distracted by its neighbor.

Masking tape is good for hanging works on paper because it sticks to painted walls, and it also comes off of the wall (and the artwork) easily. The best method is to make small loops of tape and place them on all four corners of the picture back. Scotch tape pulls the surface of the paper off, and sometimes also the paint on the wall. Masking tape is not recommended for long-term exhibition (more than a week or two), because it dries out and loses its grip, leaving tell-tale marks.

If you are hanging pictures on a bulletin board or other soft surface, thumbtacks or push pins work well. You can avoid making holes in the picture by placing pins below the bottom (forming a rack for it to sit on) and at the sides. The heads of the pins will keep the work from

falling forward onto the floor. Sculptures, clay objects, and other three-dimensional artworks need to sit on something.

Art work displayed in school hallways at children's eye level is at risk from accidental or deliberate touching; hallways sustain heavy traffic at certain times of day. You owe it to your students to protect their displayed work from damage as much as you can. Secure exhibition space in most schools is at a premium, and is often occupied by school athletic trophies.

Lockable cabinets near the school auditorium and the principal's office would be ideal for display of student art, particularly the three-dimensional kind. An inexpensive alternative, for a permanent two-dimensional display area, is full-sized sheets of fiber board (4 × 8') painted white or black and mounted horizontally. These can be covered by heavy, transparent plastic (such as plexiglass) attached by screws.

Lacking permanent display areas, any convenient hall surface can accommodate two-dimensional artwork. Many teachers solve the security problem by hanging artwork higher than children can easily reach. This solution is effective, but the art is not as visible to students as it is to adults.

Preparing Child Art for Display

For everyday purposes, no special preparation is necessary. If dry paintings are wrinkled, or if drawings have been rolled, you could stack them under some weights (such as books) for a while to flatten them out. Weighting flattens paper particularly well when it is slightly damp (not wet; paintings will stick together). You could also iron pictures on the back (use a warm, not hot, iron) or put them into the kind of dry-mount press used for photographs.

For an exhibition in the hall, putting two-dimensional work into mats makes them look finished. A mat is a colored strip of paper or cardboard (mat board) that surrounds the paper and provides the visual isolation needed to see the work as a whole, without distraction. It serves as a "frame" or, with professional work, as a buffer between the art and the wooden frame.

To make a simple mat (Fig. 18–3), cut a rectangle of mat board larger than the artwork. Cut a second rectangle out of the first one that is just

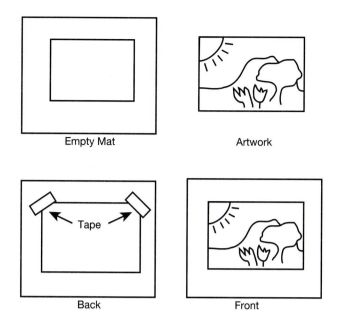

Figure 18-3 Simple mat.

The size of the mat should be proportional to the size of the artwork it contains. For a picture 18 × 24 inches, a mat should be about 3 inches wide. The bottom of the mat is always slightly wider than the sides to compensate for the fact that if it is the same size, viewers will perceive it as smaller. The color of the mat should complement the colors in the artwork that it contains.

Using a straightedge, draw the opening you wish to cut on the mat board. There is a special knife for cutting mats that consists of a handle into which you can fit a razor blade. Put the mat board to be cut on a thick piece of cardboard, or else you will cut into the surface of the table underneath. Hold the mat knife firmly and draw it steadily toward you, "freehand," along your drawn line.

The interior rectangle in a professionally made mat is always beveled (cut at a 45-degree angle to the surface of the mat board) (Fig. 18–5). When the mat board is colored, this provides a decorative white line around the picture. To do this flawlessly you need a special mat-cutting machine, although with practice you can get quite good without it—good enough for elementary art. When you begin, however, forget the diagonal; concentrate on making a smooth, straight line.

There will not be many occasions on which you want to frame child art under glass. If this should arise, simply make a mat to fit the inside of the frame. If you make the frame, or use an old one, hardware stores will cut single-strength window glass for you at little cost.

smaller than the work. You can then tape the work to the back of the mat so that, from the front, the mat overlaps all four sides of the picture. For a sturdier, more durable mat for exhibitions such as the Scholastic Art Awards, tape the work onto a cardboard cut the same size as the outer dimensions of the mat; you can attach the mat to the cardboard by a hinge at the top made from masking tape (Fig. 18–4).

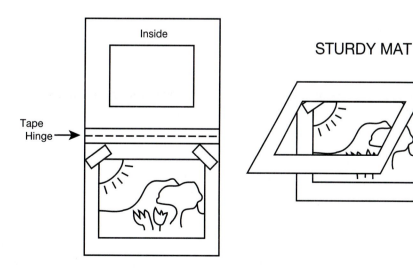

Figure 18-4 Sturdy mat.

DIAGONALLY CUT MAT BOARD

Figure 18-5 Diagonally cut mat board.

SUMMARY

Making art is an example of active learning. Children are able to solve real problems (make real artistic choices) only when they act responsibly. Creating an environment for serious art learning that is both exciting and safe with respect to using art tools and materials is as much a challenge of teaching as organizing content.

There are standards for children's responsible classroom behavior just as there are standards for the acquisition of art knowledge. As a teacher, you will need to have both. The same principles apply: you are seeking active, not passive, classroom management.

One of your primary responsibilities is to ensure that your classroom is a healthful environment for children. Some art media are potentially injurious for their users; children are more at risk than adults. Keep the hazardous ones out of your classroom altogether, no matter how interesting they may be. Observe precautions where necessary. Be alert for signs of toxicity.

There are always ways to improve the usability of your classroom for art making and viewing activities. You can rearrange furniture to improve traffic and to provide spaces for creating and looking at art. Some day you may be asked to recommend classroom features for a new building. There are standards here, too, to help you make your own "wish list."

Displaying children's art is a form of reward for your students. It is also a way to teach those children and adults who remain beyond your classroom. Know when and where to display child art. Do it often and do it well.

Stepping into the role of art teacher for the first time can be an intimidating experience, no matter how well prepared you are. There are practical as well as theoretical challenges. You will need to address both in order to create an environment where students take the study of art seriously.

NOTES

1. Crespin, Lila. (1987). *Managing materials and children with art activities.* Unpublished manuscript written for Phi Delta Kappa, Bloomington, IN.
2. Adapted from Curwin, Richard L., and Mendler, Allen N. (1988). *Discipline with dignity.* Alexandria, VA: Association for Supervision and Curriculum Development, pp. 11–12.
3. Items 1–5 are from Curwin et al., ibid., pp. 50–51.
4. McCann, Michael. (1985). *Health hazards manual for artists.* New York: Lyons and Burford, p. 3..
5. Ibid, p. viii.
6. Ibid.
7. Goodwin, Mac Arthur (ed.). (1993). *Design standards for school art facilities.* Reston, VA: National Art Education Association.
8. Ibid., p.4.

19

The Learning Environment

Visual art, partly because of its free-wheeling, playlike activities and its emphasis on unconventional thinking, has often fit uncomfortably into both the school day and our schools' stated educational purpose. Art educator Diana Korzenik observes, "Over and over again, teachers of art keep having to invent ways that art making can fit into the larger agenda of schools. . . . Studio processes are viable in schools only as long as they support and mesh with the current consensus of what schools should accomplish. In that respect, art must do what other subjects have done and still do. It must help children grow in directions the community values."[1]

If art is to be an integral part of general education, the two must have more than conceptual compatibility. Art instruction must also mesh with the logistics of American schools. Every elementary school has an organizational structure of its own, the most noticeable feature of which is its routine.

A school day is compartmentalized. Children learn in groups; classes meet and school buses arrive and depart and teachers eat lunch at specific times, and the routine is so constant it is hard to tell Friday from Monday. You cannot teach art whenever, wherever, or however you feel like it. Art competes for students' time with many other subjects. It, too, has its niche.

Art that is most compatible with the logistical aspect of elementary schools has the following structural features:

- Group instruction.
- Units with numerous components that can be completed in small amounts of time.
- A curriculum shared by classroom teachers and art specialists.
- Content that classroom teachers can teach.
- Assessability.

Serious art instruction requires at least 1 hour of time per child per week. Children may study art every day or once a week, depending on the preference and schedules of their teachers. In many schools, the weekly routine may ensure that this standard is met. Unfortunately, some elementary schools still offer students less than 1 hour of art per week.

A TEACHER'S ROLE

Strong teachers are the foundation of all good schools. To a far greater degree than history would suggest, the individual teacher's scope of influence—what happens in the classroom—is the

result of the teacher's choice.[2] As a result, most teachers need and want help in improving their skills, and most schools try to assist them in this endeavor. Staff development is the usual term for a program designed to strengthen teachers' professional effectiveness.

Teaching Strategies

Most people who choose teaching as a career are already successful teachers, if only in informal settings. Each develops ways of working with young people that seem to accomplish their educational goals. Nevertheless, teaching from instinct, or teaching the way we were taught, may not provide enough help with today's emphasis on encouraging active learning. It is a good idea to build a repertoire of effective teaching strategies.

Those who wish to teach children to be self-reliant, inventive, responsible members of society face challenges that may require help from more knowledgeable teachers. Fortunately, most effective classroom strategies will work whether you are teaching art or social studies. You can find many of them in the education literature. One good source for art teachers is *Inspiring Active Learning* by Merrill Harmin.[3]

Harmin pulls together strategies that real teachers in many schools, from kindergarten through college, find workable. Harmin assumes that schools should encourage students to learn for themselves. Students should not be passive receivers of information digested by their teacher.

Good teaching strategies involve students in the learning process in a natural way. Getting them to learn is no longer a struggle. As students become more and more interested in solving educational problems, they "become increasingly mature and responsible, and the classroom increasingly becomes a pleasant, thriving learning community."[4]

You can use active learning strategies for the following purposes:

- Ease teaching and improve learning.
- Establish a classroom that inspires all students to learn.
- Increase time-on-task for both slow and gifted students.
- Get students at risk to learn in ways that advance responsible self-management.

- Tailor an art program to meet different learning styles.
- Reduce misbehavior in and out of classrooms.
- Help new teachers get classrooms running smoothly.
- Assist in the implementation of an integrated, outcome-based curriculum.
- Shift attention from extrinsic rewards to intrinsic learning satisfactions.[5]

Harmin bases his work on the strategies of Grace Pilon.[6] He visited the classrooms of many teachers who had been Pilon's students. Harmin defines a fully inspirational classroom as one in which students exhibit five qualities, which he calls DESCA according to their initials: *dignity, energy, self-management, community,* and *awareness.* While space is too limited to describe Harmin's strategies in detail, Table 19–1 describes the characteristics of students with high and low amounts of DESCA.

Harmin offers some strategies for developing high-involvement learning, as follows:

A basic instructional strategy is the "Whip Around, Pass Option."[7]

Description: Asking each student in turn to speak to an issue or to say "I pass."
Purpose: To increase the number of students who speak up and to give students practice in responsible self-management.

* * * *

Sometimes we want to hear from many students, not just a few volunteers. In such situations, try saying: "Let's whip down the row of students by the window. When it comes your turn, either give your thoughts or say 'I pass.' You don't have to respond if you prefer not to. Let's go!"
The Whip Around, Pass Option strategy . . . raises the interest level of a class. Students often listen closely to how others respond to an issue to which they also have a response.

A basic strategy for encouraging without praising is "Attention Without Praise."[8]

Description: Giving full attention to a student, as by listening carefully, without offering praise.
Purpose: To support and encourage students without making them overdependent on approval from others.

* * * *

Sometimes we accidentally fall into praising patterns. Imagine a young student coming to a

TABLE 19-1 DESCA Scale for Rating a Class[a]

DIGNITY

1	2	3	4	5

No personal dignity: Students slouch or mope, as if feeling unimportant, weak, or hopeless. Or they act as if they will be worthless without high success or others' approval. Little evidence of self-confidence, self-respect.	**Clear dignity in all:** Talented or not, students sit and walk tall and speak up. Seem self-assured, confident, secure. Much evidence that students trust themselves and see themselves as valuable persons, worthy of respect.

ENERGY

1	2	3	4	5

Energy too low or high: Mood is slow; students seem lifeless, with much inactivity, apathy, waiting, time wasting. Or energy is too high; students seem stressed, frantic anxious, frazzled.	**Flow of comfortable energy:** The mood is vital, active, healthful. All students keep busy, engaged. No evidence of clock-watching. Time seems to fly.

SELF-MANAGEMENT

1	2	3	4	5

Students only follow orders: No evidence of self-responsibility, initiative, self-direction, personal choice. Students work passively, without personal commitment.	**All students are self-directing:** Students make appropriate choices, guide and discipline themselves, work willingly, with persistence. Students are not bossed.

COMMUNITY

1	2	3	4	5

Students are self-centered: Students act only for personal advantage with little concern for others' welfare. No evidence of teamwork, loyalty, belonging, kindness toward peers or toward teacher.	**Strong mood of togetherness:** Much sharing, cooperation, interdependence, mutuality. Students support one another and the teacher. No antagonism, rejection.

AWARENESS

1	2	3	4	5

Awareness is dull or narrow: Students seem bored, unaware, unresponsive, shallow. Work is mechanical busywork. No thinking, concentrating or searching. Student talk is impulsive, uncreative, routine, thoughtless. Much inattentiveness.	**All students are aware and alert:** Much concentration, observing, listening, thinking, noticing, evaluating. Students appear to be mindful, aware of what is going on. High level of attentiveness.

[a]Harmin, Merrill. (1994). *Inspiring active learning: A handbook for teachers.* Alexandria, VA: Association for Supervision and Curriculum Development, p. 6.

teacher with a drawing just completed. A caring teacher might easily respond, "What a beautiful picture, Terry!" or "This is a lovely blue tree, Terry," or "You printed your name just perfectly." Yet the student might be quite satisfied with a response that does not include as much praise but still shows that the teacher cares. "I Appreciate" Messages or "I'm With You" Messages provide attention without praise:

• "I Appreciate" Message. "I really like this drawing, Terry. Thank you very much for showing it to me!" Or "I really appreciate how carefully you did this drawing."

• "I'm With You" Message. "I can see from that

big smile on your face, Terry, that you're happy with this drawing! I'd feel the same way if I had drawn it. Or "You seem a bit uncertain about your drawing, Terry. Am I right? Sometimes I don't know quite what to think of my drawings either."

Students with DESCA attributes are confident of their own abilities and involved in their studies. They begin and end work by themselves without constant orders or praise. They are respectful of one another and respected by their peers. They are interested in their activities, not

bored; they are alert, thoughtful, and aware of what is going on around them. They are the kind of students who prompt us to say, "Now *there's* a good teacher!"

Supervision and Evaluation

School districts spend a lot of time and effort trying to identify their good teachers. Most teachers undergo periodic reviews of their performance. Some reviews are designed to help teachers improve. Others are for the purpose of awarding merit pay increases and tenure.

A review for the purpose of professional growth is generally called *supervision*; a review for determining merit, *evaluation*. A *supervisor* is charged with "increasing professional skills through in-service, observation, and growth-evoking feedback."[9] An *evaluator* is "a person designated to summarize the quality of professional performance over a period of time "who determines a teacher's future status."[10]

In many schools the principal is both supervisor and evaluator of his or her teachers, although in others different individuals assume these different responsibilities. At times, students, parents, the curriculum coordinator, the district personnel office, and others are involved, particularly in the supervision process. Reviews can be ongoing, twice a year, or once a year. The criteria used can range from teaching style to student performance. They can be applied subjectively or objectively.

Students presumably are the beneficiaries of effective supervision and evaluation procedures. There is no set pattern for these procedures, but there is consensus that the process should be undertaken conscientiously in order to avoid negative effects. Criteria should be well defined and objectively applied. "When handled poorly, evaluation causes suffering for all involved—the teacher, the students, the administrator, the school board, and the superintendent."[11]

Evaluation and Staff Development

Thinking of some teachers as less successful isolates them and tends to become a self-fulfilling prophecy. Teacher supervision and evaluation make more sense if seen in the larger, more positive context of creating a climate for strong teaching. Rather than thinking of review procedures as addressing the needs of marginal teachers, professor Thomas L. McGreal suggests that they be considered part of *staff development*—the term for the attention regularly given to supporting teachers and teaching in any school.[12]

In an elementary school, an institution dedicated to the education of children, the quality of teaching should be the highest priority of its staff. Many diverse problems related to teaching arise in the course of any school year. McGreal suggests that a well-articulated commitment to bettering instruction allows principals and teachers to talk constructively about them.

This commitment to good teaching should come from the superintendent's office. The superintendent can disperse his or her leadership throughout the district by establishing a group of teachers, principals, and even school board members who are leaders among their respective constituencies. They can approach the improvement of teaching in a positive, not a punitive, way. Even so, making changes requires 3 to 5 years at the least.

A district group charged with the improvement of teaching could establish district expectations of good teaching drawn from research and experience. These expectations or guidelines should inform both supervision (staff development) and evaluation procedures. Supervision and evaluation are more likely to be successful if district guidelines include the following things:

- Clear criteria, established with significant teacher involvement;
- Opportunity for teacher involvement within the evaluation process;
- Multiple ways of collecting data that provide a full picture of teaching;
- Teacher feedback activities that encourage professional growth.[13]

Teacher Supervision and Evaluation

Clear criteria are important in the evaluation of students, as you learned in Chapter 10, and they are no less so in the evaluation of teachers. These criteria should be consistent with the district expectations for good teaching. They should address administrative, personal, and professional performance as well as classroom behavior.[14]

Table 19–2 is an example of the kinds of district criteria often used in teacher evaluation. Criteria such as these not only ensure that evaluation will further district teaching goals, they help to keep evaluation procedures consistent from teacher to teacher. They also offer both the district and the teacher legal safeguards by ensuring that due process will be followed.[15]

Because evaluations of teaching are important to the school district and the teacher, they should be done with care. Because evaluations determine the course of teachers' lives, the district should make sure they are fair to the teachers subjected to them. Evaluations are most fair when the evaluator collects information from many different kinds of observations, some which are more formal than others.

TEACHERS AND NEW IDEAS

In Chapter 7, we watched three teachers—Amy, Catherine, and Nicole—begin to plan a comprehensive district art curriculum together. Once they arrive at a consensus, then what? A district curriculum is only successful if teachers will use it, and using it requires teachers to change.

When our hypothetical art curriculum is complete, someone in the district—in this case, probably the assistant superintendent—will have

TABLE 19-2 Teacher Performance: A Statement of Minimum Expectations[a]

An integral part of both tenured and nontenured staff members' employment in the school district is an ongoing appraisal by their supervisor of their ability to meet minimum expectations. As appropriate to the various jobs performed by staff members in the school district, the minimum expectations include but are not necessarily limited to, the following:

1. Meets and instructs the students in the location at the time designated.
2. Develops and maintains a classroom environment conducive to effective learning within the limits of the resources provided by the district.
3. Prepares for classes assigned, and shows written evidence of preparation on request for the immediate supervisor.
4. Encourages students to set and maintain high standards of classroom behavior.
5. Provides an effective program of instruction in accordance with the adopted curriculum and consistent with the physical limitations of the location provided and the needs and capabilities of the individuals or student groups involved.
6. Strives to implement by instruction the district's philosophy of education and to meet instructional goals and objectives.
7. Takes all necessary and reasonable precautions to protect students, equipment, materials, and facilities.
8. Maintains records as required by law, district policy, and administrative regulations.
9. Makes provisions for being available to students and parents for education-related purposes outside the instructional day when necessary and under reasonable terms.
10. Assists in upholding and enforcing school rules and administrative regulations.
11. Attends and anticipates in faculty and department meetings.
12. Cooperates with other members of the staff in planning instructional goals, objectives, and methods.
13. Assists in the selection of books, equipment, and other instructional materials.
14. Works to establish and maintain open lines of communication with students, parents, and colleagues concerning both the academic and behavioral progress of all students.
15. Establishes and maintains cooperative professional relations with others.
16. Performs related duties as assigned by the administration in accordance with district policies and practices.

The appraisal of these minimum expectations will typically be made through a supervisor's daily contact and interaction with the staff member. When problems occur in these areas, the staff member will be contacted by the supervisor to remind the staff member of minimum expectations in the problem area and to provide whatever assistance might be helpful. If the problem continues or reoccurs, the supervisor, in his or her discretion, may prepare and issue to the staff member a written notice setting forth the specific deficiency with a copy to the teacher's file. In the unlikely event that serious, intentional, or flagrant violations of these minimum expectations occur, the supervisor, at his or her discretion, may put aside the recommended procedure and make a direct recommendation for more formal and immediate action.

[a]McGreal, Thomas L. (1988). Evaluation for enhancing instruction: Linking teacher evaluation and staff development. In Sarah J. Stanley and W. James Popham (eds.). *Teacher evaluation: Six prescriptions for success.* Alexandria, VA: Association for Supervision and Curriculum Development, p. 15.

the responsibility of introducing it to the teachers. The assistant superintendent, in turn, will give our curriculum writers the challenging task of asking their colleagues to adopt it in place of their current practices, some of which have a long and (in their users' eyes, at least) successful history. Change is never comfortable. There are ways to minimize this discomfort, however, and increase the likelihood that teachers will adopt new ways of doing things.

Our curriculum committee will be teaching their colleagues a new approach to art education. Teaching adults new things differs from teaching children in this respect: adults will decide more quickly whether they are interested or uninterested in what the teacher has to say. If uninterested, the teacher must work hard to "sell" them on the new idea, and in some cases may never be able to do so.

In our scenario, the change in curriculum is partly coming from the "top down" because the superintendent wanted it But this change is also coming from the "bottom up," because our three teachers invested so much of themselves in it. The fact that the weight of the district's central office is behind the *change agents*—in this case, our curriculum committee—means that the probability of its use by other teachers is high.

Researchers at the University of Texas at Austin developed a model for successfully improving schools. They call it the Concerns-Based Adoption Model (CBAM).[16] They found that teachers respond to change in different ways, relating to their needs as individuals.

The CBAM model treats change as a growth process that takes time. Teachers need time to ask questions about what the change will mean to them in practical ways. What new things will they have to learn? How will their classroom procedures differ? How much time will they have to spend on preparing new teaching materials? Will their students like it?

Stages of Concern

Trying any new thing for the first time can be frustrating. Giving teachers time to anticipate problems and find solutions in a new curriculum increases the chances that they are likely to adopt it. Teachers know their lives will be changed by any changes in curriculum, and curriculum planners know that teachers are the most important factors in making their new curriculum a success.

Only when teachers' practical concerns are satisfied can they begin to ask for information about the new curriculum itself, and about what they can do to use it effectively. In our Chapter 7 scenario, the assistant superintendent is the person who is responsible for initiating the change. It will be important to reassure teachers that their concerns are reasonable, and that there is enough time for them to adapt to the new district expectations.[17]

The CBAM model identifies seven kinds of concerns about a new curriculum that teachers are likely to have (see Table 19–3).[18] At first (Level 0) there is little concern because little is known about the proposed changes. As teachers begin to hear about the new materials, they will be curious about them (Level 1)—particularly about such things as their origin, the reason for the change, and what the changes are likely to be.

It is important to give teachers enough information about a new curriculum to be helpful, but not so much that they become discouraged by the prospect of using it. The more teachers are involved in making decisions about the new materials, the faster their concerns become resolved. More information will be welcome as they begin to think through what a new curriculum will mean in their classrooms (Level 2).

Talking with other teachers who have used similar materials is also helpful in determining the similarities and differences between the new curriculum and their traditional art instruction. "Teachers may also be concerned about their ability to execute the new program as expected and about making mistakes that would make them look foolish. Another way teachers express personal concerns about a change is to characterize the innovation as nothing new, but as something they have always done or used to do. With this conviction, they may convince themselves they really do not have to change."[19]

Teachers will begin to use a new art curriculum only after they have decided to do so (no matter what their district expects). Their classroom practices will correspond to the kinds of concerns they voice at different times during the process of becoming familiar with it. Once teachers begin to use new materials, they must expect to "feel" their way for a while—a school year, per-

TABLE 19-3 **Stages of Concern: Typical Expressions of Concern About the Innovation**[a]

		Stages of concern	Expressions of concern
S E L F	0 1 2	Awareness Informational Personal	I am not concerned about it. (the innovation) I would like to know more about it. How will it affect me?
T A S K	3	Management	I seem to be spending all my time getting material ready.
I M P A C T	4 5 6	Consequence Collaboration Refocusing	How is my use affecting kids? I am concerned about relating what I am doing with what other instructors are doing. I have some ideas about something that would work even better.

[a]Adapted from Hord, Shirley M., Rutherford, William L., Huling-Austin, Leslie, and Hall, Gene E. (1987). *Taking charge of change*. Alexandria, VA: Association for Supervision and Curriculum Development, p. 31.

haps—until they master the new vocabulary and strategies. Their patience will be sorely tested, because the new program will consume a disproportionate amount of their time (Level 3), and encouragement at this time from more experienced teachers is invaluable.

Eventually, the new procedures will become routine (Level 4), and the familiar joys of teaching will reappear to the extent that teachers' own inventive natures will reassert themselves. They will be confident enough to extend the curriculum materials in ways that fit their particular classes. By the end of their second year, teachers are able to introduce the curriculum to colleagues (Levels 5 and 6) and act as resource people for them as they begin the change process.

Responding to Concerns

Those who want to improve curriculum in elementary schools often begin with high hopes, but such efforts at improvement have a history of failure. The cyclical nature of reform is one of the truisms of education. If Amy, Catherine, Nicole, and their assistant superintendent can view responding to teachers' concerns as critical, they may be among the few who succeed. One of the most important elements is time: time to introduce the new idea, to assimilate it, to practice it, and to use it.

Writing a curriculum is only part of the battle, and perhaps the easiest part at that; change is never an easy task. When the curriculum is finished, there must be occasions on which teachers may voice concerns and receive answers. Arranging for such occasions will fall to those responsible for, and interested in, seeing the change occur. The CBAM model suggests that the following strategies might be helpful in this regard:

- Stage 0—Awareness Concerns

 a. If possible, involve teachers in discussions and decisions about the innovation and its implementation.
 b. Share enough information to arouse interest, but not so much that it overwhelms.
 c. Acknowledge that a lack of awareness is expected and reasonable, and that no questions about the innovation are foolish.
 d. Encourage unaware persons to talk with colleagues who know about the innovation.
 e. Take steps to minimize gossip and inaccurate sharing of information about the innovation.

- Stage 1—Informational Concerns

 a. Provide clear and accurate information about the innovation.
 b. Use a variety of ways to share information—verbally, in writing, and through any available media. Communicate with individuals and with small and large groups.
 c. Have persons who have used the innovation in other settings visit with your teachers. Visits to user schools could also be arranged.

d. Help teachers see how the innovation relates to their current practices, both in regard to similarities and differences.

e. Be enthusiastic and enhance the visibility of others who are excited.

- Stage 2—Personal Concerns

 a. Legitimize the existence and expression of personal concerns. Knowing these concerns are common and that others have them can be comforting.

 b. Use personal notes and conversations to provide encouragement and reinforce personal adequacy.

 c. Connect these teachers with others whose personal concerns have diminished and who will be supportive.

 d. Show how the innovation can be implemented sequentially rather than in one big leap. It is important to establish expectations that are attainable.

 e. Do not push innovation use, but encourage and support it while maintaining expectations.

- Stage 3—Management Concerns

 a. Clarify the steps and components of the innovation. Information from innovation configurations will be helpful here.

 b. Provide answers that address the small specific "how-to" issues that are so often the cause of management concerns.

 c. Demonstrate exact and practical solutions to the logistical problems that contribute to these concerns.

 d. Help teachers sequence specific activities and set timelines for their accomplishments.

 e. Attend to the immediate demands of the innovation, not what will be or could be in the future.

- Stage 4—Consequence Concerns

 a. Provide these individuals with opportunities to visit other settings where the innovation is in use and to attend conferences on the topic.

 b. Don't overlook these individuals, give them positive feedback and needed support.

 c. Find opportunities for these persons to share their skills with others.

 d. Share with these persons information pertaining to the innovation.

- Stage 5—Collaboration Concerns

 a. Provide these individuals with opportunities to develop those skills necessary for working collaboratively.

 b. Bring together those persons, both within and outside the school, who are interested in collaboration.

 c. Help the collaborators establish reasonable expectations and guidelines for the collaborative effort.

 d. Use these persons to provide technical assistance to others who need assistance.

 e. Encourage the collaborators, but don't attempt to force collaboration on those who are not interested.

- Stage 6—Refocusing Concerns

 a. Respect and encourage the interest these persons have for finding a better way.

 b. Help these individuals channel their ideas and energies in ways that will be productive rather than counterproductive.

 c. Encourage these individuals to act on their concerns for program improvement.

 d. Help these persons access the resources they may need to refine their ideas and put them into practice.

 e. Be aware of and willing to accept the fact that these persons may replace or significantly modify the existing innovations.[20]

Within any school, the principal will play a key role in seeing that change occurs. University of Texas researchers found that principals who were most able to effect changes were actively involved, working with colleagues toward this end. Sometimes these colleagues were district curriculum coordinators or supervisors, but often they were teachers, particularly teachers respected by their peers. When these persons worked together, change occurred.

EVALUATION FOR PROGRAM IMPROVEMENT

In Chapter 10 we noted that program evaluation relies on various kinds of evidence that are less well defined than those used to assess student achievement, although student achievement scores themselves might be partial evidence of a program's success. Program evaluation criteria are also broader than those used to gauge teacher performance although teacher performance, too, might be part of the larger picture. Some of the evidence used in program evaluation is specific, such as test scores, while other evidence may be simply an evaluator's perception of the quality of a classroom environment.

Educational Criticism

The idea of knowledgeable art teaching was first introduced in Chapter 2. Someone who is extremely knowledgeable in the language of art is called a *connoisseur*. We infer that knowledgeability or connoisseurship in art comes from a great deal of experience in perceiving and appreciating art.

Many people think of knowledgeable teaching as an art form itself. In order to evaluate knowledgeable teaching, art educator Elliot W. Eisner introduced the idea of educational connoisseurship, that is, having a high degree of knowledgeability about classroom practices. Eisner compares an evaluation by an educational connoisseur to what artists produce when they create a drawing or a sculpture. "The result of their work is a qualitative whole—a symphony, poem, painting, ballet—that has the capacity to evoke . . . a kind of experience that leads us to call the work art."[21]

The function of educational connoisseurs, however, is more like that of art critics. Critics describe in words certain qualities of an art work that exist only as visual elements and the ways in which they relate to one another to create meaning. Critics help others to perceive meaning in the work of art that they would otherwise overlook.

Classroom environments are constantly changing according to the interaction of the people in them. Eisner notes that someone who is experienced in the ways of the classroom—someone who is an educational connoisseur—is able to identify things that happen that are important for learning. The educational connoisseur can bring to our attention significant classroom happenings that we would otherwise overlook.

The products of educational criticism are narratives that describe, interpret, and evaluate key occurrences in classrooms. Each narrative is different even if the classrooms observed are the same, because each connoisseur, each observer, brings to his or her observation an individual set of values and theoretical concepts. Eisner teaches observers to use language that is literary or poetic rather than mechanical in nature, in order to capture the qualitative essence of what is occurring.[22]

Examples of Criticism

Here are some excerpts from critical narratives by Eisner's students:

> School and society revisited: An educational criticism of Miss Hill's fourth-grade classroom
> The teacher exhibits great economy of movement and gesture There is also economy of voice.

. . . When the teacher does speak, however, her voice colors all experience within the confines of this classroom, and the color that is vocally applied is shocking beige. Her voice is the perfect accessory for the tan, plastic drapes which cover the windows and hang, straight, without feeling or expression. It's a voice barren of any sort of nuance, as if somehow the hum of the air conditioner were reconstituted into words. During the seven weeks I spent in this classroom, I only rarely heard this voice express anger or joy or emotion of any kind."[23]

Of Scott and Lisa and Other Friends

The room invites me in. It is a large, extended room drawn at the waist: it was once two single rooms that have come together to talk. Surely I could spend a whole childhood here. A wealth of learning materials engulfs me, each piece beckoning me to pick it up. The patchwork rug that hides the floor is soft and fluffy and warm. Some desks have gathered together for serious business. Chairs converse across semicircular tables. At the bookshelf, dozens and dozens of books slouch around, barely in rows, leaning on each others shoulders. Children's drawings line the walls. What are those masses of shiny objects growing from the ceiling like silver stalactites in the secret corners of the room? I focus in on thousands of tiny . . . beer can pull-tabs . . . crunched together, straining to pull the roof in. A massive wooden beehive called *The Honeycomb*, with geodesic cubicles in which to hide yourself. A towering ten-foot dinosaur made of wire and papier-mâché, splotched with paint . . . blue and red colors crawling up its body. The monster is smiling helplessly—is he not?—because a covey of tiny people have just been tickling him with their paintbrushes.[24]

How Educational Criticism Works

Through careful, detailed description an educational critic attempts to recreate for a reader the distinctive qualities of a classroom environment. In order to do this, the evaluator must select specific happenings to describe in detail—but not happenings at random. The evaluator must use discrimination from the beginning in selecting happenings that will convey, through a recounting of particulars, a sense of the whole.

It is up to the narrator to recreate perceived meaning through verbal images. In educational criticism, meaning is nonlinear. The evaluator reveals it through juxtaposition, implication, simile, and metaphor.

Eventually the evaluator attempts to discern the rules or structures whose order gives meaning to the described activities. The evaluator relates events observed in the classroom to theories from education, psychology, anthropology, and other social sciences. These are the analytical and interpretive processes at work.

The goal of the educational critic is to improve the educational process. To do this, it is necessary that the critic make clear what he or she values in education and what the particular situation under review would need change in order to achieve those ends. Here is where educational connoisseurship comes into play. The critic will also keep in mind that some readers, who may hold values that are quite different from those of the critic, might also find this criticism useful precisely because it presents a different point of view.

Most educational problems are multidimensional and can be seen more clearly when illuminated from several sides. There may be several layers of meaning and an insight at one level may not preclude additional insights at others. As a teacher's understanding expands, perhaps as the result of educational criticism, he or she moves further along the road toward educational connoisseurship.

Who can be an educational critic? Anyone, according to Eisner—"student, teacher, supervisor, school administrator, university professor, school board member."[25] An educational connoisseur is not always an expert called in from outside of the district. All educators can and do rely on their perceptions and interpretations to give their subordinates, colleagues, superiors, and the general public feedback in order to help them perform more effectively.

SUMMARY

Teachers, not buildings, create and maintain learning environments. They learn and elaborate strategies for doing this. School districts help them to improve their skills through staff development programs.

Part of staff development is periodic teacher review. Some reviews are made by supervisors, whose aim is to help a teacher improve professional skills. Other reviews are made by administrative superiors to determine a teacher's merit, for the purpose of salary increases and tenure.

When staff development deals with the introduction and implementation of new curricula or other new ways of doing things, special procedures must be taken if the desired changes are to become firmly established in a school district. Adults are independent learners, and they need time to accept the innovations without reservation. Eventually, if given time to voice and satisfy their concerns, teachers will discover the rewards of teaching in more skillful ways.

The success of new programs is often judged by a holistic or qualitative form of evaluation. One of these is called *educational criticism*, in which teacher's knowledgeability or connoisseurship is employed. Evaluators rely on their own classroom experiences as well as educational theory to inform them about the accuracy of their perceptions in determining the degree of success of any program.

Schools and the classrooms in them are an important part of our lives, first as children who learn in them and later as the teachers who make them work. There are other art learning environments, of course: museums, private art lessons, parks and recreation activities, popular television. With the right teacher, each can be a vehicle for active learning.

NOTES

1. Brown, Maurice, and Korzenik, Diana. (1993). *Art making and education*. Urbana, IL: University of Illinois, p. 110.
2. Brown and Korzenik, ibid., p. 113.
3. Harmin, Merrill. (1994). *Inspiring active learning: A handbook for teachers*. Alexandria, VA: Association for Supervision and Curriculum Development.
4. Ibid., p. 1.
5. Ibid., pp. 1–2.
6. Pilon, Grace. (1987). *Workshop way practical handbook*. (Grades 2–8). New Orleans, LA: Workshop Way.

 _____. (1991). *Workshop way*. New Orleans, LA: Workshop Way.
7. Ibid., p. 23. This strategy is called a *round robin* in Chapters 8 and 17.
8. Ibid., p. 65.
9. Hunter, Madeline. (1988). Create rather than await your fate in teacher evaluation. In Sarah J. Stanley and W. James Popham (eds.), *Teacher evaluation: Six prescriptions for success*. Alexandria, VA: Association for Supervision and Curriculum Development, p. 33.

10. Ibid., p. 33.
11. Costa, Arthur L. (1988). Foreword. In Stanley and Popham, ibid., p.vi.
12. McGreal, Thomas L. (1988). Evaluation for enhancing instruction: Linking teacher evaluation and staff development. Ibid., pp. 1–29.
13. Ibid., p. 13.
14. Ibid., p. 14.
15. Ibid., p. 16.
16. Hord, Shirley M., Rutherford, William L., Huling-Austin, Leslie, and Hall, Gene E. (1987). *Taking charge of change*. Alexandria, VA: Association for Supervision and Curriculum Development.
17. Ibid.
18. Hall, Gene E. (1979). The concerns-based approach for facilitating change. *Educational Horizons*, 57: 202–208.
19. Ibid., p. 31.
20. Ibid., pp. 44–46.
21. Eisner, Elliot W. (1979). *The educational imagination: On the design and evaluation of school programs*. New York: Macmillan.
22. Ibid.
23. Ibid, Robert Donmoyer, p. 229–230.
24. Ibid., Thomas Barone, p. 241.
25. Ibid., p. 221.

20

Educational Policy and the Arts

Art as we teach it today is a relatively recent phenomenon in public schools. If it can be said to have begun with Lowenfeld, it has arrived at—but certainly not concluded with—the comprehensive and rigorous approach represented by discipline-based art education (DBAE). Over the intervening years, many teachers have asked themselves, "Am I teaching the right thing? Am I doing the best job possible? What else should my students know?"

Eventually most teachers move from wondering about conditions in their own classrooms to pondering the direction of art education in general. Experienced art teachers hear themselves and their colleagues asking the same questions: "Are we teaching enough content?" "Why are many districts letting elementary art specialists go?" "Will children who study art be better readers?" "How can we enlist public support for art programs?"

Questions such as these suggest a desire for educational policies that might apply to more than one classroom, one school district, or even one state. Yet policy issues are controversial: at the outset there is seldom consensus on the best approach. As a result, policy making requires debate and compromise. Policy making takes time.

In reading through the preceding chapters, you encountered many ideas about art education

that have policy implications. You may agree with some and disagree with others. In fact, there are few theories and practices in art education without both supporters and skeptics. Before ending our journey, therefore, let us look at just five broad issues that, if analyzed, would include many topics discussed in preceding chapters. These issues have been debated in art education for a long time, and you will surely find yourself playing a part in their resolution—at least within your own school.

The following five questions perennially concern art teachers: What constitutes excellence in art education? Should there be a national curriculum? Should the teacher be an artist? Do we need more research? What role can the arts play in educational reform? Beneath their apparent simplicity lie some interesting and knotty issues. Let us look at each one briefly for what it can tell us about the choices we all face.

WHAT CONSTITUTES EXCELLENCE IN ART EDUCATION?

Over 10 years ago, art educator Laura H. Chapman pointed out that Americans value the arts but believe they are impossible to teach. She stated the educational counterpart of what Ernst

352

A. Gombrich described as the difference between *Art* versus *art* (see Chapter 15). Chapman noted that most Americans want public education to include Art (in all of the arts) in order to introduce students to "culture." At the same time, they regard the creative process as "so mysterious, intuitive, and so much a question of native talent or personal preference that teaching art to the young does not really seem to be possible or valuable."[1]

Artistic folklore depicts the artist as an eccentric, untaught genius willing to sacrifice friends, family, and fortune (if need be) in order to create. It is a view of themselves that artists hold dear, and it is natural that it permeates art education. Most art specialists choose teaching because of their fascination with making art; they regard themselves as artists. Because the myth of the eccentric genius counters what educators consider good elementary school practice, however, art teachers find themselves pulled in conflicting directions.[2]

In addition, Chapman observes that many students graduate from high school thinking that to study art is to participate in the process of making it, and "that art is undemanding, unless one has talent, and irrelevant to contemporary life, unless one has the wealth and leisure to indulge in it."[3] Is more rigorous studio experience (more emphasis on the artist) the path to excellence? Adding the study of art criticism, history, and aesthetics to school curricula alters this traditional image of art education. Therefore, when art educators become convinced that more rigor is needed in arts education, they often put forward not one but many seemingly irreconcilable definitions of excellence.

Child-Centered versus Teacher-Centered Instruction

Throughout this book we assume that teachers play an active role in art education. But should they? The authors believe that teachers are able, by virtue of greater experience, to guide students to valid realizations about art. Other teachers believe that child-initiated activity provides better art learning, however. As you address your art class, should you say, "Today we are going to . . . " (and present your own agenda), or should you say, "What would you like to work on today?" (and let your students decide). Which would the eccentric genius prefer?

Significant Content Whether teacher-centered or child-centered, different art teachers value different kinds of information. For example, should studio activity be sacrificed in order to teach art history? Should students use Harry S. Broudy's aesthetic scanning when looking at art, in preference to the critical method of Edmund B. Feldman? Should artists from "third-world" countries be considered as "advanced" as European artists? These kinds of questions require thoughtful answers.

Individuality The myth of the eccentric genius glorifies individual artistic expression. In art, individuality means that artists have different styles; in art education, it means that different children will find different solutions to the same studio assignment. Many teachers prefer individual to group instruction: each child can work on a different problem.

What does individuality mean in the more academic art disciplines? Do structured studio lessons that teach aesthetic concepts and problem solving undermine individual expression? Can we find a definition of individuality that avoids the stigma of undisciplined activity (from lack of instruction) and that also serves those art students who create with words?

Elitism In 1986, the National Art Education Association commissioned professor Ralph A. Smith to chair a committee that would define excellence in art education.[4] Smith identified an ongoing dilemma in arts education related to those addressed by Gombrich and Chapman— the dilemma between democracy and excellence. Can everyone achieve high performance levels in art, or only the most gifted? If we set high goals for some students, will we disadvantage others?

The idea of excellence reminds us that educated individuals are, by definition, part of a select group within society. As individuals move through David Feldman's levels of mastery in art (see Chapter 2), the more knowledgeable they become; the higher the level, the fewer individuals it contains. Do those who master the visual arts constitute an elite based on hard work, to which anyone can aspire? Or is this elite based on gifts that some individuals, by accident of birth or upbringing, may not share?

Public schools in the United States are institutions that reflect our democratic way of life. If the ability to make or understand art requires so much effort that only a relative few can do it, should we abandon rigor in elementary schools? Or should we hold to the democratic obligation to provide everyone with the opportunity to better themselves, even though some may be unable to respond to the challenge? Equality (a populist concept) and excellence (an elitist one) are concepts that often conflict in a democratic society.

SHOULD THERE BE A NATIONAL CURRICULUM?

Decisions about art education at the local level are often made by well intentioned school board members whose education is deficient in the arts. They, and the parents who are their constituents, typically regard art lessons as only a step away from recreation. They assume that because children use paint and clay now and then, they are learning art. When teaching in art is nondirective (perhaps for fear of stifling individuality), onlookers may be excused for thinking that nothing important is being taught.

If we could agree on what constitutes excellence, could we agree that every child should enjoy the same quality of art education? The education of children has always been a local prerogative in the United States. State boards of education and departments of education regulate local school districts in some respects, but the choice of what to teach is still primarily a local decision. In many districts the art curriculum varies from school to school. Is so much fluctuation in quality fair to our nation's school children?

Role of Government Until perhaps Sputnik in the late 1950s there was little thought of standardizing art education in all of the states. Ensuing Federal interest in supporting education, as well as supporting the arts—the National Endowment for the Arts (NEA) was established in 1965—led to an agenda for art education codified in the Artists-in-Schools program. The NEA agenda was one with which many art teachers took issue, however, because it incorporated the myth of the eccentric genius. The NEA affirmed

that artists, not elementary art teachers, knew what was best for school children.

National Art Standards More recently, art teachers have taken an interest in the content objectives (called national standards) developed as part of the Goals 2000 impetus for educational reform (see Chapter 10). Art educators themselves devised the standards in art. Once content objectives are widely accepted, will these standards constitute a national curriculum? If not, can a national curriculum be far behind?

Elliot W. Eisner points out that these standards are only the latest in a series of attempts to reform schools across the nation by making them more productive, more efficient, and more cost effective.[5] Like the move to establish behavioral objectives, the quest for standards is motivated by the desire to have everything spelled out, so that student achievement is visible and certain. Eisner believes this desire for clarity is well intentioned, but calls it conceptually shallow, suggesting that successful school reform requires more than simply knowing what students are required to do—or even whether they have done it.[6]

With respect to the implication of a national curriculum contained in the standards, Eisner questions the value of uniformity, even if there were a consensus about what to teach. He fears that in our enthusiasm for shared goals we will fail to nurture students' individual talents or to recognize their individual differences "in region, in aptitude, in interests, and in goals."[7] Eisner points out that many teachers can work toward excellence in both teaching and learning while maintaining numerous sets of standards for their students and for themselves. He suggests that national standards can never accommodate the complexity of our public educational system.

SHOULD THE TEACHER BE AN ARTIST?

Chapter 1 traces reasons for teaching art in America, and Chapter 3 describes those who teach it. We seem to have left behind the idea of an art teacher as a trainer for industry; but we still think of art teachers as artists. Art specialists are part artist and part educator. With the coming of the 1980s and the call for more widespread art educa-

tion, we now also recognize the classroom teacher as an art teacher. Do all of these teachers provide instruction of equal excellence?

Artists versus Art Specialists Crucial to the question of teacher as artist is the issue of knowledgeability. Is the artist more knowledgeable about art than the art specialist? Does the artist know more about teaching? Is a teacher good by virtue of being an artist? Is an artist always a knowledgeable teacher?

Good elementary art specialists know art. They also know how to identify and sequence art concepts, how to engage children in active learning, and how to evaluate their progress in a supportive way. They may not be geniuses, but they also are not eccentric; they are fully participating, responsible members of the educational community and viewed as such by their colleagues.

Art Specialists versus Classroom Teachers Is the art specialist a better teacher than the classroom teacher by virtue of being more knowledgeable about art? Is the art specialist equally expert in art history, art criticism, aesthetics, and studio art? Many art specialists become certified for elementary art even though their studies concentrate on secondary schools. Is knowledge of art more important than knowledge of educational practice? Can we use one argument with artists and its reverse with classroom teachers?

An effective elementary art teacher must be knowledgeable in art. How knowledgeable? David Feldman's theory about levels of mastery tells us that (on average) art teachers at each level of schooling need different kinds of art expertise. We also acknowledge that most elementary education takes place at the cultural level in a public school environment. Should elementary teachers function equally well in both art and education? Is a single teacher best, or are there advantages to the multiple-teacher cooperative teaching model presented in Chapter 3?

Published Art Texts and Curricula Teachers' knowledge of art determines the quality of their lesson content. Today elementary art teachers can find excellent content in commercially published textbooks and other curricular materials. Researchers with advanced knowledge of both art and education design these materials and continually revise them to keep up with current teaching innovations. If elementary classroom teachers use nationally distributed art textbooks and other materials, can they become as effective as art specialists in teaching art? Should art specialists also use commercial materials?

DO WE NEED MORE RESEARCH?

Research in art education is not abundant. Most empirical researchers in art education collect information on average classroom practice: what teachers do, on average, and how children respond. From this information researchers construct theories to explain how good art teachers should behave, and how most students could learn. Artists, on the other hand, trust their instincts; they believe in immediate information, personal experience, and individual responses. Teachers who tend to think of teaching as an art form, and to act like artists in their own classrooms, may be reluctant to read or apply the insights of empirical research.

Unfortunately, individual solutions to atypical situations are of little help in making broad art education reforms. It is little wonder that those art educators who become researchers, devise art educational theories, and put them to work in textbooks and curricula are usually farthest from public school classrooms. Designers of most commercially available sequential curriculum materials (as distinguished from self-contained art projects) come from higher education.

Descriptive versus Experimental Research Descriptive research predominates in art education journals, particularly studies that provide information on how children learn to make art. As the content of art education has broadened in recent years, children's responses to art have also come under scrutiny. The alternative to descriptive research is experimental research, which attempts to pose educational problems and find answers to them. Experimental researchers construct studies that test some hypothesis: "If we do this, then that should happen as a result." Experimental research is more difficult, but it provides information that has been previously unknown.

Art education researchers are generally interested in young children, concentrating more on aesthetic and graphic development than on ways to structure effective art learning. Some descriptive researchers have studied classroom environments, and a number have taken surveys to determine things such as class size, teacher preparation, size of materials and equipment budgets, and so forth among public school art programs.

Historical and Philosophical Research A few art educators conduct historical research. Some are theorists only, and conduct philosophical research. Historical and philosophical research in art education is even scarcer than empirical research, perhaps because many teachers think it even less useful. Do we need more? The "big ideas" put forward by John Dewey, Viktor Lowenfeld, and a host of more recent thinkers mentioned in preceding chapters have had a profound effect on what happens in classrooms across the country, even though teachers may not know the sources from which they come.

In this high-tech information age, such ideas spread rapidly and we should not underestimate their importance. Research of all kinds draws on expertise in the art disciplines, even though researchers may not be practicing artists, historians, critics, or aestheticians. Research findings can provide you, the teacher, assurance that the knowledge you transmit to students is trustworthy. But the information that research provides is neither unambiguous nor easily accessible. You must interpret them within the context of your educational values. Research does not solve the dilemma of the art educator torn between the myth of the eccentric genius and the desire for educational rigor.

WHAT ROLE CAN THE ARTS PLAY IN EDUCATIONAL REFORM?

Devising national standards for student achievement was a significant act for the professional arts organizations. In joining the Goals 2000 initiative for educational reform, these organizations publicly declared their allegiance to education; for the first time, by writing national standards, they retreated from their loyalty to the image of the eccentric genius. At the same time, however, arts educators have begun to think about ways the arts could use their "special ways of knowing" as a catalyst in the reform of other subject areas.

Strong Programs, Strong Schools? Arts education advocates like to say that strong arts programs make strong schools, and offer anecdotal evidence that this is so. An empirical researcher might point out that schools with strong arts programs are also strong in other ways: access to technology, good teachers, innovative class scheduling, "enrichment programs" (if art is included in this group, it is not part of the regular curriculum), and so on. These other variables make it difficult to measure the effects of the arts programs themselves.

Nevertheless, arts education supporters believe that schools with strong arts programs benefit their students in the following ways:

- Intensified student motivation to learn,
- Better attendance among students and teachers,
- Increased graduation rates,
- Improved multicultural understanding,
- Renewed and invigorated faculty,
- More highly engaged students (which traditional approaches fail to inspire),
- Development of a higher order of thinking skills, creativity, and problem-solving ability,
- Greater community participation and support.[8]

A National Center In order to encourage arts educators, artists, and arts organizations to participate in national reform efforts, one group of arts educators recommends establishing a National Center for the Arts in Education.[9] They envision a national center as the hub of an information network. The network would collect and make available arts education resources, conduct policy forums, and call attention to excellent art programs around the country.

School Reform Acting on the beliefs spelled out, arts education spokespersons assert that the avenues for understanding the world offered by the arts are necessary to the invigoration of general education. "Works of art provide effective means for linking information in history and social studies, mathematics, science, and geography. A work of art can lead to many related areas of learning, opening lines of inquiry, revealing

that art, like life, is lived in a complex world not easily defined in discrete symbols."[10] They recognize that reform of the entire public school system is necessary before this can happen, however.

The idea that studying art could reform the studying of other subjects seems to be a long way from simply throwing our hat in the ring, as art educators did when they decided to create national standards for student achievement. Abandoning the eccentric genius to that extent was difficult enough. To see art as the catalyst for reform seems like wishful thinking—but wishing for what? Do we perhaps see the eccentric genius creeping back in here, disguised as a helpful muse? Will wishing make it so?

Art educators' enthusiasm for educational reform is new enough that the rhetoric is still garbled. Reform means everything to everyone. The road to rigor has been long and difficult, and we have forgotten that the eccentric genius is uncomfortable in an institutional guise. It is doubtful that we can take only the nice parts of the myth— more likely, we must take it all. It will be difficult not to let the eccentric genius out of the box called school reform.

Nonartists' Views of Reform In 1993 the Getty Center for Education in the Arts held a conference to explore ways that the arts could play a central role in educational reform. The primary educational value of the arts to nonartists seemed to be their potential to engender in students inventive thinking, in the sense of finding innovative solutions to real-world problems. Business leaders liked the "hands-on" character of art to show students "how to work with ideas, with knowledge, and with information."[11]

Second to invention was the arts' documentation of and access to cultural diversity. The complexity of the arts seem to parallel the cultural diversity of the American population. The study of ethnic arts can bring to students of all backgrounds a sense of self and an understanding of others.

The last major conference theme dealt with technology. Visual "imagery is central to television and the other powerful communications technologies that have a special influence on young Americans."[12] Learning about the visual arts seemed able to aid students in understanding, creating, and using the images central to electronic communications media.

NAEA Strategic Plan for Reform The National Art Education Association has its own strategic plan for educational reform.[13] It addresses the meaning of being artistically literate. The NAEA plan rests on five sets of national standards its members have helped (or are helping) to develop, not only those for student achievement (see Chapter 10), but for student assessment and teaching as well.

The five categories of standards are as follows:

- Student learning: Visual arts content standards— what all students should know and be able to do,
- Alignment: System standards—how schools and other institutions should function to support the kind of art education defined in the content standards,
- Opportunity to learn: Program standards—what art programs that support the content standards look like,
- Teaching: Professional development standards— National Board for Professional Teaching Standards' criteria for certification and exemplary art teaching,
- Assessment: Student assessment standards—National Assessment of Educational Progress criteria in art.[14]

The NAEA statement stresses that national standards should not be taken as a national curriculum. Rather, they represent a consensus on the criteria that define learning and teaching. Compliance with these standards is voluntary.

SUMMARY

We have just articulated—but not answered—five questions about teaching art. There are no "right" answers; at present there is little consensus even among those with the greatest expertise in policy matters. For example, while there is widespread enthusiasm for reform, differences of opinion on what constitutes excellent student performance, teacher performance, assessment, and other practices continues to vary widely.

Perhaps the issues are too complex for consensus to be possible. As you become an experienced art teacher, you will be engaged in resolving these conundrums—if indeed they can accommo-

date a solution at all. The debates themselves serve a useful function by providing a climate of inquiry that stimulates inventive thinking.

In a spirit of educational reform, art education finally has joined itself to the national educational agenda. To some, this is a great step. To others, it lessens the integrity of art teaching because it weakens the alliance with the artist.

The eccentric genius is a stubborn old muse who refuses to go quietly. Thus, it is no wonder that the most debated policy issue during the last decade concerned DBAE, the approach to art education that challenged this value system. "DB or not DB?"—that was, and still is for many, the question.

Rather than posing the question in that form, we have chosen a different course. Discipline-based art education is too broad a topic to make meaningful discussion possible. We have broken it down into morsels that can be more easily inspected and chewed. In doing so, we find ourselves addressing the kinds of issues we have just reviewed: the nature of excellence, national standards, the role of the artist, the value of research, and school reform.

Policy debates can be constructive experiences if we recognize that those who dissent from our views also have children's best interests at heart. Art is a complex subject; teaching it to children is no less so. Surely the field of art education is broad enough to accommodate a number of points of view.

Discussing policy is a way to step back from the details and take a longer view of art education. It is easy to lose sight of the forest when the trees are so numerous and so diverse. The research organization Public Agenda surveyed 1200 Americans to find out what they want from their schools. They found them distrustful of new approaches to education. They wanted schools that are safe enough to allow serious learning, more emphasis on "basics" such as reading, writing, and math, higher standards, and traditional teaching methods.[15]

Are the assumptions of arts education advocates valid regarding educational reform? Does art offer students kinds of learning experiences unavailable in other subjects, and if so, are they valuable primarily for their "hands-on" activity, cultural diversity, and relation to electronic imagery? Or are the issues more complex? Can art education reinvigorate our public schools?

Undoubtedly it is significant for all teachers that art education is in the mainstream of 1990s educational reform. Assuredly, we find it difficult to predict where and how art education will be most effective during the new century. Most certainly we will continue to peer into the future and discuss educational policies that we hope will prove productive in the years to come. That art is important goes without saying; making art education important is up to all of us who have the knowledge and the courage to teach it well.

NOTES

1. Chapman, Laura H. *Instant art, instant culture: The unspoken policy for American schools*. New York: Teachers College, Columbia University, pp. xiii–xiv.
2. Rush, Jean C. (1995). The myth of the eccentric genius: Some thoughts about political correctness and art education. *Arts Education Policy Review*, 97 (2): 21–26.
3. Chapman, op. cit., p. xiv.
4. Smith, Ralph A. (1986). *Excellence in art education: Ideas and initiatives*. Reston, VA: National Art Education Association.
5. Eisner, Elliot W. (1995, June). Standards for American schools: Help or hindrance? Phi Delta Kappan, pp. 758–760, 762–764.
6. Ibid., p. 760.
7. Ibid., p. 762.
8. Summary—*The power of the arts to transform education: An agenda for action; The arts and education reform.* (1993, January). Recommendations of the Arts Education Partnership Working Group under the sponsorship of The John F. Kennedy Center for the Performing Arts and The J. Paul Getty Trust.
9. Ibid.
10. Ibid., p. 7.
11. Kolberg, William H. (1993). The challenge from business to arts education. In: *Perspectives on education reform: Arts education as catalyst*. Santa Monica, CA: The J. Paul Getty Trust, p. 22.
12. Ambach, Gordon M. (1993). Education reform in and through the arts. In: *Perspectives on education reform: Arts education as catalyst*. Santa Monica, CA: The J. Paul Getty Trust, p. 8.
13. NAEA begins strategic plan for education reform. (1995, October). *NAEA News*, pp. 1–2.
14. Adapted from ibid., p. 2.
15. Willis, Scott. (1995, June). What the public wants. *ASCD Education Update*, pp. 4–5.

Glossary

Abstract art Refers to art in which imagery is abstracted from the visual world, rather than art in which imagery has a natural appearance (as in *realistic* or *representational art*); art with visual ties to the real world, even though difficult to discern; art in which form (lines, shapes, textures, values, colors, and their composition) may appear more important than subject.

Accountability Legal and ethical responsibility.

Acculturation When two or more cultures in a society influence and modify one another but retain their individual identities; also, the process of a child's acquiring the values, beliefs, and customs of the culture in which it lives (see *Assimilation*).

Active learning Learning situations in which students solve problems and use knowledge in other ways that involve "higher order" thinking; also called *discovery learning* or *inquiry-based* learning.

Aerial perspective A way of suggesting pictorial space (sometimes called *depth*) in two-dimensional art by the use of progressively more subdued color contrasts and softer edges for distant things; a method of simulating atmospheric conditions (also called *atmospheric perspective*).

Aesthetic Pertaining to a sense of the beautiful in art and natural phenomena; a sensitivity to art.

Aesthetic education A reform movement in the 1960s that broadened the content of art education to include such things as art history and art criticism besides the making of art.

Aesthetic literacy The ability to "read" the visual language of art; understanding the aesthetic properties in a work of art.

Aesthetic properties Elements of art or *sensory properties*, principles of design or *formal properties*, and their symbolic capabilities or *expressive properties* (as well as technique or *technical properties*) that convey meaning in a work of art, knowledge of which comes from studying about the arts disciplines.

Aesthetic scanning A classroom application of the perceptual activity artists use when making art, and that connoisseurs use when contemplating it; seeing and identifying four kinds of aesthetic properties; see also *Visual analysis*.

Aesthetics The philosophy of art; the study of the nature and meaning of art and theories of beauty.

Alternative assessment Assessment of student achievement based on their ability to do something—solve problems, organize written material, make art, give a critique, research an artist of yesterday; asks students to construct a response rather than to select one; also called *authentic assessment* or *performance assessment*.

Analogous colors Related hues found next to one another on the color wheel such as yellow, yellow green, and green; see *Hue, Color wheel*.

Analysis In art, a deductive process of examining components of a work of art within the context of the completed whole.

Applied arts Functional products such as home appliances, furniture, interior design, automobiles, and so on, that are also beautiful objects; both mass produced and hand crafted.

Architecture The art of designing and constructing buildings; also, a building or buildings.

Art appreciation The understanding and enjoyment of art on a nonprofessional level.

Art criticism A systematic analysis of a work of art that may include some or all of the following components: description, formal analysis, interpretation, and judgment; *critics* deal with contemporary art, *historians* with art of the past.

Art history The documentation of art of the past; placing art into an historical and cultural context.

Art production Using art materials to make tutored images in an elementary art lesson or unit; in the adult world, artistry or the creation of art; organizing aesthetic concepts to convey nonverbal messages; in the adult world, the activity of an artist, usually working alone.

Art professionals In terms of the art disciplines, the aesthetician, art critic, art historian, and artist.

Art specialist teachers Elementary and secondary teachers with special certification (often K–12) whose primary responsibility is art.

Art therapy Using art to diagnose and treat personality disorders.

Artistic expression Transmission of ideas and emotions by the artist to his or her audience through a work of art.

Assemblage A three-dimensional artwork in which a variety of objects and materials are combined; see *Mixed media*.

Assessment The process of evaluating evidence in order to estimate the extent of student achievement or curriculum effectiveness.

Assimilation When ethnic groups within a society acquire the norms and values of the dominant culture of that society; see *Acculturation*.

Avant-garde In art, a movement or a group of artists perceived by the general public to be nonconformist or experimental, ahead of their time.

Balance The appearance of equilibrium in an art work; see *Principles of design*.

Camera oscura Originally, a dark chamber with a small hole in one wall through which light enters, creating an upside-down image on the opposite wall; the forerunner of the modern photographic camera.

Carving Producing a sculpture by cutting away material from a block of wood, stone, or softer material; also, the sculpture produced by this method; sometimes called *subtractive sculpture*.

Casting Producing a sculpture by pouring a liquid material that later hardens—such as plaster or molten metal—into a mold; also, a sculpture made by this process.

Ceramic Clay that has been changed into a hard, extremely durable substance through firing (baking) at a high temperature.

Ceramics The art of making objects—pottery or ceramic sculptures—out of fired clay; see *Crafts*.

Checklist A two-step rating scale; see *Rating scale*.

Chiaroscuro Literally, in Italian, "light and shade"; in two-dimensional art, changes in value that represent the changing appearance of a three-dimensional surface as light falls directly on it (sometimes referred to as *shading*); see *Value*.

Child-centered education Education organized around the needs of the child rather than around subject matter; employs teaching methods that involve as much direct contact with the physical world as possible.

Child development Physical, mental, and artistic maturation; see *Developmental styles (or stages) of graphic representation*.

Classroom teachers In elementary education, teachers of many subjects to one classroom of children at one age level; generalists in all of the subjects they teach, including art; certified K–8.

Cluster grouping Placing high-ability students in the same group, in order to challenge them.

Cognition The process of how people obtain and use knowledge.

Collaborative teaching A teaching strategy in which classroom teachers, art specialists community professionals, and university professors work together to provide a school art program.

Collage An artwork created by pasting fragments of paper, photographs, news clippings, and other materials onto a two-dimensional surface; see *Mixed media*.

Collograph A relief print made by inking layers of cardboard.

Color A visual element with three properties: *hue* (the quality that distinguishes one "color" from another, as red from green), *value* (lightness or darkness), and *intensity* (brightness or dullness); see *Visual elements*.

Color triad Any three hues equally spaced on the color wheel, such as red, yellow, and blue (a primary triad) and orange, green, and violet (a secondary triad).

Color wheel A circular chart used to display the relationships among the different hues; see *Color*.

Compacting the curriculum When advanced students take and pass a pretest in order to be excused from a lesson but still receive credit for it.

Complementary colors Any two hues opposite one another on the color wheel, such as orange and blue, red and green, or yellow and violet; equal amounts of complementaries when mixed produce a neutral; see *Hue, Color wheel*.

Composition The process of organizing an artwork; the arrangement of its visual components (elements and principles or sensory and formal properties); see *Design, Visual elements, Principles of design*.

Concept A class of two or more objects or events or aspects of images that share one or more features; concepts such as *redness*, *depth*, *diagonal*, and *contrast* are *aesthetic concepts*.

Conceptual consistency Refers, in an elementary art lesson or unit, to the integration of related concepts drawn from various art disciplines in order to produce a conceptual focus.

Content The meaning of an artwork as distinguished from its form or subject matter; see also *Lesson content*.

Content objectives The kinds of art concepts and skills that students are expected to develop as a result of schooling.

Context In a tutored image, all of the aesthetic concepts in addition to the ones taught in the lesson, which are called the *lesson content*.

Contextualism An approach to art and art criticism that stresses the relationships between art and society.

Contour An edge of an object or shape; a line that describes such an edge.

Conventional assessment Based on tests that require students to select answers rather than to generate them; generally paper-and-pencil tests.

Cool colors Blues, blue greens, blue purples—hues in which blue predominates; the opposite of *warm colors*.

Crafts or craft art Handmade objects such as pottery, jewelry, metal work, glass, and weavings that are both useful and aesthetic.

Creativity See *Invention*.

Criterion (plural, criteria) A standard on which a judgment is made (singular); distinct features or dimensions of art or performance identified for purposes of evaluating the whole (plural).

Criterion referenced Pertaining to a test that uses an absolute standard to measure what a student knows or can do.

Critical/historical/aesthetic analysis In an elementary art lesson or unit, the part of the lesson in which children study artists' use of the same concepts they used themselves in their art production; a time for *transfer of learning* and *aesthetic inquiry*.

Critical sensitivity Hurwitz's term for giftedness in understanding concepts from art criticism, history, and aesthetics; similar to *aesthetic literacy*.

Critique Art criticism practiced in a classroom for the purpose of instructing students.

Cultural diversity In education, the presence of students of differing cultures in a single classroom, or of a teacher from one cultural background teaching children from a different cultural background.

Cultural level In Feldman's levels of mastery, refers to the kinds of knowledge that all members of a culture acquire; includes folk arts, popular arts, and applied arts (see *Nonuniversal development*).

Cultural pluralism Various cultures and ethnic groups within a nation maintaining their own identities but without conflicting with the overarching values and laws of that nation.

Cultural realism See *Developmental stages of graphic representation*.

Culture The whole way of life—material, intellectual, moral, and spiritual—of a given society (*sociological definition*); the process of developing one's intellectual and moral faculties through education (*classical definition*).

Curriculum (plural, curricula) A detailed, written plan for art instruction; specifies concepts to be learned, not projects to teach them; should specify art concepts in sequence from lowest to highest grade levels in an elementary school or district.

Curriculum guide A curriculum-planning resource; may contain recommended content objectives, scope, and sequence of an art program; less specific than a curriculum.

Datum (plural, data) A single recorded observation that, along with others, provides evidence to be evaluated during the assessment process.

Deduction The use of deductive reasoning; working from the general to the specific.

Demonstration Modeling the making of art; the portion of art production when the teacher performs the work to be required of the students.

Description The process of giving a detailed account of something, either in words or in images; also, the act of depicting in art.

Design (of an artwork) Another term for the organization of an artwork; the arrangement of its visual elements (sensory properties); see *Composition; Visual elements; Principles of design*.

Developmental styles (or stages) of graphic representation Styles (or stages) through which children typically pass as they mature in art, particularly in the absence of art instruction: *scribbling* (ages 1–3), *preschematic* (3–5), *schematic* (5–8), *transitional* (8–11), and *realistic* or *cultural realism* (adolescence and beyond); some correspondence with Piaget's stages of *preoperational, concrete operations*, and *formal operations*, but no one-to-one relationship between the two systems.

Disciplinary processes Processes used by practitioners of the art disciplines during their inventive activities, including *descriptive, formal, interpretive* (both *internal* and *external*) and *evaluative* processes.

Discipline A body of knowledge with its own system of organization, methods of inquiry, and kinds of inventive processes; in art, the most commonly recognized disciplines are aesthetics, art criticism, art history, and art production

Discipline-based level In Feldman's levels of mastery, refers to art, criticism, historical investigations, or aesthetic inquiry that meets the standards of the discipline to which it belongs; the fine artists and related arts professionals who make it (see *Nonuniversal development*).

Dynamic states States of energy (such as action, inertia, motion, speed, energy, calm, frenzy) that artists can convey through visual elements and principles.

Eclectic Composed of ideas or elements borrowed from many different sources.

Educational connoisseurship Qualitative inquiry into classroom environments by highly knowledgeable professionals, generally in order to evaluate teaching.

Elements of art Formal elements that are the most fundamental components of a work of art (such as line, shape, texture, value, and color); also called *visual elements* and *sensory properties*.

Encaustic A painting medium in which hot wax is used as a vehicle for the pigments; unsuitable for elementary schools.

Environments or environmental art Art that surrounds, or shares the same space with, the viewer.

Evaluation The process of ascertaining the value or worth of something; see *Assessment*.

Evaluation criteria Distinct features or dimensions of the thing to be evaluated; also called *scoring criteria*.

Exceptional students Students with disabilities and also those with special gifts.

Expressionism A theory of art that emphasizes the communication of emotion.

Expressive properties The ways in which visual elements in a work of art, either singly or in combination (by means of design principles), convey meaning (moods, dynamic states, ideals or big ideas).

Figure-ground Refers to the perceptual tendency to divide a visual pattern into two kinds of shapes—figure (the focus of attention) and ground (remaining area)—with the figure(s) appearing to be on top of and surrounded by the ground; referred to in art as *positive shape* (figure) and *negative shape* (ground).

Fine art Artwork appreciated for its intrinsic value and typically found in art museums and galleries and discussed in art books and art magazines; distinguished from *applied arts* or *popular art*.

Folk art Arts representing the traditional artistic skills in any geographical or ethnic group; generally hand made, often serving some practical or symbolic purpose.

Foreshortening Representing an object in two-dimensional art according to the laws of *linear perspective*, when one of the object's dimensions recedes away from the picture plane into pictorial space.

Formal analysis The analysis of various aspects of form (lines, shapes, textures, values, colors, and their composition) in a work of art, as distinguished from the work's subject matter or content.

Formal properties See *Principles of design*.

Formalism A twentieth-century theory of art that emphasizes the meaning found in an artwork's formal qualities over that found in its subject matter or content.

Formative evaluation Evaluating someone or something before the completion of learning for the purpose of description, diagnosis, or improvement.

Fresco A way of painting murals on fresh plaster; the lime in the plaster binds the pigments to the wall.

General education The preparation of young people in the kinds of knowledge deemed necessary by their society in order for them to become productive adult citizens; the kind of education found in elementary schools, covering a range of subjects.

Gesso A smooth, white mixture of glue and chalk or plaster of paris; widely used before the introduction of synthetic media to coat wooden panels and canvas in preparation for drawing and painting.

Glass or glass art The art of making objects—vessels or sculptures—out of glass; see *Crafts*.

Global education Educational recognition of the fact that the world is becoming increasingly linked by international trade and by international organizations in health, education, research, police, and transnational associations.

Graphic design Advertising art.

Hatching Closely spaced parallel lines used in a drawing to suggest different shades of gray or middle values; also *cross hatching*, parallel lines at right angles to one another.

Health hazards Refers to art materials with toxic properties and hazardous equipment that do not belong in elementary school classrooms: solvents, aerosol sprays, metal fumes, dust from chalks, powdered clay and clay glazes, power tools, and so on.

Holistic Pertaining to the whole; in evaluation, refers to a global judgment; the opposite of *analytic*.

Hue The property of color that distinguishes one "color" from another; see *Color*, *Color wheel*, *Cool colors*, *Warm colors*.

Idiosyncratic level In Feldman's levels of mastery, refers to the art or art professionals who belong to the avant-garde; the highly skilled and highly inventive practitioners of their disciplines (see *Nonuniversal development*).

Image A visual likeness of a person or thing formed in a mirror, by a camera, or by an artist. Also a "mental image," a likeness held in the mind's eye.

Imagination The ability to form mental images. A creation of the mind, often dealing with images and scenarios that might be.

Inclusion Placing students with mild or moderate disabilities in regular class settings for most, if not all, of the school day; sometimes called *mainstreaming*.

Induction The use of inductive reasoning; working from the specific to the general.

Intaglio A print-making process in which the inked lines are cut or etched away; engravings and etchings are intaglio prints.

Integration In composing a curriculum, the bringing together of two or more subject matter areas—usually organized around a single theme or issue—for the purpose of creating a new unit or course of instruction; also, the bringing together of a subject matter and a skill, such as art and writing to do written art criticism; see different models of integration, including *informal*, *parallel-discipline*, *multidisciplinary unit* or *course*, and *interdisciplinary unit* or *course* in Chapter 11.

Intelligence The faculty that allows us to acquire and apply knowledge; perhaps a general intellectual ability (some people are smarter than others), or perhaps multiple abilities (people have different kinds of intellectual competencies).

Intelligence quotient (IQ) A measure that compares an individual's intellectual ability to the average intellectual performance for his or her age.

Intensity The relative purity of a color from bright to dull; see *Color*.

Interdisciplinary The bringing together of two or more educational disciplines, such as art and social studies, to create an integrated unit or course of instruction; see *Integration*.

Interpretation The act of clarifying the meaning of a work of art (by the critic, historian, or aesthetician) or of expressing or giving form to meaning (by the artist); may be both *internal* (having to do with the work) and *external* (having to do with its cultural context) processes.

Invention The ability to invent, to originate, to create.

Kinetic art A sculpture with movable parts set in motion by mechanical means or a natural source such as currents of air; see *Mobile*.

Learning contract A format designed to clarify objectives and expectations in individual instruction; signed by both student and teacher.

Lesson content Aesthetic concepts taught in art lessons or units and the inventive processes by which students use them to create new knowledge.

Levels of mastery Levels of expertise in any discipline, as identified by David Henry Feldman; see *Cultural, Discipline-based, Idiosyncratic, Unique,* and *Universal levels*.

Line A thin mark made by pencil, pen, chalk, brush, or similar tool; an outline or edge around a shape; see *Visual elements*.

Linear perspective A system of representing depth in two-dimensional art; based on the principle that parallel lines (as seen from a stationary viewpoint) appear to converge as they recede into the distance toward the horizon (the viewer's eye level), upon which are one or more *vanishing points* where the parallel lines converge; see *Foreshortening*.

Lithograph A print made from an image drawn or painted on a smooth limestone block; also, commercial offset lithography, a modern version using thin metal plates.

Medium (plural, media) The materials and methods used to make an artwork. A particular category of art such as painting, sculpture, printmaking, crafts, and so on.

Metals and jewelry Objects—jewelry, vessels, or small sculptures—made from precious metals and/ or gems; see *Crafts*.

Metaphor A figure of speech or a visual image in which a word or a symbol that ordinarily means one thing is used to describe another, as in the phrase *the dawn of mankind* or as in the painting by Magritte called *Time Transfixed*; see Chapter 6.

Mimesis Literally, imitation; a theory of art that emphasizes a relatively close resemblance between art and reality; see *Representational art*.

Mixed media Artworks in which two or more media are combined, such as *collage* or *assemblage*, two categories of mixed media peculiar to twentieth-century art.

Mobile A movable sculpture—usually suspended from a ceiling—with parts set in motion by currents of air; see *Kinetic art*.

Modeling Forming a three-dimensional artwork out of a pliable material such as clay or wax; also called *additive sculpture*.

Monoprint A one-of-a-kind print made from a painting on glass or on a table top.

Multicultural education Refers to the debate over cultural diversity in education, including even the definition and limits of diversity (see *Cultural diversity*).

Multiculturalism Refers to the discourse about cultural diversity in American society and how it should be addressed.

Multiple intelligences Howard Gardner's theory of multiple intellectual competencies: linguistic intelligence, logical-mathematical intelligence, musical intelligence, spatial intelligence, and bodily kinesthetic intelligence.

National standards In art education, content objectives developed in connection with the *Goals 2000: Educate America Act*.

Nature-nurture Shorthand for perennial debates in education over the roles of heredity and environment or between that which is universal and that which is cultural in child development.

Nonobjective art Refers to an emphasis on form (color, line, and pattern) and the complete absence of represented objects; the form is the subject matter.

Nonuniversal development The theory of David Henry Feldman that children's ways of thinking diverge as they become increasingly influenced by their surroundings; the opposite of universal development.

Norm A typical test score determined by testing many students with characteristics similar to those in a particular group; see *Standardized test*.

Norm referenced The use of a relative standard (a norm) to measure one student's performance on a test in comparison to the performance of others with similar characteristics (such as age, demographic background), as in a standardized test.

Parsons's stages of aesthetic development A scheme designed to account for children's development in responding to art; see Chapter 5.

Perception The process of acquiring information through the five senses (taste, touch, smell, hearing, and sight) and organizing it in such as way as to make sense of our surroundings or, as in *aesthetic perception*, of art.

Performance art An artwork involving an act, gesture, or stunt by the artist rather than a tangible object such as a painting or sculpture; "happenings" and "body art" are two variations.

Pictorial space An illusion of space created by an artist on a two-dimensional surface; also called *pictorial depth*.

Pigments The coloring matter in paints.

Popular art Chiefly products of the entertainment and advertising industries: comics, movies, television, photography, and so forth; distinguished from *fine art*.

Portfolio A collection of work accumulated over time containing a variety of kinds of work; may be reviewed and evaluated to assess student performance.

Preschematic stage See *Developmental stages of graphic representation*.

Primary hues (primary colors) Basic colors from which all others may be mixed; red, yellow, and blue, for pigmented colors (as distinguished from colored lights); see *Hue; Color wheel*.

Principles of design Guidelines for composing an artwork, typically including *variety, unity, rhythm,* and *balance* (terms vary); the way in which an artist employs the art elements (line, shape, and so on) in composing a work of art; also called *formal properties*.

Problem solving Artistic thinking: perceiving information, forming concepts, finding problems (forming hypotheses), reasoning, solving problems, applying the solutions to new challenges.

Rating scale A format for indicating the quality of various aspects of an object (art) or activity (student performance) by assigning it a number on a continuum, such as from 1 to 3, or 1 to 5, or 1 to 10.

Realism (realistic art) Refers to a relatively high degree of resemblance between the form of a painting or sculpture and what the eye sees in the real world.

Realistic stage See *Developmental stages of graphic representation*.

Reflected light Light reflected from surfaces in the environment; ambient, not direct, light.

Reliability With respect to a test, the ability to measure the same things no matter who gives it, to whom, wherever or whenever it is given.

Relief The projection of figures or forms from a flat background; refers both to sculpture and printing.

Representational art Refers to depicting visual features of the world realistically enough that viewers can recognize objects easily.

Rhythm In an artwork, a repetition of elements or features that are identical or similar; see *Principles of design*.

Rubric A short description or summary of more extensive material; a schema.

Schema In art, a visual symbol, code, or convention of form that corresponds structurally, but not always literally, to objects in nature.

Schematic stage See *Developmental stages of graphic representation*.

Scribbling stage See *Developmental stages of graphic representation*.

Secondary hues (secondary colors) Green, orange, and violet—each derived from mixing any two of the primary colors; see *Hue; Primary colors; Color wheel*.

Self-expression A reaffirmation of one's own being; not unique to the visual arts.

Sensory properties See *Elements of art*.

Serigraphy A print-making process that forces ink through a screen, usually a silk screen.

Shape An enclosed area, defined by its boundaries; see *Figure-ground, Visual elements*.

Social reconstructionism A radical critique of American culture by some educators who believe that U.S. education is tainted with discrimination and injustice; calls for its reform and for students to actively confront inequality and oppression.

Space (real space) The area between or surrounding shapes in two-dimensional art; also, called *volume* in three-dimensional art; sometimes referred to as *negative shape*; see *Figure-ground, Visual elements*.

Staff development An educational program designed to strengthen teachers' professional effectiveness.

Standard An acknowledged measure of quality; information that all children are expected to know; may be absolute or relative.

Standardized test Widely administered test covering knowledge and skills that all children with similar characteristics (such as age, demographic background) are expected to know; considered highly reliable; see *Norm*.

Summative evaluation In art education, evaluation of a completed work of art or student performance; a concluding appraisal based on a summary of principal points.

Symbols In art, icons (objects) or visual elements (aesthetic properties); *symbol systems* are languages couched in speech, numbers, writing and other notation, music, visual art, dancing, and other forms of expression.

Synthesis An inductive process that combines parts or separate elements to form a new and coherent whole.

Talent Traditionally considered a congenital aptitude for art possessed by a few individuals, who may or may not score high on conventional I.Q. tests; an artistic intelligence.

Technical properties Characteristics of art media and the ways in which artists manipulate them.

Technique Refers to the way or the skill with which art media are used.

Tertiary hues (tertiary colors) Any color made by mixing one primary and one secondary hue.

Test An instrument designed to collect information in order to determine knowledge, competence, or intelligence.

Texture The surface quality of things: smooth, rough, glossy, matte, and so forth (*real* texture), an important element particularly in craft art; also, *simulated* texture depicted in realistic painting and photography, sometimes more important than the texture of the work itself; also, *invented* texture, patterns created by the artist; see *Visual elements*.

Tiered assignments When advanced students study the same content as other students, but complete more elaborate assignments and take more difficult examinations.

Transitional stage See *Developmental stages of graphic representation*.

Tutored images Images made as a result of a teaching environment.

Unique level In Feldman's levels of mastery, refers to art or art professionals who are one of a kind within their disciplines, and will be for all time; for example, one Rembrandt van Rijn, one Harold Rosenberg, one Jacob Burckhardt, or one Plato; see *Nonuniversal development*.

Unity The state of being one, indivisible; in art, a perception that nothing is missing and nothing is extraneous; see *Principles of design*.

Universal development Refers to the theory that children's physical and mental maturation is the same in every culture; the rationale underlying the validity of developmental stages of graphic and aesthetic development; see *Nonuniversal development*.

Universal level In Feldman's levels of mastery, refers to images and artistic activity that are the same for all people of all cultures; occurs only in young children still relatively isolated from cultural influences; see *Nonuniversal development*.

Validity With respect to a test, the ability to measure whatever it claims to measure.

Value The relative lightness or darkness of a color; also used to describe a scale of grays from light to dark; see *Color*.

Variety Differences between and among elements or features of a composition; see *Principles of design*.

Vehicle The liquid in paint in which pigments or coloring agents are suspended.

Virtual reality An interactive computer-generated environment that substitutes for the viewer's visual field.

Visual analysis In an elementary art lesson or unit, the identification of aesthetic concepts by looking at visual images in which they are embedded; also called *focused scanning* because students search for a limited number of concepts.

Visual elements See *Elements of art*.

Vocabulary images In an elementary art lesson or unit, the images used during visual analysis to teach aesthetic concepts.

Vocabulary words In an elementary art lesson or unit, the verbal labels given to aesthetic concepts during visual analysis.

Warm colors Reds, yellows, yellow-oranges, red-violets, yellow-greens, and red-oranges; any colors (hues) in which red or yellow predominates; the opposite of *cool colors*.

Warranted assertions Credible hypotheses that have been tested over and over so many times that we accept them as true.

Wash Ink or paint thinned until it becomes translucent.

Bibliography

Art Education Today and Yesterday

Barnes, Earle, (Ed.) (1896-97). *Studies in education: A series of ten numbers devoted to child study and the history of education.* Palo Alto, CA: Stanford University.

Burton, Judith, Lederman, Arlene, & London, Peter (Eds.). (1988). *Beyond DBAE: The case for multiple visions of art education.* North Dartmouth, MA: University Council on Art Education.

Dobbs, Stephen M. (Ed.). (1979). *Arts education and back to basics.* Reston, VA: National Art Education Association.

Efland, Arthur D. (1990). *A history of art education: Intellectual and social currents in teaching the visual arts.* New York: Teachers College Press.

Eisner, Elliot W., & Ecker, David W. (1966). *Readings in art education.* Waltham, MA: Blaisdell.

Greer, W. Dwaine. (1984). Discipline-based art education: Approaching art as a subject of study. *Studies in Art Education, 25* (4).

Hamblen, Karen A. (1993). Neo-DBAE in the 1990s. *Arts and Learning SIG Proceedings Journal* (The American Educational Research Association). *10*(1), 132–141.

Korzenik, Diana. (1985). *Drawn to art: A nineteenth century American dream.* Hanover, NH: University Press of New England.

Logan, Fred. (1955). *Growth of art in American schools.* New York: Harper & Brothers.

Lowenfeld, Viktor. (1947). *Creative and mental growth.* New York: MacMillan.

Mann, Horace. (1844). *Common School Journal,* Vol. VI.

Mathias, Margaret. (1924). *The beginnings of art in the public schools.* New York: Scribner.

National Art Education Association (1994). *The national visual arts standards.* Reston, VA: Author.

Smith, Ralph A. (1986). *Excellence in art education: Ideas and initiatives.* Reston, VA: National Art Education Association.

Wygant, Foster. (1983). *Art in American schools in the nineteenth century.* Cincinnati: Interwood.

Wygant, Foster.r (1993). *School art in American culture.* Cincinnati: Interwood.

The Rationale for Art Education

American Council for the Arts. (1988). *Why we need the arts: 8 quotable speeches by leaders in education, government, business and the arts.* New York: Author.

Arnheim, Rudolf. (1989). *Thoughts on art education.* Los Angeles: The Getty Center for Education in the Arts.

Broudy, Harry S. (1972). *Enlightened cherishing: An essay on aesthetic education.* Urbana and Chicago: University of Illinois.

Broudy, Harry S. (1974). *General education: The search for a rationale.* Bloomington, IN: Phi Delta Kappa.

Broudy, Harry S. (1988). *The uses of schooling.* New York and London: Routledge.

College Entrance Examination Board. (1985). *Academic preparation for college: What students need to know and be able to do.* New York: College Board Publications.

Eisner, Elliot W. (1986). *The role of discipline-based art education in America's schools.* Los Angeles: Getty Center for Education in the Arts.

Feldman, David H. (1980). *Beyond universals in cognitive development.* Norwood, NJ: Ablex.

Gardner, Howard. (1991). *The unschooled mind: How children think and how schools should teach,* p. 9. New York: Basic Books.

Levi, Albert William, & Smith, Ralph A. (1991). *Art education: A critical necessity.* Chicago and Urbana and Chicago: University of Illinois.

National Arts Convention. (1988). *Why we need the arts.* New York: American Council for the Arts.

SALOMON, G. (1979). *The interaction of media, cognition and learning.* San Francisco: Jossey-Bass.

SMITH, RALPH A. (Ed.) (1987, 1989). *Discipline-based art education: Origins, meaning, and development.* Urbana and Chicago: University of Illinois.

WORKING GROUP ON THE ARTS IN HIGHER EDUCATION. (1988). *Arts education: Beyond tradition and advocacy.* Reston, VA: NASM, NASAD, NAST, NASD, and ICFAD.

KNOWLEDGE ABOUT ART FOR TEACHING

ADDISS, STEPHEN, & ERICKSON, MARY. (1993). *Art history and education.* Urbana and Chicago, IL: University of Illinois.

BROWN, MAURICE, & KORZENIK, DIANA. (1993). *Art making and education,* p. 121. Urbana and Chicago, IL: University of Illinois.

CONSORTIUM OF NATIONAL ARTS EDUCATION ASSOCIATIONS. (1994). *National standards for art education: What every young American should know and be able to do in the arts.* Reston, VA: Music Educators National Conference

DAVIS, DONALD JACK, & McCARTER, R. WILLIAM. (1994). An experiment in school/museum/university collaboration. *Metropolitan Universities, IV* (4), 25-34.

FELDMAN, EDMUND B. (1972). *Varieties of visual experience: Art as image and idea* (2nd ed.). Englewood Cliffs, NJ: Prentice Hall.

GREER, W. DWAINE. (1980). A structure of discipline concepts for DBAE. *Studies in Art Education, 28* (4), 227-233.

CHILDREN'S ARTISTIC DEVELOPMENT

ALLAND, ALEXANDER. (1983). *Playing with form: Children draw in six cultures.* New York: Columbia University.

BRITTAIN, W. LAMBERT. (1991). *Creativity, art, and the young child.* New York: Macmillan.

BUTTERWORTH, GEORGE (ED.). (1977). *The child's representation of the world.* New York and London: Plenum.

FREEMAN, NORMAN. (1980). *Strategies of representation in young children: Analysis of spatial skills and drawing processes.* London and New York: Academic (Harcourt Brace Jovanovich).

GARDNER, HOWARD. (1980). *Artful scribbles: The significance of children's drawings.* New York: Basic Books.

GARDNER, HOWARD. (1990). *Art education and human development.* Los Angeles, CA: The J. Paul Getty Trust.

GOLOMB, CLAIRE. (1974). *Young children's sculpture and drawing.* CAMBRIDGE: HARVARD UNIVERSITY.

GOLOMB, CLAIRE. (1992). *The child's creation of a pictorial world.* Berkeley, CA: University of California.

GOLOMB, CLAIRE (ED.). (1995). *The development of artistically gifted children: Selected case studies.* Hillsdale, NJ: Lawrence Erlbaum Associates.

KAMPEN. MARTIN. (1991). *Children's drawings.* New York: Plenum.

KELLOGG, RHODA. (1969). *Analyzing children's art.* Palo Alto, CA: National Press Books.

LARK-HOROVITZ, BETTY, LEWIS, HILDA, & LUCA, MARK (1973). *Understanding children's art for better teaching*

(2nd ed.). Columbus, OH: Charles E. Merrill.

LOWENFELD, VIKTOR. (1952). *Creative and mental growth* (revised ed.). New York: Macmillan.

CHILDREN'S CRITICAL AND AESTHETIC DEVELOPMENT

BELL, CLIVE. (1914/1949). *Art.* London: Ghatto and Windus.

BLOCKER, H. GENE. (1979). *Philosophy of art.* New York: Charles Scribner's Sons.

DANTO, ARTHUR C. (1992). *Beyond the brillo box.* New York: Farrar, Straus, Giroux.

DANTO, ARTHUR C. (1981). *The transfiguration of the commonplace: A Philosophy of art.* Cambridge, MA: Harvard University.

DEWEY, JOHN. (1938/1958). *Art as experience.* New York: Capricorn Books.

DICKIE, GEORGE. (1974). *Art and the aesthetic: An institutional analysis.* Ithaca, NY: Cornell University.

FRY, ROGER. (1920). *Vision and design.* London: Ghatto and Windus.

GARDNER, HOWARD, WINNER, ELLEN, & KIRCHER, MARY. (1975). Children's conceptions of the arts. *Journal of Aesthetic Education, 9* (3), 60-77

GARDNER, HOWARD, & PERKINS, DAVID (EDS.). (1988, 1989). *Art, mind & education: Research from Project Zero.* Urbana and Chicago: University of Illinois.

GREENBURG, CLEMENT. (1961). *Art and culture.* Boston: Beacon.

HARDIMAN, GEORGE W., & ZERNICH, THEODORE. (1985). Discrimination of style in painting: A developmental study. *Studies in Art Education, 26* (3), 157-162.

LANGER, SUSANNE K. (1957). *Philosophy in a new key: A study in the symbolism of reason, rite, and art* (3rd ed.). Cambridge, MA: Harvard University.

NATIONAL ART EDUCATION ASSOCIATION. (1990). *Quality art education: Goals for schools.* Reston, VA: Author.

PARSONS, MICHAEL J. (1987). *How we understand art.* Cambridge: Cambridge University.

SMITH, RALPH A., & SIMPSON, ALAN (EDS.). (1991). *Aesthetics and arts education.* Urbana and Chicago: University of Illinois.

TOLSTOY, LEO. (1896). Art as the communication of feeling. in George Dickie and R. J. Sclafani (1977), *Aesthetics: A critical anthology,* p. 66. New York: St. Martin's Press.

WEITZ, MORRIS. (1962). The role of theory in aesthetics. In Joseph Margolis (Ed.), *Philosophy looks at the arts* (pp. 48-60). New York: Charles Scribner's Sons (Original work published 1956)

THINKING WITHOUT WORDS

ARNHEIM, RUDOLF. (1969). *Visual thinking.* Berkeley: University of California.

ARNHEIM, RUDOLF. (1974). *Art and visual perception: A psychology of the creative eye* (The new version). Berkeley and Los Angeles: The University of California Press.

BARRON, FRANK. (1969). *The creative person and creative process.* NY: Holt, Rinehart & Winston.

Bourne, Lyle E. (1966). *Human conceptual behavior*. Boston: Allyn and Bacon

Broudy, Harry S. (1987). *The role of imagery in learning*. Los Angeles: The Getty Center for Education in the Arts.

Caine, Renate Nummela, & Caine, Geoffrey. (1991). *Making connections: Teaching and the human brain*. Alexandria, VA: Association for Supervision and Curriculum Development.

De la Croix, Horst, & Tansey, Richard. (1991). *Gardner's art through the ages* (9th ed.). San Diego: Harcourt Brace Jovanovich.

Dorn, Charles M. (1994). *Thinking in art: A philosophical approach to art education*. Reston, VA: National Art Education Association.

Feldman, Edmund B. (1982). *The artist*. Englewood Cliffs, NJ: Prentice Hall.

Feldman, Edmund B. (1985). *Thinking about art*. Englewood Cliffs, NJ: Prentice Hall.

Gardner, Howard. (1982). *Art, mind, and brain*. New York: Basic Books.

Gardner, Howard. (1983). *Frames of mind: The theory of multiple intelligences*. New York: Basic Books.

Gardner, Howard. (1993). *Multiple intelligences: The theory in practice; a reader*. New York: Basic Books.

Gibson, Eleanor J. (1969). *Principles of perceptual learning and development*. New York: Appleton-Century-Crofts.

Gibson, James J. (1966). *The senses considered as perceptual systems*. Boston: Houghton Mifflin.

Gilhooly, K. J. [sic] (1988). *Thinking: directed, undirected, and creative* (2nd Ed.). NY: Academic Press.

Gombrich, Ernst H. (1969). *Art and illusion: A study in the psychology of pictorial representation (paperback edition)*. Princeton, NJ: Princeton University.

Goodman, Nelson. (1968). *Languages of art: An approach to a theory of symbols*. Indianapolis: Bobbs-Merrill.

Hadamard, Jacques. (1945). *The psychology of invention in the mathematical field*. Princeton, NJ: Princeton University Press.

Halpern, Donald F. (1989). *Thought and knowledge: An introduction to critical thinking* (2nd Ed.). Hillsdale, NJ: Erlbaum.

Hoopes, J. (Ed.). (1991). *Peirce on signs: Writings on semiotics by Charles Sanders Peirce*. Columbia, NC: Chapel Hill, NC: University of North Carolina.

Kemeny, John G. (1959). *A philosopher looks at science*. New York: Van Nostrand.

Malkus, U., Feldman, David, & Gardner, Howard. (1988). Dimensions of mind in early childhood. In A. Pelligrini (Ed.), *The psychological bases of early education*, pp. 25-38. Chichester, U.K.: Wiley.

Marzano, Robert J. (1992). *A different kind of classroom: Teaching with dimensions of learning*. Alexandria, VA: Association for Supervision and Curriculum Development.

Moody, William J. (Ed.). (1990). *Artistic intelligences: Implications for education*. New York: Teachers College Press.

Nickerson, Raymond S., Perkins, David N., & Smith, Edward E. (1985). *The teaching of thinking*. Hillsdale, NJ: Erlbaum.

Perkins, David N. (1981). *The mind's best work*. Cambridge, MA: Harvard University.

Perkins, David N. (1984). Creativity by design. *Educational Leadership*, 42, 18-25.

Perkins, David N. (1986). *Knowledge as design*. Hillsdale, NJ: Erlbaum.

Piaget, Jean. (1955). *The language and thought of the child*. New York: Meridian.

Piaget, Jean. (1969). *The mechanisms of perception*. New York: Basic Books.

Piaget, Jean, & Inhelder, Bärbel. (1967). *The child's conception of space*. New York: Norton.

Piaget, Jean, & Inhelder, Bärbel. (1971). *Mental imagery in the child*. New York: Basic Books.

Popper, Karl. (1962, 1978). *Conjectures and refutations*. London: Routledge & Kegan Paul.

Resnick, Lauren B., & Klopfer, Leopold E. (Eds.). (1989). *Toward the thinking curriculum: Current cognitive research* (1989 ASCD Yearbook). Alexandria, VA: Association for Supervision and Curriculum Development.

Rush, Jean C. (1979). Acquiring a concept of artistic style. *Studies in Art Education*, 20 (3), 43-51.

Schlain, Leonard. (1991). *Art & physics: Parallel visions in space, time & light*. New York: William Morrow.

Sylwester, Robert. (1995). *A celebration of neurons: An educator's guide to the human brain*. Alexandria, VA: Association for Supervision and Curriculum Development.

Weiskrantz, Lawrence (Ed.). (1988). *Thought without language*. Oxford, England: Oxford University Press.

Whitehead, Alfred North (1929). *The aims of education*. New York: Macmillan.

Planning an Art Program

Alexander, Kay, & Day, Michael (Eds.). (1990). *Discipline-based art education: A curriculum sampler*. Los Angeles: Getty Center for Education in the Arts.

Association for Supervision and Curriculum Development. (1995). *Toward a coherent curriculum*. Alexandria, VA: Author.

Barkan, Manuel, Chapman, Laura H., & Kern, Evan J. (1970). *Guidelines: Curriculum development for aesthetic education*. St. Louis: Central Midwestern Regional Educational Laboratory (CEMREL).

Bloom, Benjamin S. (1954). *Taxonomy of educational objectives. Handbook I: Cognitive domain*. New York: Longmans, Green.

Brandt, Ronald S. (Ed.). (1988). *Content of the curriculum*. Alexandria, VA: Association for Supervision and Curriculum Development.

Brooks, J. G., & Brooks, M. G. (1993). *In search of understanding: The case for constructivist classrooms*. Alexandria, VA: Association for Supervision and Curriculum Development.

Broudy, Harry S. (1976). Three modes of teaching and their evaluation. In W. J. Gephart (Ed.), *Evaluation in teaching*, pp. 5-11. Bloomington, IN: Phi Delta Kappa.

California State Department of Education. (1982). *Visual and performing arts framework for California public schools: Kindergarten through grade twelve*. Author.

Clark, Gilbert A. (1991). *Examining discipline-based art education as a curriculum construct*. Bloomington, IN: ERIC:Art (Indiana University).

Dunn, Phillip C. (1995). *Creating curriculum in art*, p. 20. Reston, VA: National Art Education Association.

Efland, Arthur. (1977). *Planning art education in the mid-

dle/secondary schools of Ohio. Columbus, OH: State of Ohio, Department of Education.

EISNER, ELLIOT W. (1979). *The educational imagination: On the design and evaluation of school programs.* New York: Macmillan.

EISNER, ELLIOT W. (1982). *Cognition and curriculum: A basis for deciding what to teach.* New York: Longman.

GLATTHORN, ALLAN A. (1994). *Developing a quality curriculum.* Alexandria, VA: Association for Supervision and Curriculum Development.

HURWITZ, AL (ED.). (1978). *Programs of promise: Art in the schools.* New York: Harcourt Brace Jovanovich.

J. PAUL GETTY TRUST. (1993). *Improving visual arts education: Final report on the Los Angeles Getty Institute for Educators on the Visual Arts.* Los Angeles: Author.

JONES, BEAU F., PALINCSAR, ANNEMARIE S., OBLE, DONNA S., & CARR, EILEEN G. (1987). *Strategic teaching and learning: Cognitive instruction in the content areas.* Alexandria, VA: Association for Supervision and Curriculum Development.

LONDON, PETER (ED.). (1994). *Exemplary art education curricula: A guide to guides.* Reston, VA: National Art Education Association.

MOLNAR, ALEX. (ED.), *Current thought on curriculum* (1985 ASCD Yearbook). Alexandria, VA: Association for Supervision and Curriculum Development.

TYLER, RALPH. (1950). *Basic principles of curriculum and instruction.* Chicago: University of Chicago.

WALKER, DECKER (1990). *Fundamentals of curriculum.* New York: Harcourt Brace Jovanovich.

WOLF, DENNIE PALMER. (1992). Becoming knowledge: The evolution of art education curriculum. In Philip Jackson (Ed.), *Handbook of research on curriculum,* pp. 945-963. New York: Macmillan.

ZUMWALT, KAREN K. (ED.). (1986). *Improving teaching.* Alexandria, VA: Association for Supervision and Curriculum Development.

THINKING AND TALKING ABOUT ART

ARMSTRONG, THOMAS. (1994). *Multiple intelligences in the classroom.* Alexandria, VA: Association for Supervision and Curriculum Development.

BATTIN, MARGARET P., FISHER, JOHN, MOORE, RONALD, & SILVERS, ANITA. (1989). *Puzzles about art: An aesthetics casebook.* New York: St. Martin's Press.

BARRETT, TERRY. (1995). *Lessons in art criticism.* ERIC: Art (Indiana University) and Santa Monica, CA: The Getty Center for Education in the Arts.

CSIKSZENTMIHALYI, MIHALY, & ROBINSON, RICK E. (1990). *The art of seeing: An interpretation of the aesthetic encounter.* Los Angeles: Getty Center for Education in the Arts.

CROMER, JIM. (1990). *History, theory, and practice of art criticism in art education.* Reston, VA: National Art Education Association.

EATON, MARCIA M. (1988). *Basic issues in aesthetics.* Belmont, CA: Wadsworth.

ERICKSON, MARY (ED.). *Lessons about art in history and history in art.* Bloomington IN: ERIC:Art (Indiana University) (p. vii) and Santa Monica, CA: The Getty Center for Education in the Arts.

ERICKSON, MARY. (1983). Teaching Art History as inquiry process. *Art Education, 35* (5), 28-31.

FELDMAN, EDMUND B. (1967). *Art as image and Idea.* Englewood Cliffs, NJ: Prentice Hall.

FELDMAN, EDMUND B. (1994). *Practical art criticism.* Englewood Cliffs, NJ: Prentice Hall.

FITZPATRICK, VIRGINIA L. (1992). *Art history: A contextual inquiry course.* Reston, VA: National Art Education Association.

HAGAMAN, SALLY. (1990). Philosophical aesthetics in art education: A further look toward implementation. *Art Education, 43* (4), 30-35.

HARDIMAN, GEORGE W. AND ZERNICH, THEODORE. (1985). Discrimination of style in painting: A developmental study. *Studies in Art Education, 26* (3), 157-162.

HEWETT, GLORIA J., & RUSH, JEAN C. (1987). Finding buried treasures: Aesthetic scanning with children. *Art Education, 40* (1), 41-43.

HURWITZ, AL, & MADEJA, STANLEY S. (1977). *The joyous vision: Source book for elementary art appreciation.* Englewood Cliffs, NJ: Prentice Hall.

LANKFORD, E. LOUIS. (1992). *Aesthetics: Issues and inquiry.* Reston VA: National Art Education Association.

LIPMAN, MATTHEW. (1974). *Harry Stottlemeier's discovery.* Montclair NJ: Institute for the Advancement of Philosophy of Children.

PARSONS, MICHAEL J., & BLOCKER, H. GENE. (1993). *Aesthetics and education.* Urbana and Chicago: University of Illinois Press.

PERKINS, DAVID N. (1994). *The intelligent eye: Learning to think by looking at art.* Santa Monica, CA: The Getty Center for Education in the Arts.

RADER, MELVIN (ED.). (1979). *A modern book of esthetics.* New York: Holt, Rinehart and Winston.

SAYRE, HENRY M. (1989). *Writing about art.* Englewood Cliffs, NJ: Prentice Hall.

MAKING ART BY SOLVING PROBLEMS

ARMSTRONG, THOMAS. (1994). *Multiple intelligences in the classroom.* Alexandria, VA: Association for Supervision and Curriculum Development.

BEANE, JAMES A. (ED.). (1995). *Toward a coherent curriculum* (1995 ASCD Yearbook). Alexandria, VA: Association for Supervision and Curriculum Development.

CAINE, RENATE N., & CAINE, GEOFFREY. (1991). *Making connections: Teaching and the human brain.* Alexandria, VA: Association for Supervision and Curriculum Development.

GARDNER, HOWARD, & PERKINS, DAVID N. (1988). *Art, mind, and education: Research from Project Zero.* Urbana and Chicago: University of Illinois Press.

MARZANO, ROBERT J., BRANDT, RONALD S., HUGHES, CAROLYN S., JONES, BEAU F., PRESSEISEN, BARBARA Z., RANKIN, STUART C., & SUHOR, CHARLES. (1988). *Dimensions of thinking: A framework for curriculum and instruction.* Alexandria, VA: Association for Supervision and Curriculum Development.

MOODY, WILLIAM J. (ED.). (1990). *Artistic intelligences: Implications for education.* New York and London: Teachers College Press.

NICKERSON, RAYMOND S., PERKINS, DAVID N., & SMITH, EDWARD E. (1985). *The teaching of thinking.* Hillsdale, NJ: Erlbaum.

RESNICK, LAUREN B., & KLOPFER, LEOPOLD E. (EDS.). (1989). *Toward the thinking curriculum: Current cognitive research* (1989 ASCD Yearbook). Alexandria, VA: Association for Supervision and Curriculum Development.

RUCKER, RUDY. (1987). *Mind tools.* Boston: Houghton Mifflin.

RUSH, JEAN C. (1987). Interlocking images: The conceptual core of a discipline-based art unit. *Studies in art Education, 28* (4), 206-220.

RUSH, JEAN C. (1989). Coaching by conceptual consistency: Problems, solutions, and tutored images. *Studies in Art Education, 31* (1), 46-57.

ASSESSMENT

ARMSTRONG, C. *Designing assessment in art.* Reston, VA: National Art Education Association.

BOUGHTON, DOUGLAS, & LIGTVOET, JOHAN (EDS.). (1996). *Evaluating and assessing the visual arts in education: International perspectives.* New York: Teachers College, Columbia University.

CLARK, GILBERT, ZIMMERMAN, ENID, & ZURMUEHLEN, MARILYN. (1987). *Understanding art testing.* Reston, VA: National Art Education Association.

CONSORTIUM OF NATIONAL ARTS EDUCATION ASSOCIATIONS. (1994). *National standards for arts education,* pp. 121-127. Reston, VA: Author.

DAY, MICHAEL D. (1985). Evaluating student achievement in discipline-based art programs. *Studies in Art Education, 26* (4), 232-240.

ECKER, DAVID. W. (1981). *Qualitative evaluation in the arts: Proceedings of the First Summer Institute on Qualitative Evaluation in the Arts.* New York: New York University.

EISNER, ELLIOT. W. (1979). *The educational imagination: On the design and evaluation of school programs.* New York: Macmillan.

GARDNER, HOWARD. (1989). Zero-based arts education: An introduction to ARTS PROPEL. *Studies in Art Education, 30* (2), 71-83.

GRUBER, DONALD D. (1994). Evaluation of student achievement in K-12 art education programs: a balanced approach. *Art Education, 47* (2), 40-44.

GUSKEY, THOMAS R. (ED.). (1996). *Communicating student learning* (1996 ASCD Yearbook). Alexandria, VA: Association for Supervision and Curriculum Development.

HAMBLEN, KAREN. (1988). If it is to be tested, it will be taught: a rationale worthy of examination. *Art Education, 41* (5), 59-62.

HERMAN, JOAN L., ASCHBACHER, PAMELA R., & WINTERS, LYNN. (1992). *A practical guide to alternative assessment.* Alexandria, VA: Association for Supervision and Curriculum Development.

LOKV, NETHERLANDS INSTITUTE FOR ARTS EDUCATION. (1996). *Art & fact: Learning effects of arts education.* Utrecht, The Netherlands: Author.

MACGREGOR, RONALD N. (1992, November). A short guide to alternative assessment practices. *Art Education,* pp. 34-38.

MARZANO, R. J., PICKERING, D, & MCTIGHE, J. (1993). *Assessing student outcomes: Performance assessment using the dimensions of learning model.* Alexandria, VA: Association for Supervision and Curriculum Development.

NATIONAL ASSESSMENT OF EDUCATIONAL PROGRESS IN ART. (1978). *Knowledge about art.* Washington, DC: National Center for Educational Statistics, U. S. Department of Health, Education and Welfare, Education Division.

NATIONAL ASSESSMENT OF EDUCATIONAL PROGRESS IN ART. (1978). *Attitudes toward art.* Washington, DC: National Center for Educational Statistics, U. S. Department of Health, Education and Welfare, Education Division.

NATIONAL ASSESSMENT OF EDUCATIONAL PROGRESS IN ART. (1981, December). *Art and young Americans, 1974-79: Results from the second national art assessment.* Denver, CO: Author.

PERRONE, VITO (ED.). (1991). *Expanding student assessment.* Alexandria, VA: Association for Supervision and Curriculum Development.

SMITH-SHANK, DEBORAH L., & HAUSMAN, JEROME J. (1994). *Evaluation in art education.* Illinois Art Education Association.

STAKE, ROBERT. (1975). *Evaluating the arts in education: A responsive approach.* Columbus, OH: Charles Merrill.

WILSON, BRENT. (1971). Evaluation of learning in art education. In B. Bloom, J. Hastings, & G. Madaus (Eds.), *Handbook on formative and summative evaluation of student learning.* New York: McGraw-Hill.

WOLF, DENNIE PALMER, & PISTONE, NANCY. (1991). *Taking full measure: rethinking assessment through the arts.* New York: College Entrance Examination board.

INTEGRATING ART WITH OTHER SUBJECTS

ACKERMAN, DAVID B. (1989). Intellectual and practical criteria for successful curriculum integration. In Heidi Hayes Jacobs (Ed.), *Interdisciplinary curriculum: Design and implementation,* pp. 25-37. Alexandria, VA: Association for Supervision and Curriculum Development.

ACKERMAN, DAVID B., & PERKINS, DAVID N. (1989). Integrating thinking and learning skills across the curriculum. In Heidi Hayes Jacobs (Ed.), *Interdisciplinary curriculum: Design and implementation,* pp. 77-95. Alexandria, VA: Association for Supervision and Curriculum Development.

ARMSTRONG, CARMEN. (1990). *Development of the aesthetics resource: An aid for integrating aesthetics into art curricula and instruction.* De Kalb, IL: Author.

CLARK, GILBERT, ZIMMERMAN, ENID, & ZURMUEHLEN, MARILYN. (1987). *Understanding art testing.* Reston, VA: National Art Education Association.

DRAKE, SUSAN. (1993). *Planning integrated curriculum: The call to adventure.* Alexandria, VA: Association for Supervision and Curriculum Development.

ERNST, KAREN. (1994). *Picturing learning: Artists & writers in the classroom.* Portsmouth, NH: Heinemann.

GLATTHORN, ALLAN A. (1994). *Developing a quality curriculum.* Alexandria, VA: Association for Supervision and Curriculum Development.

JACOBS, HEIDI HAYES (ED.). (1989). *Interdisciplinary curriculum: Design and implementation.* Alexandria, VA: Association for Supervision and Curriculum Development.

KROGH, SUZANNE. (1990). *The integrated early childhood curriculum.* New York: McGraw-Hill.

OLSHANSKY, BETH. (1995). Picture this: An arts-based literacy program. *Educational Leadership, 53* (1), 44-47.

PERKINS, DAVID N. (1989). Selecting fertile themes for integrated learnin g. In Heidi Hayes Jacobs (Ed.), *Interdisciplinary curriculum: Design and implementation,* pp. 67-76. Alexandria, VA: Association for Supervision and Curriculum Development.

ART FOR CULTURALLY DIVERSE CLASSROOMS

ANDERSON, LEE F. (1991). A rationale for global education. In Kenneth A. Tye (Ed.), *Global Education: From thought to action* (1991 ASCD Yearbook), pp. 13-34. Alexandria VA : Association for Supervision and Curriculum Development .

BANKS, JAMES A., & LYNCH, JAMES (EDS.). (1986). *Multicultural education in Western societies.* New York: Praeger.

CHALMERS, F. GRAEME. (1992). D.B.A.E. as multicultural education. *Art Education, 45* (3), 16-19.

CHALMERS, F. GRAEME. (1996). *Celebrating pluralism: Art, education, and cultural diversity.* Los Angeles: Getty Center for Education in the Arts.

DISSANAYAKE, ELLEN. (1992). *Homo aestheticus: Where art comes from and why.* New York: The Free Press (Macmillan).

GRANT CARL A., & SLEETER, CHRISTIAN E. (1993). Race, class, gender, exceptionality, and education reform. In James A. Banks & Cherry A. McGee Banks (Eds.), *Multicultural education issues and perspectives* (2nd ed.). Boston: Allyn and Bacon.

HAMBLEN, KAREN A. (1988). Cultural literacy through multiple DBAE repertoires. *Journal of Multi-cultural and Cross-cultural Research in Art Education, 6* (1), 88-93.

LAMAY, STEVEN L. (1991). Global education: A conflict of images. In Kenneth A. Tye (Ed.), *Global education: From thought to action* (1991 ASCD Yearbook), pp. 53-59. Alexandria VA : Association for Supervision and Curriculum Development.

MASON, RACHEL. (1994). Artistic achievement in Japanese junior high schools. *Art Education, 47* (1), 8-19.

MCFEE, JUNE KING. (1988). Art and society. *Issues in discipline-based art education: Strengthening the stance, extending the horizons.* Los Angeles, CA: The Getty Center for Education in the Arts.

MCFEE, JUNE KING. (1961). *Preparation for art.* Belmont, CA. Wadsworth.

MCFEE, JUNE KING. (1993). Some perspectives from the social sciences. In *Seminar proceedings: Discipline-based art education and cultural diversity.* Santa Monica, CA: The J. Paul Getty Trust.

MCFEE, JUNE KING, & DEGGE, ROGENA. (1977). *Art, culture, and environment: A catalyst for teaching.* Dubuque, IA: Wadsworth.

OKAZAKI, AKIO. (1984). An overview of the influence of American art education literature on the development of Japanese art education. *Journal of Multi-cultural and Cross-cultural Research in Art Education.*

SMITH, RALPH A. (1994). *General knowledge in arts education: An interpretation of E.D. Hirsch's Cultural Literacy.* Urbana and Chicago: University of Illinois.

STUHR, PATRICIA L. (1994) Multicultural art education and social reconstruction. *Studies in Art Education , 35* (3), 171-178.

TYE, KENNETH A. (ED.). (1990). *Global education: From thought to action.* Alexandria, VA: Association for Supervision and Curriculum Development.

YOUNG, BERNARD (ED.). (1990). *Art, culture, and ethnicity.* Reston, VA: National Art Education Association.

ART FOR CHILDREN WITH DISABILITIES

ANDERSON, FRANCES. (1994). *Art-centered education and therapy for children with disabilities.* Springfield, IL: Charles C. Thomas

ANDERSON, FRANCES. (1992). *Art for all the children: Approaches to art therapy for children with disabilities.* Springfield, IL: Charles C. Thomas.

BLANDY, DOUGLAS. (1989). Ecological and normalizing approaches to disabled students and art education. *Art Education, 42* (3), 7-11.

GUAY, DORIS M. (1994). Students with disabilities in the art classroom: How prepared are we? *Studies in Art Education, 36* (1), 44-56.

HENLEY, DAVID. (1992). *Exceptional children: Exceptional art. teaching art to special needs.* Worcester, MA: Davis.

RODRIGUEZ, SUSAN. (1984). *The special artist's handbook: Art activities and adaptive aids for handicapped students.* Englewood Cliffs, NJ: Prentice Hall.

RUBIN, JUDITH. (1978). *Child art therapy.* New York: Van Nostrand Reinhold.

UHLIN, DONALD M., & DE CHIARA, EDITH. (1984). *Art for exceptional children* (3rd ed.). Dubuque, IA: Wm. C. Brown.

ULMAN, ELINOR, & DACHINGER, PENNY (EDS.). (1975). *Art therapy in theory and practice.* New York: Schocken Books.

VILLA, RICHARD A., & THOUSAND, JACQUELINE S. (EDS.). (1995). *Creating an inclusive school.* Alexandria, VA: Association for Supervision and Curriculum Development.

WILLIS, SCOTT. (1994, October). Making schools more inclusive. ASCD *Curriculum Update,* pp. 1-8.

ART FOR CHILDREN WITH SPECIAL GIFTS AND TALENTS

CLARK, GILBERT A., & ZIMMERMAN, ENID. (1987). *Resources for educating artistically talented students.* Syracuse N. Y.: Syracuse University.

CLARK, GILBERT A., & ZIMMERMAN, ENID. (1992). Issues and practices related to identification of gifted and talented students in the visual arts. *Translations: From Theory to Practice, 2* (2), n. p.

CSIKSZENTMIHALYI, MIHALY, & ROBINSON, RICK. E. (1986). Culture, time, and the development of talent. In Robert J. Sternberg and Janet E. Davidson, *Conceptions of giftedness,* p. 264. Cambridge, England: Cambridge University Press.

HURWITZ, AL. (1983). *The gifted and talented in art: A guide to program planning.* Worcester, MA: Davis.

MADEJA, STANLEY S. (ED). (1983). *Gifted and talented in art education.* Reston, VA: National Art Education Association

ROGERS, KAREN B. (1992). The relationship of grouping practices to the education of the gifted and talented Learner. *Translations: From Theory to Practice, 2* (1), n.p.

SALOME, RICHARD A. (1992). Research pertaining to the gifted in art. *Translations: From Theory to Practice, 2* (1), n.p.

SALOME, RICHARD A. (1992), Editor's introduction. *Translations: From Theory to Practice 2* (2)

WINEBRENNER, SUSAN. (1992). *Teaching gifted kids in the regular classroom.* Minneapolis: Free Spirit.

THE LANGUAGE OF ART

ARNASON, H. HARVARD. (1986). *History of modern art: Painting, sculpture, architecture, photography.* Englewood Cliffs, NJ: Prentice Hall; New York: Harry N. Abrams.

ARNHEIM, RUDOLF. (1974). *Art and visual perception: A psychology of the creative eye* (The new version). Berkeley and Los Angeles: The University of California Press.

COLE, HERBERT M. (1990). *Icons: Ideals and power in the art of Africa.* Washington, DC: Smithsonian Institution.

BARLEY, NIGEL. (1994). *Smashing pots: Works of clay from Africa.* Washington, DC: Smithsonian Institution.

FAULKNER, RAY, ZIEGFELD, EDWIN, & HILL, GERALD. (1941, 1949, 1956). *Art today: An introduction to the fine and functional arts.* New York: Henry Holt.

FICHNER-RATHUS, LOIS. (1989). *Understanding Art* (2nd ed.). Englewood Cliffs, NJ: Prentice Hall.

GOMBRICH, ERNST H. (1969). *Art and illusion: a study in the psychology of pictorial representation* (paperback edition). Princeton, NJ: Princeton University.

GOMBRICH, ERNST H. (1972). *The story of art* (12th ed.). New York, NY: Phaidon.

HENKES, ROBERT. (1995). *Native American painters of the twentieth century: The works of 61 artists.* Jefferson, NC: McFarland.

HOBBS, JACK A. (1991). *Art in Context* (4th ed.). San Diego CA: Harcourt Brace Jovanovich.

HOBBS, JACK A., & DUNCAN, ROBERT L. (1992) *Art, Ideas and Civilization* (2nd ed.). Englewood Cliffs, NJ: Prentice Hall.

ITTEN, JOHANNES. (1964). *Design and form: The basic course at the Bauhaus.* New York: Reinhold.

NATIONAL MUSEUM OF AFRICAN ART. (1987). *The art of West African kingdoms.* Washington, DC: Smithsonian Institution.

OLIVEIRA, NICHOLAS DE, OXLEY, NICOLA, & PETRY, MICHAEL (WITH TEXTS BY MICHAEL ARCHER). (1994). *Installation art.* Washington, DC: Smithsonian Institution.

OCVIRK, OTTO G., STINSON, ROBERT E., WIGG, PHILIP R., BONE, ROBERT O., & CAYTON, DAVID L. (1994). *Art fundamentals: Theory & practice* (7th ed.). Madison, WI, Dubuque, IA: Brown & Benchmark.

PRUSSIN, LABELLE. (1995). *African nomadic architecture: Space, place, and gender.* Washington, DC: Smithsonian Institution.

RICHARDSON, JOHN A., COLEMAN, FLOYD W., & SMITH, MICHAEL J. (1984). *Basic Design: Systems, Elements, Applications.* Englewood Cliffs, NJ: Prentice Hall.

RODRIQUEZ, SUSAN. (1988). *Art smart.* Englewood Cliffs, NJ: Prentice Hall.

Stoops, Jack, & Samuelson, Jerry. (1983). *Design Dialogue.* Worcester, MA: Davis.

SMITH, RALPH A. (1966). *Aesthetics and art criticism in art education.* Chicago: Rand McNally.

ZELANSKI, PAUL, & FISHER, MARY P. (1990) *The Art of Seeing* (2nd ed.). Englewood Cliffs, NJ: Prentice Hall.

THE TECHNIQUES OF ART FOR TEACHING

EDWARDS, BETTY. (1979). *Drawing on the right side of the brain.* Los Angeles: J. P. Tarcher.

ENSTICE, WAYNE, & PETERS, MELODY. (1990). *Drawing: Space, form, expression.* Englewood Cliffs, NJ: Prentice Hall.

HELLER, JULES. (1978). *Papermaking.* New York: Watson-Guptill.

MIRANKER, CATHY, & ELLIOTT, ALISON. (1995). *The computer museum guide to the best software for kids.* New York: Harper Collins.

NELSON, GLENN C. (1978). *Ceramics* (4th ed.). New York: Holt, Rinehart and Winston.

NICOLAIDES, KIMON. (1941). *The natural way to draw.* Boston: Houghton Mifflin.

ROMANO, CLARE, AND ROSS, JOHN. (1972). *The complete printmaker.* New York: Macmillan.

WILSON, MARJORIE, & WILSON, BRENT (1982). *Teaching children to draw: A guide for teachers and parents.* Englewood Cliffs, NJ: Prentice Hall.

WILSON, BRENT, HURWITZ, AL, & WILSON, MARJORIE. (1987). *Teaching drawing from art.* Worcester, MA: Davis.

CARTOON AND COMIC-STRIP ART

EISNER, WILL. (1985). *Comics and sequential art.* Tamarack, FL: Poorhouse Press.

ENGE, M. THOMAS. (1990). *Comics as culture.* Jackson, Miss.: University of Mississippi.

GOULART, RON (ED.). (1990). *Encyclopedia of American comics.* New York: Facts on File.

HALL, JUSTIN. (1994, November). Contrasting experience. *The Comics Journal,* #172, p. 8.

HARVEY, ROBERT C. (1994). *The art of the funnies: An aesthetic history.* Jackson, Miss.: University of Mississippi.

HOBBS, JACK A. (1995). Comic relief is in the news. *Learning, 24* (1), 48-49.

HOBBS, JACK, & SALOME, RICHARD. (1995). *The visual experience* (2nd ed). Worcester, MA: Davis.

McLUHAN, MARSHALL. (1964). *Understanding media.* New York: McGraw-Hill.

McLOUD, SCOTT. (1993). *Understanding comics: The invisible art.* New York: Harper Collins.

MOSHER, MIKE. (1994, August). On teaching kids comics. *The Comics Journal,* #170, p. 89.

SPIEGELMAN, ART. (1986). *Maus: A survivor's tale.* New York: Pantheon Books.

WERTHAM, FREDERIC, (1954). *Seduction of the innocent.* New York: Rinehart.

FILM HISTORY AND CRITICISM

BORDWELL, DAVID, & THOMPSON, KRISTIN. (1993). *Film art*. New York: McGraw-Hill.

BORDWELL, DAVID, STAIGER, JANET, & THOMPSON, KRISTIN. (1985). *The classical Hollywood cinema: Film style and mode of production to 1960*. New York: Columbia University.

COOK, DAVID. (1981). *A history of narrative film*. New York: W. W. Norton.

ERHLICH, LINDA. (1995). Animation for children: David Ehrlich and the Cleveland Museum of Art Workshop. *Art Education*, 48 (2), 24-27.

GIANNETTI, LOUIS. (1987). *Understanding movies* (4th ed). Englewood Cliffs: Prentice Hall.

MAST, GERALD, COHEN, MARSHALL, AND BRANDY, LEO (1992). *Film theory and criticism*. Oxford: Oxford University Press.

SOBCHACK, THOMAS AND VIVIAN (1987). *An introduction to film*. Boston: Little, Brown & Co.

MANAGING ART CLASSROOMS AND MATERIALS

BROOKS, JACQUELINE G., & BROOKS, MARTIN G. (1993). *In search of understanding: The case for constructiivist classrooms*. Alexandria, VA: Association for Supervision and Curriculum Development.

BROUCH, VIRGINIA M., & FUNK, FRANCHON F. (EDS.). (1987). *Appleseeds*. Reston, VA: National Art Education Association.

CRESPIN, LILA. (1987). *Managing materials and children with art activities*. Unpublished manuscript written for Phi Delta Kappa, Bloomington, IN.

CURWIN, RICHARD L., & MENDLER, ALLEN N. (1988). *Discipline with dignity*. Alexandria, VA: Association for Supervision and Curriculum Development.

HARMIN, MERRILL. (1994). *Inspiring active learning: A handbook for teachers*. Alexandria, VA: Association for Supervision and Curriculum Development.

JOHNSON, DAVID, JOHNSON, ROGER, AND HOLUBEC, EDYTHE JOHNSON. (1994). *Cooperative learning in the classroom*. Alexandria, VA: Association for Supervision and Curriculum Development.

KOHN, ALFIE. (1996). *Beyond discipline: From compliance to community*. Alexandria, VA: Association for Supervision and Curriculum Development.

MCCANN, MICHAEL. (1985). *Health hazards manual for artists*. New York: Lyons & Burford.

QUALLEY, CHARLES. (1986). *Safety in the artroom*. Reston, VA: National Art Education Association.

REISSMAN, ROSE. (1994). *The evolving multicultural classroom*. Alexandria, VA: Association for Supervision and Curriculum Development.

SUSI, FRANK. (1995). *Student behaviors in art classrooms: The dynamics of discipline*. Reston, VA: National Art Education Association.

UNITED STATES DEPARTMENT OF EDUCATION. (1986). *What works: Research about teaching and learning*. Washington, DC: Author.

THE SCHOOL LEARNING ENVIRONMENT

DAVIS, DONALD JACK, & MCCARTER, R. WILLIAM. *An experiment in school/museum/university collaboration*. (Unpublished manuscript.)

EISNER, ELLIOT W. (1991). *The enlightened eye: Qualitative inquiry and the enhancement of educational practice*. New York: Macmillan.

EISNER, ELLIOT W., & PESHKIN, A. (EDS.). (1990). *Qualitative inquiry in education: The continuing debate*. New York: Teachers College, Columbia University.

GALBRAITH, LYNN (ED.). (1995). *Preservice art education: Issues and practice*. Reston, VA: National Art Education Association.

J. PAUL GETTY TRUST. (1993). *Improving visual arts education: Final report on the Los Angeles Getty Institute for Educators on the Visual Arts*. Los Angeles: Author.

J. PAUL GETTY TRUST. (1993). *Perspectives on education reform: Arts education as catalyst*. Los Angeles: Author.

GLICKMAN, CARL D. (ED.). (1992). *Supervision in transition* (1992 ASCD yearbook). Alexandria, VA: Association for Supervision and Curriculum Development.

JOYCE, BRUCE (ED.). (1990). *Changing school culture through staff development* (1990 ASCD yearbook). Alexandria, VA: Association for Supervision and Curriculum Development.

KATZ, JONATHAN. (1988). *Arts & education handbook: A guide to productive collaborations*. Washington, DC: National Assembly of State Arts Agencies.

LIEBERMAN, ANN & MILLER, LYNNE. (1984). *Teachers, their world, and their work: Implications for school improvement*. Alexandria, VA: Association for Supervision and Curriculum Development.

STANLEY, SARAH J., & POPHAM, W. JAMES (EDS.). (1988). *Teacher evaluation: Six prescriptions for success*. Alexandria, VA: Association for Supervision and Curriculum Development

WILSON, BRENT. (1996). *The quiet evolution: Implementing discipline-based art education in six regional professional development consortia*. Los Angeles: The Getty Center for Education in the Visual Arts..

ZUMWALT, KAREN K. (ED.). (1986). *Improving teaching*. (1986 ASCD yearbook). Alexandria, VA: Association for Supervision and Curriculum Development.

EDUCATIONAL POLICY AND THE ARTS

ARTS EDUCATION AND AMERICANS PANEL. (1977). *Coming to our senses*. New York: McGraw-Hill.

BROMMER, GERALD, & GATTO, JOSEPH. (1984). *Careers in art: An illustrated guide*. Worcester, MA: Davis.

CHAPMAN, LAURA H. (1982). *Instant art, instant culture: The unspoken policy for American schools*. New York: Teachers College Press.

EISNER, ELLIOT W. (1995, June). Standards for American schools: Help or hindrance? *Phi Delta Kappan*, pp. 758-759, 761-64.

ELMORE, RICHARD F., & FUHRMAN, SUSAN H. (1994). *The governance of curriculum* (1994 ASCD Yearbook). Alexandria, VA: Association for Supervision and Curriculum Development.

GETTY CENTER FOR EDUCATION IN THE VISUAL ARTS. (1985). *Beyond creating: The place for art in America's schools.* Los Angeles, CA: The J. Paul Getty Trust.

GETTY CENTER FOR EDUCATION IN THE VISUAL ARTS. (1993). *Perspectives on education reform: Arts education as catalyst.* Los Angeles, CA: The J. Paul Getty Trust.

GETTY CENTER FOR EDUCATION IN THE VISUAL ARTS. (1993). *Improving visual arts education.* Los Angeles, CA: The J. Paul Getty Trust.

HARDIMAN, GEORGE W., & ZERNICH, THEODORE (EDS.). (1988). *Discerning art: Concepts and issues.* Champaign, IL: Stipes.

LANIER, VINCENT. (1991). *The world of art education.* Reston, VA: National Art Education Association.

LEONHARD, CHARLES. (1991). *The status of arts education in American public schools.* Urbana and Chicago: University of Illinois.

MATTIL, EDWARD L. (PROJECT DIRECTOR). (1966). *A seminar in art education for research and curriculum development* (Cooperative Research Project V002). University Park, PA: The Pennsylvania State University.

NATIONAL COMMISSION ON EXCELLENCE IN EDUCATION. (1983). *A nation at risk: The imperative for educational reform.* Washington, DC: U.S. Government Printing Office.

NATIONAL ENDOWMENT FOR THE ARTS. (1988). *Towards civilization: A report on arts education.* Washington, DC. Author.

NATIONAL RESEARCH CENTER OF THE ARTS (LOUIS HARRIS AND ASSOCIATES). (1992). *Americans and the arts VI: Nationwide survey of public opinion.* New York: American Council for the Arts.

SMITH, RALPH A., & BERMAN, RONALD (EDS.). (1992). *Public policy and the aesthetic interest: Critical essays on defining cultural and educational relations.* Urbana and Chicago: University of Illinois.

YAKEL, NORMAN C. (ED.). (1992). *The future: Challenge of change.* Reston, VA: National Art Education Association.

ART EDUCATION RESOURCE MATERIALS FOR THE CLASSROOM

ANDERSON, WARREN H. (1965). *Art learning situations for elementary education.* Belmont, CA: Wadsworth.

BAGLEY, MICHAEL T. (1987). *Using imagery in creative problem solving.* New York: Trillium.

BRIGHAM, DON L. (1989). *Focus on fine arts: Visual arts.* Reston, VA: National Art Education Association.

CHANDRA, JACQUELINE. (1994). *African arts & Cultures.* Worcester, MA: Davis.

CHAPMAN, LAURA H. (1978). *Approaches to art in education.* New York: Harcourt Brace Jovanovich.

CHAPMAN, LAURA H. (1985). *Discover art: Levels 1-6.* Worcester, MA: Davis.

CHAPMAN, LAURA H. (1989). *Teaching art: 1-3 and 3-6.* Worcester, MA: Davis.

CHAPMAN, LAURA H. (1992). *A world of images.* Worcester, MA: Davis.

CHAPMAN, LAURA H. (1992). *Images and ideas.* Worcester, MA: Davis.

CHAPMAN, LAURA H. (1994). *Adventures in art: Grades 1-6.* Worcester, MA: Davis.

COLBERT, CYNTHIA, & TAUNTON, MARTHA. (1990). *Discover art kindergarten.* Worcester, MA: Davis.

D'ALLEVA, ANNE. (1993). *Native American arts & cultures.* Worcester, MA: Davis.

EISNER, ELLIOT W. (1972). *Educating artistic vision.* New York: Macmillan.

ERNST, KAREN. (1993). *Picturing learning: Artists and writers in the classroom.* Portsmouth, NH: Heinemann.

FELDMAN, EDMUND B. (1970). *Becoming human through art: Aesthetic experience in the school.* Englewood Cliffs, NJ: Prentice Hall.

GILBERT, RITA. (1994). *Living with art* (4th ed). McGraw-Hill.

GRIGSBY, EUGENE J., JR. (1977). *Art and ethnics: Background for teaching youth in a pluralistic society.* Dubuque: William C. Brown.

GREER, W. DWAINE (PROGRAM COORDINATOR, SOUTH WEST REGIONAL EDUCATIONAL LABORATORY). (1977). *The SWRL Elementary Art Program.* Bloomington, IN: Phi Delta Kappa.

HERBERHOLZ, BARBARA, & HANSON, LEE. (1995). *Early childhood art* (5th ed.). Madison, WI, Dubuque, IA: Brown & Benchmark.

HOBBS, JACK A., & SALOME, RICHARD A. (1994). *The Visual Experience* (2nd ed.) Worcester, MA: Davis.

HUBBARD, GUY. (1982). *Art for elementary classrooms.* Englewood Cliffs, NJ: Prentice Hall.

HUBBARD, GUY. (1987). *Art in action: Levels 1-6.* San Diego: Coronado.

JOHNSON, ANDRA (ED.). (1992) *Art education: elementary.* Reston, VA: National Art Education Association.

KAUFMAN, IRVING. (1966). *Art and education in contemporary culture.* New York: Macmillan.

LANSING, KENNETH M. (1970). *Art, artists, and art education.* New York: McGraw-Hill.

LINDERMAN, EARL, & HERBERHOLZ, DONALD. (1964). *Developing artistic and perceptual awareness: Art practice in the elementary classroom.* Dubuque, IA: Wm. C. Brown.

MACK, STEVIE, & CHRISTINE, DEBORAH. (1985). *Expressions of a Decade:CRIZMAC Master Pack.* Tucson, AZ: CRIZMAC Art & Cultural Education Materials.

MCFEE, JUNE KING. (1961). *Preparation for art.* Belmont, CA: Wadsworth.

MCKIM, ROBERT H. (1972). *Experiences in visual thinking.* Monterey, CA: Brooks Cole.

MITTLER, GENE A. (1986). *Art in focus.* Encina, CA: Glencoe.

MOORE, RONALD (ED.). (1995). *Aesthetics for young people.* Reston, VA: National Art Education Association.

RAGANS, ROSALIND. (1988). *Art Talk.* Mission Hills, CA: Glencoe.

SILVERMAN, RONALD H. (1982). *Learning about art: A practical approach.* Newport Beach, CA: Romar Arts.

SMITH, NANCY R. (1983). *Experience & art: Teaching children to paint.* New York: Teachers College Press.

THOMPSON, CHRISTINE (ED.). (1995). *The visual arts and early childhood learning.* Reston, VA: National Art Education Association.

WACHOWIAK, FRANK. (1985). *Emphasis art: A qualitative art program for elementary and middle schools* (4th ed.). New York: Harper & Row.

Photo Credits

Chapter 2

Figure: 2-6, page 25: Copyright Archivi Alinari, 1990/Art Resource.

Chapter 3

Figure: 3-11, page 38: 20th-century photograph of the model, 20.3 x 19.8 cm (image size). Gift of the Architects Collaborative. Courtesy of the Busch-Reisinger Museum/Harvard University Art Museums.

Chapter 5

Figure: 5-3, page 65: Silkscreen ink on wood. Each box 17⅛ x 17⅛ x 14." © 1997 The Andy Warhol Foundation for the Visual Arts/Artists Rights Society (ARS), New York.

Chapter 6

Figures: 6-3, page 76: oil on canvas, 1938, 147 x 98.17 cm. Photograph © 1996, The Art Institute of Chicago. All Rights Reserved. © 1997 C. Herscovici, Brussels/Artists Rights Society (ARS), New York; **6-6, page 80:** "Large Reclining Nude," formerly "The Pink Nude," 1935. Oil on canvas, 26 x 36½" (66 x 92.7 cm). The Cone Collection formed by Dr. Claribel Cone and Miss Etta Cone of Baltimore, Maryland/The Baltimore Museum of Art (BMA) 1950.258. © 1997 Succession H. Matisse, Paris/Artists Rights Society (ARS), New York; **6-7, page 83:** *Study of a Plaster Cast*, Amsterdam, Van Gogh Museum (Vincent van Gogh Foundation).

Chapter 9

Figures: 9-6, page 137: Kathe Kollwitz, German. Gift of L. Aaron Lebowich. Courtesy of Museum of Fine Arts, Boston. © 1997 VG Bild-Kunst, Bonn/Artists Rights Society (ARS). New York; **9-7, page 138:** © 1997 Elizabeth Catlett/Licensed by VAGA, New York, N.Y. **9-12, page 147:** Ink on paper, 10¼ x 7½" (26.0 x 19.0 cm);

9-17K, page 154: ink on paper, 20¼ x 15⅛" (51.3 x 38.4 cm); **9-17L, page 154:** ink on paper, 16 x 11" (40.6 x 28.6 cm); **9-17M, page 154:** ink on paper, 10¼ x 7½" (26.0 x 19.0 cm); **9-17N, page 154:** pencil on paper, 8⅝ x 8¾" (22.0 x 22.2 cm); **9-17O, page 154:** ink and wash on paper, 9⅜ x 12½" (23.8 x 31.8 cm); **9-18P, page 156:** ink and wash on paper, 10¼ x 7¾" (25.8 x 19.6 cm); **9-18Q, page 156:** ink on paper, 13¼ x 8¾ (33.6 x 22.3 cm); **9-18R, page 156:** ink on paper, 8⅝ x 6⅜ (21.8 x 16.1, cm); **9-18S, page 156:** charcoal on paper, 18⅛ x 12¾" (45.5 x 32.5 cm); **9-18T, page 156:** pencil, ink and wash on paper, 7⅝ x 9¾" (19.3 x 24.7 cm).

Chapter 11

Figure: 11-2, page 188: from *Horton Hatches the Egg* by Dr. Seuss. TM and © 1940 and renewed 1968 by Dr. Seuss Enterprises, L.P. Reprinted by permission of Random House, Inc.

Chapter 12

Figures: 12-1, page 200: © 1994 Etta Hulme/Fort Worth Star-Telegram; **12-3, page 208:** Frank Driggs Collection/Archive Photos.

Chapter 14

Figures: 14-2, page 230: "Docteur Jean-Louis Robin," graphite, with stumping, on ivory wove paper, c. 1808/09, 28.4 x 22.3 cm. Gift of Mrs. Emily Crane Chadbourne, 1953.204/photograph © 1996, The Art Institue of Chicago. All Rights Reserved; **14-3, page 230:** Lebrun, Rico, USA (1900-1964). Santa Barbara Museum of Art, Gift of Mr. and Mrs. Arthur B. Sachs; **14-12, page 238:** Gray scale from *The World of Art, 2/e,* by Henry Sayre. **14-14, page 240:** Charles White, b. 1918. Collection of Whitney Museum of American Art.

Chapter 15

Figures: 15-1, page 257: from *The Art of Responsive Drawing,* © 1973. Reprinted by permission of Prentice-Hall, Inc., Upper Saddle River, NJ; **15-2, page 258:** © The Board of Trustees of the Victoria & Albert Museum, London; **15-7, page 262:** The Metropolitan Museum of Art, Amelia B. Lazarus Fund, 1910, #10.228.3; **15-18, page 268:** Lithograph, printed in color, 49⅝ x 36⅛" (126 x 91.17 cm). The Museum of Modern Art, New York. Gift of A. Conger Goodyear. Photograph © 1997, The Museum of Modern Art, New York; **15-23, page 272:** Paul Strand, American. Alfred Stieglitz Collection, #1949.885/Photograph © 1996. The Art Institute of Chicago. All Rights Reserved. **15-25, page 273:** Talbot (1800-1877), Heliphila, 1839. The Bertolini Album, leaf 18. Salted paper print photogenic drawing, 17.0 x 17.3 cm. The Metropolitan Museum of Art, Harris Brisbane Dick Fund, 1936, #36.37.

Chapter 16

Figures: 16-20, page 289: Esto Photographics, Inc., #1PP42. Ezra Stoller/ © Esto; **16-24, page 292:** Copyright by Fred W. McDarrah.

Chapter 17

Figure: 17-4, page 317: from Spiegelman, Art (1986). "Maus: A Survivor's Tale." © 1986 Random House, Inc., Pantheon Books, New York.

Index